Oil Paintings in Public Ownership in
Tyne & Wear Museums

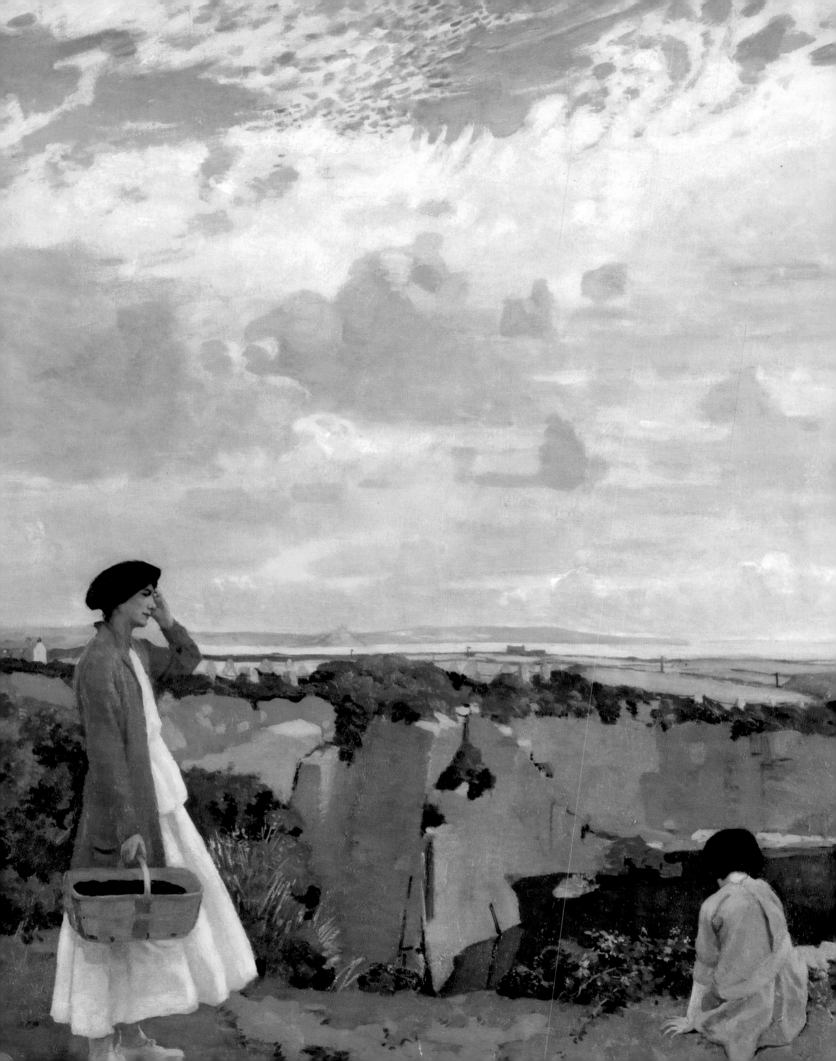

Oil Paintings in Public Ownership in Tyne & Wear Museums

The Public Catalogue Foundation

Andrew Ellis, Director
Sonia Roe, Editor
Christine MacKinnon, Tyne & Wear Museums
Coordinator
Robert Glowacki, Todd-White Art Photography

First published in 2008 by the Public Catalogue Foundation, 33 Maiden Lane, Covent Garden, London WC2E 7JS.

© 2008 the Public Catalogue Foundation, registered charity number 1096185. Company limited by guarantee incorporated in England and Wales with number 4573564. VAT registration number 833 0131 76. Registered office: The Courtyard, Shoreham Road, Upper Beeding, Steyning, West Sussex, BN44 3TN.

We wish to thank the individual artists and all the copyright holders for their permission to reproduce the works of art. Exhaustive efforts have been made to locate the copyright owners of all the images included within this catalogue and to meet their requirements. Any omissions or mistakes brought to our attention will be duly attended to and corrected in future publications. Owners of copyright in the paintings illustrated who have been traced are listed in the Further Information section.

Photographs of paintings are © the collections that own them, except where otherwise acknowledged.

Forewords to each collection are © the respective authors.

The responsibility for the accuracy of the information presented in this catalogue lies solely with the holding collections. Suggestions that might improve the accuracy of the information contained in this catalogue should be sent to the relevant collection and emailed to info@thepcf.org.uk.

ISBN 1-904931-44-8 (hardback)
ISBN 1-904931-45-6 (paperback)

Tyne and Wear photography: Robert Glowacki, Todd-White Art Photography

Designed by Sally Jeffery

Distributed by the Public Catalogue Foundation, 33 Maiden Lane, Covent Garden London WC2E 7JS Telephone 020 7395 0330

Printed and bound in the UK by Butler & Tanner Printers Ltd, Frome, Somerset

Cover image:

Martin, John 1789–1854
The Destruction of Sodom and Gomorrah (detail), 1852
Laing Art Gallery, (see p. 180)

Image opposite title page:

Harvey, Harold C., 1874–1941, *Blackberrying* (detail), 1917, South Shields Museum and Art Gallery, (p. 255)

Back cover images (from top to bottom):

Gauguin, Paul 1848–1903
The Breton Shepherdess, 1886 (detail)
Laing Art Gallery, (see p. 144)

Janssens, Abraham c.1575–1632
Diana after the Chase, c.1618 (detail)
Shipley Art Gallery, (see p. 39)

Lowry, Laurence Stephen 1887–1976
River Wear at Sunderland, 1961 (detail)
Sunderland Museum & Winter Gardens, (see p. 300)

Christie's is proud to be the sponsor of The Public Catalogue Foundation in its pursuit to improve public access to paintings held in public collections in the UK.

Christie's is a name and place that speaks of extraordinary art. Founded in 1766 by James Christie, the company is now the world's leading art business. Many of the finest works of art in UK public collections have safely passed through Christie's, as the company has had the privilege of handling the safe cultural passage of some of the greatest paintings and objects ever created. Christie's today remains a popular showcase for the unique and the beautiful.
In addition to acquisition through auction sales, Christie's regularly negotiates private sales to the nation, often in lieu of tax, and remains committed to leading the auction world in the area of Heritage sales.

CHRISTIE'S

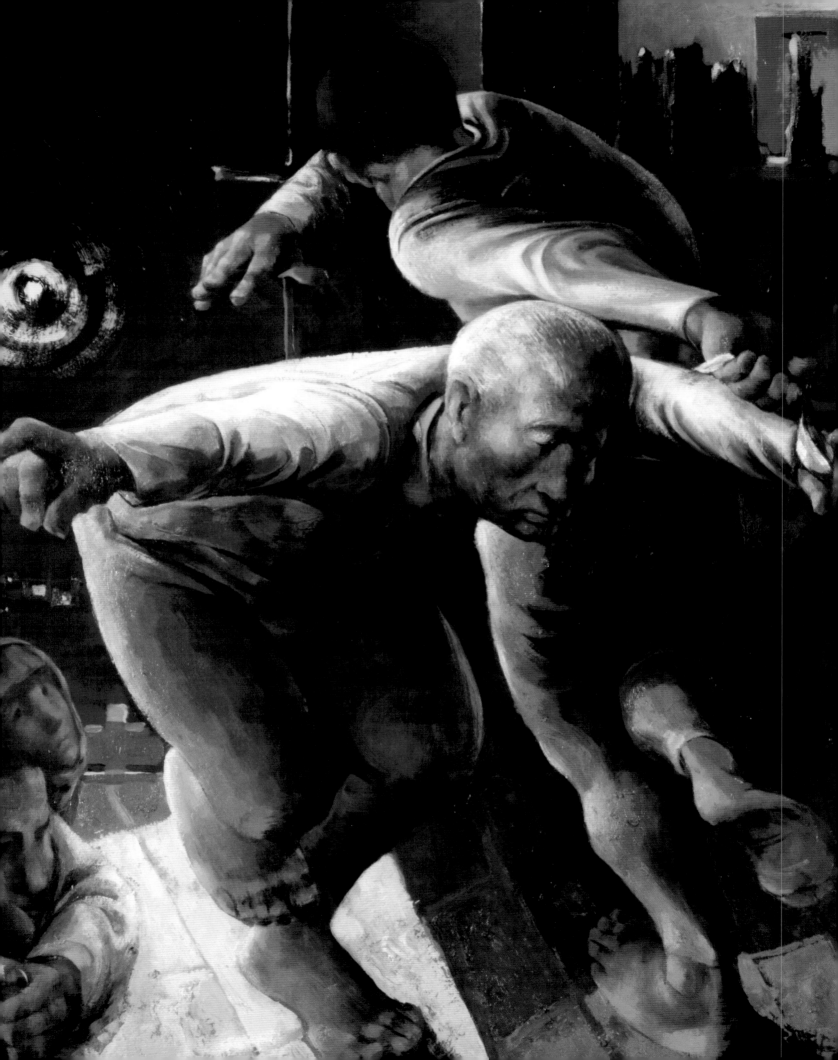

Contents

Facing page: Ayrton, Michael, 1921–1975, *Slow Dance for the Nativity* (detail), 1958, Sunderland Museum and Winter Gardens, (p. 273)

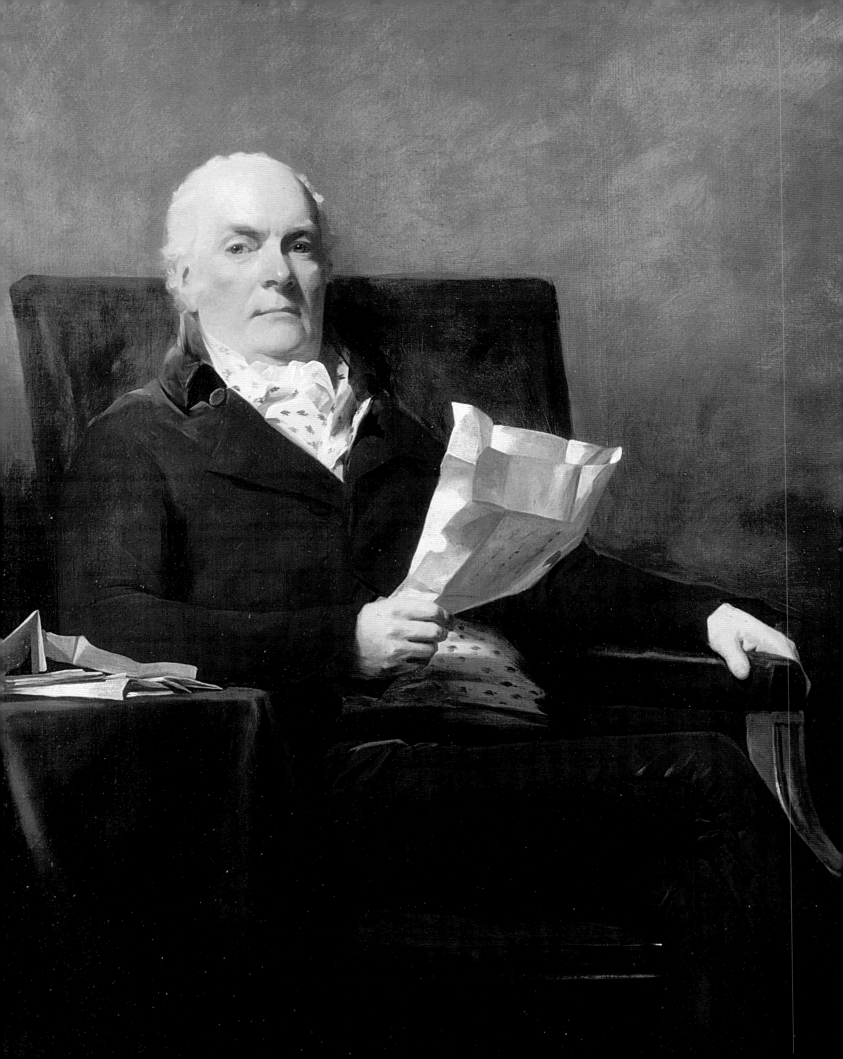

Foreword

The call to arms for the North East came to us from Professor Kenneth McConkey, the distinguished Professor of Art History at the University of Northumbria. With him on side, strong institutional and financial support came from Renaissance North East (the North East Regional Museums Hub) and Tyne & Wear Museums in particular. The result is this, the first of three catalogues covering the North East region.

If I focus now on the Laing Art Gallery, it is not just because it is the largest in this catalogue but because it is a collection of national importance. The Cullercoats artists are strongly represented and could compete with, say, the Newlyn School for public recognition. Their impact was wide, as the American painter, Winslow Homer, illustrates. The Laing, though, is much more than a local gathering. Its curators continued to build the collection throughout the twentieth century and its strength in British Art of this period is remarkable.

So why is it not a greater place of popular cultural pilgrimage, for visitors from both home and abroad? Why is it that in Italy, and Spain, Venice and Florence, Barcelona and Seville, are visited as readily as the metropolis – but that here in Britain, London rules alone?

London's performing Arts attract some 12.5 million visitors a year, who spend over £400 million on theatre tickets alone. Which is wonderful. London has 250 museums and galleries and 7 of the top 40 in the world. We are rightly proud of London, but London is only a fraction of what is on offer in Britain. Why does someone not say so, and in a voice loud enough for all to hear?

I think the reason lies in the failure to recognise that the regional collections such as the Laing, with their extraordinary wealth of art, are all parts of one National Collection and that they need to be understood and promoted as such. This unique National Asset needs a single National Voice.

This Foundation, with its tiny resources, cannot be that voice. But we can, through these catalogues and more importantly, through our Internet project, spread the word around the globe. If 2012 is to be a Cultural Olympics for this country as a whole, though, more needs doing. To this end we are looking into the possibility offered by two supportive charities, of producing a series of regional exhibitions in London, to tell visitors and residents alike what treasures can be seen all over this country simply by getting on a train.

I am hugely grateful not only to Alec Coles, Director of Tyne & Wear Museums, but also to his many colleagues who worked so hard to ensure the data was available for us in the right form. The Northern Rock Foundation provided substantial financial funding for this volume and the other two catalogues of the region which will follow. Without the support of the Trustees of the Northern Rock Foundation, these catalogues might not have been possible. Fenwick Ltd stepped in to complete the funding and for this and more I am much indebted to my fellow Mercer, John Fenwick, and to the Chairman of Fenwick Ltd, Mark Fenwick. Finally, my thanks go to Chris Mackinnon, our County Coordinator, for all her hard work in bringing this splendid volume into existence.

Fred Hohler, Chairman

Facing page: Raeburn, Henry, 1756–1823, *Robert Allan of Kirkliston (1740–1818)* (detail), 1800, Laing Art Gallery, (p. 196)

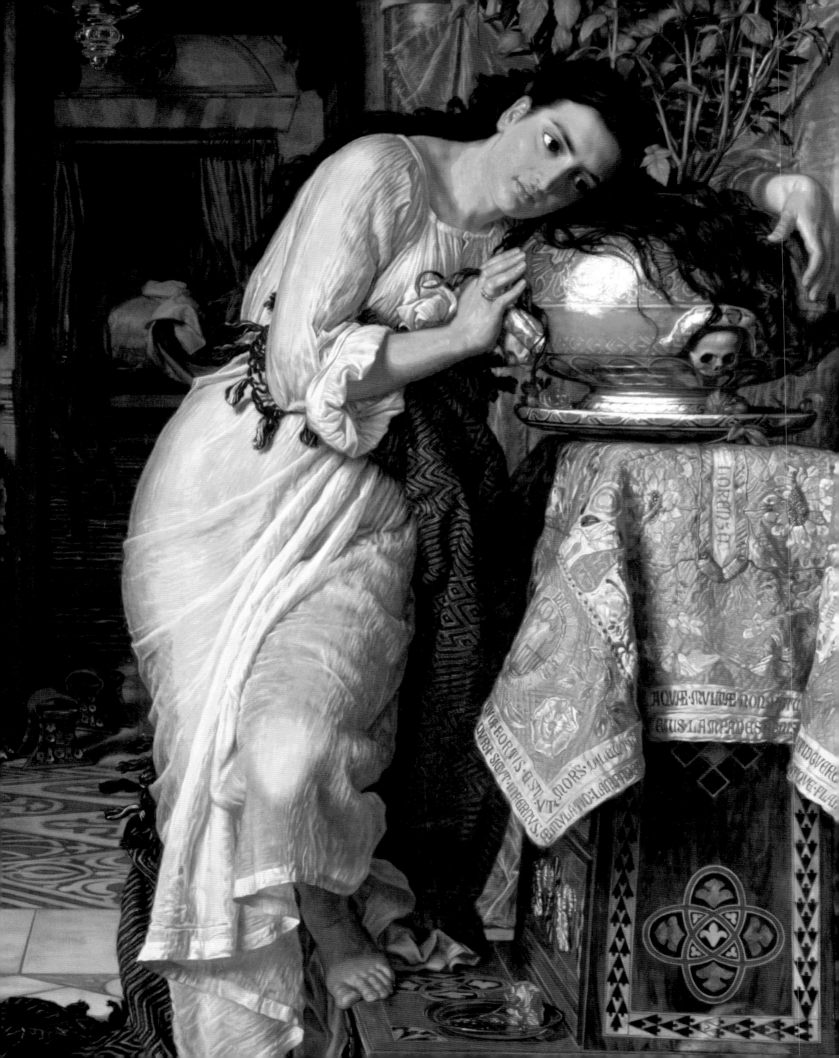

The text visible on the cloth reads in part:

AQVAE MVLTAE NON...
...LVS LAMPADES...
...VIA FORTIS EST VT MORS VILECTIO...
...DVRA SICVT INFERNVS EMVLATIO LAMPAD...

Preface

I am delighted to provide the Preface to this important volume of the Public Catalogue Foundation on the collections of Tyne & Wear Museums.

It is a great privilege to be Chair of the Tyne & Wear Museums Joint Committee, and therefore responsible for one of the largest regional museums services in the country, and one that is almost unique in terms of its funding arrangements

Tyne & Wear Museums is also leader of the North East Regional Museums Hub. Through the Hub, we have taken the lead in ensuring that not only this volume, but also two complementary volumes, covering the remainder of the North East, will appear.

The Public Catalogue Foundation is a bold endeavour in every respect, and is extremely timely in featuring our extraordinary painting collections. It has been increasingly difficult to secure funding for published catalogues of our collections and this will represent the first such survey of our collections for some 20 years, and the most comprehensive ever.

The production and publication of this volume will serve to open up the entirety of our exceptional collections to a much wider audience: catalogues will, for instance, be made available to a wide range of educational institutions in the region. Additionally, the work that has been carried out to produce the catalogue will be used to create a series of web resources that will greatly extend the range and reach of Tyne & Wear Museums' collections online.

I am particularly grateful to the Public Catalogue Foundation, to the Northern Rock Foundation, Fenwick Ltd and to the Museums, Libraries and Archive Council's *Renaissance* programme for their generous financial support of this volume. I am also grateful to all of those who worked on its production, particularly the Tyne & Wear Museums staff who sought to ensure that not a painting was missed in this great endeavour.

Councillor Ged Bell, Chairman, Tyne & Wear Museums

Facing page: Hunt, William Holman, 1827–1910, *Isabella and the Pot of Basil* (detail), 1867, Laing Art Gallery, (p. 166)

The Public Catalogue Foundation

The Public Catalogue Foundation is a registered charity. It is publishing a series of illustrated catalogues of all oil paintings in public ownership in the United Kingdom.

The rationale for this project is that whilst the United Kingdom holds in its public galleries and civic buildings arguably the greatest collection of oil paintings in the world, an alarming four in five of these are not on view. Furthermore, few collections have a complete photographic record of their paintings let alone a comprehensive illustrated catalogue. In short, what is publicly owned is not publicly accessible.

The Public Catalogue Foundation has three aims. First, it intends to create a complete record of the nation's collection of oil, tempera and acrylic paintings in public ownership. Second, it intends to make this accessible to the public through a series of affordable catalogues which will later go online. Finally, it aims to raise funds for the conservation and restoration of paintings in participating collections through the sale of catalogues by these collections.

Collections benefit substantially from the work of the Foundation not least from the digital images that are given to them for free following photography and the increased recognition that the catalogues bring. These substantial benefits come at no financial cost to the collections. The Foundation is funded by a combination of support from individuals, companies, the public sector and charitable trusts.

Financial Supporters

The Public Catalogue Foundation would like to express its profound appreciation to the following organisations and individuals who have made the publication of this catalogue possible.

Donations of £10,000 or more

Fenwick Ltd
Northern Rock Foundation

Renaissance North East

Donations of £5,000 or more

Department for Culture, Media and Sport
Friends of the Laing Art Gallery
Stavros Niarchos Foundation

Tyne & Wear Museums
Tyne & Wear Museums' Business Partners

Donations of £1,000 or more

Culture North East
Friends of Sunderland Museums
MLA North East

The Monument Trust
P. F. Charitable Trust

Other Donations

Friends of the Shipley Art Gallery

Friends of South Shields Museum and Arbeia Roman Fort

National Supporters

The Bulldog Trust
Covent Garden, London
The John S. Cohen Foundation
Marc Fitch Fund
Hiscox plc
The Monument Trust
National Gallery Trust

Stavros Niarchos Foundation
P. F. Charitable Trust
The Pilgrim Trust
The Bernard Sunley Charitable Foundation
Garfield Weston Foundation

National Sponsor

Christie's

Acknowledgements

The Public Catalogue Foundation would like to thank the individual artists and copyright holders for their permission to reproduce for free the paintings in this catalogue. Exhaustive efforts have been made to locate the copyright owners of all the images included within this catalogue and to meet their requirements. Copyright credit lines for copyright owners who have been traced are listed in the Further Information section.

The Public Catalogue Foundation would like to express its great appreciation to the following organisations for their kind assistance in the preparation of this catalogue:

Bridgeman Art Library
Flowers East
Marlborough Fine Art
National Association of Decorative & Fine Arts Societies (NADFAS)
National Gallery, London
National Portrait Gallery, London
Royal Academy of Arts, London
Tate

The participating collections included in this catalogue would like to express their thanks to the following organisations which have so generously enabled them to acquire paintings featured in this catalogue:

Friends of Sunderland Museum
Friends of the Laing Art Gallery
North Eastern Shipbuilders Ltd
Northern Arts
The City of Newcastle upon Tyne Archives
The City of Newcastle upon Tyne Library
The Contemporary Art Society
The Guild of St George
The Heritage Lottery Fund
The Insurance Fund
The Museums and Galleries Commission
The Museums, Libraries and Archives Council
The National Art Collections Fund
The National Heritage Memorial Fund
The Northern Art Collections Fund
The Pilgrim Trust
The Port of Sunderland Authority
The Port of Tyne Authority
The Victoria and Albert Museum Purchase Grant Fund
The Walker Mechanics Institute
The War Artists Advisory Committee

Catalogue Scope and Organisation

Medium and Support

The principal focus of this series is oil paintings. However, tempera and acrylic are also included as well as mixed media, where oil is the predominant constituent. Paintings on all forms of support (e.g. canvas, panel, etc.) are included as long as the support is portable. The principal exclusions are miniatures, hatchments or other purely heraldic paintings and wall paintings *in situ*.

Public Ownership

Public ownership has been taken to mean any paintings that are directly owned by the public purse, made accessible to the public by means of public subsidy or generally perceived to be in public ownership. The term 'public' refers to both central government and local government. Paintings held by national museums, local authority museums, English Heritage and independent museums, where there is at least some form of public subsidy, are included. Paintings held in civic buildings such as local government offices, town halls, guildhalls, public libraries, universities, hospitals, crematoria, fire stations and police stations are also included.

Geographical Boundaries of Catalogues

The geographical boundary of each county is the 'ceremonial county' boundary. This county definition includes all unitary authorities. Counties that have a particularly large number of paintings are divided between two or more catalogues on a geographical basis.

Criteria for Inclusion

As long as paintings meet the requirements above, all paintings are included irrespective of their condition and perceived quality. However, painting reproductions can only be included with the agreement of the participating collections and, where appropriate, the relevant copyright owner. It is rare that a collection forbids the inclusion of its paintings. Where this is the case and it is possible to obtain a list of paintings, this list is given in the Paintings Without Reproductions section. Where copyright consent is refused, the paintings are also listed in the Paintings Without Reproductions section. All paintings in collections' stacks and stores are included, as well as those on display. Paintings which have been lent to other institutions, whether for short-term exhibition or long-term loan, are listed under the owner collection. In addition, paintings on long-term loan are also included under the borrowing institution when they are likely to remain there for at least another five years from the date of publication of this catalogue. Information relating to owners and borrowers is listed in the Further Information section.

Layout

Collections are grouped together under their home town. These locations are listed in alphabetical order. In some cases collections that are spread over a number of locations are included under a single owner collection. A number of collections, principally the larger ones, are preceded by curatorial forewords. Within each collection paintings are listed in order of artist surname. Where there is more than one painting by the same artist, the paintings are listed chronologically, according to their execution date.

The few paintings that are not accompanied by photographs are listed in the Paintings Without Reproductions section.

There is additional reference material in the Further Information section at the back of the catalogue. This gives the full names of artists, titles and media if it has not been possible to include these in full in the main section. It also provides acquisition credit lines and information about loans in and out, as well as copyright and photographic credits for each painting. Finally, there is an index of artists' surnames.

Key to Painting Information

Almost all paintings are reproduced in the catalogue. Where this is not the case they are listed in the Paintings Without Reproductions section. Where paintings are missing or have been stolen, the best possible photograph on record has been reproduced. In some cases this may be black and white. Paintings that have been stolen are highlighted with a red border. Some paintings are shown with conservation tissue attached to parts of the painting surface.

Adam, **Patrick William** 1854–1929
Interior, Rutland Lodge: Vista through Open Doors 1920
oil on canvas 67.3 × 45.7
LEEAG.PA.1925.0671.LACF

Artist name This is shown with the surname first. Where the artist is listed on the Getty Union List of Artist Names (ULAN), ULAN's preferred presentation of the name is given. In a number of cases the name may not be a firm attribution and this is made clear. Where the artist name is not known, a school may be given instead. Where the school is not known, the painter name is listed as *unknown artist*. If the artist name is too long for the space, as much of the name is given as possible followed by (…). This indicates the full name is given at the rear of the catalogue in the Further Information section.

Painting title A painting title followed by *(?)* indicates that the title is in doubt. Where the alternative title to the painting is considered to be better known than the original, the alternative title is given in parentheses. Where the collection has not given a painting a title, the publisher does so instead and marks this with an asterisk. If the title is too long for the space, as much of the title is given as possible followed by *(…)* and the full title is given in the Further Information section.

Execution date In some cases the precise year of execution may not be known for certain. Instead an approximate date will be given or no date at all.

Artist dates Where known, the years of birth and death of the artist are given. In some cases one or both dates may not be known with certainty, and this is marked. No date indicates that even an approximate date is not known. Where only the period in which the artist was active is known, these dates are given and preceded with the word *active*.

Medium and support Where the precise material used in the support is known, this is given.

Dimensions All measurements refer to the unframed painting and are given in cm with up to one decimal point. In all cases the height is shown before the width. An (E) indicates where a painting has not been measured and its size has been calculated by sight only. If the painting is circular, the single dimension is the diameter. If the painting is oval, the dimensions are height and width.

Collection inventory number In the case of paintings owned by museums, this number will always be the accession number. In all other cases it will be a unique inventory number of the owner institution. (P) indicates that a painting is a private loan. Details can be found in the Further Information section. Accession numbers preceded by 'PCF' indicate that the collection did not have an accession number at the time of catalogue production and therefore the number given has been temporarily allocated by the Public Catalogue Foundation. The symbol indicates that the reproduction is based on a Bridgeman Art Library transparency (go to www.bridgeman.co.uk) or that Bridgeman administers the copyright for that artist.

Facing page: Drummond, Malcolm, 1880–1945, *19, Fitzroy Street* (Walter Richard Sickert's studio) (detail), 1912–1914, Laing Art Gallery, (p. 135)

THE PAINTINGS

Tyne and Wear Museums

It is with great pleasure that we welcome the publication of the Public Catalogue Foundation's volume for Tyne & Wear Museums.

Tyne & Wear Museums (TWM) is a major regional museum and art gallery service – in a sense, it is a federation of museums. The primary funding partners are the five Tyne & Wear local authorities: Newcastle, Sunderland, Gateshead, South Tyneside and North Tyneside. In addition, TWM is a sponsored body of the Department for Culture, Media and Sport (DCMS) which provides annual grant in aid.

The public collections from these five local authorities are featured in this volume, but only those that are located within the collections of TWM: it does not include paintings held by the five authorities that have not been incorporated into those collections. The ten local authority museums and galleries managed by TWM are:

Newcastle upon Tyne	*Discovery Museum*
	*Laing Art Gallery**
Sunderland	*Monkwearmouth Station Museum*
	*Sunderland Museum and Winter Gardens**
	Washington F-Pit
Gateshead	*Shipley Art Gallery**
North Tyneside	*Segedunum Roman Fort*
	Stephenson Railway Museum
South Tyneside	*Arbeia Roman Fort*
	*South Shields Museum and Art Gallery**

All ten sites show paintings from the TWM collections (sometimes on a temporary basis), but those marked with an asterisk are the primary centres for oil paintings.

TWM has a management agreement with Newcastle University in respect of the Hancock Museum. At the time of publication, the Museum is undergoing major re-development as the Great North Museum, which will also incorporate the collections of the University's Museum of Antiquities and the Shefton Museum. By 2008, this agreement will also be expanded to include management of the Hatton Gallery. The collections held in these University museums and galleries are variously owned, including by the University itself, as well as by two learned societies. For this reason, these collections are not featured in this volume, but will be covered in a separate volume dealing with North East England.

Since 2003, TWM has also been the leader of the North East Regional Museums Hub under the Museum, Library and Archive Council's *Renaissance* programme and is pleased to have led the campaign, together with colleagues at the Public Catalogue Foundation to ensure that the whole region will be covered by, in total, three volumes.

TWM holds important Fine and Decorative Art collections that were, in

1998, designated as being of national importance under the Government's Museum Designation scheme. More importantly, TWM is committed to making these collections accessible to the widest possible audience, attracting over 1.5 million visits to our museums and galleries each year, and another million through our websites. Just as important is the composition of these audiences, and we are proud to boast high numbers of visitors from a wide range of backgrounds. Our record of attracting new audiences that are not traditional users of museums and galleries is, arguably second to none.

The publication of this volume will ensure that all our painting collections are known to a much wider audience, for the first time. These collections have grown over the years through bequests, donations, transfers and purchases. Like many other regional galleries, TWM is indebted to a wide range of public charitable funders which have supported the development of the Collection. Notable support has been provided by the (then) National Art Collections Fund, the Contemporary Art Society, the Museums and Galleries Commission/ Victoria and Albert Museum Purchase Grant Fund and the Heritage Lottery Fund.

TWM's art collections are concentrated in four venues, each with its own character. The Laing Art Gallery in Newcastle is, in many ways, a flagship. It was established in 1904 with funds from Alexander Laing, a wine and spirit merchant. Laing had no collection, so the Gallery's collection has been built steadily over the last 104 years. It has an outstanding collection of nineteenth-century British paintings, including work by a number of Pre-Raphaelite painters, notably Edward Burne-Jones and William Holman Hunt. The Laing is also home to a comprehensive collection of work by the extraordinary British Romantic artist John Martin. Its most famous painting, however, is not British at all, but Paul Gaugin's *Breton Shepherdess*.

It is perhaps worth remarking that the Laing Art Gallery's most celebrated collection is its collection of 4,000-plus watercolours, which range from the seventeenth century up to the present day; but that is perhaps the subject of a future publication!

Gateshead's Shipley Art Gallery is also the result of the generosity of one man – Joseph Shipley. Shipley bequeathed £30,000 in 1908 to build a gallery to show his collection of paintings. Eventually, the Shipley Art Gallery opened in Gateshead in 1917. A selection of 504 oil paintings and watercolours of all schools and periods, predominantly from Shipley's own collection was made to create the Gallery's first permanent collection.

In many ways, the significance of the Shipley's Collection has been understated for many years. In fact, the Gallery's collection includes a significant number of important Dutch and Flemish Old Master paintings, a small group of Italian eighteenth-century paintings (including long-term loans of work by Canaletto, Guardi and Panini), and outstanding continental paintings including *Christ Washing the Feet of the Disciples*, attributed to Jacopo Comin, otherwie known as Tintoretto. One of the pleasures of producing this volume is the chance to make the Shipley's collection better known to a wider audience.

Sunderland Museum and Winter Gardens was the first local authority museum to be established under the Museums Act of 1846: Colchester established its public museum on the same day, but Sunderland has always claimed primacy! The first recorded acquisition of a painting was a

commission: *The Opening of the South Dock* by Mark Thompson, painted in 1856. The Collection grew slowly at first until the opening of a new museum building in 1879 when Thomas Dixon was instrumental in obtaining support from artists and intellectuals including Rossetti and Ruskin. This stimulated rapid expansion of the Collection and in 1908 the Dickinson Bequest significantly enhanced the fine art collection. Sunderland's Collection includes key works by L. S. Lowry who spent a considerable amount of time on the North East coast.

South Shields Museum and Art Gallery's collections grew from the amalgamation of collections from the South Shields Literary, Mechanical and Scientific Institution and the Working Men's Club in 1870. The Collection has grown steadily since, boosted by gifts from local collector Thomas Reed and his bequest of 1921. It is, predictably, strong in coastal and maritime themes with a good collection of work by Tyneside artist John Scott.

In addition to the paintings in the TWM collections which are associated with a particular museum or gallery, there is a small collection of maritime and industrial paintings held in the Discovery Museum as part of the TWM history collections.

This Tyne & Wear Museums volume in the Public Catalogue Foundation series will give voice to a collection which, apart from its better-known highlights, has been too quiet for too long. It is a very timely intervention and we welcome its publication and the interest that it will create.

Alec Coles, Director

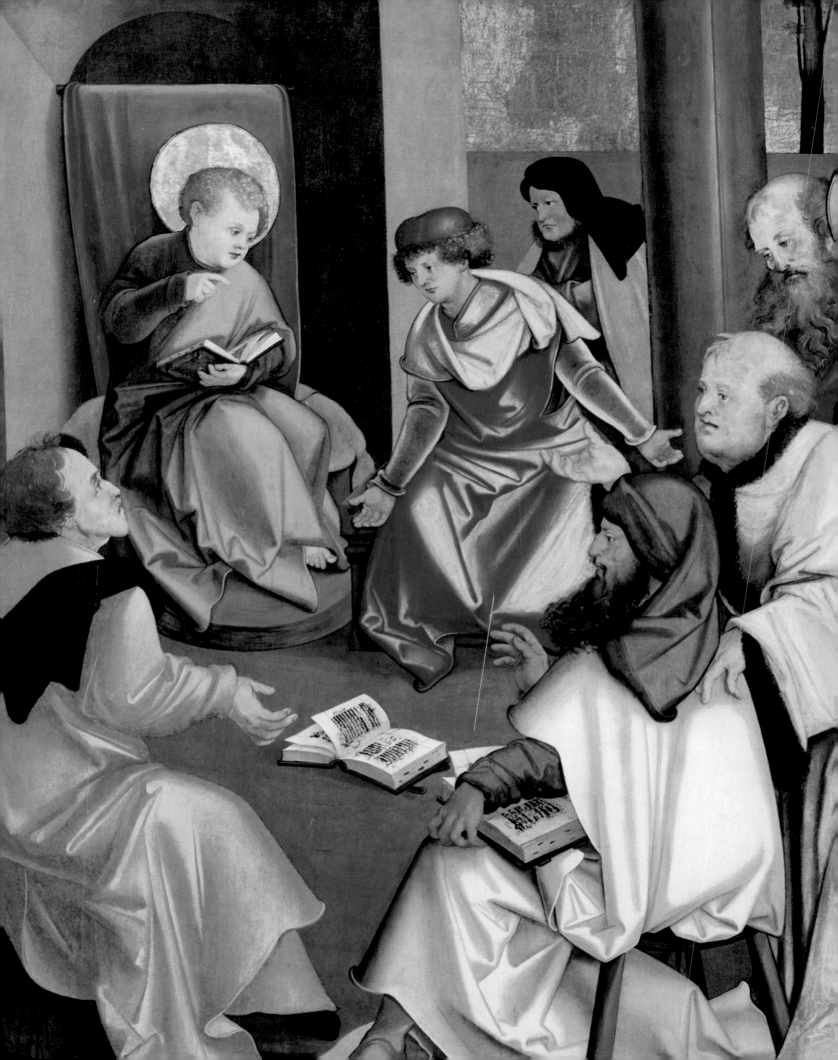

Shipley Art Gallery

The basis of the Gallery's fine art collection was the bequest of solicitor Joseph Shipley in 1909 which provided funding for a new gallery to be built, and for his collection of paintings to be displayed within it. The new gallery was opened in 1917. The highlights of the bequest are a group of outstanding Dutch and Flemish paintings and some fine Victorian paintings. As a result, the Shipley Art Gallery has one of the finest provincial collections of Dutch and Flemish sixteenth- and seventeenth-century paintings in the UK.

The collections now also include watercolours, prints and drawings, sculpture (notably a fine bust of *Alexander Pope* by Louis François Roubilliac), decorative art, particularly glass, ceramics and metalwork, and a nationally important contemporary craft collection.

Shipley is reported to have bought his first painting at the age of 16. He bought most of his works through dealers, building his collection during the last decades of the nineteenth century. His tastes were wide-ranging, and he looked for works by famous artists, and also for specific subjects. He particularly liked landscapes and paintings with a strong moral meaning.

By the time Shipley died, he had amassed an astonishing 2,500 paintings. He was an extremely wealthy man, and left a large amount of money to charity. His art collection was first offered to Newcastle, with £30,000 to extend an existing gallery, but not the Laing as he considered it too small. There was much discussion and debate over the bequest and its associated conditions. Eventually, Newcastle declined the bequest and the collection was offered to Gateshead, with the £30,000 to build a new gallery. The Corporation accepted the bequest and the Shipley was completed in 1917. The pictures were examined by experts, and a number sold. A selection of 504 oil paintings and watercolours was made to create the gallery's initial permanent collection, known as the Shipley Bequest.

His remarkable collection of Dutch, Flemish and other western European paintings includes important pictures by Hans Schäufelein, Abraham Janssens, Benjamin Cuyp, Jacob Grimmer, Salomon Rombouts, Jan van der Heyden, Arent van Tongeren, Michele Pace del Campidoglio, Johann Loth and Jan van Kessel, as well as works attributed to Philips de Koninck and Cornelis Beelt. Two particularly popular works are Edouard Bisson's *Winter* and Charles Landelle's *Ruth*.

The Shipley's collection of British paintings has increased significantly since Shipley's original bequest. The works are mostly from the nineteenth century and landscapes predominate, together with genre subjects and some portraits. Notable works include Richard Redgrave's *The Poor Teacher*, Atkinson Grimshaw's Whistlerian *Greenwich, Half Tide* and Frederick Mason Sheard's *Harvesters Resting*. There are also significant paintings by John Robertson Reid, David Wilkie Wynfield, Neils Møller Lund, and local artists Thomas Miles Richardson, Ralph Hedley and Henry Hetherington Emmerson. Twentieth-century works include pictures by Winifred Nicholson and Norman Cornish.

Since 1917 the Collection has continued to grow, with important acquisitions including Charles Lock Eastlake's *Boaz and Ruth*, Hendrik van

Facing page: Schäufelein, Hans, c.1480/1485–1538/1540, *Christ in the Temple* (detail), c.1510–1530, Shipley Art Gallery, (p. 71)

Balen's *Moses Striking the Rock* and David Teniers' *Interior of a Tavern*, given by the National Art Collections Fund in 1985.

An outstanding work, acquired by Tyne & Wear Museums in 1986, is the major painting attributed to the Venetian artist Jacopo Robusti, known as Tintoretto. Now on display in the Shipley's main gallery, *Christ Washing the Disciples' Feet* was originally painted for the church of San Marcuola in Venice. Removed from the church and replaced by a copy in 1648, it was eventually given to St Nicholas' Church (now cathedral) in Newcastle, and was purchased by Tyne & Wear Museums in 1986. Two other versions of the painting are known in addition to the copy. Other Italian paintings at the Shipley include a small group of eighteenth-century works, with significant long-term loans of paintings by Canaletto, Guardi and Panini.

More recently, a painting of great regional importance was purchased for the gallery in 2002 with significant funding from the Heritage Lottery Fund and other public and private gifts and donations. *The Blaydon Races* by William Irving illustrates one of the most significant sporting events in the North East's calendar, made famous by the song called *The Blaydon Races,* written by the Tyneside music-hall singer Geordie Ridley.

Featuring a number of celebrated local 'characters', Irving's painting of the 1862 meeting, when it was first exhibited in the window of an art dealer's shop in Newcastle, attracted the attention of such a large crowd that the manager of the shop was asked by the police to draw the blinds. Irving was primarily a cartoonist and *The Blaydon Races* was by far his most significant work. It would have probably appealed to his sense of humour had he known that one day his painting would hang beside a Tintoretto!

Amy Barker, Curator

Albani, Francesco (after) 1578–1660
The Baptism of Christ
oil on canvas 147 x 200.5
TWCMS : C7364

Andreis, Alex de 1871–1939
Spanish Cavalier
oil on canvas 81.5 x 65.5
TWCMS : F9403

Ansdell, Richard (attributed to) 1815–1885
Sheep
oil on canvas 71 x 91.5
TWCMS : B4909

Appel, Jacob 1680–1751
Coast Scene, Debarkation
oil on canvas 96.4 x 135
TWCMS : G1165

Armfield, George 1808–1893
Dogs 1870
oil on canvas 26 x 30.7
TWCMS : B6227

Armfield, George 1808–1893
Terriers Ratting
oil on canvas 28 x 38.1
TWCMS : B3239

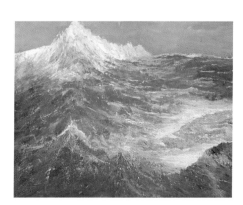

Armstrong, Alan active 20th C
Rough Seas
oil on panel 40.5 x 50.7
TWCMS : F6137

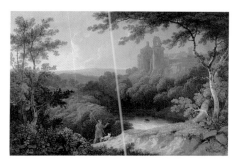

Arnald, George 1763–1841
Ruins of Rosslyn Castle, Midlothian 1810
oil on canvas 54.3 x 82
TWCMS : B8402

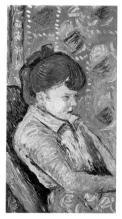

Ashby, Roger active 1966–1969
Jeanne c.1966
oil on board 77.8 x 42.5
TWCMS : F9381

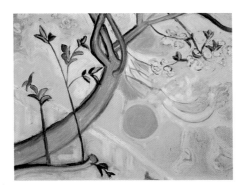

Ashby, Roger active 1966–1969
Apple Blossom
oil on canvas 71.1 x 91.6
TWCMS : C11275

Asselyn, Jan (attributed to) after 1610–1652
An Old Bridge
oil on panel 41.4 x 46.2
TWCMS : B6236

Atkinson, John II 1863–1924
Cowhill Fair c.1900–1919
oil on board 53.5 x 66.5
TWCMS : F6131

Atkinson, John II 1863–1924
Ploughing c.1900–1919
tempera on paper 54 x 74.3
TWCMS : G11556

Aumonier, James 1832–1911
Thames Scene 1880
oil on canvas 66.2 x 134.5
TWCMS : E8499

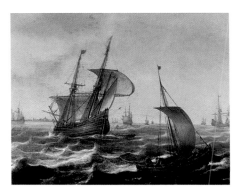

Backhuysen, Ludolf I (attributed to)
1630–1708
Sea Piece
oil on panel 36.2 x 46.2
TWCMS : C181

Baldry, George W. active c.1865–c.1925
John Rowell 1884
oil on canvas 91.5 x 61.3
TWCMS : F9404

Baldry, George W. active c.1865–c.1925
Mrs Clara Rowell 1884
oil on canvas 90.9 x 61
TWCMS : F9405

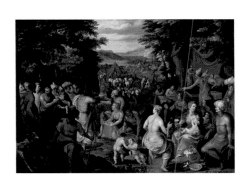

Balen, Hendrik van I 1575–1632
Moses Striking the Rock
oil on panel 75.7 x 106.1
TWCMS : F9427

Balmer, George 1805–1846
Coast Scene with Fishing Boats
oil on canvas 25.5 x 30.5
TWCMS : B6206

Balmer, George 1805–1846
Holy Island, Northumberland
oil on canvas 30.7 x 36
TWCMS : F12318

Balmer, George 1805–1846
Old Bridge
oil on canvas 19.8 x 25.5
TWCMS : B6208

Balmer, George 1805–1846
Scottish Lake Scene, Thunderstorm
oil on canvas 61.2 x 121.9
TWCMS : B3789

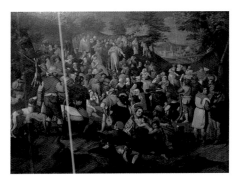

Balten, Pieter c.1525–c.1598
St John the Baptist Preaching before c.1590
oil on panel 97.8 x 123.6
TWCMS : B9986

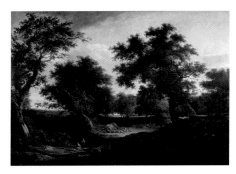

Barker, Benjamin II 1776–1838
Landscape 1811
oil on canvas 130.3 x 182.2
TWCMS : F12346

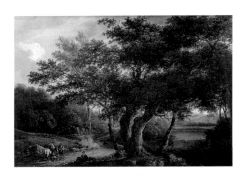

Barker, Benjamin II (attributed to)
1776–1838
A Road near a Lake 1821
oil on canvas 33.5 x 46.6
TWCMS : B3236

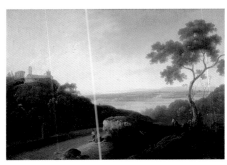

Barker, Thomas Jones (attributed to)
1815–1882
Landscape
oil on canvas 62.4 x 93.3
TWCMS : G1155

Barrass, Dennis b.1942
Saltwell Towers 1961
oil on canvas 50.5 x 76
TWCMS : F6106

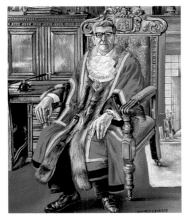

Barrass, Dennis b.1942
The Mayor of Gateshead 1965
oil on canvas 61 x 50.8
TWCMS : F9398

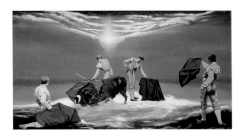

Barrass, Dennis b.1942
Matador's Dream 1968
oil on canvas 61.1 x 106.4
TWCMS : F6129

Barrass, Dennis b.1942
The Blue Lion 1968
oil on canvas 60.5 x 127
TWCMS : F6134

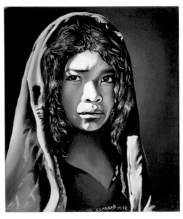

Barrass, Dennis b.1942
Moonlight Girl 1972
oil on canvas 60.6 x 50.8
TWCMS : F9426

Barrass, Dennis (attributed to) b.1942
Saltwell Towers 1961
oil on canvas 50.5 x 76
TWCMS : F6106

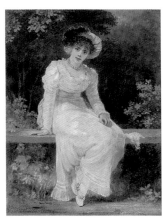

Barrett, Jerry 1814–1906
Lady Seated in a Garden
oil on canvas 51.5 x 38
TWCMS : B6210

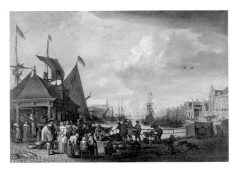

Beelt, Cornelis (attributed to) 1640–1702
A Fish Market
oil on canvas 111.9 x 158.4
TWCMS : C174

Bega, Cornelis Pietersz. (style of)
1631/1632–1664
Dutch Interior
oil on canvas 37 x 30.7
TWCMS : G1171

Belder, R. H. b.1910
Waves
oil on canvas 46.8 x 65.9
TWCMS : C11269

Belin de Fontenay, Jean-Baptiste (style of)
1653–1715
Flowers
oil on panel 81 x 58.8
TWCMS : C176

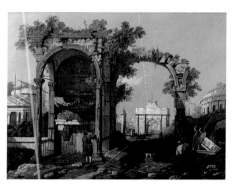

Bellotto, Bernardo (attributed to)
1722–1780
*Ruins and Figures, Outskirts of Rome near the
Tomb of Cecilia Metella* c.1750–1775
oil on canvas 71.2 x 92.2
TWCMS : C187

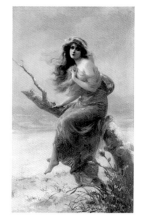

Bisson, Edouard 1856–1939
Winter 1904
oil on canvas 161.9 x 97.9
TWCMS : F12329

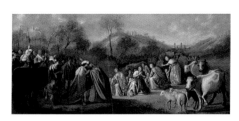

Bleker, Gerrit Claesz. (attributed to)
c.1600–1656
The Meeting of Jacob and Esau
oil on panel 52.7 x 106.5
TWCMS : G1174

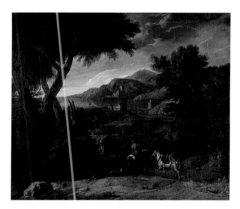

Bloemen, Jan Frans van 1662–1749
Landscape with Pack Mules
oil on canvas 107.4 x 121
TWCMS : B9997

Blythe, Peter active 20th C
Australian Gum
oil on canvas 61 x 50.5
TWCMS : F6119

Boccaccio, Gino active 20th C
The Market, Norfolk
oil on canvas 60.4 x 73
TWCMS : F9421

Bonington, Richard Parkes (attributed to)
1802–1828
Cromer, Norfolk
oil on panel 30.7 x 46.1
TWCMS : B3798

Both, Jan (attributed to) c.1618–1652
Landscape
oil on canvas 68.5 x 84.7
TWCMS : B4248

Botticelli, Sandro (after) 1444/1445–1510
Detail from Botticelli's 'Primavera'
oil on panel 50.7 x 36.5
TWCMS : F6124

Boudewyns, Adriaen Frans (attributed to)
1644–1711
River Scene with Figures c.1680–1700
oil on panel 31.3 x 50.5
TWCMS : B8417

Bough, Samuel 1822–1878
Borrowdale, Cumbria
oil on canvas 33.1 x 43
TWCMS : F9368

Boulogne, Valentin de (style of) 1591–1632
The Chaste Susannah
oil on canvas 173.8 x 211.6
TWCMS : C179

Bout, Peeter (attributed to) 1658–1719
Landscape with Old Houses c.1680–1700
oil on panel 31.4 x 50.4
TWCMS : B8419

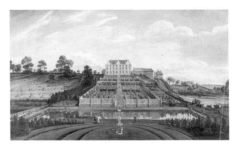

Bouttats, Johann Baptiste c.1690–1738
Dutch Mansion with Garden 1730
oil on canvas 98 x 159.8
TWCMS : B9987

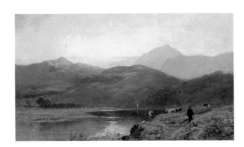

Breanski, Alfred de 1852–1928
A Scottish Lake
oil on canvas 30.5 x 51.5
TWCMS : B4912

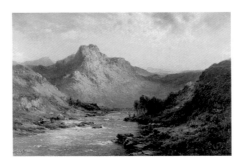

Breanski, Alfred de 1852–1928
Glengarry, Scottish Highlands
oil on canvas 50.9 x 76.1
TWCMS : E8470

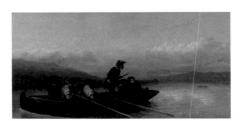

Bromley, William 1769–1842
The Escape
oil on canvas 75.6 x 153.2
TWCMS : B4905

Brown, James Miller active 1875–1910
Windsor Castle
oil on canvas 45.8 x 61
TWCMS : B6240

Brugghen, Hendrick ter (attributed to)
1588–1629
Pilate Washing His Hands c.1615–1628
oil on canvas 103 x 139
TWCMS : C7376

Bruyères, Hippolyte 1801–1856
The Proposal
oil on panel 44.4 x 35.7
TWCMS : B4947

Burgess, John Bagnold 1830–1897
Spanish Lady with a Fan
oil on canvas 76.6 x 51.4
TWCMS : B4237

Buttersworth, Thomas 1768–1842
*Rescue of the 'Guardian's' Crew by a French
Merchant Ship, 2 January 1790*
oil on board 30 x 42.6
TWCMS : C7357

T. C. active 19th C
Ambleside Mill
oil on canvas 36 x 51
TWCMS : B3214

Calderon, Philip Hermogenes 1833–1898
His Reverence 1876
oil on canvas 91.5 x 71.4
TWCMS : F9414

Callow, John 1822–1878
Off Scarborough
oil on canvas 76.7 x 127.5
TWCMS : B4919

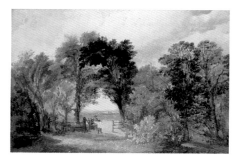

Calvert, Edward 1799–1883
A Woodland Glade
oil on canvas 25.2 x 35.5
TWCMS : B6204

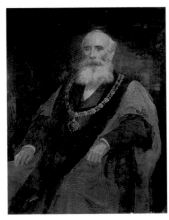

Campbell, John Hodgson 1855–1927
Alderman Thomas McDermott, Mayor 1899
oil on canvas 123.6 x 96.7
TWCMS : R237

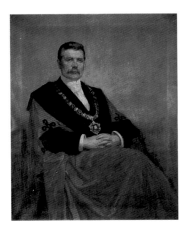

Campbell, John Hodgson 1855–1927
Francis Joseph Finn 1899
oil on canvas 125.5 x 100.3
TWCMS : R238

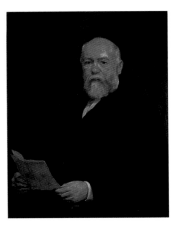

Campbell, John Hodgson 1855–1927
Alderman Thomas Hall 1902
oil on canvas 92 x 71.7
TWCMS : R236

Campbell, John Hodgson 1855–1927
*Robert Affleck, JP, Chairman of the Board of
Guardians*
oil on canvas
TWCMS : R234

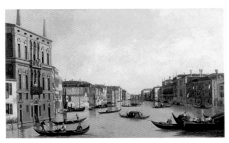

Canaletto (after) 1697–1768
*Grand Canal, Venice, Looking Northeast from
the Palazzo Balbi to the Rialto Bridge*
c.1730–1765
oil on canvas 92.5 x 151.8
TWCMS : C7370

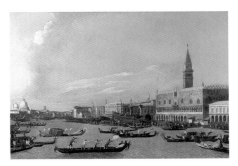

Canaletto (after) 1697–1768
*Venice, the Bucintoro Returning to the Molo on
Ascension Day*
oil on canvas 116.4 x 170.1
TWCMS : C7353

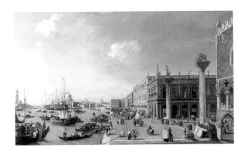

Canaletto (style of) 1697–1768
The Molo, Venice, Looking West c.1735–1765
oil on canvas 114.7 x 170.1
TWCMS : C186

Carmichael, John Wilson 1800–1868
Shipping off the Italian Coast c.1836–1837
oil on canvas 35.5 x 66.2
TWCMS : F12315

Carmichael, John Wilson 1800–1868
A Clipper and an East Indiaman Leaving Port
1854
oil on canvas 88.8 x 137.9
TWCMS : B4911

Carmichael, John Wilson 1800–1868
Shipping in the Bay of Naples 1854
oil on canvas 35.5 x 66.5
TWCMS : F6136

Carmichael, John Wilson 1800–1868
Sea Piece with Ships 1856
oil on canvas 85.5 x 137.1
TWCMS : B4231

Carmichael, John Wilson 1800–1868
Shipping 1856
oil on canvas 35.5 x 66.4
TWCMS : F12314

Carmichael, John Wilson (attributed to)
1800–1868
*A Breezy Evening off the Mouth of the
Mersey* 1841
oil on canvas 77 x 128
TWCMS : B4221

Carmichael, John Wilson (attributed to)
1800–1868
Fishing Boats off Scarborough
oil on canvas 92.6 x 153.4
TWCMS : B3230

Carolus, Jean 1814–1897
Afternoon Tea 1879
oil on canvas 70 x 97
TWCMS : B3771

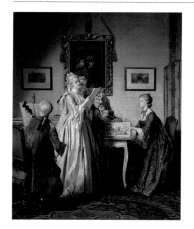

Carolus, Jean 1814–1897
Harmony 1879
oil on canvas 95.8 x 78.3
TWCMS : B3212

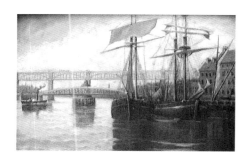

Carr, H. active 19th C
Newcastle, High Level and Swing Bridges
oil on canvas 38 x 56
TWCMS : G1198

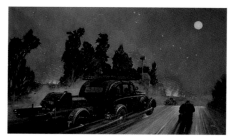

Carr, Leslie b.1891
Regional Call
oil on canvas 76.6 x 126.7
TWCMS : E8488

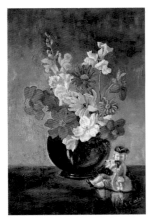

Carter, Eva I. 1870–1963
Autumn Flowers
oil on canvas 53.5 x 35.7
TWCMS : F6111

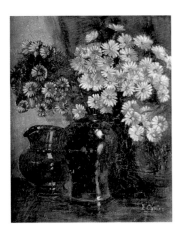

Carter, Eva I. 1870–1963
Michaelmas Daisies
oil on canvas 50.8 x 40.5
TWCMS : F6114

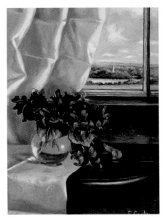

Carter, Eva I. 1870–1963
Purple and Gold
oil on board 44.7 x 33.9
TWCMS : G425

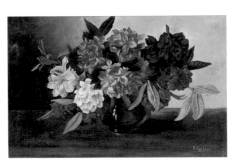

Carter, Eva I. 1870–1963
Rhododendrons
oil on canvas 50.8 x 76
TWCMS : H6482

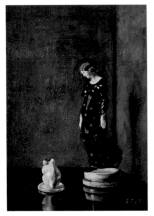

Carter, Eva I. 1870–1963
Study in Grey and Gold
oil on canvas 50.8 x 35.4
TWCMS : F6120

Carter, Eva I. 1870–1963
Sweet Peas
oil on board 35 x 22
TWCMS : F6121

Carter, Eva I. 1870–1963
The Green Jug
oil on canvas 20.2 x 40.3
TWCMS : F6109

Carter, Eva I. 1870–1963
Yellow Marguerites
oil on canvas 36 x 22
TWCMS : F6108

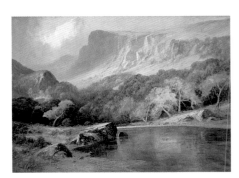

Carter, Francis Thomas 1853–1934
Borrowdale, Cumbria
oil on canvas 81.2 x 111.9
TWCMS : F6140

Facing page: Auerbach, Frank Helmuth, b.1931, *Julia* (detail), 1987, Laing Art Gallery, (p. 110)

Carter, Francis Thomas 1853–1934
North Wales
oil on canvas 123.8 x 184.6
TWCMS : F9365

Carter, Francis Thomas 1853–1934
The Derwent near Lintz Green
oil on canvas 76.7 x 131.8
TWCMS : F6139

Cartier, Victor Émile 1811–1866
Landscape with Cattle
oil on canvas 53.5 x 73
TWCMS : B4227

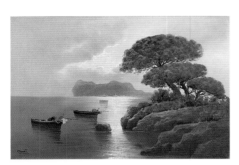

Casati active 20th C
Seascape
oil on canvas 61.4 x 92.2
TWCMS : C11278

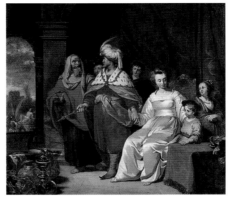

Casteleyn, Casper (attributed to)
active c.1653–1660
Croesus Showing Solon His Riches c.1655
oil on canvas 97.2 x 109.1
TWCMS : C198

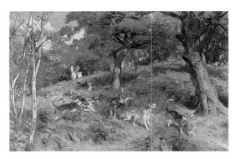

Charlton, John 1849–1917
Hunting Scene 1913
oil on canvas 50.8 x 76.2
TWCMS : E8484

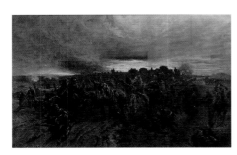

Charlton, John 1849–1917
The German Retreat from the Marne 1915
oil on canvas 175.5 x 275
TWCMS : G435

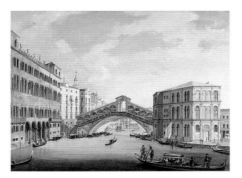

Chilone, Vincenzo (attributed to)
1758–1839
*Grand Canal, Venice, with Riva del Carbon
and the Rialto Bridge* 1820–1830
oil on canvas 45.6 x 60
TWCMS : C7354

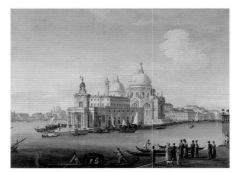

Chilone, Vincenzo (attributed to)
1758–1839
*The Church of Santa Maria della Salute,
Venice* 1820–1830
oil on canvas 45.4 x 60
TWCMS : C7356

Cipper, Giacomo Francesco 1664–1736
Figure Study, Woman with Mouse Trap
oil on canvas 147.4 x 118.6
TWCMS : G1190

Cipper, Giacomo Francesco 1664–1736
Man Lighting a Pipe
oil on canvas 149.5 x 119
TWCMS : G1180

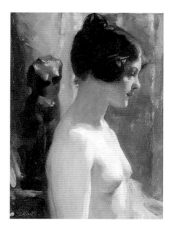

Clark, James 1858–1943
Models
oil on canvas 47 x 37
TWCMS : F9400

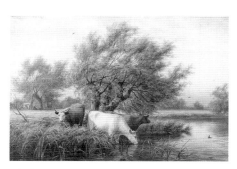

Clark, Joseph Dixon 1849–1944
Cattle
oil on canvas 61.5 x 88.5
TWCMS : B3755

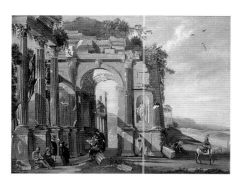

Codazzi, Viviano c.1604–1670
Temple Ruins c.1630
oil on canvas 151 x 203
TWCMS : C7363

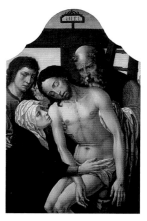

Coecke van Aeslt, Pieter the elder (studio of)
1502–1550
The Descent from the Cross
oil on panel 103 x 69
PCF1

Collins, William 1788–1847
The Return of the Fishing Boats
oil on canvas 92 x 160.8
TWCMS : B4939

Collins, William (attributed to) 1788–1847
Beach, Boys Sailing a Toy Boat
oil on canvas 30.4 x 41
TWCMS : B3766

Colyer, Edwaert (attributed to)
c.1640–c.1707
The Musician c.1670–1680
oil on panel 24.5 x 21
TWCMS : B4229

Colyer, J. M. active 19th C
Girl with Flowers and a Windmill
tempera on panel 33 x 25.5
TWCMS : F6145

Cook, Alan R.
Regatta at Beadnell, Northumberland
oil on board 41.7 x 90.2
TWCMS : H4424

Cooke, Edward William (attributed to)
1811–1880
Coast Scene with Fishing Boats
oil on canvas 45.5 x 76
TWCMS : B3238

Cooper, Thomas Sidney 1803–1902
*A Sunny Summer Evening in the
Meadows* 1901
oil on canvas 101.8 x 152.7
TWCMS : B3780

Cope, Charles West 1811–1890
Genius between Tragedy and Comedy
oil on canvas 91.5 x 103
TWCMS : B3250

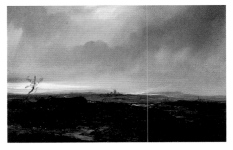

Cope, T. active 19th C
Moorland
oil on canvas 28.1 x 40.5
TWCMS : B4926

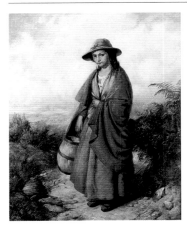

Corbould, John active 19th C
A Welsh Milkmaid
oil on canvas 60.5 x 51
TWCMS : B4218

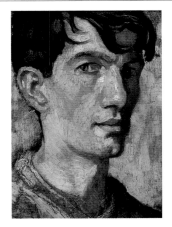

Cornish, Norman Stansfield b.1919
Self Portrait c.1950
oil on board 38.5 x 27.7
TWCMS : F9376

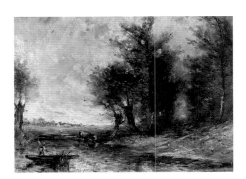

Corot, Jean-Baptiste-Camille (style of)
1796–1875
Landscape
oil on canvas 54.5 x 73.5
TWCMS : B4212

Costello, J. active 19th C
The Election of a Doge, Venice
oil on canvas 122.1 x 172.9
TWCMS : B4213

Courtois, Jacques (attributed to) 1621–1676
Landscape with Horsemen
oil on canvas 63.2 x 102.3
TWCMS : C160

Cox, David the elder (attributed to)
1783–1859
Menlough Castle, Galway, Ireland
oil on canvas 71 x 106.5
TWCMS : B4205

Cox, David the elder (attributed to)
1783–1859
Wooded Landscape
oil on canvas 79.8 x 63.5
TWCMS : B3208

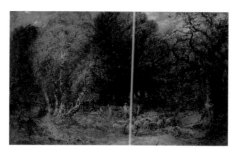

Cox, David the elder (style of) 1783–1859
A Sylvan Scene
oil on canvas 81.5 x 122.5
TWCMS : B4243

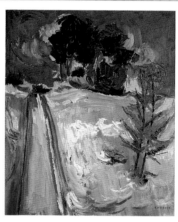

Cozens, Ken
The Red Path 1959
oil on canvas 51 x 41
TWCMS : F6104

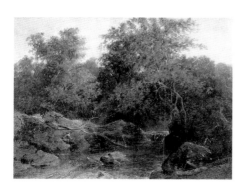

Creswick, Thomas (style of) 1811–1869
A Cumberland Trout Stream
oil on canvas 46 x 61.5
TWCMS : B6202

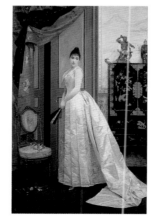

Croegaert, Georges 1848–1923
Lady with a Fan 1888
oil on panel 50.5 x 33
TWCMS : F12328

Crome, John (attributed to) 1768–1821
Landscape
oil on panel 22.2 x 29.7
TWCMS : E8493

Crome, John (attributed to) 1768–1821
View near Norwich
oil on canvas 38.6 x 48.9
TWCMS : C182

Croner, J. active 19th C
A River Scene by Moonlight
oil on canvas 35.5 x 60.5
TWCMS : B6209

Croos, Anthonie Jansz. van der
c.1606–1662/1663
*Landscape with the Ruined Castle of Brederode
and a Distant View of Haarlem* 1655
oil on panel 48.2 x 66.5
TWCMS : B9998

Cuyp, Aelbert (after) 1620–1691
Landscape with Cattle
oil on canvas 49.3 x 63.7
TWCMS : B6247

Cuyp, Aelbert (follower of) 1620–1691
Dutch River Scene with Cattle
oil on panel 68.1 x 94.1
TWCMS : B8409

Cuyp, Benjamin Gerritsz. 1612–1652
The Adoration of the Shepherds c.1630–1650
oil on panel 75 x 98
TWCMS : C167

Dalens, Dirck III (attributed to) 1688–1753
Landscape with Figures and Cattle
oil on canvas 64 x 77.5
TWCMS : C7375

Dalens, Dirck III (attributed to) 1688–1753
Ruins with Figures and Cattle
oil on canvas 63.8 x 77.5
TWCMS : C7361

Dall, Nicholas Thomas d.1776/1777
Classical Landscape 1768
oil on canvas 87.4 x 116.8
TWCMS : C7397

Danby, Francis (attributed to) 1793–1861
River with Old Ruins, Sunset
oil on canvas 101.2 x 166.2
TWCMS : B4916

Davis, Edward Thompson 1833–1867
Grandfather's Tale 1860
oil on canvas 46 x 57
TWCMS : F12331

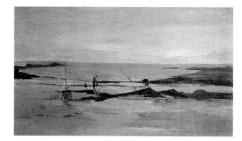

Davison, Thomas b.1934
Roker Beach
oil on canvas 56.8 x 92
TWCMS : H6481

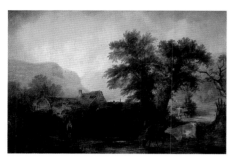

Dawson
Landscape
oil on canvas 55.8 x 79.2
TWCMS : F6107

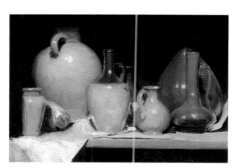

Dawson, Byron Eric 1896–1968
Still Life 1919
oil on canvas 35.7 x 51.3
TWCMS : F12341

Dean, Donald b.1930
Construction 1962
oil on canvas 22.8 x 27.7
TWCMS : F6110

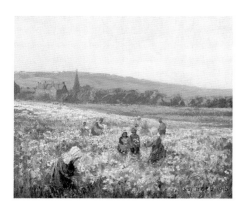

Dees, John Arthur 1876–1959
*The Dog Daisy Field, Low Fell,
Gateshead* 1910
oil on canvas 51.2 x 61.2
TWCMS : F9425

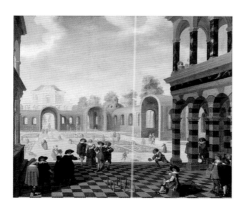

Delen, Dirck van 1604/1605–1671
A Dutch Garden Scene 1636
oil on canvas 67.3 x 81.3
TWCMS : C7367

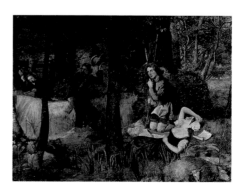

Deverell, Walter Howell 1827–1854
*Scene from 'As You Like It' by William
Shakespeare*
oil on panel 70.5 x 91.9
TWCMS : B4206

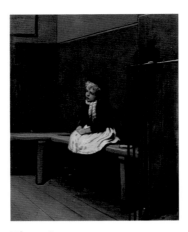

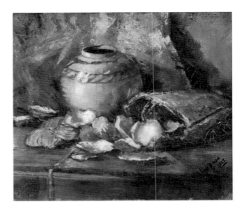

**Dietrich, Christian Wilhelm Ernst
(attributed to)** 1712–1774
Head of an Old Man (God the Father)
oil on panel 14.7 x 10.6
TWCMS : C157

Dixon, A.
The Lost Child
oil on canvas 50.7 x 40.7
TWCMS : B4906

Dixon, Dudley b.c.1900
Still Life 1927
oil on canvas 34 x 40.5
TWCMS : F12340

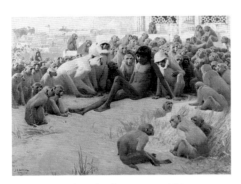

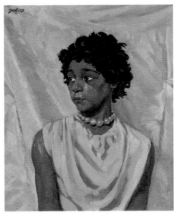

Dollman, John Charles 1851–1934
Mowgli Made Leader of the Bandar-log 1918
oil on canvas 95.7 x 128.3
TWCMS : F12342

Doxford, James 1899–1978
Vera Gomez c.1950
oil on canvas 61.4 x 51
TWCMS : F9391

Doxford, James 1899–1978
Asters c.1964
oil on board 61 x 50.5
TWCMS : F6113

Droochsloot, Cornelis 1630–1673
Dutch Village Scene 1666
oil on panel 39.4 x 51.7
TWCMS : B6235

Droochsloot, Joost Cornelisz. (style of)
1586–1666
A Dutch Village
oil on panel 32.5 x 38
TWCMS : C7393

Durdon, A. R. active 20th C
Harbour Scene
oil on canvas 51.3 x 71.2
TWCMS : F6132

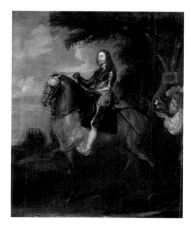

Dyck, Anthony van (after) 1599–1641
An Equestrian Portrait of Charles I (1600–1649)
oil on canvas 101.6 x 86.2
TWCMS : G2250

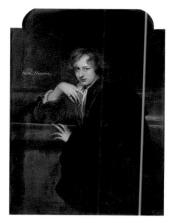

Dyck, Anthony van (after) 1599–1641
Self Portrait, When a Youth
oil on canvas 132.4 x 98
TWCMS : G1168

East, Alfred 1849–1913
Arundel, Early Morning
oil on canvas 102.8 x 153
TWCMS : F9359

Eastlake, Charles Lock 1793–1865
Boaz and Ruth c.1853
oil on canvas 121.9 x 161.6
TWCMS : F9373

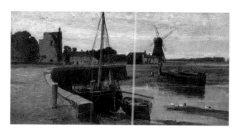

Ellis, Edwin 1841–1895
Harbour with Fishing Cobles
oil on canvas 58.4 x 107
TWCMS : B4241

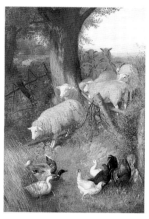

Emmerson, Henry Hetherington
1831–1895
The Intruders 1876
oil on canvas 140.3 x 93.1
TWCMS : F9370

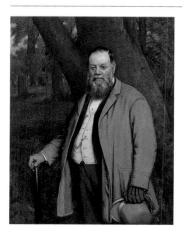

Emmerson, Henry Hetherington
1831–1895
Alderman George Davidson 1890
oil on canvas 140 x 109
TWCMS : R242

Emmerson, Henry Hetherington
1831–1895
Alderman George Davidson 1890
oil on canvas 142 x 111.6
TWCMS : R243

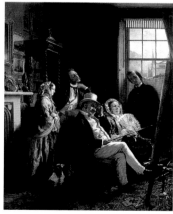

Emmerson, Henry Hetherington
1831–1895
The Critics
oil on canvas 105.6 x 81.3
TWCMS : H6465

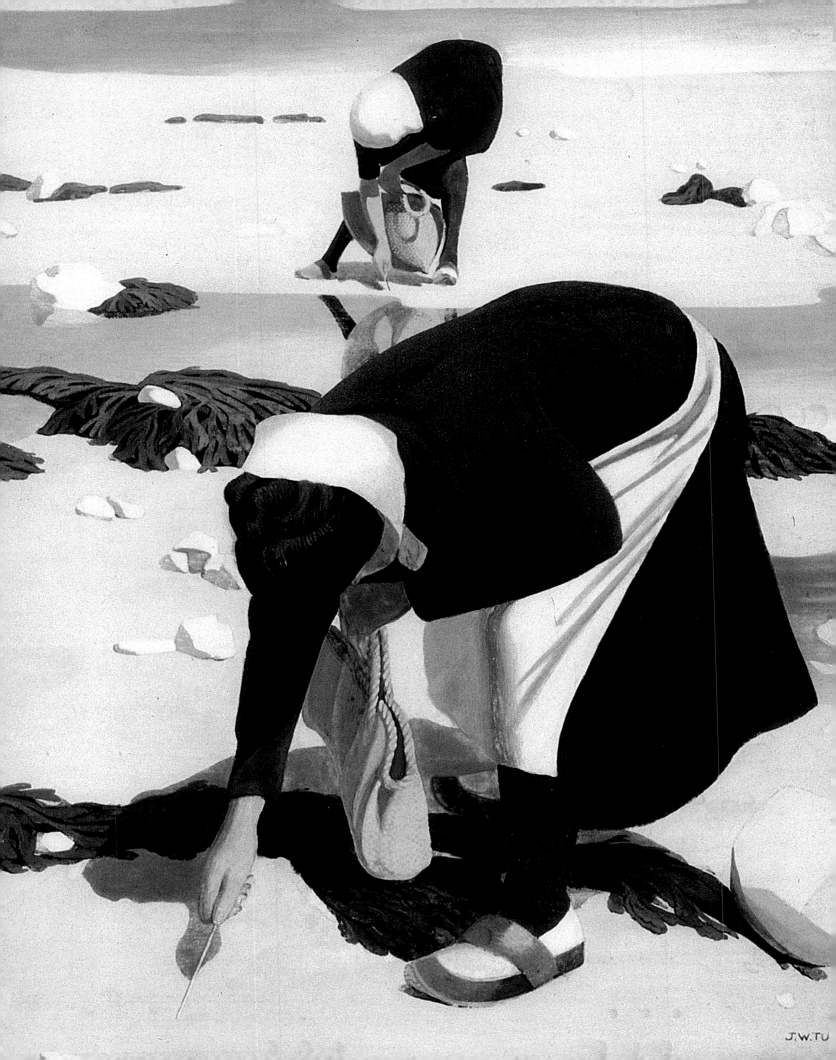

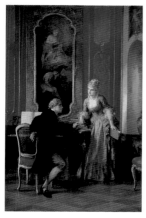

Erdmann, Otto 1834–1905
The Music Lesson 1879
oil on canvas 74.5 x 52
TWCMS : B4216

Ewbank, John Wilson c.1799–1847
Breadalbane Ferry, Loch Tay
oil on panel 16.8 x 23.7
TWCMS : E8479

Ewbank, John Wilson c.1799–1847
Loch Fyne, Herring Fishing
oil on metal 25.6 x 36
TWCMS : B6225

Ewbank, John Wilson c.1799–1847
Tantallon Castle, East Lothian
oil on panel 15 x 28.3
TWCMS : B3201

Farrier, Robert 1796–1879
Old Wooden Leg 1830
oil on panel 64 x 51.5
TWCMS : F12338

Fenn, William Wilthieu c.1827–1906
Trellis Vine on the Lake of Lugano
oil on canvas 56.1 x 106.5
TWCMS : B4940

Fischer, Paul 1786–1875
Queen Victoria's Aviary c.1852
oil on canvas 58.7 x 122
TWCMS : E8487

Flegel, Georg (attributed to) 1566–1638
Still Life with Shellfish and Eggs c.1590–1630
oil on panel 56.8 x 103.5
TWCMS : B4244

Fleury, James Vivien de active 1847–1896
Morning on Lake Garda, Italy 1861
oil on canvas 81 x 122
TWCMS : B3752

Facing page: Tucker, James Walker, 1898–1972, *Gathering Shell Fish, St Servan* (detail), c.1932, Laing Art Gallery, (p. 218)

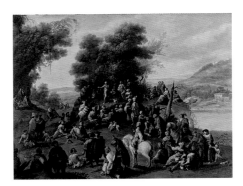

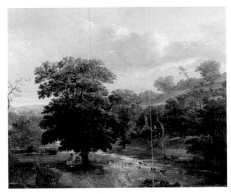

Foschi, Francesco (attributed to)
1710–1780
Winter Scene in the Italian Alps c.1735–1765
oil on canvas 99.2 x 136
TWCMS : B9996

Francken, Frans II (attributed to)
1581–1642
John the Baptist Preaching
oil on metal 80.6 x 107.6
TWCMS : C155

Gainsborough, Thomas (style of)
1727–1788
Landscape, Stream with Figures
oil on canvas 63.4 x 76.4
TWCMS : B8420

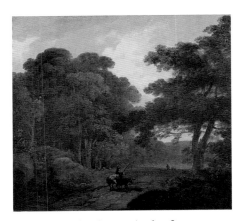

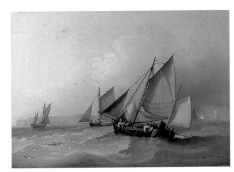

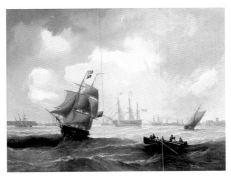

Gainsborough, Thomas (style of)
1727–1788
Wooded Landscape
oil on panel 18.5 x 20.4
TWCMS : C169

Garthwaite, William 1821–1899
Herring Fishing 1852
oil on canvas 30.3 x 43.2
TWCMS : B3247

Garthwaite, William 1821–1899
Entrance of a River with Shipping 1854
oil on canvas 46.5 x 61.9
TWCMS : B3211

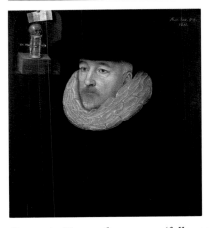

Geeraerts, Marcus the younger (follower of)
1561–1635
Portrait of a Man c.1611
oil on canvas 69.2 x 58.8
TWCMS : C152

Gibb, Thomas Henry 1833–1893
Landscape with Highland Cattle
oil on canvas 127.7 x 102
TWCMS : F12344

Gill, William Ward 1823–1894
View Near Ludlow 1858
oil on board 30 x 55.1
TWCMS : B3232

Gillie, Ann 1906–1995
Kitchen Table 1956
oil on board 30 x 83.7
TWCMS : F6122

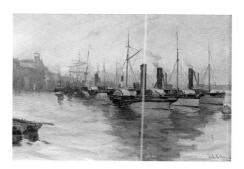

Gilroy, John William 1868–1944
Quayside
oil on canvas 35.5 x 53.4
TWCMS : F6135

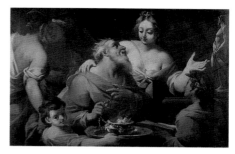

Giordano, Luca (style of) 1634–1705
King Solomon Offering Incense to an Idol
oil on canvas 89.7 x 138.4
TWCMS : C197

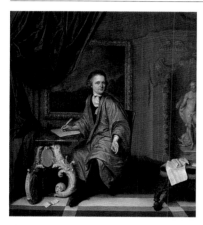

Goor, Jan van active 1674–1694
Portrait of an Unknown Man 1694
oil on canvas 68.9 x 61
TWCMS : B4902

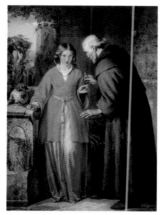

Grant, William James 1829–1866
Juliet and the Friar 'Take thou this phial'
(from Willliam Shakespeare's Romeo and
Juliet)
oil on panel 85 x 61.8
TWCMS : F6128

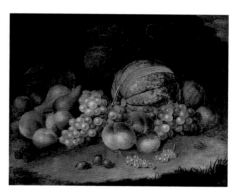

Gray, George 1758–1819
Fruit
oil on canvas 41.4 x 50.9
TWCMS : B4936

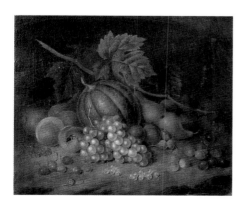

Gray, George 1758–1819
Fruit
oil on canvas 41.5 x 50.9
TWCMS : B4938

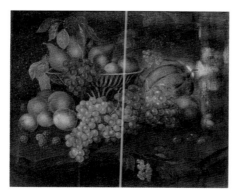

Gray, George 1758–1819
Fruit
oil on canvas 53.2 x 62.3
TWCMS : C7368

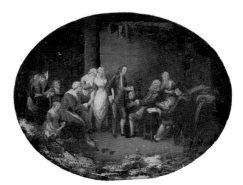

Greuze, Jean-Baptiste (after) 1725–1805
The Village Bridegroom
oil on wood 32.5 x 41
TWCMS : B3792

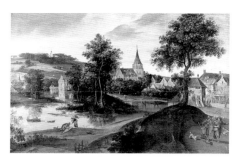

Grimmer, Jacob 1525–1590
Tobias and the Angel 1567
oil on panel 52 x 80
TWCMS : C189

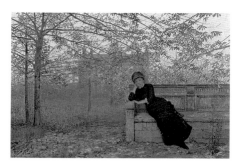

Grimshaw, John Atkinson 1836–1893
Autumn Regrets 1882
oil on canvas 70 x 101.5
TWCMS : B4945

Grimshaw, John Atkinson 1836–1893
November Morning, Knostrop Hall, Leeds
1883
oil on canvas 61 x 86.4
TWCMS : B3783

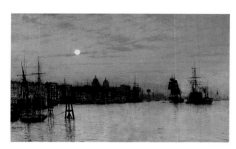

Grimshaw, John Atkinson 1836–1893
Greenwich, Half Tide 1884
oil on canvas 56.1 x 91.4
TWCMS : B3761

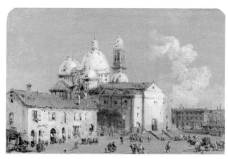

Guardi, Francesco (follower of) 1712–1793
San Giustina from the Prato della Valle, Padua
oil on paper 19.1 x 28.4
TWCMS : B4949

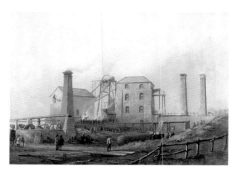

Hair, Thomas H. 1810–1882
Hartley Colliery after the Disaster 1869
oil on canvas 41.5 x 56.7
TWCMS : B3242

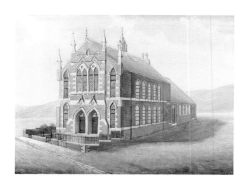

Hall, R. M. active 1887–1888
Moor Street Primitive Methodist Church 1888
oil on board 43.7 x 59.9
TWCMS : 1993.2029

Hancock, Charles 1802–1877 & **Noble,
James Campbell** 1846–1913
Highland Landscape with Sheep and Dogs
oil on canvas 46 x 66.5
TWCMS : B3751

Haughton, Benjamin 1865–1924
On the Quantocks, Somerset
oil on panel 24.5 x 34.5
TWCMS : F6150

Havell, William 1782–1857
A Stormy Day
oil on board 39.4 x 57.5
TWCMS : B8437

Hayes, Edwin 1819–1904
Off the Port of Boulogne 1874
oil on canvas 51.6 x 76.3
TWCMS : B4942

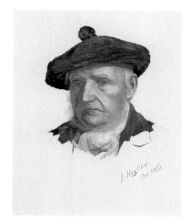

Hayllar, James 1829–1920
Man's Head 1885
oil on card 24.5 x 20
TWCMS : F9395

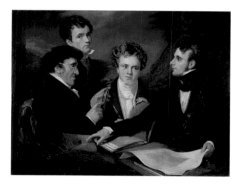

Hayter, John 1800–1891
A Controversy on Colour
oil on canvas 112.1 x 143
TWCMS : B8434

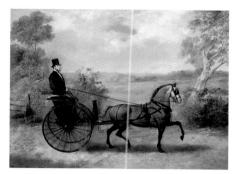

Heaning, A.
Man in a Gig 1862
oil on canvas 64 x 84
TWCMS : E8472

Hedgecock, Derek d.1999
View of Newcastle upon Tyne and Gateshead c.1970
oil on board 80 x 121
TWCMS : M4398

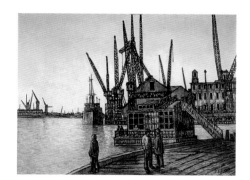

Hedgecock, Derek d.1999
View on the River Tyne
oil on board 91 x 122
TWCMS : M4397

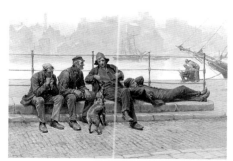

Hedley, Ralph 1848–1913
Out of Work 1888
oil on canvas 88.2 x 129.2
TWCMS : C11482

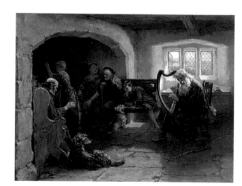

Hedley, Ralph 1848–1913
The Lay of the Last Minstrel 1890
oil on canvas 102.5 x 123.6
TWCMS : F12343

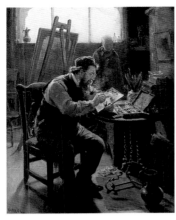

Hedley, Ralph 1848–1913
Stephen Brownlow 1892
oil on board 53.4 x 42.3
TWCMS : F12337

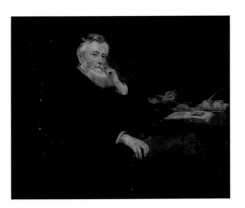

Hedley, Ralph 1848–1913
Spence Watson 1897
oil on canvas 116.4 x 134
TWCMS : E8466

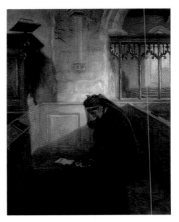

Hedley, Ralph 1848–1913
The Widow 1899
oil on canvas 163 x 129
TWCMS : 2006.8318

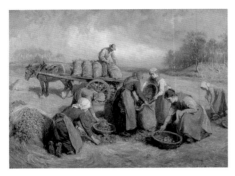

Hedley, Ralph 1848–1913
Potato Gatherers, Northumberland 1903
oil on canvas 86.4 x 116.8
TWCMS : G430

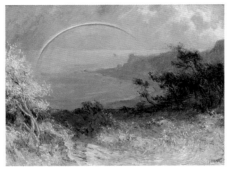

Hedley, Ralph 1848–1913
Summer Time 1904
oil on canvas 46.4 x 61.4
TWCMS : G432

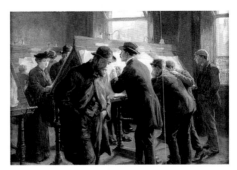

Hedley, Ralph 1848–1913
Seeking Situations
oil on canvas 95.6 x 132.7
TWCMS : G445

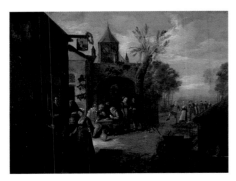

**Heemskerck, Egbert van the elder
(attributed to)** 1634/1635–1704
Exterior of a Dutch Ale House
oil on canvas 68.5 x 89.9
TWCMS : C192

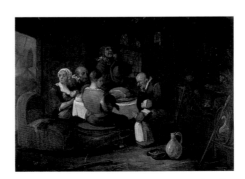

Heemskerck, Egbert van the elder (style of)
1634/1635–1704
Grace before Meat
oil on metal 20.2 x 29
TWCMS : C156

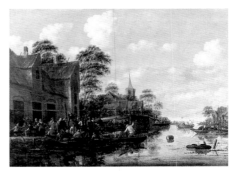

Heeremans, Thomas c.1640–1697
The Dutch Fair, Villagers Snatching at a Goose
1664
oil on panel 60.3 x 84
TWCMS : G1178

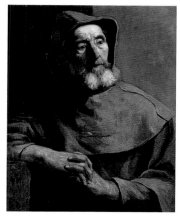

Hemy, Thomas Marie Madawaska
1852–1937
On the Look-Out 1878
oil on canvas 66.7 x 54.7
TWCMS : F9422

Henzell, Isaac 1815–1876
Wayside Gossip 1846
oil on canvas 69.5 x 90.5
TWCMS : B4925

Hepple, Wilson 1854–1937
The Last of the Old Tyne Bridge 1900
oil on canvas 92 x 153
TWCMS : B4908

Herring, John Frederick II 1815–1907
Interior of a Stable 1849
oil on canvas 41.2
TWCMS : B3231

Herring, John Frederick II 1815–1907
Watering Horses 1850
oil on canvas 40.8
TWCMS : B3233

Hesketh, Richard 1867–1919
Harter Fell, Eskdale
oil on canvas 70.5 x 91.1
TWCMS : G421

Heusch, Willem de (attributed to)
c.1625–c.1692
River Scene with Figures
oil on canvas 69.2 x 84.5
TWCMS : C7351

Heyden, Jan van der 1637–1712
Wooded Landscape c.1690–1700
oil on canvas 31.7 x 43.3
TWCMS : B6230

Heyn, August 1837–1920
The Village Politicians 1877
oil on panel 33.3 x 46
TWCMS : B3217

Hill, Ernest F. active 1897–1940
Terrier and Hedgehog
oil on canvas 45.8 x 56.5
TWCMS : F6101

Hill, James John 1811–1882
Near Stratford-upon-Avon
oil on canvas 51 x 61.5
TWCMS : G424

Hobbema, Meindert (after) 1638–1709
River Scene
oil on canvas 24.4 x 34.5
TWCMS : C7384

Hobley, Edward George 1866–1916
Cumberland Hills 1896
oil on canvas 162.3 x 255.1
TWCMS : G431

Hodgson, Stannard active 19th C
The Young Picnickers
oil on canvas 59.8 x 85.6
TWCMS : B3768

Hold, E. F.
The Orphan 1877
oil on canvas 61 x 46
TWCMS : B3245

Holland, James 1800–1870
The Deserted Village (Goldsmith's)
oil on canvas 97.5 x 153.4
TWCMS : B3206

Holland, James 1800–1870
Low Water, Trebarwith Strand, Tintagel, Cornwall
oil on canvas 97.6 x 152.9
TWCMS : B4907

Hondecoeter, Melchior de (follower of)
1636–1695
Poultry
oil on canvas 44.1 x 59
TWCMS : B8426

Facing page: La Thangue, Henry Herbert, 1859–1929, *Gathering Bracken*, (detail), c.1899, Laing Art Gallery, (p. 171)

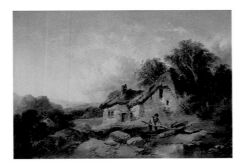

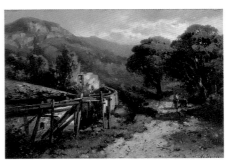

Hondecoeter, Melchior de (follower of)
1636–1695
The Poultry Yard
oil on canvas 132.5 x 157.7
TWCMS : G1189

Horlor, Joseph 1809–1887
Near Hailsham, Sussex 1859
oil on canvas 46.5 x 67
TWCMS : B4215

Hulk, Abraham I 1813–1897
Landscape and Mill
oil on panel 17.3 x 25.2
TWCMS : B6201

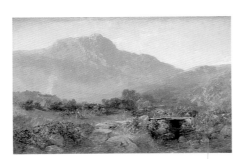

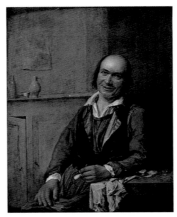

Hunt, Alfred William 1830–1896
Capel Curig, Snowdonia, North Wales 1855
oil on canvas 26.8 x 42
TWCMS : E8475

Hutten, T. F.
Portrait of a Man Smiling 1837
oil on panel 35.4 x 27
TWCMS : C7391

Huysmans, Cornelis (attributed to)
1648–1727
Landscape
oil on canvas 49.3 x 61
TWCMS : B8422

Huysmans, Jan Baptist (attributed to)
1654–1716
Wooded Landscape c.1700
oil on canvas 71.5 x 91.7
TWCMS : C7369

Ibbetson, Julius Caesar 1759–1817
Kenwood, Lord Mansfield's Pedigree Cattle
1797
oil on canvas 28 x 39.4
TWCMS : C7365

Irving, William 1866–1943
Joseph Cowen 1899
oil on canvas 124 x 94
TWCMS : R232

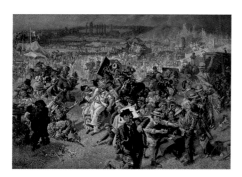

Irving, William 1866–1943
The Blaydon Races, a Study from Life 1903
oil on canvas 95 x 140
TWCMS : 2002.1617

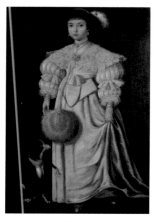

Jackson, Gilbert (attributed to)
active 1621–1658
Portrait of a Girl, Aged 8 1632
oil on canvas 108.8 x 75.7
TWCMS : F9406

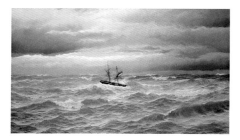

James, David 1834–1892
Sea Piece 1882
oil on canvas 76.5 x 127
TWCMS : B4931

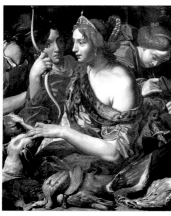

Janssens, Abraham c.1575–1632
Diana after the Chase c.1618
oil on panel 126.2 x 97
TWCMS : G1185

Jay, William Samuel 1843–1933
The Ring Dove's Elysium
oil on canvas 122.4 x 85.9
TWCMS : B3767

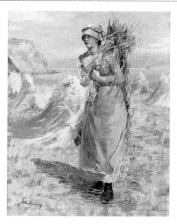

Jobling, Isabella 1851–1926
Haymaking 1893–1900
oil on canvas 45.5 x 36
TWCMS : F6138

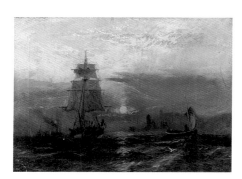

Jobling, Robert 1841–1923
Sunset with Boats 1872
oil on canvas 40.4 x 55.9
TWCMS : G439

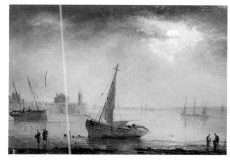

Jublin, Alexis
A Harbour 1781
oil on panel 9.4 x 13.4
TWCMS : F12333

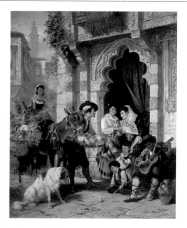

Kemm, Robert 1837–1895
A Spanish Fruit Seller
oil on canvas 127.5 x 102.5
TWCMS : B3784

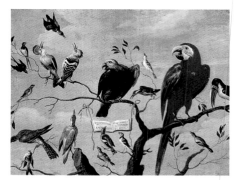

Kessel, Jan van II 1626–1679
A Chorus of Birds c.1650–1675
oil on metal 19 x 25.1
TWCMS : C7373

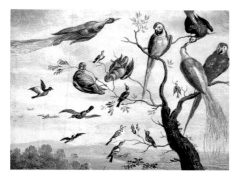

Kessel, Jan van II 1626–1679
The Chorus of Birds c.1650–1675
oil on metal 19 x 24.5
TWCMS : C7383

Kidd, William 1790–1863
Old Cottages at Petersfield, Hampshire 1820
oil on board 27.5 x 38.6
TWCMS : B4943

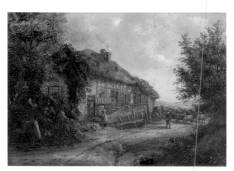

Kidd, William 1790–1863
Cottages at Petersfield, Hampshire 1839
oil on board 28.9 x 38.8
TWCMS : B4924

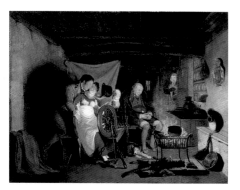

Kidd, William 1790–1863
The Stolen Kiss
oil on canvas 43.5 x 53.7
TWCMS : F12336

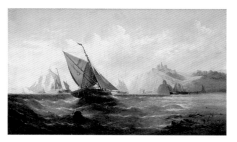

Knight, George active 1872–1892
Off the Coast 1880
oil on canvas 76.3 x 127.3
TWCMS : B3219

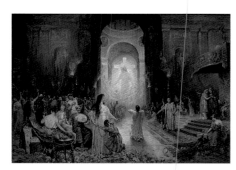

Knowles, Davidson 1851–1901
The Sign of the Cross 1897
oil on canvas 241.3 x 304.5
TWCMS : F12326

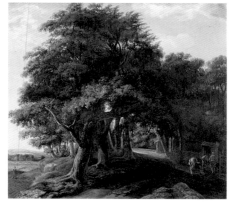

Koninck, Philips de (attributed to)
1619–1688
Landscape, the Edge of a Wood 1679
oil on canvas 100 x 108
TWCMS : C7378

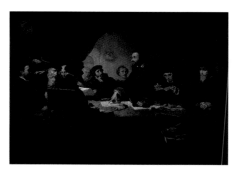

Labouchère, Pierre Antoine 1807–1873
After Darkness, Light c.1852
oil on canvas 213.3 x 301.5
TWCMS : F12327

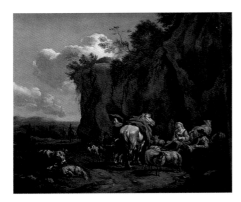

Laer, Pieter van 1599–c.1642
Horseman with Cattle and Figures
oil on canvas 48.9 x 58
TWCMS : B9989

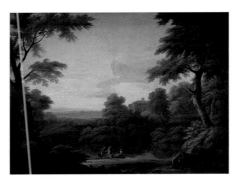

Lambert, George c.1700–1765
Classical Landscape
oil on canvas 112.4 x 147.4
TWCMS : B8407

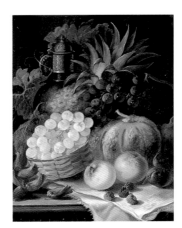

Lance, George (attributed to) 1802–1864
Fruit Piece
oil on canvas 51 x 41
TWCMS : B4209

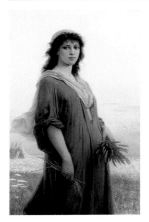

Landelle, Charles 1821–1908
Ruth 1886
oil on canvas 135.3 x 86.5
TWCMS : B4203

Landseer, Edwin Henry (after) 1802–1873
A Random Shot
oil on board 32 x 47
TWCMS : F9355

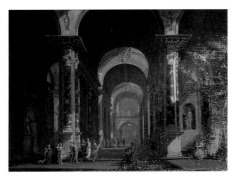

Langevelt, Rutger van 1635–1695
Interior of a Classical Building with a Marriage Ceremony
oil on panel 57.8 x 77.3
TWCMS : B4238

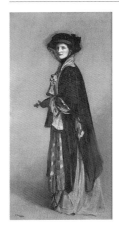

Lavery, John 1856–1941
Mrs Katherine Vulliamy 1908
oil on canvas 198.4 x 100
TWCMS : F12297

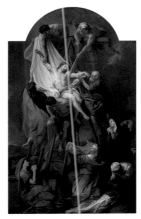

Le Brun, Charles 1619–1690
The Descent from the Cross
oil on copper 96 x 59.6
TWCMS : C11703 (P)

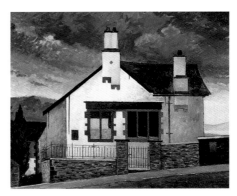

Lee, Barry S.
Coniston, Cumbria 1953
oil on canvas 60.7 x 76.1
TWCMS : E8481

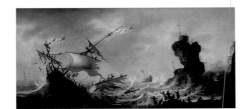

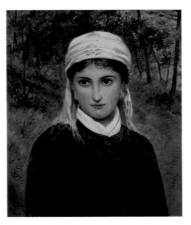

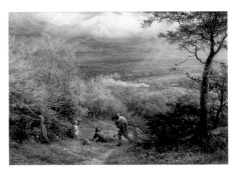

Leyden, Jan van active 1652–1669
The Wreck
oil on panel 45 x 95.4
TWCMS : G1167

Lidderdale, Charles Sillem 1831–1895
An Italian Lady 1882
oil on canvas 60 x 50.6
TWCMS : B3772

Linnell, James Thomas 1826–1905
The Last Gleam 1872
oil on canvas 71.8 x 102
TWCMS : G440

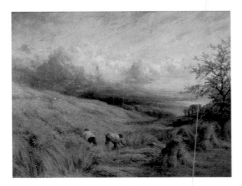

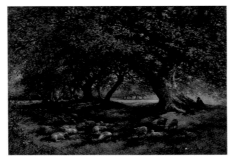

Linnell, John (attributed to) 1792–1882
A Cornfield in Surrey
oil on canvas 71.9 x 91.2
TWCMS : B3777

Linnell, John (attributed to) 1792–1882
A Sylvan Scene
oil on canvas 82.5 x 116.7
TWCMS : B3234

Linnell, John (attributed to) 1792–1882
Landscape with Cornfield
oil on canvas 31.5 x 51
TWCMS : B3765

Linnell, John (attributed to) 1792–1882
The Belated Traveller
oil on canvas 63.5 x 76.5
TWCMS : B4240

Linnell, William 1826–1906
*People Fleeing from a Ruined Eastern
Village* 1870
oil on canvas 138.6 x 199.5
TWCMS : B3758

Linnell, William 1826–1906
Shepherdess with Sheep 1874
oil on canvas 60.6 x 91.5
TWCMS : B4910

Locatelli, Andrea (attributed to) 1695–1741
Landscape with River
oil on canvas 109 x 214.8
TWCMS : B9990

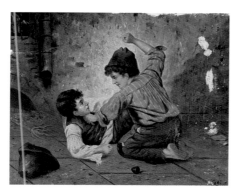

Lodi, Gaetano 1830–1886
Boys Fighting
oil on canvas 42 x 52.7
TWCMS : F9410

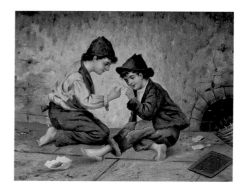

Lodi, Gaetano 1830–1886
Boys Smoking
oil on canvas 42.2 x 53
TWCMS : F9409

Loose, Basile de 1809–1885
For the Sick Poor
oil on canvas 80.5 x 67.3
TWCMS : B4211

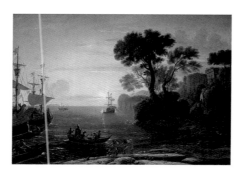

Lorrain, Claude (after) 1604–1682
Coast Scene with the Landing of Aeneas in Latium
oil on canvas 95.5 x 134.4
TWCMS : C173

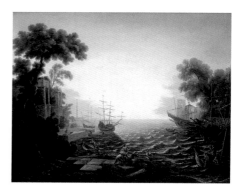

Lorrain, Claude (after) 1604–1682
The Embarkation of St Ursula
oil on canvas 120.5 x 128.8
TWCMS : G1173

Loth, Johann Carl 1632–1698
Abraham Visited by the Angels c.1660–1670
oil on canvas 142.3 x 168.2
TWCMS : G1182

Lowe, Arthur 1866–1940
Old Church, Colston Bassett, Nottinghamshire
oil on canvas 66 x 91.5
TWCMS : E8497

Lucas, Albert Durer 1828–1919
Heath, Heather, Furze and Sundew 1880
oil on canvas 25.6 x 20.4
TWCMS : B6220

Lucy, Charles 1814–1873
The Interview of Milton with Galileo
oil on canvas 127.2 x 106.5
TWCMS : B3773

Lund, Niels Møller 1863–1916
After Rain 1889–1892
oil on canvas 127.2 x 102.1
TWCMS : F12323

Macdonald, Ian b.1946
Friday Night Out 1974
oil on canvas 124.3 x 89
TWCMS : C3354

Mack, J.
Hurlstone Point, Somerset c.1972
oil on board 40.5 x 60.8
TWCMS : F9361

Mackay, Thomas 1851–1909
Contentment 1880
oil on canvas 30.5 x 23.3
TWCMS : B6211

Mackie, Sheila Gertrude b.1928
The Red Handkerchief c.1952
oil on canvas 62.4 x 87.7
TWCMS : F9399

Macklin, Thomas Eyre 1867–1943
Whittle Mill 1904
oil on canvas 128 x 193.5
TWCMS : F9366

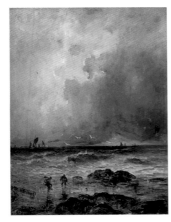

Manzoni, P. active 1850–1900
On the French Coast 1879
oil on canvas 111.8 x 86.8
TWCMS : B3205

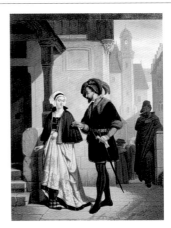

Marsell, G.
Faust and Margaret 1876
oil on panel 35.1 x 27.3
TWCMS : F9431

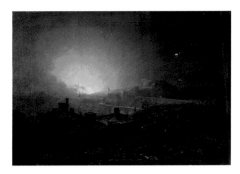

Martin, John (style of) 1789–1854
The Fire, Edinburgh
oil on canvas 67.2 x 92.4
TWCMS : B4239

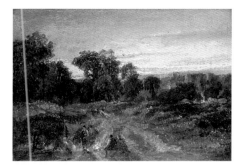

Mason, T. active 19th C
A Gypsy Encampment
oil on panel 13.4 x 17.5
TWCMS : B6238

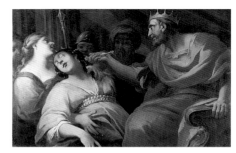

Matteis, Paolo de' 1662–1728
Esther before King Ahasuerus
oil on canvas 89.4 x 138.2
TWCMS : B9985

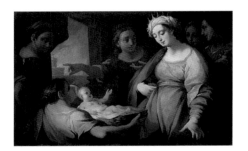

Matteis, Paolo de' 1662–1728
The Finding of Moses
oil on canvas 89.8 x 139.1
TWCMS : C7352

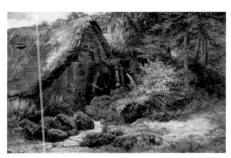

Mawson, Elizabeth Cameron 1849–1939
Holy Street Mill
oil on canvas 92 x 137.9
TWCMS : F9362

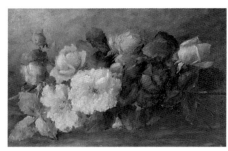

Mayer, J.
Roses
oil on canvas 27.5 x 42.5
TWCMS : B4219

Mayer, J.
Washerwomen in a Garden
oil on board 23.5 x 18.6
TWCMS : B6218

McCulloch, Horatio 1805–1867
The Haunt of the Red Deer 1849
oil on canvas 135.2 x 196
TWCMS : F9367

McCulloch, Horatio 1805–1867
A Scottish Landscape
oil on panel 44 x 57
TWCMS : B4217

McCulloch, Horatio 1805–1867
On the Clyde
oil on canvas 35.5 x 48.2
TWCMS : B6222

McEune, Robert Ernest 1876–1952
Head of a Lady 1896
oil on canvas 54.3 x 40.7
TWCMS : M2551

McEune, Robert Ernest 1876–1952
Head of an Old Man 1896
oil on canvas 51.8 x 41.1
TWCMS : M2554

McEune, Robert Ernest 1876–1952
Woman in Eastern Headdress 1896
oil on canvas 45.4 x 39.5
TWCMS : M2555

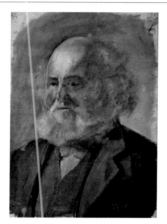

McEune, Robert Ernest 1876–1952
Head of an Old Man 1897
oil on paper 55 x 38.2
TWCMS : M2552

McEune, Robert Ernest 1876–1952
Still Life with Shell 1897
oil on canvas 40.7 x 53
TWCMS : M2533

McEune, Robert Ernest 1876–1952
Still Life with Silver Cup 1897
oil on canvas 40.5 x 53.3
TWCMS : M2553

McEune, Robert Ernest 1876–1952
Oil Study of a Sculptured Figure 1898
oil on paper 76 x 50.3
TWCMS : M2535

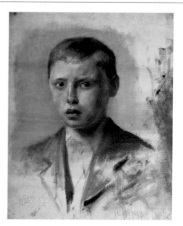

McEune, Robert Ernest 1876–1952
Portrait of a Boy 1898
oil on canvas 52.1 x 41.3
TWCMS : M2545

Facing page: Gear, William, 1915–1997, *Composition printanier* (detail), 1950, Laing Art Gallery, (p. 144)

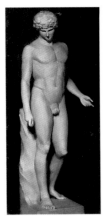

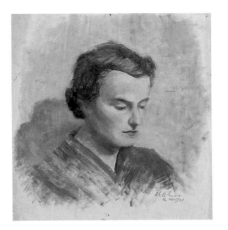

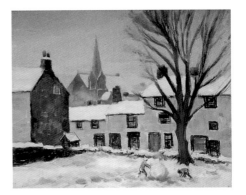

McEune, Robert Ernest 1876–1952
Oil Study of a Statue of Antinous 1900
oil on canvas 72.2 x 33.1
TWCMS : M2534

McEune, Robert Ernest 1876–1952
*Mrs Smith of the Royal Grammar School,
Newcastle* 1943
oil on paper 40.6 x 38.1
TWCMS : K17295

McEune, Robert Ernest 1876–1952
Penrith, Cumbria 1949
oil on board 37.9 x 45.5
TWCMS : M1908

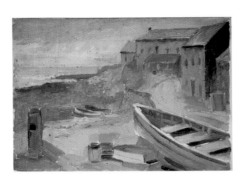

McEune, Robert Ernest 1876–1952
Boy, 1897
oil on canvas 37.4 x 21
TWCMS : M2541

McEune, Robert Ernest 1876–1952
By the Sea
oil on board 25.3 x 35.3
TWCMS : M1903

McEune, Robert Ernest 1876–1952
Class Study
oil on board 32.5 x 23.5
TWCMS : M1901

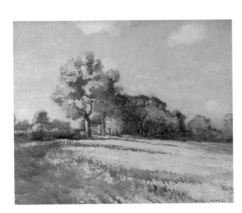

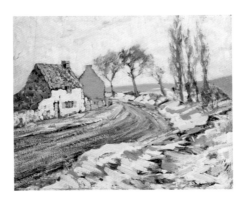

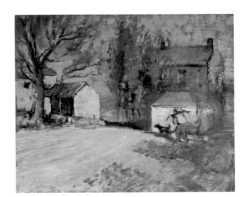

McEune, Robert Ernest 1876–1952
Cornfield With Woods
oil on board 55 x 65.8
TWCMS : C11282

McEune, Robert Ernest 1876–1952
Cottage Lane in Winter
oil on board 50.5 x 62
TWCMS : C11479

McEune, Robert Ernest 1876–1952
Farm (?)
oil on board 53.2 x 64.6
TWCMS : M1750.2

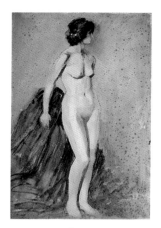

McEune, Robert Ernest 1876–1952
Female Nude
oil on card 60.6 x 40.3
TWCMS : M2540.1

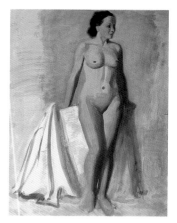

McEune, Robert Ernest 1876–1952
Female Nude
oil on paper 76.2 x 57.4
TWCMS : M2547

McEune, Robert Ernest 1876–1952
Female Nude
oil on paper 75.7 x 57
TWCMS : M2548

McEune, Robert Ernest 1876–1952
Fisherman Mending a Lobster Pot
oil on board 40.5 x 30.3
TWCMS : M1906

McEune, Robert Ernest 1876–1952
Head of a Girl
oil on canvas 46.1 x 40.8
TWCMS : M2549

McEune, Robert Ernest 1876–1952
Head of a Girl
oil on canvas 52.5 x 38.1
TWCMS : M2550

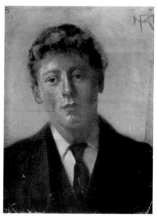

McEune, Robert Ernest 1876–1952
Head of a Young Man
oil on canvas 45.6 x 32.4
TWCMS : M2537

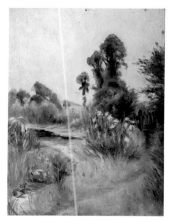

McEune, Robert Ernest 1876–1952
Landscape
oil on card 32.5 x 24.1
TWCMS : M1904

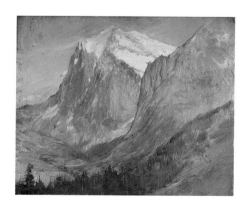

McEune, Robert Ernest 1876–1952
Mountains
oil on board 37.8 x 45.4
TWCMS : M1912

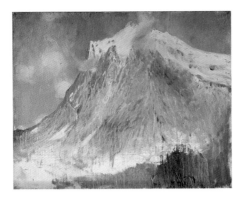

McEune, Robert Ernest 1876–1952
Mountains
oil on board 37.9 x 45.3
TWCMS : M1913

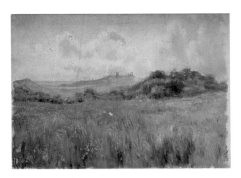

McEune, Robert Ernest 1876–1952
Northumberland
oil on board 25.3 x 35.3
TWCMS : M1902

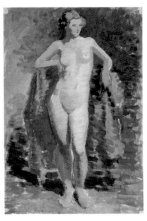

McEune, Robert Ernest 1876–1952
Nude Female
oil on paper 57.2 x 38
TWCMS : M2536

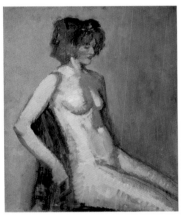

McEune, Robert Ernest 1876–1952
Nude Woman
oil on board 64.6 x 53.2
TWCMS : M1750.1

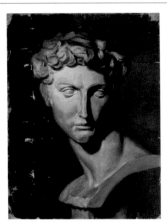

McEune, Robert Ernest 1876–1952
Oil Study of a Plaster Bust
oil on canvas 55.9 x 40.6
TWCMS : M2532

McEune, Robert Ernest 1876–1952
Oil Study of a Plaster Bust
oil on canvas 43.8 x 31.6
TWCMS : M2542

McEune, Robert Ernest 1876–1952
Oil Study of a Plaster Bust
oil on canvas 53.1 x 39.8
TWCMS : M2543

McEune, Robert Ernest 1876–1952
Oil Study of Statue with Discus
oil on canvas 81.2 x 52
TWCMS : M2544

McEune, Robert Ernest 1876–1952
Oil Study of the Head of a Girl
oil on canvas 56.9 x 38.5
TWCMS : M2546

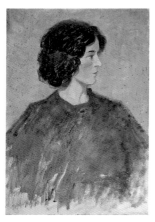

McEune, Robert Ernest 1876–1952
Portrait of a Lady
oil on card 60.6 x 40.3
TWCMS : M2540.2

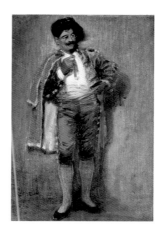

McEune, Robert Ernest 1876–1952
Portrait of a Matador
oil on canvas 35.5 x 24.5
TWCMS : F9383

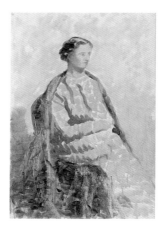

McEune, Robert Ernest 1876–1952
Portrait of a Seated Girl
oil on paper 57.1 x 37.9
TWCMS : M1851

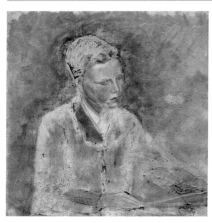

McEune, Robert Ernest 1876–1952
Portrait of a Young Man
oil on canvas 35.4 x 35.2
TWCMS : M2539

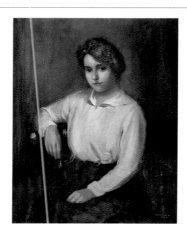

McEune, Robert Ernest 1876–1952
Portrait of the Artist's Wife
oil on board 73.3 x 51.5
TWCMS : F9385

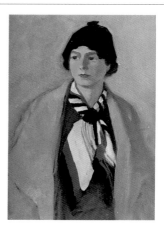

McEune, Robert Ernest 1876–1952
Portrait of the Artist's Wife
oil on canvas 91.4 x 71.4
TWCMS : F9413

McEune, Robert Ernest 1876–1952
River Scene
tempera on card 27 x 38
TWCMS : M195

McEune, Robert Ernest 1876–1952
St Alban's Row, Carlisle
oil on board 55.6 x 66
TWCMS : H4434

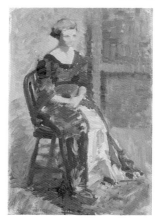

McEune, Robert Ernest 1876–1952
Sketch of a Seated Lady
oil on paper 56 x 38.1
TWCMS : K17255

McEune, Robert Ernest 1876–1952
Sky and Lake
oil on paper 25.4 x 35.5
TWCMS : M1852

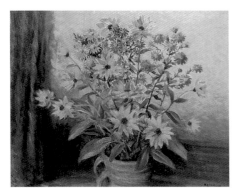

McEune, Robert Ernest 1876–1952
Still Life, Flowers
oil on board 51 x 61.5
TWCMS : F6112

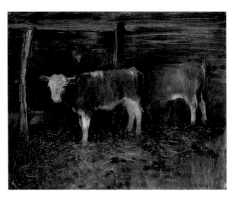

McEune, Robert Ernest 1876–1952
Swiss Calves in the Bernese Oberland
oil on board 37.5 x 45.5
TWCMS : M1907

McEune, Robert Ernest 1876–1952
Switzerland
oil on board 38 x 45.4
TWCMS : M1909

McEune, Robert Ernest 1876–1952
Switzerland
oil on board 37.7 x 45.4
TWCMS : M1910

McEune, Robert Ernest 1876–1952
Switzerland
oil on board 37.8 x 45.3
TWCMS : M1911

McEune, Robert Ernest 1876–1952
The Thames at Windsor
oil on board 54 x 76
TWCMS : C11466

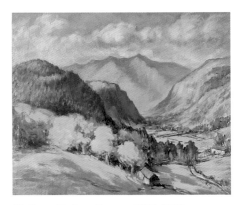

McEune, Robert Ernest 1876–1952
Valley Landscape
oil on board 55.7 x 65.7
TWCMS : C11473

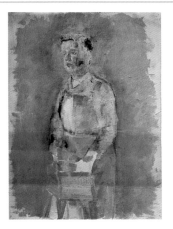

McEune, Robert Ernest 1876–1952
Young Man
oil on canvas 44.3 x 31.6
TWCMS : M2538

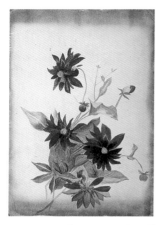

McEune, Robert Ernest (attributed to)
1876–1952
Flowers
oil on card 44.5 x 31
TWCMS : M1905

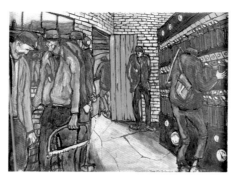

McGuinness, Tom 1926–2006
Miners' Lamp Room 1962
oil on board 56 x 76
TWCMS : F9420

McNairn, John 1910–c.1975
Landscape, Midlem
oil on canvas 40.5 x 58.5
TWCMS : E8483

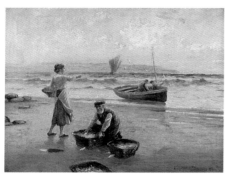

McSwiney, Eugene Joseph 1866–1936
Landing a Catch, A
oil on canvas 30.7 x 40.6
TWCMS : A59

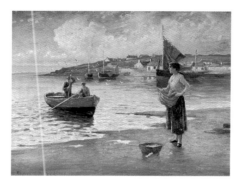

McSwiney, Eugene Joseph 1866–1936
Landing a Catch, B
oil on canvas 30.7 x 40.6
TWCMS : A60

Meadows, Arthur Joseph 1843–1907
Low Tide, Mount Orgueil, Jersey 1881
oil on canvas 25.5 x 35.7
TWCMS : F12317

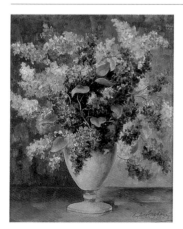

Meehan, Myles 1904–1974
Lilac 1958
oil on canvas 61 x 50.7
TWCMS : F6123

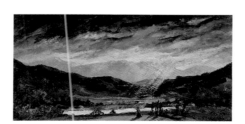

Meehan, Myles 1904–1974
Storm over the Pyrenees 1959
oil on board 30.3 x 60.5
TWCMS : E8491

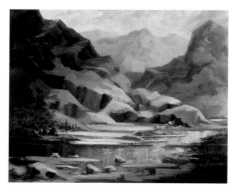

Meehan, Myles 1904–1974
The Rhone River 1961
oil on board 51.1 x 61
TWCMS : C11270

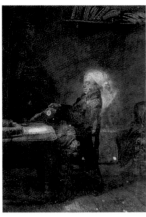

Meerts, Franz 1836–1896
Old Man Sharpening a Quill Pen
oil on canvas 40.5 x 31.5
TWCMS : F6147

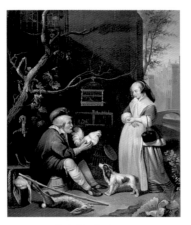

Metsu, Gabriel (after) 1629–1667
Dutch Bird Seller
oil on metal 39.1 x 31.9
TWCMS : B8427

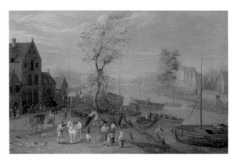

Michau, Theobald (attributed to)
1676–1765
Village Scene c.1700–1730
oil on panel 22.7 x 33.9
TWCMS : G1164

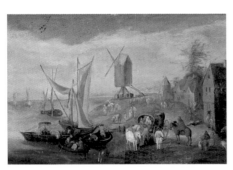

Michau, Theobald (attributed to)
1676–1765
River with Windmill
oil on panel 23.3 x 34.1
TWCMS : G1172

Michau, Theobald (style of) 1676–1765
River with Windmills
oil on panel 27.7 x 30.5
TWCMS : C188

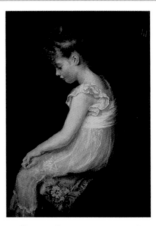

Millais, John Everett (attributed to)
1829–1896
Meditation 1879
oil on canvas 91.5 x 61.4
TWCMS : B3210

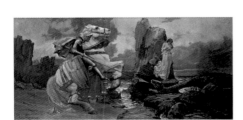

Mitchell, John Edgar 1871–1922
Perseus and Andromeda 1905
oil on canvas 117.6 x 238.8
TWCMS : F12345

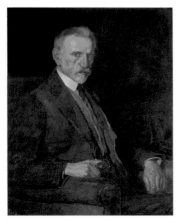

Mitchell, John Edgar 1871–1922
John Oxberry (1857–1940)
oil on canvas 92 x 71
TWCMS : F9387

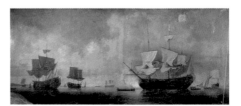

Monamy, Peter 1681–1749
Sea Piece with War Vessels
oil on canvas 73 x 160
TWCMS : C178

Facing page: Nevinson, Christopher, 1889–1946, *Twentieth Century* (detail), 1932–1935, Laing Art Gallery, (p. 188)

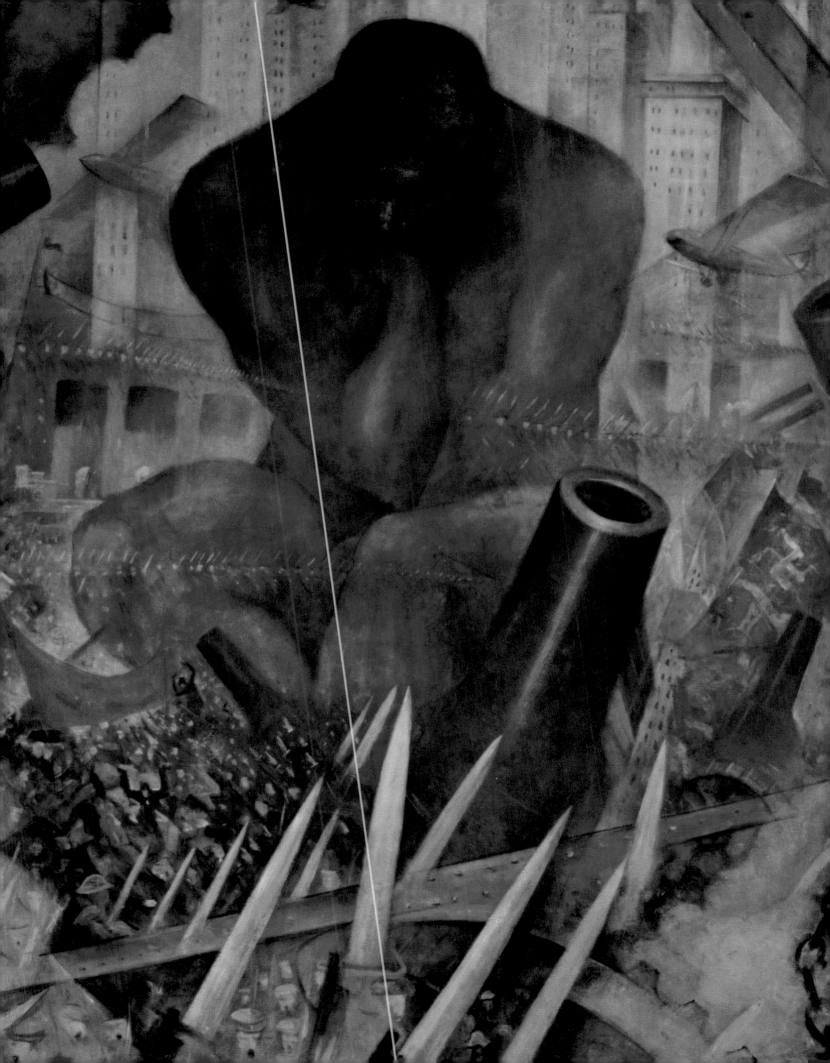

Monnoyer, Jean-Baptiste (style of)
1636–1699
Flowers and Fruit
oil on canvas 83.7 x 61.7
TWCMS : C165

Moore, Edward d.1920
Sea Piece
oil on canvas 63.5 x 127.3
TWCMS : B6224

Moore, Henry 1831–1895
Seascape 1882
oil on canvas 45 x 76.1
TWCMS : F12316

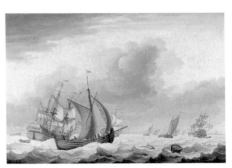

Mooy, Cornelis Pietersz. de 1632–1696
Dutch Shipping c.1655–1690
oil on canvas 59.9 x 84.3
TWCMS : C7386

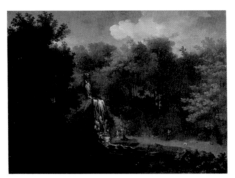

More, Jacob (attributed to) 1740–1793
Landscape with Waterfall
oil on canvas 86.4 x 114.3
TWCMS : B8439

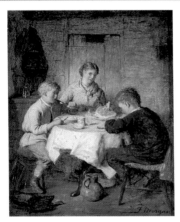

Morgan, Frederick 1856–1927
Dinner Time
oil on panel 12.2 x 10
TWCMS : B3248

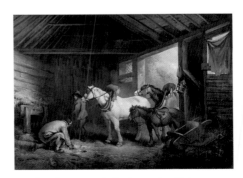

Morland, George (after) 1763–1804
Interior of a Stable
oil on canvas 97.7 x 135.8
TWCMS : B8406

Morland, George (style of) 1763–1804
A Halt by the Way 1797
oil on canvas 45.7 x 76.4
TWCMS : B8410

Moroni, Giovanni Battista (style of)
c.1525–1578
The Musician
oil on canvas 95.1 x 75.7
TWCMS : C177

Morris, Philip Richard 1838–1902
Beach with Figures
oil on board 26.5 x 40.9
TWCMS : B6214

Mosscher, Jacob van c.1615–after 1655
Landscape in the Dunes
oil on panel 35.5 x 51
TWCMS : B3235

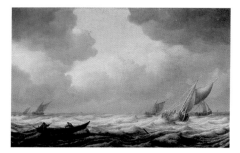

Mulier, Pieter the elder c.1615–1670
Dutch Shipping
oil on panel 47.5 x 68.5
TWCMS : C180

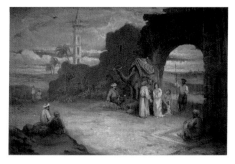

Muller, William James (after) 1812–1845
Eastern Scene (The White Slave)
oil on canvas 106.7 x 153
TWCMS : B4250

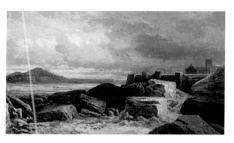

Muller, William James (after) 1812–1845
Rocky Coast Scene
oil on panel 39.2 x 68.7
TWCMS : B4210

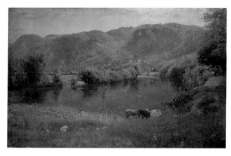

Murray, David 1849–1933
Church Pool 1899
oil on canvas 122 x 183
TWCMS : F9369

Murray, David 1849–1933
Ullswater, Silver and Gold 1917
oil on canvas 81.5 x 97.8
TWCMS : G423

Murray, David 1849–1933
Crofts on the Island of Lewis 1921
oil on canvas 137.5 x 167.5
TWCMS : F9378

Murray, David 1849–1933
The Watering Place c.1927
oil on canvas 61.3 x 91.7
TWCMS : H6466

Murray, David 1849–1933
Green Summertime
oil on canvas 122 x 182
TWCMS : F9360

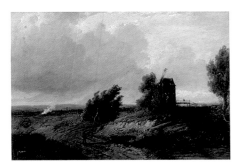

Nasmyth, Patrick (style of) 1787–1831
Landscape with an Old Mill 1828
oil on panel 25.3 x 35.7
TWCMS : B6226

Neal, James
Flowers
oil on board 75.5 x 63.2
TWCMS : F6117

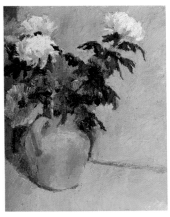

Newman, Harold active 20th C
Chrysanthemum
oil on board 57.5 x 44.7
TWCMS : F6115

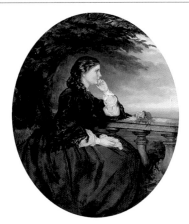

Nicholls, Charles Wynne 1831–1903
Portrait of Lady under a Tree c.1864
oil on canvas 60 x 50.3
TWCMS : C11702

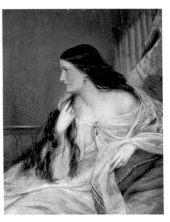

Nicholls, Charles Wynne 1831–1903
Anne McNair Alison, née Nicholls 1866
oil on panel 31.5 x 26
TWCMS : G1195

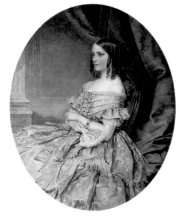

Nicholls, Charles Wynne 1831–1903
Lady in Lilac
oil on canvas 61 x 50.5
TWCMS : G1193

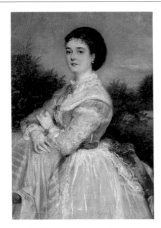

Nicholls, Charles Wynne 1831–1903
Portrait of a Lady
oil on canvas 42.6 x 30.9
TWCMS : C11701

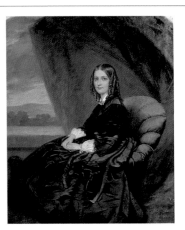

Nicholls, Charles Wynne 1831–1903
Portrait of Lady in a Black Dress
oil on canvas 64 x 50.5
TWCMS : G1194

Nicholson, Winifred 1893–1981
Mount Zara 1973
oil on canvas 78.1 x 53.3
TWCMS : C3355

Nicol, Erskine 1825–1904
Toothache
oil on canvas 53.2 x 43
TWCMS : F12332

Niemann, Edmund John 1813–1876
*A View on the Wharf near Pateley Bridge,
Yorkshire*
oil on canvas 100.7 x 125.3
TWCMS : B4214

Niemann, Edmund John (attributed to)
1813–1876
A Welsh Valley
oil on canvas 35.5 x 49
TWCMS : B3793

Niemann, Edmund John (attributed to)
1813–1876
Landscape
oil on canvas 35.2 x 46
TWCMS : B3775

Nijmegen, Gerard van 1735–1808
A Breezy Day 1789
oil on canvas 112.3 x 85.2
TWCMS : B6233

North, John William 1842–1924
The Sweet Meadow Waters of the West
oil on canvas 145.9 x 201.8
TWCMS : B3763

**Nursey, Claude Lorraine Richard
Wilson** 1816–1873
The Draught Players 1844
oil on canvas 71.2 x 91.8
TWCMS : B6234

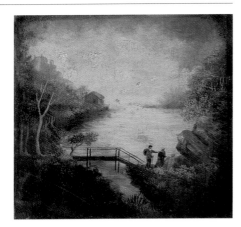

O'Connor, Patrick active 19th C
Killarney Castle
oil on panel 19 x 20.2
TWCMS : E8485

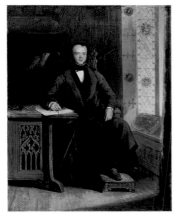

Oliphant, John active 1832–1847
William Wailes (1808–1881) c.1845
oil on canvas 92.2 x 70.9
TWCMS : G442

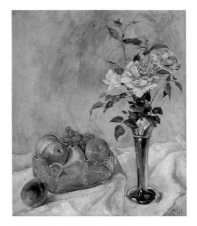

Orlik, Emil 1870–1932
Still Life with Roses and Fruit c.1925
oil on canvas 67 x 55.3
TWCMS : F9371

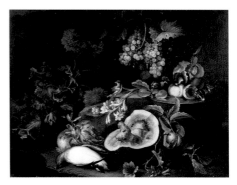

Pace del Campidoglio, Michele
1610–probably 1670
Fruit, Flowers and Birds c.1635–1665
oil on canvas 93.2 x 117.9
TWCMS : B9995

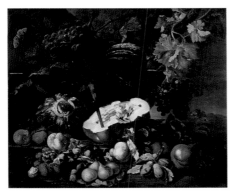

Pace del Campidoglio, Michele
1610–probably 1670
Fruit Piece c.1635–1665
oil on canvas 87.8 x 104.4
TWCMS : C175

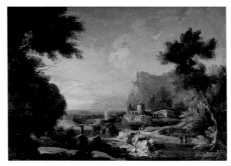

Pagano, Michele c.1697–1732
Classical Landscape
oil on canvas 24.7 x 33.6
TWCMS : B9993

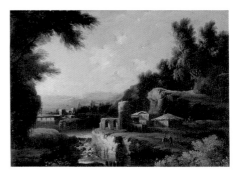

Pagano, Michele c.1697–1732
Landscape
oil on canvas 25 x 33.8
TWCMS : B9992

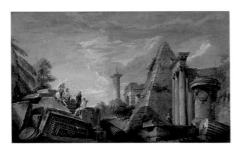

Panini, Giovanni Paolo (after) c.1692–1765
Classical Ruins with Figures
oil on canvas 68.6 x 119.8
TWCMS : C7385

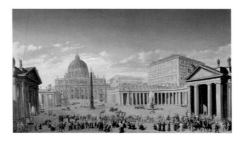

Panini, Giovanni Paolo (after) c.1692–1765
St Peter's, Rome
oil on canvas 117.5 x 200.5
TWCMS : G1192

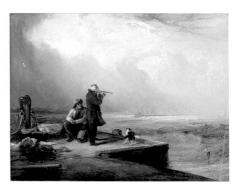

Parker, Henry Perlee 1795–1873
The Look Out, Shields Harbour 1831
oil on panel 35.5 x 45.5
TWCMS : B3800

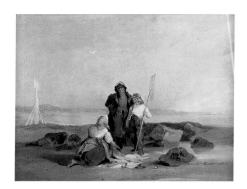

Parker, Henry Perlee 1795–1873
Fisherfolk on a Beach
oil on canvas 34 x 43.7
TWCMS : B4208

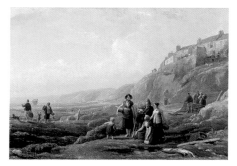

Parker, Henry Perlee 1795–1873
Old Cullercoats, Spate Gatherers
oil on canvas 85 x 125.7
TWCMS : B4922

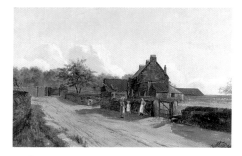

Parker, James
Eighton Banks, Gateshead 1833
oil on canvas 30.8 x 46.2
TWCMS : E8477

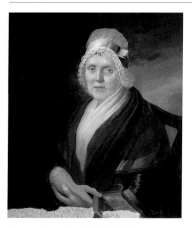

Parry, Joseph 1744–1826
Portrait of a Lady 1800
oil on canvas 72.8 x 63.6
TWCMS : C183

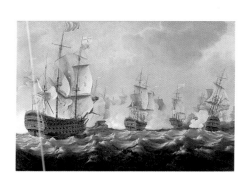

Paton, Richard 1717–1791
A Naval Engagement
oil on canvas 86.2 x 120.9
TWCMS : C7359

Paul, John Dean 1775–1852
Dedham Church, Suffolk
oil on canvas 41.8
TWCMS : B3788

Paul, John Dean 1775–1852
Dedham Vale, Suffolk
oil on canvas 30.5 x 45.8
TWCMS : B3764

Paul, John Dean 1775–1852
Landscape
oil on canvas 92.2 x 128.2
TWCMS : B8431

Paul, John Dean 1775–1852
Landscape
oil on canvas 35.6 x 46.2
TWCMS : C7380

Paul, John Dean 1775–1852
Willy Lott's Cottage
oil on canvas 41.5
TWCMS : B3796

Peel, James 1811–1906
View in Borrowdale, Cumbria c.1846–1886
oil on canvas 43.5 x 66.5
TWCMS : B3222

Peel, James 1811–1906
A Ford on the Whiteadder, Berwickshire
oil on canvas 51.2 x 76.4
TWCMS : B3249

Peel, James 1811–1906
Landscape with a Farm
oil on canvas 35.4 x 53.3
TWCMS : B3226

Peel, James 1811–1906
Landscape with a River and Two Fishermen
oil on canvas 61 x 101.4
TWCMS : F12320

Peel, James 1811–1906
Landscape with Farm Buildings
oil on canvas 20.5 x 30.8
TWCMS : B6205

Peel, James 1811–1906
Marshlands
oil on canvas 43.3 x 66.3
TWCMS : B3795

Peel, James 1811–1906
The Market Cart
oil on canvas 43.3 x 67.9
TWCMS : B3782

Pelham, Thomas Kent c.1831–1907
Venetian Balcony Scene 1859
oil on canvas 87.4 x 129.5
TWCMS : B4917

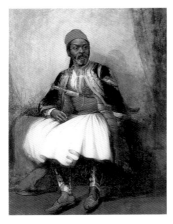

Pelham, Thomas Kent c.1831–1907
Portrait of a Moor in National Costume
oil on canvas 61 x 46
TWCMS : B4224

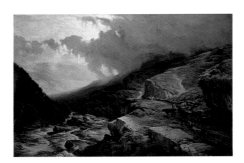

Percy, Sidney Richard 1821–1886
Glencoe, Scotland 1880
oil on canvas 125.3 x 158.3
TWCMS : B3769

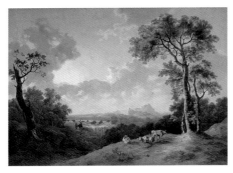

Pether, Abraham 1756–1812
Landscape with a Waterfall 1783
oil on canvas 94.3 x 130.5
TWCMS : B6244

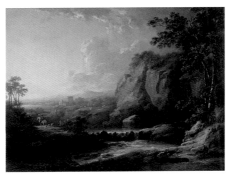

Pether, Abraham (attributed to) 1756–1812
Wooded Landscape
oil on canvas 49 x 65.2
TWCMS : G1176

Pether, Henry c.1801–1880
*The Doge's Palace, Venice, with the Columns of
Saint Mark and Saint Theodore* c.1862
oil on canvas 76.5 x 127.2
TWCMS : G1177

Pether, Sebastian 1790–1844
Landscape by Moonlight c.1825–1840
oil on canvas 35.8 x 44.8
TWCMS : B4946

Pether, Sebastian 1790–1844
Lake Scene, Moonlight
oil on board 14.4 x 20.9
TWCMS : B3204

Pettitt, George active 1857–1862
*Stepping Stones on the River Rothay, under
Loughrigg* 1857
oil on canvas 76.5 x 103
TWCMS : B4202

Phillips, John 1817–1867
Gipsy and Girl
oil on canvas 111.5 x 86
TWCMS : F9393

Pillement, Jean (style of) 1728–1808
River with Old Bridge
oil on canvas 48.5 x 82
TWCMS : C195

Pitt, William active 1849–1900
Warwick Castle 1852
oil on canvas 38.2 x 51.2
TWCMS : B4935

Pocock, Nicholas 1740–1821
Coastal Scene c.1794
oil on canvas 50.2 x 74.3
TWCMS : B9988

Pocock, Nicholas 1740–1821
Sea Piece with British Men-of-War
1800–1810
oil on canvas 43.8 x 60.7
TWCMS : C7355

Poole, James c.1804–1886
A Silent Glen 1826
oil on canvas 49.4 x 74.1
TWCMS : B8411

Poole, Paul Falconer (attributed to)
1807–1879
The Well 1875
oil on board 35.3 x 30
TWCMS : B3203

Potter, Paulus (after) 1625–1654
A Dutch Milkmaid
oil on panel 24.8 x 33.1
TWCMS : B8418

Poussin, Nicolas (after) 1594–1665
Moses Striking the Rock
oil on canvas 105.8 x 137.2
TWCMS : G1183

Powell, Charles Martin (attributed to)
1775–1824
Sea Piece with War Vessels
oil on panel 35.2 x 50.4
TWCMS : G1160

Facing page: Helmick, Howard, 1845–1907, *The Wayward Daughter* (detail), 1878, South Shields Museum
and Art Gallery, (p. 256)

Pringle, David active 1851–1900
Rural Scene with a Row of Cottages 1851
oil on canvas 30.8 x 45.7
TWCMS : F6105

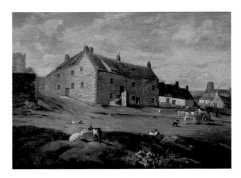

Pringle, David active 1851–1900
Carr Hill Old Houses, Gateshead 1900
oil on canvas 56 x 76
TWCMS : E8498

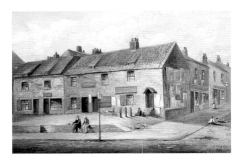

Pringle, David active 1851–1900
Johnson's Quay, Gateshead 1900
oil on canvas 30.5 x 46
TWCMS : F6103

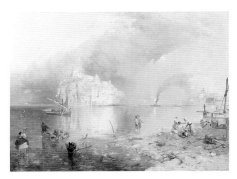

Pyne, James Baker 1800–1870
The Island of Ischia 1855
oil on canvas 91.3 x 122
TWCMS : B3215

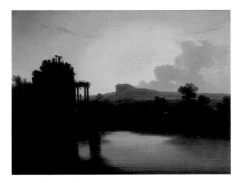

Pyne, James Baker 1800–1870
Eventide
oil on canvas 72.2 x 93
TWCMS : B8428

Pyne, James Baker (attributed to)
1800–1870
Lake Scene with Castle
oil on canvas 26 x 36
TWCMS : B4923

Rathbone, John c.1750–1807
River Scene
oil on canvas 51.9 x 66.7
TWCMS : B8440

Redgrave, Richard 1804–1888
The Poor Teacher 1845
oil on canvas 63.8 x 76.4
TWCMS : B3202

Reid, James Eadie b.c.1866
Canon Moore Ede 1901
oil on canvas 102 x 76.4
TWCMS : F9389

Reid, John Robertson 1851–1926
Shipmodel Maker with Harbour 1908
oil on canvas 147.4 x 114
TWCMS : 2003.3

Reinagle, Philip 1749–1833
Foliage, Flowers and Birds 1796
oil on canvas 124.5 x 154
TWCMS : G1169

Rembrandt van Rijn (after) 1606–1669
Self Portrait 19th C
oil on canvas 76.3 x 64.1
TWCMS : B8401

Rendall, Colin active 1876
A View of Derbyshire
oil on canvas 76.3 x 127
TWCMS : B4232

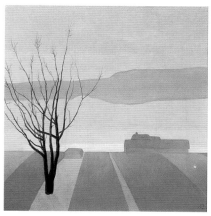

Reuss, Albert 1889–1976
Landscape 1946
oil on canvas 53.1 x 51
TWCMS : F6102

Reuss, Albert 1889–1976
Woman Dressing 1946
oil on canvas 61.2 x 51
TWCMS : C11272

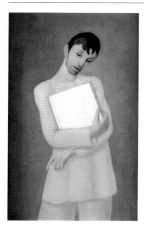

Reuss, Albert 1889–1976
The Poet 1948
oil on canvas 71 x 50.8
TWCMS : F9402

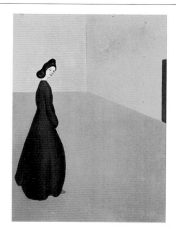

Reuss, Albert 1889–1976
Woman in an Empty Room
oil on canvas 61 x 46.5
TWCMS : 2006.8319

Reynolds, Joshua (after) 1723–1792
The Holy Family with St John
oil on canvas 60.6 x 50.6
TWCMS : C158

Ricci, Marco (attributed to) 1676–1730
Landscape
oil on canvas 86 x 116
TWCMS : C163

Ricci, Sebastiano 1659–1734
The Ascension of Christ
oil on canvas 99.8 x 75.5
TWCMS : C153

Richardson, Thomas Miles I 1784–1848
The Old Leith Walk, Edinburgh c.1840–1845
oil on canvas 75.7 x 129.7
TWCMS : B3229

Richardson, Thomas Miles I 1784–1848
Carlisle, Cumbria
oil on canvas 49 x 60.4
TWCMS : G420

Richardson, Thomas Miles I 1784–1848
The Market Cart
oil on canvas 88.7 x 75.5
TWCMS : B8404

Robbe, Louis 1806–1899
The Sand Dunes of Calais 1868
oil on canvas 123 x 180.5
TWCMS : B3790

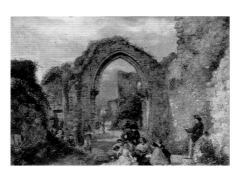

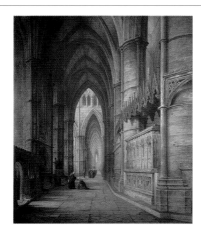

Roberts, David (attributed to) 1796–1864
A Church Interior
oil on canvas 52.3 x 62.4
TWCMS : B6250

Roberts, David (attributed to) 1796–1864
Picnic Party
oil on canvas 24.5 x 34.5
TWCMS : B4948

Roberts, David (attributed to) 1796–1864
The Tomb of Edward III, Westminster Abbey
oil on canvas 92 x 80
TWCMS : B4932

Robertson, Annie Theodora b.1896
Bedburn, County Durham
oil on canvas 50.7 x 61
TWCMS : C11271

Robinson, William 1866–1945
Old Lady in a Shawl 1941
oil on canvas 45.5 x 33.2
TWCMS : F9418

Robinson, William 1866–1945
Goose Girl 1942
oil on canvas 50.6 x 61
TWCMS : F9419

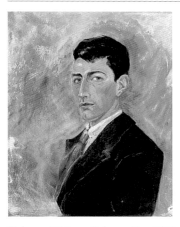

Robson-Watson, John active 1928–c.1971
Self Portrait 1928
oil on canvas 61.1 x 51.2
TWCMS : F9397

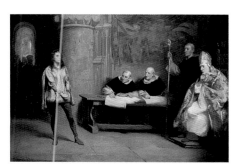

Roe, Fred 1864–1947
The Trial of Jeanne d'Arc
oil on canvas 53 x 73.5
TWCMS : F6126

Rogers, Charlie b.1930
Redheugh Crossroads, Gateshead 1970
oil on board 50.5 x 62
TWCMS : H4427

Rombouts, Salomon c.1652–c.1702
Landscape with Cottages by the Water's Edge
oil on panel 64.3 x 109.3
TWCMS : G1154

Roos, Philipp Peter (attributed to)
1657–1706
A Landscape with a Milkmaid
oil on canvas 100 x 130.9
TWCMS : B4233

Rosa, Salvator (after) 1615–1673
Pilate Washing His Hands
oil on canvas 51.5 x 63
TWCMS : F9411

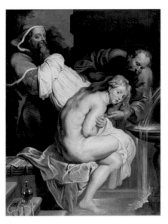

Rowell, R. active late 19th C–20th C
View of the North Tyne River
oil on canvas 61 x 91.5
TWCMS : C7398

Rubens, Peter Paul (after) 1577–1640
Susannah and the Elders
oil on canvas 167.7 x 123
TWCMS : G1191

Rubens, Peter Paul (after) 1577–1640
The Brazen Serpent
oil on canvas 93.7 x 118.3
TWCMS : C161

Ryott, William 1817–1883
The Road to Redheugh Hall 1856
oil on panel 35 x 50.5
TWCMS : E8500

Ryott, William 1817–1883
Rural Scene 1864
oil on board 47 x 40
TWCMS : B3216

Ryott, William 1817–1883
View in Jesmond Dene, Newcastle upon Tyne 1873
oil on canvas
TWCMS : F6141

Salimbeni, Ventura 1568–1613
The Madonna and Child with Saints
oil on metal 27.3 x 22.5
TWCMS : C7371

Savry, Hendrik 1823–1907
Cattle
oil on canvas 69 x 115
TWCMS : E8490

Savry, Hendrik 1823–1907
Cattle in a Meadow
oil on canvas 81 x 127
TWCMS : B3770

Schalcken, Godfried (style of) 1643–1706
Candlelight Scene
oil on panel 40.5 x 30.5
TWCMS : B6228

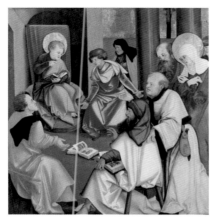

Schäufelein, Hans c.1480/1485–1538/1540
Christ in the Temple c.1510–1530
oil on panel 138.2 x 133.5
TWCMS : G1186a

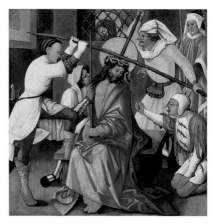

Schäufelein, Hans c.1480/1485–1538/1540
The Reviling of Christ c.1510–1530
oil on panel 138.2 x 133.5
TWCMS : G1186b

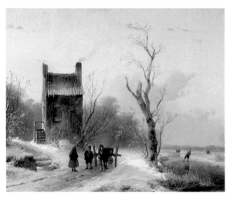

Schelfhout, Andreas 1787–1870
Winter Scene 1850
oil on canvas 18 x 21.5
TWCMS : F12322

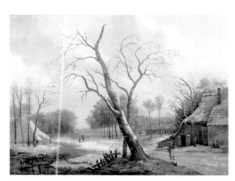

Schelfhout, Andreas (style of) 1787–1870
Dutch Winter Scene c.1810–1850
oil on panel 37.9 x 45.4
TWCMS : C7392

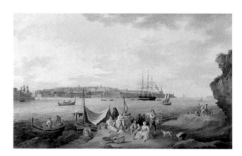

Schranz, Anton 1769–1839
Harbour Scene, Malta
oil on card 40.9 x 63.2
TWCMS : C172

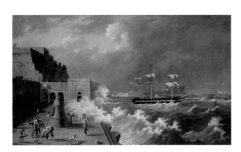

Schranz, Anton 1769–1839
Harbour Scene, Malta
oil on card 41 x 63
TWCMS : C196

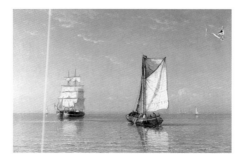

Schutz, Johannes Fredrick 1817–1888
Shipping in a Calm 1878
oil on canvas 69.4 x 105.3
TWCMS : B4223

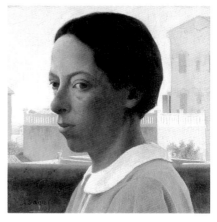

Segal, Arthur 1875–1944
Portrait on a Veranda, Spain 1933
oil on board 36.5 x 36.5
TWCMS : F9382

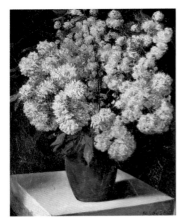

Segal, Arthur 1875–1944
Flower Study 1944
oil on canvas 70.2 x 57.4
TWCMS : F6116

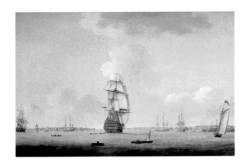

Serres, Dominic 1722–1793
Shipping
oil on canvas 30.5 x 45.1
TWCMS : B4904

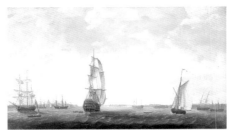

Serres, Dominic 1722–1793
Shipping
oil on canvas 49.5 x 88.1
TWCMS : G1158

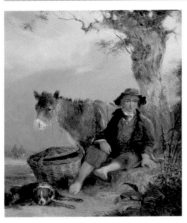

Shayer, William 1788–1879
A Donkey and a Youth 1844
oil on panel 35.5 x 30.1
TWCMS : E8474

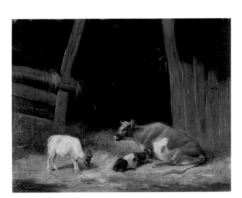

Shayer, William (attributed to) 1788–1879
The Cow Byre
oil on canvas 25 x 30.5
TWCMS : B3240

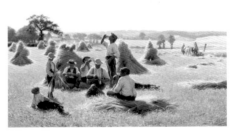

Sheard, Thomas Frederick Mason
1866–1921
Harvesters Resting 1898
oil on canvas 146.7 x 200
TWCMS : F9380

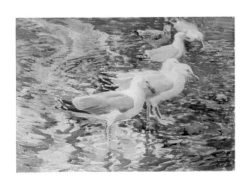

Simpson, Charles Walter 1885–1971
Herring Gulls
oil on board 53.9 x 73.5
TWCMS : F6133

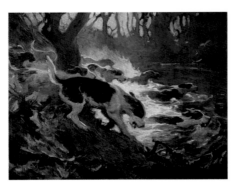

Simpson, Charles Walter 1885–1971
Otter Hunting
tempera on paper 61 x 76
TWCMS : E8473

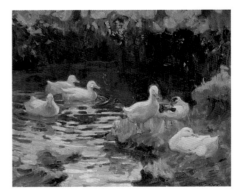

Simpson, Charles Walter 1885–1971
The Duck Pond
oil on paper 51 x 61
TWCMS : E8471

Facing page: Duffield, William, 1816–1863, *Fruit* (detail), 1853, Sunderland Museum and Winter Gardens, (p. 285)

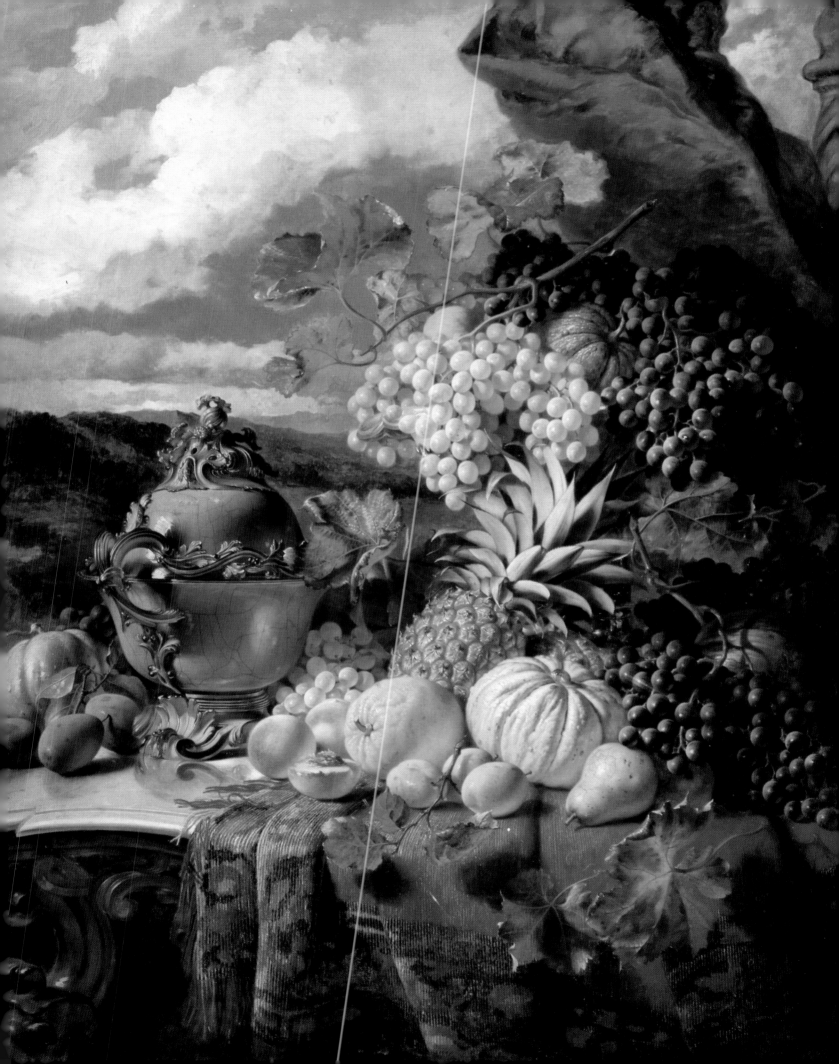

Simpson, Ruth 1889–1964
Thomas Reed
oil on canvas 67 x 57.7
TWCMS : F9379

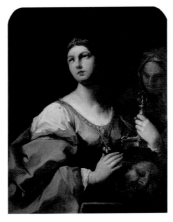

Sirani, Giovanni Andrea (style of)
1610–1670
Judith with the Head of Holofernes
oil on canvas 115 x 90
TWCMS : G1181

Slater, John Falconar 1857–1937
Landscape with Torrent
oil on board 86.3 x 137.5
TWCMS : F9364

Slater, John Falconar 1857–1937
Lombardy Poplars
oil on canvas 50.4 x 39
TWCMS : E8494

Slater, John Falconar 1857–1937
River Scene with Pink Mountain
oil on canvas 127.3 x 76.3
TWCMS : E8480

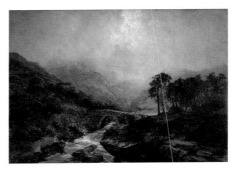

Slater, John Falconar 1857–1937
Scottish Highlands
oil on canvas 91.5 x 127.3
TWCMS : F9357

Smith, Anthony John b.1953
*Mr R. Hughes Arranges Flowers in a Most
Attractive Manner* 1977
oil & collage on canvas 108 x 108
TWCMS : B1150

Smith, John 'Warwick' 1749–1831
River Scene
oil on canvas 46 x 60.7
TWCMS : C184

Smith, John 'Warwick' 1749–1831
River with Bridge
oil on canvas 45.7 x 61.2
TWCMS : B8441

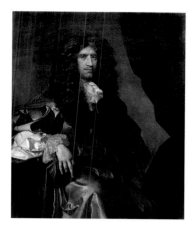

Soest, Gerard (attributed to) c.1600–1681
Unidentified Portrait 1664–1668
oil on canvas 126.7 x 103
TWCMS : B8436

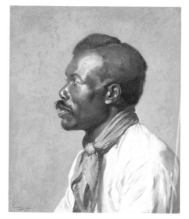

Somerville, Howard 1873–1952
Zulu Head 1921
oil on canvas 61 x 51
TWCMS : F9390

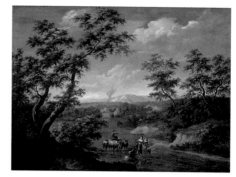

Spalthof, Jan Philip (attributed to)
active 1700–1724
Landscape with Peasants and Cows c.1700
oil on canvas 86.9 x 113.2
TWCMS : G1161

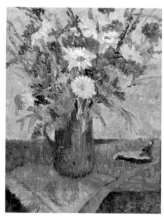

Speed, S. A. active 1954
Flower Study
oil on board 50.6 x 40.8
TWCMS : F6118

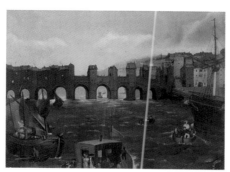

Stack, T. H. active 19th C
Bridge over a River
oil on canvas 38.6 x 51
TWCMS : E8486

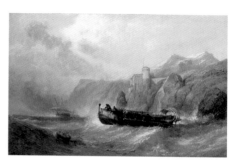

Stanfield, Clarkson 1793–1867
Coastal Scene 1862
oil on canvas 44.6 x 66.2
TWCMS : F12319

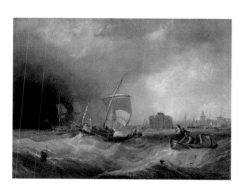

Stanfield, Clarkson (after) 1793–1867
The Coming Storm, Calais
oil on canvas 74.9 x 98.3
TWCMS : G438

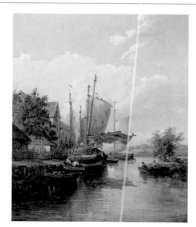

Stark, James 1794–1859
Canal Scene
oil on canvas 36.1 x 30.5
TWCMS : B3776

Stark, James 1794–1859
Cattle in the Woods
oil on canvas 52.7 x 43.3
TWCMS : E8482

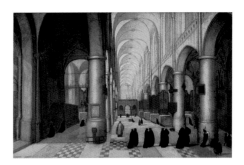

Steenwijck, Hendrick van the elder (after)
c.1550–1603
St Pieters at Louvain, a Christening Party
oil on canvas 63.5 x 93.7
TWCMS : C7382

Sticks, George Blackie 1843–1938
Evening on the Loch 1876
oil on canvas 25.5 x 20.5
TWCMS : F12334

Sticks, George Blackie 1843–1938
The Kyles of Bute, Argyll, Scotland 1876
oil on canvas 25.5 x 20.5
TWCMS : F12335

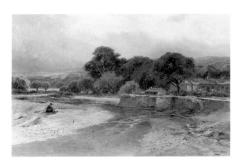

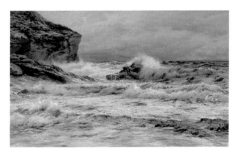

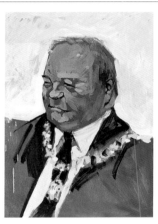

Sticks, Harry James 1867–1938
On the Wear, Stanhope 1900
oil on canvas 40.5 x 61
TWCMS : E8467

Sticks, Harry James 1867–1938
'Breakers', Whitley Bay 1915
oil on canvas 40.7 x 66
TWCMS : E8468

Stuart, Robin b.1970
Councillor Joe Mitchinson 2005
acrylic on board 70 x 45
TWCMS : 2006.4023

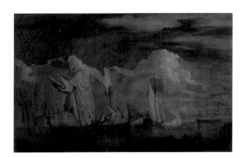

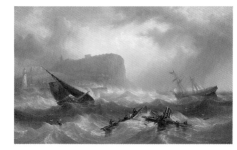

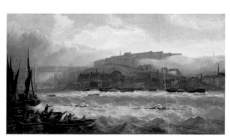

Swaine, Francis c.1720–1782
Shipping Piece with a Ship Firing Gun
oil on canvas 71.4 x 109.4
TWCMS : C7388

Swift, John Warkup 1815–1869
Wreck off Scarborough 1863
oil on canvas 78.7 x 122
TWCMS : B4934

Swift, John Warkup 1815–1869
Cooper versus Chambers, Race on the Tyne
1865
oil on canvas 71 x 125
TWCMS : G1197

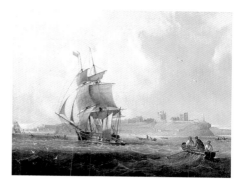

Swift, John Warkup 1815–1869
Mouth of the Tyne
oil on canvas 45.9 x 53.4
TWCMS : B3209

Syer, John 1815–1885
Way over the Moor 1883
oil on canvas 106.8 x 142
TWCMS : B3794

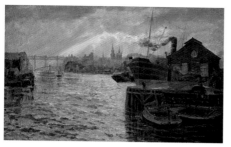

Sykes, Samuel 1846–1920
*The Tyne with the High Level Bridge,
Newcastle* 1920
oil on board 50.2 x 76.1
TWCMS : F12347

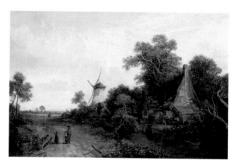

Taylor, E. active late 19th C
Landscape with a Windmill
oil on canvas 67.6 x 99.2
TWCMS : B4914

Teasdale, John 1848–1926
Churchyard with a Ruined Chapel
oil on board 32 x 50.7
TWCMS : E8496

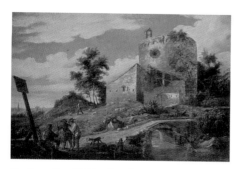

Teniers, David I (style of) 1582–1649
Bridge with Buildings and Figures
oil on panel 17.2 x 25.5
TWCMS : B4235

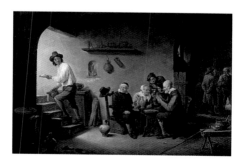

Teniers, David II 1610–1690
Interior of a Tavern c.1640
oil on panel 52.7 x 76.2
TWCMS : G443

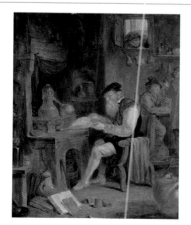

Teniers, David II (after) 1610–1690
The Alchemist
oil on panel 25.3 x 21
TWCMS : C7362

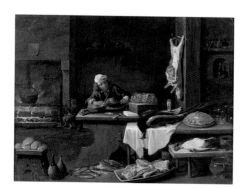

Teniers, David II (style of) 1610–1690
The Kitchen of a Dutch Mansion
oil on panel 47.5 x 60.9
TWCMS : B6243

Thomas, C. P.
Old Keep, Newcastle 1920
oil on canvas 30.5 x 25.2
TWCMS : F6146

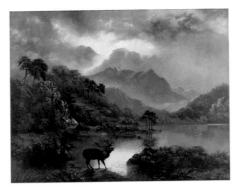

Thompson, B. M.
Prelude to the Fight 1895
oil on canvas 101.6 x 127.1
TWCMS : G441 (P)

Thompson, Constance b.1882
Water Lilies 1905
oil on board 22.8 x 43.9
TWCMS : F6144

Thompson, Constance b.1882
River Scene, Punting 1906
oil on canvas 25.5 x 35.7
TWCMS : F6148

Thompson, Constance b.1882
Pears and Leaves 1907
oil on canvas 23 x 28.3
TWCMS : F9352

Thompson, Constance b.1882
Coastal Scene, Small and Bay 1908
oil on canvas 33 x 43.5
TWCMS : F9354

Thompson, Constance b.1882
Tynemouth Priory Ruins 1917
oil on canvas 30.5 x 46
TWCMS : F9353

Thompson, Constance b.1882
Daffodils
oil on board 38.1 x 25.4
TWCMS : F6143

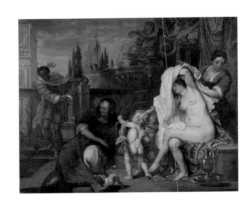

Thys, Pieter 1624–1677
Bathsheba
oil on canvas 197.5 x 242.7
TWCMS : B9984

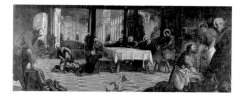

Tintoretto, Jacopo (attributed to)
1519–1594
Christ Washing the Disciples' Feet
oil on canvas 215.5 x 533.3
TWCMS : E3691

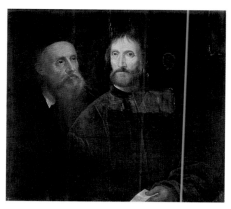

Titian (after) c.1488–1576
Titian and Andrea de Franceschi
oil on canvas 83.8 x 95.2
TWCMS : C159

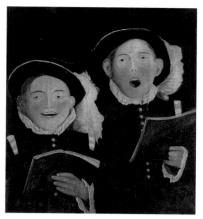

Titley, W. J.
The Choir Boys of St Paul's School 1938
oil on panel 78.7 x 71
TWCMS : F9415

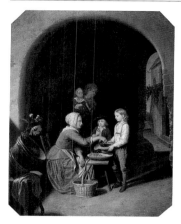

Tol, Dominicus van (attributed to)
c.1635–1676
A Dutch Fruit Seller
oil on canvas 53.5 x 42
TWCMS : B6229

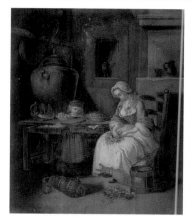

Tol, Dominicus van (follower of)
c.1635–1676
Kitchen Scene
oil on metal 39 x 32
TWCMS : F9423

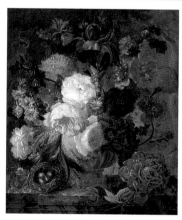

Tongeren, Arent van active 1684–1689
Flowers and Bird's Nest
oil on canvas 54.9 x 46.7
TWCMS : B8425

Train, Edward 1801–1866
Mountain Torrent 1849
oil on canvas 73 x 97.7
TWCMS : B3779

Train, Edward 1801–1866
A Scottish Waterfall 1854
oil on canvas 62.2 x 80.3
TWCMS : B6215

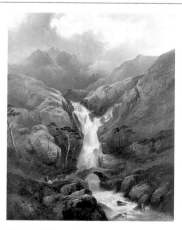

Train, Edward 1801–1866
A Mountain Scene with a Waterfall 1857
oil on canvas 114.7 x 91.8
TWCMS : B4941

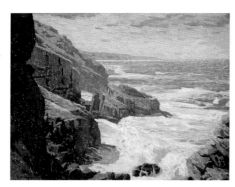

Tucker, James Walker 1898–1972
A Stormy Sea
oil on canvas 40.9 x 51.1
TWCMS : G436

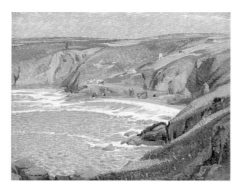

Tucker, James Walker 1898–1972
The Bay at Gurnard's Head, Cornwall
oil on canvas 40.5 x 51
TWCMS : G437

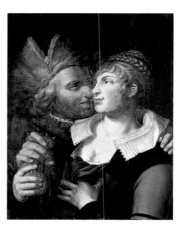

unknown artist
Mercenary Love 1619
oil on panel 76.5 x 59.3
TWCMS : C166

unknown artist
Landscape with Christ Healing a Blind Man
c.1620–1630
oil on panel 55 x 98.5
TWCMS : G1153

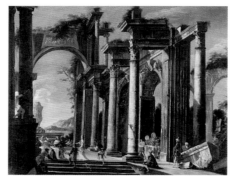

unknown artist 17th C
The Head of John the Baptist Presented to Herod
oil on canvas 102.5 x 127.2
TWCMS : C199

unknown artist 18th C
A Dutch River Scene
oil on panel 28.9 x 40.2
TWCMS : C7399

unknown artist 18th C
A Landscape with Houses
oil on panel 18.5 x 26
TWCMS : B6248

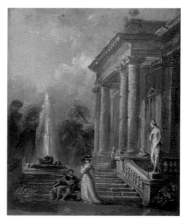

unknown artist 18th C
A Terrace Scene
oil on metal 17.6 x 13.7
TWCMS : C154

unknown artist 18th C
An Old English Mill
oil on panel 35.6 x 24.7
TWCMS : C185

unknown artist 18th C
Classical Landscape with Figures
oil on board 27.7 x 35.5
TWCMS : C7379

unknown artist 18th C
Filial Love
oil on canvas 204 x 183
TWCMS : G427

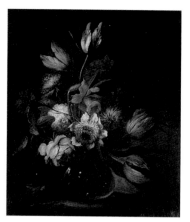

unknown artist 18th C
Flowers in a Vase
oil on canvas 48.3 x 40
TWCMS : B6231

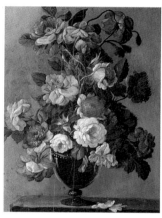

unknown artist 18th C
Flowers in a Vase
oil on canvas 45.8 x 35.2
TWCMS : C7358

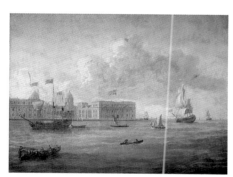

unknown artist 18th C
*Greenwich Hospital off Which Lies the Royal
Yacht*
oil on canvas 92.9 x 122.8
TWCMS : C7396

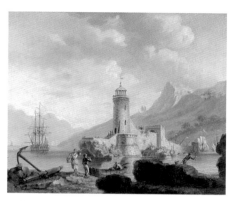

unknown artist 18th C
Harbour with Lighthouse
oil on canvas 63.4 x 76.4
TWCMS : B8412

unknown artist 18th C
Landscape with Castle
oil on canvas 82.5 x 65.7
TWCMS : G1156

unknown artist 18th C
Landscape with Tomb
oil on canvas 48.5 x 61.5
TWCMS : B8403

unknown artist 18th C
Portrait of a Man
oil on canvas 66.1 x 55.4
TWCMS : B6232

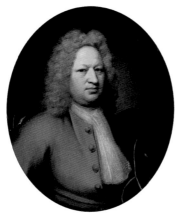

unknown artist 18th C
Portrait of a Man
oil on canvas 78.7 x 64.4
TWCMS : B6241

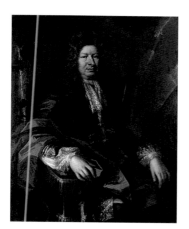

unknown artist 18th C
Portrait of a Man
oil on canvas 121.6 x 98.3
TWCMS : B8432

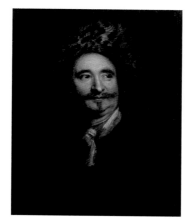

unknown artist 18th C
Portrait of a Man in a Fur Hat
oil on canvas 65.8 x 53.3
TWCMS : B8424

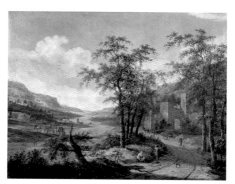

unknown artist 18th C
River Scene with Figures
oil on canvas 69.8 x 89.2
TWCMS : G1188

unknown artist 18th C
River Scene with Ruins
oil on canvas 63.9 x 76
TWCMS : B8421

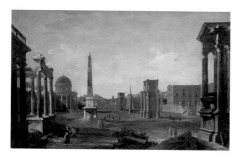

unknown artist 18th C
Roman Capriccio with Obelisk
oil on canvas 97.2 x 148.4
TWCMS : C168

unknown artist 18th C
St Anne and the Young Virgin
oil on canvas 114.3 x 81.5
TWCMS : G1187

unknown artist 18th C
St Jerome
oil on panel 62.3 x 52
TWCMS : C170

unknown artist 18th C
Still Life
oil on canvas 55 x 77.2
TWCMS : C151

Facing page: Wadsworth, Edward Alexander, 1889–1949, *Marine Set* (detail), 1936, Laing Art Gallery, (p. 232)

unknown artist 18th C
The Angels Appearing to the Shepherds
oil on canvas 21.6 x 27.7
TWCMS : F6149

unknown artist 18th C
Troubadour Performing Outside an Inn
oil on panel 25.5 x 21.3
TWCMS : G417

unknown artist late 18th C
View of Messina, Sicily
oil on canvas 66.7 x 92.5
TWCMS : G1166

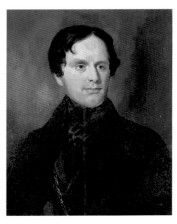

unknown artist
Alderman George Hawks c.1840
oil on canvas 141.4 x 115.8
TWCMS : F9408

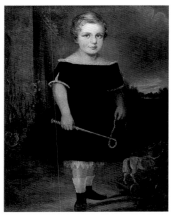

unknown artist
Child with a Whip c.1840
oil on canvas 90 x 71
TWCMS : F9394

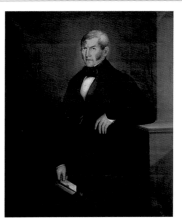

unknown artist
John Hawks c.1840
oil on canvas 141.4 x 115.8
TWCMS : F9408

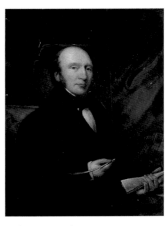

unknown artist
Portrait of a Man c.1850
oil on canvas 92.4 x 72.7
TWCMS : R244

unknown artist
Trading Post at Canton c.1850–1880
oil on canvas 44 x 67.7
TWCMS : C7372

unknown artist
Richard Wellington Hodgson, Mayor c.1854
oil on canvas 127.5 x 102.2
TWCMS : R235

unknown artist
The Great Fire of Newcastle upon Tyne c.1854
oil on canvas 50.8 x 60.5
TWCMS : F6142

unknown artist
Alderman Walter de Lancey Willson, Mayor
c.1892
oil on canvas 84.2 x 73
TWCMS : R240

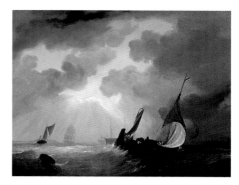

unknown artist early 19th C
A Gale at Sea
oil on canvas 71 x 91.5
TWCMS : B6246

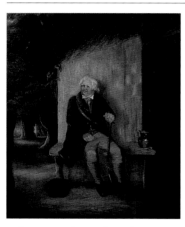

unknown artist early 19th C
A Gamekeeper
oil on canvas 63.5 x 50
TWCMS : F9401

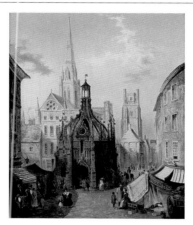

unknown artist early 19th C
Chichester Cross
oil on canvas 61.2 x 50.9
TWCMS : G1157

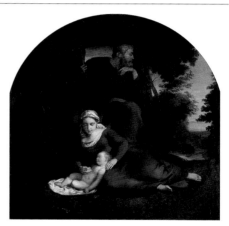

unknown artist mid-19th C
Holy Family, Rest on the Flight into Egypt
oil on canvas 92.1 x 92
TWCMS : F6125

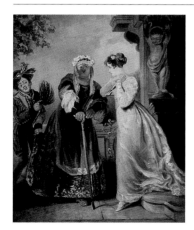

unknown artist mid-19th C
Juliet and the Nurse
oil on card 24.5 x 21.3
TWCMS : B4928

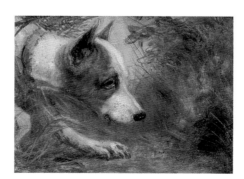

unknown artist 19th C
A Dog's Head
oil on board 17.6 x 24.1
TWCMS : B6219

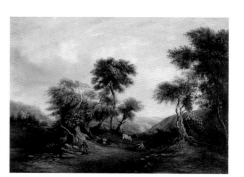

unknown artist 19th C
A Landscape with Figures and Cattle
oil on canvas 38.2 x 51.6
TWCMS : B6223

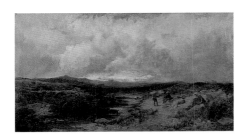

unknown artist 19th C
A Moorland Scene
oil on canvas 64.5 x 115.6
TWCMS : B3224

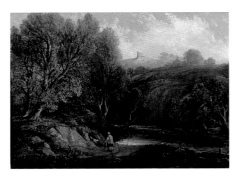

unknown artist 19th C
A River Scene
oil on canvas 30.5 x 40.5
TWCMS : B3791

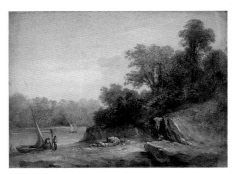

unknown artist 19th C
A River Scene
oil on panel 16.4 x 24.3
TWCMS : B6239

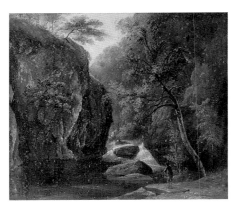

unknown artist 19th C
A Rocky Stream
oil on canvas 56.2 x 71.6
TWCMS : B4937

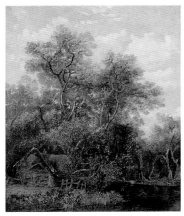

unknown artist 19th C
A Shaded Pool
oil on canvas 34.4 x 30.1
TWCMS : B3781

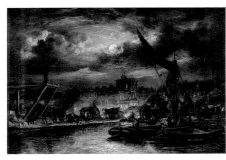

unknown artist 19th C
A Wharf on the Thames, Moonlight
oil on canvas 25.1 x 35.6
TWCMS : B4930

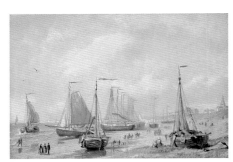

unknown artist 19th C
Beach with Fishing Boats
oil on canvas 19.2 x 30.5
TWCMS : B4950

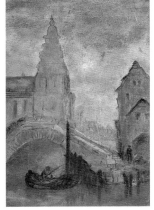

unknown artist 19th C
Canal Scene
oil on canvas 23.3 x 15.2
TWCMS : F9351

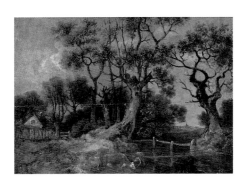

unknown artist 19th C
Cattle in a Stream
oil on panel 42 x 55.6
TWCMS : B6242

unknown artist 19th C
Chinese Harbour (European Legations)
oil on canvas 43.8 x 66.8
TWCMS : G1152

unknown artist 19th C
Classical Landscape with River and Ruins
oil on canvas 100 x 130
TWCMS : B3225

unknown artist 19th C
Clovelly, North Devon
oil on board 32.4 x 46.3
TWCMS : B3754

unknown artist 19th C
Coast Scene
oil on metal 20.4 x 27.5
TWCMS : C7381

unknown artist 19th C
Coast Scene with Boats
oil on board 18.4 x 25.3
TWCMS : B4944

unknown artist 19th C
Dr Guthrie, Edinburgh
oil on board 46 x 36.4
TWCMS : B4929

unknown artist 19th C
Dutch Cottages and Figures
oil on panel 14.4 x 17.2
TWCMS : B4247

unknown artist 19th C
Dutch Shipping
oil on canvas 45 x 63.5
TWCMS : B3220

unknown artist 19th C
Elizabeth Hawks
oil on canvas 136.9 x 111.3
TWCMS : F9374

unknown artist 19th C
Galliot in a Gale
oil on canvas 21.5 x 45.6
TWCMS : B6203

unknown artist 19th C
Interior of an English Inn
oil on panel 26.7 x 34.3
TWCMS : G1163

unknown artist 19th C
John Abbot Esq.
oil on board 25.7 x 20.5
TWCMS : F9384

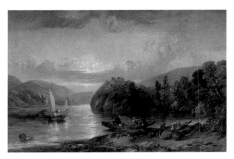

unknown artist 19th C
Lake Scene
oil on canvas 87 x 98.5
TWCMS : B4201

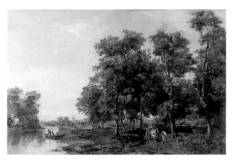

unknown artist 19th C
Landscape
oil on canvas 62 x 92.5
TWCMS : B8405

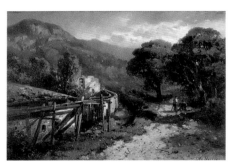

unknown artist 19th C
Landscape
oil on canvas 53.3 x 81.3
TWCMS : C7394

unknown artist 19th C
Landscape
oil on canvas 56 x 69.7
TWCMS : G448

unknown artist 19th C
Landscape with Horses and Cart
oil on canvas 23.5 x 31.4
TWCMS : B6217

unknown artist 19th C
Landscape with Pool
oil on canvas 45.8 x 37.8
TWCMS : B9999

unknown artist 19th C
Landscape with Shepherd and Flock
oil on panel 28 x 38.2
TWCMS : G1162

unknown artist 19th C
Mrs John Swan
oil on canvas 91.5 x 71.2
TWCMS : F9392

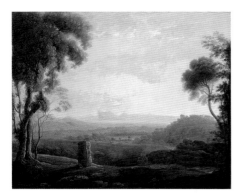

unknown artist 19th C
Open Landscape
oil on canvas 64.4 x 77.6
TWCMS : B8429

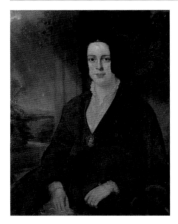

unknown artist 19th C
Portrait of a Lady in Black with a Cameo
oil on canvas 91 x 71.3
TWCMS : F9388

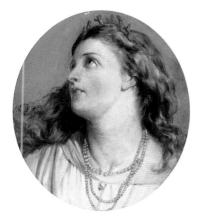

unknown artist 19th C
Portrait of a Lady with a Pearl Necklace
oil on panel 18.8 x 16.5
TWCMS : B3753

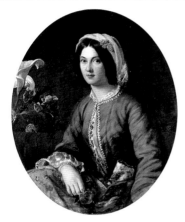

unknown artist 19th C
Portrait of a Young Woman
oil on canvas 99.9 x 79
TWCMS : B4915

unknown artist 19th C
River Scene
oil on canvas 15.5 x 20.4
TWCMS : B4245

unknown artist 19th C
River Scene with a Fisherman
oil on canvas 53 x 80.2
TWCMS : E8489

unknown artist 19th C
River Scene with a Fisherman and Ruins
oil on canvas 76.1 x 60.9
TWCMS : F12350

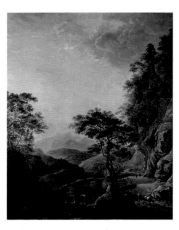

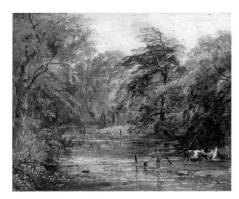

unknown artist 19th C
River Scene with Village
oil on canvas 37 x 69.5
TWCMS : B3227

unknown artist 19th C
Rocky Landscape
oil on canvas 93 x 78
TWCMS : B6245

unknown artist 19th C
Scene in Charlecote Park, Warwickshire
oil on board 45.6 x 55.2
TWCMS : B6237

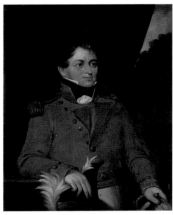

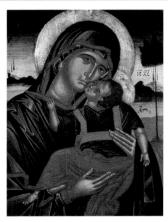

unknown artist 19th C
Sir Robert Shafto Hawks
oil on canvas 91.5 x 73.8
TWCMS : F9386

unknown artist 19th C
Virgin and Child
oil on panel 34.1 x 24.4
TWCMS : G1151

unknown artist 19th C
Wooded Landscape
oil on canvas 51.2 x 69
TWCMS : B3787

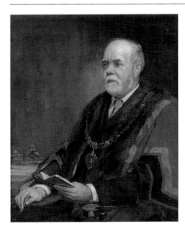

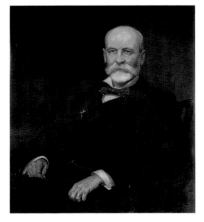

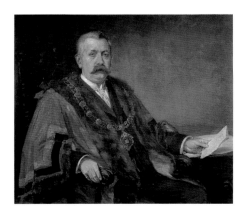

unknown artist
Lancelot Tulip Penman, Mayor c.1905
oil on canvas 95.5 x 91.8
TWCMS : R241

unknown artist
Alderman Walter de Lancey Wilson c.1911
oil on canvas 87 x 76
TWCMS : R240

unknown artist
William John Costelloe, Mayor c.1911
oil on canvas 93.1 x 106.8
TWCMS : R239

Facing page: Caffieri, Hector, 1847–1932, *Little Truant* (detail), c.1880–1900, Sunderland Museum
and Winter Gardens, (p. 278)

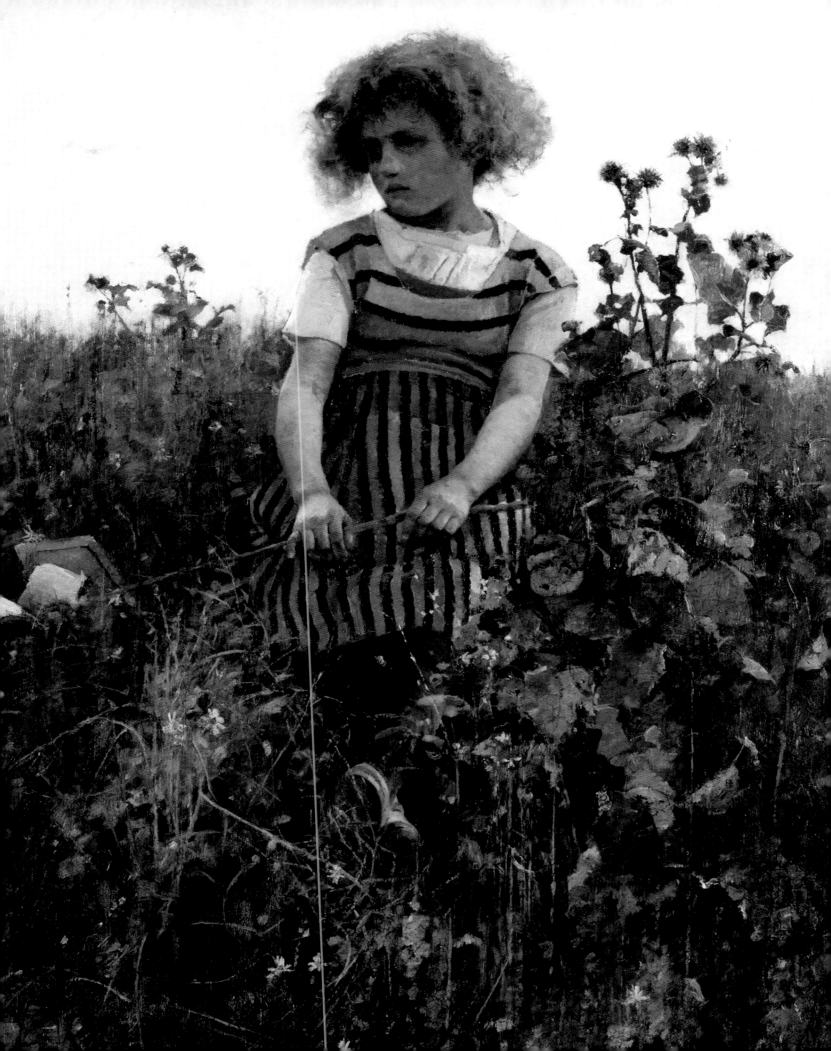

unknown artist
Still Life 1967
oil on board 37.2 x 61.6
TWCMS : H6485

unknown artist 20th C
Bridge over River with Houses
oil on canvas 35.9 x 45
TWCMS : F9356

unknown artist 20th C
Flooded Fields in Holland with Silver Birches
oil on panel 20.1 x 28.8
TWCMS : G446

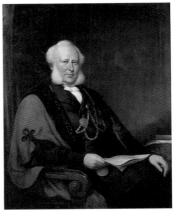

unknown artist
Alderman Morrison
oil on canvas 127.2 x 101.7
TWCMS : G15276

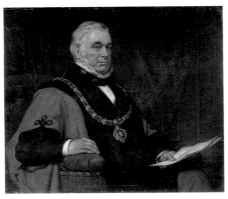

unknown artist
Alderman W. Brown, Mayor
oil on canvas 96.6 x 109
TWCMS : R233

unknown artist
Moorland Road
oil on panel 46.5 x 66.1
TWCMS : B8414

unknown artist
*Portrait of an Unidentified Alderman**
oil on canvas 75.5 x 62.5
TWCMS : 2008.106

unknown artist
Robert Stirling Newall (1812–1889)
oil on canvas 59.5 x 49
TWCMS : 2008.105

unknown artist
The Runner
oil on canvas 51.4 x 40.8
TWCMS : 2003.128

Unterberger, Franz Richard 1838–1902
Ville d'Amalfi
oil on canvas 81.8 x 66.7
TWCMS : B3221

Van de Beigh, Lucas active early 19th C
Landscape with Cattle
oil on panel 56.5 x 72.3
TWCMS : B4222

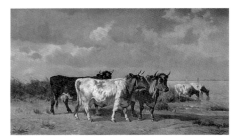

van Myer, Otto active 19th C
Dutch Canal, with Cattle
oil on canvas 76.5 x 127.2
TWCMS : B3759

Varley, John II 1850–1933
Game El Syer, Cairo 1880
oil on canvas 76 x 58.3
TWCMS : B3797

Varley, John II 1850–1933
The Mosque of Emir Mindar, Cairo 1880
oil on canvas 76.1 x 58.5
TWCMS : B3786

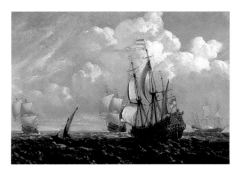

Velde, Willem van de II (after) 1633–1707
Fresh Gale
oil on panel 32.9 x 43.5
TWCMS : C190

Velde, Willem van de II (follower of)
1633–1707
Sea Piece with Shipping c.1660
oil on canvas 66.3 x 102
TWCMS : C171

Velde, Willem van de II (style of) 1633–1707
Dutch Shipping
oil on canvas 76 x 126.9
TWCMS : C200

Venne, Adriaen van de 1589–1662
Peasants Brawling
oil on panel 44.5 x 35.6
TWCMS : C7360

Venneman, Karel Ferdinand 1802–1875
The Itinerant Fiddler
oil on panel 39.2 x 35
TWCMS : B8438

Verbeeck, Cornelis (attributed to)
c.1590–c.1637
Dutch Sea Piece
oil on panel 25 x 46.2
TWCMS : C7377

Verlat, Charles Michel Maria (after)
1824–1890
Horses Straining at a Load 1864
oil on canvas 20.7 x 33.5
TWCMS : B4234

Vernet, Claude-Joseph (style of) 1714–1789
Storm off the French Coast
oil on canvas 43.3 x 58.7
TWCMS : B8430

Vickers, Alfred (attributed to) 1786–1868
Coast Scene near a Cinque Port 1865
oil on panel 29.6 x 45.7
TWCMS : B4207

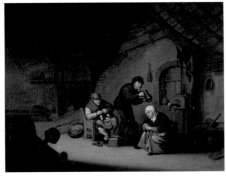

Victoryns, Anthonie (style of)
c.1620–c.1656
Dutch Interior with Figures
oil on canvas 24.3 x 31
TWCMS : C7366

Vivian, Jane active 1861–1877
Gondolas on a Lake 1873
oil on canvas 61 x 107
TWCMS : B3228

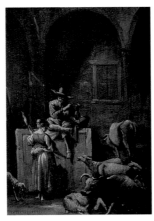

Vogel, T. de active 18th C
A Musician
oil on canvas 38 x 25
TWCMS : B8413

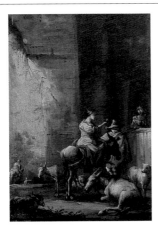

Vogel, T. de active 18th C
Figures and Cattle
oil on canvas 37.9 x 25.2
TWCMS : B8415

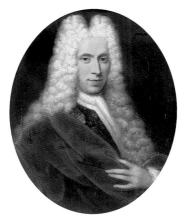

Vollevens, Johannes II 1685–1758
Portrait of a Courtier in a Wig 1719
oil on canvas 83 x 66.7
TWCMS : B9991

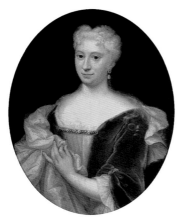

Vollevens, Johannes II 1685–1758
Portrait of a Lady 1719
oil on canvas 86.7 x 66
TWCMS : B9994

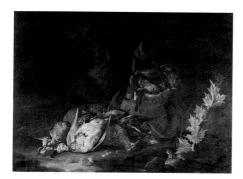

Vonck, Jan 1631–1663/1664
Dead Game
oil on canvas 76 x 101.8
TWCMS : B10000

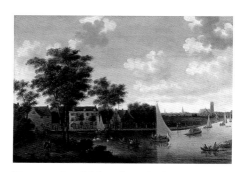

Vosmaer, Daniel (attributed to)
active 1650–1700
Dutch Canal Scene
oil on panel 71.7 x 105.3
TWCMS : C7374

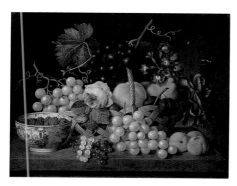

Voss, T.
Flowers and Fruit Study 1813
oil on panel 38.5 x 47
TWCMS : B4225

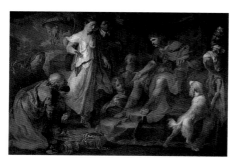

Vouet, Simon (attributed to) 1590–1649
The Continence of Scipio
oil on canvas 162.3 x 235.7
TWCMS : F9430

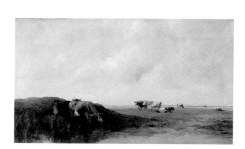

Wainewright, Thomas Francis 1794–1883
Cows in a Meadow 1869
oil on canvas 53.5 x 91.5
TWCMS : B3241

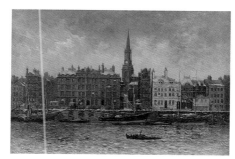

Wallace, John 1841–1905
Quayside, Newcastle upon Tyne 1886
oil on canvas 61 x 91.8
TWCMS : B4228

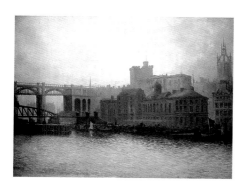

Wallace, John 1841–1905
Newcastle upon Tyne from the River 1887
oil on canvas 76.4 x 127.2
TWCMS : B4918

Wallace, John 1841–1905
Kilingham Mills 1900
oil on canvas 71 x 92
TWCMS : F12325(P)

Wallace, John 1841–1905
Prudhoe Castle, Northumberland
oil on canvas 51.4 x 76.8
TWCMS : B3774

Walton, Edward Arthur 1860–1922
Suffolk Lane
oil on canvas 71.2 x 91.8
TWCMS : C11276

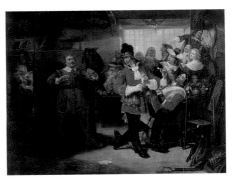

Ward, Edward Matthew 1816–1879
Sergeant Bothwell Challenging Balfour
oil on canvas 83.8 x 107
TWCMS : B3756

Wardle, Arthur (attributed to) 1864–1949
Terrier Watching a Rabbit Warren
oil on canvas 61.3 x 46
TWCMS : B4230

Waterlow, Ernest Albert 1850–1919
*Winter in the Lauterbrunnen Valley,
Switzerland*
oil on canvas 101.8 x 153
TWCMS : G422

Watson, George (attributed to) 1767–1837
The Three Brothers, the Sons of Thomas Dallas
oil on canvas 128.8 x 112.8
TWCMS : B4242

Watts, Frederick William 1800–1870
Landscape with a Stream
oil on canvas 70.2 x 91.4
TWCMS : B4920

Watts, George Frederick 1817–1904
*The Family of Darius before Alexander the
Great* (after Paolo Veronese) 1837–1840
oil on canvas 46 x 91.5
TWCMS : F6127

Way, William Cossens 1833–1905
Turnip Field
oil on canvas 41 x 76.4
TWCMS : E8476

Webb, James 1825–1895
Coast Scene, an Approaching Storm 1859
oil on canvas 59.1 x 89.5
TWCMS : B4236

Webb, James 1825–1895
The White Cliffs of Dover 1859
oil on canvas 65.7 x 89.7
TWCMS : B4204

Webb, James 1825–1895
Boats Leaving Harbour 1868
oil on canvas 76.5 x 128
TWCMS : B6221

Webb, James 1825–1895
Cartagena, Spain 1874
oil on panel 29.7 x 55.8
TWCMS : F6130

Webb, James (attributed to) 1825–1895
Homeward Bound
oil on canvas 63.5 x 114.5
TWCMS : B3237

Webb, James (attributed to) 1825–1895
Richmond Castle, Yorkshire
oil on canvas 78.7 x 140
TWCMS : B3244

Webb, James (attributed to) 1825–1895
Seascape with French Shipping
oil on canvas 60.9 x 91.9
TWCMS : B3243

Webb, James (attributed to) 1825–1895
Venetian Canal Scene
oil on canvas 98.6 x 137.4
TWCMS : B8435

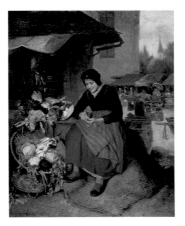

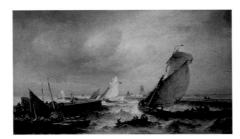

Webb, William Edward 1862–1903
Douglas Harbour, Isle of Man
oil on canvas 76.7 x 127.7
TWCMS : B3778

Weben, J. W.
Counting Her Gains 1894
oil on canvas 77.5 x 62.6
TWCMS : B3799

Weber, Theodor Alexander 1838–1907
Fishing Boats Leaving Ostend Harbour
oil on canvas 92 x 154
TWCMS : B3762

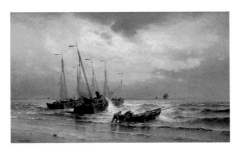

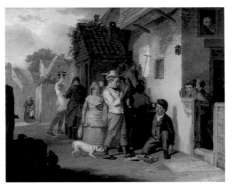

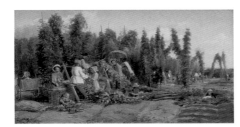

Weber, Theodor Alexander (attributed to)
1838–1907
Fishing Boats
oil on canvas 59.9 x 96.8
TWCMS : F9358

Webster, Thomas George 1800–1886
Genius c.1830–1860
oil on canvas 50 x 61
TWCMS : B3246

Webster, Thomas George 1800–1886
Hop Garden 1858
oil on board 22.9 x 41
TWCMS : E8495

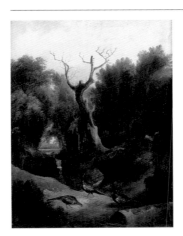

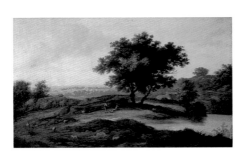

Weir, J. T. active 19th C
Wooded Landscape with Pheasants
oil on canvas 71 x 61.2
TWCMS : C193

Weisbrod, Carl Wilhelm 1743–1806
River Scene
oil on canvas 24.4 x 34.5
TWCMS : C7384

West, Kevin Barry
The Ninth Hour
oil on canvas 60.5 x 55
TWCMS : 2008.104

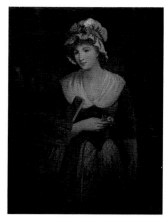

Wheatley, Francis (attributed to)
1747–1801
Portrait of a Milkmaid
oil on canvas 122 x 91.5
TWCMS : F9407

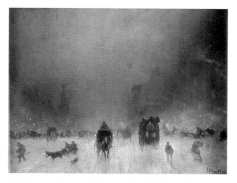

Whistler, James Abbott McNeill (style of)
1834–1903
A Foggy Night in London
oil on canvas 35.5 x 49
TWCMS : B4226

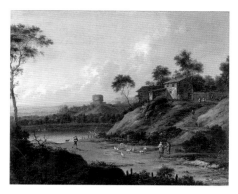

Wijnants, Jan (style of) c.1635–1684
Landscape with River
oil on canvas 62.5 x 78.1
TWCMS : G1175

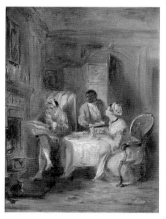

Wilkie, David (style of) 1785–1841
The Invalid's Breakfast
oil on board 22.5 x 17.7
TWCMS : B4901

Williams, Alan active 20th C
Landscape 1
oil on canvas 50.5 x 61
TWCMS : E8478

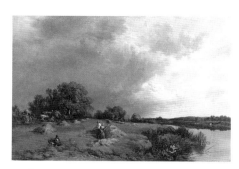

Williams, Alfred Walter 1824–1905
Haymaking, Sunshine and Showers 1857
oil on canvas 105.1 x 155.1
TWCMS : B3785

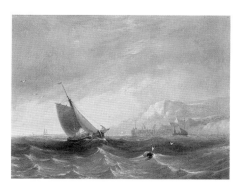

Williams, T.
Sea Piece
oil on board 28.7 x 36.3
TWCMS : B6207

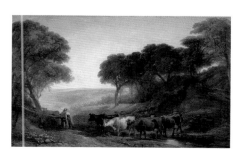

Willis, Henry Brittan 1810–1884
Crossing the Stream 1847
oil on canvas 90.4 x 137.7
TWCMS : F9372

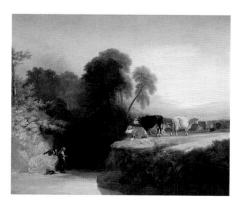

Willis, Henry Brittan 1810–1884
Cows on the Banks of a Stream
oil on canvas 63.5 x 77
TWCMS : B4249

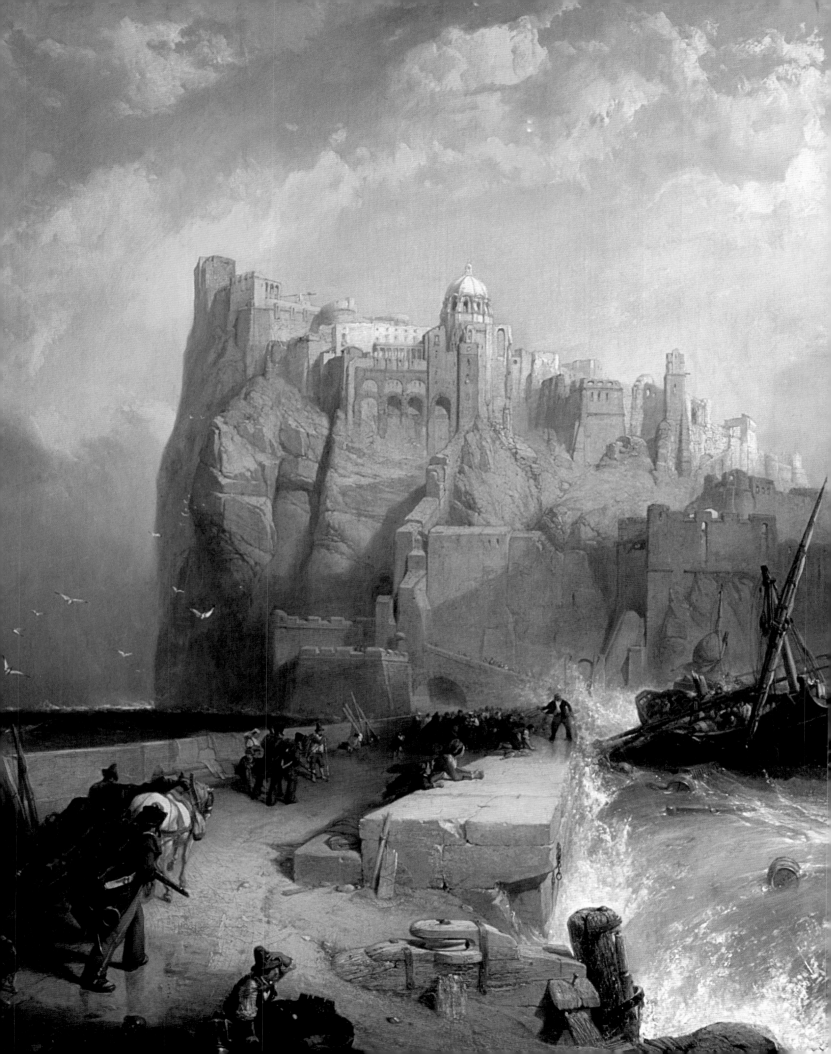

Wilson, Richard (after) 1714–1787
Classical Landscape
oil on canvas 13 x 18
TWCMS : B4933

Wilson, Richard (style of) 1714–1787
On the Coast
oil on canvas 64.5 x 77.4
TWCMS : G1179

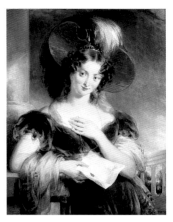

Wood, John 1801–1870
The Love Letter 1830
oil on canvas 92.3 x 72
TWCMS : B4921

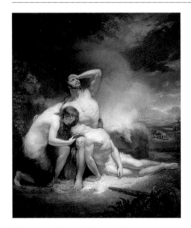

Wood, John 1801–1870
The Death of Abel
oil on canvas 127.3 x 101.9
TWCMS : F12330

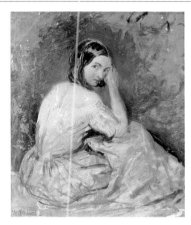

Woolmer, Alfred Joseph 1805–1892
Portrait of a Young Woman
oil on canvas 27.8 x 23.7
TWCMS : C7395

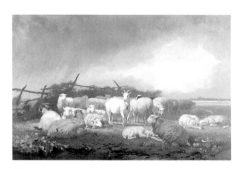

Woutermaertens, Edouard 1819–1897
Sheep and Goats Sheltering c.1860
oil on canvas 70.4 x 103
TWCMS : B4927

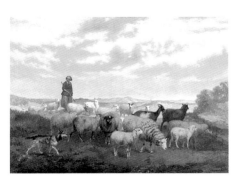

Woutermaertens, Edouard 1819–1897
Shepherdess with Flock c.1860
oil on canvas 71.5 x 99.3
TWCMS : B4903

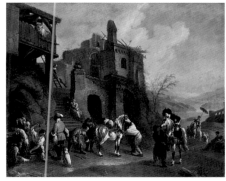

Wouwerman, Philips (after) 1619–1668
The Farrier's Shop
oil on canvas 138.7 x 168
TWCMS : C7389

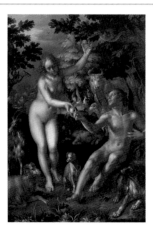

Wtewael, Joachim Anthonisz. 1566–1638
The Temptation of Adam and Eve 1614
oil on canvas 164.5 x 111
TWCMS : G1184

Facing page: Stanfield, Clarkson, 1793–1867, *The Castle of Ischia from the Mole, Italy* (detail), Sunderland Museum
and Winter Gardens, (p. 317)

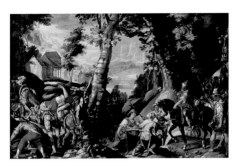

Wtewael, Joachim Anthonisz. 1566–1638
The Meeting of David and Abigail
oil on canvas 97.8 x 140.7
TWCMS : C164

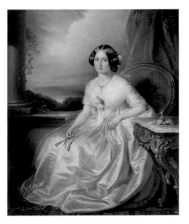

Wulffaert, Adrianus 1804–1873
Portrait of a Lady 1846
oil on canvas 83 x 76.5
TWCMS : F9377

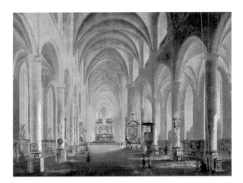

Wyck, Thomas (follower of) 1616–1677
A Church Interior
oil on panel 39.9 x 53
TWCMS : B4220

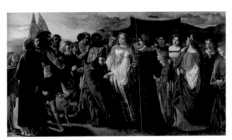

Wynfield, David Wilkie 1837–1887
The Lady's Knight
oil on canvas 108.3 x 148.8
TWCMS : B3207

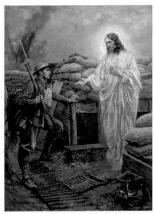

Ximenes, Pio d.1919
'Abide with me' 1919
oil on canvas 105.5 x 79.3
TWCMS : F12321

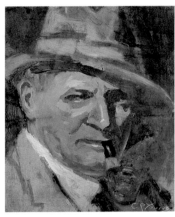

Young, C. P. active 20th C
Head of a Man in Grey with a Pipe
tempera on canvas 30.5 x 25.5
TWCMS : F9416

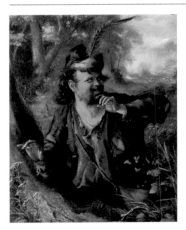

Young, J.
The Vagrant 1875
oil on canvas 51 x 40.5
TWCMS : E8469

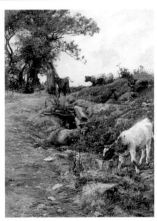

Young-Hunter, John 1874–1955
The Midday Meal 1895
oil on canvas 102.1 x 71.5
TWCMS : B3760

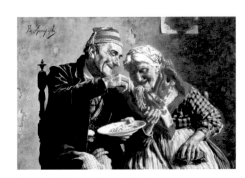

Zampigi, Eugenio 1859–1944
Sharing Their Pleasures
oil on canvas 37 x 52
TWCMS : F12324

Laing Art Gallery

In 1900, Alexander Laing, a wine and spirit manufacturer, offered to build an art gallery, bearing his name, to commemorate 50 years of successful business in Newcastle. The City Council accepted enthusiastically, and the gallery opened to the public on the 13th October 1904. Laing was a public-spirited businessman, rather than a connoisseur or collector and the Laing is unusual amongst British regional galleries in having been established without a collection. The first curator, C. Bernard Stevenson, was known to joke that he may have needed to resort to exhibiting the wood shavings left by joiners for the opening exhibition.

The *Special Inaugural Exhibition by British and Foreign Artists,* concentrating on works by the British School from Hogarth onwards, was a triumph. It consisted of loans from local collectors and national institutions. As a result of its success the Council decided to build a permanent collection along similar lines to the exhibition. This decision set the tone for the British character of the Laing's fine art collections. From its earliest days the Laing benefited from a large number of important gifts and bequests – many of them from prominent local industrialists and other public figures and also, later, from the Contemporary Art Society.

These gifts included oil paintings and watercolours. The latter laid the foundations for an outstanding watercolour collection. Today, the Collection also contains prints and drawings, sculpture and decorative arts.

Much of the Collection has been purchased and the Gallery has benefited from funding for key works from, amongst others, the National Art Collections Fund, the Museums, Libraries and Archives Council/ Victoria and Albert Museum Purchase Grant Fund and in more recent years the Heritage Lottery Fund. The support of the Friends of the Laing Art Gallery also continues to be instrumental in building the Collection.

The collection of nineteenth-century British oil paintings is significant with two world-famous masterpieces of Pre-Raphaelite art: Edward Burne-Jones's *Laus veneris* is regarded by many authorities as his single finest and most representative work, while William Holman Hunt's *Isabella and the Pot of Basil* is universally recognised as one of his most important compositions. *Isabella* was purchased by James Hall, a local collector of Pre-Raphaelite art. His descendent, Dr Wilfred Hall, donated the work to the gallery in 1952.

Local collectors have always supported the Laing, often lending key works from their collections for long-term public display. The North East had a small but dedicated group of collectors of Pre-Raphaelite art, a few of whose significant pieces eventually made their way into the gallery's collection. The local collector James Leathart, a lead manufacturer, commissioned a family portrait from Arthur Hughes, *Mrs Leathart and Her Three Children,* which was purchased for the Collection in 1998. The artist and follower of the Pre-Raphaelite movement Charles William Mitchell was the son of the collector and Newcastle industrialist Charles Mitchell of Jesmond Towers. His magnificent work *Hypatia* was donated to the Laing Art Gallery by his descendent Major Charles Mitchell in 1940 and is a striking example of Victorian art.

Accompanying these works are major paintings by William Bell Scott, onetime Master of the Government School of Design at Newcastle. Outstanding works by Lawrence Alma-Tadema, John William Waterhouse and Edward Poynter demonstrate the Classical revival of the later nineteenth century. All the major genres within Victorian art are represented, including work by John Frederick Lewis, Joseph Noel Paton and Alfred de Breanski, while Edwin Landseer, (renowned court painter to Queen Victoria), is represented by several paintings, including a magnificent pair of animal portraits commissioned in 1867 for the Great Hall of Chillingham Castle. A particular strength of the Collection lies in the representation of the so-called Rustic Naturalists; George Clausen, Henry Herbert La Thangue, and their contemporaries. Clausen's *The Stone Pickers* was purchased in 1907 from an annual exhibition, *Artists of the Northern Counties*; an opportunity for up-and-coming artists based in the North to show and sell their work.

The Gallery has the most comprehensive collection in the world of the work of locally-born British Romantic artist John Martin. Two outstanding examples of his work include *The Destruction of Sodom and Gomorrah* and *The Bard*. The former work was donated in 1951 in memory of John Frederick Weidner, JP, Lord Mayor of Newcastle upon Tyne, (1912–1913). Along with the purchase of several works in 1976 from the private collection of Charlotte and Robert Frank, these formed the nucleus of a collection of works by Martin which now encompasses nine oil paintings, seven watercolours and drawings, and over eighty prints. A popular artist in his day, Martin nonetheless felt he never received the recognition from the British establishment that was his due. His powerful and unique vision is now represented in collections around the world including Tate Britain.

From the eighteenth century, the Collection contains a particularly fine group of portraits, ranging from large-scale works by Thomas Hudson and Allan Ramsay, to a group of three family portraits by Joseph Wright of Derby. One of Sir Joshua Reynolds' finest full-length portraits *Mrs Elizabeth Riddell* (1763) was purchased in 1965. There are also fascinating conversation and genre pieces by Francis Hayman and Johann Zoffany. The changing styles of the later eighteenth century are demonstrated by Henry Raeburn and James Ward.

The important collection of early twentieth century paintings includes Edwardian portraits by John Singer Sargent, Augustus Edwin John and John Lavery, an unusual self-portrait by William Orpen, and *Holy Motherhood*, a major symbolist work by Thomas Cooper Gotch.

The work of the Newlyn school of artists is represented by Laura and Harold Knight and by Ernest and Dod Procter. The Camden Town Group is represented by Walter Sickert, Malcolm Drummond and Gilbert Spencer; the Bloomsbury Group by Duncan Grant; and the Glasgow Boys by Ernest Atkinson Hornel.

The strength of the Collection continues with two exceptional works; Stanley Spencer's *The Lovers (The Dustmen)* and Christopher Wood's *Sleeping Fisherman, Ploaré, Brittany*.

There are major landscapes by John Piper and Sheila Mary Fell. The abstraction of David Bomberg, Anne Redpath and Ivon Hitchens contrasts with the work of John Nash, War Artist James Bateman, and the inimitable L. S. Lowry. Figurative painting is also strongly represented, including Edward

Wadsworth's Surrealist *Marine Set* and the brooding vision of Christopher Nevinson's *Twentieth Century*, while works by Matthew Arnold Bracy Smith, Sylvia Gosse, and William McTaggart explore the boundaries of still life and portraiture.

Pre and post-war abstraction are less well represented, but there are major works by Terry Frost, Ben Nicholson and Victor Pasmore, the latter of whom taught for a time at Newcastle University. Major contemporary works have also been added to the Collection, including paintings by R. B. Kitaj and John Bratby, together with large-scale works by Steven Campbell, Adrian Wiszniewski and Gillian Ayres.

Although the Collection is predominantly British in character there is a small nucleus of European paintings including Dieric Bouts' fifteenth-century Flemish work *The Miracle of the Gallows*, Gregorio de' Ferrari's Italian Baroque *The Flight into Egypt*, and an exquisite sixteenth-century *The Adoration of the Magi* by an unknown artist. Paul Gauguin's *The Breton Shepherdess* is another of the great masterpieces in the Collection. Given by the National Art Collections Fund in 1945, it was selected for the Laing from a bequest of French and English Impressionist and Post-Impressionist works.

It is a tribute to the knowledge and foresight of successive curators that the Laing has amassed a collection now considered of national if not international significance. Over the past 100 years, the Laing has been transformed from an empty building to the North East's premier art gallery.

Julie Milne, Curator

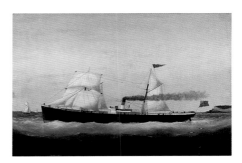

Adam, Eduard Marie 1847–1929
Sailing Boats, Le Havre 1877
oil on canvas 62.1 x 92.1
TWCMS : G1338

Adams, Alan Henry 1892–1988
View of Suffolk
oil on canvas 38.5 x 45.3
TWCMS : R1553

Adams, John Clayton 1840–1906
Hay Field 1891
oil on canvas 81.6 x 122.3
TWCMS : G1507

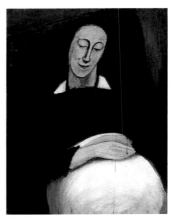

Adams, Ruth 1893–1949
Sleeping Woman
oil on canvas 101.7 x 76.3
TWCMS : F3493

Adams, Ruth 1893–1949
Trewithal Farm
oil on canvas 61.1 x 45.7
TWCMS : G508

Alder, Helen Baker b.1950
Head VII 1990
acrylic & bodycolour on paper
115 x 101.1 (E)
TWCMS : 1993.4403

Alder, Helen Baker b.1950
Head X 1990
acrylic & bodycolour on paper
110 x 81.2 (E)
TWCMS : 1993.4402

Alder, Helen Baker b.1950
Head XI 1990
acrylic & bodycolour on paper
114.5 x 101 (E)
TWCMS : 1993.4401

Allen, Harry Epworth 1894–1958
Eyam, Derbyshire c.1936
pencil & tempera on paper 35.2 x 51.2
TWCMS : F13748

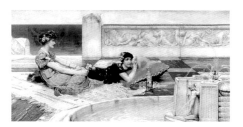

Alma-Tadema, Lawrence 1836–1912
Love in Idleness c.1891
oil on canvas 87 x 165.5
TWCMS : B8120

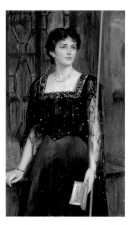

Anderson, Charles Goldsborough
1865–1936
Mrs Goldsborough Anderson c.1900
oil on canvas 127.2 x 71.3
TWCMS : C700

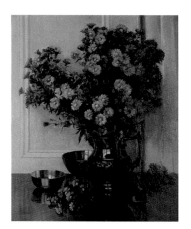

Anderson, William S. 1878–1929
Lustre c.1921
oil on canvas 56 x 45.8
TWCMS : C694

Anderson, William S. 1878–1929
Still Life
oil on canvas 46.1 x 56.2
TWCMS : C682

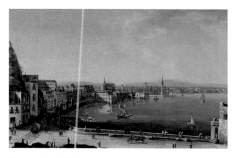

Antoniani, Pietro 1740–1750–1805
A Harbour in Italy (St Lucia)
oil on canvas 31 x 47.5
TWCMS : C3935

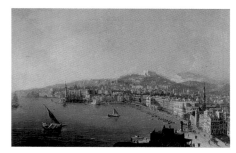

Antoniani, Pietro 1740–1750–1805
Naples
oil on canvas 30.5 x 47.2
TWCMS : C3931

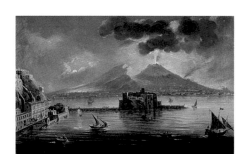

Antoniani, Pietro 1740–1750–1805
Naples at Night with Vesuvius Erupting
oil on canvas 30.6 x 47.5
TWCMS : C3937

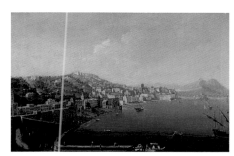

Antoniani, Pietro 1740–1750–1805
Naples with Vesuvius
oil on canvas 30.5 x 47.2
TWCMS : C3933

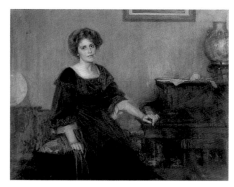

Appleyard, Frederick 1874–1963
Portrait of a Lady
oil on canvas 101.5 x 127.5
TWCMS : G531

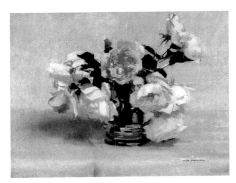

Appleyard, Frederick 1874–1963
Roses
oil on board 30.2 x 40.9
TWCMS : C3908

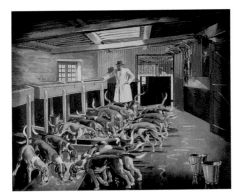

Appleyard, Joseph 1908–1960
Cleveland Hounds at Feeding Time c.1938
oil on canvas 50.8 x 61
TWCMS : C666 (P)

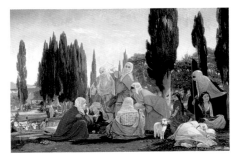

Armitage, Edward 1817–1896
Souvenir of Scutari 1857
oil on canvas 122 x 183
TWCMS : B8124

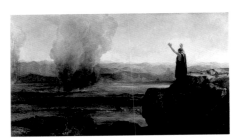

Armitage, Edward 1817–1896
The Cities of the Plain 1876
oil on canvas 104.5 x 183
TWCMS : C9998

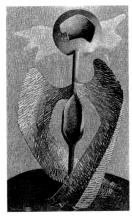

Armstrong, John 1893–1973
Icarus 1961
oil on canvas 71.2 x 40.5
TWCMS : G1301

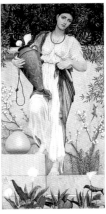

Armstrong, Thomas 1832–1911
Woman with Lilies 1876
oil on canvas 183 x 91.5
TWCMS : B8119

Arpad, Romek 1883–1960
Still Life
oil on canvas 54.4 x 67.8
TWCMS : H983

Atkin, Gabriel 1897–1937
Portrait of an Unknown Woman
oil on canvas 51 x 38
TWCMS : 2006.1893

Atkin, Gabriel 1897–1937
Prince Serge of Chernatzki
oil on canvas 60.7 x 45
TWCMS : M5106

Facing page: Spencer, Stanley, 1891–1959, *The Lovers (The Dustmen)* (detail), 1934, Laing Art Gallery, (p. 211)

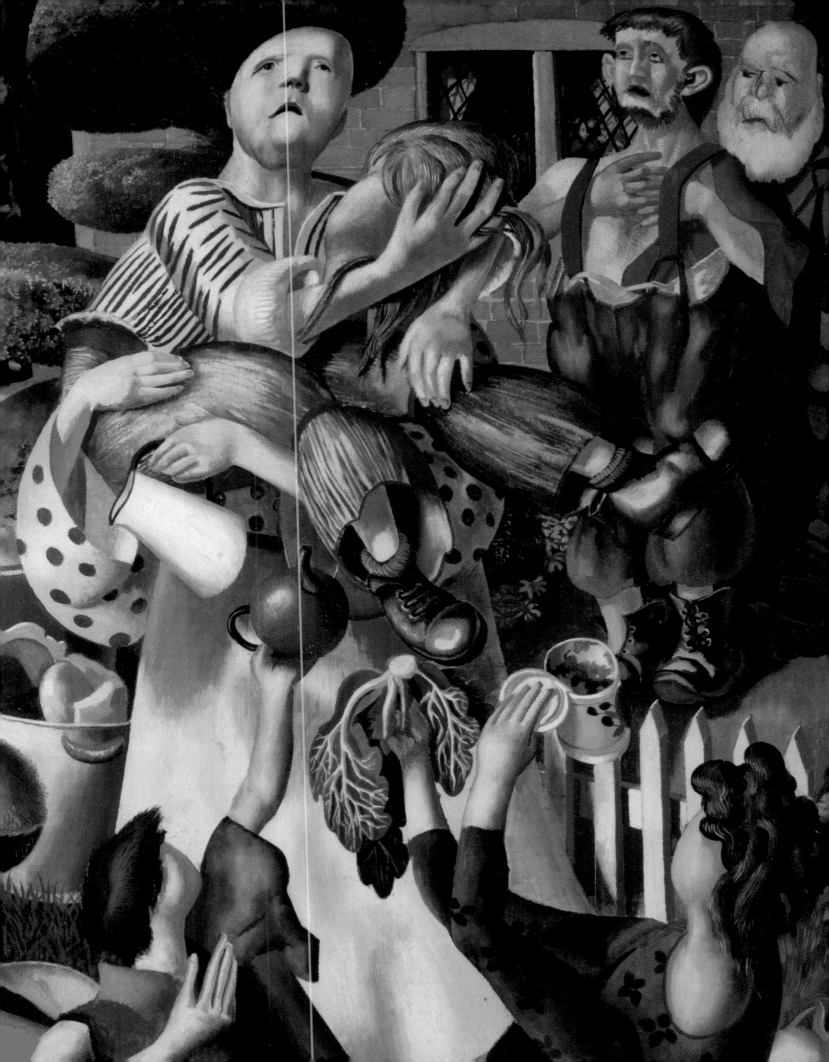

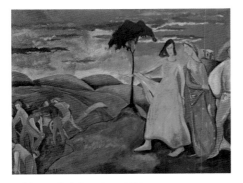

Atkin, Gabriel 1897–1937
Work
oil on board 48 x 61
TWCMS : 2006.1884

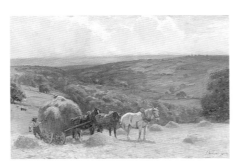

Atkinson, John II 1863–1924
Haymaking 1900
oil on canvas 51 x 76.3
TWCMS : C668

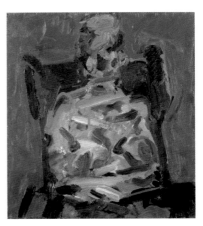

Auerbach, Frank Helmuth b.1931
Julia 1987
acrylic on wood 45.8 x 40.6 (E)
TWCMS : 1999.1291

Ayres, Gillian b.1930
Papua 1988
oil on canvas 274.3 x 274.4
TWCMS : P581

Ball, Martin b.1948
Fane 1980–1981
acrylic on canvas 212.6 x 121.4
TWCMS : G3367

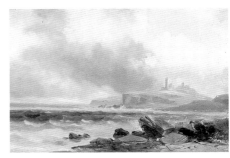

Balmer, George 1805–1846
Dunstanburgh Castle, Northumbria c.1825–
1840
oil on panel 30.3 x 45.8
TWCMS : C10041

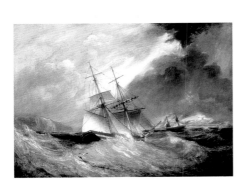

Balmer, George 1805–1846
The Brig 'Hermaphrodite' 1830
oil on canvas 63 x 89.6
TWCMS : G1325

Balmer, George 1805–1846
The Bass Rock c.1830
oil on board 25 x 30
TWCMS : C10042

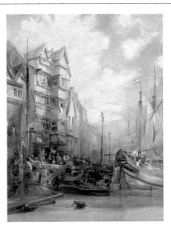

Balmer, George 1805–1846
'Grey Horse Inn', Quayside, Newcastle upon Tyne c.1830–1835
oil on canvas 84 x 61.2
TWCMS : B8150

Banner, Delmar Harmond 1896–1983
Scafell, Cumbria 1938–1944
oil on canvas 76.5 x 101.5
TWCMS : F13605

Bannister, T. W. active 19th C
John Theodore Hoyle (1808–1873), Coroner of Newcastle
oil on canvas 75.9 x 63.5
TWCMS : G1741

Bardwell, Thomas 1704–1767
Captain Robert Fenwick (1716–1802), His Wife Isabella Orde (d.1789), and Her Sister Ann c.1746
oil on canvas 143 x 119.7
TWCMS : 1997.3934

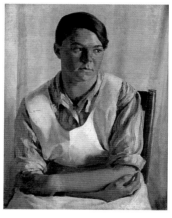

Bateman, James 1893–1959
The Cook 1924
oil on canvas 61.7 x 51.3
TWCMS : G4615

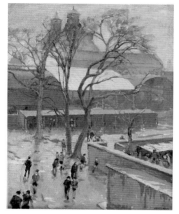

Bateman, James 1893–1959
The Schoolyard c.1931
oil on canvas 45.8 x 35.5
TWCMS : C10037

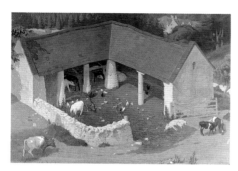

Bateman, James 1893–1959
The Field Byre 1933
oil on canvas 80.3 x 112.5
TWCMS : C10608

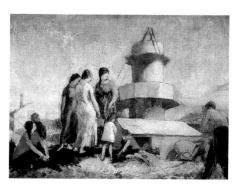

Bateman, James 1893–1959
The Lime Burner c.1936
pencil, oil & wax on panel 31.6 x 42.8
TWCMS : C662

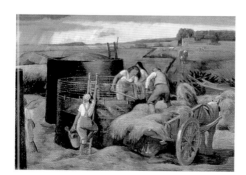

Bateman, James 1893–1959
Silage c.1940
oil on canvas 50.9 x 71.1
TWCMS : F3430

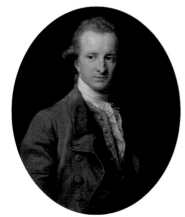

Batoni, Pompeo 1708–1787
Henry Swinburne (1743–1803) 1779
oil on canvas 70.8 x 57.5
TWCMS : C3940

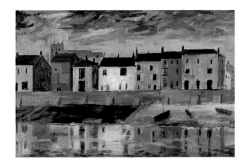

Beattie, Basil b.1935
Sea Wall, Hartlepool
oil on canvas 50.7 x 76.3
TWCMS : G12974

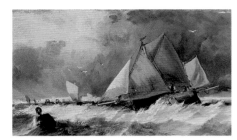

Beavis, Richard 1824–1896
Fishing Boats, Brighton
oil on board 14.3 x 24.5
TWCMS : B6667

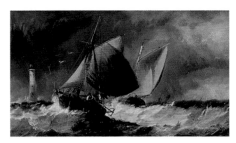

Beavis, Richard 1824–1896
Fishing Craft off the Eddystone Lighthouse
oil on panel 13.9 x 23.9
TWCMS : B6681

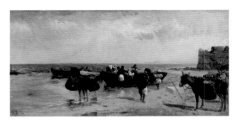

Beavis, Richard 1824–1896
Fruit Boats on the Mediterranean
oil on canvas 30.8 x 61.3
TWCMS : D1283

Bell, Trevor b.1930
Three Blue Lines 1962
oil on canvas 91.7 x 121.9
TWCMS : G534

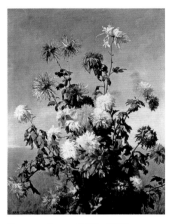

Benner, Jean 1836–1909
Study of Flowers
oil on canvas 146.7 x 114.5
TWCMS : G1991

Bertram, Robert John Scott 1871–1953
*Newcastle upon Tyne from Gateshead, the
Great Flood, AD 1771*
oil on canvas 320 x 817
TWCMS : G4636

Best, Eleanor 1875–1957
Winter Sunlight
oil on canvas 76.8 x 64
TWCMS : F13249.2

Best, Eleanor 1875–1957
Women in a Gymnasium
oil on canvas 67.5 x 55
TWCMS : F13249.1

Birch, Samuel John Lamorna 1869–1955
Landscape 1905
oil on canvas 45.9 x 61
TWCMS : C692

Bird, Robert b.1921
Spanish Gold 1964–1965
acrylic, card & enamel on board
122.1 x 101.5
TWCMS : H981

Blacklock, William James 1816–1858
*The Ruins of Kirkoswald Castle,
Cumberland* 1854
oil on canvas 30.5 x 40.4
TWCMS : G12975

Bland, Emily Beatrice 1864–1951
Dover Cliffs
oil on board 21.8 x 27.1
TWCMS : B7443

Bloemen, Jan Frans van (attributed to)
1662–1749
Campagna Landscape
oil on canvas 72.2 x 137.2
TWCMS : F13604

Bolton, Sylbert b.1959
Time Out 1992
acrylic on canvas 122 x 121.8
TWCMS : 1994.108

Bomberg, David 1890–1957
Sunset, the Bay, North Devon 1946
oil on canvas 61.2 x 76.3
TWCMS : C3903

Bone, Stephen 1904–1958
Hospital Ship c.1944
oil on board 26.8 x 39.2
TWCMS : F3426

Bossche, Balthasar van den 1681–1715
The Studio of Giovanni Bologna 1706
oil on canvas 58.5 x 82.9
TWCMS : G4765

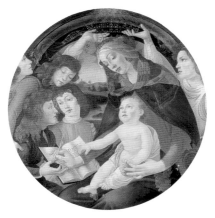

Botticelli, Sandro (after) 1444/1445–1510
The Madonna of the Magnificat 19th C
oil on canvas 111.8
TWCMS : G1941

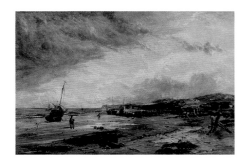

Bough, Samuel 1822–1878
Coast Scene
oil on canvas 50.8 x 76.3
TWCMS : F4788

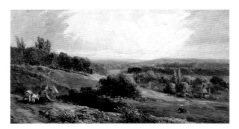

Bough, Samuel (attributed to) 1822–1878
Landscape with Children
oil on canvas 25.3 x 46.3
TWCMS : C13483

Bouguereau, William-Adolphe 1825–1905
The Penitent 1876
oil on canvas 88.7 x 55.5
TWCMS : G10309

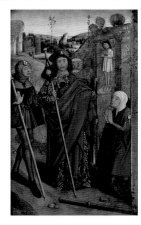

Bouts, Dieric the elder (attributed to)
c.1415–1475
The Miracle of the Gallows c.1435–1460
tempera on canvas 89.2 x 54.8
TWCMS : D2991

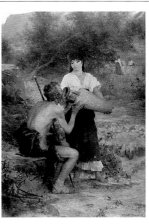

Bramtot, Alfred Henri 1852–1894
Compassion 1882
oil on canvas 257.4 x 174.7
TWCMS : G4634

Brangwyn, Frank 1867–1956
Mending the Nets 1887
oil on canvas 60.7 x 91
TWCMS : G4614

Bratby, John Randall 1928–1992
Gloria with Angst 1960
oil on canvas 182.9 x 75.8
TWCMS : E3533

Breanski, Alfred de 1852–1928
Sentinels of the Forest c.1870–1890
oil on canvas 76.7 x 127.3
TWCMS : G3895

Breanski, Alfred de 1852–1928
Henley Regatta 1881
oil on canvas 61.6 x 92.2
TWCMS : G1509

Breanski, Alfred de 1852–1928
River Foyers at Abertarff, Invernesshire
oil on canvas 92 x 61
TWCMS : G2340

Brick, Michael b.1946
Sous-Bois II 1977–1978
acrylic on canvas 230.4 x 97
TWCMS : F5154

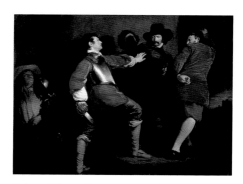

Briggs, Henry Perronet 1791/1793–1844
*The Discovery of the Gunpowder Plot and the
Taking of Guy Fawkes* c.1823
oil on canvas 149 x 199
TWCMS : B8115

Bromly, Thomas b.1930
*Painting, 1966 (Divided Square No.4 Red and
Blue)* 1966
acrylic on canvas 121.7 x 121.8
TWCMS : G1987

Brooker, William 1918–1983
Naxos 1962 1962
oil on canvas 76 x 101.9
TWCMS : G4760

Brown, Alexander Kellock 1849–1922
Winter Twilight c.1904
oil on canvas 118 x 142.5
TWCMS : G4155

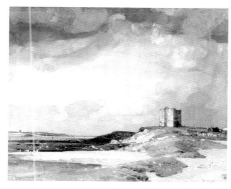

Brown, John Alfred Arnesby 1866–1955
The Watch Tower c.1923
oil on canvas 89.1 x 112.3
TWCMS : F9125

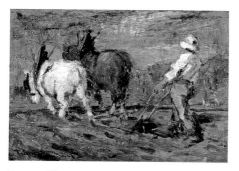

Brown, Thomas Austen 1859–1924
Ploughing 1887
oil on panel 24.8 x 35.6
TWCMS : D1287

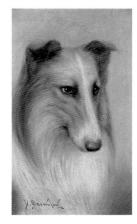

Brownlow, George Washington 1835–1876
Collie
oil on board 28.1 x 18
TWCMS : F9143

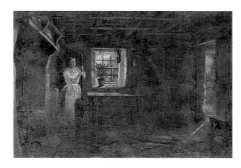

Brownlow, George Washington 1835–1876
Cottage Interior
oil on board 30.6 x 47
TWCMS : G12985

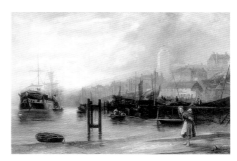

Brownlow, Stephen 1828–1896
North Shields 1880
oil on canvas 50.7 x 76.4
TWCMS : F9131

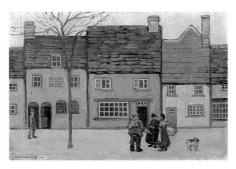

Bryce, Helen Bryne active 1918–1931
Street Scene 1920
oil on canvas 35.6 x 50.8
TWCMS : G465

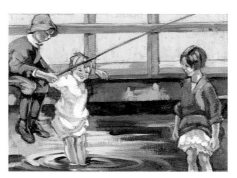

Bryce, Helen Bryne active 1918–1931
Fishing c.1920–1930
oil & pencil on canvas 23.8 x 32.5
TWCMS : C13504

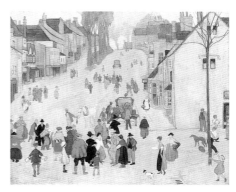

Bryce, Helen Bryne active 1918–1931
High Street, Burford, Oxfordshire 1922
oil & pencil on canvas 40.8 x 51
TWCMS : H982

Bullock, Ralph 1867–1949
Benton Golf Course
oil on board 25.4 x 35.6
TWCMS : E5259

Bullock, Ralph 1867–1949
Farm
oil on board 25 x 35.6
TWCMS : E5258

Bullock, Ralph 1867–1949
The Entry of Princess Margaret into Newcastle upon Tyne, 1503
oil on canvas 249.5 x 810
TWCMS : G4639

Bunbury, Henry William 1750–1811
A Windy Day c.1790–1810
oil on canvas 9.3 x 25
TWCMS : C3938

Bunbury, Henry William 1750–1811
The Dancing Bear c.1790–1810
oil on canvas 10.1 x 28.1
TWCMS : C3939

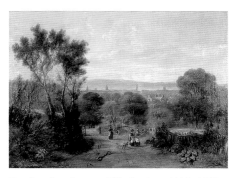

Burdon Sanderson, Elizabeth c.1825–1925
View in Jesmond, Newcastle upon Tyne c.1845
oil on canvas 63.7 x 86.6
TWCMS : F5155

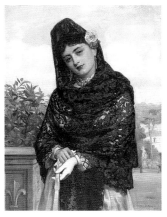

Burgess, John Bagnold 1830–1897
The Trysting Place 1877
oil on canvas 75 x 54.8
TWCMS : 1995.302

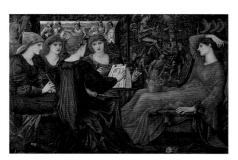

Burne-Jones, Edward 1833–1898
Laus veneris 1873–1875
oil on canvas 122.5 x 183.3
TWCMS : B8145

Burns, Joanne b.1959
Beach after Cullercoats,
Northumberland 1989–1990
acrylic on canvas 91 x 121.6
TWCMS : R1556

Burns, Peter
Empty Stockyard, Hawthorn Leslie's, Hebburn,
South Tyneside 1978
acrylic on canvas 122.3 x 83.3
TWCMS : 1993.4404

Callcott, Augustus Wall 1779–1844
Windsor Castle from the Old Bridge
c.1810–1830
oil on canvas 61.4 x 91.6
TWCMS : B8112

Callow, William (attributed to) 1812–1908
On the Medway
oil on canvas 127.1 x 76.3
TWCMS : G1515

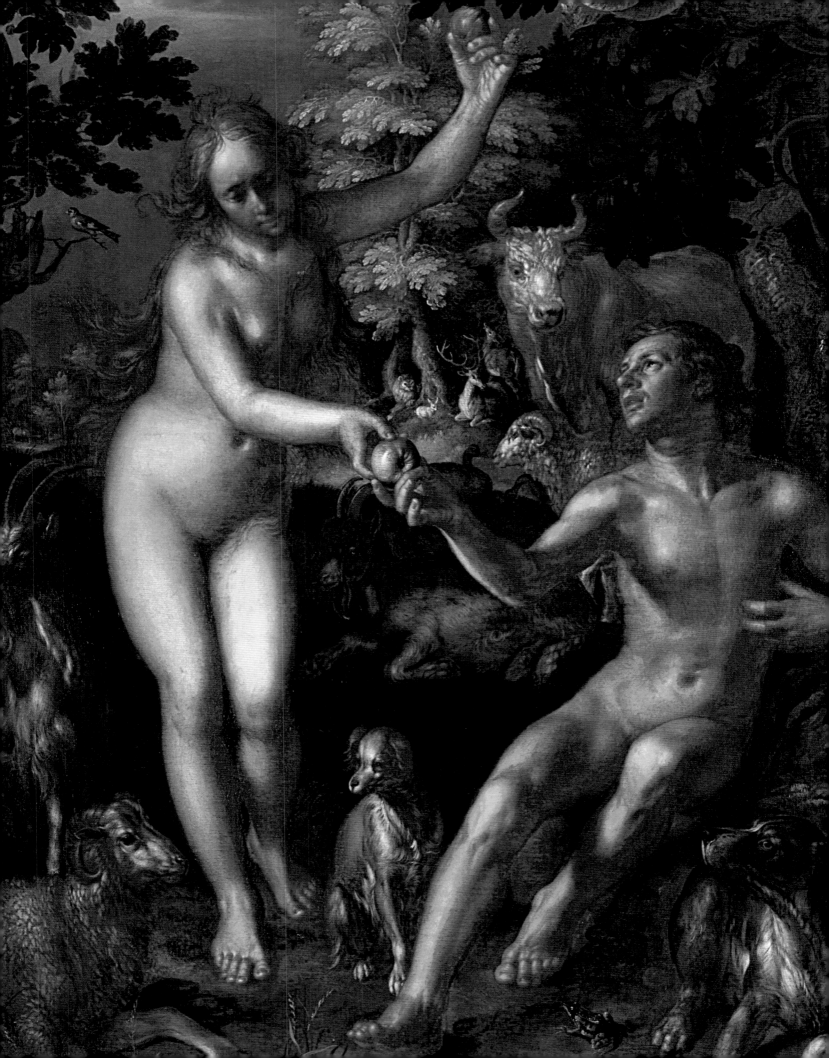

Calvert, Frederick (attributed to)
c.1785–c.1845
Coast Scene
oil on canvas 31.2 x 41
TWCMS : F4624

Calvert, Samuel 1828–1913
Tynemouth Bar 1883
oil on canvas 40 x 61.1
TWCMS : G540

Cameron, David Young 1865–1945
Balquhidder, Stirlingshire c.1916
oil on canvas 152.5 x 229.6
TWCMS : C601

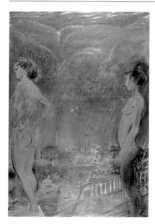

Camp, Jeffery b.1923
Thames 1986
oil on canvas 292 x 118
TWCMS : P579

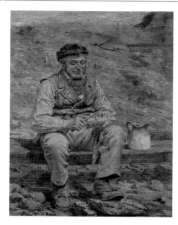

Campbell, John Hodgson 1855–1927
Workman Eating Lunch 1886–1887
oil on canvas 91.9 x 71.5
TWCMS : F3491

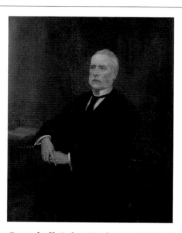

Campbell, John Hodgson 1855–1927
John Hall (1824–1899) 1905
oil on canvas 127.7 x 101.5
TWCMS : E5277

Cantrill, Molly active 1968–1987
Steps: Westgate Gallery 1968–1969
oil on board 69.5 x 44.5 (E)
TWCMS : M5129

Carelli, Consalvo (attributed to) 1818–1900
View of Capri
oil on canvas 50.2 x 69
TWCMS : C13529

Carelli, Consalvo (attributed to) 1818–1900
View of the Bay of Naples
oil on canvas 48.1 x 69.5
TWCMS : C13467

Facing page: Wtewael, Joachim Anthonisz., 1566–1638, *The Temptation of Adam and Eve* (detail), 1614,
Shipley Art Gallery, (p. 101)

Carmichael, John Wilson 1800–1868
Priory and Castle, Tynemouth c.1825–1845
oil on wood 24 x 69
TWCMS : 1996.1725

Carmichael, John Wilson 1800–1868
The Mayor's Barge on the Tyne 1828
oil on canvas 87.6 x 138.5
TWCMS : B6661

Carmichael, John Wilson 1800–1868
Brinkburn Grange and the Ruins of Brinkburn Priory 1834
oil on canvas 47 x 71.2
TWCMS : F3497

Carmichael, John Wilson 1800–1868
Cullercoats from Tynemouth 1835
oil on canvas 48.3 x 71.9
TWCMS : J15708

Carmichael, John Wilson 1800–1868
Shipping Inshore, a Boat Ferrying Passengers c.1835–1845
oil on canvas 79.9 x 112
TWCMS : G527

Carmichael, John Wilson 1800–1868
Landscape with a Country House 1838
oil on canvas 33 x 44.5
TWCMS : F4616

Carmichael, John Wilson 1800–1868
Shipping in the Open Sea 1838
oil on canvas 84.5 x 122
TWCMS : G526

Carmichael, John Wilson 1800–1868
Sunderland Old Pier and Lighthouse with Ryhope Church in the Distance 1840
oil on canvas 44.4 x 59.3
TWCMS : F5156

Carmichael, John Wilson 1800–1868
Durham 1841
oil on canvas 60.7 x 91.6
TWCMS : B6662

Carmichael, John Wilson 1800–1868
Holme Eden, near Carlisle 1843
oil on canvas 61.7 x 92.1
TWCMS : B7416

Carmichael, John Wilson 1800–1868
Interior of St Peter's Church, Newcastle upon Tyne after 1843
oil on paper 72.2 x 59.2
TWCMS : B7415

Carmichael, John Wilson 1800–1868
Coast Scene 1845
oil on panel 25.1 x 35.6
TWCMS : F5195

Carmichael, John Wilson 1800–1868
The Entrance to Beaufront Castle 1845
oil on canvas 44.6 x 63.7
TWCMS : B6699

Carmichael, John Wilson 1800–1868
The Garden Front, Beaufront Castle 1845
oil on canvas 44.5 x 63.5
TWCMS : B6660

Carmichael, John Wilson 1800–1868
Leith and Edinburgh from the Firth of Forth 1847
oil on board 25 x 35.1
TWCMS : F4629

Carmichael, John Wilson 1800–1868
Marsden Rocks, Sunderland 1847
oil on board 25.1 x 35.2
TWCMS : C13500

Carmichael, John Wilson 1800–1868
Men-of-War off Portsmouth Harbour 1848
oil on canvas 52.7 x 76.8
TWCMS : B6684

Carmichael, John Wilson 1800–1868
Seascape 1851
oil on canvas 35.4 x 50.9
TWCMS : F4625

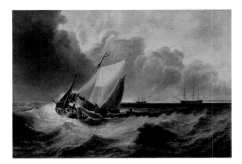

Carmichael, John Wilson 1800–1868
Seascape, Recollection of Turner 1857
oil on canvas 35.7 x 51.2
TWCMS : F9114

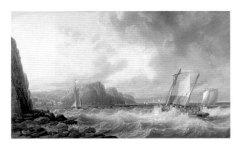

Carmichael, John Wilson 1800–1868
Off the Yorkshire Coast, Staithes 1861
oil on canvas 61.2 x 102
TWCMS : C10645

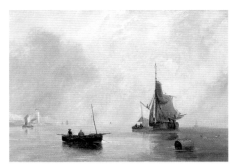

Carmichael, John Wilson 1800–1868
Off North Shields
oil on canvas 43.2 x 61
TWCMS : C663

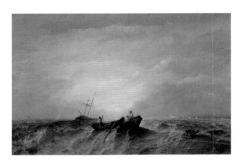

Carmichael, John Wilson 1800–1868
Off Redcar
oil on canvas 60.8 x 91.5
TWCMS : C13489

Carmichael, John Wilson 1800–1868
Tynemouth from Cullercoats
oil on board 24.9 x 35.6
TWCMS : E3539

Carmichael, John Wilson (attributed to)
1800–1868
After a Storm 1854
oil on canvas 71.8 x 91
TWCMS : F4636

Carmichael, John Wilson (attributed to)
1800–1868
Dutch Galliots off the Coast
oil on panel 39.6 x 46.7
TWCMS : C679

Carmichael, John Wilson (attributed to)
1800–1868
Seascape with Wreckage
oil on canvas 50.8 x 76.1
TWCMS : C13487

Carmichael, John Wilson (attributed to)
1800–1868
The 'Elswick' off Tynemouth
oil on canvas 66 x 106.2
TWCMS : G9601 (P)

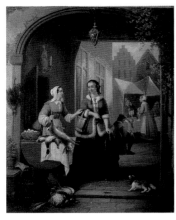

Carpentero, Henri Joseph Gommarus
1820–1874
Dutch Market Scene
oil on panel 42 x 33.9
TWCMS : C13495

Carr, Henry Marvell 1894–1970
Sister Edna Morris, Queen Alexandra's
Imperial Military Nursing Service 1943
oil on canvas 51.1 x 41.4
TWCMS : C10629

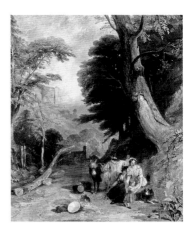

Carrick, Thomas (attributed to) 1802–1874
& Richardson, Thomas Miles I (attributed
to) 1784–1848
Richmond, Yorkshire
oil on canvas 76 x 63.4
TWCMS : F5189

Carse, Andreas Duncan 1876–1938
Roses 1931
oil on canvas 60.9 x 76.1
TWCMS : G1328

Carter, Eva I. 1870–1963
Portrait of the Artist's Mother
oil on canvas 46 x 35.5
TWCMS : B655

Carter, Frank Thomas 1853–1934
Eel Crag, Borrowdale c.1907
oil on canvas 81.4 x 127.2
TWCMS : G1501

Carter, Frank Thomas 1853–1934
Lake District
oil on canvas 76.5 x 127.1
TWCMS : G4604

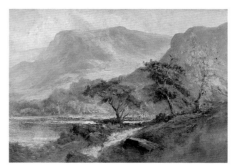

Carter, Frank Thomas 1853–1934
Landscape with Hills
oil on board 54.9 x 76.3
TWCMS : C13493

Carter, Frank Thomas 1853–1934
Sunset, Lake Scene
oil on board 15.8 x 47
TWCMS : G3240

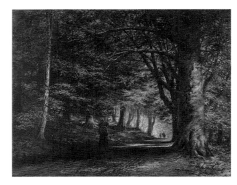

Carter, Frank Thomas 1853–1934
Sunset, Rocky Stream
oil on board 15.7 x 47
TWCMS : G3241

Carter, Frank Thomas 1853–1934
Whitley Bay
oil on canvas 40.6 x 66.2
TWCMS : G10307

Catterns, Edward Railton active 1876–1907
Beech Avenue, Inverary 1876
oil on canvas 86.6 x 111.9
TWCMS : G3861

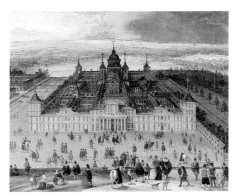

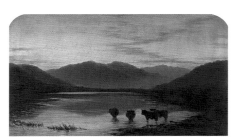

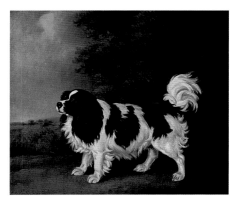

Caullery, Louis de before 1582–after 1621
The Escorial, near Madrid, Spain
oil on panel 51.3 x 66.6
TWCMS : G4766

Chalmers, J.
Dunloskin, Argyll and Bute 1872
oil on canvas 61.4 x 107
TWCMS : F5118

Chalon, Henry Bernard 1770–1849
Study of a King Charles Spaniel 1800
oil on canvas 66.4 x 76.1
TWCMS : E5291

Chapman, William 1817–1879
Portrait of a Man 1873
oil on canvas 76.1 x 63.5
TWCMS : G522

Charlton, John 1849–1917
The Huntsman 1908
oil on canvas 212 x 153.5
TWCMS : G3900

Charlton, John 1849–1917
The Women c.1910
oil on canvas 152.2 x 244.3
TWCMS : C9999

Charlton, John 1849–1917
*French Artillery Crossing the Flooded Aisne
and Saving the Guns* 1915
oil on canvas 112 x 183.5
TWCMS : C10000

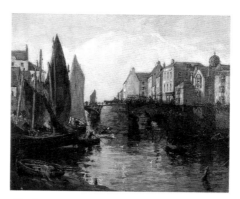

Charlton, William Henry 1846–1918
Whitby 1902
oil on canvas 63.5 x 76.2
TWCMS : C10603

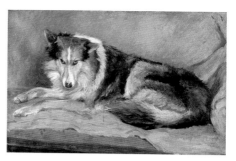

Charlton, William Henry 1846–1918
Collie Dog 1915
oil on canvas 70.7 x 106.7
TWCMS : G1305

Cina, Colin b.1943
MH/20 1971
acrylic on textile 243.8 x 243.8
TWCMS : B6696

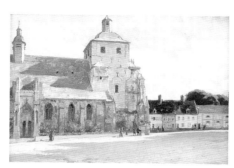

Clark, James 1858–1943
Church at Montreuil-sur-Mer after 1915
oil on panel 40.1 x 62
TWCMS : F9109

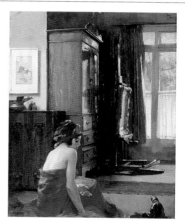

Clark, James 1858–1943
The Artist's Studio
oil on canvas 45.7 x 36
TWCMS : F9112

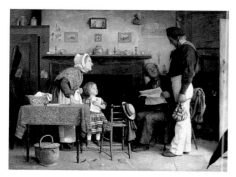

Clark, Joseph 1835–1913
The Return of the Runaway c.1862
oil on canvas 46 x 61.4
TWCMS : B8137

Clausen, George 1852–1944
Contemplation 1878
oil on canvas 41 x 30.7
TWCMS : B8125

Clausen, George 1852–1944
The Stone Pickers 1887
oil on canvas 107.6 x 79.2
TWCMS : B8126

Clausen, George 1852–1944
Dusk 1903
oil on canvas 62.2 x 73.7
TWCMS : C3904

Clay, Rachel b.1907
Beatrice Webb, née Potter (1858–1943)
oil on canvas 76.3 x 56.1
TWCMS : A17

Clennell, Luke 1781–1840
The Baggage Wagon c.1812
oil on canvas 63.5 x 76.7
TWCMS : B6670

Coessin de la Fosse, Charles-Alexandre
1829–c.1900
Threshing
oil on canvas 166.7 x 272.5
TWCMS : G4164

Cole, George 1808–1883
Landscape with Figures 1845
oil on canvas 60.5 x 106.4
TWCMS : G1332

Cole, George 1808–1883
Landscape
oil on canvas 45.8 x 61.1
TWCMS : C691

Cole, George Vicat 1833–1893
Landscape with Cottage and Figures 1858
oil on canvas 31.3 x 46.3
TWCMS : D1295

Cole, George Vicat 1833–1893
Landscape with Figure and Dog
oil on canvas 35.6 x 51.2
TWCMS : D1281

Cole, Leslie 1910–1976
*The Shaping of the Keel Plate of a
Corvette* 1942
oil on canvas 50.5 x 63.7
TWCMS : F3427

Facing page: Farthing, Stephen, b.1950, *Fish Dish* (detail), 1978, Sunderland Museum and Winter Gardens, (p. 287)

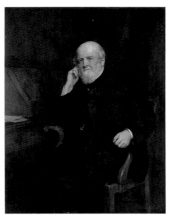

Colley, Andrew 1859–1910
Venetian Embroidery Makers c.1905
oil on canvas 99.1 x 148.5
TWCMS : G1517

Collier, John 1850–1934
Lady Laing (1831–1913) 1893
oil on canvas 142 x 111
TWCMS : T1734 (P)

Collier, John 1850–1934
Sir James Laing (1823–1901) 1893
oil on canvas 142 x 111
TWCMS : T1733 (P)

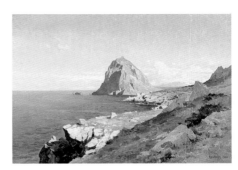

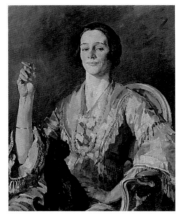

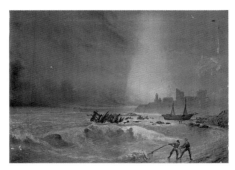

Compton, Edward Harrison 1881–1960
Cape Zafferano, Sicily 1927
oil on canvas 84.3 x 119.9
TWCMS : F9123

Connard, Philip 1875–1958
Fanny Fillipi Dowson
oil on canvas 92.2 x 71.6
TWCMS : G1940

Connell, William active 1871–1925
Seascape off Tynemouth 1871
oil on canvas 51 x 68.5
TWCMS : G3373

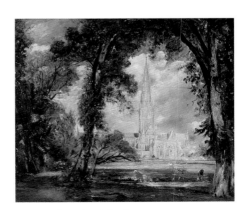

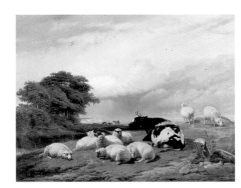

Constable, John (after) 1776–1837
Salisbury Cathedral from the Bishop's Grounds
19th C
oil on canvas 77.3 x 93.8
TWCMS : B8117

Cooper, Julian b.1947
Autumn 1973
oil on canvas 74 x 66
TWCMS : B657

Cooper, Thomas George 1836–1901
In the Marshes near Ramsgate, Isle of Thanet
1867
oil on canvas 71.3 x 91.5
TWCMS : F5176

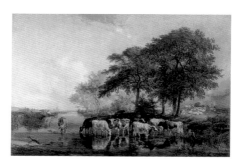

Cooper, Thomas Sidney 1803–1902
Canterbury from Tonford 1853
oil on canvas
TWCMS : G10310

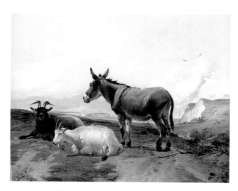

Cooper, Thomas Sidney 1803–1902
On the Downs 1863
oil on panel 35.2 x 45.8
TWCMS : B8132

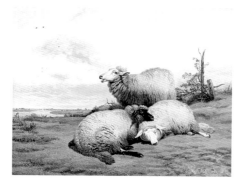

Cooper, Thomas Sidney 1803–1902
Midday Repose 1866
oil on panel 35.2 x 45.8
TWCMS : B8129

Cooper, Thomas Sidney (after) 1803–1902
Cattle and Sheep 1839
oil on canvas 75.6 x 54.9
TWCMS : C10044

Cooper, Thomas Sidney (after) 1803–1902
Landscape with Cattle in Marshland 19th C
oil on canvas 76.2 x 126.7
TWCMS : G1979

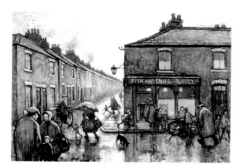

Cornish, Norman Stansfield b.1919
Wet Friday 1975
oil on board 69.5 x 97.5
TWCMS : A15

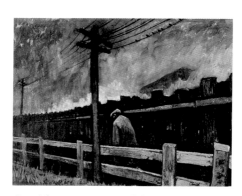

Cornish, Norman Stansfield b.1919
Pit Road
oil on board 90.9 x 119.2
TWCMS : G12960

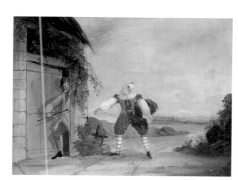

Corvan, Ned 1829–1865
Billy Purvis Stealing the Bundle
oil on canvas 46 x 61
TWCMS : B6382

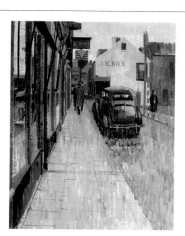

Coulter, Robert G. active 1953
Tubwell Row, Darlington
oil on canvas 76.3 x 61.4
TWCMS : G1303

Cowen, Lionel J. b.c.1847
Girl with a Letter
oil on canvas 66.4 x 35.5
TWCMS : F9146

Cox, David the elder 1783–1859
Pandy Mill 1843
oil on canvas 35.5 x 46.1
TWCMS : B8116

Craft, John 1815–1875
William Corbell (b.1808) 1836
oil on canvas 53 x 45.5
TWCMS : G12994

Crawhall, J. C. active late 19th C-early 20th C
Pony and Cart
oil on canvas 18.1 x 30.6
TWCMS : E5297

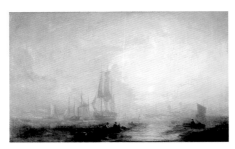

Crawhall, William b.c.1831
Mouth of the Tyne
oil on canvas 91.3 x 125.7
TWCMS : G3899

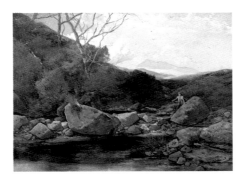

Creswick, Thomas 1811–1869
A Trout Stream
oil on canvas 45.8 x 62
TWCMS : B8118

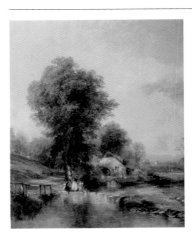

Creswick, Thomas 1811–1869
Landscape
oil on canvas 63.5 x 53.3
TWCMS : B8139

Crisp, John Harris 1914–1983
Oil on Board 1962
oil & sand on board 122 x 91.7
TWCMS : G2344

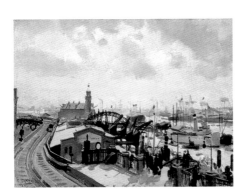

Cundall, Charles Ernest 1890–1971
Hamburg Docks
oil on panel 26.3 x 35.1
TWCMS : C10035

Currie, Ken b.1960
Shot Boy (First Revision) 1996–1998
oil on canvas 185 x 154
TWCMS : 1999.1292 (P)

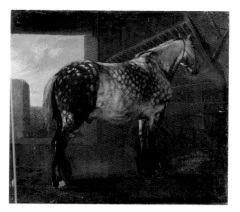

Cuyp, Aelbert (after) 1620–1691
A Dapple Grey Horse
oil on canvas 45.7 x 50.7
TWCMS : G3858

Dadd, Frank 1851–1929
Follow the Drum 1914
oil on canvas 76.5 x 153.3
TWCMS : G1513

Dalby, David (attributed to) 1794–1836
*Bartholomew Kent in Racing Colours after
Running the Irish Curragh* 1824
oil on canvas 58 x 76
TWCMS : F13610

Dalby, David (attributed to) 1794–1836
*John Hall Kent in Hunting Attire Seated on a
Horse* 1825
oil on canvas 56.7 x 85.6
TWCMS : F13606

Dalziel, James B. active 1848–1908
Figures in Woodland 1872
oil on canvas 76.5 x 63.8
TWCMS : G550

Dalziel, James B. active 1848–1908
River Scene 1872
oil on canvas 61.2 x 51
TWCMS : G5669

Dalziel, James B. active 1848–1908
Figures in Woodland 1874
oil on panel 23.8 x 32.5
TWCMS : F5192

Dalziel, James B. active 1848–1908
Rocks and Trees with Stream 1874
oil on canvas 46.3 x 35.6
TWCMS : F5193

Dalziel, James B. active 1848–1908
Shipping Offshore 1876
oil on board 37.3 x 44.6
TWCMS : F9139

Dalziel, James B. active 1848–1908
Woody Landscape 1901
oil on canvas 50.8 x 40.9
TWCMS : C697

Dalziel, James B. active 1848–1908
Coniston, Cumbria
oil on canvas 50.9 x 76.5
TWCMS : F5186

Dalziel, James B. active 1848–1908
River Scene with Rocks and Trees
oil on board 19.5 x 27.6
TWCMS : E3538

Daniell, William 1769–1837
*View of Newcastle upon Tyne, Taken from a
Windmill to the East of St Ann's* c.1802–1803
oil on canvas 95.3 x 186
TWCMS : 2005.3459

Davie, Alan b.1920
Holy Man's Garden I 1962
oil on canvas 122 x 152.5
TWCMS : B7409

Dawson, Byron Eric 1896–1968
Dawn 1927
oil on canvas 78.8 x 184.9
TWCMS : H978

Dawson, Byron Eric 1896–1968
*John Baliol, King of Scotland, Doing Homage
to King Edward I in the Great Hall of the
Castle, Newcastle upon Tyne, 1292* c.1929
oil on canvas 244.5 x 808.5
TWCMS : G4637

Dawson, Byron Eric 1896–1968
Caravans, Figures and Helter-Skelter 1930
oil on canvas 51.4 x 62.1
TWCMS : B6378

Dawson, Byron Eric 1896–1968
Newcastle in the Reign of Elizabeth I c.1956
oil on canvas 203.5 x 427
TWCMS : G4761

Dawson, Henry 1811–1878
Mansfield Forest, Noon
oil on canvas 128 x 173.5
TWCMS : G4160

Dawson, Henry (attributed to) 1811–1878
Boy with Calves and a Trough
oil on panel 17.9 x 22.7
TWCMS : C13250

Dawson, Montague J. 1895–1973
The 'Young Australian' c.1935–1950
oil on canvas 71.3 x 106.5
TWCMS : F9121

Day, W. H. active 19th C
River Landscape with Figures
oil on canvas 51.4 x 40.7
TWCMS : G12996

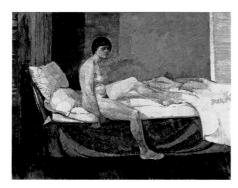

de Grey, Roger 1918–1995
Seated Figure
oil on canvas 71.2 x 91.5
TWCMS : F5178

Dean, Catherine 1905–1983
Flower Study 1941
oil on canvas 91.4 x 71.2
TWCMS : F13638

Dees, John Arthur 1876–1959
Upland Farm, Middleton 1941
oil on canvas 50.6 x 61.1
TWCMS : G3371

Delpy, Hippolyte-Camille 1842–1910
The Potato Harvest
oil on canvas 199.2 x 342.3
TWCMS : G4633

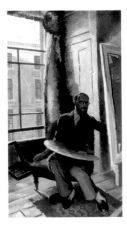

Dicker, Charles George Hamilton
1896–1977
Artist Painting c.1930
oil on canvas 91.5 x 49.7
TWCMS : C9994

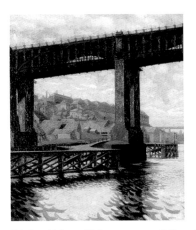

Dickey, Edward Montgomery O'Rourke
1894–1977
Robert Stephenson's Bridge (The High Level Bridge) c.1927
oil on canvas 65.6 x 56.5
TWCMS : B7406

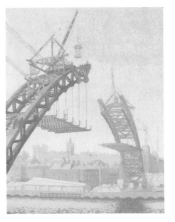

Dickey, Edward Montgomery O'Rourke
1894–1977
The Building of the Tyne Bridge 1928
oil on canvas 101.7 x 76.2
TWCMS : C10604

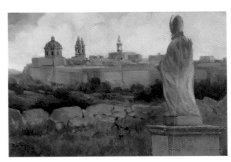

Dingli, B. R. (attributed to)
Città Vecchia
oil on board 30.6 x 44.3
TWCMS : C13509

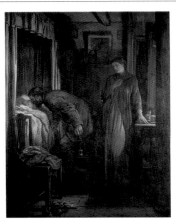

Dixon, Alfred 1842–1919
'Get Up!' The Caller Calls 'Get Up!' c.1884
oil on canvas 183.3 x 141.9
TWCMS : G3308

Dixon, William (attributed to) d.1830
John Martin (1789–1856) c.1816–1820
oil on panel 25 x 19.9
TWCMS : C3943

Dixon, William (attributed to) d.1830
John Dobson (1787–1865) c.1820
oil on board 43.8 x 32
TWCMS : F13737

Dixon, William (attributed to) d.1830
John Dobson (1787–1865) c.1822–1828
oil on board 18.4 x 14.9
TWCMS : C13481

Dixon, William (attributed to) d.1830
John Dobson (1787–1865)
oil on board 33.3 x 25.5
TWCMS : C10615

Dobson, Edward Scott 1918–1986
Composition with Red Sphere 1961
oil on canvas 50.5 x 76.2
TWCMS : F9144

Dollman, John Charles 1851–1934
The Village Artist 1899
oil on canvas 60.9 x 50.7
TWCMS : C10605

Dollman, John Charles 1851–1934
Study for 'The Unknown' 1912
oil on canvas 45.5 x 76.5
TWCMS : C604

**Dommerson, William Raymond
(attributed to)** 1850–1927
Italian Coast Scene
oil on canvas 39.5 x 64.3
TWCMS : C10627

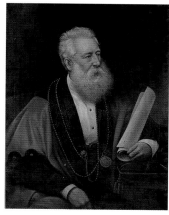

Douglass, John
Richard Cail c.1873
oil on canvas 112.3 x 86.9
TWCMS : G4195

Dring, William D. 1904–1990
Dr Wilfred Hall, MA, DSc, FRCS
oil on canvas 64 x 76.1
TWCMS : E5278 ✾

Drummond, Malcolm 1880–1945
19, Fitzroy Street (Walter Richard Sickert's
studio) 1912–1914
oil on canvas 71 x 50.8
TWCMS : B670

Duffy, Louis active c.1935–1950
Aftermath 1941
oil on canvas 71.1 x 60.7
TWCMS : F3457

Dunlop, Ronald Ossory 1894–1973
*Harbour and Customs House, Dún Laoghaire,
Ireland* c.1930–1939
oil on canvas 76.1 x 101.7
TWCMS : F3498

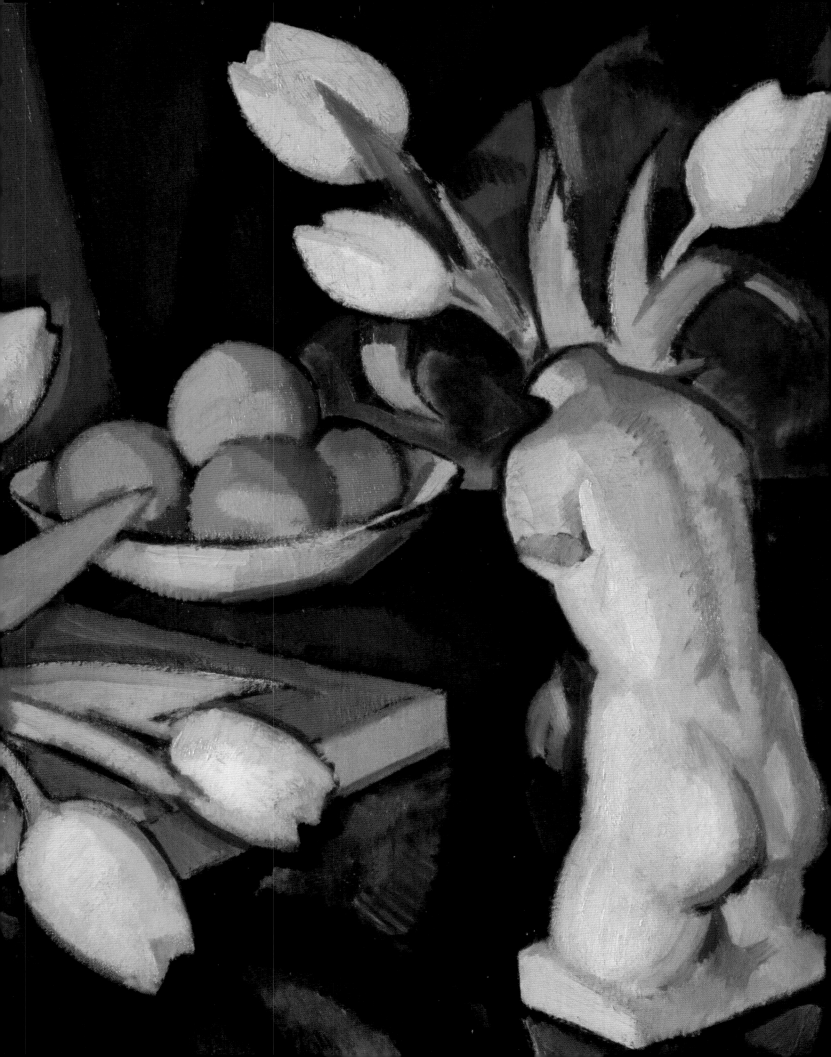

Dunlop, Ronald Ossory 1894–1973
Figure Study
oil & watercolour on paper 58.8 x 46
TWCMS : G470

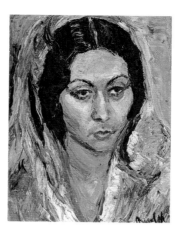

Dunlop, Ronald Ossory 1894–1973
Lalita
oil on canvas 40.4 x 30.6
TWCMS : F9115

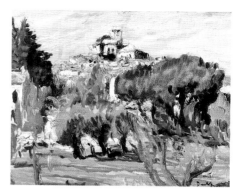

Dunlop, Ronald Ossory 1894–1973
South of France
oil on board 27 x 35
TWCMS : F4615

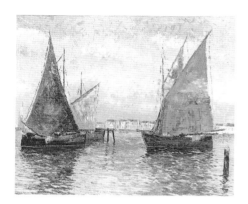

Duval active 20th C
Sailing Boats
oil on canvas 51 x 61
TWCMS : C688

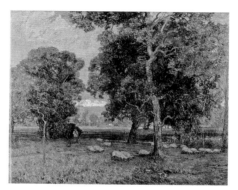

East, Alfred 1849–1913
A Gleam before the Storm c.1900
oil on canvas 122 x 151.7
TWCMS : G3897

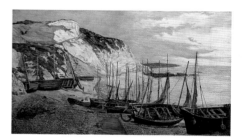

Edwards, Edwin 1823–1879
Beer Head, South Devon c.1879
oil on canvas 108 x 183.5
TWCMS : G4152

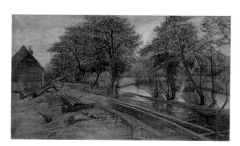

Edwards, Edwin 1823–1879
A Timberyard on the Wey, Guildford
oil on canvas 112.7 x 190
TWCMS : G4156

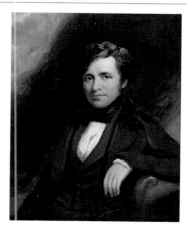

Ellerby, Thomas active 1821–1857
John Wilson Carmichael (1799–1868) 1839
oil on panel 25.7 x 20.2
TWCMS : D3461

Elliott, Robinson 1814–1894
The Two Misses Kent
oil on canvas 76.3 x 63.6
TWCMS : C10618

Facing page: Peploe, Samuel John, 1871–1935, *Yellow Tulips and Statuette* (detail), c.1912–1927, Laing Art Gallery, (p. 194)

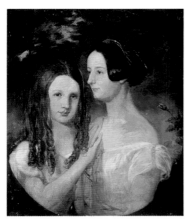

Elliott, Robinson 1814–1894
The Two Misses Preston
oil on canvas 61.3 x 51.2
TWCMS : G4199

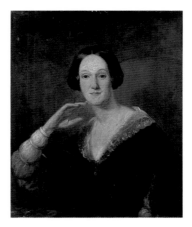

Elliott, Robinson (attributed to) 1814–1894
The Wife of John Hall Kent
oil on canvas 76.1 x 63.8
TWCMS : F13642

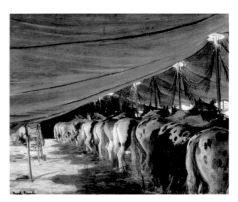

Elwell, Frederick William 1870–1958
Sanger's Ring Horses
oil on canvas 51 x 61.3
TWCMS : B6379

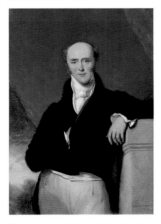

Emmerson, Henry Hetherington
1831–1895
*The Right Honourable Earl Grey (1764–1845),
KG* 1848
oil on board 33.7 x 23.5
TWCMS : G4787

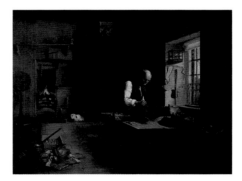

Emmerson, Henry Hetherington
1831–1895
The Village Tailor c.1851
oil on canvas 53.6 x 70.1
TWCMS : B6663

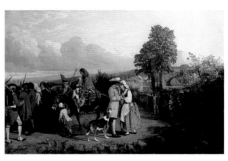

Emmerson, Henry Hetherington
1831–1895
Evangeline 1857
oil on canvas 106.7 x 158
TWCMS : B8144

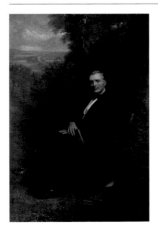

Emmerson, Henry Hetherington
1831–1895
John Mawson 1868
oil on canvas 225.9 x 150.3
TWCMS : G4168

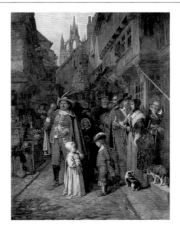

Emmerson, Henry Hetherington
1831–1895
The Lost Child c.1870
oil on canvas 183.5 x 137.6
TWCMS : G4647

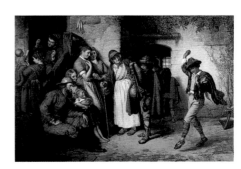

Emmerson, Henry Hetherington
1831–1895
A Foreign Invasion c.1871
oil on canvas 117.7 x 172.7
TWCMS : G3888

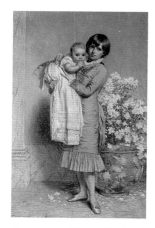

Emmerson, Henry Hetherington
1831–1895
Our Baby 1882
oil on canvas 116.9 x 76.4
TWCMS : G4192

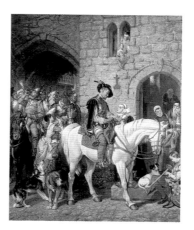

Emmerson, Henry Hetherington
1831–1895
Johnny Armstrong (d.1530) 1886
oil on canvas 206 x 168.7
TWCMS : G10305

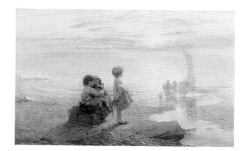

Emmerson, Henry Hetherington
1831–1895
Early Morning off the Coast 1888
oil on canvas 32.8 x 51
TWCMS : F13738

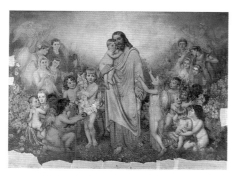

Emmerson, Henry Hetherington
1831–1895
God's Nursery 1894
oil on canvas 212.7 x 292
TWCMS : G4644

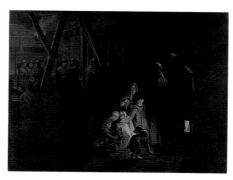

Emmerson, Henry Hetherington
1831–1895
Hartley Pit Disaster
oil on canvas 101.6 x 134.6
TWCMS : 1994.659

Engelbach, Florence 1872–1951
Old Woman Knitting c.1910
oil on canvas 75.3 x 64.9
TWCMS : F3487

Engelbach, Florence 1872–1951
Gladioli c.1933
oil on canvas 65.2 x 54.4
TWCMS : F3486

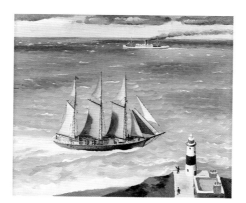

Eurich, Richard Ernst 1903–1992
Round the Point 1931
oil on canvas 50.8 x 60.7
TWCMS : G4616

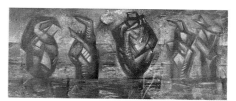

Evans, Merlyn Oliver 1910–1973
Prehistoric Landscape 1945
oil on canvas 31.7 x 75.7
TWCMS : G538

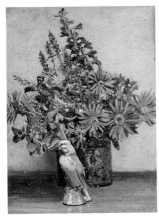

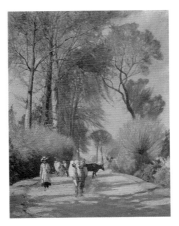

Everett, John 1876–1949
A Scheme in Blue
oil on board 36.3 x 27.2
TWCMS : F9134

Everett, John 1876–1949
Country Lane with Figure and Cows
oil on board 57.3 x 43
TWCMS : G2834

Everett, John 1876–1949
River Scene with Fisherman
oil on canvas 55.9 x 86.8
TWCMS : G537

Everett, John 1876–1949
Still Life (Spotted Dog)
oil on board 36.2 x 27.2
TWCMS : F9135

Everett, John 1876–1949
Tree Study
oil on canvas 50.9 x 35.4
TWCMS : G544

Ewbank, John Wilson c.1799–1847
North Shields 1825
oil on canvas 23 x 33.4
TWCMS : F3420

Ewbank, John Wilson c.1799–1847
Edinburgh from Ratho c.1829
oil on canvas 25.5 x 39.3
TWCMS : C13484

Ewbank, John Wilson (attributed to)
c.1799–1847
Coast Scene
oil & pencil on board 29 x 47.2
TWCMS : F4639

Ewbank, John Wilson (attributed to)
c.1799–1847
Coast Scene, Cullercoats, Northumberland
oil & pencil on card 28.5 x 47
TWCMS : F5196

Faed, Thomas 1826–1900
The Orange Seller
oil on canvas 46 x 35.4
TWCMS : C664

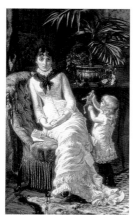

Farasyn, Edgard 1858–1938
Sad News c.1880–1883
oil on canvas 119.9 x 73.4
TWCMS : G1749

Farmer, Alexander (Mrs) active 1855–1867
Still Life
oil on canvas 28 x 38.2
TWCMS : C13492

Fell, Sheila Mary 1931–1979
Planting Potatoes III 1967
oil on canvas 86.5 x 112
TWCMS : G3893

Fell, Sheila Mary 1931–1979
High Tide
oil on canvas 35.7 x 45.6
TWCMS : H975

Fennell, John Grenville 1807–1885
Loch Arrochar
oil on canvas 58.6 x 76.3
TWCMS : F3492

Ferrari, Gregorio de' 1644–1726
The Flight into Egypt c.1680–1700
oil on canvas 164.6 x 208.7
TWCMS : G4767

Fisher, Mark 1841–1923
The Farm Pond
oil on canvas 39 x 53.6
TWCMS : E5251

Fletcher, Edwin 1857–1945
Seascape
oil on canvas 60.7 x 91.1
TWCMS : G2599

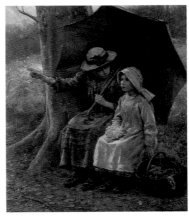

Fletcher, William Teulon Blandford
1858–1936
A Bow in the Clouds
oil on canvas 82.1 x 71.3
TWCMS : G1329

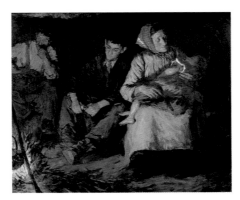

Forbes, Stanhope Alexander 1857–1947
Round the Camp Fire 1903
oil on canvas 76.2 x 92.2
TWCMS : F5160 🐝

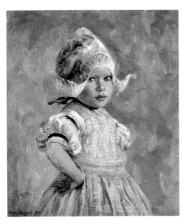

Fowler, Beryl 1881–1963
A Maid of Volendam 1911
oil on canvas 60.9 x 50.7
TWCMS : F13611

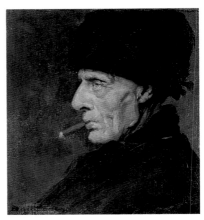

Fowler, Beryl 1881–1963
A Volendam Fisherman 1911
oil on canvas 30.4 x 28.5
TWCMS : G2821

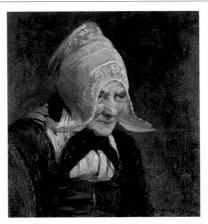

Fowler, Beryl 1881–1963
Old Woman 1911
oil on canvas 30.7 x 28.5
TWCMS : F9133

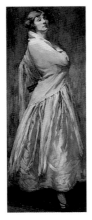

Fowler, Beryl 1881–1963
The White Shawl 1925
oil on board 176.6 x 67
TWCMS : G4178

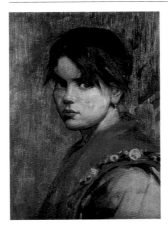

Fowler, Beryl 1881–1963
Annunciate
oil on canvas 45.8 x 36
TWCMS : F9136

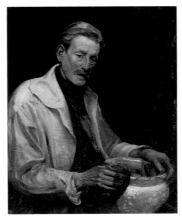

Fowler, Robert 1853–1926
The Connoisseur
oil on canvas 91.6 x 71.5
TWCMS : G1324

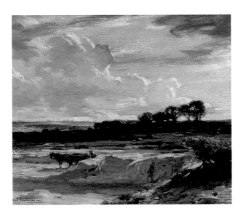

Friedenson, Arthur A. 1872–1955
A Sand Pit 1917
oil on panel 32.8 x 39.1
TWCMS : C13470

Frost, Terry 1915–2003
Red and Black Plus 3 1962
oil on canvas 254 x 152.4
TWCMS : B6697

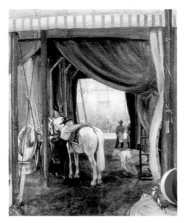

Fullerton, J. G. active 1929–1947
Saddling a Circus Horse 1935
oil on board 31.7 x 25.4
TWCMS : B6380

Fullerton, J. G. active 1929–1947
Circus Ponies in Stalls 1947
oil on canvas 25.4 x 30.4
TWCMS : B6381

Gainsborough, Thomas 1727–1788
Peasant Ploughing with Two Horses
1750–1753
oil on canvas 49.1 x 59.1 (E)
TWCMS : H7616

Garvie, Thomas Bowman 1859–1944
By the Waters of Babylon 1887
oil on canvas 102.5 x 127.8
TWCMS : C3929

Garvie, Thomas Bowman 1859–1944
The Parish Clerk of Lyndon 1891
oil on canvas 45.8 x 41
TWCMS : F4634

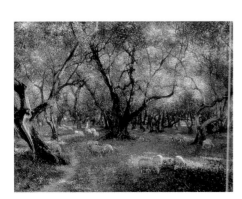

Garvie, Thomas Bowman 1859–1944
Olives of St Rocco 1911
oil on canvas 86.5 x 111.7
TWCMS : G1998

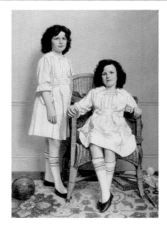

Garvie, Thomas Bowman 1859–1944
*The Twins (Winifred and Leonora Reid,
b.1911)* 1920
oil on canvas 124.5 x 86.4
TWCMS : G2347

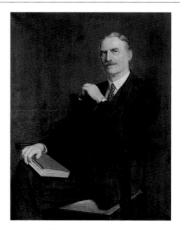

Garvie, Thomas Bowman 1859–1944
Henry Bell Saint 1925
oil on canvas 116.9 x 91.4
TWCMS : G1747

Garvie, Thomas Bowman 1859–1944
Alderman George Bargate Bainbridge, JP 1927
oil on canvas 122.6 x 91.8
TWCMS : G4607

Garvie, Thomas Bowman 1859–1944
An October Flood, Ludlow, Shropshire 1930
oil on canvas 41.1 x 61.4
TWCMS : F4626

Gates, Sebastian active 1904–1937
Spoils of the Orchard
oil on canvas 20.6 x 40.2
TWCMS : G2825

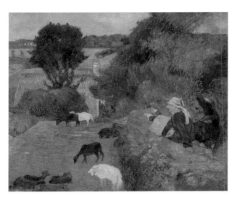

Gauguin, Paul 1848–1903
The Breton Shepherdess 1886
oil on canvas 60.4 x 73.3
TWCMS : C643

Gauld, John Richardson 1885–1961
Resting Model
oil on canvas 111.4 x 91.2
TWCMS : G1740

Gear, William 1915–1997
Autumn Landscape 1950
oil on canvas 183.2 x 127
TWCMS : C10622

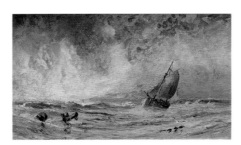

Gear, William 1915–1997
Composition printanier 1950
oil on canvas 103.2 x 90.5
TWCMS : G1343

George, Charles 1872–1937
Seascape with Ship
oil on panel 16.2 x 27.1
TWCMS : E5299

Gertler, Mark 1892–1939
Thomas Balston (1883–1967) 1934
oil on panel 37.5 x 29.9
TWCMS : C9997

Facing page: Watson, George (attributed to), 1767–1837, *The Three Brothers, the Sons of Thomas Dallas* (detail),
Shipley Art Gallery, (p. 96)

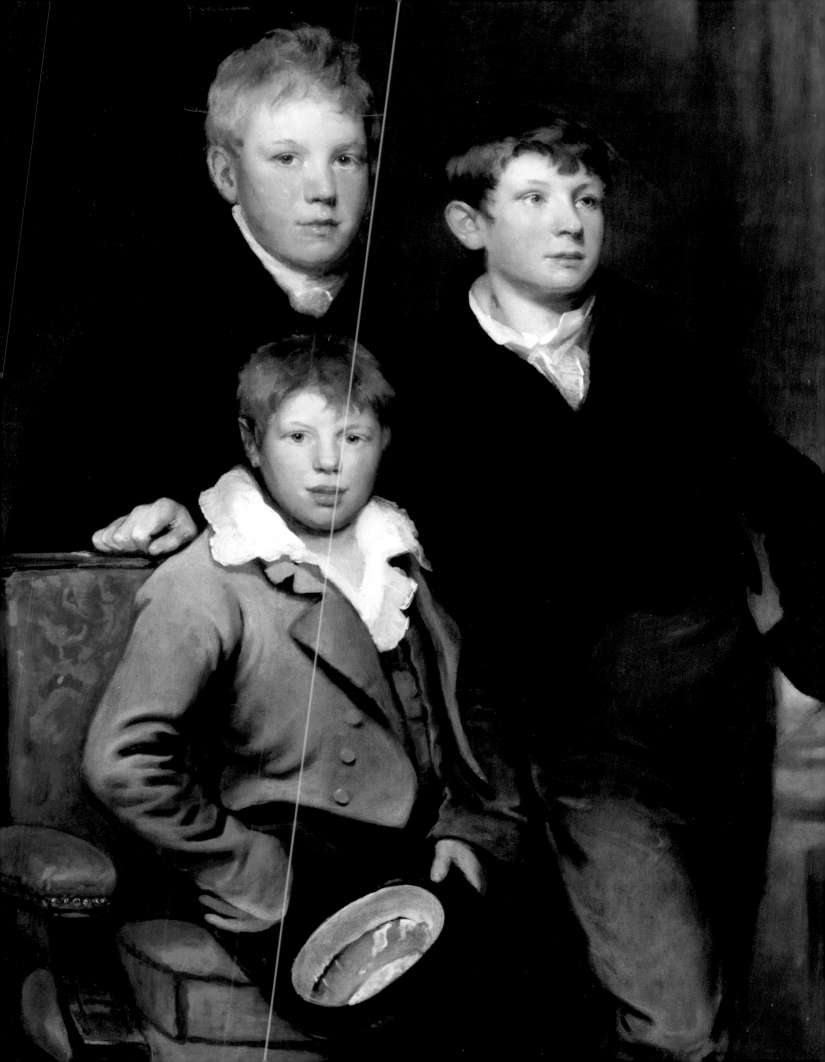

Gibb, Thomas Henry 1833–1893
Summertime on the Cheviots 1884
oil on canvas 46.5 x 61.8
TWCMS : G3374

Gibb, Thomas Henry 1833–1893
Highland Loch with Stag 1886
oil on canvas 116.2 x 178.3
TWCMS : G3853

Gibb, Thomas Henry 1833–1893
On Tarras Moss 1891
oil on canvas 60.9 x 91.5
TWCMS : G1318

Gillie, Ann 1906–1995
The Riverside 1959
oil on board 76 x 114.5
TWCMS : F5159

Gillie, Ann 1906–1995
Icelandic Theme c.1963
oil on board 45.5 x 91.4
TWCMS : C669

Gillie, Ann 1906–1995
Seawrack 1972
oil on textile 22
TWCMS : 1994.101

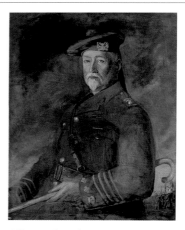

Gillies, William George 1898–1973
Still Life with Yellow Flowers
oil on canvas 75.2 x 93
TWCMS : G528

Gilmour, Elaine 1931–1990
Shrubs c.1960
oil on canvas 46.6 x 31.1
TWCMS : F9142

Gilroy, John Thomas Young 1898–1985
Sir T. Oliver, Tyneside Scottish
oil on canvas 91.5 x 71.2
TWCMS : G3859

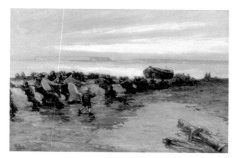

Gilroy, John William 1868–1944
*Hauling up the Lifeboat, Holy Island,
Northumberland* c.1910–1920
oil on canvas 60.9 x 91.2
TWCMS : G2596

Gleghorn, Thomas b.1925
Home Town 1961
oil on board 122 x 177.9
TWCMS : G12964

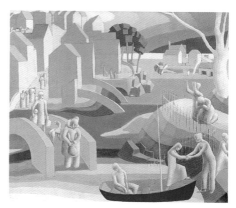

Glover, Flora A. P.
The Flood c.1941
oil & pencil on panel 39.5 x 44.4
TWCMS : F5197

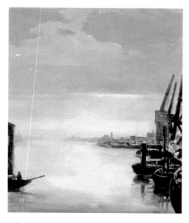

Glover, Kenneth M. 1887–1966
On the Tyne c.1927
oil on canvas 40.7 x 36
TWCMS : C13466

Goede, Jules de 1937–2007
Outer Space 1969
oil on canvas 126.9 x 126.9
TWCMS : G2346

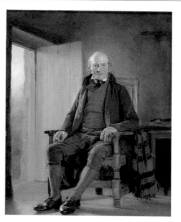

Good, Thomas Sword 1789–1872
A Northumbrian Farmer c.1820–1834
oil on panel 39.3 x 31.7
TWCMS : B6693

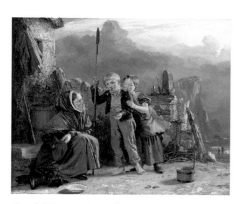

Good, Thomas Sword 1789–1872
The Expected Penny c.1820–1840
oil on panel 37.7 x 45.9
TWCMS : B6657

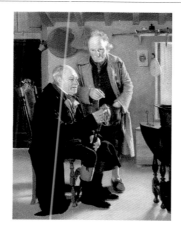

Good, Thomas Sword 1789–1872
Examining the Sword 1822
oil on panel 33.3 x 27.3
TWCMS : B6672

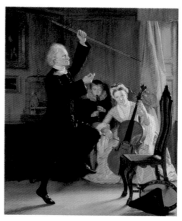

Good, Thomas Sword 1789–1872
The Power of Music 1823
oil on panel 40.5 x 33.1
TWCMS : B6671

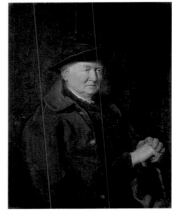

Good, Thomas Sword 1789–1872
Portrait of an Old Man
oil on canvas 91.6 x 71.2
TWCMS : G12982

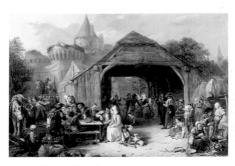

Goodall, Frederick 1822–1904
Merrymaking 1841
oil on canvas 87.3 x 128.3
TWCMS : G1512

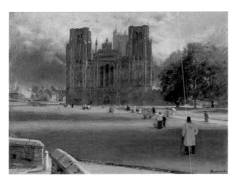

Goodwin, Albert 1845–1932
Wells Cathedral 1889
oil on board 26.7 x 34.7
TWCMS : C13508

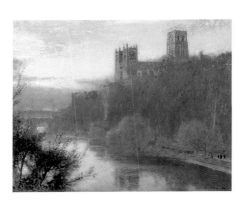

Goodwin, Albert 1845–1932
Durham Cathedral 1910
oil on canvas 88.2 x 109.9
TWCMS : G501

Gosse, Laura Sylvia 1881–1968
Dieppe, la Place Nationale before 1935
oil on canvas 71.4 x 30.5
TWCMS : C623

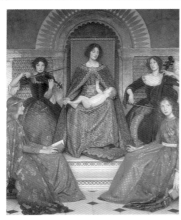

Gotch, Thomas Cooper 1854–1931
Holy Motherhood c.1902
oil & gold leaf on canvas 184.4 x 153.7
TWCMS : B682

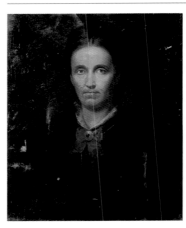

Gow, Andrew Carrick 1848–1920
Mrs William Glover
oil on canvas 60.7 x 51
TWCMS : G3860

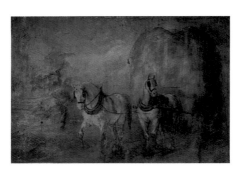

Gow, Andrew Carrick 1848–1920
The Haycart
oil on board 25.7 x 39
TWCMS : C10649b

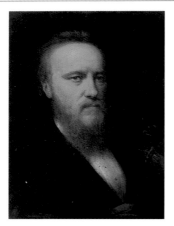

Gow, Andrew Carrick 1848–1920
William Glover
oil on canvas 51.1 x 41.5
TWCMS : G3370

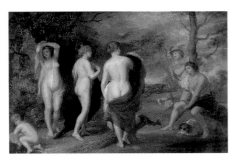

Gow, Andrew Carrick (after) 1848–1920
The Judgement of Paris (after Peter Paul
Rubens)
oil on board 25.7 x 39
TWCMS : C10649a

Gowing, Lawrence 1918–1991
Briar and Hawthorn at Savernake 1952
oil on canvas 51.1 x 66
TWCMS : F5190

Graham, Anthony 1828–1908
Landscape with Sheep
oil on canvas 61.3 x 91.2
TWCMS : F5167

Graham, Peter 1836–1921
Landscape with Cattle 1893
oil on canvas 158.8 x 224.3
TWCMS : G4176

Grant, Duncan 1885–1978
The Hammock 1921–1923
oil on canvas 81.7 x 146.5
TWCMS : C10606

Grant, Duncan 1885–1978
Provençal Landscape 1929
oil on canvas 72.7 x 91.5
TWCMS : A16

Grant, Duncan 1885–1978
Roses in a Vase
oil on canvas 50.6 x 44.6
TWCMS : H974

Gray, George 1758–1819
Thomas Bewick (1753–1828) c.1780
oil on card 57 x 45.9
TWCMS : C10614

Gray, George 1758–1819
Study of Fruit c.1794–1811
oil on canvas 47.7 x 61.2
TWCMS : C681

Gray, George 1758–1819
Study of Fruit with Squirrel c.1794–1811
oil on canvas 37.8 x 45.3
TWCMS : C680

Greaves, Walter (attributed to) 1846–1930
Strand
oil on panel 35.2 x 25
TWCMS : F9113

Greenberg, Mabel 1889–1933
Helen before 1931
oil & pencil on canvas 50.7 x 40.7
TWCMS : C10613

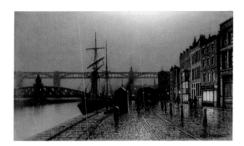

Grimshaw, Arthur E. 1868–1913
The Quayside, Newcastle upon Tyne 1895
oil on canvas 28.6 x 46.1
TWCMS : B8140

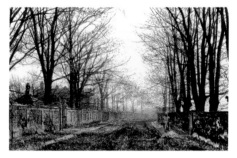

Grimshaw, John Atkinson 1836–1893
Under the Beeches 1892
oil on canvas 30.5 x 45.8
TWCMS : C10650

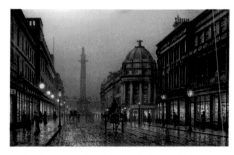

Grimshaw, Louis Hubbard 1870–1944
Grainger Street, Newcastle upon Tyne 1902
oil on board 28.7 x 43.8
TWCMS : G471

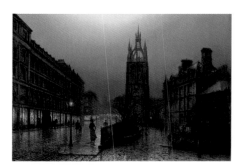

Grimshaw, Louis Hubbard 1870–1944
St Nicholas Street, Newcastle upon Tyne 1902
oil on board 29.1 x 42.6
TWCMS : G472

Grundy, Cuthbert Cartwright 1846–1946
Plas Mawr, Conwy, North Wales 1917
oil on canvas 61.4 x 92.5
TWCMS : G1331

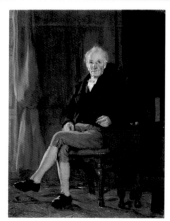

Guthrie, James 1859–1930
Thomas Bewick (1753–1828) (after Thomas
Sword Good) 1884
oil on canvas 40.9 x 30.3
TWCMS : C10036

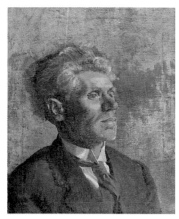

Gwynne-Jones, Allan 1892–1982
The Unshaved Man 1922–1923
oil on canvas 46 x 35.8
TWCMS : C9993

Hacking, Helen active late 20th C
The Director
oil on board 34.2 x 33.7
TWCMS : M4089

Haddock, Aldridge 1931–1996
Merces 1967
oil on board 91.5 x 122
TWCMS : G1511

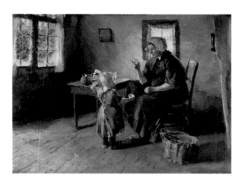

Hage, Matthijs 1882–1961
Mother's Darling
oil on canvas 59.2 x 80
TWCMS : F13739

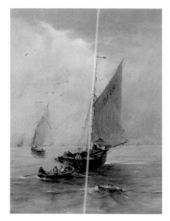

Hair, Thomas H. 1810–1882
Ship 'Mary'
oil on canvas 30.5 x 22.9
TWCMS : F3418

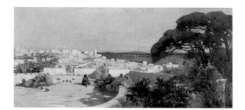

Haité, George Charles 1855–1919/1924
The City of Tangier
oil on canvas 45.8 x 97.7
TWCMS : G10302

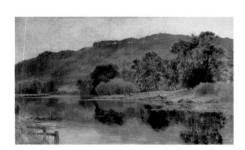

Halfnight, Richard William 1855–1925
River Landscape
oil on canvas 76.5 x 127.7
TWCMS : G3890

Hall, Frederick 1860–1948
The Duck Pond c.1903
oil on canvas 63.5 x 76.3
TWCMS : F5175

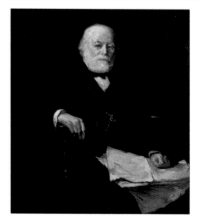

Hall, Frederick 1860–1948
Sir Lothian Bell (1816–1904)
oil on canvas 111.7 x 96.6
TWCMS : G4196

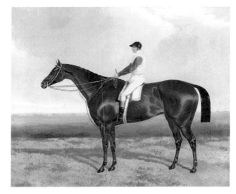

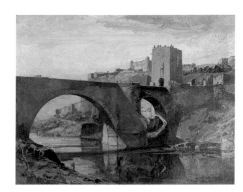

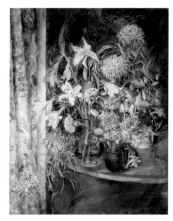

Hall, Harry (attributed to) 1814–1882
'Bee's Wing' c.1840–1845
oil on canvas 63.5 x 76.2
TWCMS : B8128

Hall, Oliver 1869–1957
Alcántara Bridge, Toledo, Spain c.1926
oil on canvas 102.2 x 127.5
TWCMS : G1997

Hamer, Cheryl b.1952
La Belle 1989
oil on canvas 122.1 x 91.3
TWCMS : P577

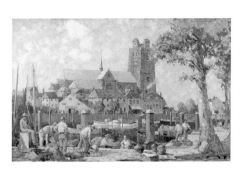

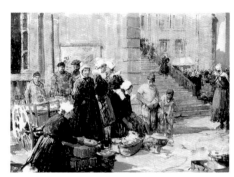

Hankey, William Lee 1869–1952
Dordrecht, Holland 1934
oil on canvas 72.5 x 113
TWCMS : F5170

Hankey, William Lee 1869–1952
Butter Market, Concarneau c.1939
oil on canvas 54.4 x 72.5
TWCMS : F5179

Hardie, Charles Martin 1858–1916
Touchstone and Audrey 1890
oil on canvas 46.2 x 31
TWCMS : F4635

Hardy, Heywood 1843–1933
Squire and Daughter
oil on canvas 61.2 x 85.1
TWCMS : G10303

Hardy, Thomas Bush 1842–1897
Towing Boats out of Calais 1878
oil on canvas 51.4 x 82
TWCMS : G1339

Hart, Solomon Alexander 1806–1881
Athaliah's Dismay at the Coronation of Joash
c.1858
oil on canvas 167.2 x 272.5
TWCMS : B8141

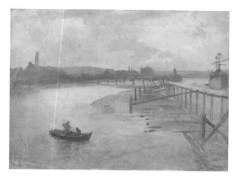

Hatton, Richard George 1865–1926
Jarrow Slake
oil on canvas 30.3 x 40.5
TWCMS : F3403

Haughton, Benjamin 1865–1924
Landscape with Haystacks
oil on panel 30.6 x 39.8
TWCMS : F4620

Haughton, Moses the elder 1734–1804
Fish 1802
oil on panel 48.2 x 60.8
TWCMS : C13471

Hawthorne, Elwin 1905–1954
At the Edge of Epping, Essex 1929
oil on canvas 36.2 x 46.3
TWCMS : D1251

Haydon, Benjamin Robert 1786–1846
Shall I Resign? 1832
oil on canvas 75.3 x 63.2
TWCMS : G549

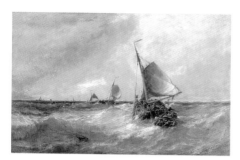

Hayes, Edwin 1819–1904
Dutch Pinks 1876
oil on canvas 102.5 x 153.2
TWCMS : G2595

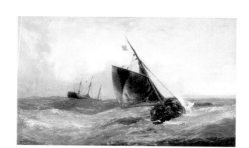

Hayes, Edwin 1819–1904
Rough Passage 1879
oil on canvas 76.9 x 129.3
TWCMS : G1505

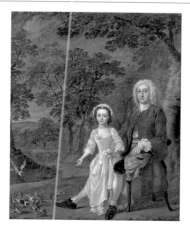

Hayman, Francis c.1708–1776
*William Ellis (1707–1771), and His Daughter
Elizabeth (1740–1795)* c.1745
oil on canvas 76.5 x 64
TWCMS : C3941

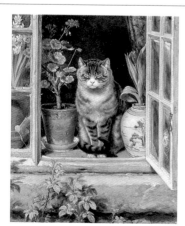

Hedley, Ralph 1848–1913
Blinking in the Sun 1881
oil on canvas 53 x 42.9
TWCMS : B6682

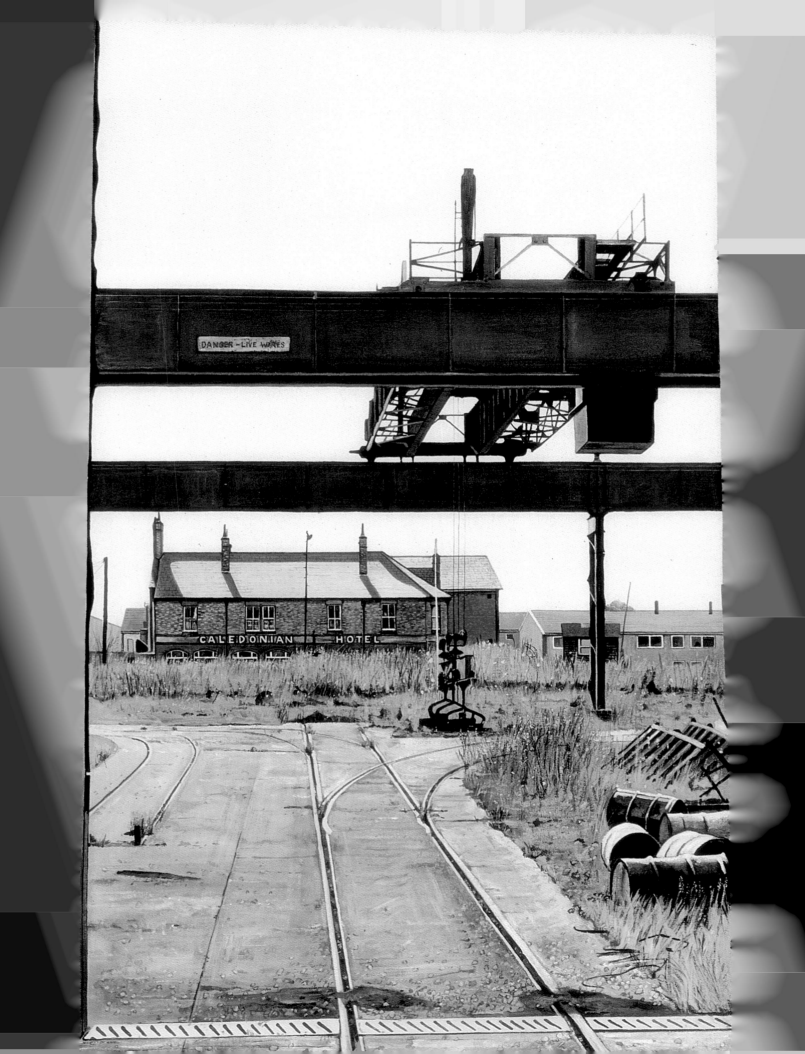

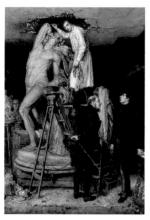

Hedley, Ralph 1848–1913
John Graham Lough in His Studio 1881
oil on canvas 89 x 60.5
TWCMS : N2302

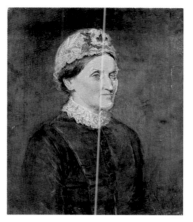

Hedley, Ralph 1848–1913
Portrait of an Old Woman 1881
oil on canvas 61.3 x 50.8
TWCMS : C10617

Hedley, Ralph 1848–1913
*Proclaiming Stagshaw Fair at Corbridge,
Northumberland* 1882
oil on canvas 67.2 x 94.5
TWCMS : B6656

Hedley, Ralph 1848–1913
In School 1883
oil on canvas 51 x 41
TWCMS : G4779

Hedley, Ralph 1848–1913
The Ballad Seller, the Black Gate 1884
oil on canvas 94.8 x 67.4
TWCMS : B6665

Hedley, Ralph 1848–1913
Last in Market 1885
oil on canvas 123.2 x 86.3
TWCMS : B6686

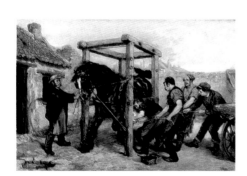

Hedley, Ralph 1848–1913
Shoeing the Bay Mare c.1885–1890
oil on canvas 66 x 94
TWCMS : B8149

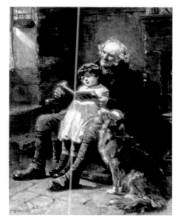

Hedley, Ralph 1848–1913
A. B. C. 1887
oil on canvas 127 x 101.8
TWCMS : G2338

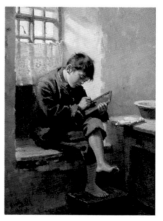

Hedley, Ralph 1848–1913
Home Lessons 1887
oil on canvas 38.2 x 28.2
TWCMS : G4776

Facing page: Burns, Peter, *Empty Stockyard, Hawthorn Leslie's, Hebburn, South Tyneside* (detail), 1978,
Laing Art Gallery, (p. 117)

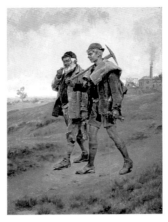

Hedley, Ralph 1848–1913
Going Home 1888
oil on canvas 76.5 x 55.9
TWCMS : K8097

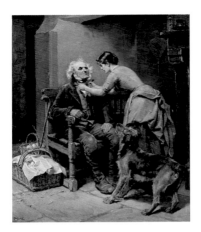

Hedley, Ralph 1848–1913
Preparing for Market 1888
oil on canvas 122.4 x 102.5
TWCMS : G2339

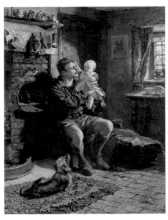

Hedley, Ralph 1848–1913
Geordie Haa'd the Bairn 1890
oil on canvas 77.5 x 62.7
TWCMS : H6478

Hedley, Ralph 1848–1913
Sketch for 'Seeking Sanctuary' 1890
oil on canvas 45.8 x 35.4
TWCMS : F9111

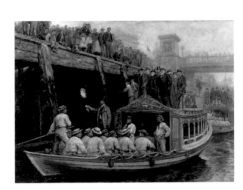

Hedley, Ralph 1848–1913
Barge Day 1891
oil on canvas 140.5 x 188.6 (E)
TWCMS : 2006.810

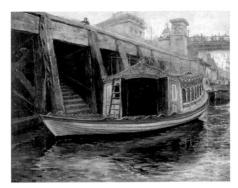

Hedley, Ralph 1848–1913
Sketch for 'The Lord Mayor's Barge' 1891
oil on canvas 42.3 x 52.3
TWCMS : C10612

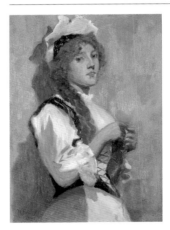

Hedley, Ralph 1848–1913
A Girl in Costume Knitting 1893
oil on panel 40 x 29.4
TWCMS : J3352

Hedley, Ralph 1848–1913
The Old Kitchen 1893
oil on canvas 35.8 x 46.4
TWCMS : C686

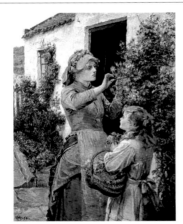

Hedley, Ralph 1848–1913
Roses for the Invalid 1894
oil on canvas 104.4 x 81.3
TWCMS : F9145

Hedley, Ralph 1848–1913
Henry Hetherington Emmerson (1831–1895)
1895
oil on canvas 45.6 x 35.3
TWCMS : B6689

Hedley, Ralph 1848–1913
Meal Time 1895
oil on canvas 35.7 x 45.5
TWCMS : G4780

Hedley, Ralph 1848–1913
Self Portrait 1895
oil on canvas 43.2 x 50.8
TWCMS : B6687

Hedley, Ralph 1848–1913
Barred Out (29 May) 1896
oil on canvas 102.9 x 85.7
TWCMS : G2336

Hedley, Ralph 1848–1913
Passing the Doctor 1896
oil on canvas 131.1 x 156.7
TWCMS : G2332

Hedley, Ralph 1848–1913
The Veteran 1896
oil on canvas 119.7 x 162
TWCMS : G1986

Hedley, Ralph 1848–1913
Woodsawyers 1896
oil on canvas 101.8 x 76.2
TWCMS : G2053

Hedley, Ralph 1848–1913
Blind Beggar 1897
oil on canvas 56.2 x 40.8
TWCMS : F4617

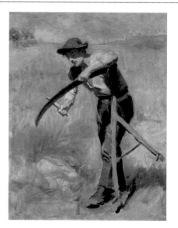

Hedley, Ralph 1848–1913
Sharpening the Scythe 1897
oil on canvas 68.7 x 50.8
TWCMS : F5157

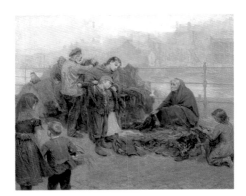

Hedley, Ralph 1848–1913
Paddy's Clothes Market, Sandgate 1898
oil on canvas 97.4 x 120.5
TWCMS : B6688

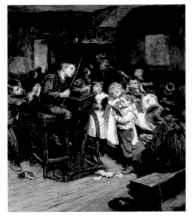

Hedley, Ralph 1848–1913
The Monitor 1898
oil on canvas 110.3 x 93.5
TWCMS : G1993

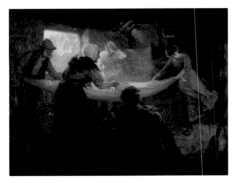

Hedley, Ralph 1848–1913
The Winnowing Sheet 1898
oil on canvas 121.6 x 161.7
TWCMS : G1748

Hedley, Ralph 1848–1913
The Threshing Floor c.1898
oil on canvas 121.3 x 161
TWCMS : B6655

Hedley, Ralph 1848–1913
Threshing the Gleanings 1899
oil on canvas 104.9 x 90.8
TWCMS : G2335

Hedley, Ralph 1848–1913
Alderman Sir H. W. Newton, JP 1901
oil on canvas 228.8 x 135.6
TWCMS : G4630

Hedley, Ralph 1848–1913
Elsie Wright 1902
oil on canvas 30.1 x 24
TWCMS : C10030

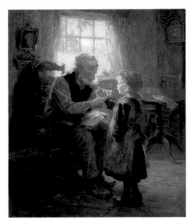

Hedley, Ralph 1848–1913
Mittens 1907
oil on canvas 76.3 x 63.6
TWCMS : F5188

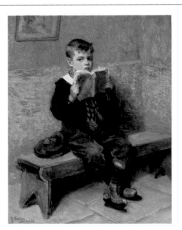

Hedley, Ralph 1848–1913
Kept In 1908
oil on panel 41 x 32.7
TWCMS : F9108

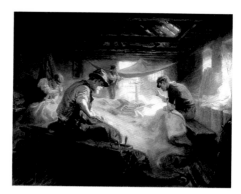

Hedley, Ralph 1848–1913
The Sail Loft 1908
oil on canvas 86.6 x 109.7
TWCMS : G4628

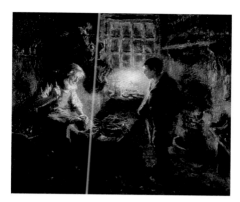

Hedley, Ralph 1848–1913
The Cobbler's Shop 1909
oil on panel 45.7 x 55.1
TWCMS : G4777

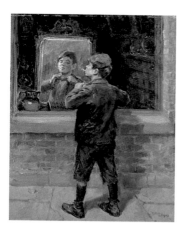

Hedley, Ralph 1848–1913
The Old Curiosity Shop 1909
oil on panel 40.5 x 32.1
TWCMS : F9120

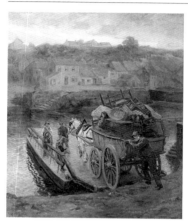

Hedley, Ralph 1848–1913
Crossing Hylton Ferry 1912
oil on canvas 126.8 x 107.1
TWCMS : G2342

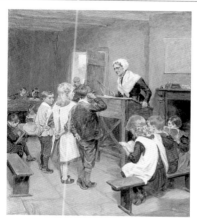

Hedley, Ralph 1848–1913
The Village School 1912
oil on canvas 102.5 x 87.5
TWCMS : B6694

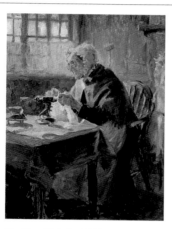

Hedley, Ralph 1848–1913
Old Woman Ironing
oil on canvas 45.7 x 35.6
TWCMS : G4778

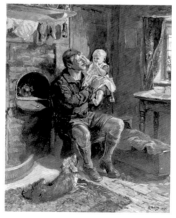

Hedley, Ralph (after) 1848–1913
Geordie Haa'd the Bairn 1890
oil on canvas 53.4 x 42.3
TWCMS : G4775 (P)

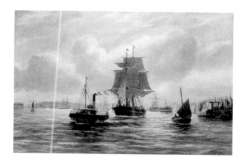

Hemy, Bernard Benedict 1845–1913
Seascape c.1880–1910
oil on canvas 51.1 x 76.7
TWCMS : F4627

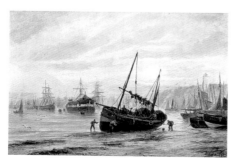

Hemy, Bernard Benedict 1845–1913
Seascape, Mouth of the Tyne c.1880–1910
oil on canvas 51.2 x 76.7
TWCMS : G542

159

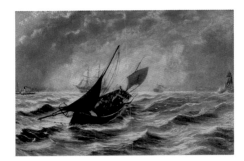

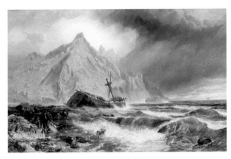

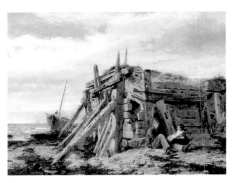

Hemy, Bernard Benedict 1845–1913
Seascape
oil on canvas 61.4 x 91.7
TWCMS : G543

Hemy, Charles Napier 1841–1917
Wreck of a Frigate on the Southern Coast of Spain 1863
oil on canvas 50.8 x 76.7
TWCMS : B6685

Hemy, Charles Napier 1841–1917
Under the Breakwater c.1863
oil on canvas 45.7 x 60.7
TWCMS : G4763

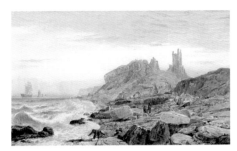

Hemy, Charles Napier 1841–1917
Among the Shingle at Clovelly, North Devon 1864
oil on canvas 43.5 x 72.1
TWCMS : G4629

Hemy, Charles Napier 1841–1917
Ruins of a Northumbrian Keep 1864
oil on canvas 43.5 x 68.9
TWCMS : G10314

Hemy, Charles Napier 1841–1917
Sunset Shadows 1865
oil on canvas 43.2 x 66.4
TWCMS : C3920

Hemy, Charles Napier 1841–1917
Porpoises Chasing Mackerel c.1882–1917
oil on canvas 117 x 213.5
TWCMS : C3922

Hemy, Charles Napier 1841–1917
Redbridge, Southampton 1890
oil on canvas 50.5 x 76.7
TWCMS : G4648

Hemy, Charles Napier 1841–1917
Study for 'Pilchards' c.1897
oil on paper 34 x 46.9
TWCMS : H952

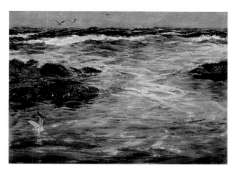

Hemy, Charles Napier 1841–1917
Sea Study at Portscatho, Cornwall 1901
oil on board 35.1 x 48.7
TWCMS : C3906

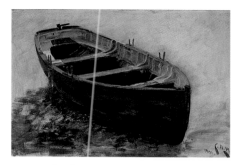

Hemy, Charles Napier 1841–1917
Study of a Boat 1901
oil on paper 49.5 x 71.7
TWCMS : C3905

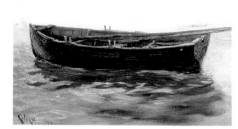

Hemy, Charles Napier 1841–1917
Study of a Boat 1901
oil on paper 48.8 x 70.7
TWCMS : C3907

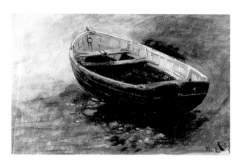

Hemy, Charles Napier 1841–1917
Study of a Dinghy 1901
oil on paper 45.5 x 67.8
TWCMS : C3916

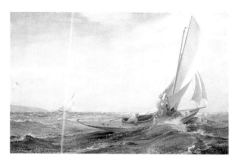

Hemy, Charles Napier 1841–1917
Through Sea and Air 1910
oil on canvas 122.3 x 183.7
TWCMS : B6664

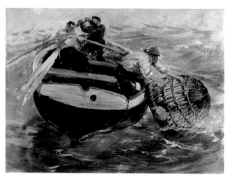

Hemy, Charles Napier 1841–1917
Hauling in Lobster Pots
oil on paper 43.2 x 55.9
TWCMS : G17028

Hemy, Charles Napier 1841–1917
Lobster Pot
oil on paper 37.5 x 53.5
TWCMS : G17035

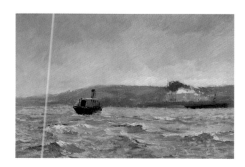

Hemy, Charles Napier 1841–1917
Seascape with a Tug
oil on paper 45.5 x 66.5
TWCMS : C3917

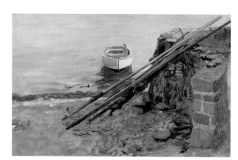

Hemy, Charles Napier 1841–1917
Study in a Harbour
oil on board 44.5 x 66.7
TWCMS : C3909

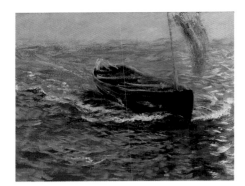

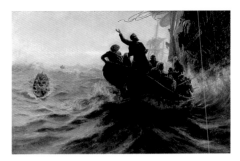

Hemy, Charles Napier 1841–1917
Study of a Sailing Dinghy
oil on paper 44.2 x 56.7
TWCMS : C10602

Hemy, Charles Napier 1841–1917
Trees
oil on paper 50.8 x 35.6
TWCMS : H963

Hemy, Thomas Marie Madawaska
1852–1937
Women and Children First 1892
oil on canvas 141.7 x 214.8
TWCMS : G4174 (P)

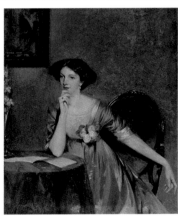

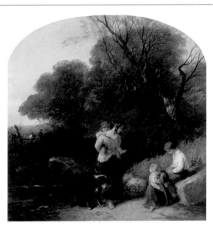

Henderson, Nigel 1917–1985
Face at the Window I 1977
oil & photograph on paper 50.5 x 40.4
TWCMS : E1183

Henry, George F. 1858–1943
Lady Margaret Sackville (1881–1963) c.1910
oil on canvas 127.3 x 101.8
TWCMS : G1746

Henzell, Isaac 1815–1876
Landscape with Figures
oil on canvas 61.1 x 57.1
TWCMS : F13740

Hepper, George 1839–1868
Self Portrait (?) c.1865
oil on canvas 44 x 33.5 (E)
TWCMS : M4088

Hepper, George 1839–1868
Sheep on a Cliff's Edge c.1865–1868
oil on canvas 51.4 x 61
TWCMS : F5183

Hering, George Edwards 1805–1879
Near Arona, Lago Maggiore 1859 (?)
oil on canvas 107 x 184.8
TWCMS : G3304

Facing page: Sheard, Thomas Frederick Mason, 1866–1921, *Harvesters Resting* (detail), 1898,
Shipley Art Gallery, (p. 72)

Herring, John Frederick I 1795–1865
Horses in a Farmyard c.1840–1850
oil on canvas 71.4 x 94
TWCMS : B8131

Hesketh, Richard 1867–1919
In Borrowdale, Cumbria c.1918
oil on canvas 115 x 151.8 (E)
TWCMS : G3305

Hesketh, Richard 1867–1919
Upper Eskdale, Cumbria c.1918
oil on canvas 115.5 x 151.4 (E)
TWCMS : G3306

Highmore, Joseph (attributed to)
1692–1780
Portrait of a Man
oil on canvas 52.6 x 42.2
TWCMS : C3949

Hill, Rowland Henry 1873–1952
The Primrose Gatherers 1920
oil on canvas 56.1 x 68.9
TWCMS : F4650

Hill, William Robert active 1830–1884
Portrait of a Man Seated 1830
oil on canvas 53.8 x 44.1
TWCMS : C13465

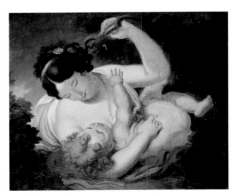

Hilton, William II 1786–1839
Cupid Disarmed
oil on canvas 85.2 x 97.9
TWCMS : G1744

Hirst, Derek 1930–2006
Shangri-La Number III 1962
acrylic on board 126.5 x 101.5
TWCMS : G2345

Hitchens, Ivon 1893–1979
Terwick Mill, No.7, Splashing Fall c.1947
oil on canvas 52 x 105.8
TWCMS : B7407

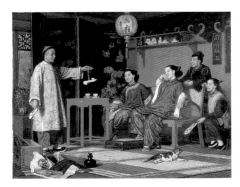

Hodgson, John Evan 1831–1895
*Chinese Ladies Looking at European
Curiosities* 1868
oil on canvas 70.8 x 91.5
TWCMS : B8123

Hodgson, Louisa 1905–1980
*The Collingwood Monument, Tynemouth,
Trafalgar Night* c.1930–1938
tempera on panel 52 x 72.3
TWCMS : F4761

Hodgson, Louisa 1905–1980
*Corpus Christi Day in Newcastle upon Tyne,
c.1450 (The Shipwright's Guild)* before 1934
tempera on canvas 245 x 851.5
TWCMS : G4640

Hornel, Edward Atkinson 1864–1933
Leisure Moments 1896
oil on canvas 61.5 x 51.3
TWCMS : D3497

Hornel, Edward Atkinson 1864–1933
The Little Mushroom Gatherers 1902
oil on canvas 91 x 76.5
TWCMS : C649

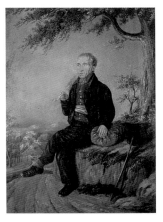

Howe, Ralph active early 19th C
James Howe
oil on canvas 20.6 x 18.6
TWCMS : E5298

Hubbard, Eric Hesketh 1892–1957
Big Top with Caravans
oil on canvas 36 x 46.2
TWCMS : B6383

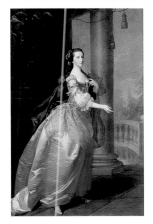

Hudson, Thomas 1701–1779
Anne, Countess of Northampton (d.1763)
c.1759–1760
oil on canvas 237 x 149.5
TWCMS : F3470

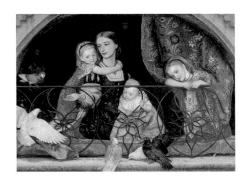

Hughes, Arthur 1832–1915
Mrs Leathart and Her Three Children
1863–1865
oil on canvas 54.7 x 92.7
TWCMS : 1997.129

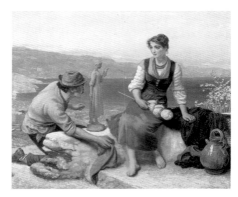

Hughes, Arthur 1832–1915
The Potter's Courtship c.1886
oil on canvas 71.7 x 86.3
TWCMS : B8146

Hughes-Stanton, Herbert Edwin Pelham
1870–1937
Welsh Hills near Barmouth 1918
oil on canvas 101.8 x 127.5
TWCMS : G4163

Hulme, Frederick William 1816–1884
Woodland Scene 1878
oil on canvas 76.8 x 127.5
TWCMS : G4603

Hunt, Alfred William 1830–1896
Wasdale Head from Styhead Pass,
Cumbria c.1854
oil on canvas 86.5 x 112.5
TWCMS : G3857

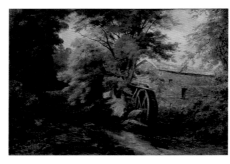

Hunt, Alfred William 1830–1896
A North Country Stream 1883
oil on canvas 81.3 x 122.7
TWCMS : G12981 (P)

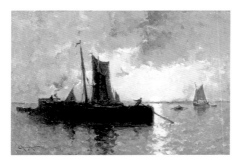

Hunt, E. Aubrey 1855–1922
River Scene with Shipping 1884
oil on canvas 70.8 x 102.7
TWCMS : G1337

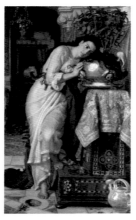

Hunt, William Holman 1827–1910
Isabella and the Pot of Basil 1867
oil on canvas 187 x 116.5
TWCMS : B8147

Jack, Richard 1866–1952
Anglesey, Wales
oil on canvas 63.4 x 76.4
TWCMS : G536

Jackson, F. active 19th C
View of the Tyne, the Ferry
oil on panel 15.5 x 21
TWCMS : C9989

Jackson, F. active 19th C
View of the Tyne, Two Anglers
oil on panel 15.5 x 21
TWCMS : C9988

James, Louis 1920–1996
The Entrance 1962
oil on canvas 101.7 x 126.8
TWCMS : H979

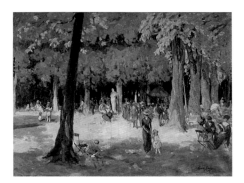

Jamieson, Alexander 1873–1937
The Gardens, Versailles 1912
oil on canvas 86.8 x 112.2
TWCMS : G1313

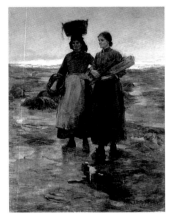

Jobling, Isabella 1851–1926
Fisherfolk 1893
oil on canvas 121.6 x 91
TWCMS : 1993.4418

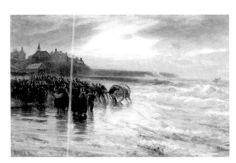

Jobling, Robert 1841–1923
The Lifeboat Off 1884
oil on canvas 50.8 x 76
TWCMS : C695

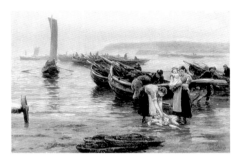

Jobling, Robert 1841–1923
Sea Fret c.1884
oil on canvas 50.5 x 75.8
TWCMS : G10316

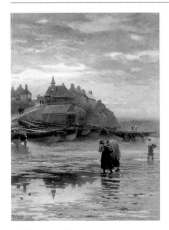

Jobling, Robert 1841–1923
Darkness Falls from the Wings of Night 1886
oil on canvas 128.1 x 92.2
TWCMS : B6680

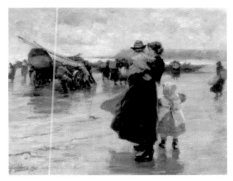

Jobling, Robert 1841–1923
Hauling the Boats 1890
oil on canvas 30.6 x 40.8
TWCMS : F9118

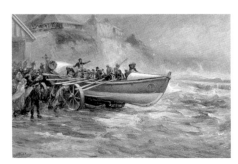

Jobling, Robert 1841–1923
Launching the Cullercoats Lifeboat 1902
oil on canvas 50.7 x 76.7
TWCMS : B6692

Jobling, Robert 1841–1923
Self Portrait c.1913
oil on canvas 91.3 x 70.8
TWCMS : G1743

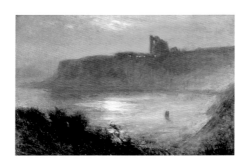

Jobling, Robert 1841–1923
Moonlight, Tynemouth Priory c.1922
oil on canvas 60.8 x 91.4
TWCMS : G4605

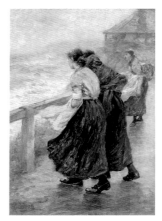

Jobling, Robert 1841–1923
Anxious Times
oil on canvas 35.7 x 25.5
TWCMS : B652

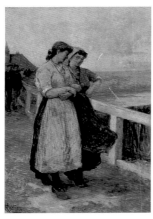

Jobling, Robert 1841–1923
Pleasant Times
oil on canvas 35.7 x 25.5
TWCMS : B653

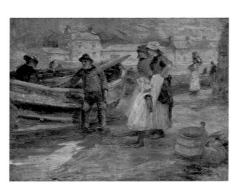

Jobling, Robert 1841–1923
Harbour Scene with Fishermen
oil on canvas 35.5 x 45.7
TWCMS : D4808

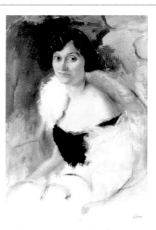

John, Augustus Edwin 1878–1961
*The White Feather Boa (Lady Elizabeth
Asquith, 1897–1945)* 1919
oil on canvas 92.5 x 65.1
TWCMS : C602

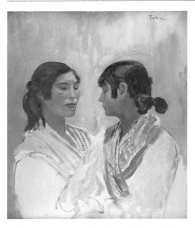

John, Augustus Edwin 1878–1961
Two Gitanas (Two Romany Women) c.1921
oil on canvas 72.5 x 60.4
TWCMS : C6952

Johnson, Nerys Ann 1942–2001
Untitled, Grey, Green, Blue and Black 1974
oil on canvas 33 x 62
TWCMS : 2002.1631

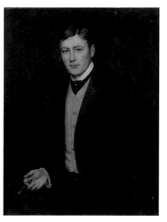

Jopling, Louise 1843–1933
J. M. Jopling (1831–1884) c.1874
oil on canvas 101.4 x 75.8
TWCMS : F12070

Joseph, Peter b.1929
Composition 1965
oil on canvas 183.5 x 183.3
TWCMS : G4179

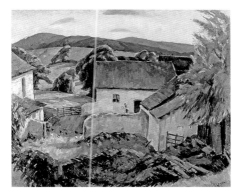

Jowett, Percy Hague 1882–1955
Cider Press Farm, Llantarnam, Wales c.1931
oil on canvas 63.9 x 76
TWCMS : G10315

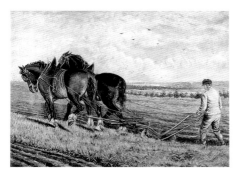

Kent, Anna Sophia d.1959
The Ploughman c.1890
oil on canvas 55.8 x 76
TWCMS : F13614

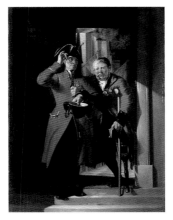

Kidd, William 1790–1863
The Army
oil on canvas 70.2 x 51.7
TWCMS : G518

Kidd, William 1790–1863
The Navy
oil on canvas 71.8 x 53
TWCMS : C10646

Kiddier, William 1859–1934
The Bridge
oil on canvas 84.5 x 96.5
TWCMS : G1334

Kiddier, William 1859–1934
Windmill and Dyke
oil on canvas 84.3 x 97
TWCMS : G502

Kilbourn, Oliver 1904–1993
End of Shift c.1934–1941
oil on canvas 59.6 x 76.2
TWCMS : G548

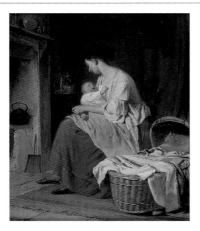

King, Haynes 1831–1904
Mother and Child 1873
oil on canvas 35.9 x 30.4
TWCMS : F4628

Kitaj, R. B. 1932–2007
Germania: To the Brothel 1985–1987
oil on canvas 121.6 x 91.5
TWCMS : P559

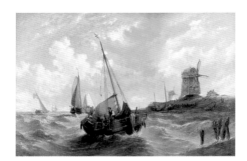

Knell, William Adolphus 1802–1875
Seascape with Boats
oil on canvas 61 x 91.5
TWCMS : G1349

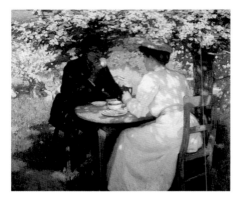

Knight, Harold 1874–1961
In the Spring Time 1908–1909
oil on canvas 132.3 x 158.2
TWCMS : C6963

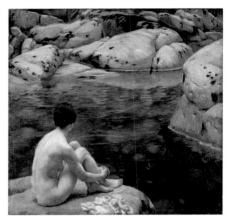

Knight, Harold 1874–1961
The Bathing Pool c.1916
oil on canvas 76.6 x 76.7
TWCMS : C6964

Knight, Harold 1874–1961
The Seamstress 1920
oil on canvas 46 x 46
TWCMS : C6966

Knight, Harold 1874–1961
At the Piano c.1921
oil on canvas 61.5 x 51
TWCMS : C6965

Knight, John William Buxton
1842/1843–1908
On the Medway, Breezy March 1877
oil on canvas 88.9 x 152.3
TWCMS : G516

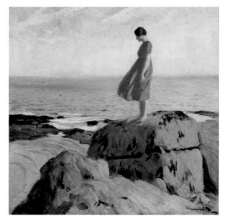

Knight, Laura 1877–1970
A Dark Pool c.1908–1918
oil on canvas 46 x 45.8
TWCMS : C6968

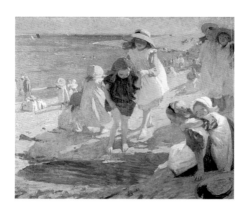

Knight, Laura 1877–1970
The Beach c.1909
oil on canvas 127.6 x 153.2
TWCMS : C651

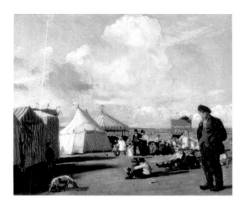

Knight, Laura 1877–1970
The Fair c.1919
oil on canvas 61.7 x 92.1
TWCMS : C6967

Knight, William 1872–1958
Landscape with Haystack
oil on canvas 50.9 x 61.3
TWCMS : B669

Koninck, Salomon (attributed to)
1609–1656
A Philosopher c.1640–1655
oil on canvas 103.9 x 93.3
TWCMS : G1995

Kops, Franz 1846–1896
Henry Straker 1890
oil on canvas 32.2 x 20.6
TWCMS : F9141

Koster, Jo (after) 1869–1944
Joseph Skipsey (1832–1903) after 1894
oil on canvas 76.5 x 61.3
TWCMS : G1321

La Thangue, Henry Herbert 1859–1929
Gathering Bracken c.1899
oil on canvas 119.3 x 100.4
TWCMS : C648

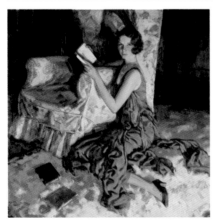

Lambart, Alfred 1902–1970
Juliet, Daughter of Richard H. Fox of Surrey
1931
oil on canvas 137.2 x 136.8
TWCMS : E5275

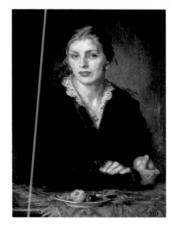

Landau, Dorothea 1881–1941
Lady with Fruit (Gladys Holman Hunt,
b.1878) 1917
oil on canvas 72.5 x 54.8
TWCMS : G1323

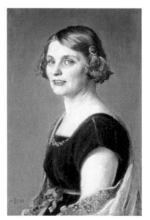

Landau, Dorothea 1881–1941
Bohémienne 1922
oil on canvas 68.7 x 45.8
TWCMS : F13612

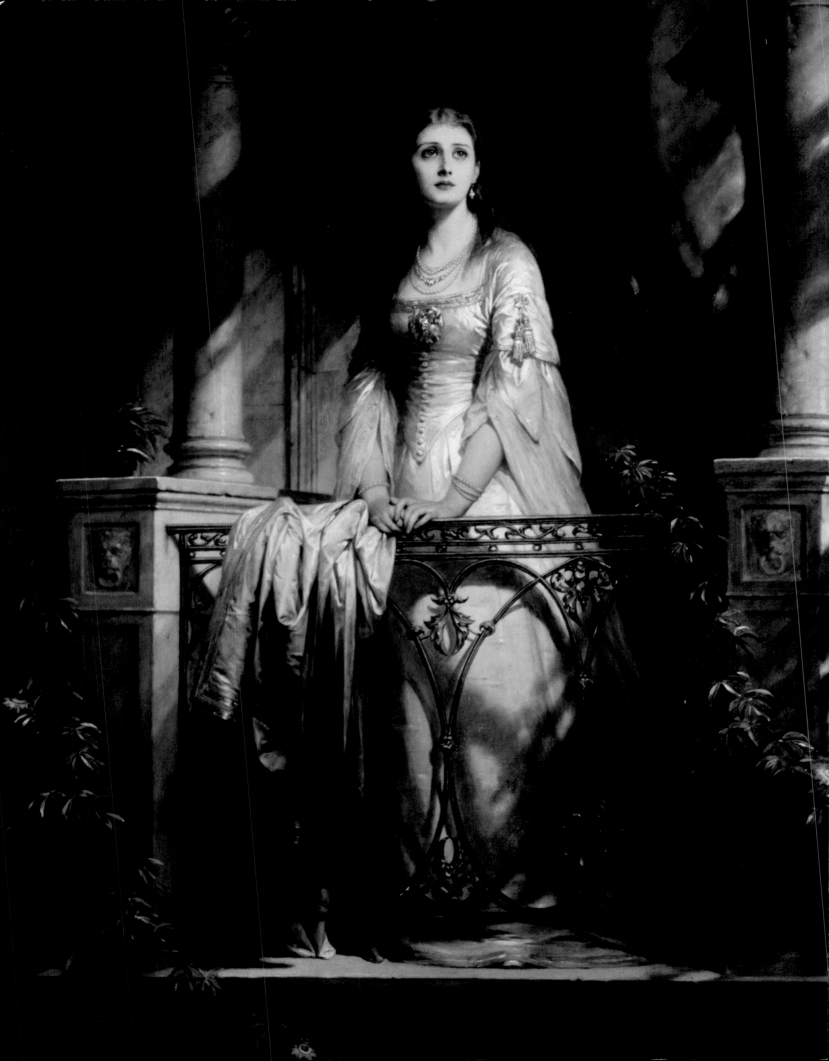

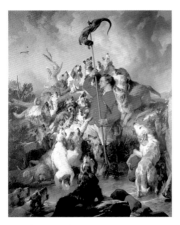

Landseer, Edwin Henry 1802–1873
The Otter Speared, the Earl of Aberdeen's Otterhounds c.1844
oil on canvas 200 x 153.7
TWCMS : B8130

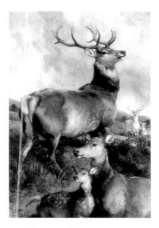

Landseer, Edwin Henry 1802–1873
Deer of Chillingham Park, Northumberland c.1867
oil on canvas 228.5 x 155.3
TWCMS : B8127

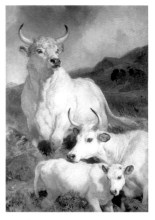

Landseer, Edwin Henry 1802–1873
Wild Cattle of Chillingham, Northumberland c.1867
oil on canvas 228.9 x 156.3
TWCMS : B8133

Langley, William active 1880–1920
Loch Etive, Argyll and Bute
oil on canvas 51.2 x 76.8
TWCMS : G3376

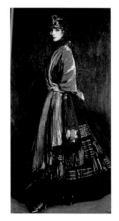

Lavery, John 1856–1941
Hazel in Black and Gold 1916
oil on canvas 183.4 x 92.3
TWCMS : G2553

Lawrence, Alfred Kingsley 1893–1975
The Building of Hadrian's Bridge (Pons Aelii) over the Tyne, c.122 AD (study for a lunette decoration) before 1925
oil on canvas 45.9 x 102
TWCMS : G1309

Lawrence, Alfred Kingsley 1893–1975
The Building of Hadrian's Bridge (Pons Aelii) over the Tyne, c.122 AD 1925
oil on canvas 245 x 812
TWCMS : G4635

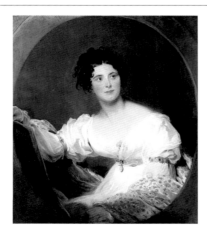

Lawrence, Thomas 1769–1830
Mrs Littleton (1789–1846) c.1822
oil on canvas 99.8 x 89.1
TWCMS : C3946

Lawrence, Thomas (after) 1769–1830
The Duke of Wellington (1769–1852)
early 19th C
oil on canvas 261.6 x 158.8
TWCMS : G4643

Facing page: Dicksee, Thomas Francis, 1819–1895, *Juliet* (detail), 1877, Sunderland Museum and Winter Gardens, (p. 284)

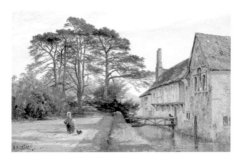

Leader, Benjamin Williams 1831–1923
Igtham Mote, Kent c.1868
oil on board 40.9 x 61
TWCMS : C665

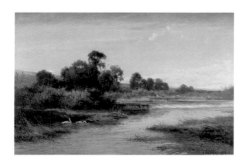

Leader, Benjamin Williams 1831–1923
Goring-on-Thames, Oxfordshire 1873
oil on canvas 50.8 x 76.7
TWCMS : G1308

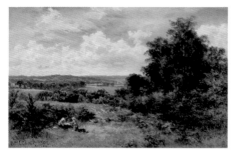

Leader, Benjamin Williams 1831–1923
Landscape 1897
oil on canvas 30.5 x 46
TWCMS : G10304

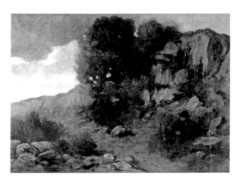

Legros, Alphonse 1837–1911
Landscape 1863–1900
oil on canvas 109 x 147.8
TWCMS : F5161

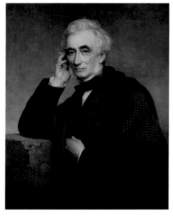

Lehmann, Rudolph 1819–1905
Dr Collingwood Bruce (1805–1892) 1877
oil on canvas 91.5 x 71.2
TWCMS : G1739

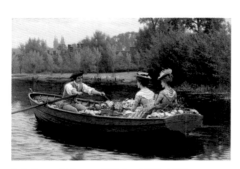

Leighton, Edmund Blair 1852–1922
Market Day 1900
oil on canvas 32 x 47
TWCMS : C13517

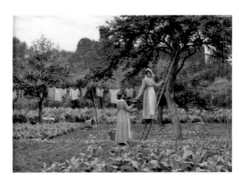

Leighton, Edmund Blair 1852–1922
September 1915
oil on panel 25.1 x 35.5
TWCMS : D1284

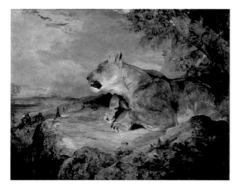

Lewis, John Frederick 1805–1876
The Lioness c.1824–1827
oil on canvas 102 x 127.6
TWCMS : B6695

Liberi, Pietro (after) 1605–1687
Diana Resting after the Chase 19th C
oil on canvas 153.3 x 236.8
TWCMS : G4166

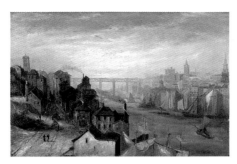

Liddell, Thomas Hodgson 1860–1925
Newcastle upon Tyne from Gateshead c.1880
oil on canvas 60.7 x 91.6
TWCMS : 2003.569

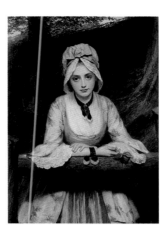

Lidderdale, Charles Sillem 1831–1895
The Trysting Place 1878
oil on canvas 107.2 x 76.9
TWCMS : G2810

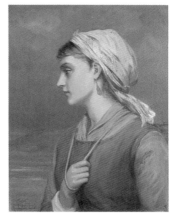

Lidderdale, Charles Sillem 1831–1895
A Fishergirl
oil on canvas 41.2 x 30.8
TWCMS : G3369

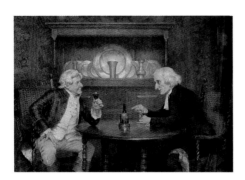

Lomax, John Arthur 1857–1923
A Rare Vintage
oil on panel 31.5 x 42.4
TWCMS : C13514

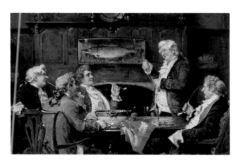

Lomax, John Arthur 1857–1923
How the Old Squire Caught the Big Jack
oil on panel 30.4 x 45.7
TWCMS : D1280

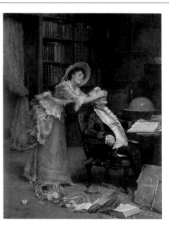

Lomax, John Arthur 1857–1923
Interrupted Studies
oil on panel 45.5 x 35.4
TWCMS : D1292

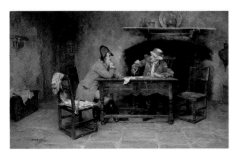

Lomax, John Arthur 1857–1923
The Moneylender
oil on panel 30 x 45.6
TWCMS : C13496

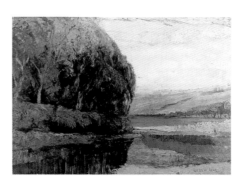

Lowe, Arthur 1866–1940
Evening
oil on canvas 66 x 91.2
TWCMS : F5172

Lowe, Arthur 1866–1940
Farm Buildings
oil on canvas 31 x 51
TWCMS : 2006.1892

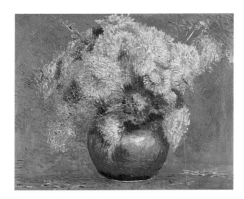

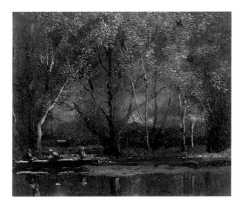

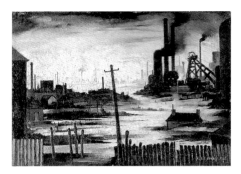

Lowe, Arthur 1866–1940
Still Life, Chrysanthemums
oil on board 40.2 x 50.4
TWCMS : H989

Lowe, Arthur 1866–1940
When the Evening Sun Is Low
oil on board 36.8 x 43.7
TWCMS : H988

Lowry, Laurence Stephen 1887–1976
River Scene 1935
oil on board 37.5 x 51.4
TWCMS : B7405

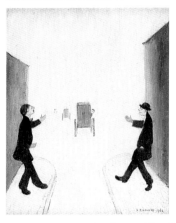

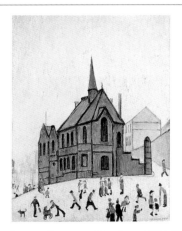

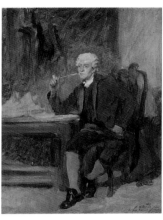

Lowry, Laurence Stephen 1887–1976
My Two Uncles 1962
oil on canvas 39.7 x 29.6
TWCMS : 1997.124

Lowry, Laurence Stephen 1887–1976
Old Chapel, Newcastle upon Tyne 1965
oil on canvas 60.8 x 45.7
TWCMS : B6677

Lucas, Seymour 1849–1923
A Sketch Given to my Friend, G. Robinson
1882
oil on canvas 51.3 x 40.8
TWCMS : C13464

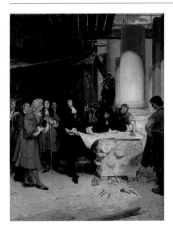

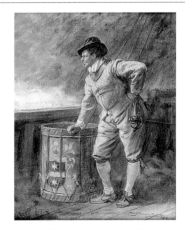

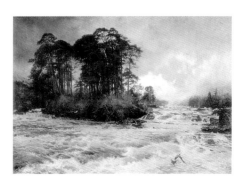

Lucas, Seymour 1849–1923
St Paul's, the King's Visit to Wren 1888
oil on canvas 164.8 x 121.8
TWCMS : G4172

Lucas, Seymour 1849–1923
The Drum Watch 1916
oil on canvas 43.2 x 33
TWCMS : C13513

Lund, Niels Møller 1863–1916
Mid the Wild Music of the Glen 1888
oil on canvas 135 x 183.6
TWCMS : G4173

Lund, Niels Møller 1863–1916
Newcastle upon Tyne from Gateshead 1895
oil on canvas 70.2 x 125.9
TWCMS : G12962

Lund, Niels Møller 1863–1916
Newcastle upon Tyne from the East 1898
oil on canvas 122 x 183.4
TWCMS : G12963

Lund, Niels Møller 1863–1916
Corfe Castle, Dorset 1909
oil on canvas 76.6 x 89.9
TWCMS : G1333

R. M. active 20th C
Abstract
oil on canvas 67.5 x 47
TWCMS : 2006.1899

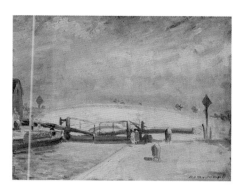

MacDougall, William Brown 1869–1936
Canal Scene, Welton Lock and Lodge 1927
oil on board 35.6 x 45.8
TWCMS : G2831

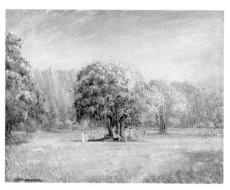

MacDougall, William Brown 1869–1936
Blossom Time, Epping Forest, Essex
oil on canvas 80.2 x 98.3
TWCMS : F3494

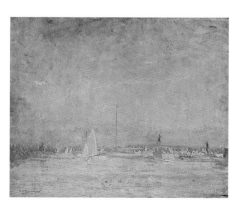

MacDougall, William Brown 1869–1936
Early Evening on the Aut River
oil on board 63.8 x 76.2
TWCMS : G3378

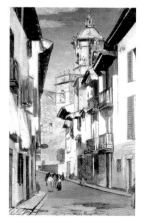

MacGregor, William York 1855–1923
A Street in Fuenterrabía c.1908
oil on canvas 91.2 x 55.8
TWCMS : G1989

Mackay, Thomas 1851–1909
The Trumpeter c.1870
oil on canvas 183.3 x 122.4
TWCMS : G4170

Macklin, Thomas Eyre 1867–1943
Portrait of an Alderman 1900
oil on canvas 127 x 101.6
TWCMS : G15252

Macklin, Thomas Eyre 1867–1943
Portrait of an Alderman c.1900
oil on canvas 143.5 x 113
TWCMS : 2006.1902

Macklin, Thomas Eyre 1867–1943
Alexander Laing (1828–1905) 1903
oil on canvas 228.9 x 139.7
TWCMS : G4631

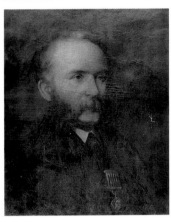

Macklin, Thomas Eyre 1867–1943
Portrait of the Artist's Father 1903 (?)
oil on canvas 54 x 40.9
TWCMS : F9138

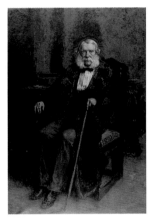

Macklin, Thomas Eyre 1867–1943
*Alderman Sir Charles Frederick Hamond
(1867–1943)*
oil on canvas 197.8 x 131.8
TWCMS : G4165

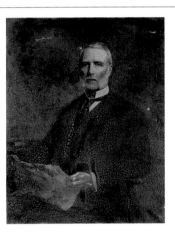

Macklin, Thomas Eyre 1867–1943
John Hall (1824–1899)
oil on canvas 102 x 77
TWCMS : E5276

Maclise, Daniel 1806–1870
*Alfred the Saxon King (Disguised as a
Minstrel) in the Tent of Guthrum the Dane*
c.1852
oil on canvas 122.2 x 219.4
TWCMS : B8138

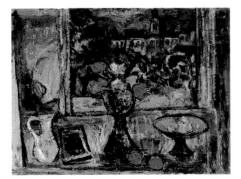

MacTaggart, William 1903–1981
Studio Table 1959
oil on canvas 86.1 x 111.9
TWCMS : G12959

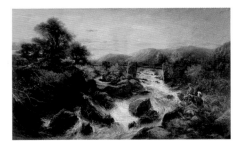

MacWhirter, John 1839–1911
A Spate in the Highlands
oil on canvas 76.5 x 127.2
TWCMS : G2343

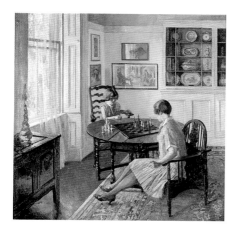

Mainds, Allan Douglass 1881–1945
A Lesson in Chess 1931–c.1933
oil on canvas 145.2 x 144.8
TWCMS : G4183

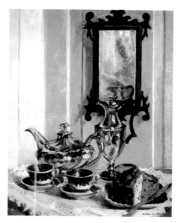

Mainds, Allan Douglass 1881–1945
Silver and Spode c.1942
oil on canvas 61 x 50.8
TWCMS : F3485

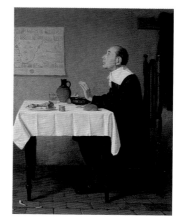

Marks, Henry Stacey 1829–1898
Thanks for Small Mercies 1864
oil on canvas 46 x 35.7
TWCMS : B6375

Marr, Leslie b.1922
The Stiperstones, Shropshire before 1965
oil on canvas 71.2 x 91.7
TWCMS : F5177

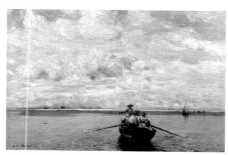

Marsh, Arthur Hardwick 1842–1909
Cockle Gatherers 1885
oil on canvas 30.8 x 45.7
TWCMS : D1297

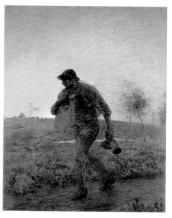

Marsh, Arthur Hardwick 1842–1909
*The Ploughman Homeward Plods His Weary
Way*
oil on canvas 91.5 x 71.5
TWCMS : G1994

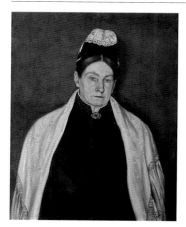

Marston, C. active late 19th C
Portrait of Old an Lady
oil on canvas 76 x 60.8
TWCMS : F13601

Martin, John 1789–1854
Clytie 1814
oil on canvas 62 x 92.7
TWCMS : C6979

Martin, John 1789–1854
*View of the Entrance of Carisbrooke Castle, Isle
of Wight* 1815
oil on canvas 29.5 x 44.5
TWCMS : C6982

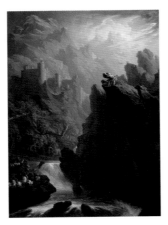

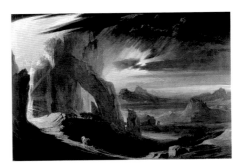

Martin, John 1789–1854
Edwin and Angelina 1816
oil on canvas 29 x 44
TWCMS : C6981

Martin, John 1789–1854
The Bard c.1817
oil on canvas 215.5 x 157
TWCMS : C6976

Martin, John 1789–1854
The Expulsion of Adam and Eve from Paradise
1823–1827
oil on canvas 77.2 x 112.3
TWCMS : C6978

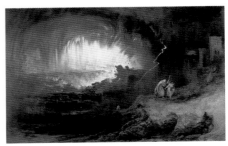

Martin, John 1789–1854
Solitude 1843
oil on canvas 50.7 x 91.6
TWCMS : C6980

Martin, John 1789–1854
Arthur and Aegle in the Happy Valley 1849
oil on canvas 122 x 182.5
TWCMS : C6977

Martin, John 1789–1854
The Destruction of Sodom and Gomorrah 1852
oil on canvas 136.3 x 212.3
TWCMS : C6975

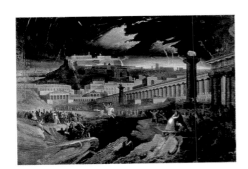

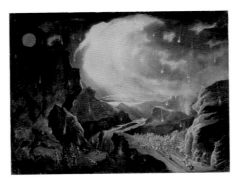

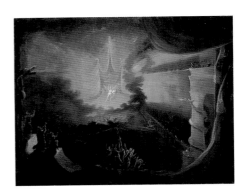

Martin, John (after) 1789–1854
Marcus Curtius after 1827
oil on canvas 83.1 x 120.8
TWCMS : J2274

Martin, John (follower of) 1789–1854
Biblical Destruction Scene 19th C
oil on canvas 91.4 x 121.5
TWCMS : C6996

Martin, John (follower of) 1789–1854
Satan (?) 19th C
oil on canvas 79.3 x 103.2
TWCMS : C6998

Facing page: Lowry, Laurence Stephen, 1887–1976, *Dockside, Sunderland* (detail), 1962, Sunderland Museum
and Winter Gardens, (p. 300)

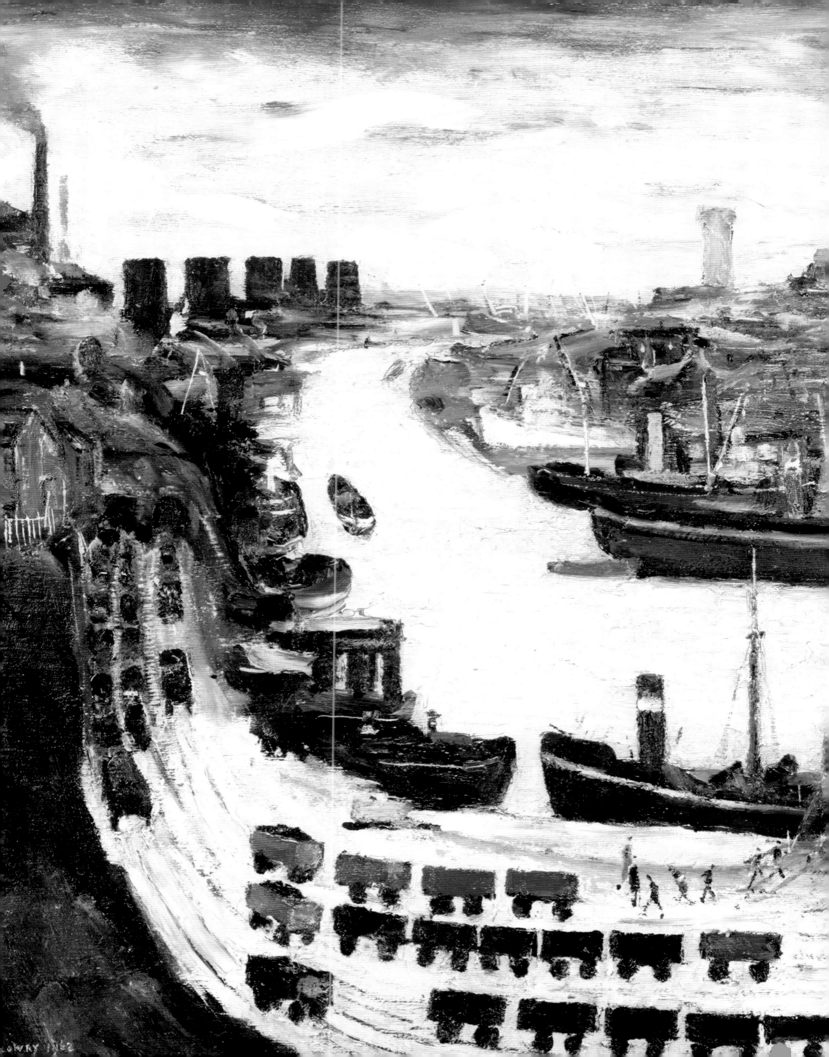

Mason, Frank Henry 1876–1965
After Trafalgar 1907
oil on canvas 88.6 x 127.3
TWCMS : G2598

McAlpine, William active 1840–1880
Evening on the Medway
oil on canvas 46.1 x 81.6
TWCMS : G519

McCulloch, Horatio 1805–1867
Inverlochy, Fort William, Scotland
oil on canvas 70.8 x 91.8
TWCMS : G1327

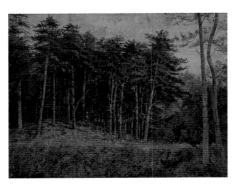

McDonald, G. A. active 20th C
Study of Fir Trees
oil on canvas 43.5 x 56.2
TWCMS : G4200

McEune, Robert Ernest 1876–1952
Councillor John Moore 1928
oil on canvas 66.4 x 56.1
TWCMS : G1347

McEwan, R.
The Aberuchills (The Loch Aber Hills) 1873
oil on canvas 47.4 x 76.4
TWCMS : F3489

McGlashan, Archibald A. 1888–1980
Head of a Child
oil on canvas 27.8
TWCMS : C13501

McKenna, Stephen b.1939
Hommage à Piranesi 1990
oil on canvas 80 x 99.8
TWCMS : 1994.104

McKenzie, R. A.
Benwell High Cross, Newcastle upon Tyne 1893
oil on canvas 20.5 x 25.7
TWCMS : C13498

McLean, Bruce b.1944
Towards a Performance, Good Manners or
Physical Violence III 1985
acrylic on paper 170 x 132
TWCMS : P570

Mellor, William 1851–1931
Oak Beck, Harrogate
oil on canvas 61.4 x 91.9
TWCMS : F13603

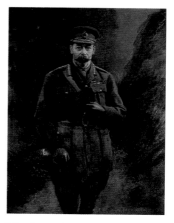

Mendoza, A.
His Majesty King George V (1865–1936) 1917
oil on canvas 143.7 x 112
TWCMS : G4169

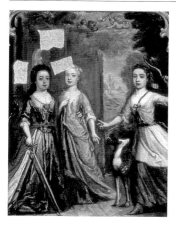

Mignard, Pierre I (attributed to) 1612–1695
Portrait of Three Children
oil on canvas 90.8 x 70.8
TWCMS : G5684

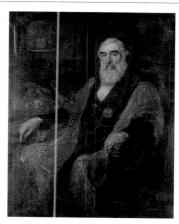

Mitchell, Charles William 1854–1903
Alderman Thomas Robinson c.1879
oil on canvas 130 x 104.5
TWCMS : G15253

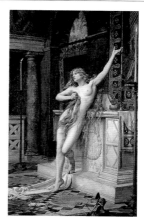

Mitchell, Charles William 1854–1903
Hypatia 1885
oil on canvas 244.5 x 152.5
TWCMS : B8111

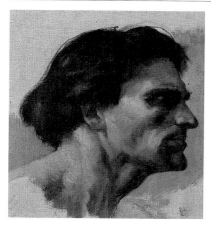

Mitchell, Charles William 1854–1903
Study of a Head
oil on canvas 17.1 x 15.6
TWCMS : F5153

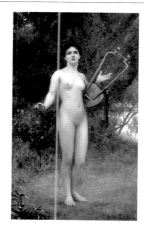

Mitchell, Charles William 1854–1903
The Spirit of Song
oil on canvas 160.2 x 99.1
TWCMS : G4167

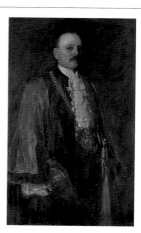

Mitchell, John Edgar 1871–1922
Alderman A. Munro Sutherland c.1916–1917
oil on canvas 126.9 x 78
TWCMS : G1990

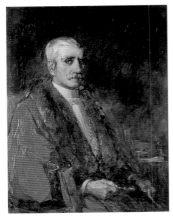

Mitchell, John Edgar 1871–1922
Alderman George Harkus (d.1915), JP
oil on canvas 91.9 x 71
TWCMS : G2055

Mole, John Henry 1814–1886
The Listeners c.1835–1847
oil on board 32 x 25.5
TWCMS : C13491

Molnár, C. Pál 1894–1981
The Nativity c.1930–1940
tempera on panel 52.3 x 47.2
TWCMS : C677

Montague, Alfred 1832–1883
River Scene
oil on canvas 37.5
TWCMS : C13510

Montague, Alfred 1832–1883
Winter Scene
oil on canvas 38.2
TWCMS : C13506

Montalba, Clara 1842–1929
Old Watch Tower, Amsterdam 1889
oil on canvas 91.3 x 71.2
TWCMS : G4601

Moore, Henry 1831–1895
Broken Weather, North Coast of Cornwall 1890
oil on canvas 42.3 x 66
TWCMS : G1307

Morgan, John 1823–1886
Whom to Punish? c.1850–1875
oil on canvas 51 x 40.4
TWCMS : G545

Morland, George 1763–1804
Paying the Ostler 1788–c.1804
oil on canvas 71.9 x 92.4
TWCMS : C3950

Morris, Philip Richard 1838–1902
Girl on a Balcony Watching a Couple by a Lake
oil on board 15.6 x 25.2
TWCMS : D1290

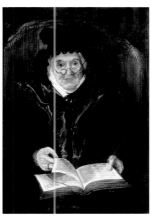

Morton, Andrew 1802–1845
Portrait of an Old Lady 1823
oil on panel 92 x 62.5
TWCMS : F13639

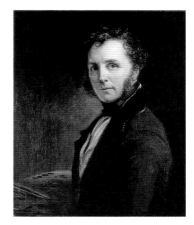

Morton, Andrew 1802–1845
Self Portrait c.1826–1828
oil on canvas 76.6 x 64.3
TWCMS : G1345

Morton, Andrew 1802–1845
Joseph Morton (father of the artist)
oil on canvas 77.1 x 64.2
TWCMS : G1320

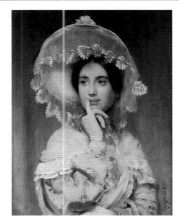

Morton, George 1851–1904
Figure Study
oil on canvas 55.7 x 43.2
TWCMS : F3488

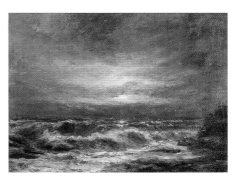

Morton, George Arthur active early 20th C
Rough Sea in Moonlight
oil on canvas 74 x 100.3
TWCMS : M4079

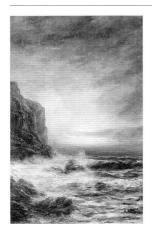

Morton, George Arthur active early 20th C
Seascape with Rough Sea
oil on canvas 141 x 89
TWCMS : M4071

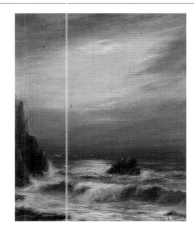

Morton, George Arthur active early 20th C
Stormy Sea and Rocks
oil on canvas 57.4 x 47.1
TWCMS : 1994.668

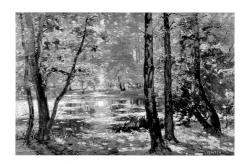

Mostyn, Thomas Edwin 1864–1930
*Sunlight, Burnham Beeches,
Buckinghamshire* c.1900–1910
oil on canvas 101.8 x 152.3
TWCMS : F4649

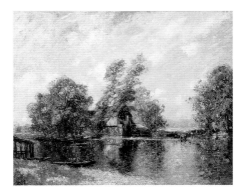

Mostyn, Thomas Edwin 1864–1930
The Old Mill, Houghton,
Cambridgeshire c.1907
oil on canvas 101.5 x 127.2
TWCMS : G3307

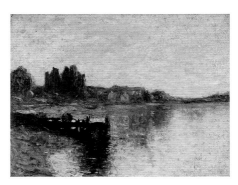

Mostyn, Thomas Edwin 1864–1930
Kirkcudbright Castle
oil on canvas 35 x 46.5
TWCMS : F3421

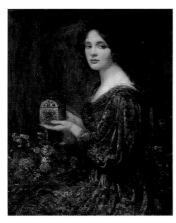

Mostyn, Thomas Edwin 1864–1930
The Jewelled Casket
oil on canvas 91.4 x 71.2
TWCMS : G1737

Muirhead, David 1867–1930
The Harbour, Stonehaven
oil on canvas 25.9 x 35.8
TWCMS : F5194

Mullan, G. active 19th C
Mountainous River Landscape
oil on canvas 50.5 x 76.1
TWCMS : G12998

Mulready, Augustus Edwin 1844–1905
A Recess on a London Bridge 1879
oil on canvas 43.6 x 53.5
TWCMS : D1294

Munnings, Alfred James 1878–1959
Going to the Meet c.1913
oil on canvas 51.5 x 61.2
TWCMS : B690

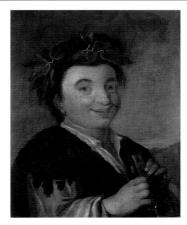

Murillo, Bartolomé Esteban (after)
1618–1682
Pan 19th C
oil on canvas 54.8 x 45.9
TWCMS : G547

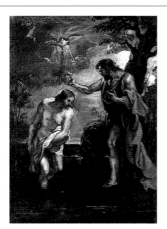

Murillo, Bartolomé Esteban (after)
1618–1682
The Baptism of Christ 19th C
oil on canvas 43.3 x 30.5
TWCMS : C10034

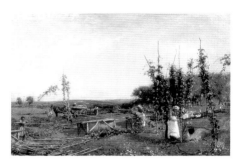

Murray, David 1849–1933
Nooning in the Hop Gardens 1889
oil on canvas 122.2 x 183.2
TWCMS : F9122

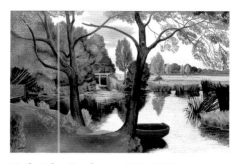

Nash, John Northcote 1893–1977
Mill Pond Evening c.1933
oil on canvas 50.8 x 76.5
TWCMS : B7417 🐝

Nash, Thomas Saunders 1891–1968
Christ before the People 1928
oil & pencil on paper 32.3 x 39
TWCMS : C13505

Nash, Thomas Saunders 1891–1968
Crucifixion c.1932
oil on canvas 122.4 x 107.3
TWCMS : G2051

Nasmyth, Patrick 1787–1831
Landscape with Figures 1823
oil on canvas 71.2 x 96.2
TWCMS : G467

Nasmyth, Patrick 1787–1831
The Aberuchills (The Loch Aber Hills) 1824
oil on panel 19.9 x 27.4
TWCMS : C13482

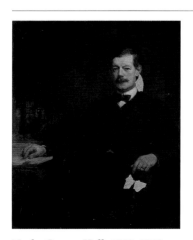

Neale, George Hall 1863–1940
Sir George E. Carter
oil on canvas 132.3 x 107.2
TWCMS : G1745

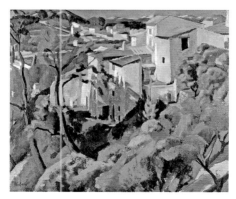

Nelson, Geoffrey C. active 1914–1931
Vieux Cagnes 1927
oil on canvas 54.2 x 65.5
TWCMS : G10311

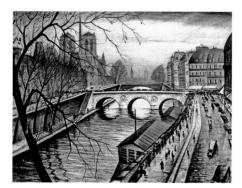

Nevinson, Christopher 1889–1946
*Notre Dame de Paris from Quai des Grands
Augustins* c.1920–1930
oil & tempera on canvas 70.8 x 91.5
TWCMS : G4618 🐝

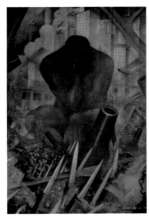

Nevinson, Christopher 1889–1946
Twentieth Century 1932–1935
oil on canvas 183.7 x 122.5
TWCMS : C6954

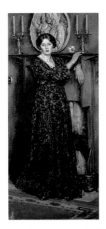

Newbery, Francis Henry 1855–1946
The Lady of the Carnation c.1919
oil on canvas 162.8 x 73.2
TWCMS : C606

Newton, Duncan b.1945
The Rite of Spring 1983
acrylic, enamel & oil on canvas 182.9 x 226
TWCMS : J15606

Nicholls, Bertram 1883–1974
Old Mill, Midhurst, West Sussex 1944
oil on canvas 71.3 x 91.5
TWCMS : G533

Nicholson, Ben 1894–1982
1933 (design) 1933
oil & pencil on panel 25.4 x 51.6
TWCMS : B6698

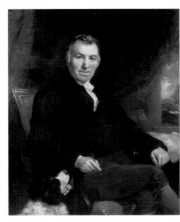

Nicholson, William 1781–1844
Thomas Bewick (1753–1828) c.1814
oil on canvas 127.2 x 101.6
TWCMS : C6962

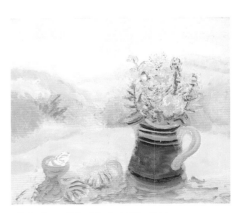

Nicholson, Winifred 1893–1981
Evening at Boothby 1953
oil on canvas 50.5 x 60.6
TWCMS : M2090

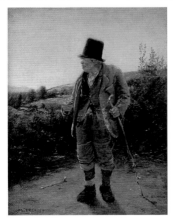

Nicol, Erskine 1825–1904
Old Mickie 1859
oil on canvas 35.4 x 27.8
TWCMS : F4633

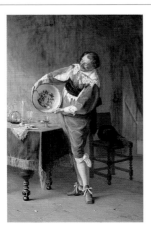

Nicol, John Watson 1856–1926
The Bottom of the Punch Bowl 1879
oil on canvas 88.6 x 57.9
TWCMS : G2349

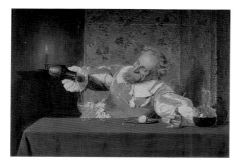

Nicol, John Watson 1856–1926
A Nightcap 1880
oil on canvas 39.2 x 56.4
TWCMS : C693

Niemann, Edmund John 1813–1876
Evening on the French Coast 1856
oil on canvas 63.3 x 114.1
TWCMS : G1508

Niemann, Edmund John 1813–1876
Newcastle upon Tyne 1862–1863
oil on canvas 137.8 x 246.4
TWCMS : G4619

Norman, M. active 20th C
Central Station, Newcastle upon Tyne
oil on canvas 61.3 x 91.6
TWCMS : F4792

Northbourne, James Walter John
1869–1932
Evening 1913
oil on panel 27.6 x 84
TWCMS : E5260

Oakes, John Wright 1820–1887
Loch Muick, Aberdeenshire 1867
oil on canvas 122.7 x 167.6
TWCMS : G1750

O'Connor, James Arthur 1791–1841
Landscape 1836
oil on panel 25.2 x 30.4
TWCMS : F3419

Ogilvie, Frank Stanley (after)
1858–after 1935
Interior, Woman Reading to an Old Man 1889
oil on canvas 92.8 x 72.3
TWCMS : G503

Oliver, Daniel 1830–1916
Holy Island, Northumberland 1902
oil on canvas 30.4 x 45.8
TWCMS : G2832

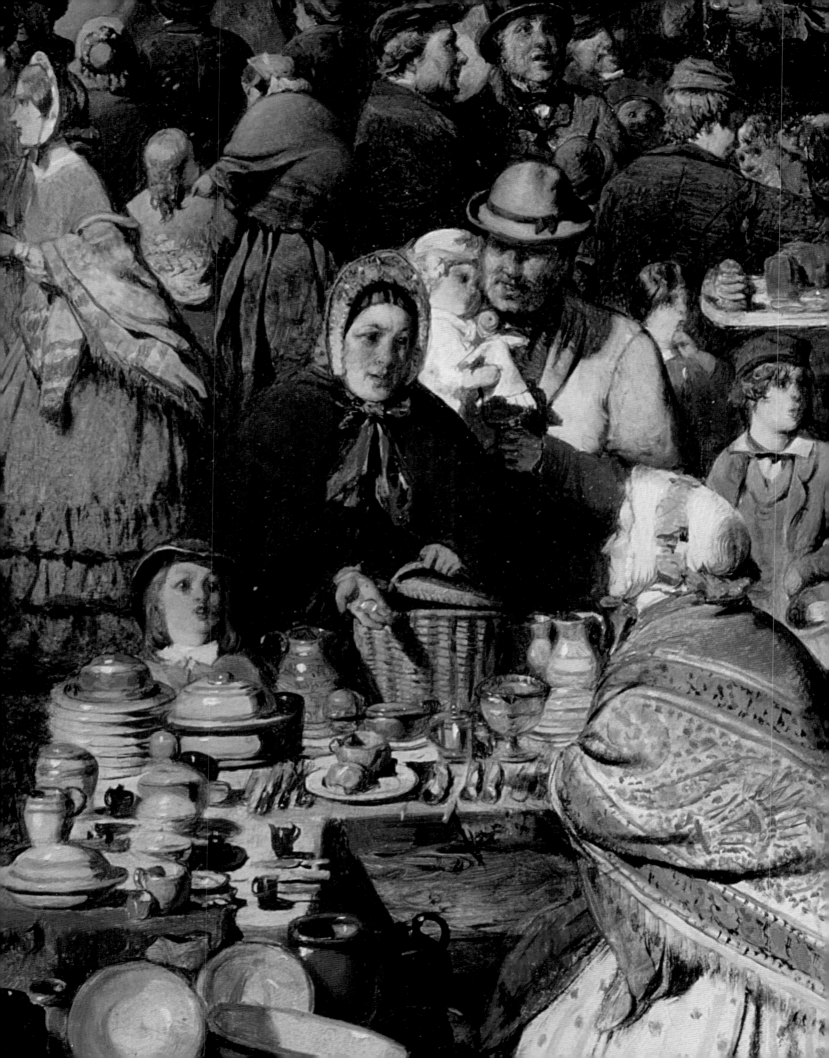

Olsson, Albert Julius 1864–1942
Evening, St Ives, Cornwall c.1900–1905
oil on canvas 63.6 x 76.3
TWCMS : F5174

O'Neill, Daniel 1920–1974
The Doll Maker
oil on canvas 61.2 x 76.3
TWCMS : F9147

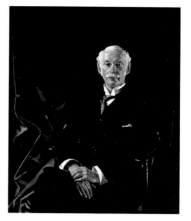

Orpen, William 1878–1931
Sir Charles Algernon Parsons (1854–1931)
c.1905–1910
oil on canvas 127.4 x 102.2
TWCMS : G1996

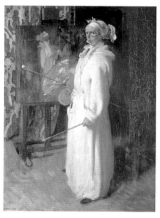

Orpen, William 1878–1931
Portrait of the Artist 1908
oil on canvas 92.8 x 72.1
TWCMS : B685

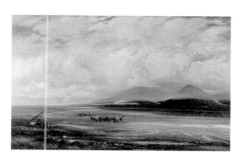

Orrock, James 1829–1913
The Solway, Criffel in the Distance 1896
oil on canvas 81.3 x 127.5
TWCMS : G4153

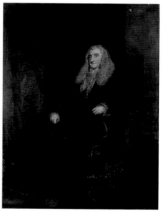

Owen, William 1769–1825
Lord Stowell (1745–1836) c.1813
oil on canvas 214.3 x 158.1
TWCMS : G4186

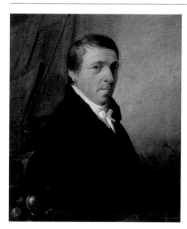

Parker, Henry Perlee 1795–1873
George Gray (1758–1819) 1815–1819
oil on metal 15.7 x 12.6
TWCMS : C13497

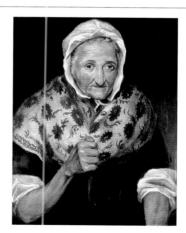

Parker, Henry Perlee 1795–1873
Judy Dowling, Keeper of the Town Hutch
1815–c.1820
oil on canvas 68.8 x 57.1
TWCMS : G4790

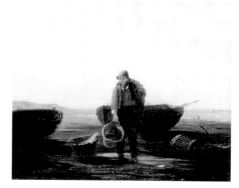

Parker, Henry Perlee 1795–1873
The Fisherman c.1820–1840
oil on canvas 25.4 x 30.5
TWCMS : C13494

Facing page: Ritchie, John, active 1857–1875, *A Border Fair* (detail), c.1865, Laing Art Gallery, (p. 201)

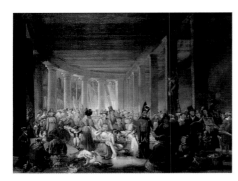

Parker, Henry Perlee 1795–1873
The Old Fish Market, Sandhill, Newcastle upon Tyne c.1826–1830
oil on canvas 115 x 152.1 (E)
TWCMS : D3460

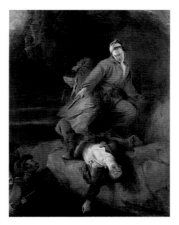

Parker, Henry Perlee 1795–1873
Smugglers Attacked 1827
oil on canvas 144.2 x 109.2
TWCMS : B6675

Parker, Henry Perlee 1795–1873
The Outlook 1834
oil on panel 29.8 x 38.3
TWCMS : D2989

Parker, Henry Perlee 1795–1873
The Banquet Given on the Occasion of the Opening of the Grainger Market, Newcastle upon Tyne, 1835 c.1835
oil on canvas 96 x 159.8
TWCMS : B6666

Parker, Henry Perlee 1795–1873
Smugglers Playing Cards 1837/1847
oil on canvas 61.9 x 50
TWCMS : B6669

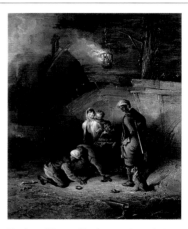

Parker, Henry Perlee 1795–1873
Pitmen Playing Quoits 1840
oil on canvas 82 x 69.5
TWCMS : B6673

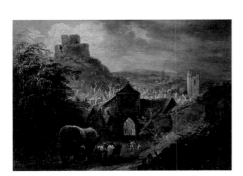

Parker, Henry Perlee 1795–1873
Glastonbury, Somerset
oil on board 14.8 x 19.4
TWCMS : C13485

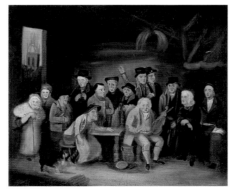

Parker, Henry Perlee (after) 1795–1873
Eccentric Characters of Newcastle
oil on canvas 62.8 x 75.5
TWCMS : G4774

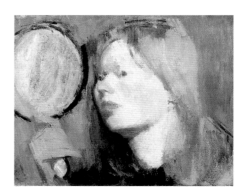

Pasmore, Victor 1908–1998
Girl with a Mirror c.1942–1945
oil on canvas 30.6 x 40.8
TWCMS : C6951

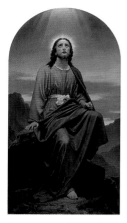

Paton, Joseph Noel 1821–1901
The Man of Sorrows 1875
oil on canvas 224.4 x 118.7
TWCMS : C3926

Pattison, Thomas William 1894–1993
The Building of the New Castle, Newcastle upon Tyne, c.1177 AD c.1925
oil on canvas 245 x 804.5
TWCMS : G4642

Pattison, Thomas William 1894–1993
Tankers at Middle Dock, South Shields
c.1945–1951
oil on canvas 51.7 x 71
TWCMS : C687

Pattison, Thomas William 1894–1993
On the Tyne, Shipbuilding
oil on canvas 198 x 457
TWCMS : G4762

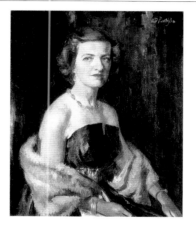

Pattison, Thomas William 1894–1993
Portrait of a Lady
oil on canvas 76.5 x 63.6
TWCMS : G1344

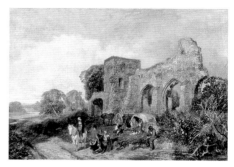

Peel, James 1811–1906
Easby Abbey, North Yorkshire c.1852–1856
oil on canvas 66.2 x 91.7
TWCMS : G1302

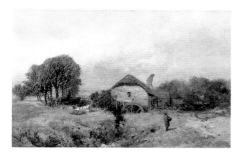

Peel, James 1811–1906
Mill near Sheppard, Devon c.1865
oil on canvas 35.7 x 56.4
TWCMS : F4622

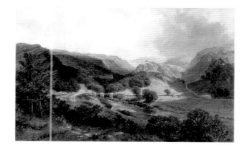

Peel, James 1811–1906
Pont-y-Pant and the Lledr Valley, North Wales
1877
oil on canvas 77 x 122.3
TWCMS : G4602

Peel, James 1811–1906
Cotherstone, Yorkshire
oil on canvas 68.7 x 117.6
TWCMS : G1504

Pelham, Thomas Kent c.1831–1907
An Italian Girl
oil on canvas 91.4 x 63.7
TWCMS : G1742

Penny, Edward (attributed to) 1714–1791
Sir William Benett c.1740–1743
oil on canvas 51 x 35.7
TWCMS : E1160

Peploe, Samuel John 1871–1935
Yellow Tulips and Statuette c.1912–1927
oil on canvas 55.6 x 50.8
TWCMS : B8110

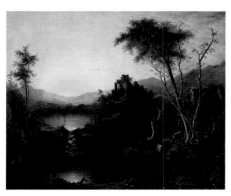

Pether, Sebastian (attributed to) 1790–1844
Landscape with Ruins
oil on canvas 63.4 x 76.4
TWCMS : F13640

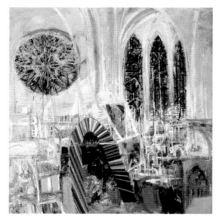

Philipson, Robin 1916–1992
Cathedral Interior, Thanksgiving c.1965
oil on canvas 101.3 x 101.5
TWCMS : G1326

Piper, John 1903–1992
Town from Water Meadows c.1935–1938
oil on canvas 57.8 x 122
TWCMS : C13486

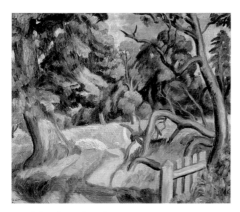

Pitchforth, Roland Vivian 1895–1982
The Elm Tree 1930
oil on canvas 46 x 54.9
TWCMS : F4621

Pitchforth, Roland Vivian 1895–1982
The Removal
oil on canvas 86.5 x 112
TWCMS : C10607

Pittuck, Douglas Frederick 1911–1993
Figures in an Industrial Setting
oil on board 91.5 x 121.8
TWCMS : F4551

Poelenburgh, Cornelis van 1594/1595–1667
Landscape with Ruins and Figures
oil on canvas 38.1 x 31.8
TWCMS : C3947

Pollentine, Alfred 1836–1890
The Grand Canal, Venice 1881
oil on canvas 23.3 x 38.5
TWCMS : E5256 (P)

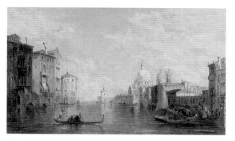

Pollentine, Alfred 1836–1890
Santa Maria della Salute, Venice
oil on canvas 23.5 x 38.8
TWCMS : E5255 (P)

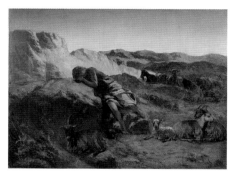

Poole, Paul Falconer 1807–1879
The Prodigal Son 1869
oil on canvas 94.2 x 124.7
TWCMS : G2597

Powell, James
Billy Purvis (1784–1853) c.1820
oil on paper 52.5 x 28.5
TWCMS : C611

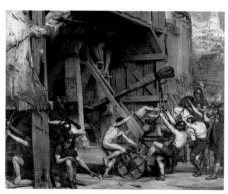

Poynter, Edward John 1836–1919
The Catapult 1868–1872
oil on canvas 155.5 x 183.8
TWCMS : B6377

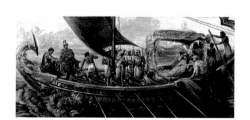

Pringle, Agnes c.1853–1934
The Flight of Antony and Cleopatra from the Battle of Actium c.1897
oil on canvas 99.6 x 198.7
TWCMS : G10308

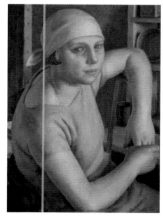

Procter, Dod 1892–1972
Girl in Blue 1925
oil on canvas 61 x 45.5
TWCMS : C9996

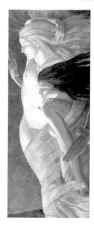

Procter, Ernest 1886–1935
Night and Evening c.1930
oil on canvas 158.2 x 62.4
TWCMS : G466

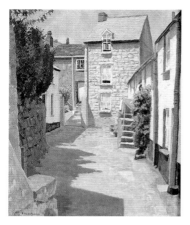

Procter, Ernest 1886–1935
The Cottage c.1931
oil on canvas 61.5 x 51.7
TWCMS : F9124

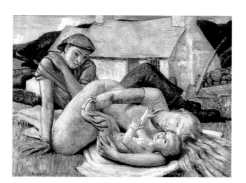

Procter, Ernest 1886–1935
The Family 1935
oil on canvas 77.3 x 102.8
TWCMS : F3499

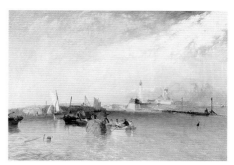

Pyne, James Baker 1800–1870
*The Harbour, Littlehampton, West
Sussex* 1851
oil on canvas 53.7 x 76.5
TWCMS : B8113

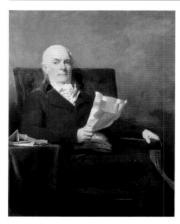

Raeburn, Henry 1756–1823
Robert Allan of Kirkliston (1740–1818) 1800
oil on canvas 125.5 x 100.2
TWCMS : C6959

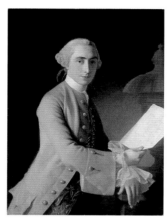

Ramsay, Allan 1713–1784
James Adam (1732–1794) 1754
oil on canvas 91.5 x 68.8
TWCMS : C3923

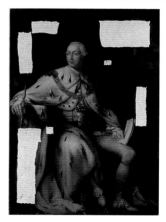

Ramsay, Allan (after) 1713–1784
George III (1738–1820)
oil on canvas 186.8 x 133.3
TWCMS : G4189

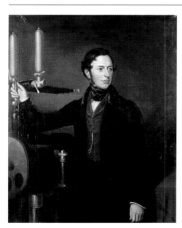

Ramsay, James 1786–1854
William Armstrong (1810–1900) c.1840
oil on canvas 125.7 x 100 (E)
TWCMS : J17289

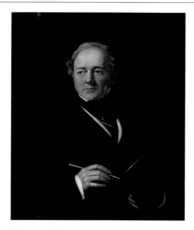

Ramsay, James 1786–1854
Self Portrait 1848
oil on canvas 77.7 x 65.2
TWCMS : G4771

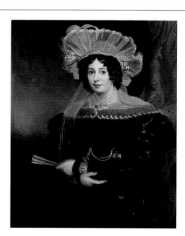

Ramsay, James (attributed to) 1786–1854
Mrs Richard Grainger c.1827
oil on canvas 117.2 x 92
TWCMS : G1942

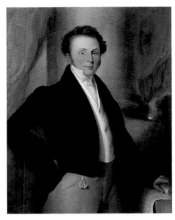

Ramsay, James (attributed to) 1786–1854
Richard Grainger (1797–1861) c.1827
oil on canvas 116.7 x 91.7
TWCMS : G1943

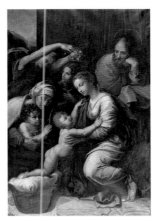

Raphael (after) 1483–1520
The Holy Family of Francis I 19th C
oil on canvas 214.5 x 144.4
TWCMS : G4161

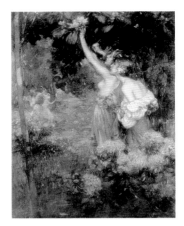

Rea, Cecil Wiliam 1860–1935
Fields Elysian c.1906
oil on canvas 112.2 x 87
TWCMS : G2600

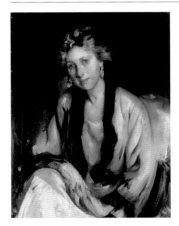

Rea, Cecil Wiliam 1860–1935
Portrait of a Lady
oil on canvas 91.2 x 70.8
TWCMS : F3500

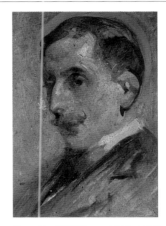

Rea, Cecil Wiliam 1860–1935
Self Portrait
oil on board 30.6 x 21.8
TWCMS : G2822

Redfern, June b.1951
The Arc 1985
oil on canvas 240 x 121.5 (E)
TWCMS : M5128.2

Redfern, June b.1951
The Arc 1985
oil on canvas 240 x 121.5 (E)
TWCMS : M5128.1

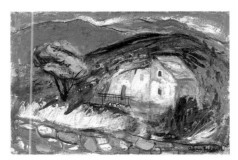

Redpath, Anne 1895–1965
The Valley of San Martino di Lota, Corsica
c.1950–1960
oil on board 50.6 x 76.2
TWCMS : C9992

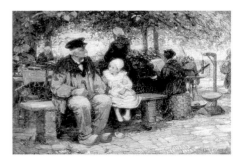

Reid, Flora 1860–c.1940
Comrades 1905
oil on canvas 62.3 x 92.5
TWCMS : G1311

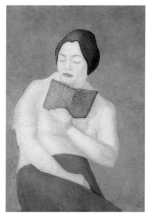

Reuss, Albert 1889–1976
Lady Reading a Book c.1940–1945
oil on canvas 58.8 x 40.8
TWCMS : C673

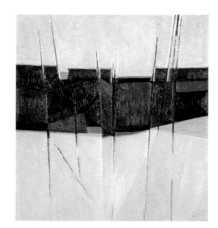

Reynolds, Alan b.1926
Pastoral 1959
oil on board 111.5 x 101.1
TWCMS : G1999

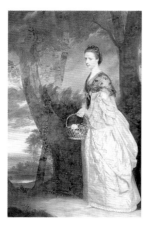

Reynolds, Joshua 1723–1792
Mrs Elizabeth Riddell (1730–1798) 1763
oil on canvas 239 x 148.5
TWCMS : E1197

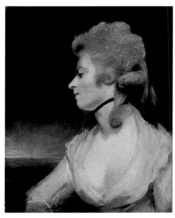

Reynolds, Joshua (after) 1723–1792
Mrs Robinson (1758–1800) late 18th C
oil on canvas 64 x 50.8
TWCMS : C3945

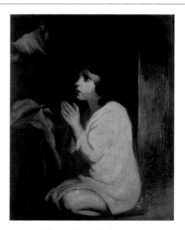

Reynolds, Joshua (after) 1723–1792
The Infant Samuel late 18th C
oil on canvas 86.4 x 69.6
TWCMS : G2809

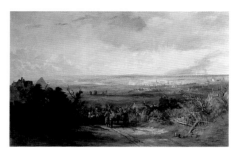

Richardson, Thomas Miles I 1784–1848
Newcastle from Gateshead Fell c.1816
oil on canvas 142.2 x 233.7
TWCMS : B6691

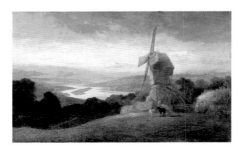

Richardson, Thomas Miles I 1784–1848
The Tyne from Windmill Hills, Gateshead
c.1818 (?)
oil on canvas 75.1 x 122.7
TWCMS : B6678

Richardson, Thomas Miles I 1784–1848
The Old Mill, Ambleside, Cumbria c.1822
oil on canvas 64.5 x 91.4
TWCMS : F5171

Richardson, Thomas Miles I 1784–1848
Barnard Castle, County Durham c.1826
oil on canvas 77.1 x 107.6
TWCMS : G2334

Facing page: Procter, Dod, 1892–1972, *Girl in Blue* (detail), 1925, Laing Art Gallery, (p. 195)

Richardson, Thomas Miles I 1784–1848
*Evening View on Heaton Dene, Lancashire,
from an Eminence near Mable's Mill* 1831
oil on canvas 96.5 x 134.7
TWCMS : B6690

Richardson, Thomas Miles I 1784–1848
*Young Anglers, Barras Bridge, Newcastle upon
Tyne* before 1835
oil on canvas 99.3 x 83.3
TWCMS : B6679

Richardson, Thomas Miles I 1784–1848
Jedburgh Abbey, Scotland c.1835
oil on canvas 43.4 x 63.9
TWCMS : F4638

Richardson, Thomas Miles I 1784–1848
Lindisfarne Priory, Northumberland 1837 (?)
oil on canvas 72.8 x 107.3
TWCMS : B6659

Richardson, Thomas Miles I 1784–1848
Teesdale, County Durham 1840
oil on panel 35.3 x 53.4
TWCMS : F4631

Richardson, Thomas Miles I 1784–1848
Lake Lucerne with William Tell's Chapel 1844
oil on canvas 66.3 x 91.4
TWCMS : G500

Richardson, Thomas Miles I 1784–1848
*Excavations for the High Level Bridge,
Newcastle upon Tyne* c.1846
oil on canvas 96.7 x 83.2
TWCMS : B6658

Richardson, Thomas Miles I 1784–1848
Conway Castle, North Wales
oil on canvas 109.4 x 165.3
TWCMS : G3887

Richardson, Thomas Miles I (attributed to)
1784–1848
Landscape, Bridge and Figures
oil on canvas 51 x 76.5
TWCMS : F4618

Richardson, Thomas Miles I (attributed to)
1784–1848
Percy Bay, Tynemouth
oil on canvas 50.5 x 76.1
TWCMS : C667

Richardson, Thomas Miles II 1813–1890
Highland Lake Scene
oil on board 25 x 38.1
TWCMS : D1286

Richardson, Thomas Miles II 1813–1890
Tynemouth Castle from Percy Bay
oil on board 24.7 x 36.6
TWCMS : D1285

Richmond, William Blake 1842–1921
The Hun and the Crucifix
oil on panel 41.9 x 53.4
TWCMS : C671

Ritchie, John active 1857–1875
A Border Fair c.1865
oil on canvas 69 x 106.5
TWCMS : H18251

Roberts, David 1796–1864
Edinburgh Castle from the Grassmarket 1837
oil on panel 50.5 x 40
TWCMS : B8114

Roberts, Derek b.1947
Early Summer 1984
oil on canvas 87.2 x 68.1
TWCMS : P597

Robertson, Charles Kay active 1888–1931
Judge William Digby Seymour before 1894
oil on canvas 142.8 x 112
TWCMS : G4177

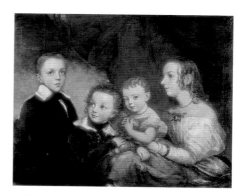

Robertson, Christina active 1823–1850
A Group of Children c.1850
oil on canvas 102.2 x 127.5
TWCMS : G3898

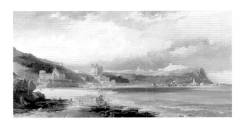

Roe, Henry Robert
Scarborough, North Yorkshire 1882
oil on canvas 61.2 x 122.2
TWCMS : G1342

Rogers, Claude 1907–1979
The Broad Walk, Regent's Park 1938
oil on canvas 71.1 x 91.5
TWCMS : G4613

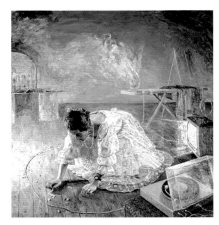

Rowe, Elizabeth b.1955
Dysphoria 1990
oil on canvas 224.5 x 212.5
TWCMS : S1516

Rowntree, Kenneth 1915–1997
Black Painting 1 1962
oil on hessian 59.4 x 60.5
TWCMS : C645

Rowntree, Kenneth 1915–1997
West Front, Durham 1974
acrylic, clay & wood on textile 70.9 x 70.1
TWCMS : C644

Royle, Stanley 1888–1961
Dappled Sunlight on Snow 1924
oil on canvas 71.1 x 91.5
TWCMS : G1346

Ruben, Franz Leo 1842–1920
Venice 1884
oil on canvas 60 x 86.4
TWCMS : G10312

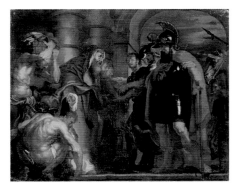

Rubens, Peter Paul (after) 1577–1640
The Meeting of Abraham and Melchisedech
18th C (?)
oil on canvas 93.2 x 116.5
TWCMS : G3894

Ryott, James Russell c.1788–1851
Newgate, Newcastle upon Tyne c.1820
oil on board 33.7 x 46.5
TWCMS : C10616

Ryott, James Russell c.1788–1851
The Keep, Newcastle upon Tyne 1830
oil on board 35 x 47.3
TWCMS : G4782

Sadler, Walter Dendy 1854–1923
The Village Postman c.1880–1900
oil on canvas 86.8 x 61.3
TWCMS : G2333

Saedeleer, Valerius de 1867–1942
Landscape with Apple Tree
oil on canvas 36.2 x 43.9
TWCMS : C13503

Sanquirico, Alessandro 1777–1849
*View of the Projected Foro Bonaparte, Milan
1800* c.1800
oil on canvas 53.2 x 91.8
TWCMS : C3936

Sansbury, Geoff b.1941
A1(M) to Zoe 1962
card, oil & paper on board 152.3 x 152.1
TWCMS : G4181

Sansbury, Geoff b.1941
*Two Interior States. Blossom/Small Black
Menace* 1967
oil on canvas 150.8 x 150.8
TWCMS : G2348

Sargeant, Gary b.1939
Viaduct, Durham 1962
oil & newspaper on board 59.2 x 75
TWCMS : G12961

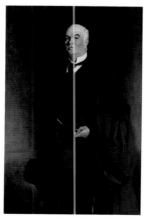

Sargent, John Singer 1856–1925
Henry Richardson 1902
oil on canvas 147.7 x 97.7
TWCMS : C607

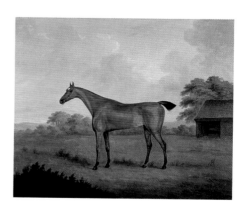

Sartorius, John Nost 1759–1828
Chestnut Horse in a Landscape 1815
oil on canvas 63.4 x 77.3
TWCMS : G4627

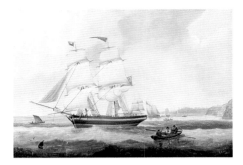

Scott, John 1802–1885
Seascape with Shipping 1845
oil on canvas 53.5 x 76.3
TWCMS : C675

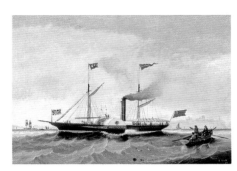

Scott, John 1802–1885
The Steam Tug 'Alfred' off Tynemouth c.1856
oil on canvas 53.4 x 76.1
TWCMS : F5182

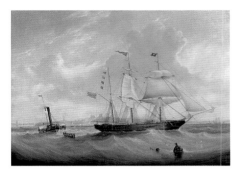

Scott, John 1802–1885
The Sailing Ship 'Anne' Leaving the River Tyne
1859
oil on canvas 75.6 x 106
TWCMS : B6674

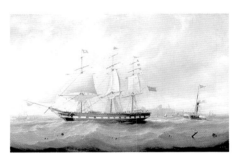

Scott, John 1802–1885
Tynemouth with Shipping 1859
oil on canvas 75.2 x 116.4
TWCMS : G1336

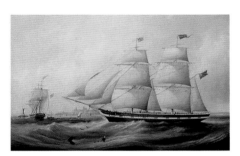

Scott, John 1802–1885
The Sailing Ship 'Isabella' 1861
oil on canvas 61.3 x 91.8
TWCMS : F4793

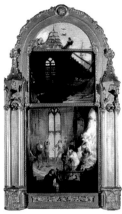

Scott, William Bell 1811–1890
*Bell-Ringers and Cavaliers Celebrating the
Entrance of Charles II into London on
Restoration* c.1842
oil on canvas 98.6 x 41.5
TWCMS : B8142

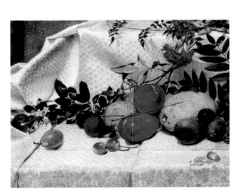

Scott, William Bell 1811–1890
Study of Flowers and Fruit 1860
oil on canvas 30.7 x 40.6
TWCMS : B8143

Seddon, Christine b.1915
Standing Figure and Landscape No.4 1970
oil on canvas 91.4 x 45.9
TWCMS : 1994.103

Sefton, Brian b.1938
Landscape Reference, Over and Under 1966
oil on canvas 149.3 x 121.5
TWCMS : G1992

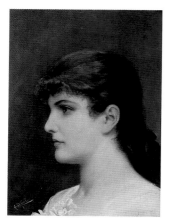

Seifert, Alfred 1850–1901
Study of a Head
oil on panel 35.5 x 26.7
TWCMS : C13511

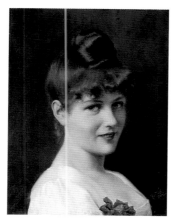

Seifert, Alfred 1850–1901
Study of a Head
oil on panel 35 x 26.7
TWCMS : C13512

Shackleton, William 1872–1933
Amberley 1902
oil on canvas 55 x 116
TWCMS : C3925

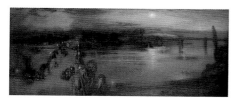

Shackleton, William 1872–1933
Putney Bridge 1903
oil on canvas 55.7 x 125
TWCMS : C3927

Shackleton, William 1872–1933
Study for 'The Mussel Gatherers'
oil on board 29.4 x 41.2
TWCMS : G1730

Sharkey, J.
Alnwick Castle, Northumberland 1850
oil on canvas 23 x 30.2
TWCMS : G4197

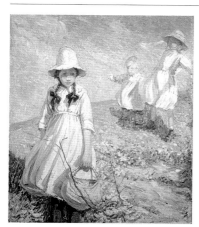

Sharp, Dorothea 1874–1955
The Primrose Way before 1916
oil on canvas 120 x 91.7
TWCMS : F5115

Shaw, John Byam Liston 1872–1919
The Fool Who Would Please Every Man 1903
oil on canvas 98.7 x 128.6
TWCMS : G2808

Shayer, William 1788–1879
Landscape with Cattle
oil on canvas 61.2 x 50.8
TWCMS : C696

Shayer, William (attributed to) 1788–1879
Gypsy Encampment
oil on canvas 40.6 x 61
TWCMS : C13516

Sheringham, George 1884–1937
Fan Design
oil on paper 31.5 x 50.5
TWCMS : B651

Sherrin, David b.1868
Near Guildford, Surrey
oil on canvas 107.2 x 167.5
TWCMS : G4151

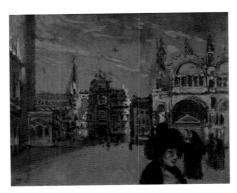

Sickert, Walter Richard 1860–1942
Piazza San Marco, Venice c.1903–1906
oil on canvas 40.7 x 50.8
TWCMS : C10621

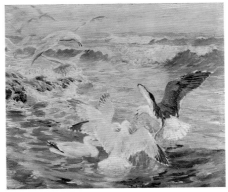

Simpson, Charles Walter 1885–1971
Herring Gulls and a Black Back c.1913
oil on canvas 183.2 x 217.9
TWCMS : G4171 (P)

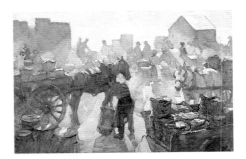

Simpson, Charles Walter 1885–1971
The Herring Season c.1924
oil on canvas 122.2 x 183.5
TWCMS : F4646

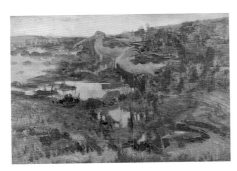

Simpson, Charles Walter 1885–1971
Marshland
oil on card 50.6 x 73.5
TWCMS : F9119

Simpson, Charles Walter 1885–1971
The Afterglow
oil on board 51 x 61
TWCMS : F4786

Simpson, William Graham b.1855
Thomas Young (d.1888) 1876
oil on canvas 112 x 86.5
TWCMS : H3608

Singleton, Henry 1766–1839
Lingo and Cowslip
oil on canvas 33.8 x 29.6
TWCMS : E3540

Skelton, Joseph Ratcliffe 1865–1927
Kirkstall Abbey, Leeds
oil on canvas 37.9 x 53.4
TWCMS : G2824

Slater, John Falconar 1857–1937
Quayside at North Shields c.1890–1910
oil on canvas 93 x 123
TWCMS : 1994.107

Slater, John Falconar 1857–1937
The Wood Cart c.1890–1910
oil on card 54.7 x 78.6
TWCMS : G2828

Slater, John Falconar 1857–1937
Seascape c.1890–1920
oil on canvas 50.4 x 76.3
TWCMS : F4790

Slater, John Falconar 1857–1937
Winter Scene c.1890–1920
oil on card 54.4 x 76.9
TWCMS : G2827

Slater, John Falconar 1857–1937
Two Horses and a Caravan c.1900–1920
oil on canvas 64.5 x 77.5
TWCMS : C612

Slater, John Falconar 1857–1937
Seascape 1905
oil on canvas 76.6 x 127.3
TWCMS : G1506

Slater, John Falconar 1857–1937
Cullercoats, Northumberland 1910
oil, pencil & watercolour on card 60.7 x 43.6
TWCMS : G3351

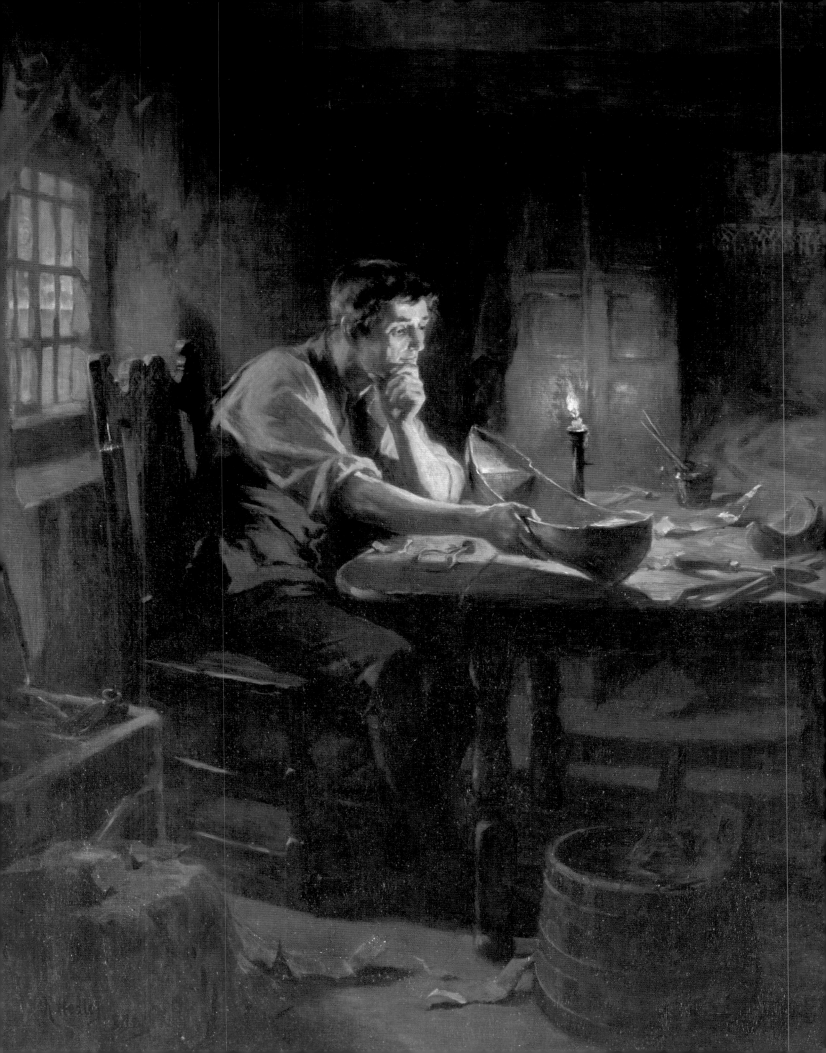

Slater, John Falconar 1857–1937
A Glen
oil on canvas 35.6 x 25.5
TWCMS : C10032

Slater, John Falconar 1857–1937
Cottage and Stream
oil on board 37.4 x 53.1
TWCMS : G1705

Slater, John Falconar 1857–1937
Hexham, Northumberland
oil on canvas 147.4 x 239
TWCMS : G4632

Slater, John Falconar 1857–1937
Landscape with Mountain Stream
oil on board 91.6 x 70.9
TWCMS : G3892

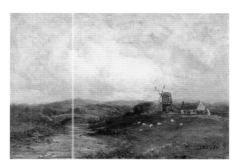

Slater, John Falconar 1857–1937
Landscape with Windmill
oil on board 37.6 x 54.1
TWCMS : G1703

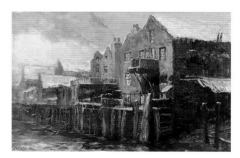

Slater, John Falconar 1857–1937
North Shields, North Tyneside
oil on canvas 50.3 x 75.6
TWCMS : G539

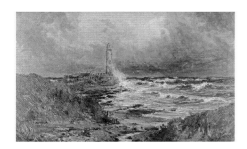

Slater, John Falconar 1857–1937
St Mary's Lighthouse
oil on canvas 76.5 x 126.9
TWCMS : G1514

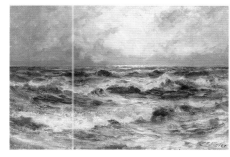

Slater, John Falconar 1857–1937
Seascape
oil on canvas 50.8 x 76.3
TWCMS : F5181

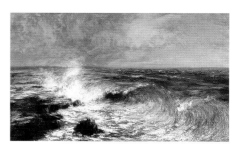

Slater, John Falconar 1857–1937
Seascape
oil on canvas 76.6 x 127.4
TWCMS : G523

Facing page: Hedley, Ralph, 1848–1913, *The Invention of the Lifeboat* (detail), 1896, South Shields Museum and Art Gallery, (p. 255)

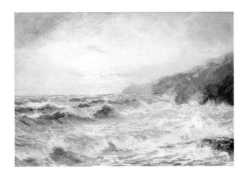

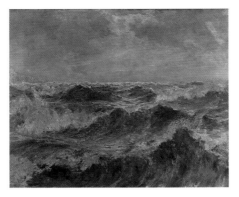

Slater, John Falconar 1857–1937
Seascape
oil on card 55.9 x 78.4
TWCMS : G2826

Slater, John Falconar 1857–1937
Seascape
oil on canvas 107.3 x 129.4
TWCMS : G3891

Slater, John Falconar 1857–1937
Tynemouth Pier
oil on canvas 83.9 x 221.6
TWCMS : G3885

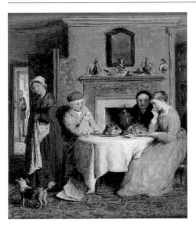

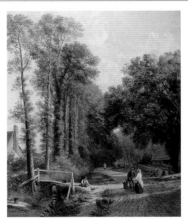

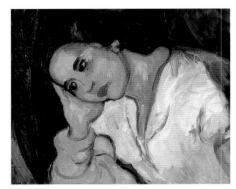

Smith, George 1829–1901
Study for 'The Early Visitor'
oil on panel 20.9 x 17.6
TWCMS : D1289

Smith, George V.
Country Lane 1863
oil on canvas 61 x 50.6
TWCMS : F3490

Smith, Matthew Arnold Bracy 1879–1959
Creole Girl c.1923–1924
oil on canvas 50 x 60.8
TWCMS : C6953

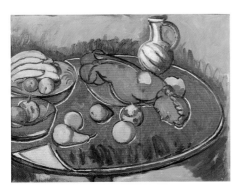

Smith, Matthew Arnold Bracy 1879–1959
Still Life with Green Background 1955
oil on canvas 71.2 x 91.5
TWCMS : B7403

Smyth, Montague 1863–1965
An Eventide
oil on canvas 67.7 x 100.8
TWCMS : G499

Snow, John Wray 1800–1854
Charles William Bigge (1773–1849) c.1836
oil on canvas 127 x 101
TWCMS : E3734

Spear, Ruskin 1911–1990
Still Life with Fish c.1948
oil on canvas 46.3 x 61.3
TWCMS : C6955

Spencelayh, Charles 1865–1958
A Cure for Everything c.1947
oil on canvas 71.2 x 91.8
TWCMS : F3496

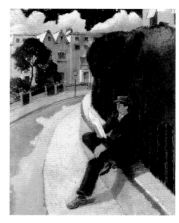

Spencer, Gilbert 1893–1979
Lansdowne Crescent, London 1931
oil on panel 40.5 x 32.5
TWCMS : C9995

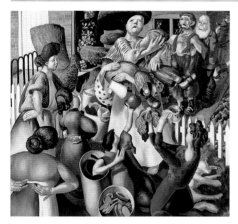

Spencer, Stanley 1891–1959
The Lovers (The Dustmen) 1934
oil on canvas 115 x 123.5
TWCMS : B7412

Spenlove-Spenlove, Frank 1866–1933
The Green Shutters, Viaticum, Belgium 1918
oil on canvas 76.8 x 129
TWCMS : G1516

Stephenson, Kate active late 19th C
William Stephenson
oil on canvas 75.5 x 59.2 (E)
TWCMS : 1994.671

Stevenson, Bernard Trevor Whitworth
1899–1985
Lock near Barnoldswick, Lancashire 1940
oil on board 50.9 x 60.8
TWCMS : C13469

Sticks, George Blackie 1843–1938
Tantallon Castle, near Berwick, Scotland 1872
oil on canvas 121.6 x 91.7
TWCMS : G2331

Sticks, George Blackie 1843–1938
*Derwentwater and Bassenthwaite Lakes,
Keswick* 1877
oil on canvas 46 x 35.8
TWCMS : E3536

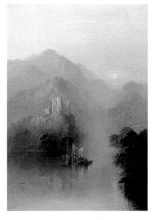

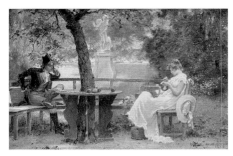

Sticks, George Blackie 1843–1938
Mountainous Landscape and Stream, Keswick
1877
oil on canvas 45.7 x 35.4
TWCMS : G2829

Sticks, George Blackie 1843–1938
Dewy Eve 1883
oil on canvas 76.4 x 51.4
TWCMS : G521

Stone, Marcus C. 1840–1921
In Love 1913
oil on canvas 31.1 x 48.8
TWCMS : D1293

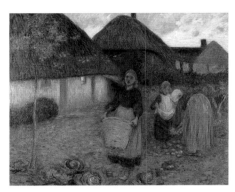

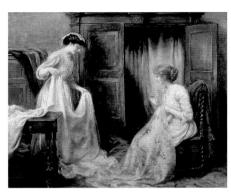

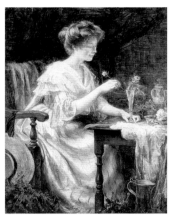

Stott, Edward 1859–1918
The Widow's Acre c.1900
oil on canvas 60.1 x 74.8
TWCMS : B6654

Straker, Henry 1860–1943
The Linen Cupboard c.1900
oil on canvas 92 x 114.3
TWCMS : G2000

Straker, Henry 1860–1943
Her Task c.1910
oil on canvas 91.7 x 71.4
TWCMS : G2052

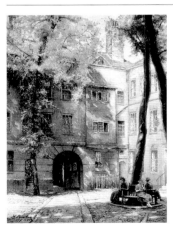

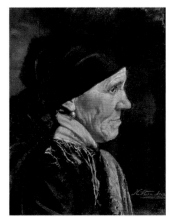

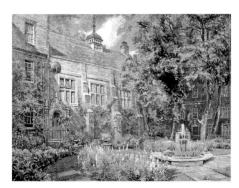

Straker, Henry 1860–1943
Hanover Square 1922
oil on canvas 91.7 x 71.4
TWCMS : G1304

Straker, Henry 1860–1943
Bavarian Peasant Woman
oil on canvas 49.7 x 39
TWCMS : F9137

Straker, Henry 1860–1943
Garden
oil on canvas 70.9 x 91.5
TWCMS : F5168

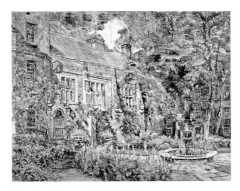

Straker, Henry 1860–1943
Garden
oil on canvas 70.9 x 91.1
TWCMS : F5169

Straker, Henry 1860–1943
Garden Scene
oil on canvas 64 x 87.7
TWCMS : F4789

Straker, Henry 1860–1943
Interior Study
oil on canvas 61.5 x 39
TWCMS : G12988

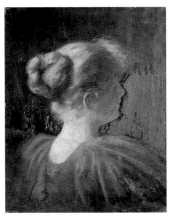

Straker, Henry 1860–1943
Portrait of a Woman in Profile
oil on canvas 62 x 48.7
TWCMS : G2830

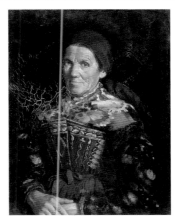

Straker, Henry 1860–1943
Portrait of an Old Woman
oil on canvas 73.5 x 56.5
TWCMS : G511

Straker, Henry 1860–1943
Ruins in a Wood
oil on canvas 79.8 x 60.2
TWCMS : G510

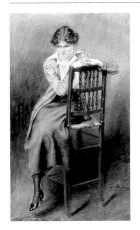

Straker, Henry 1860–1943
Seated Woman
oil on canvas 70.9 x 42.6
TWCMS : G505

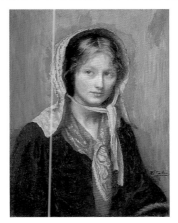

Straker, Henry 1860–1943
Tess
oil on canvas 71.1 x 56.3
TWCMS : G506

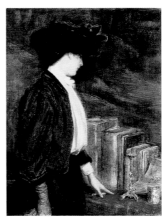

Straker, Henry 1860–1943
Woman Looking at Books
oil on canvas 71.3 x 53.6
TWCMS : G507

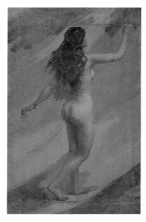

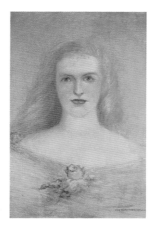

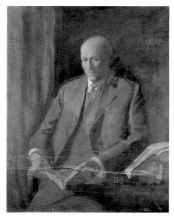

Straker, Henry (attributed to) 1860–1943
Nude Female Figure
oil on canvas 76.8 x 48
TWCMS : F5184

Strother-Stewart, Ida Lillie 1890–1954
Francis, Wife of Ronald Adamson
oil on canvas 65.4 x 47.2
TWCMS : G4793

Strother-Stewart, Ida Lillie 1890–1954
Portrait of a Man
oil on canvas 110.7 x 85.3
TWCMS : F5165

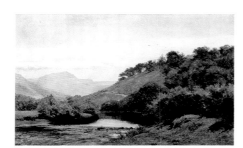

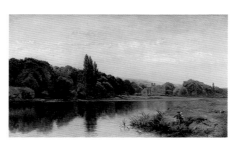

Surtees, John 1819–1915
On the Lledr, Wales 1870
oil on canvas 40.2 x 66.3
TWCMS : C13488

Surtees, John 1819–1915
*Summertime on the Thames, Bisham Church
and Abbey, Berkshire* c.1875
oil on canvas 61.6 x 107.5
TWCMS : G1350

Surtees, John 1819–1915
Portrait of an Old Woman
oil on panel 28 x 21.7
TWCMS : D4807

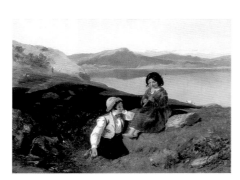

Surtees, John 1819–1915
Young Companions
oil on canvas 45.5 x 60.5
TWCMS : E3534

Sutton, Philip b.1928
View from Falmouth, Cornwall 1970
oil on canvas 127 x 127
TWCMS : B6376

Swan, Douglas 1930–2000
The Milking Machine
oil on canvas 113.5 x 92.9
TWCMS : G1341

Swarbreck, Samuel Dukinfield c.1799–1863
Rosslyn Chapel, Roslin, Midlothian c.1853
oil on canvas 33.2 x 28.3
TWCMS : D1288

Swift, John Warkup 1815–1869
Seascape with Boats
oil on canvas 61 x 91.4 (E)
TWCMS : G1312

Swift, John Warkup 1815–1869
Seascape with Shipping
oil on canvas 61 x 91.8 (E)
TWCMS : G1503

Swinburne, Marjorie
Four Hour Sketch 1926
oil on canvas 49.6 x 41
TWCMS : C670

Swinburne, Marjorie
Portrait of a Man
oil on canvas 50.2 x 40.6
TWCMS : G2833

Syer, John 1815–1885
Mountainous Landscape
oil on canvas 66.7 x 107
TWCMS : G517 (P)

Talmage, Algernon Mayow 1871–1939
Freshness of Morning 1920
oil on canvas 63.5 x 76.2
TWCMS : F4791

Teasdale, John 1848–1926
Black Gate c.1884
oil on canvas 30.7 x 23.7
TWCMS : G4784

Teniers, David II (after) 1610–1690
Interior with Figures 19th C
oil on panel 35 x 25
TWCMS : E3541

Thomson, John Leslie 1851–1929
Washing Place, Normandy c.1918
oil on canvas 55.7 x 96.6
TWCMS : F4648

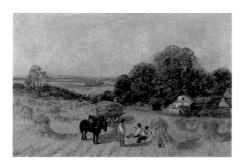

Thorpe, W. (attributed to) active 19th C
Cornfield
oil on canvas 40.5 x 61.2
TWCMS : F5180

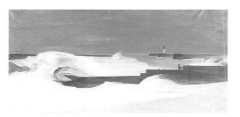

Thubron, Harry 1915–1985
Winter Sea 1951
oil on canvas 60.3 x 122
TWCMS : F13602

Thubron, Harry 1915–1985
Painting in Plaster and Plaster Cloth 1960
oil, cloth & plaster on board 70.5 x 66.6
TWCMS : G509

Tirr, Willy 1915–1991
Abstract 1962
oil on canvas 152.9 x 122.2
TWCMS : H991

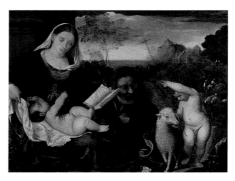

Titian (style of) c.1488–1576
The Holy Family with Saint John 17th-18th C
oil on panel 55.4 x 73.5
TWCMS : G530

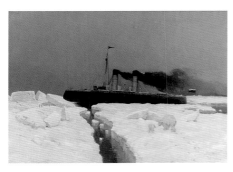

Tolidze, S.
Ice Breaker 'Ermac' 1899
oil on canvas 80.8 x 118.3
TWCMS : G1510

Torrance, James 1859–1916
April, Boat of Garten, Scotland
oil on panel 26.2 x 35.3
TWCMS : C10648

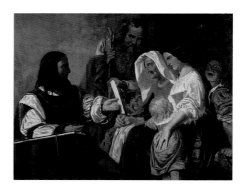

Townsend, Henry James 1810–1890
Leonardo and His Models c.1846
oil on canvas 137.8 x 177.8
TWCMS : G3303

Facing page: Reuss, Albert, 1889–1976, *The Poet* (detail), 1948, Shipley Art Gallery, (p. 67)

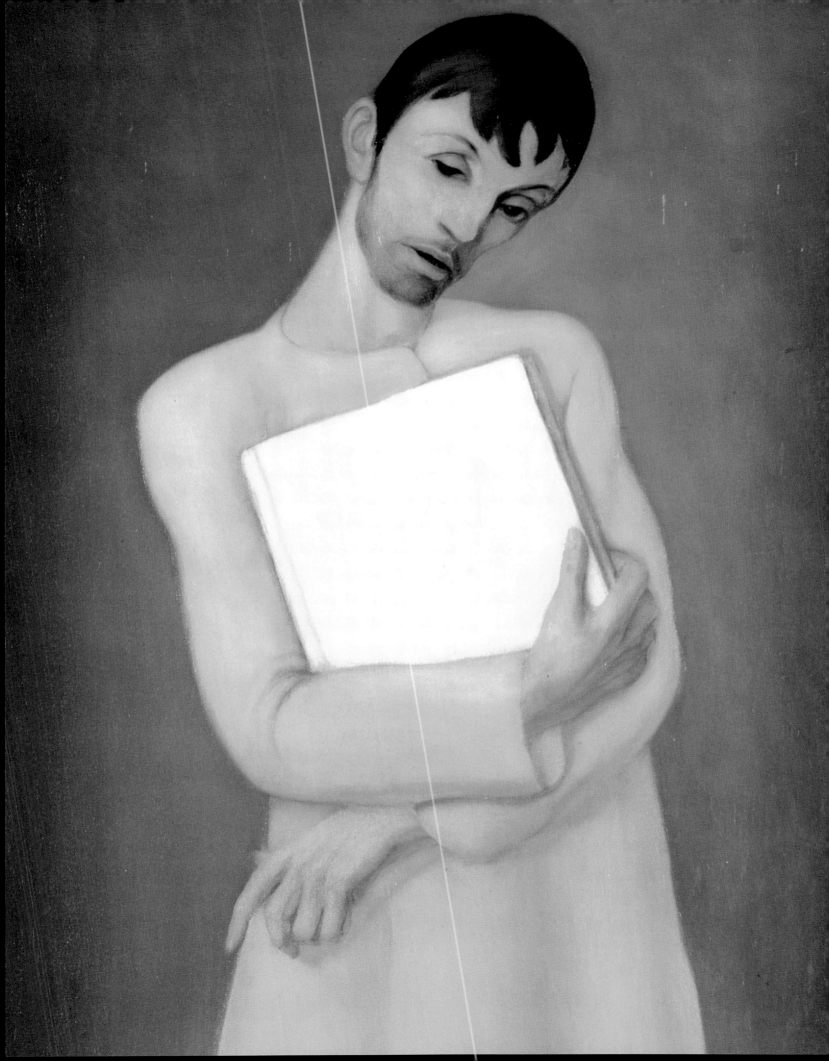

Train, Edward 1801–1866
Mountainous Landscape 1848
oil on canvas 72.2 x 101.2
TWCMS : G4606

Train, Edward 1801–1866
Landscape with Waterfall 1859
oil on canvas 46 x 38
TWCMS : C672

Tucker, James Walker 1898–1972
Amiens, France 1922
oil on canvas 51.2 x 60.8
TWCMS : C678

Tucker, James Walker 1898–1972
*Charles I in Newcastle upon Tyne, 13 May
1646* before 1931
oil & pencil on canvas 249.5 x 810.5
TWCMS : G4638

Tucker, James Walker 1898–1972
Gathering Shell Fish, St Servan, France c.1932
tempera on panel 25 x 35.5
TWCMS : C13525

Tucker, James Walker 1898–1972
Hiking c.1936
tempera on panel 51.2 x 60.3
TWCMS : B6676

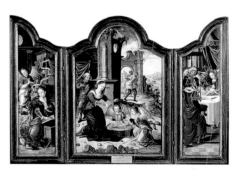

Tudgay, I. active 1836–1865
Seascape 1850
oil on canvas 61 x 91.5
TWCMS : F13250

Tunnard, John 1900–1971
Installation A 1939
oil, bodycolour & watercolour on canvas
76 x 121.8
TWCMS : C6957

unknown artist 15th C
Annunciation (left wing), *Nativity* (centre
panel), *Circumcision* (right wing)
oil on panel 72 x 20.2; 71.4 x 47.7; 72 x 20.3
TWCMS : F4613

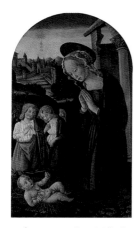

unknown artist 15th C
Madonna and Child with Two Angels in a Landscape
tempera on panel 70.8 x 41.5
TWCMS : G546

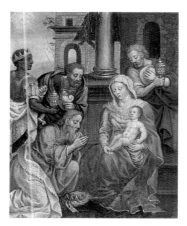

unknown artist 16th C
The Adoration of the Magi
oil on panel 10.2 x 8.1
TWCMS : G3337

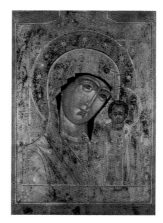

unknown artist late 16th C–early 17th C
Icon of Virgin and Child
metal & oil on plaster 45 x 33.7
TWCMS : E8245

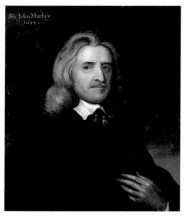

unknown artist
Sir John Marlay 1644
oil on canvas 76.2 x 63.3
TWCMS : G4788

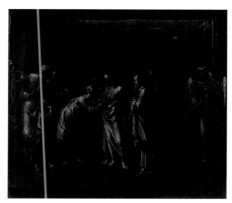

unknown artist 17th C
Christ Appearing to the Disciples
oil on canvas 67.3 x 75.8
TWCMS : E3535

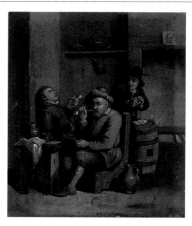

unknown artist 17th C
Dutch Interior
oil on metal 20.2 x 16.8
TWCMS : C10025

unknown artist 17th C
Head of St John
oil on canvas 35 x 44.3
TWCMS : G3372

unknown artist 17th C
St Joachim and the Virgin Mary
oil on canvas 148.9 x 92.7
TWCMS : G4194

unknown artist 17th C
The Flight into Egypt
oil on canvas 100 x 149.5
TWCMS : G4159

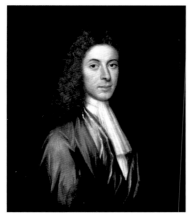

unknown artist
George Bacon (c.1674–1702/1703) c.1700
oil on canvas 75.5 x 62.9
TWCMS : C641

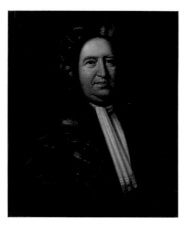

unknown artist
John Bacon (1644/1645–1736) c.1710–1720
oil on canvas 76.3 x 62.7
TWCMS : F3467

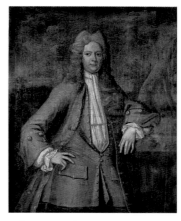

unknown artist
Portrait of a Gentleman c.1710–1720
oil on canvas 127.5 x 104.5
TWCMS : F3469

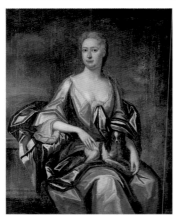

unknown artist
Portrait of a Lady c.1710–1720
oil on canvas 128 x 104.3
TWCMS : F3468

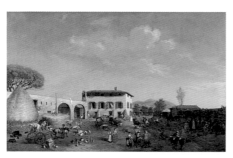

unknown artist
A Farmyard c.1740
oil on canvas 62.2 x 93.2
TWCMS : C3932

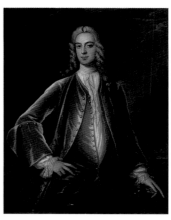

unknown artist
Sir William Middleton (d.1757) c.1740–1750
oil on canvas 127 x 102.2
TWCMS : C3948

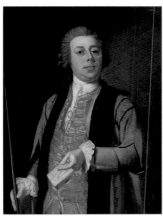

unknown artist
Portrait of a Newcastle Alderman
c.1760–1770
oil on canvas 91.7 x 71.1
TWCMS : F3465

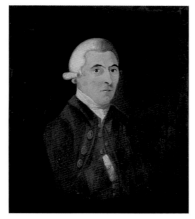

unknown artist
Benjamin Gibson c.1770–1780
oil on canvas 75.3 x 64.5
TWCMS : F3466

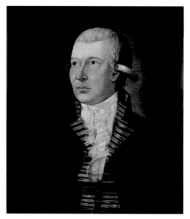

unknown artist
Richard Errington (1720–1796) c.1780
oil on canvas 61.4 x 52
TWCMS : F3464

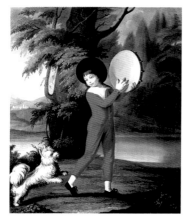

unknown artist
Boy Holding a Tambourine, with a Dog
c.1780–1800
oil on canvas 76.4 x 63.7
TWCMS : G4182

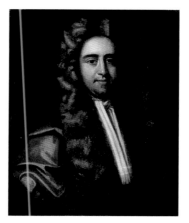

unknown artist early 18th C
William Bacon (d.1748)
oil on canvas 75.5 x 60.8
TWCMS : F3463

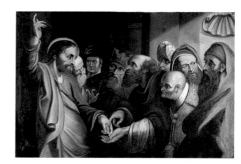

unknown artist 18th C (?)
Christ and the Tribute Money
oil on canvas 99.8 x 146.3
TWCMS : G3886

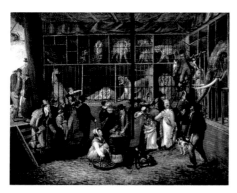

unknown artist
Menagerie 1810–c.1820
oil on canvas 65.4 x 82.6
TWCMS : C625

unknown artist
New Bridge over Pandon Dene, Newcastle upon Tyne c.1812
oil on canvas 61 x 91.6
TWCMS : C690

unknown artist
Robert Laidlaw (1783–1855) 1823 (?)
oil on canvas 91.6 x 71.6
TWCMS : G1322

unknown artist
Mary Ann Laidlaw (1799–1870) 1823 (?)
oil on canvas 91.6 x 71
TWCMS : F13613

unknown artist
'A' Pit, Backworth, Newcastle upon Tyne
1823–1867
oil on canvas 43 x 54 (E)
TWCMS : 2002.1678

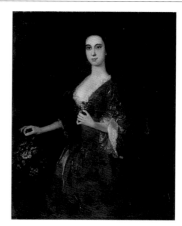

unknown artist
Portrait of a Lady c.1840
oil on canvas 126.7 x 101.4
TWCMS : D4841

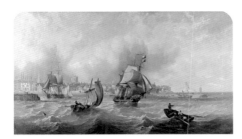

unknown artist
Mouth of River 1843 (?)
oil on canvas 66 x 113.8
TWCMS : G525

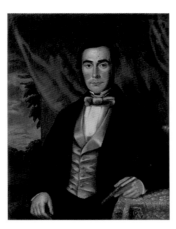

unknown artist
Thomas Green, Painter 1852
oil on canvas 223.2 x 148.5
TWCMS : 1994.664

unknown artist
Billy Purvis (1784–1853) 1854
oil on canvas 47.3 x 44.5
TWCMS : G4191

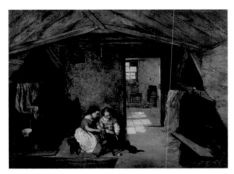

unknown artist
Reverend John Wesley's Study, Orphan House,
Newcastle, 1856 c.1856
oil on canvas 46.1 x 61.3
TWCMS : D1291

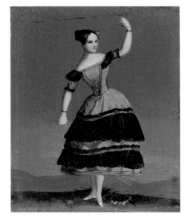

unknown artist
Dancing Girl before 1859
oil & ink on metal 9.6 x 7.5
TWCMS : E5252

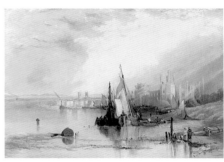

unknown artist
Caernarvon Castle, North Wales 1859
oil on canvas 60.9 x 87.7
TWCMS : F4798

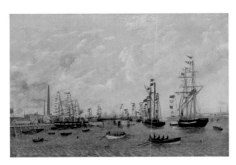

unknown artist
The Opening of Tyne Dock, 3 March
1859 c.1860
oil on canvas 60 x 91
TWCMS : 1999.1628

unknown artist
Still Life 1879
oil on canvas 61.3 x 50.7
TWCMS : G12987

unknown artist early 19th C
Armoured Soldiers in Mountainous Landscape
oil on canvas 139.4 x 192.6
TWCMS : G3889

unknown artist early 19th C
Portrait of Two Women
oil on canvas 24.3 x 29.4
TWCMS : D4810

unknown artist mid-19th C
Landscape
oil on canvas 33.5 x 45.9
TWCMS : D3000

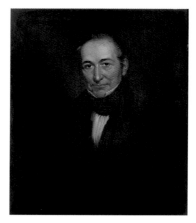

unknown artist mid-19th C
William Armstrong
oil on canvas 76.6 x 63.6
TWCMS : G529

unknown artist 19th C
Billy Purvis (1784–1853)
oil on board 50.5 x 40.1
TWCMS : B6386

unknown artist 19th C
Billy Purvis (1784–1853)
oil on canvas 75.9 x 63.4
TWCMS : B6388

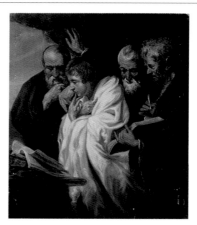

unknown artist 19th C
Christ in the Temple
oil on canvas 55.8 x 48
TWCMS : G4190

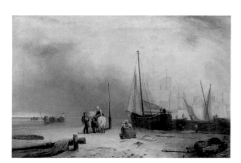

unknown artist 19th C
Coast Scene with Boats and Figures
oil on canvas 61.5 x 91.5
TWCMS : G524

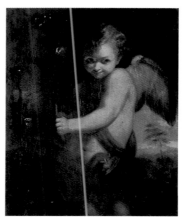

unknown artist 19th C
Cupid
oil on canvas 76.6 x 63.6
TWCMS : G1319

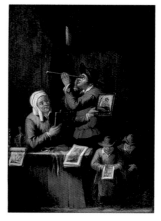

unknown artist 19th C
Dutch Interior
oil on panel 35.2 x 25.3
TWCMS : C13480

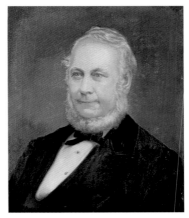

unknown artist 19th C
Emerson Muschamp Bainbridge (1817–1892)
oil on paper 61 x 51
TWCMS : F5158

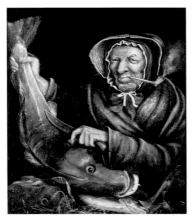

unknown artist 19th C
Euphemia Scott (The Fishwife)
oil on canvas 74.2 x 63.4
TWCMS : G4783

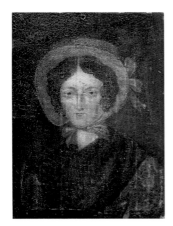

unknown artist 19th C
Grace Darling (1815–1842)
oil on canvas 17.5 x 12.9
TWCMS : F13629

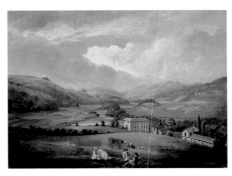

unknown artist 19th C
Haydon Bridge, Hexham, Northumberland
oil on board 23 x 30.5
TWCMS : C6983

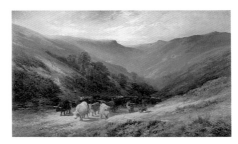

unknown artist 19th C
Highland Cattle
oil on canvas 46 x 76.4
TWCMS : G3375

unknown artist 19th C
Interior with a Carcass
oil on panel 55 x 44.7
TWCMS : F4623

unknown artist 19th C
Interior with a Seated Woman
oil on canvas 35.5 x 50.9
TWCMS : D1296

unknown artist 19th C
'John Bowes'
oil on board
TWCMS : S1261

unknown artist 19th C
John Brand
oil on panel 28.9 x 23.6
TWCMS : E5254

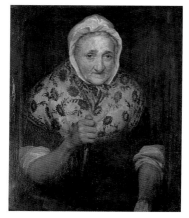

unknown artist 19th C
Judith Dowling
oil on canvas 75.4 x 62.9
TWCMS : G1306

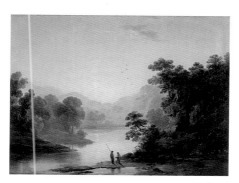

unknown artist 19th C
Landscape
oil on board 30.5 x 40.6
TWCMS : C13472

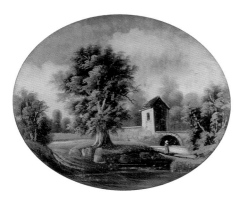

unknown artist 19th C
Landscape
oil on glass 38.5 x 46.4
TWCMS : H12583

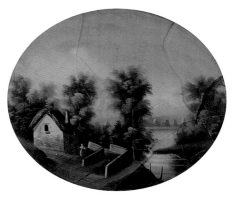

unknown artist 19th C
Landscape
oil on glass 38.2 x 46.7
TWCMS : H12584

unknown artist 19th C
Landscape with Figures, Sunset
oil on panel 17.3 x 22.7
TWCMS : G4758

unknown artist 19th C
Landscape with Gipsy Encampment
oil on canvas 30.4 x 53.3
TWCMS : F4619

unknown artist 19th C
Landscape with Horse and Cart
oil on panel 19.9 x 27.7
TWCMS : G12991

unknown artist 19th C
Man with Horse and Lantern
oil on canvas 91.8 x 71.1
TWCMS : G1738

unknown artist 19th C
Mary, Queen of Scots (1542–1587)
oil on canvas 83.6 x 65
TWCMS : F5187

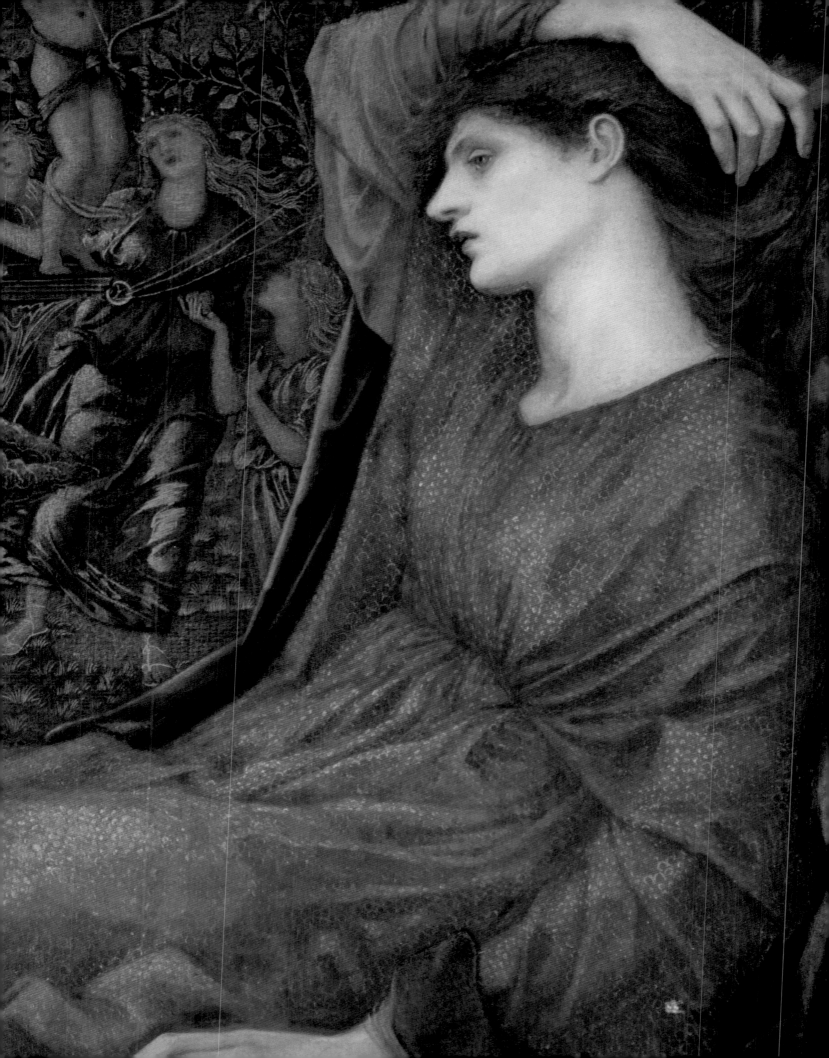

unknown artist 19th C
Moonlight Scene with Ruins
oil on canvas 15.5 x 20.4
TWCMS : G4757

unknown artist 19th C
Pietà
oil on canvas 154 x 128 (E)
TWCMS : 2006.1895

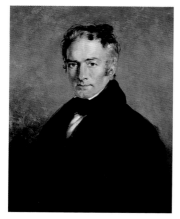

unknown artist 19th C
Portrait of a Gentleman
oil on canvas 75.9 x 63.4
TWCMS : G1348

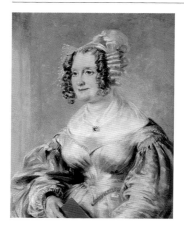

unknown artist 19th C
Portrait of a Lady
oil on canvas 76.6 x 63.4
TWCMS : F13641

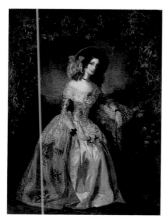

unknown artist 19th C
Portrait of a Lady
oil on canvas 59.4 x 44.2
TWCMS : G3368

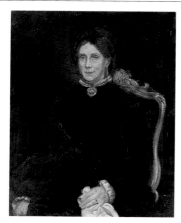

unknown artist 19th C
Portrait of a Lady
oil on canvas 90.8 x 70.9
TWCMS : G15254

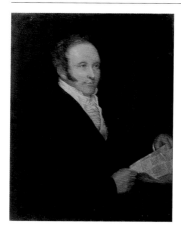

unknown artist 19th C
Portrait of a Man
oil on canvas 92 x 71.1
TWCMS : F5166

unknown artist 19th C
Portrait of a Man
oil on canvas 91.5 x 70.8
TWCMS : H987

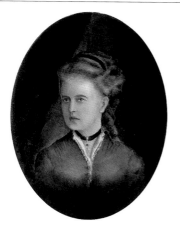

unknown artist 19th C
Portrait of a Young Woman
oil on board 35 x 26
TWCMS : M5130

Facing page: Burne-Jones, Edward, 1833–1898, *Laus veneris* (detail), Laing Art Gallery, (p. 117)

unknown artist 19th C
Rustic Portrait
oil on canvas 69 x 43
TWCMS : M5107

unknown artist 19th C
Scene Outside an Inn
oil on canvas 48.4 x 55.5
TWCMS : G12986

unknown artist 19th C
Seated Man
oil on panel 17.6 x 13.5
TWCMS : E5253

unknown artist 19th C
The Great Fire of Newcastle upon Tyne
oil on mother of pearl & glass 16.4 x 23.6
TWCMS : H12578

unknown artist 19th C
The Judgement of Paris
oil on canvas 100 x 149.5
TWCMS : G3896

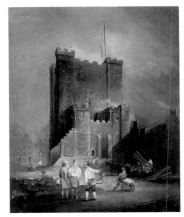

unknown artist 19th C
The Keep, Newcastle upon Tyne
oil on panel 29.8 x 25.5
TWCMS : G4785

unknown artist 19th C
The River Tyne at Prudhoe
oil on canvas 48.5 x 70.3
TWCMS : G12997

unknown artist 19th C
The Tug 'Sunbeam'
oil on canvas 60.9 x 92
TWCMS : F5116

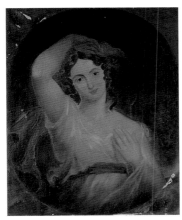

unknown artist 19th C
The Wife of Bartholomew Kent (Lady Susan Butler)
oil on canvas 76.2 x 63.5
TWCMS : F13609

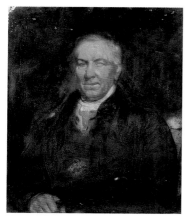

unknown artist 19th C
Thomas Bewick (1753–1828)
oil on canvas 76.1 x 63.5
TWCMS : G3379

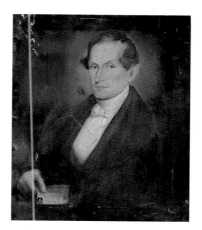

unknown artist 19th C
Thomas Wilcke
oil on canvas 76.3 x 64.3
TWCMS : G12995

unknown artist 19th C
Woodland Scene
oil on canvas 30.3 x 40.8
TWCMS : G12999

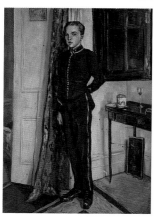

unknown artist 19th C
Youth in Soldier's Uniform
oil on canvas 55.5 x 40
TWCMS : M5105

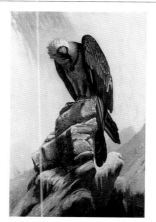

unknown artist late 19th
Eagle on a Cliff
oil on canvas 143.5 x 88.6
TWCMS : F5163

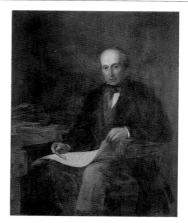

unknown artist late 19th C
Portrait of a Man
oil on canvas 125.2 x 100.2
TWCMS : 1994.670

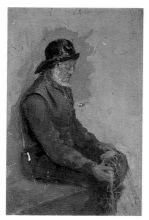

unknown artist late 19th C
Seated Fisherman
oil on board 45.2 x 30.4
TWCMS : F9132

unknown artist
Setting Up the Fair 1934
oil on board 26.6 x 34.9
TWCMS : B6385

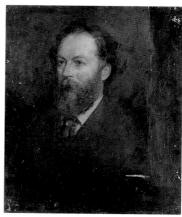

unknown artist early 20th C
Portrait of a Man
oil on canvas 61.2 x 51
TWCMS : G4198

unknown artist early 20th C
Shipping Scene
oil on canvas 158 x 226
TWCMS : 2006.1901

unknown artist early 20th C
Study of Trees
oil on canvas 45.7 x 56
TWCMS : G3377

unknown artist 20th C
Abstract
emulsion (?) & acrylic on board 160.5 x 199
TWCMS : 2006.1897

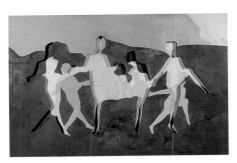

unknown artist 20th C
Dancing Figures
acrylic on board 123 x 183
TWCMS : 2006.1900

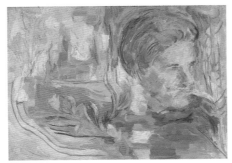

unknown artist 20th C
Expressionistic Abstract
oil on canvas 40.5 x 56
TWCMS : M5111

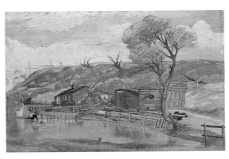

unknown artist 20th C
Landscape with Pond
oil on board 30.8 x 46.3
TWCMS : D4809

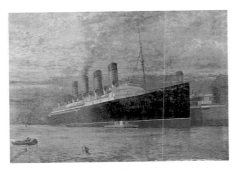

unknown artist 20th C
'Mauritania'
oil on canvas 158 x 226 (E)
TWCMS : 2006.1898

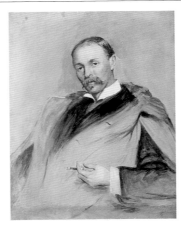

unknown artist 20th C
Portrait of a Gentleman Holding a Cigarette
oil on canvas 91.3 x 71
TWCMS : G12993

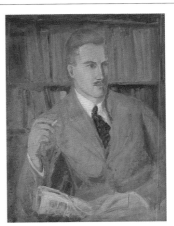

unknown artist 20th C
Portrait of an Unknown Man
oil on canvas 66 x 51
TWCMS : 2006.1894

unknown artist 20th C
Portrait of a Woman
oil on canvas 56 x 40.5
TWCMS : M4849

unknown artist 20th C
Portrait of a Young Man
oil on canvas 46 x 36
TWCMS : M5113

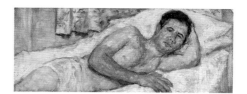

unknown artist 20th C
Reclining Figure
oil on canvas 23 x 57.5
TWCMS : M5109

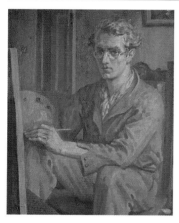

unknown artist 20th C
Self Portrait
oil on canvas 47 x 37.5
TWCMS : M5103

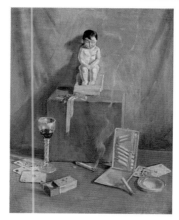

unknown artist 20th C
Still Life, the Little Philosopher
oil on canvas 71.4 x 56
TWCMS : G12992

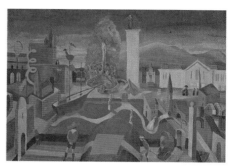

unknown artist 20th C
Town Scene
oil on canvas 51 x 69
TWCMS : 2006.1896

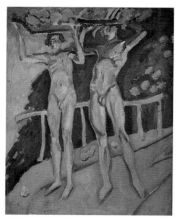

unknown artist 20th C
Two Nudes
oil on canvas 46 x 35.5
TWCMS : M5108

unknown artist late 20th C
Jesmond Dene, Newcastle upon Tyne
acrylic on canvas 214 x 153.4
TWCMS : 1994.658

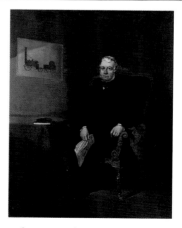

unknown artist
Robert Stephenson with 'Rocket'
oil on canvas 124 x 102
TWCMS : C6232

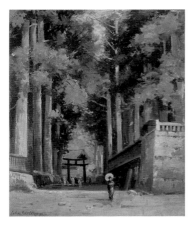

Varley, John II 1850–1933
Avenue of Cryptomeria Leading to the Temple of Fiaharajinshu, Nikko, Japan 1890
oil on panel 33 x 27.9
TWCMS : B8121

Vaughan, John Keith 1912–1977
Woodman in a Clearing 1955
oil on canvas 91.5 x 71.3
TWCMS : B7401

Verboeckhoven, Eugène Joseph 1799–1881
Sheep in a Byre 1856
oil on panel 17.9 x 23.7
TWCMS : E5295

Vinall, Joseph William Topham 1873–1953
The Port of Liverpool
oil on canvas 70.9 x 91.5
TWCMS : G1502

Votture, Jean active 20th C
Fishermen with Nets
oil on canvas 51 x 65.3
TWCMS : G15251

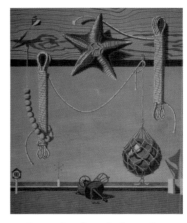

Wadsworth, Edward Alexander 1889–1949
Marine Set 1936
tempera on panel 76.1 x 63.7
TWCMS : C6956

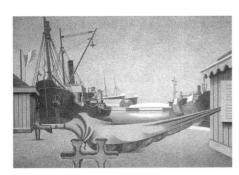

Wadsworth, Edward Alexander 1889–1949
Le Havre, France 1939
tempera on panel 63.8 x 89.2
TWCMS : B7404

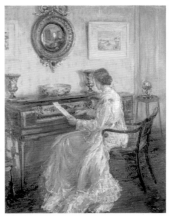

Walker, Ethel 1861–1951
The Forgotten Melody 1902
oil on canvas 113.5 x 88.5
TWCMS : C628

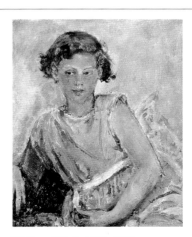

Walker, Ethel 1861–1951
In a Pensive Mood
oil on canvas 61.5 x 51.2
TWCMS : G504

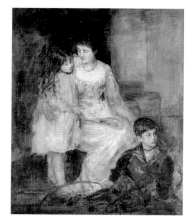

Walker, Ethel 1861–1951
Mrs Walker and Her Children
oil on canvas 114.4 x 91.4
TWCMS : G2341

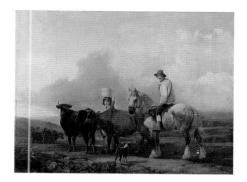

Wall, B. (attributed to) active 19th C
Landscape with Figures and Cattle
oil on canvas 35.5 x 46
TWCMS : C13507

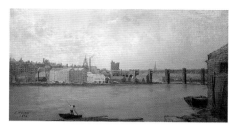

Wallace, John 1841–1905
Newcastle upon Tyne from the South-West
1884
oil on canvas 40.8 x 76.2
TWCMS : F4630

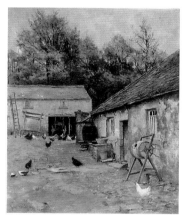

Wallace, John 1841–1905
Farmyard Scene 1891
oil on canvas 45.7 x 38
TWCMS : E3544

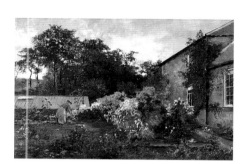

Wallace, John 1841–1905
October Bloom, Ravensworth 1901
oil on canvas 51.2 x 76.6
TWCMS : G10301

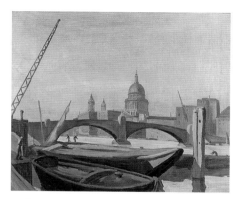

Walton, Allan 1891–1948
St Paul's before 1928
oil on canvas 76.7 x 91.9
TWCMS : G2350

Ward, Florence 1912–1984
Quartz Inset before 1965
oil & plaster on board 66.4 x 111.3
TWCMS : F5173

Ward, Florence 1912–1984
Integrated Shapes before 1968
oil & textile on board 73.5 x 98.8
TWCMS : G532

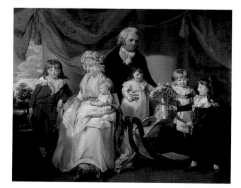

Ward, James 1769–1859
Michael Bryan and His Family 1798–1799
oil on canvas 169.5 x 211
TWCMS : C6960

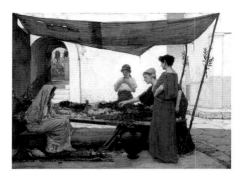

Waterhouse, John William 1849–1917
A Grecian Flower Market c.1880
oil on canvas 57.8 x 79.3
TWCMS : B8122

Waterhouse, Nora active 1963
Linked Forms c.1963
oil on board 55 x 71.7
TWCMS : C674

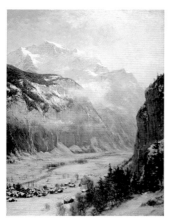

Waterlow, Ernest Albert 1850–1919
Mountainous Landscape in Winter
c.1885–1910
oil on canvas 127 x 93.7
TWCMS : G2337

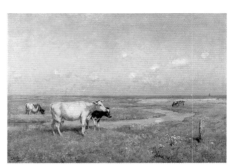

Waterlow, Ernest Albert 1850–1919
Suffolk Marshes c.1902
oil on canvas 86.9 x 122
TWCMS : F3495

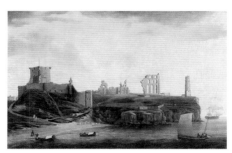

Waters, Ralph I 1720–1798
*Figures and Bathing Machines in the Bay
below Tynemouth Castle* 1784
oil on canvas 72.1 x 112.4
TWCMS : M5117

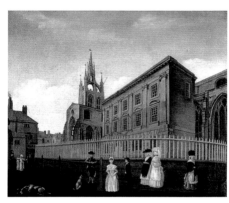

Waters, Ralph II (attributed to) 1749–1817
*St Nicholas' Church, Newcastle upon Tyne,
from the South-East* c.1789
oil on canvas 77.4 x 88.3
TWCMS : G172

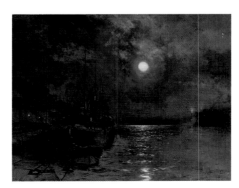

Waterston, George Anthony c.1858–c.1918
Moonlight on the Tyne 1893
oil on canvas 86.1 x 112
TWCMS : 1999.1629

Watson, Harry 1871–1936
A Tale by the Way c.1922
oil on canvas 86.5 x 102
TWCMS : F5117

Watson, Lyall 1908–1994
The Market Place c.1960
oil on board 121.5 x 182.8
TWCMS : 1994.675

Facing page: Atkin, Gabriel, 1897–1937, *Work* (detail), Laing Art Gallery, (p. 110)

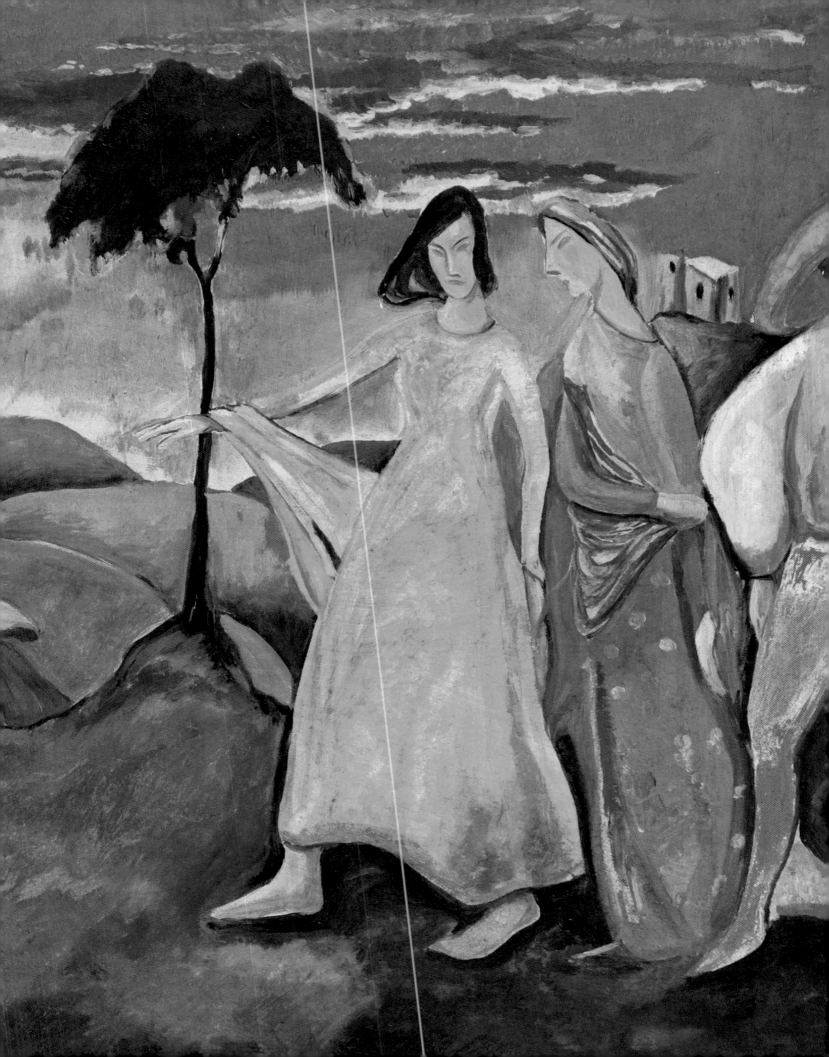

Watson, Robert F. 1815–1885
Ships and Fishing Boats in Rough Seas 1857
oil on panel 50.9 x 75.9
TWCMS : G4162

Webb, James 1825–1895
Seville, Spain 1870–1871
oil on canvas 76.6 x 127.5
TWCMS : G10306

Webb, James 1825–1895
*View of Mayence, Germany, with Market
Boats* c.1871
oil on canvas 96.5 x 167.7
TWCMS : G10313

Webb, James 1825–1895
Sunset after Rain 1875
oil on canvas 35.5 x 61
TWCMS : C13490

Webster, George 1797–1864
Boats, Mouth of the Tyne
oil on panel 17.4 x 25.2
TWCMS : C13499

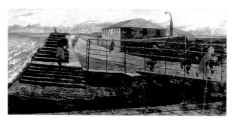

Weight, Carel Victor Morlais 1908–1997
The Alarm c.1974
oil on canvas 74.8 x 150.5
TWCMS : B6700

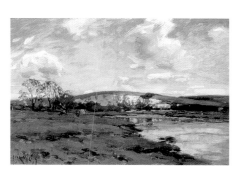

Weiss, José 1859–1919
A Bright Day on the Arun c.1899
oil on panel 25 x 38.1
TWCMS : F5191

Wells, Henry Tanworth 1828–1903
Lord Armstrong (1810–1900)
oil on canvas 242 x 150.2
TWCMS : G4184

Welton, Peter b.1933
Rich Picture 1963
oil on canvas 120.8 x 107.2
TWCMS : H980

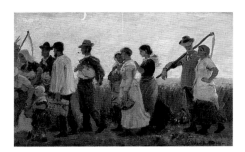

Wetherbee, George Faulkner 1851–1920
The Harvest Moon 1881
oil on canvas 32.4 x 51.4
TWCMS : D1282

Wil, W. D.
Young Man in Uniform 1915
oil on canvas 71.2 x 35.7
TWCMS : C10045

Wilkie, David 1785–1841
Reading the News c.1820
oil on panel 40.6 x 33
TWCMS : F13736

Wilkinson, Edward Clegg b.1862
Spring, Piccadilly 1887
oil on canvas 92.3 x 137.5
TWCMS : G4781

Willats, Stephen b.1943
Endless Cycle (panel 1) 1985
acrylic, photograph, ink, concrete & letraset
140.1 x 100
TWCMS : P582.1

Willats, Stephen b.1943
Endless Cycle (panel 2) 1985
acrylic, photograph, ink, concrete & letraset
140.1 x 100
TWCMS : P582.2

Willis, John Henry b.1887
*Ascension Day on the Tyne in the Eighteenth
Century* before 1935
oil on canvas 320 x 813
TWCMS : G4641

Wilson, Harry P. active 1935–1938
10 a.m. c.1938
tempera on board 61.2 x 76.4
TWCMS : D2970

Wilson, Harry P. active 1935–1938
Roundabout and Swings c.1938
oil on canvas 39.8 x 58.4
TWCMS : C647

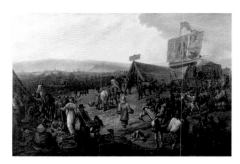

Wilson, John H. 1774–1855
Fair on the Town Moor, Newcastle c.1810
oil on canvas 78.7 x 191.3
TWCMS : G4789

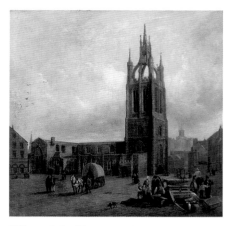

Wilson, John H. 1774–1855
St Nicholas Church, Newcastle upon Tyne
oil on canvas 55.2 x 57.2
TWCMS : G5272

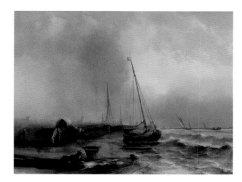

Wilson, John H. (attributed to) 1774–1855
Seascape with Boats and Figures
oil on canvas 46 x 61.2
TWCMS : C676

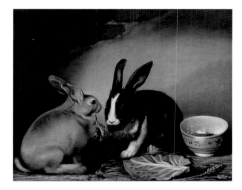

Wilson, Joseph Thomas (attributed to)
1808–1882
Rabbits c.1856–c.1882
oil on canvas 41.2 x 51.2
TWCMS : C13515

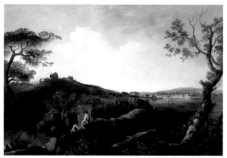

Wilson, Richard 1714–1787
The Alban Hills, Italy 1751–1757
oil on canvas 73.6 x 101.4
TWCMS : C6958

Wilson, Richard (after) 1714–1787
Landscape with Fishermen 18th C
oil on canvas 133.3 x 205.4
TWCMS : G4154

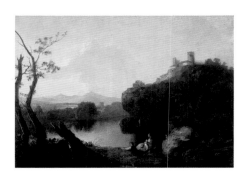

Wilson, Richard (after) 1714–1787
On the Arno, Italy 18th C
oil on canvas 89.5 x 127.3
TWCMS : G4158

Wiszniewski, Adrian b.1958
Aloft in the Loft 1987
acrylic on canvas 213 x 213
TWCMS : P571

Wit, Jacob de 1695–1754
Autumn and Winter c.1714–1750
oil on canvas 78.9 x 132.6
TWCMS : C3930

Wit, Jacob de 1695–1754
Spring and Summer c.1714–1750
oil on canvas 78.9 x 132
TWCMS : C3934

Wood, Christopher 1901–1930
Sleeping Fisherman, Ploaré, Brittany 1930
oil on board 37.8 x 72.8
TWCMS : G4617

Wood, Frank 1904–1985
Morning, Cromford, Derbyshire 1938
tempera on panel 25.6 x 34.7
TWCMS : C13502

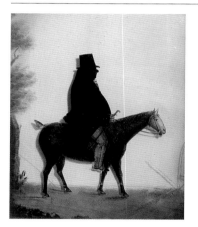

Woodhouse, John b.1800
Silhouette of John Charlton 1835
oil on glass 35.3 x 29.4 (E)
TWCMS : H12580

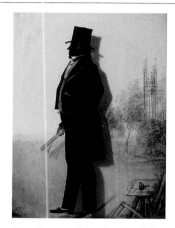

Woodhouse, John (style of) b.1800
Silhouette of a Man with St Thomas' Church
oil on glass 32.6 x 24.7
TWCMS : H12579

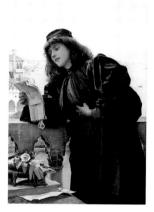

Woods, Henry 1846–1921
Portia 1887
oil on canvas 87.1 x 57.1
TWCMS : B8136

Workman, Harold 1897–1975
Preparations
oil on canvas 51.2 x 61.5
TWCMS : B6384

Woutermaertens, Edouard 1819–1897
Study of Sheep
oil on panel 44 x 57.4
TWCMS : C10647

Wouwerman, Philips (follower of)
1619–1668
A Hawking Party 17th C
oil on canvas 57.2 x 53.2
TWCMS : G17023

Wright, Joseph of Derby 1734–1797
Miss Jane Monck 1760
oil on canvas 125.7 x 101.3 (E)
TWCMS : D3498

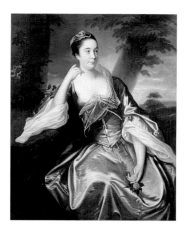

Wright, Joseph of Derby 1734–1797
Mrs Lawrence Monck 1760
oil on canvas 127.5 x 101.7
TWCMS : C3942

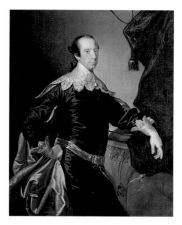

Wright, Joseph of Derby 1734–1797
Lawrence Monck 1760
oil on canvas 126.9 x 102.5
TWCMS : C3944

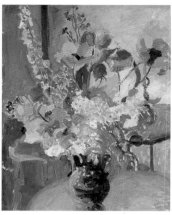

Wyatt, Irene 1903–1987
Summer Flowers
oil on canvas 77.1 x 61.4
TWCMS : G1330

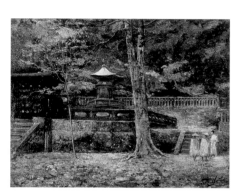

Yates, Frederic 1854–1919
Japanese Shrine
oil on panel 38.9 x 51
TWCMS : F9116

Yuan-chia, Li 1929–1994
Banner before 1972
acrylic on hessian 201.5 x 140.8
TWCMS : G1314

Yuan-chia, Li 1929–1994
Banner before 1972
acrylic on hessian 201.9 x 138.2
TWCMS : G1315

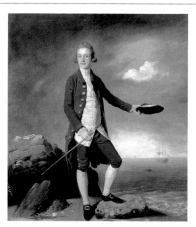

Zoffany, Johann 1733–1810
Sir Francis Holvering c.1760–1780
oil on canvas 76.2 x 64.1
TWCMS : C6961

Tyne & Wear Museums Maritime and Industrial Collection

Whilst the great majority of paintings in the TWM collections are associated with the collection of a particular museum or gallery, there is a small collection of maritime and industrial paintings held at the Discovery Museum which forms part of the TWM history collections. This small collection of oil paintings is mostly of ships, shipbuilding and the ubiquitous portraits of 'worthy gentlemen' associated with the industry. An early view of a colliery in a rural setting from about 1830 is an interesting exception. A John Scott painting of the paddle tug 'Black Prince' at the mouth of the Tyne, dated 1874, the year of her launch, was probably a commission from her proud owner Mr Allen of Westoe. Six paintings by Peter Burns from 1978, five of them portraits of workers, provide an artist's view of North East shipbuilding shortly before it effectively came to an end.

Ian Whitehead, Keeper of Maritime History

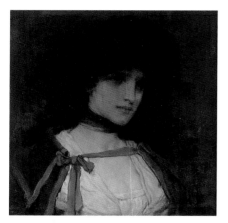

Boughton, George Henry 1833–1905
Bessie
oil on canvas 47.2 x 48.3 (E)
TWCMS : C683

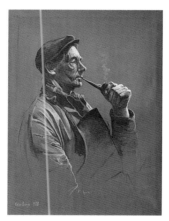

Burns, Peter
Albert with a Pipe 1978
oil on canvas 170 x 80.9
TWCMS : 2008.110

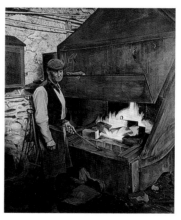

Burns, Peter
Blacksmith's Striker (Standing by a Forge)
1978
oil on canvas 125.7 x 98.7 (E)
TWCMS : 2008.117

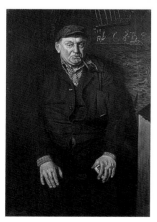

Burns, Peter
Fred the Pipe 1978
oil on canvas 121.8 x 81.7
TWCMS : 2008.113

Burns, Peter
Drag Chains and Anchor
oil on canvas 101.8 x 127
TWCMS : 2008.111

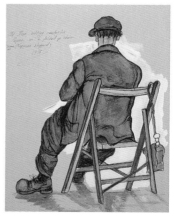

Burns, Peter
Old Man Reading a Newspaper
oil on paper 42 x 31
TWCMS : 2008.120

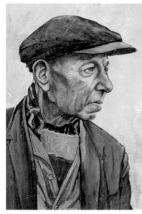

Burns, Peter
Portrait of a Man Wearing a Cap
oil on canvas 69.6 x 46.3 (E)
TWCMS : 2008.112

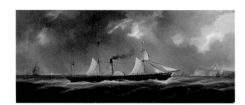

Carmichael, John Wilson 1800–1868
Leith and Newcastle Packet 1838
oil on canvas 32 x 72.8
TWCMS : 2008.116

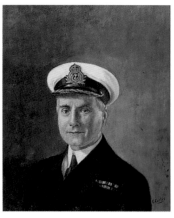

Carter, E.
Captain E. W. Swan (1883–1948)
oil on canvas 54.1 x 43.2
TWCMS : E6718

de Martino, Edoardo 1838–1912
'Esmeralda'
oil on canvas 66.8 x 114.2 (E)
TWCMS : 2000.6077

Dring, William D. 1904–1990
Dr Wilfred Hall (one of the founders of the
Museum)
oil on canvas 66.1 x 55.9
TWCMS : E6719

Duggan, J.
Huntley's Repair Yard c.1888
oil on canvas 41.4 x 75
TWCMS : M3069

Eltringham, S. G. (attributed to)
'Mauretania' 1807
oil on canvas 75 x 126.6
TWCMS : 2008.109

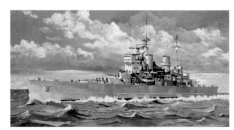

Grainger, Norman
'HMS Duke of York'
oil on canvas 49.8 x 90.4
TWCMS : 2001.3740

Hepple, Wilson 1854–1937
*King Edward VII's Progress through Newcastle
upon Tyne, Having Opened the Royal Victoria
Infirmary and Armstrong College* 1907
oil on canvas 101.6 x 152.7
TWCMS : G15285

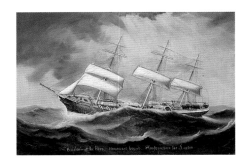

Kensington, C.
'Pericles'
oil on canvas 50.2 x 75.6
TWCMS : 1993.9576

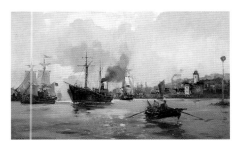

Mason, Frank Henry 1876–1965
'John Bowes' (?)
oil on canvas 58.6 x 97.8 (E)
TWCMS : 2008.118

McLachlan, M.
'SS Western' c.1860
oil on canvas 78 x 54.4 (E)
TWCMS : 2008.107

Salisbury, Frank O. (attributed to)
1874–1962
Launcelot E. Smith (?)
oil on canvas 110 x 84.6 (E)
TWCMS : 1993.9580

Scott, John 1802–1885
'Black Prince' 1874
oil on canvas 49.5 x 74.4 (E)
TWCMS : 2008.108

Shepherd, David b.1941
*Shipping Scene**
oil on canvas 47.3 x 71.8 (E)
TWCMS : 2008.119

Small, J. W.
*Launching a Vessel**
oil on board 50.4 x 31.8
TWCMS : 2008.121

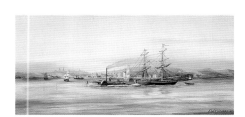

Thompson, Frank Wildes 1836–1905
'Perseverence'
oil on board 19.2 x 40.5
TWCMS : 2001.3705

unknown artist
Alexander Hall (1760–1849)
oil on canvas 78.6 x 68.1 (E)
TWCMS : 1993.9581

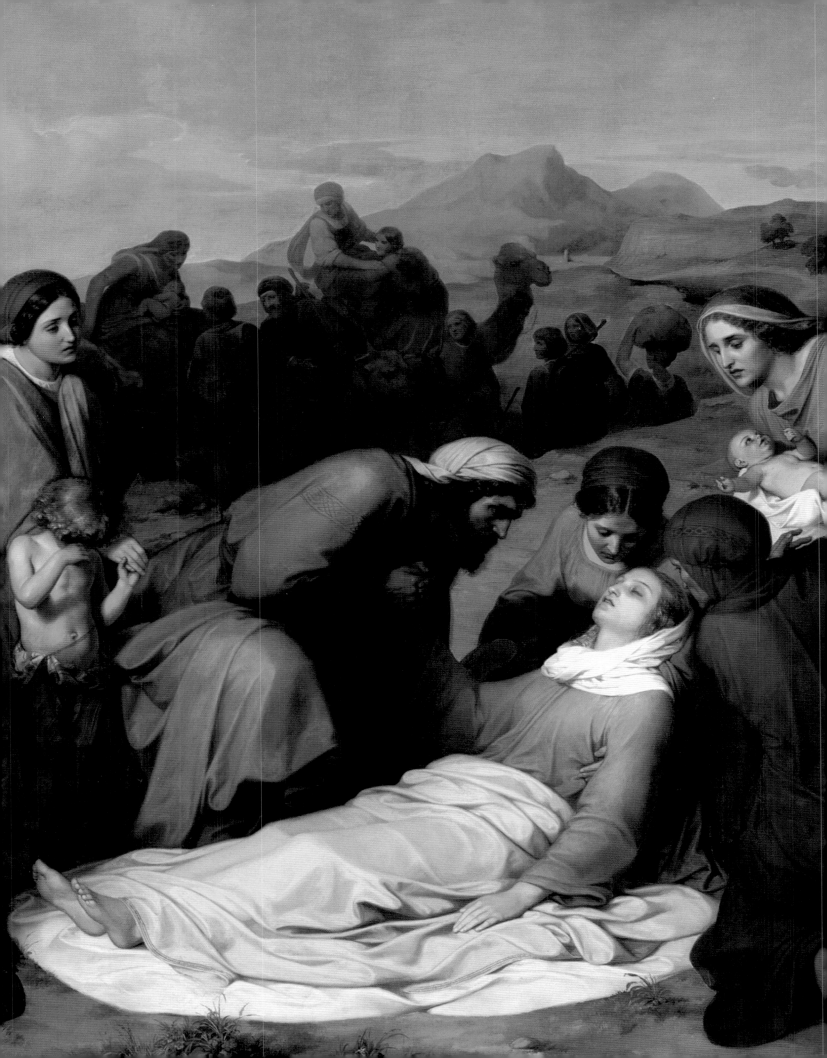

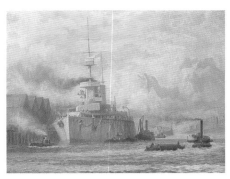

unknown artist
Fitting out of HMS 'Superb' at Walker
oil on canvas 88 x 115 (E)
TWCMS : 1993.11025

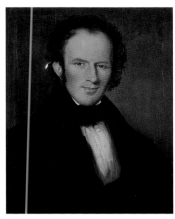

unknown artist
James Hall (1804–1869)
oil on canvas 89.6 x 76.8 (E)
TWCMS : 1993.9578

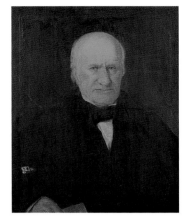

unknown artist
James Wilson (1765–1857)
oil on canvas 89.5 x 76.9 (E)
TWCMS : 1993.9579

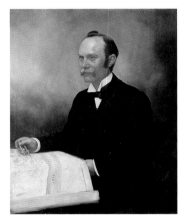

unknown artist
John Tunstall Clarke
oil on canvas 74.5 x 59 (E)
TWCMS : 2004.2742

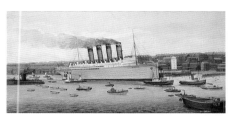

unknown artist
'Mauretania'
oil on canvas 33.5 x 69.5
TWCMS : 2001.3773

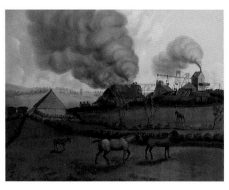

unknown artist
North East Colliery, c.1835
oil on canvas 49 x 59.7 (E)
TWCMS : 1996.102

unknown artist
Portrait of a Man
oil on canvas 78.6 x 63 (E)
TWCMS : 2008.114

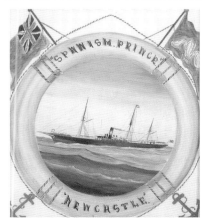

unknown artist
'Spanish Prince'
oil on glass 25.4 x 23.3 (E)
TWCMS : 2008.115

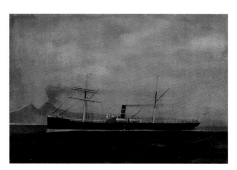

unknown artist
'SS Knarwater of Newcastle'
oil on paper 39.3 x 58.1 (E)
TWCMS : E2245

Facing page: Metz, Gustav, 1817–1853, *The Death of Rachel* (detail), 1847, Sunderland Museum
and Winter Gardens, (p. 302)

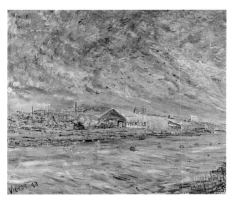

Victor
'*Vickers*' 1943
oil on canvas 59.4 x 69.8
TWCMS 2000.2290

South Shields Museum and Art Gallery

South Shields Museum and Art Gallery's collections originated in the nineteenth century. The collections of the South Shields Literary, Mechanical and Scientific Institution were combined with the Working Men's Club in 1870. The combined institutions' buildings, library and museum were subsequently transferred to the Corporation for the creation of a public library and museum. The library opened in 1873 and the museum followed in 1876. The collections transferred to the new museum were wide-ranging, including archaeology and history, together with a small number of paintings. The Museum's collection of paintings, prints and drawings has grown steadily since the 1870s, through purchases, gifts and bequests. They were given a particular boost by gifts from local collector Thomas Reed, followed by his bequest in 1921.

The painting collection is largely of nineteenth- and twentieth-century works by British artists. Whilst it is particularly strong in works with a local connection, there are also some fine nineteenth- and twentieth-century paintings by nationally recognised artists. These include Charles Napier Hemy, the accomplished marine artist, who passed his early career in Newcastle before moving to London, and then to Cornwall. He drew and painted a number of North East scenes, including *The Last Boat In*, which shows a small fishing boat coming into the Fish Quay at North Shields as dusk is falling. His impressive painting, *London River, the Limehouse Barge Builders* (1877) is an excellent example of his work at that time. Hemy wrote 'I painted the picture altogether from nature, sitting in a barge and talking with the workmen'. Amongst other paintings of note is Thomas Sidney Cooper's *The Approaching Storm* (1875), a remarkably impressive and dramatic composition, and *Blackberrying* by Harold Harvey.

Works with local subject matter are of particular importance for the history of South Tyneside, charting the changes as South Shields and the Tyne developed over the years. One of the earliest local topographical paintings in the Collection is *South Shields Market Place* painted in about 1800 by an

unknown artist. The picturesque view across the mouth of the Tyne to the ruins of Tynemouth Abbey has attracted artists since the later eighteenth century, including J. M. W. Turner who drew it on his first visit to the North East in 1797. The South Shields Collection contains a number of paintings of this scene by North East artists, both local and from elsewhere in the country.

Not surprisingly, given the location of South Shields, maritime subjects are a strong feature of the Collection, showing the shipping and topography of the Tyne and the North East coast, from the days of sail to steam. Of particular note are the works by the Tyneside artist, John Scott, whose meticulously accurate portraits of sailing vessels in and around the Tyne are of great interest to maritime historians. Scott also tackled more ambitious subjects, such as the ceremonial opening of the Tyne Dock in 1859 which he portrayed with great liveliness. This was an event of major significance, and the Museum also has a painting of it by Mark Thompson who recorded the scene in a very different, more sombre way. Several oil paintings and watercolours by Bernard Benedict Hemy, one of Charles Napier Hemy's brothers, are also in the South Shields Collection. These are all of local maritime scenes, set on the river or along the coast.

There are a number of portraits of local dignitaries in the Collection, including one of Alderman John Clay, the first Mayor of South Shields, painted in about 1852. One particularly fine portrait is George Hayter's study of the local MP, Robert Ingham, painted in 1838 and used to create his well-known painting *The Meeting of the First Reform Parliament* now in the National Portrait Gallery.

Juliet Horsley, Regional Hub Exhibitions Manager & Alisdair Wilson, Curator

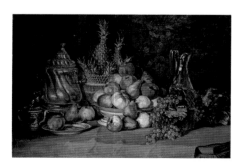

Baron, Théodore 1840–1899
Still Life
oil on canvas 100.6 x 150.4
TWCMS : G4236

Boot, William Henry James 1848–1918
Homewards c.1885–1910
oil on canvas 61 x 92.2
TWCMS : G5223

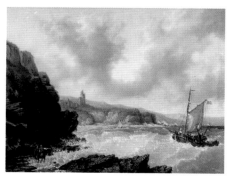

Bough, Samuel 1822–1878
Off the Scottish Coast 1854
oil on canvas 47.4 x 61.2
TWCMS : G5214

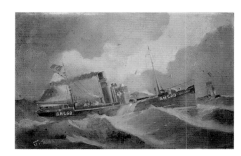

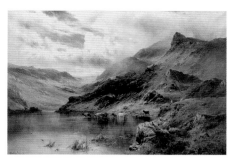

Bourne, J. active 1890s–1914
The Trawler 'Ben Lora'
oil on board 30.3 x 46.7
TWCMS : G4219

Bourne, J. active 1890s–1914
The Trawler 'Ben Lora'
oil on canvas 30.3 x 46.7
TWCMS : G4220

Breanski, Alfred de 1852–1928
Cattle Watering on Ben A'An
oil on canvas 112.4 x 163.5
TWCMS : G5227

Brown, James Miller active 1875–1910
The Abbey Bridge, Barnard Castle, County Durham 1882
oil on board 47 x 62.5
TWCMS : G4242

Brown, James Miller active 1875–1910
Barnard Castle, County Durham c.1882
oil on board 47 x 62.5
TWCMS : G4268

Carmichael, John Wilson 1800–1868
Westoe Village, South Shields 1835
oil on canvas 38.2 x 53.3
TWCMS : G7254

Carmichael, John Wilson 1800–1868
The Naval Review, Spithead 1853
oil on canvas 102.5 x 167
TWCMS : G5228

Carmichael, John Wilson (follower of)
1800–1868
The Entrance to the Tyne
oil on canvas 43.1 x 60.5
TWCMS : G4260

Carter, Frank Thomas 1853–1934
The Head of the Lake, Derwentwater, Cumbria c.1912
oil on canvas 81.8 x 112.2
TWCMS : G5221

Carter, Frank Thomas 1853–1934
Borrowdale, Cumbria
oil on canvas 152 x 224
TWCMS : G5209

Carter, Frank Thomas 1853–1934
Derwent Flowing into Derwentwater, Cumbria
oil on canvas 61.6 x 91.6
TWCMS : G5222

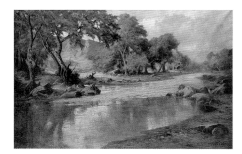

Carter, Frank Thomas 1853–1934
The Other Side of Borrowdale, Cumbria
oil on canvas 152 x 224
TWCMS : G5208

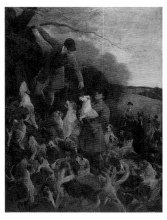

Charlton, John 1849–1917
Besieged 1895
oil on canvas 184.3 x 138.2
TWCMS : G5236

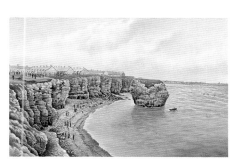

Cleet, James Henry 1840–1913
Rescue near Souter Point, South Shields 1896
oil on canvas 51.5 x 77.4
TWCMS : G4531

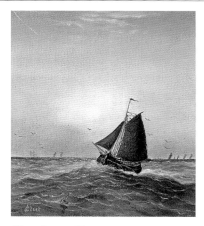

Cleet, James Henry 1840–1913
Dutch Fisherman
oil on canvas 17.2 x 15.4
TWCMS : G4533

Cleet, James Henry 1840–1913
Sailing Ship
oil on canvas 17.3 x 15.4
TWCMS : G4532

Cleet, James Henry 1840–1913
The Mission Ship
oil on canvas 38.2 x 47.9
TWCMS : G4530

Cleveley, John c.1712–1777
*A Sheer Hulk, Refitting an East
Indiaman* 1758
oil on canvas 64.2 x 103
TWCMS : G4250

Cookson, Catherine 1906–1998
Riverbank Study
oil on canvas 30.5 x 40.7
TWCMS : 1999.1910

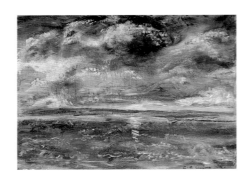

Cookson, Catherine 1906–1998
Seascape
oil on canvas 26 x 35.5
TWCMS : 1999.1912

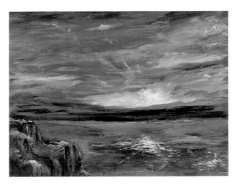

Cookson, Catherine 1906–1998
Sunrise
oil on canvas 39 x 50
TWCMS : 1999.1911

Cookson, Catherine 1906–1998
Waterfall
oil on canvas 60.4 x 45.8
TWCMS : 1999.1913

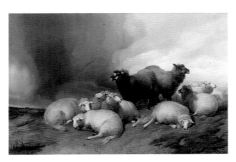

Cooper, Thomas Sidney 1803–1902
The Approaching Storm 1875
oil on canvas 61.5 x 91.6
TWCMS : G4254

Dack, Tom b.1933
'Fireside' in the River Tyne c.1950
oil on canvas 50 x 75
TWCMS : 2007.5804

Dobson, Cowan 1894–1980
Lady Helene Paris Chapman, née MacGowan
1934
oil on canvas 150.5 x 86.7
TWCMS : G5242

Eales, George
*The Engine Cottage, The Lawe, South
Shields* 1901
oil on canvas 30.7 x 40.7
TWCMS : G4289

Elliott, Robinson 1814–1894
Robert Ingham (1793–1875) 1842
oil on board 75.8 x 63.5
TWCMS : G7251

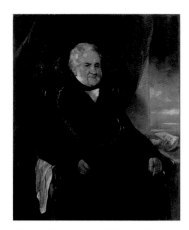

Elliott, Robinson 1814–1894
Alderman George Potts, Mayor
(1852–1853) c.1853
oil on board 128 x 104
TWCMS : K20736

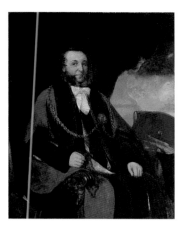

Elliott, Robinson 1814–1894
Alderman Thomas Stainton, Mayor
(1855–1856) 1857
oil on board 128.3 x 102.6
TWCMS : G5240

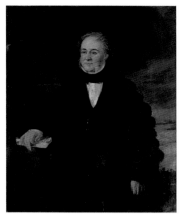

Elliott, Robinson 1814–1894
Thomas Salmon (1794–1871), First Town
Clerk of South Shields Borough Corporation
(1850–1871) c.1871
oil on canvas 127 x 101.8
TWCMS : 1999.1896

Elliott, Robinson 1814–1894
The Three Half Moons', Rothbury,
Northumberland 1887
oil on canvas 61.3 x 91.9
TWCMS : G4255

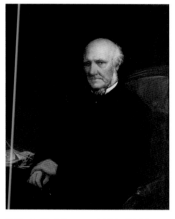

Elliott, Robinson 1814–1894
Mr John P. Elliott 1889
oil on canvas 192 x 71
TWCMS : 1999.1897

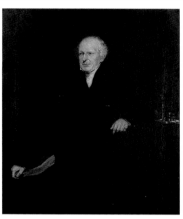

Elliott, Robinson 1814–1894
Dr Thomas Masterman Winterbottom
(1766–1859)
oil on canvas 129.5 x 105
TWCMS : G4234

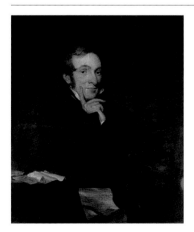

Elliott, Robinson 1814–1894
Dr Thorburn
oil on canvas 92 x 77.3
TWCMS : 1999.1898

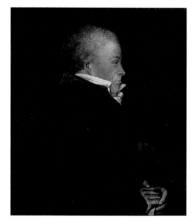

Elliott, Robinson 1814–1894
George Pringle
oil on canvas 76.3 x 64
TWCMS : G4262

Elliott, Robinson 1814–1894
On the Black Burn, near Rothbury,
Northumberland
oil on canvas 51.3 x 69
TWCMS : G4259

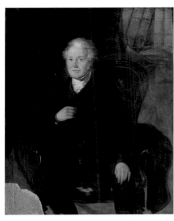

Elliott, Robinson 1814–1894
Robert Ingham (1793–1875)
oil on canvas 128 x 102.5
TWCMS : G5238

Elliott, Robinson (attributed to) 1814–1894
*Alderman John Williamson, JP, Mayor
(1858–1860 & 1868–1869)* c.1869
oil on canvas 127 x 102
TWCMS : 1999.1899

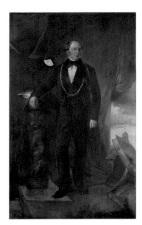

Elliott, Robinson (style of) 1814–1894
*Alderman John Clay, Mayor (1850–1852),
First Mayor of South Shields Borough
Corporation* c.1852
oil on canvas 239 x 147.8
TWCMS : G7263

Elliott, Robinson (style of) 1814–1894
Alderman John Toshach, Mayor (1854–1855)
c.1855
oil on canvas 127.1 x 101.5
TWCMS : G5244

Elliott, Robinson (style of) 1814–1894
*Alderman Terrot Glover (1802–1885), Mayor
(1857–1858 & 1872–1874)* c.1858
oil on board 126.8 x 101.3
TWCMS : G5245

Emmerson, Henry Hetherington
1831–1895
Donald McNeill 1890
oil on canvas 117.1 x 89.1
TWCMS : G5212

Emmerson, Henry Hetherington
1831–1895
Joseph Mason Moore, Mayor (1870–1871)
1893
oil on canvas 142.6 x 112.4
TWCMS : G5243

Evans, J.
Dolly Peel (1782–1857) 1891
oil on board 62.1 x 47.1
TWCMS : G7258

Feild, Maurice 1905–1988
James Kirkup (b.1918)
oil on canvas 45 x 40
TWCMS : 2007.5814

Facing page: Martin, John, 1789–1854, *The Bard* (detail), c.1817, Laing Art Gallery, (p. 180)

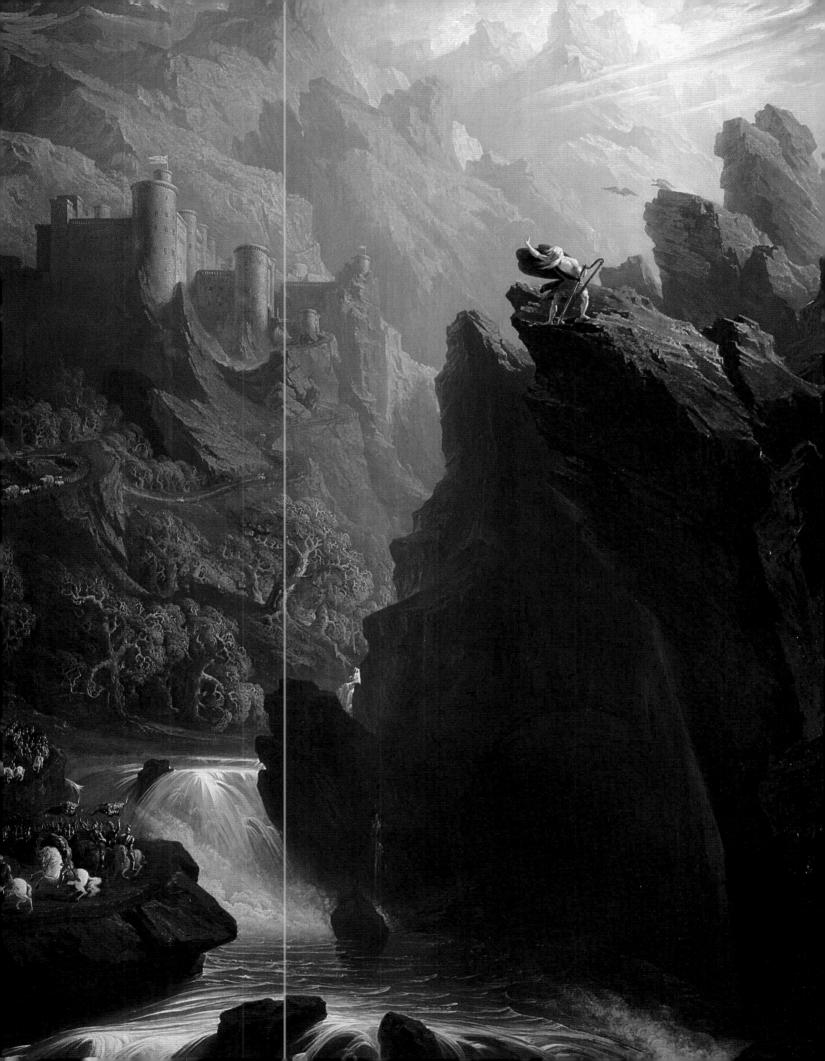

Fong, Lai active c.1880–c.1910
The 'Lydgate' 1896
oil on canvas 64.5 x 90
TWCMS : G4283

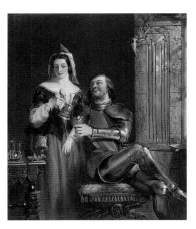

Frith, William Powell 1819–1909
The Knight and the Maid 1868
oil on canvas 76.5 x 62.4
TWCMS : G4257

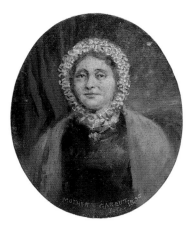

Garbut, Joseph 'Putty' 1820–1885
Mother Garbut 1835
oil on board 19.4 x 15.8
TWCMS : G4205

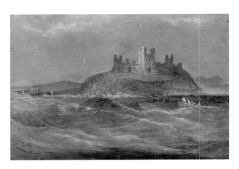

Garbut, Joseph 'Putty' 1820–1885
Coastal Scene with Castle 1872
oil on panel 33.3 x 48.1
TWCMS : G4213

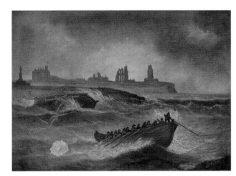

Garbut, Joseph 'Putty' 1820–1885
Going to the Wreck 1875
oil on canvas 45.8 x 61.1
TWCMS : G4235

Garbut, Joseph 'Putty' 1820–1885
Shields Harbour 1879
oil on canvas 44.8 x 72.4
TWCMS : G4233

Garbut, Joseph 'Putty' 1820–1885
Dolly Peel (1782–1857) 1880
oil on board 22.5 x 17
TWCMS : G7268

Garbut, Joseph 'Putty' 1820–1885
The County Hotel, Westoe, South Shields 1884
oil on canvas 68.9 x 105.7
TWCMS : G5219

Garbut, Joseph 'Putty' 1820–1885
Shields Harbour, 1821
oil on board 29.1 x 43.8
TWCMS : G4223

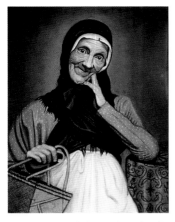

Garbut, Joseph 'Putty' (style of) 1820–1885
Dolly Peel (1782–1857) c.1880
oil on board 53 x 40.4
TWCMS : G7257

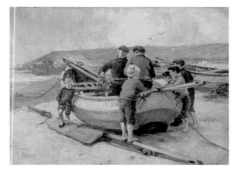

Gilroy, John William 1868–1944
In the Haven
oil on canvas 38 x 50.9
TWCMS : G4243

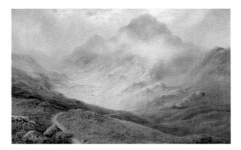

Hargate, Edward 1835–1895
Mountain Scene
oil on canvas 51.2 x 76.7
TWCMS : G4261

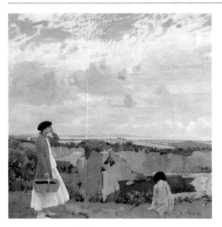

Harvey, Harold C. 1874–1941
Blackberrying 1917
oil on canvas 71.4 x 71.8
TWCMS : G4271

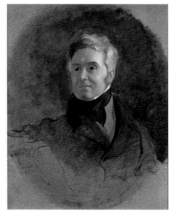

Hayter, George 1792–1871
Robert Ingham Esq. (1793–1875), MP 1838
oil on panel 35.5 x 29.5
TWCMS : K20750

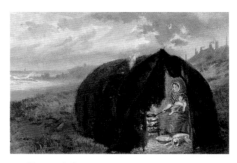

Hedley, Ralph 1848–1913
Gypsies Camped on the Beach, South Shields
1876
oil on canvas 23 x 34
TWCMS : 2007.5803

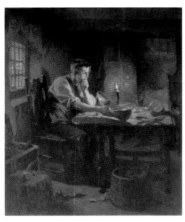

Hedley, Ralph 1848–1913
The Invention of the Lifeboat 1896
oil on canvas 109.1 x 92.2
TWCMS : G5211

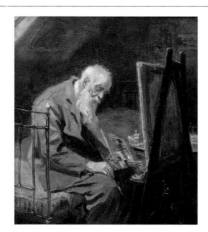

Hedley, Ralph 1848–1913
Ars longa, vita brevis 1900
oil on canvas 35.8 x 30.8
TWCMS : G4282

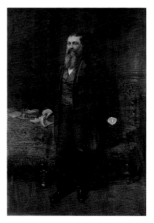

Hedley, Ralph 1848–1913
*Alderman John Potts Wardle, Mayor
(1882–1883)* 1906
oil on canvas 232.5 x 152.5
TWCMS : G5247

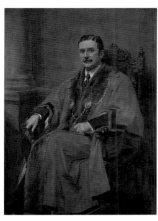

Hedley, Ralph 1848–1913
*Alderman John Robert Lawson, JP, Mayor
(1900–1901)* c.1911
oil on canvas 159 x 117.4
TWCMS : 1999.1902

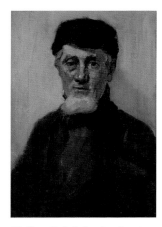

Hedley, Ralph (style of) 1848–1913
Ralph Cruikshanks 1903
oil on canvas 33.1 x 23.1
TWCMS : G4279

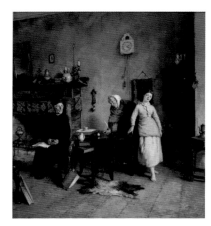

Helmick, Howard 1845–1907
The Wayward Daughter 1878
oil on canvas 69.2 x 61.4
TWCMS : G5213

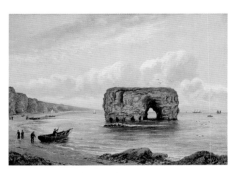

Hemy, Bernard Benedict 1845–1913
Marsden Rock c.1880–1900
oil on canvas 36.1 x 51
TWCMS : G4247

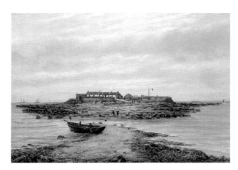

Hemy, Bernard Benedict 1845–1913
St Mary's Island c.1885–1895
oil on canvas 36 x 51.4
TWCMS : G5218

Hemy, Bernard Benedict 1845–1913
The Entrance to the Tyne c.1895
oil on canvas 61.3 x 91.8
TWCMS : G4214

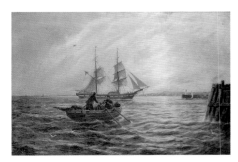

Hemy, Bernard Benedict 1845–1913
Seascape
oil on canvas 61 x 91.2
TWCMS : G4202

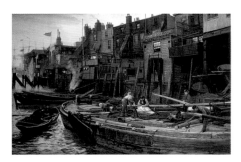

Hemy, Charles Napier 1841–1917
London River, the Limehouse Barge-Builders
1877
oil on canvas 91.5 x 137
TWCMS : G5210

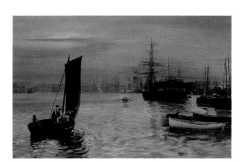

Hemy, Charles Napier 1841–1917
The Last Boat In 1878
oil on canvas 57 x 74.9
TWCMS : K20733

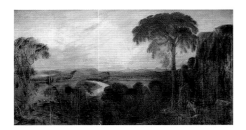

Hill, David Octavius 1802–1870
The Vale of the Forth and Stirling
oil on canvas 137.8 x 245
TWCMS : G5235

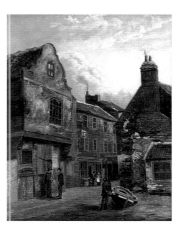

Hodge, Robert b.c.1875
Old Shields, Wapping Street and Union Lane
1896
oil on canvas 48.3 x 37.9
TWCMS : G4201

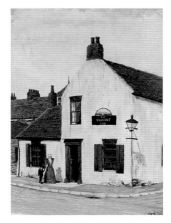

Hopkinson, Joseph W. active 1965–1967
'The Old Vigilant' Inn 1965
oil on canvas 46 x 35.7
TWCMS : G5249

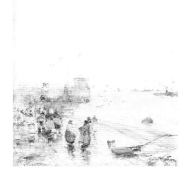

Horton, George Edward 1859–1950
North Shields Fish Quay c.1896
oil on canvas 40.6 x 31.6
TWCMS : G5764

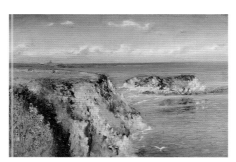

Ireland, Jennie Moulding d.1945
The Island, Marsden
oil on canvas 30.8 x 45.8
TWCMS : G4246

Jefferson, Charles George 1831–1902
Shields Beach and Tynemouth Castle 1873
oil on board 29.1 x 45.6
TWCMS : G4216

Jefferson, Charles George 1831–1902
Trow Rocks, South Shields 1888
oil on canvas 61.3 x 91.7
TWCMS : G4285

Jefferson, Charles George 1831–1902
Jesmond Dene, Newcastle upon Tyne 1893
oil on canvas 76.1 x 63.5
TWCMS : G4253

Jefferson, Charles George 1831–1902
Frenchman's Bay, South Shields
oil on canvas 64.6 x 77
TWCMS : G4286

Jefferson, Charles George 1831–1902
Shipwreck off Tynemouth
oil on canvas 43.8 x 71.8
TWCMS : G4210

Jobling, Robert 1841–1923
Fishergirl and Child 1883
oil on canvas 139 x 90.5
TWCMS : G5231

Jobling, Robert 1841–1923
Winter Fuel 1910
oil on canvas 30.5 x 40.7
TWCMS : G4209

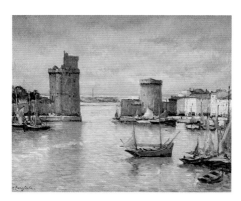

Kell, Robert John Shipley d.1934
*Peacocks Farm and Ballast Hills, Newcastle
upon Tyne* 1892
oil on board 23.7 x 30.6
TWCMS : G4222

King, Yeend 1855–1924
Christmas Morning c.1900
oil on panel 28.1 x 17.6
TWCMS : G5233

Langlade, Pierre 1812–1909
La ville de La Rochelle, France
oil on canvas 60.3 x 72.9
TWCMS : G4274

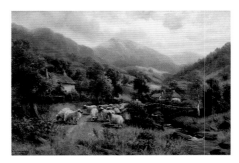

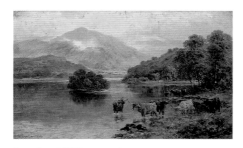

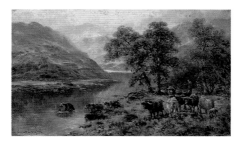

Langley, William active 1880–1920
Aber, North Wales
oil on canvas 51.3 x 76.5
TWCMS : G4267

Langley, William active 1880–1920
Loch Katrine
oil on canvas 30.6 x 50.8
TWCMS : G4211

Langley, William active 1880–1920
The Pass of Brander, Argyll and Bute
oil on canvas 30.3 x 50.8
TWCMS : G4212

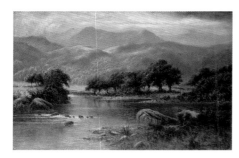

Leader, Charles active 1900
Landscape
oil on canvas 61.2 x 92
TWCMS : G5226

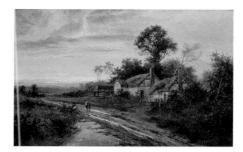

Leader, Charles active 1900
Twilight
oil on canvas 51 x 75.9
TWCMS : G4258

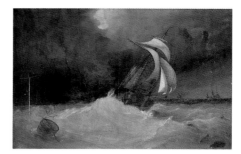

Leathem, William J. 1815–1857
Sea Piece 1852
oil on canvas 122.8 x 184.2
TWCMS : G4275

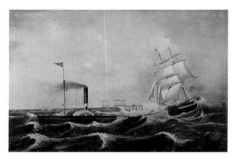

Lee, Nicholas
The Brig 'Brotherly Love' and Tug 'William'
(copy after John Scott) 1881
oil on canvas 61.4 x 91.5
TWCMS : G4251

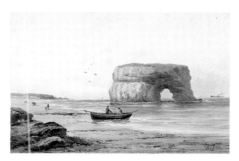

Liddell, John Davison 1859–1942
Marsden Rock c.1885–1910
oil on board 31.1 x 46.3
TWCMS : G4218

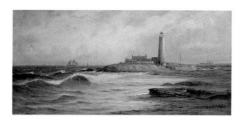

Liddell, John Davison 1859–1942
St Mary's Island
oil on canvas 30.5 x 61
TWCMS : G4221

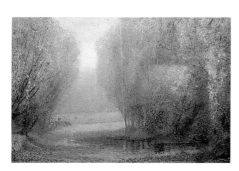

Lowe, Arthur 1866–1940
Dry Watercourse
oil on board 46.6 x 67.8
TWCMS : G4229

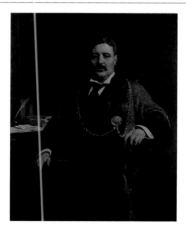

Macklin, Thomas Eyre 1867–1943
*Alderman Thomas Dunn Marshall, Mayor
(1898–1899)* 1900
oil on canvas 127.7 x 102.5
TWCMS : 1999.1901

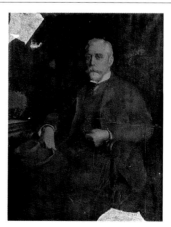

Macklin, Thomas Eyre 1867–1943
Edmund John Jasper Browell 1908
oil on canvas 122.3 x 91.3
TWCMS : G5239

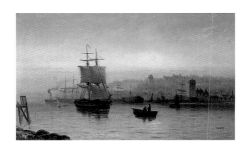

McLea, Duncan Fraser 1841–1916
The Mouth of the River Tyne, North Bank
1875
oil on canvas 30.2 x 50.8
TWCMS : G4238

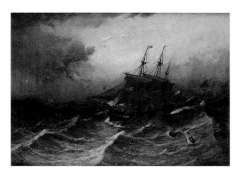

McLea, Duncan Fraser 1841–1916
Sailing Vessel in a Storm 1882
oil on canvas 51.1 x 69
TWCMS : G4226

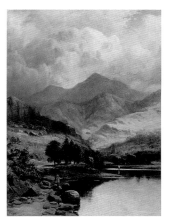

McLea, Duncan Fraser 1841–1916
Scottish Landscape 1884
oil on canvas 45.8 x 36.3
TWCMS : G4294

McLea, Duncan Fraser 1841–1916
*The Opening of the Albert Edward Dock and
Port of Tyne* 1884
oil on canvas 31.2 x 61.6
TWCMS : G5248

McLea, Duncan Fraser 1841–1916
*The Wreck of the Barque 'Jacob Rothenberg',
28 November 1878* 1887
oil on canvas 50.7 x 76.4
TWCMS : G4207

McLea, Duncan Fraser 1841–1916
Self Portrait c.1890
oil on board 30.9 x 25.9
TWCMS : G4280

McLea, Duncan Fraser 1841–1916
Robert Watson (1815–1885) 1891
oil on board 61.8 x 46.2
TWCMS : G4290

McLea, Duncan Fraser 1841–1916
The Wreck off the South Pier 1897
oil on canvas 30.5 x 46.2
TWCMS : G4293

McLea, Duncan Fraser 1841–1916
A Bit of Old Shields 1898
oil on canvas 20.6 x 30.9
TWCMS : G7255

McLea, Duncan Fraser 1841–1916
The Entrance to the Tyne, Sunset 1899
oil on canvas 40.8 x 61.3
TWCMS : G4215

McLea, Duncan Fraser 1841–1916
Bents House 1900
oil on board 30.8 x 46.8
TWCMS : G4244

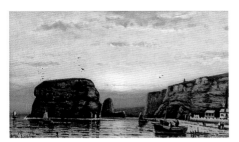

McLea, Duncan Fraser 1841–1916
Marsden Bay 1911
oil on board 31.2 x 52.2
TWCMS : G4224

Morton, J. S. active mid-20th C
South Shields Market Place
oil on board 46.1 x 61.3
TWCMS : G4300

Nelson, Oliver
Peacocks Farm and Cottages 1895
oil on canvas 21.5 x 40.7
TWCMS : G4288

O'Brien, Alfred Ainslie 1912–1988
To the Rear of Woodbine Street, South Shields
1976
acrylic on canvas 71.1 x 61.2
TWCMS : G7262

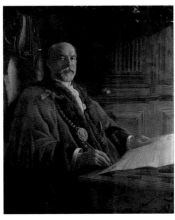

Ogilvie, Frank Stanley 1858–after 1935
Alderman Robert Readhead, Mayor
(1893–1894, 1894–1895 & 1910–1912) 1912
oil on canvas 127.5 x 102
TWCMS : G5246

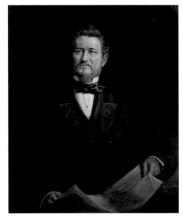

Ogilvie, Frank Stanley 1858–after 1935
John Thomas 1912–1913
oil on canvas 127.4 x 101.7
TWCMS : G5237

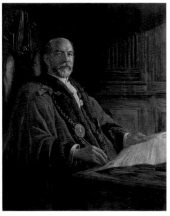

Ogilvie, Frank Stanley (copy of)
1858–after 1935
Alderman Robert Readhead, Mayor
(1893–1894, 1894–1895 & 1910–1912) 1912
oil on canvas 128.2 x 104.1
TWCMS : 1999.1900

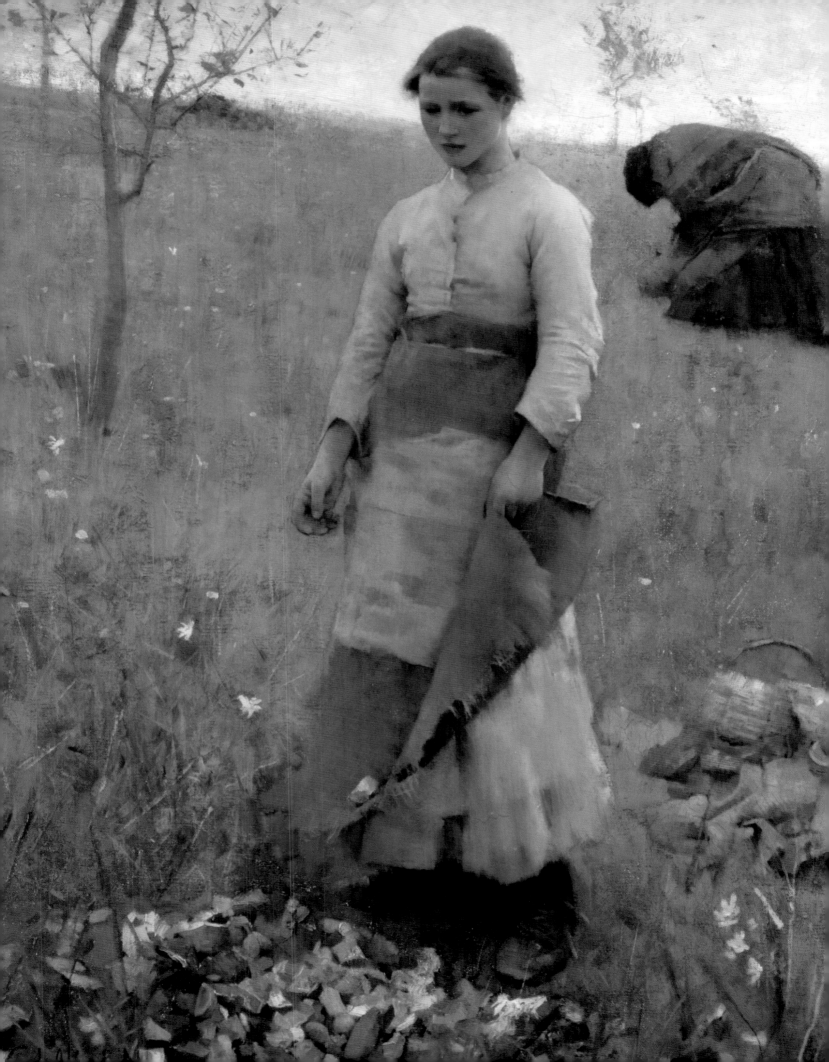

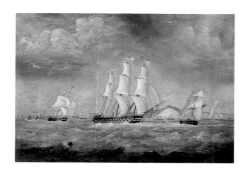

Oliver, William 1804–1853
Shipping off Dover c.1858
oil on canvas 65.8 x 90.8
TWCMS : G4284

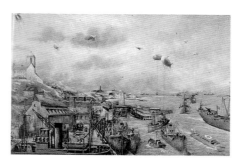

Pearson, J. active 1942–1964
Wartime Scene at the Mouth of the Tyne 1942
oil on canvas 61.2 x 92
TWCMS : G4276

Pearson, J. active 1942–1964
Comical Corner, 1929 1957
oil on panel 48.8 x 36.4
TWCMS : G4295

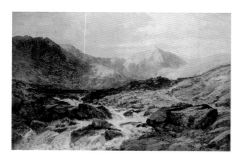

Pettitt, Edwin Alfred 1840–1912
The Glaslyn Stream 1877
oil on canvas 51.6 x 76.2
TWCMS : G4266

Pick, Anton 1840–c.1905
Alpine Scene 1878
oil on canvas 68.8 x 105.6
TWCMS : G5230

Reed, Colin C.
Venice 1956
oil on paper 35.4 x 25.1
TWCMS : J12956

Robinson, C.
The 'Agincourt' Entering the Tyne 1884
oil on canvas 63.6 x 101.2
TWCMS : G4273

Robson, J. active 1958
Marsden Cottage, Salmon's Hall
oil on board 16.2 x 25.2
TWCMS : G5217

Robson, John
The Hartley Men 1930
oil on canvas 79 x 103.9
TWCMS : G7264

Facing page: Clausen, George, 1852–1944, *The Stone Pickers* (detail), 1887, Laing Art Gallery, (p. 125)

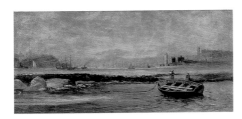

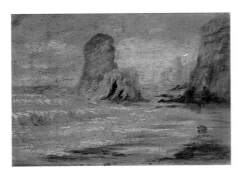

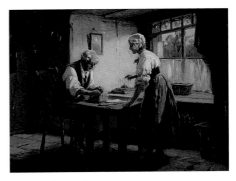

Robson, Robert Kirton
The Mouth of the Tyne from the Black Middens
1888
oil on board 24.9 x 50.4
TWCMS : G4245

Robson, Robert Kirton (style of)
The Southern End of Marsden Bay
oil on canvas 27.7 x 38.2
TWCMS : G4296

Rosell, Alexander 1859–1922
A Present for the Front c.1914–1918
oil on canvas 25.8 x 33.3
TWCMS : G4281

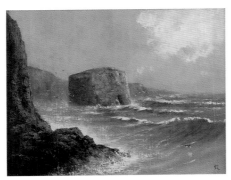

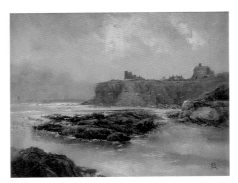

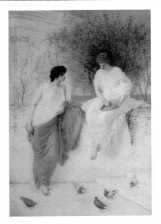

Rutherford, Charles active 1890–1911
Marsden Rock
oil on board 37 x 47.5
TWCMS : G4248

Rutherford, Charles active 1890–1911
North Bay, Tynemouth
oil on board 37.2 x 47.5
TWCMS : G4249

Schafer, Henry Thomas 1854–1915
Feeding the Pigeons 1887
oil on canvas 94.5 x 64.8
TWCMS : G4256

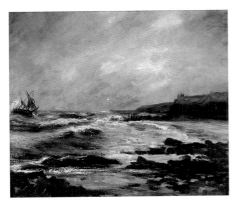

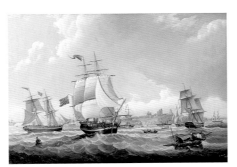

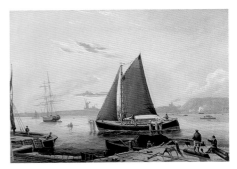

Scott, H. C. B.
*The Wreck of the Russian Ketch 'Julerneck' off
Marsden Cliffs, 1901*
oil on board 39.7 x 46.7
TWCMS : G4292

Scott, John 1802–1885
The Brig 'Margaret' 1845
oil on canvas 63.5 x 93.1
TWCMS : G4232

Scott, John 1802–1885
Tyne Wherry at the Mill Dam 1850
oil on canvas 53.8 x 77
TWCMS : G4204

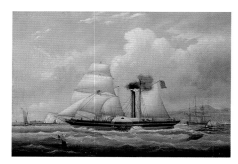

Scott, John 1802–1885
The Paddle-Tug 'Henry Wright' 1852
oil on canvas 53.8 x 76.2
TWCMS : G4227

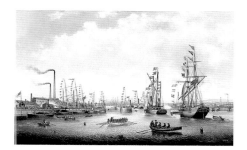

Scott, John 1802–1885
The Opening of Tyne Dock 1859
oil on canvas 103 x 153.8
TWCMS : G4230

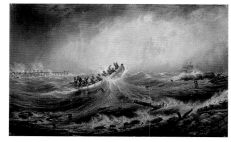

Scott, John 1802–1885
A Wreck off the South Pier 1861
oil on canvas 93.2 x 146.8
TWCMS : G7261

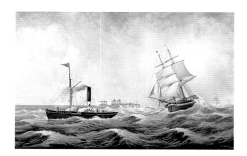

Scott, John 1802–1885
The Brig 'Brotherly Love' and Tug 'William'
1875
oil on canvas 68.7 x 106.5
TWCMS : G7260

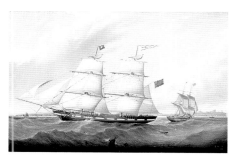

Scott, John 1802–1885
The Collier Brig 'Mary' 1885
oil on board 55.8 x 83.9
TWCMS : G4228

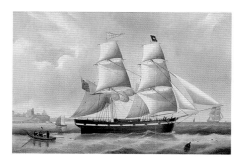

Scott, John 1802–1885
The Collier Brig 'Sicily'
oil on canvas 53.7 x 76.7
TWCMS : G4237

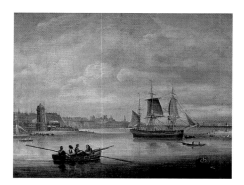

Scott, John 1802–1885
The Entrance to the Tyne
oil on canvas 41.3 x 53.8
TWCMS : G4203

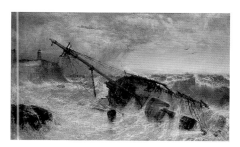

Scott, John 1802–1885
The Wreck
oil on board 91.9 x 148.6
TWCMS : G5220

Shearer, Jacob b.1846
Shipwreck 1879
oil on canvas 31 x 46.2
TWCMS : G4297

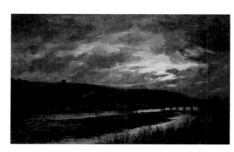

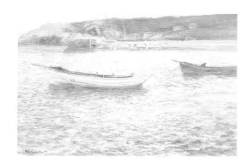

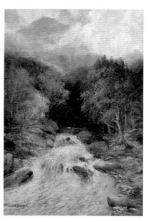

Slater, John Falconar 1857–1937
Afterglow, Hexham, Northumberland
oil on canvas 128.5 x 204.3
TWCMS : G5234

Slater, John Falconar 1857–1937
Cullercoats Bay
oil on canvas 51.1 x 76.5
TWCMS : G5250

Stanger, J. H. active early 20th C
A Mountain Forest
oil on canvas 91.5 x 61.4
TWCMS : G4265

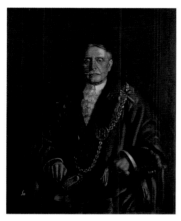

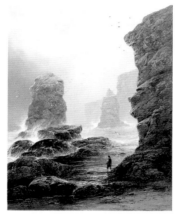

Stephenson, Henry active 1889–1921
Alderman John Taylor, Mayor (1915–1916)
1921
oil on canvas 113.6 x 92
TWCMS : G5241

Sticks, George Blackie 1843–1938
The Cliffs at Marsden Bay 1898
oil on canvas 92.5 x 71.5
TWCMS : G5224 (P)

Surtees, John 1819–1915
*A Fine Morning in the Valley of the Lledr,
North Wales* 1871
oil on canvas 61.2 x 107.2
TWCMS : G4264

Thompson, Mark 1812–1875
The Opening of Tyne Dock 1859
oil on canvas 91.4 x 153.1
TWCMS : G7253

Thornton, Ronald William b.1936
Marine Grotto, Marsden 1969
oil on board 39.5 x 49.3
TWCMS : G4299

unknown artist
South Shields Market Place c.1800
oil on canvas 70.5 x 121.2
TWCMS : G7259

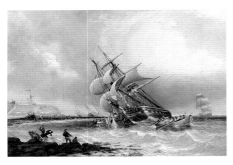

unknown artist
Shipwrecks off the Tyne c.1825–1850
oil on canvas 51.4 x 74.2
TWCMS : G4298

unknown artist
Harbour and Castle at Sunset 1838
oil on canvas 81.5 x 148.5
TWCMS : G5232

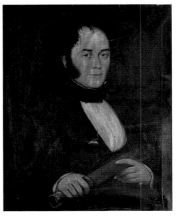

unknown artist
Portrait of a Man c.1850
oil on canvas 75.1 x 61.5
TWCMS : G4263

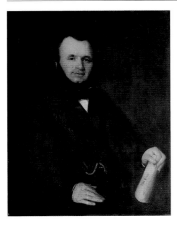

unknown artist
James Cochran Stevenson (1825–1905) c.1866
oil on board 92.3 x 72.2
TWCMS : G4269

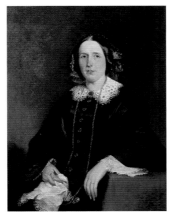

unknown artist
*Elisa Ramsay Stevenson, née Anderson
(1830–1908)* c.1860–1866
oil on board 92.1 x 71.8
TWCMS : G4270

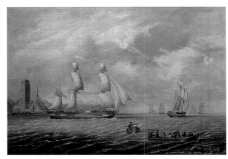

unknown artist
The Brig 'Darius' 1862
oil on canvas 65 x 91.7
TWCMS : G7256

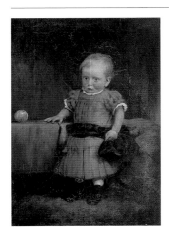

unknown artist
Portrait of a Child c.1885
oil on canvas 38.6 x 28.5
TWCMS : G4278

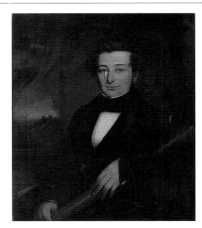

unknown artist mid-19th C
Portrait of a Young Man
oil on canvas 76 x 63.2
TWCMS : G4277

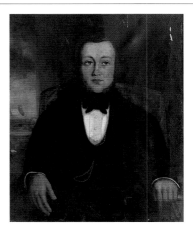

unknown artist mid-19th C
Portrait of an Unknown Man
oil on canvas 76.4 x 63.7
TWCMS : G5215

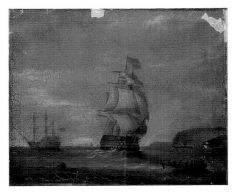

unknown artist 19th C
British Men-O'-War
oil on canvas 64 x 76.7
TWCMS : G4252

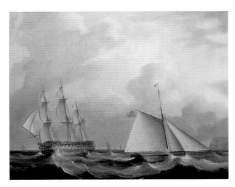

unknown artist 19th C
East Indiaman and Cutter
oil on canvas 63.5 x 76.4
TWCMS : G4241

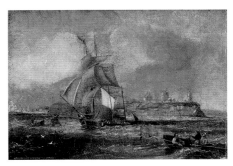

unknown artist 19th C
Entrance to the Tyne
oil on canvas 26.8 x 38.3
TWCMS : G7267

unknown artist
Portrait of an Unknown Man (possibly Harry
McDermott) c.1920
oil on board 47.5 x 35.5
TWCMS : G4206

unknown artist
Farmyard Scene
oil on canvas 50.8 x 68.6
TWCMS : G4208

Vernet, Horace (after) 1789–1863
The Departure of Napoleon for Elba
oil on canvas 81.8 x 101.2
TWCMS : G5229

Sunderland Museum and Winter Gardens

Sunderland Museum was the first local authority museum outside London to be established following the Museums Act of 1846. The Sunderland Corporation took over the collections of the Sunderland Natural History and Antiquarian Society, which included a small number of oil paintings.

The first recorded fine art acquisition for the newly established museum was a commission by the Corporation. Mark Thompson, a Sunderland artist, was charged with recording an event of major significance to the rapidly developing town, the opening of the new South Dock in 1850, for which he was paid 30 guineas. The painting is still in the Collection. This may be the first occasion in which a town council anywhere in the country commissioned a painting.

The Collection grew slowly, at first, until the opening of the new museum and library building in 1879. Thomas Dixon was a key figure in this development. A self-educated cork-cutter in Sunderland, Dixon corresponded with major intellectuals and literary figures and gained support from artists and intellectuals including Dante Gabriel Rossetti and John Ruskin. Alphonse Legros' *Thomas Dixon* was a one-hour demonstration piece, painted on the day that the new museum building opened in 1879. Dixon was said not to be well at the time, and this is apparent in his pale and drawn features. Rossetti gave two drawings to the Museum to mark the occasion, and in the following year, Ruskin produced a design for the interior of the new art gallery in a room previously used for other purposes. The creation of the gallery stimulated the rapid expansion of the Collection.

By 1898, the Collection had grown to 104 paintings and was significantly enhanced by the Dickinson Bequest of 31 paintings in 1908. Growth has continued over the years, with the most controversial acquisition being the purchase in 1930 of Richard Jack's *Love Tunes the Shepherd's Reed* which some councillors considered 'unsuitable for display in the gallery'. The artist's reply to this was, 'To attack a picture like this in these days of scanty bathing costumes is absurd. The people who condemn that picture should wear paper bags on their heads when they go to the seaside lest they see something that might shock them'. The *Sunderland Echo* made a successful public appeal to raise the £300 purchase price.

The Museum relied heavily on gifts and bequests in the early years of the twentieth century, with no works at all being purchased between 1904 and 1920. Donations were used to buy paintings until 1939, when an annual purchase fund was set up. In the 1960s, the Collection benefited from a new purchase policy and the advice of Dennis Farr from the Tate Gallery, which led to the acquisition of paintings by artists including Ruskin Spear, Robin Philipson and Allen Jones.

The oil painting collection now numbers over 500 works, mostly by British artists, from the nineteenth and twentieth centuries. There is a strong collection of paintings with a particular local significance, either because they record local scenes or people, or because they are by artists from the region including Clarkson Stanfield, John Wilson Carmichael, the Hemy brothers and Ralph Hedley. Maritime scenes are well represented, not surprisingly as Sunderland has a busy port and a long history as an important centre for

shipbuilding. Paintings without a local connection include some fine nineteenth-century works by artists such as Sebastian Pether, Thomas Francis Dicksee, Thomas Faed and Edwin Landseer.

L. S. Lowry is an artist of particular importance to Sunderland. During the last 15 years of his life he was a regular visitor to Sunderland, which became a second home for him. He used the Seaburn Hotel as a base for travelling throughout the region, and produced some remarkable work as a result of this close association. The permanent collection now includes four oil paintings by the artist, as well as others on long-term loan, and a number of drawings. Three of the oil paintings (*Dockside, Sunderland; The Sea at Sunderland*, and *Self Portrait 1*) were purchased in 2005 with the aid of grants from the Heritage Lottery Fund, the Museums, Libraries and Archives Council/Victoria and Albert Museum Purchase Grant Fund and the Friends of Sunderland Museums. Lowry visited the Museum on a number of occasions, and particularly liked Thomas Marie Madawaska Hemy's *Old Sunderland* and Thomas Francis Dicksee's *Juliet*.

Other twentieth century artists represented in the Collection in addition to those already mentioned include Keith Vaughan and Michael Ayrton. More recently, the contemporary collection has grown with the help of the Contemporary Art Society's distribution scheme. For instance, work by Stephen Farthing and Ged Quinn has been added.

Juliet Horsley, Regional Hub Exhibitions Manager

Facing page: Irving, William, 1866–1943, *The Blaydon Races, a Study from Life* (detail), 1903, Shipley Art Gallery, (p. 39)

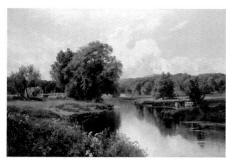

Adams, John Clayton 1840–1906
Weeds by the River Dart 1893
oil on canvas 107.5 x 153
TWCMS : B11467

Allan, Griselda b.1905
*The Construction of Thompson's Shipyard,
Southwick* 1944
oil on canvas 50 x 79
TWCMS : E2742

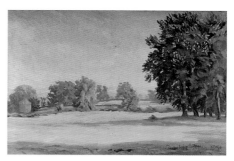

Allan, Griselda b.1905
Berkshire Landscape 1951
oil on canvas 38.1 x 55.9
TWCMS : B1276

Allan, Griselda b.1905
Clematis
oil on canvas 74 x 31 (E)
TWCMS : E2704.3a

Allan, Griselda b.1905
Larkspur
oil on canvas 74 x 31 (E)
TWCMS : E2704.9a

Allan, Griselda b.1905
Michaelmas Daisy
oil on canvas 74 x 31 (E)
TWCMS : E2704.13a

Allinson, Adrian Paul 1890–1959
Flower Piece
oil on board 92.1 x 70.5
TWCMS : B11458

Anderson, E.
*Introduction of Printing into England, Caxton,
1477* 1925
oil on canvas 73.5 x 200.5
TWCMS : E2704.3

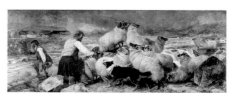

Ansdell, Richard 1815–1885
A Spate in Glen Spean, Inverness c.1868
oil on canvas 76.5 x 203.5
TWCMS : B10587

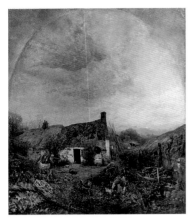

Anthony, Henry Mark (attributed to)
1817–1886
Sunset, the Woodman's Cottage
oil on canvas 145 x 124.5
TWCMS : B4588

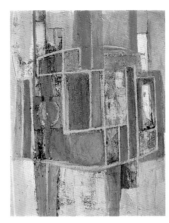

Archer, Roy D. active 1963–1964
Yellow Figure 1963
oil on hardboard 76.2 x 58.4
TWCMS : B1300

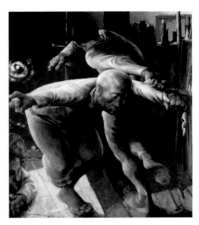

Ayrton, Michael 1921–1975
Slow Dance for the Nativity 1958
oil on board 101 x 90.8
TWCMS : G62

Bailey, Dulcie
Bramble
oil on canvas 74 x 31 (E)
TWCMS : E2704.1a

Bailey, Dulcie
Daffodil
oil on canvas 74 x 31 (E)
TWCMS : E2704.13b

Bailey, Dulcie
Foxglove
oil on canvas 74 x 31 (E)
TWCMS : E2704.5a

Banner, Delmar Harmond 1896–1983
Great Gable from Wandope
oil on canvas 61.6 x 92.1
TWCMS : B11457

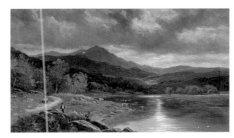

Barland, Adam active 1843–1916
Mountain Landscape with River 1869
oil on canvas 25.4 x 45
TWCMS : B4589

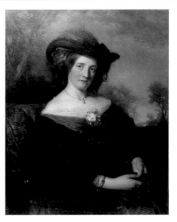

Baxter, Charles 1809–1879
Mrs Thompson of Sunderland
oil on canvas 102.6 x 79.4
TWCMS : B9423

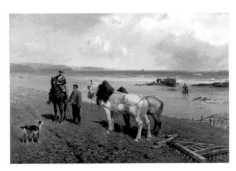

Beavis, Richard 1824–1896
The Story of the Wreck c.1872
oil on canvas 54 x 77.5
TWCMS : B10554

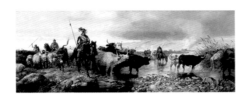

Beavis, Richard 1824–1896
A Border Raid on an English Castle 1880
oil on canvas 77 x 199.5
TWCMS : B1266

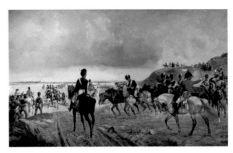

Beavis, Richard 1824–1896
The Passage of the Bidassoa 1886
oil on canvas 122.5 x 207
TWCMS : B10584

Beddall, Kathlyn b.1920
Sunlight in Old Church Street, Chelsea 1949
oil on canvas 39 x 49.5
TWCMS : E2703

Bell, J. active 1885–1895
'SS J. W. Taylor', Sunderland
oil & gilt paint on porcelain 30.8 x 25.9
TWCMS : J6813

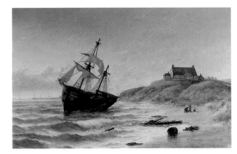

Bell, Stuart Henry 1823–1896
Bents Farm, Whitburn 1885
oil on canvas 62 x 92
TWCMS : B9427

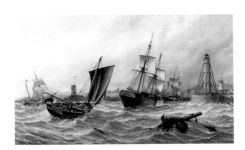

Bell, Stuart Henry 1823–1896
*Moving of the Old North Pier Lighthouse,
Sunderland, 1841* 1887
oil on canvas 92 x 153
TWCMS : B10563

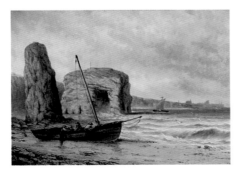

Bell, Stuart Henry 1823–1896
Marsden Rock 1891
oil on canvas 40.8 x 56
TWCMS : R311

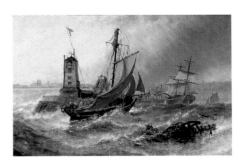

Bell, Stuart Henry 1823–1896
*Sunderland, 1855, Morning after a Heavy
South-Eastern Gale* 1892
oil on canvas 33.3 x 48.3
TWCMS : B9409

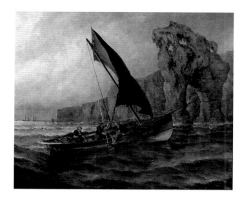

Bell, Stuart Henry 1823–1896
'Sea-Coopering' Fishing Up Christmas Cheer
1894
oil on canvas 63.8 x 76.9
TWCMS : J14150

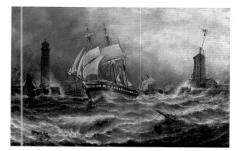

Bell, Stuart Henry 1823–1896
*Sunderland Harbour in 1859, the Barque
'Hedvig'* 1895
oil on canvas 61.5 x 92
TWCMS : B9437

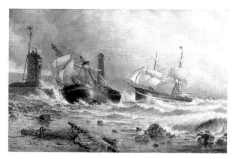

Bell, Stuart Henry 1823–1896
Wreck in Sunderland Harbour (as it appeared
about 1850) 1896
oil on canvas 51 x 76.5
TWCMS : B9415

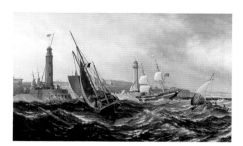

Bell, Stuart Henry 1823–1896
*Entrance to Sunderland Harbour in a North-
East Gale*
oil on canvas 61 x 101.5
B9436 (P)

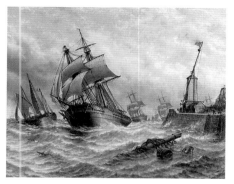

Bell, Stuart Henry 1823–1896
Old South Pier and Lighthouse, Sunderland
oil on canvas 41 x 50.8
B9185 (P)

Bell, Stuart Henry 1823–1896
Sunderland Harbour in 1854
oil on canvas 92 x 153
TWCMS : B9445

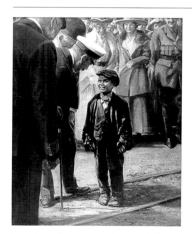

Berrie, John Alexander Archibald
1886–1962
*King George V at Doxford's Shipyard,
16 June 1917* c.1917
oil on canvas 127 x 102
TWCMS : B4574

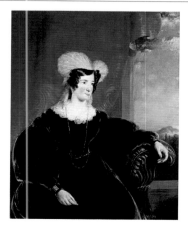

Bewick, William (attributed to) 1795–1866
Mrs Andrew White c.1836–c.1840
oil on canvas 129 x 101.6
TWCMS : B5628

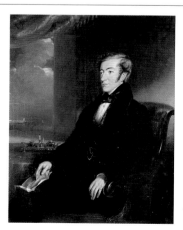

Bewick, William (attributed to) 1795–1866
*Andrew White (1792–1856), Mayor of
Sunderland*
oil on canvas 127 x 102
TWCMS : B4583

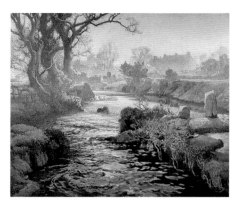

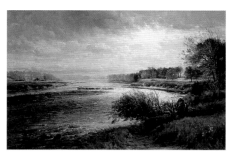

Birch, Samuel John Lamorna 1869–1955
The Morning Mist
oil on canvas 51 x 62
TWCMS : B11464

Blackman, E
Poppy
oil on canvas 74 x 31 (E)
TWCMS : E2704.1a

Blair, John 1850–1934
*The Tweed above Norham Castle,
Northumberland* 1887
oil on canvas 112 x 167.5
TWCMS : B11468

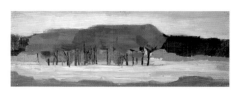

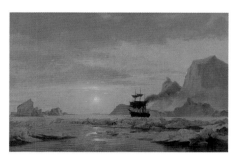

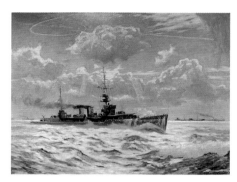

Bolton, Elaine
Landscape with Trees 1962
oil on board 32.2 x 91.4
TWCMS : 1998.306

Bradford, William 1823–1892
Arctic Regions
oil on canvas 87 x 132.4
TWCMS : B2515

Bradshaw, George Fagan 1888–1961
'HMS Delhi' 1942
oil on wood 76.5 x 101.6
TWCMS : B3558

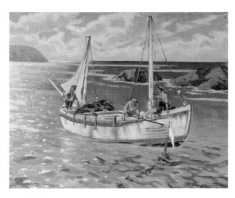

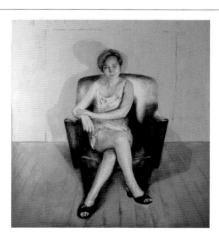

Bradshaw, George Fagan 1888–1961
Lobster Fishing
oil on canvas 40.6 x 50.9
TWCMS : B1256

Brett, John 1830–1902
Procession of Craft up to Bristol in a Fog 1888
oil on canvas 107 x 214
TWCMS : B10581

Brewster, Paul b.1960
Christina Kirk 1997
oil on canvas 170.7 x 161.4
TWCMS : 1998.301

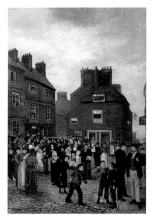

Brown, J. Gillis 1808–1892
Salvation Army 1884
oil on canvas 91.5 x 61
TWCMS : B2531

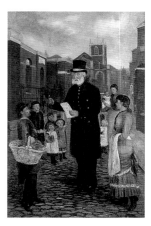

Brown, J. Gillis 1808–1892
Tommy Sanderson, Town Crier 1884
oil on canvas 91.5 x 61
TWCMS : B2530

Brown, J. Gillis 1808–1892
William Brown of Monkwearmouth 1885
oil on canvas 49.5 x 39.5
TWCMS : 2008.102

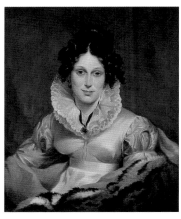

Brown, R.
Miss Barnes 1823
oil on canvas 76.1 x 62.5
TWCMS : B3587

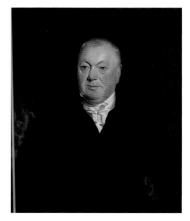

Brown, R.
Dr William Barnes
oil on canvas 76.5 x 63.5
TWCMS : B1287

Buckner, Richard 1812–1883
Portrait of a Lady Wearing a White Dress
oil on canvas 239 x 148.5
TWCMS : B3571

Burgess, Arthur James Wetherall
1879–1957
The 'Reedsman'
oil on hardboard 30.5 x 44.7
TWCMS : P728

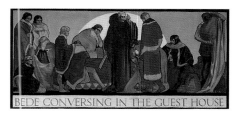

Burgess, G.
Bede Conversing in the Guest House 1925
oil on canvas 73.5 x 212
TWCMS : E2704.1

Burrows, Robert 1810–1893
Gainsborough's Lane 1868
oil on board 22.8 x 21.6
TWCMS : B3591

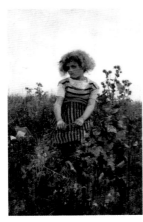

Caffieri, Hector 1847–1932
Little Truant c.1880–1900
oil on canvas 100.7 x 65.4
TWCMS : B2519

Cairns, Joyce W. b.1947
Midnight Manoeuvres 1986
oil on hardboard 180.5 x 120
TWCMS : P711

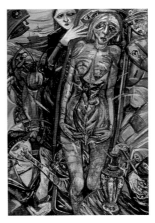

Cairns, Joyce W. b.1947
Warning Bell on the North Pier 1986
oil on hardboard 181 x 121
TWCMS : P712

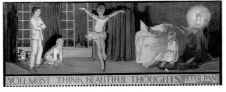

Campbell, M.
'You must think beautiful thoughts ', (from
'Peter Pan' by J. M. Barrie)
oil on canvas 73.5 x 183
TWCMS : E2704.4

Campbell, Meriel b.1912
Lackagh Bridge, County Donegal, Ireland
1956
oil on canvas 40.6 x 50.8
TWCMS : B1293

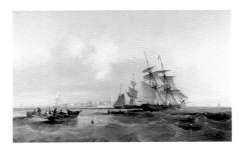

Carmichael, John Wilson 1800–1868
Old Hartlepool 1835
oil on canvas 66 x 107
TWCMS : B10565

Carmichael, John Wilson 1800–1868
Murton Colliery, County Durham 1843
oil on canvas 61 x 91.5
TWCMS : B2534

Carmichael, John Wilson 1800–1868
The Opening of Sunderland South Docks,
20 June 1850 1850
oil on canvas 102.5 x 163
TWCMS : B9450

Carmichael, John Wilson 1800–1868
The Opening of Sunderland South Docks,
20 June 1850 1850
oil on canvas 102.2 x 163.7
TWCMS : E3483

Carmichael, John Wilson 1800–1868
Entrance to Sunderland Harbour 1862
oil on board 20.3 x 35.6
TWCMS : B9194

Carmichael, John Wilson 1800–1868
Sunderland Pier 1862
oil on board 20.5 x 36
TWCMS : B9193

Carmichael, John Wilson 1800–1868
Sunderland Harbour 1864
oil on canvas 61 x 92
TWCMS : B9449

Carmichael, John Wilson 1800–1868
Off Whitby 1865
oil on canvas 50.8 x 82
TWCMS : B5625

Carmichael, John Wilson 1800–1868
Shipping on the Solent, off Calshot Castle 1865
oil on canvas 50.8 x 82
TWCMS : B9444 (P)

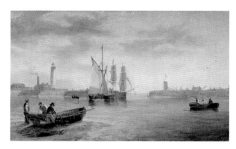

Carmichael, John Wilson 1800–1868
Sunderland Harbour, 1866
oil on millboard 20.3 x 33
TWCMS : B9180

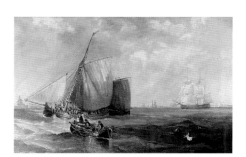

Carmichael, John Wilson 1800–1868
Wind Freshening off Hull
oil on canvas 61 x 96.3
TWCMS : B9402

Carmichael, John Wilson (attributed to)
1800–1868
*Sunderland Pier with the Old
Lighthouse* c.1845
oil on canvas 25.5 x 35
TWCMS : B9420

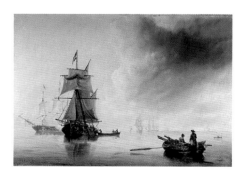

Carmichael, John Wilson (attributed to)
1800–1868
Shipping in a Calm
oil on canvas 35.3 x 50.8
TWCMS : B9182

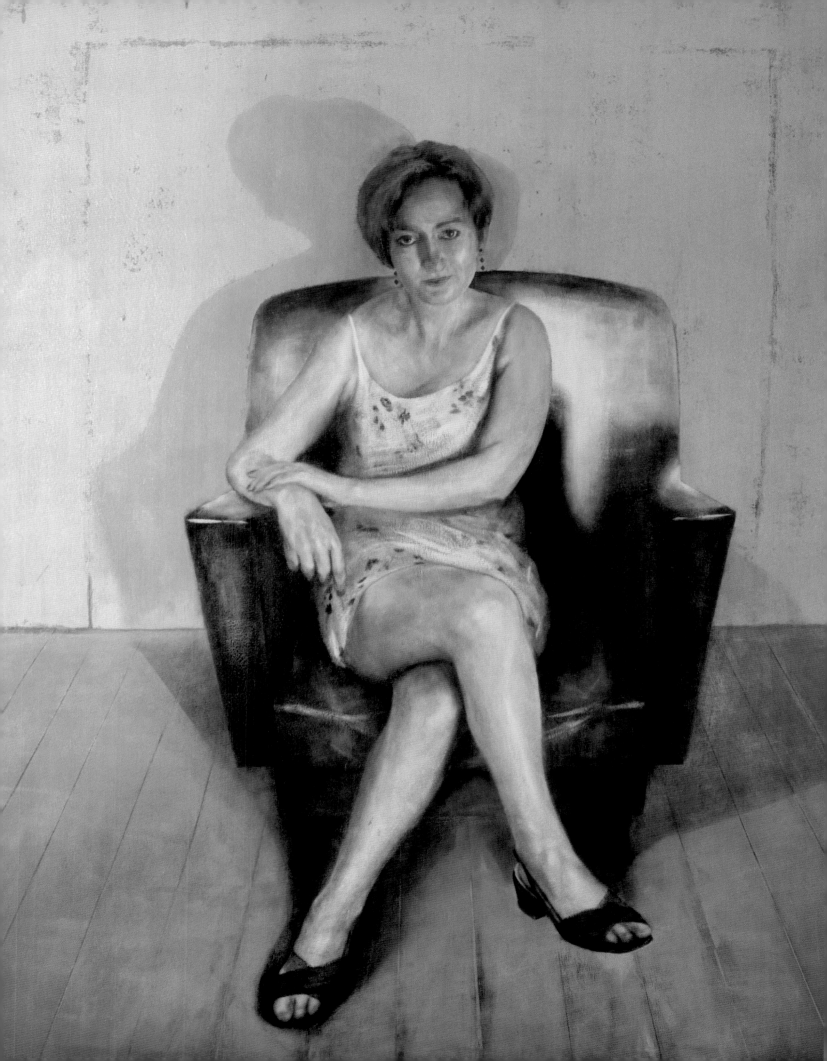

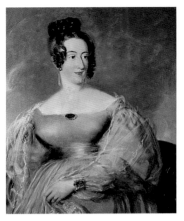

Chalon, Alfred Edward (follower of)
1780–1860
Sarah Dorothy Hall (1831–1874) c.1850
oil on canvas 91.5 x 76.2
TWCMS : B3573

Chalon, John James 1778–1854
Shipping in an Estuary
oil on canvas 106.7 x 173.7
TWCMS : C439

Chevalier, Nicholas 1828–1902
Sunny Climes, Tahiti 1883
oil on canvas 99 x 152.5
TWCMS : B2513

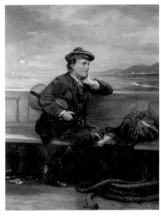

Chevalier, Nicholas 1828–1902
Seeking Fortune
oil on canvas 122 x 91.5
TWCMS : B5627

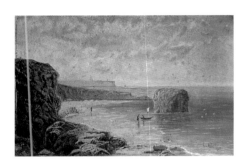

Christie, Ernest C. 1863–1937
Marsden Bay 1901
oil on millboard 31.2 x 47
TWCMS : B4596

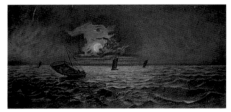

Christie, J. W. (attributed to)
Seascape
oil on board 25.3 x 50.5 (E)
TWCMS : K6204

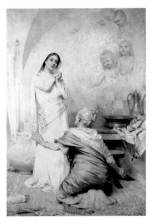

Clark, James 1858–1943
Magnificat 1886
oil on canvas 162 x 106
TWCMS : B10556

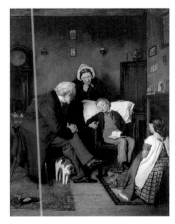

Clark, Joseph 1835–1913
The Sick Boy c.1857
oil on canvas 67.3 x 50.8
TWCMS : B10553

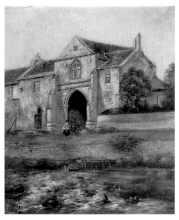

Claughan, Edward. W.
Kepier Hospital Gateway, Durham 1884
oil on canvas 30.5 x 25.4
TWCMS : B9413

Facing page: Brewster, Paul, b.1960, *Christina Kirk* (detail), 1997, Sunderland Museum and Winter Gardens, (p. 276)

Clough, Prunella 1919–1999
Midland Landscape II
oil on board 81.3 x 75.2
TWCMS : B6904

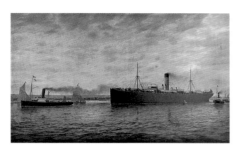

Cockerham, Charles active c.1900–1935
'SS Winkfield' Bound for South Africa with Troops, July 1890
oil on canvas 87 x 142.9
TWCMS : B3578 (P)

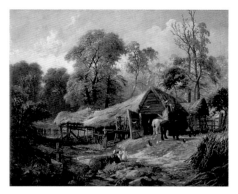

Cole, George Vicat (attributed to)
1833–1893
Farmyard with Stables 1873
oil on canvas 50.8 x 61
TWCMS : B4553

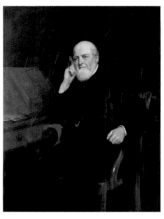

Collier, John 1850–1934
James Laing (1823–1901) c.1896
oil on canvas 139.7 x 111.8
TWCMS : B4571

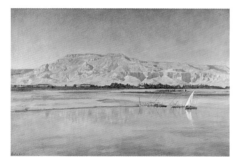

Collier, John 1850–1934
Theban Hills from Luxor 1920
oil on canvas 55.3 x 79.4
TWCMS : B2535

Colquhoun, Alice E.
The Pied Piper of Hamelin 1925
oil on canvas 73.5 x 172
TWCMS : E2704.10

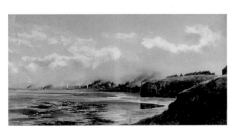

Connell, William active 1871–1925
Holey Rock, Roker, Sunderland
oil on glass 44.5 x 86.5
TWCMS : B3574

Cornthwaite, René
Columbine
oil on canvas 74 x 31
TWCMS : E2704.12

Cornthwaite, René
Cornflower
oil on canvas 74 x 31 (E)
TWCMS : E2704.15a

Cracknell, Gertie
Viper's Bugloss
oil on canvas 74 x 31
TWCMS : E2704.15b

Cracknell, Gertie
Water Flag
oil on canvas 74 x 31 (E)
TWCMS : E2704.14a

Cracknell, Gertie
Wild Rose
oil on canvas 74 x 31
TWCMS : E2704.11

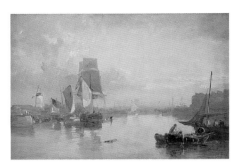

Crawford, Edmund Thornton 1806–1885
Shields Harbour 1837
oil on board 32 x 47
TWCMS : B4575

Crosby, Frederick Gordon 1885–1943
Well at Fulwell, 1879 c.1930
oil on plywood 35.5 x 25.1
TWCMS : B4580

Crosby, Frederick Gordon 1885–1943
The Village Pond and West Farm, Fulwell
oil on panel 29.8 x 48
TWCMS : G52

Crosby, William 1830–1910
Roker Beach c.1860–1885
oil on canvas 60 x 104.5
TWCMS : P740

Crosby, William 1830–1910
William Snowball 1875
oil on canvas 128.3 x 101.6
TWCMS : B3562

Crosby, William 1830–1910
Edward Backhouse (1808–1879) 1881
oil on canvas 77 x 64
TWCMS : B3580

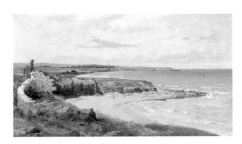

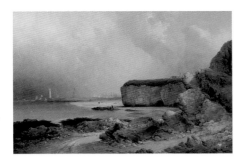

Crosby, William 1830–1910
Whitburn Bay 1884
oil on canvas 45.8 x 78.8
TWCMS : B4557

Crosby, William 1830–1910
Holey Rock, Roker, Sunderland before 1903
oil on canvas 61 x 91.5
B9435 (P)

Crozier, William b.1930
Red Hill 1963
oil on board 99.5 x 99
TWCMS : C4362

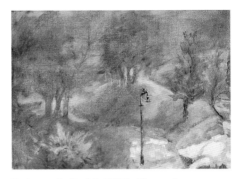

Dalrymple-Smith, Edith Alexandra
1895–1958
Mowbray Park, Sunderland, Early Morning
oil on board 38 x 50.8
TWCMS : B5643

Danby, James Francis 1816–1875
Loch Fyne with Inverary Castle from the South West 1852
oil on canvas 77.5 x 123
TWCMS : B1270

Danby, Thomas 1818–1886
Poet's Dream
oil on canvas 90.8 x 160
TWCMS : B2514

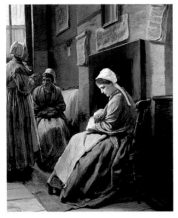

Dibdin, J. active 19th C
Shipping
oil on canvas 77.5 x 126.7
TWCMS : B3561

Dicksee, Thomas Francis 1819–1895
Juliet 1877
oil on canvas 106.5 x 71
TWCMS : B10552

Dixon, Alfred 1842–1919
Forsaken 1879
oil on canvas 127 x 100.4
TWCMS : B4558

Dixon, Alfred 1842–1919
Thomas Dixon (1831–1880)
oil on canvas 50.8 x 41.6
TWCMS : B1262

Dodd, Francis 1874–1949
Spring in the Suburbs 1925
oil on canvas 63.5 x 76
TWCMS : B11463

Douglas, Phoebe Sholto b.1906
Clarence Lawson Wood (1878–1957) 1936
oil on canvas 61.6 x 50.8
TWCMS : B3554

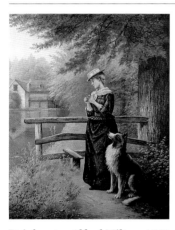

Drinkwater, Alfred Milton 1860–1917
Portrait of a Woman and a Dog 1891
oil on canvas 91.7 x 71.2
TWCMS : B3579

Drinkwater, Alfred Milton 1860–1917
Landscape with Lake 1894
oil on glass 20 x 25.2
TWCMS : B4586

Drinkwater, Alfred Milton 1860–1917
Landscape with Mountain and Lake 1894
oil on glass 20 x 25.5
TWCMS : B4587

Drinkwater, H. F. C. 1862–1949
Girdle Cake Cottage on the Wear 1899
oil on canvas 71.8 x 92.4
TWCMS : B9429

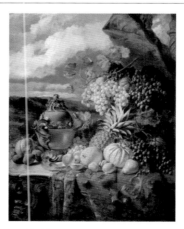

Duffield, William 1816–1863
Fruit 1853
oil on canvas 127 x 101
TWCMS : B2508

Elliott, Robinson 1814–1894
School Time 1864
oil on panel 30.5 x 22.3
TWCMS : B2518

Emmerson, Henry Hetherington
1831–1895
Wool Gathering before 1883
oil on canvas 62.2 x 123.2
TWCMS : B2523

Emmerson, Henry Hetherington
1831–1895
North Tyne
oil on millboard 11.4 x 25.1
TWCMS : B5605

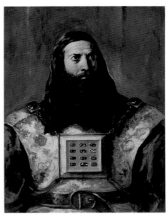

Etty, William (attributed to) 1787–1849
Aaron the High Priest
oil on board 91.5 x 68.5
TWCMS : B2526

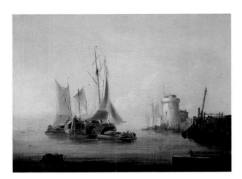

Ewbank, John Wilson c.1799–1847
Calm Morning off the Dutch Coast c.1841
oil on canvas 48 x 65
TWCMS : B9184

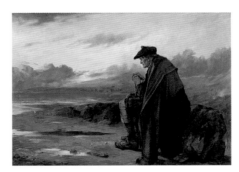

Faed, Thomas 1826–1900
'Oh, why I left my hame?' 1886
oil on canvas 112.8 x 156
TWCMS : C434

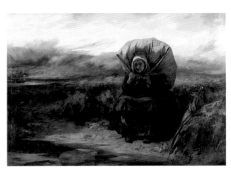

Faed, Thomas 1826–1900
'And with the burden of many years' 1888
oil on canvas 153.5 x 213.5
TWCMS : B4582

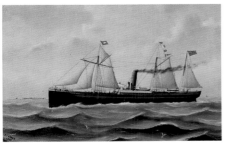

Fannen, John 1857–1904
Steamship 'German Emperor' 1889
oil on board 38.3 x 61
TWCMS : B9186

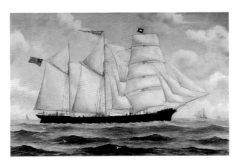

Fannen, John 1857–1904
Iron Barque 'Regent' 1892
oil & pencil on canvas 51.1 x 76.5
TWCMS : B9417

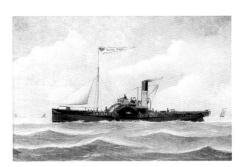

Fannen, John 1857–1904
The 'Royal Duke' 1896
oil on canvas 39 x 59.3
TWCMS : P741

Farthing, Stephen b.1950
Fish Dish 1978–1979
acrylic & wax on canvas 185.3 x 134.5
TWCMS : G65

Fell, Sheila Mary 1931–1979
Winter, Cumberland I
oil on canvas 101.6 x 127
TWCMS : C448

Ferguson, James W. active 1885–1922
The Tug 'Rescue' Towing the Brig 'Polly' into Sunderland Harbour 1885
oil on millboard 29 x 45.5
TWCMS : B4597

Foley, Henry John 1818–1874
Market Day at a Town in Normandy, France
oil on canvas 40.6 x 61
TWCMS : B1289

French, Nancy
Honeysuckle
oil on canvas 74 x 31 (E)
TWCMS : E2704.7a

French, Nancy
Thistle
oil on canvas 74 x 31 (E)
TWCMS : E2704.6a

Frost, Terry 1915–2003
Suspended Forms 1967
acrylic & collage on canvas 132.1 x 121.7
TWCMS : C450

Gallon, Robert 1845–1925
Tributary of the Wharfe, Yorkshire 1883
oil on canvas 76.2 x 127
TWCMS : B4563

Garland, Henry 1834–1913
Crossing the Ford
oil on canvas 94 x 160
TWCMS : B3556

Garrick, Jean Olive d.1972
Abstract No.3
oil on canvas 50.8 x 40.3
TWCMS : B5601

Garrick, Jean Olive d.1972
The Snow Scene
oil on board 40.6 x 50.7
TWCMS : K6203

Garrick, Jean Olive d.1972
Yachts, Roker
oil on canvas 35.6 x 47
TWCMS : B4600

Garrick, Jean Olive d.1972
Young Girl
oil on canvas 61 x 50.8
TWCMS : B5602

Garvie, Thomas Bowman 1859–1944
Harry Poore Everett 1936
oil on canvas 157.8 x 101
TWCMS : B1255

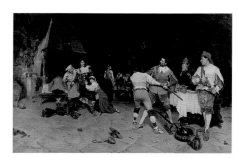

Giachi, E. active 1890–1891
Tavern Brawl 1890
oil on canvas 62.2 x 98
TWCMS : C435

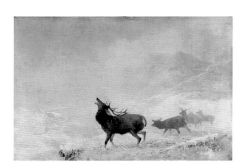

Gibb, Thomas Henry 1833–1893
Thus Far 1883
oil on canvas 61 x 91.5
TWCMS : B1261

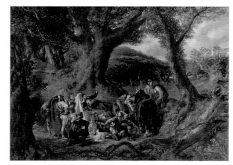

Gilbert, John 1817–1897
Brigands Dividing the Booty c.1871–1873
oil on canvas 78 x 109.2
TWCMS : C438

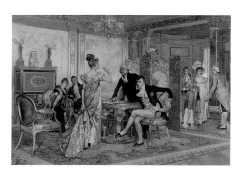

Glindoni, Henry Gillard 1852–1913
'To be or not to be' 1902
oil on canvas 106.7 x 152.5
TWCMS : B1251

Facing page: Grant, William James, 1829–1866, *Juliet and the Friar 'Take thou this phial'* (from William Shakespeare's *'Romeo and Juliet'*) (detail), Shipley Art Gallery, (p. 31)

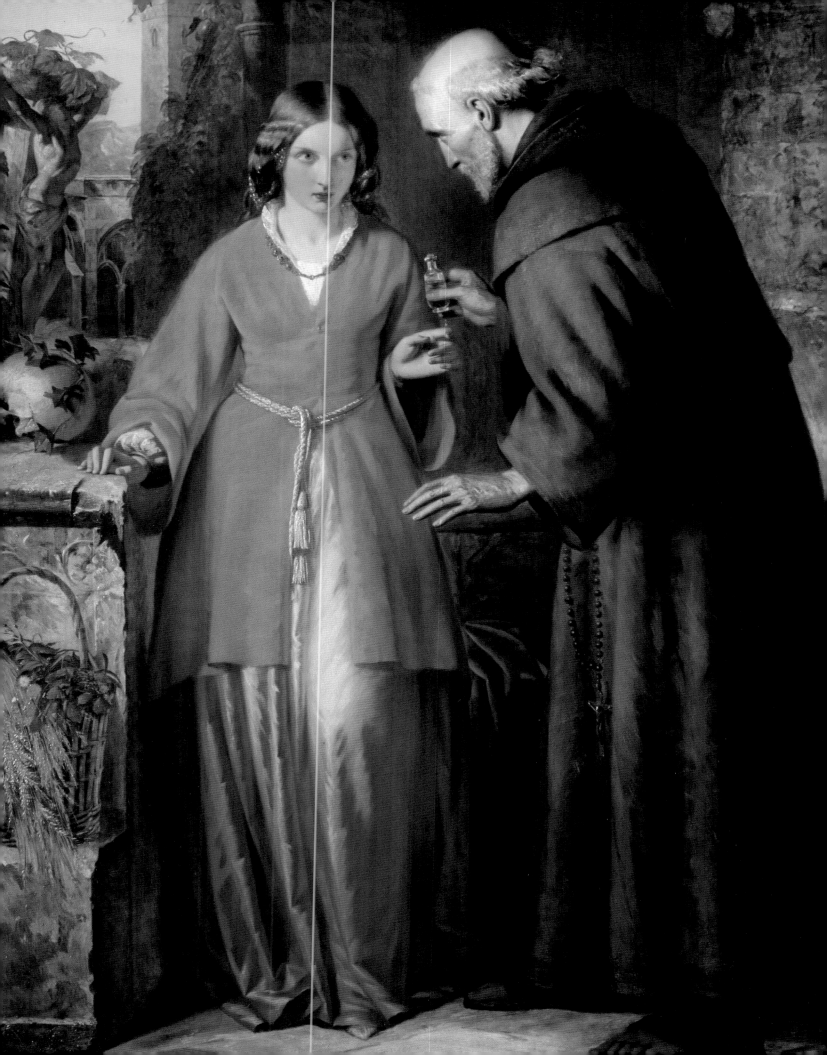

Goodall, Frederick 1822–1904
Subsiding of the Nile c.1870–c.1885
oil on canvas 61 x 127
TWCMS : B2543

Graham, George 1881–1949
Wensley Village, Yorkshire 1911
oil on canvas 60.2 x 76.2
TWCMS : B1286

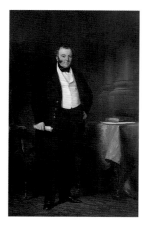

Grant, Francis 1803–1878
George Hudson (1800–1871) 1846
oil on canvas 239 x 147
TWCMS : 2007.5155

Green, Ernest d.1960
Durham Road, Silksworth Lane Corner c.1920
oil on board 25.4 x 30.2
TWCMS : B9411

Green, Ernest d.1960
'Dun Cow' Inn, Seaton village 1922
oil on wood 40.6 x 50.8
TWCMS : B4565

Green, Ernest d.1960
Seaton Village 1922
oil on wood 40 x 50.2
TWCMS : B4567

Green, Ernest d.1960
Seaton Village 1922
oil on wood 40.6 x 50.8
TWCMS : B4568

Grimshaw, Louis Hubbard 1870–1944
Sunderland Harbour 1899
oil on canvas 29 x 44.5
TWCMS : 1997.3671

Gross, Anthony 1905–1984
Wheatfield 1962
oil on canvas 45 x 60.5
TWCMS : C4359

Halfnight, Richard William 1855–1925
Eventide
oil on canvas 128 x 102.3
TWCMS : B1265

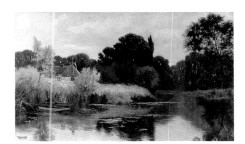

Halfnight, Richard William 1855–1925
Summertime on the Thames
oil on canvas 76.2 x 127.6
TWCMS : B4562

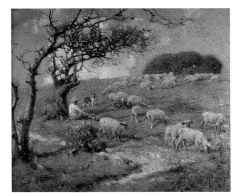

Hall, Frederick 1860–1948
Hampshire Downs c.1920
oil on canvas 64.8 x 76.9
TWCMS : B2503

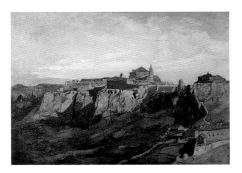

Hall, Oliver 1869–1957
Ronda, Spain
oil on canvas 55.9 x 81.3
TWCMS : B11470

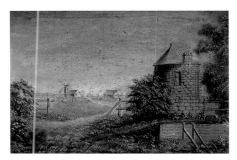

Hall, R. M. active 1887–1888
Mill at Ryhope Grange, Sunderland 1887
oil on canvas 19 x 29
TWCMS : E4192

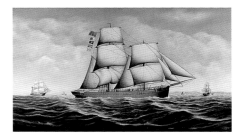

Hard, R.
The Brig 'Thomas and Elizabeth' of Sunderland 1879
oil on canvas 54 x 92.1
TWCMS : B3553

Harding, James Duffield 1798–1863
Beilstein on the Moselle, Germany
oil on canvas 81.3 x 137.2
TWCMS : B9448

Harper, Edward b.1970
Gun Street c.2000
acrylic on canvas 153 x 245
TWCMS : 2001.2861

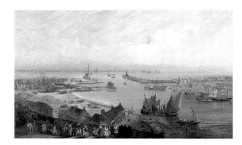

Hastings, Edward 1781–1861
Sunderland Harbour from Roker
c.1850–c.1855
oil on canvas 91.5 x 151.5
TWCMS : B10567

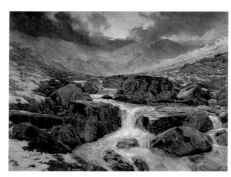

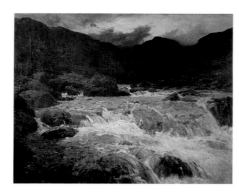

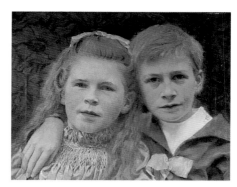

Haswell, John 1855–1925
Mountain Torrent, Melting Snow c.1908
oil on canvas 51.1 x 69
TWCMS : B4593

Haswell, John 1855–1925
After the Storm
oil on canvas 62 x 76.5
TWCMS : B11460

Haswell, John 1855–1925
Philip and V. M. Haswell, Aged 8 and 6
oil on canvas 35.5 x 45.6
TWCMS : B4579

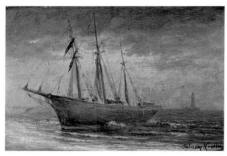

Hedley, Johnson 1848–1914
'Emily Smead', Aground at Sunderland
1904–1905
oil on millboard 20.4 x 30.9
TWCMS : B2502

Hedley, Johnson 1848–1914
Girdle Cake Cottage 1912
oil on panel 24.1 x 34.4
TWCMS : T1702

Hedley, Johnson 1848–1914
Hylton Ferry c.1912
oil on canvas 27 x 38
TWCMS : E2740

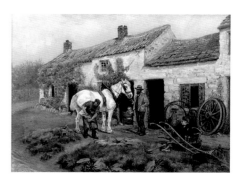

Hedley, Johnson 1848–1914
Holey Rock, Roker, Sunderland
oil on canvas 50.8 x 76.2
TWCMS : B2522

Hedley, Johnson 1848–1914
Red House Farm, Tunstall Road
oil on canvas 25.4 x 36.4
TWCMS : B9410

Hedley, Ralph 1848–1913
Smithy, Hexham, Bridge End 1885
oil on canvas 66 x 91.5
TWCMS : B2550

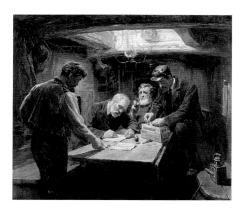

Hedley, Ralph 1848–1913
Duty Paid 1896
oil on canvas 109 x 126.5
TWCMS : C445

Hedley, Ralph 1848–1913
John Dickinson (d.1908) 1898
oil on canvas 110 x 88.3
TWCMS : B1296

Hedley, Ralph 1848–1913
Ralph Milbanke Hudson (1849–1938), JP
1900
oil on canvas 142 x 113
TWCMS : B3572

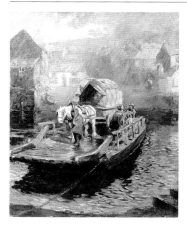

Hedley, Ralph 1848–1913
Hylton Ferry 1910
oil on canvas 62.9 x 50.8
TWCMS : B2548

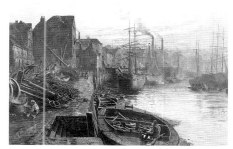

Hemy, Thomas Marie Madawaska
1852–1937
Old Sunderland 1885
oil on canvas 154 x 232.7
TWCMS : C6395

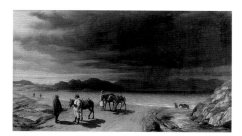

Herbert, John Rogers 1810–1890
Landscape with Lake and Greek Soldiers
oil on canvas 89 x 162.5
TWCMS : B10580

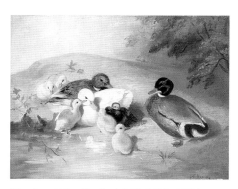

Herring, John Frederick II 1815–1907
Ducks and Ducklings
oil on millboard 22.9 x 29.9
TWCMS : B2541

Herring, John Frederick II 1815–1907
The Valley of Love, Hendon, Sunderland
oil on board 15.2 x 20.2
TWCMS : H15541

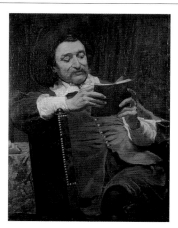

Hindley, Godfrey C. active 1873–1914
A Chapter of Accidents 1880
oil on canvas 94.5 x 75
TWCMS : B3583

Hiram (attributed to) active early 20th C
'SS Hesleyside'
oil on board 15.4 x 30.5
TWCMS : G73

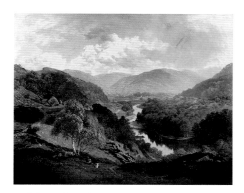

Holder, Edward Henry 1847–1922
Borrowdale, Cumbria 1888
oil on canvas 112.5 x 139.5
TWCMS : E2712

Holmes, Walter b.1936
The 'Challenger' 1988
oil on hardboard 28.9 x 44.3 (E)
TWCMS : P738

Hopper, J. D.
The Valley of Love, Hendon, Sunderland 1890
oil on canvas 41 x 61.3
TWCMS : J6804

Hornel, Edward Atkinson 1864–1933
In a Japanese Garden 1922
oil on canvas 80 x 71
TWCMS : B11466

Horsley, Thomas (attributed to)
active 1784–1790
Reverend John Wesley (1703–1791) c.1784
oil on canvas 61 x 49.5
TWCMS : B3551

Huckwell, T. active late 20th C
The 'Cedarbank'
oil on canvas 74.6 x 99.8
TWCMS : P737

Hudson, John 1829–1897
Snow 'Charles Henry' 1860
oil on canvas 41 x 61
TWCMS : B9187

Hudson, John 1829–1897
Brig 'Friends' c.1866
oil on canvas 57.2 x 85.1
TWCMS : B3559

Hudson, John 1829–1897
'SS Cogent' of Sunderland 1884–1885
oil on canvas 65.4 x 122
TWCMS : B2525

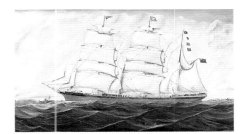

Hudson, John 1829–1897
Barque 'Lota'
oil on canvas 68.5 x 122
TWCMS : B9432

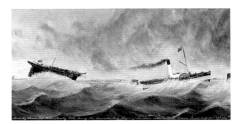

Hudson, John 1829–1897
Steam Tug 'Rescue'
oil on canvas 61 x 118
TWCMS : B10562

Hudson, R. M. 1899–1956
North Dock, Sunderland 1955
oil on canvas 49 x 59.5
TWCMS : E2710

Hughes, Terence active 20th C
Blue Landscape
acrylic on wood 47.6 x 40.7
TWCMS : B1272

Hughes-Stanton, Herbert Edwin Pelham
1870–1937
The Road to the Sea 1914
oil on canvas 25.5 x 35.5
TWCMS : B5639

Hughes-Stanton, Herbert Edwin Pelham
1870–1937
Autumn Day from Brithdir, North Wales 1918
oil on canvas 51 x 69
TWCMS : B5638

Hulk, Abraham I (attributed to) 1813–1897
Dutch Fishing Boats
oil on canvas 41 x 61.6
TWCMS : B9197

Hulk, Abraham II 1851–1922
Alverston Mill, Isle of Wight
oil on canvas 116 x 76.2
TWCMS : B9424

Hunt, Edgar 1876–1953
Farmyard Scene 1901
oil on canvas 50.8 x 76.6
TWCMS : B1264

Hunt, Edgar 1876–1953
Just in Time 1903
oil on canvas 50.8 x 68.9
TWCMS : B2501

Hunt, Edgar 1876–1953
Hens with Their Young 1905
oil on canvas 51.4 x 76.2
TWCMS : B4561

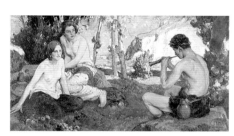

Hunt, Walter 1861–1941
Babes in the Wood 1893
oil on canvas 153 x 101
TWCMS : C444

Jack, Richard 1866–1952
Love Tunes the Shepherd's Reed 1920
oil on canvas 121.9 x 224.8
TWCMS : C442

Jack, Richard 1866–1952
Stansfield Richardson, JP
oil on canvas 152.5 x 101.6
TWCMS : B3577

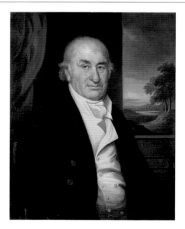

Jack, Richard 1866–1952
Mrs Stansfield Richardson, MBE 1921
oil on canvas 152.5 x 101.6
TWCMS : B2507

Jack, Richard 1866–1952
Irish Landscape
oil on canvas 35.5 x 53.4
TWCMS : B1297

Jefferson, John active 1811–1825
Robert Thompson (1748–1831) 1825
oil on canvas 81.5 x 66
TWCMS : B3584

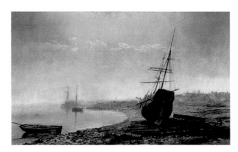

Jobling, Robert (attributed to) 1841–1923
Boats on a Slipway 1875
oil on canvas 40.6 x 66
TWCMS : B4555

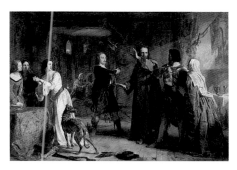

Johnston, Alexander 1815–1891
A Scene from 'The Lady of the Lake'
oil on canvas 113 x 163.2
TWCMS : B10558

Jones, Allen b.1937
Sun Plane 1963
oil & acrylic on cotton 244 x 274.3
TWCMS : C4361

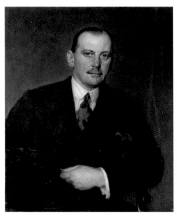

Jonniaux, Alfred 1882–1974
A Member of the Short (Shipbuilding) Family
oil on canvas 76.2 x 63.5
TWCMS : B1290

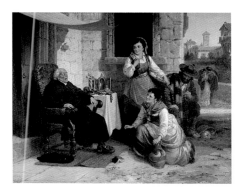

Kemm, Robert 1837–1895
The Sleeping Priest
oil on canvas 102.2 x 127.3
TWCMS : B2509

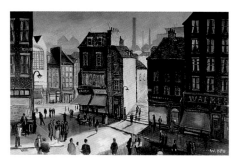

Kite, W. F. active mid-20th C
Street Scene No.1
oil on hardboard 49.8 x 75.3
TWCMS : 1998.307

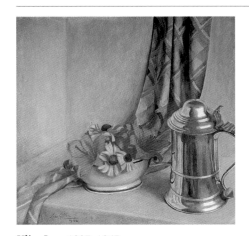

Klin, Leo 1887–1967
Silver Tankard 1944
tempera on board 31.2 x 36
TWCMS : B5637

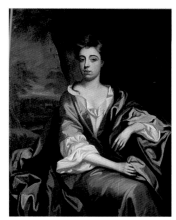

Kneller, Godfrey (style of) 1646–1723
Jane Ettrick (d.1700) 1696 (?)
oil on canvas 124 x 101
TWCMS : B3575 (P)

Koekkoek, Hendrik Pieter 1843–c.1890
Landscape with Cattle
oil on canvas 61 x 91.5
TWCMS : B4554

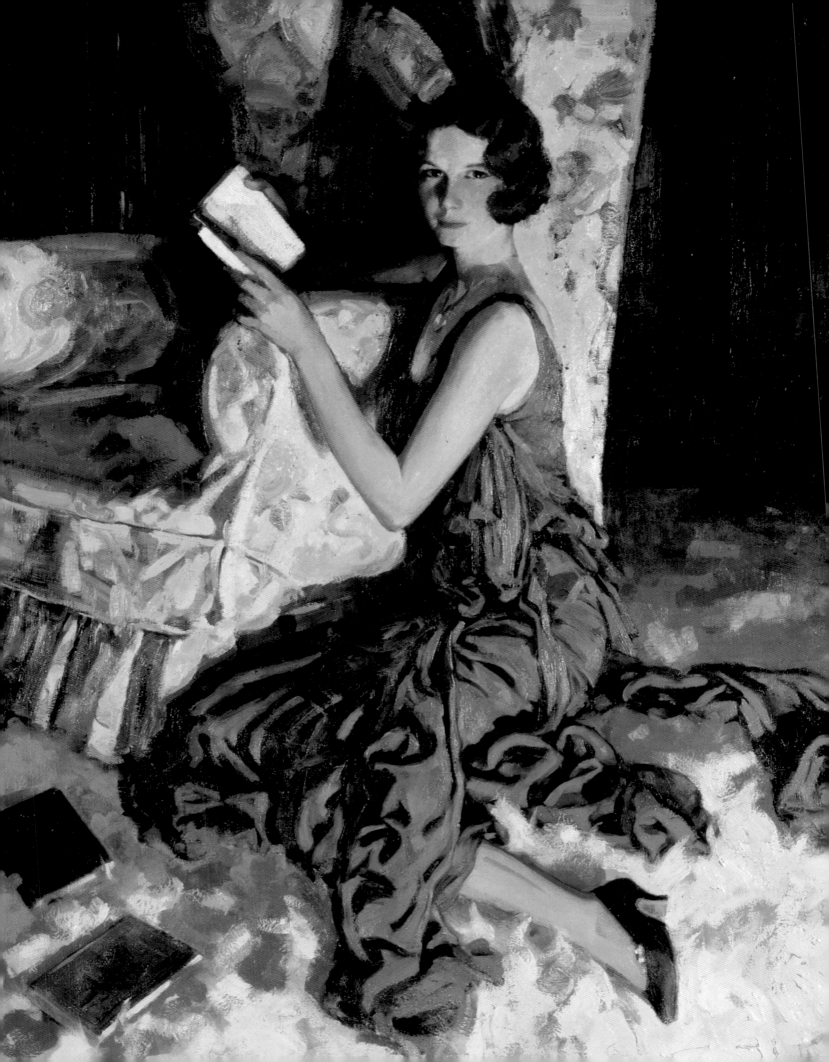

Lambert, Walter H. 1870/1871–1950
Cottage and Garden 1892
oil on canvas 30.5 x 35.2
TWCMS : B4598

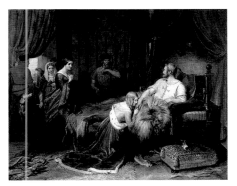

Landseer, Charles 1799–1879
A Scene from Walter Scott's 'The Talisman'
c.1840–1860
oil on canvas 102.1 x 127.3
TWCMS : B10557

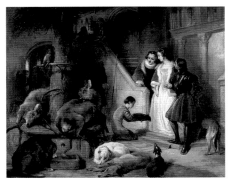

Landseer, Edwin Henry 1802–1873
Bolton Court in Olden Times
oil on canvas 101.6 x 127
TWCMS : B2511

Lee, Rosa b.1957
Reflection c.1991
oil on canvas 208 x 198
TWCMS : 1996.1801

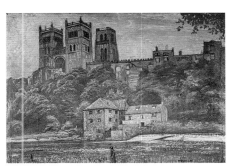

Lee, Sydney 1866–1949
Durham Cathedral
oil on canvas 90.2 x 127
TWCMS : B1258

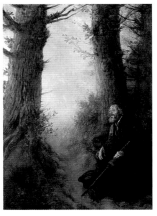

Legros, Alphonse 1837–1911
Tired Wanderer 1878
oil on canvas 150 x 107
TWCMS : C12824

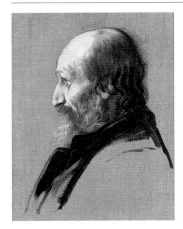

Legros, Alphonse 1837–1911
Thomas Dixon (1831–1880) 1879
oil on canvas 48.3 x 38.1
TWCMS : B9404

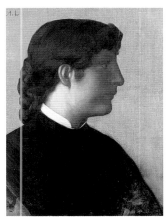

Legros, Alphonse 1837–1911
Portrait of a Lady c.1879
oil on canvas 48.5 x 38.5
TWCMS : B9405

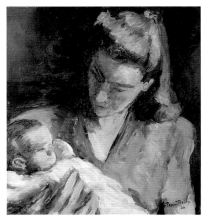

Leycester-Roxby, Edmund 1913–2001
Mother and Child 1944
oil on board 29.2 x 28
TWCMS : B2539

Facing page: Lambart, Alfred, 1902–1970, *Juliet, Daughter of Richard H. Fox of Surrey* (detail), 1931,
Laing Art Gallery, (p. 171)

Lindoe, V.
Ancient Mariner, 'Alone, alone, all, all alone, alone on a wide, wide sea!' 1923
oil on canvas 74.3 x 239
TWCMS : E2704.8

Lindoe, V.
The Walrus and the Carpenter', from Lewis Carroll
oil on canvas 73.5 x 205.5
TWCMS : E2704.2

Linnell, John (attributed to) 1792–1882
On the Thames
oil on panel 20 x 34.9
TWCMS : B2549

Lowe, Arthur 1866–1940
Tollerton Lake, near Nottingham
oil on canvas 68 x 91.5
TWCMS : B1253

Lowes, Audrey
Broom
oil on canvas 74 x 31 (E)
TWCMS : E2704.2a

Lowes, Audrey
Globe Flower
oil on canvas 74 x 31 (E)
TWCMS : E2704.9b

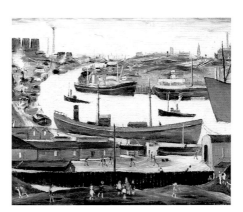

Lowry, Laurence Stephen 1887–1976
River Wear at Sunderland 1961
oil on board 51 x 60
TWCMS : C4363

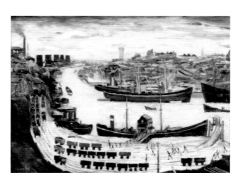

Lowry, Laurence Stephen 1887–1976
Dockside, Sunderland 1962
oil on canvas 56 x 76
TWCMS : R321

Lowry, Laurence Stephen 1887–1976
The Sea at Sunderland 1965
oil on braid 29 x 39
TWCMS : R324

Lowry, Laurence Stephen 1887–1976
Self Portrait I 1966
oil on board 60.2 x 50.1
TWCMS : R322

Lowry, Laurence Stephen 1887–1976
Girl in a Red Hat on a Promenade c.1972
oil on canvas 45.5 x 61
TWCMS : R320 (P)

Lowry, Laurence Stephen 1887–1976
Self Portrait II
oil on board 50.5 x 40
TWCMS : R323

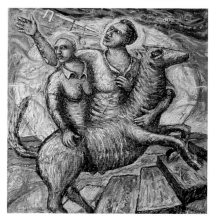

MacPherson, Neil b.1954
The Singing Lovers' Farewell 1986
acrylic & collage on board 96 x 80.8
TWCMS : 1998.302

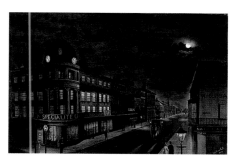

Marshall, Daniel Whiteley active 1875–1900
*Mackie's Corner, Sunderland, High Street West,
Looking East* 1884
oil on canvas 61 x 91.4
TWCMS : B9426

Marshall, Daniel Whiteley active 1875–1900
Reverend Arthur A. Rees 1884
oil on canvas 51.1 x 45.7
TWCMS : B3567

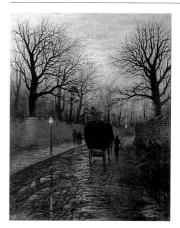

Marshall, Daniel Whiteley active 1875–1900
Tunstall Road, Sunderland c.1888
oil on canvas 91.4 x 71.5
TWCMS : C11827

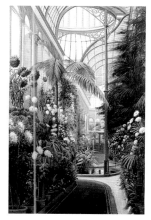

Marshall, Daniel Whiteley active 1875–1900
Winter Gardens Interior, Sunderland c.1895
oil on canvas 92.1 x 61
TWCMS : B9425

Marshall, Daniel Whiteley active 1875–1900
Fawcett Street, Sunderland about 1895
oil on canvas 20.3 x 30.5
TWCMS : B9414

Marshall, Daniel Whiteley active 1875–1900
John Green
oil on canvas 61 x 50.8
TWCMS : B2537

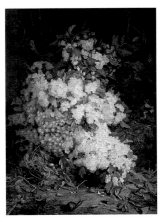

Marshall, John Fitz 1859–1932
Fragrant Hawthorn 1885
oil on canvas 69.5 x 51.1
TWCMS : B1268

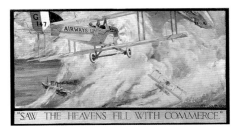

McCrum, J. P.
'*Saw the heavens fill with commerce*' 1924
oil on canvas 73.7 x 198
TWCMS : E2704.9

McCrum, J. P.
Early Man on the Wear
oil on canvas 73.7 x 214
TWCMS : E2704.14

McLea, Duncan Fraser 1841–1916
Robert Thompson's Shipyard at Southwick
oil on canvas 58.4 x 89.5
TWCMS : C422

Merriott, Jack 1901–1968
The Open Gate
oil on canvas 50.2 x 60.6
TWCMS : B1277

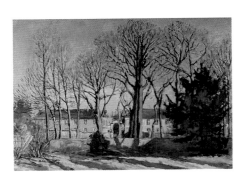

Methuen, Paul Ayshford 1886–1974
Winter Landscape, Corsham, Wiltshire
oil on canvas 66 x 93
TWCMS : B11461

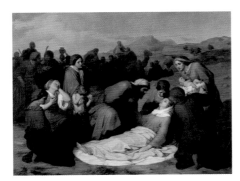

Metz, Gustav 1817–1853
The Death of Rachel 1847
oil on canvas 181.5 x 239
TWCMS : B4581

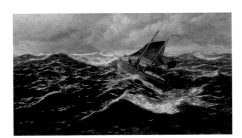

Miles, Thomas Rose active 1869–c.1910
Away to the Goodwin Sands (Dover Lifeboat)
oil on canvas 61.2 x 107
TWCMS : B7902

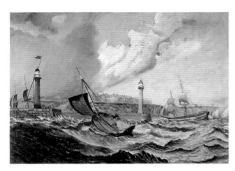

Mills, R.
Off Sunderland 1871
oil on canvas 25.5 x 37.8
TWCMS : B9181

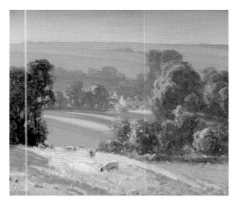

Milner, Frederick 1855–1939
In the Heart of the Cotswolds
oil on canvas 51.5 x 61.5
TWCMS : B5641

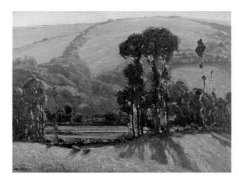

Milner, Frederick 1855–1939
In the Valley, Vale of Lanherne, Cornwall
oil on canvas 115.6 x 152.5
TWCMS : B3582

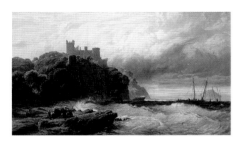

Mogford, John 1821–1885
Culzean Castle, Ayrshire 1877
oil on canvas 92 x 152
TWCMS : B11469

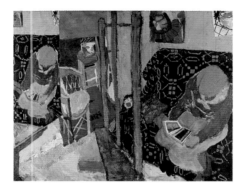

Moore, Sally b.1962
Figure in a Studio c.1983
oil on canvas 122 x 152.5
TWCMS : K16047

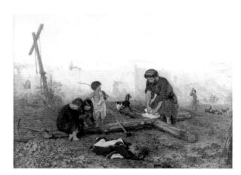

Morris, Philip Richard 1838–1902
Where They Crucified Him 1862
oil on canvas 66.1 x 91.5
TWCMS : B10559

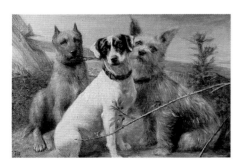

Moseley, Richard S. c.1843–1914
'Rose', 'Shamrock' and 'Thistle' 1884
oil on canvas 51.5 x 76.9
TWCMS : B1259

Mostyn, Thomas Edwin 1864–1930
In an Old-World Garden
oil on canvas 76 x 102.3
TWCMS : B5626

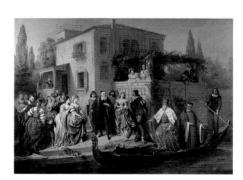

Muller, Robert Antoine c.1821–1883
Visit of the Doge of Venice to Titian
1870–1871
oil on canvas 95.2 x 132.7
TWCMS : B2510

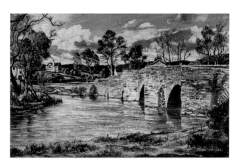

Muncaster, Claude 1903–1979
March Morning, Newby Bridge,
Cumbria 1950
oil on canvas 49.5 x 75
TWCMS : E2708

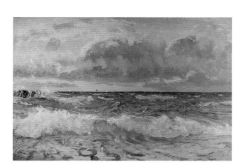

Murray, David 1849–1933
Where the Wind and the Waves and a Lone
Shore Meet 1910
oil on canvas 122 x 183
TWCMS : B5629

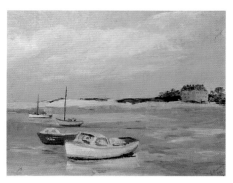

Murray, Edward active 1973–1974
Low Tide, Bembridge, Isle of Wight 1973
oil on board 33.7 x 43.4 (E)
TWCMS : 1999.154

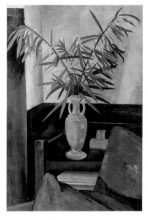

Nash, John Northcote 1893–1977
Flowers in a Blue Vase
oil on canvas 72 x 47.5
TWCMS : E2707

Newton, Herbert H. 1881–1959
Steepy Shore, French Riviera 1926
oil on canvas 52.1 x 76.4
TWCMS : B1283

Niemann, Edmund John 1813–1876
Richmond Castle, Yorkshire 1875
oil on canvas 33.3 x 51
TWCMS : C417

Noble, John Sargeant 1848–1896
On the Moors c.1870–1890
oil on canvas 116.9 x 152.5
TWCMS : B2512

Nockolds, Roy Anthony 1911–1979
Short Sunderland Flying Boat on Convoy
Patrol 1942
oil on canvas 70.5 x 91.7
TWCMS : B3552

Norman, Walter 1912–1994
Wear Tugs 1954
oil on board 29.9 x 40
TWCMS : B9412

Norman, Walter 1912–1994
River Wear, Sunderland with Shipyards 1955
oil on board 50.5 x 63.5
TWCMS : B9416

Normand, Ernest 1857–1923
Esther Denouncing Haman to King Ahasuerus
1888
oil on canvas 167 x 244.5
TWCMS : B5635

Ogilvie, Frank Stanley c.1856–after 1935
Robert Cameron (1825–1913), MP
oil on canvas 112 x 142
TWCMS : B1281

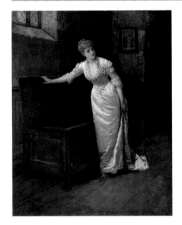

Oliver, William 1823–1901
Mistletoe Bough
oil on canvas 90.8 x 71.1
TWCMS : B2536

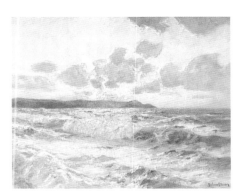

Olsson, Albert Julius 1864–1942
Off Cornwall c.1900–1905
oil on canvas 61 x 76.2
TWCMS : B11459

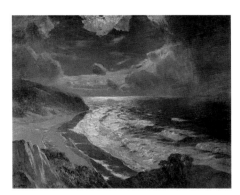

Olsson, Albert Julius 1864–1942
Coast Scene, Moonlight
oil on canvas 101.6 x 127
TWCMS : B1294

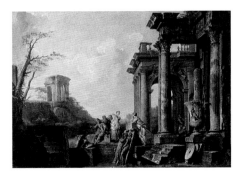

Panini, Giovanni Paolo c.1692–1765
*Architectural Capriccio, Roman Ruins with
Figures* c.1715–1740
oil on canvas 73.8 x 99
TWCMS : C11830

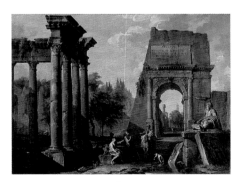

Panini, Giovanni Paolo c.1692–1765
*Architectural Capriccio, Arch of Titus with
Figures* c.1715–1740
oil on canvas 73.6 x 99.3
TWCMS : C11831

Paoletti, Antonio Ermolao 1834–1912
Little Rest, St Mark's Square
oil on canvas 50.8 x 76.2
TWCMS : TB1275

Parker, Henry Perlee 1795–1873
Smugglers on the Look-Out 1850
oil on canvas 76.9 x 63.5
TWCMS : B5644

Parkin, A.
Steamship Entering Sunderland Harbour 1894
oil on board 38.5 x 50.5
TWCMS : 2008.127

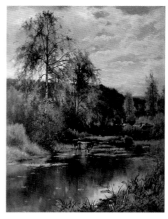

Parton, Ernest 1845–1933
Derbyshire Farmstead 1880–1889
oil on canvas 153 x 115
TWCMS : B1284

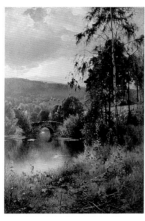

Parton, Ernest 1845–1933
Landscape in Derbyshire 1884
oil on canvas 152.7 x 107
TWCMS : B1291

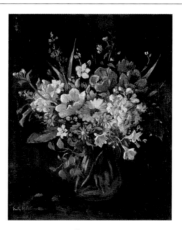

Paterson, Emily Murray 1855–1934
Spring Bunch
oil on canvas 45.7 x 38.1
TWCMS : B1299

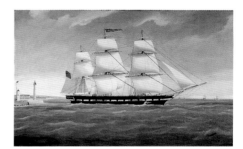

Paulson, E. active 1845–1865
'City of Carlisle'
oil on canvas 60.9 x 94
TWCMS : H22117

Peace, John b.1933
Whitburn with Stormy Sky 1966
oil on board 35 x 43
TWCMS : C6366

Pearson, Raymond active 1954
Cornfield, Houghall, County Durham
oil on canvas 58.7 x 84.2
TWCMS : B1298

Peel, James 1811–1906
Landscape in Cumberland 1868 (possibly 1863)
oil on canvas 76.2 x 121.9
TWCMS : C440

Facing page: Jackson, Gilbert (attributed to), active 1621–1658, *Portrait of a Girl, Aged 8* (detail), 1632, Shipley Art Gallery, (p. 39)

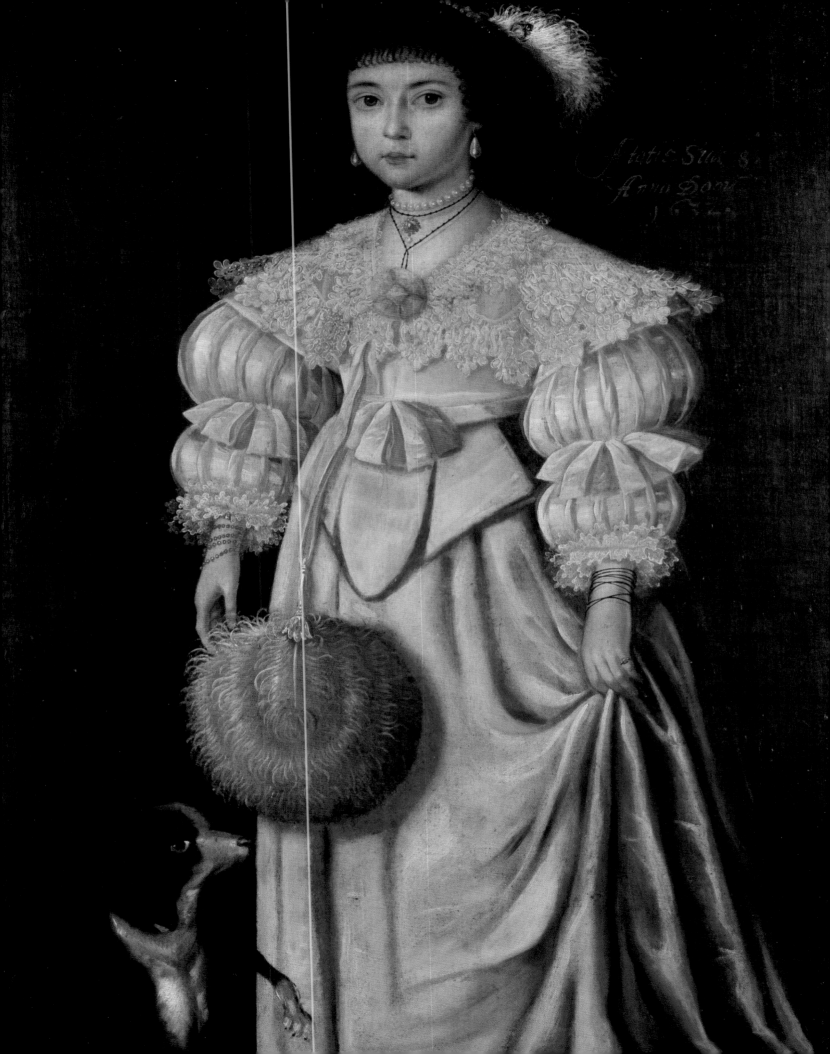

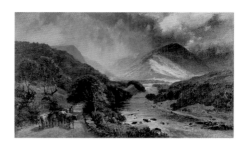

Peel, James 1811–1906
Borrowdale, Cumbria
oil on canvas 61 x 101.6
TWCMS : B2547

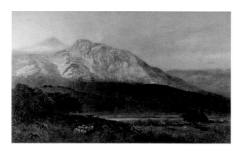

Peel, James 1811–1906
Sunrise on Loughrigg, Cumbria
oil on canvas 75.5 x 121.3
TWCMS : B2520

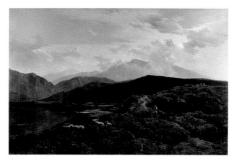

Percy, Sidney Richard 1821–1886
Lake in North Wales 1856
oil on canvas 98.1 x 152.5
TWCMS : B1278

Perugini, Charles Edward 1839–1918
Labour of Love
oil on canvas 91.5 x 71
TWCMS : B4584

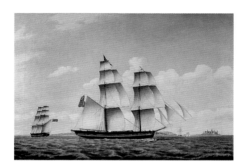

Petersen, Jakob 1774–1854/1855
'Favourite'
oil on canvas 66.9 x 97.5
TWCMS : H22116

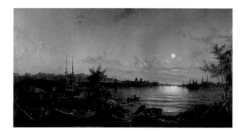

Pether, Sebastian 1790–1844
The Thames at Greenwich
oil on canvas 94 x 167
TWCMS : B10566

Philipson, Robin 1916–1992
Church Interior with Chandeliers
oil on canvas 91 x 101.6
TWCMS : C447

Porter, Michael b.1948
Close to the Ground Series 1991
oil & PVA on paper 101 x 137.4
TWCMS : T1706

Potter, J.
Roker Promenade 1904
oil on canvas 35.6 x 50.8
TWCMS : B4564

Potter, J.
Roker Promenade 1904
oil on canvas 35.6 x 50.8
TWCMS : B4566

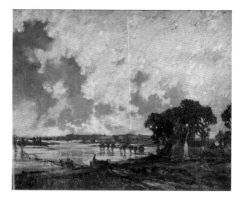

Priestman, Bertram 1868–1951
Evening on the Marshes 1921
oil on canvas 64 x 76
TWCMS : B3588

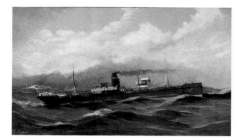

Purvis, Thomas G. 1861–1933
'SS Clan MacDougall'
oil on canvas 33.3 x 55
TWCMS : K16048

Pyne, James Baker 1800–1870
Thirlmere 1869
oil on canvas 86.6 x 130.8
TWCMS : B6798

Pyne, James Baker (attributed to)
1800–1870
View in Wales
oil on wood 26.7 x 36.9
TWCMS : B2529

Quinn, Ged b.1963
The Happy Garden 2004
oil on linen 183 x 215
TWCMS : 2006.2251

Rae, Henrietta 1859–1928
J. E. Dawson 1924
oil on canvas 152.5 x 122
TWCMS : B2506

Rae, Siebel M.
It is very nice to think the world is full of meat
and drink, with little children saying grace, in
every kind of Christian place' (…)
oil on canvas 73.5 x 193
TWCMS : E2704.6

Ramsay, J. A.
Sunderland Lighthouse 1863
oil on canvas 50.5 x 76.2
TWCMS : B9418

Ray, Richard A. 1884–1968
A Fisherman's Home, Venice 1921
oil on panel 35 x 26
TWCMS : B3581

Ray, Richard A. 1884–1968
Sunshine after Rain, Clymping, Sussex 1922
oil on board 30.5 x 40
TWCMS : B9443

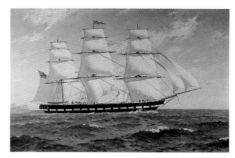

Ray, Richard A. 1884–1968
The 'Helvellyn' 1945
oil on canvas 60.6 x 91
TWCMS : 1998.309

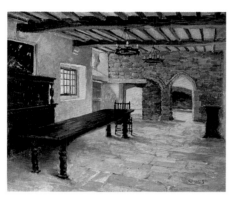

Read, C. Stanley active 1956–1959
Washington Old Hall 1956
oil on board 49.5 x 59.5
TWCMS : C12826

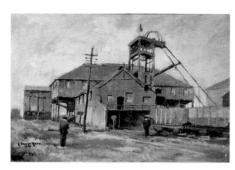

Read, C. Stanley active 1956–1959
Glebe Colliery, County Durham 1959
oil on board 36 x 53
TWCMS : C12825

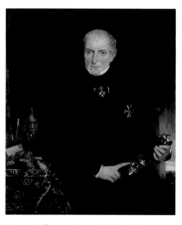

Reay, John active 1838–1900
Dr William Reid Clanny (1776–1850)
1841–1850
oil on canvas 107.4 x 87.4
TWCMS : C436

Richardson, Thomas Miles I 1784–1848
Prudhoe Castle, Northumberland
oil on canvas 43 x 61
TWCMS : B9401

Richardson, Thomas Miles I 1784–1848
Sunderland Piers in a Storm
oil on board 25.4 x 35.3
TWCMS : B9419

Richter, Herbert David 1874–1955
Diana 1936
oil on canvas 125.1 x 74.9
TWCMS : B1267

Rios, Luigi da 1844–1892
The Fashion Plate 1886
oil on canvas 61 x 41.3
TWCMS : B9406

Robertson, David Thomas 1879–1952
Cox Green, County Durham 1902
oil on canvas 28 x 38.4
TWCMS : C12827

Robertson, David Thomas 1879–1952
Snow on Tunstall Hills, Sunderland 1925
oil on canvas 101.6 x 153.4
TWCMS : B2527

Robertson, David Thomas 1879–1952
Dr Carruthers of Southwick
oil on canvas 167.5 x 97
TWCMS : B1282

Robinson, R. active 1797–1802
*John Emery as Tyke in Thomas Morton's
'The School of Reform'*
oil on canvas 53.4 x 42
TWCMS : B2532

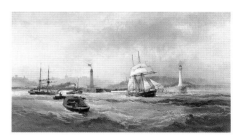

Roe, Robert Ernest 1852–1921
Harbour Entrance, Sunderland c.1890–1893
oil on canvas 61 x 106.7
TWCMS : B9421

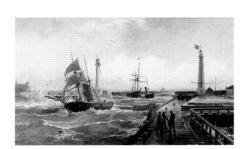

Roe, Robert Ernest 1852–1921
Between Sunderland Piers
oil on canvas 30.5 x 51
TWCMS : B9196

Rogerson, Edith Hardy
Plant Form c.1954
oil on canvas 50.8 x 35.6
TWCMS : B1273

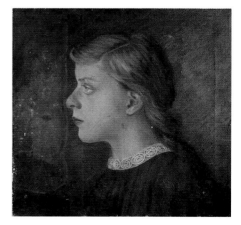

Rutledge, William 1865–1918
Portrait of a Young Girl c.1910
oil on canvas 30.5 x 31.7 (E)
TWCMS : B4594

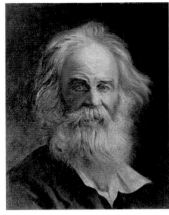

Rutledge, William 1865–1918
Walt Whitman (1819–1892)
oil on canvas 57.2 x 44.5
TWCMS : B3560

Sajó, Gyula 1918–1979
Landscape with Playing Children
oil & tempera on board 53 x 74.3
TWCMS : R317

Sant, James 1820–1916
General Tytche
oil on canvas 99 x 78.8
TWCMS : B7903

Schafer, Henry c.1841–c.1900
*Interior of the Church of St Lawrence,
Nuremberg, Germany* c.1875
oil on canvas 60 x 45.7
TWCMS : B2540

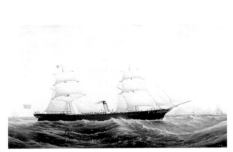

Scott, John 1802–1885
'SS Hiogo' 1867
oil on canvas 63.8 x 112.1 (E)
TWCMS : P729

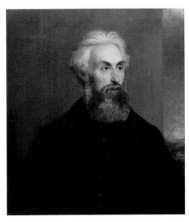

Scott, John (attributed to) 1802–1885
William Brockie (1811–1896)
oil on canvas 76.2 x 63.5
TWCMS : B3566

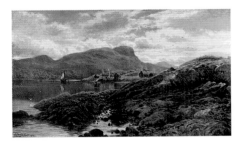

Scott, John Douglas b.c.1845
Highland Loch, Rosshire, Scotland 1880
oil on canvas 66.4 x 76.2
TWCMS : B3557

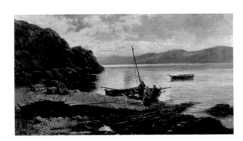

Scott, John Douglas b.c.1845
Plockton on Loch Kishorn, Rosshire, Scotland
1882
oil on canvas 76.5 x 132.7
TWCMS : B1263

Sefton, Brian b.1938
Organic Development, Cluster 1966
oil on canvas 71 x 76
TWCMS : B5640

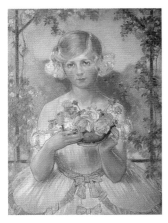

Shackleton, William 1872–1933
Jane with a Bowl of Roses
oil on canvas 50.8 x 40.6
TWCMS : B1271

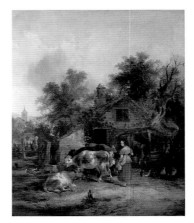

Shayer, William (attributed to) 1788–1879
A Farmstead, Milking Time
oil on canvas 132 x 110
TWCMS : B10560

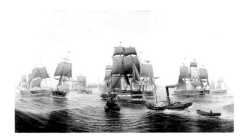

Shearer, Jacob b.1846
The Baltic Fleet Leaving Sunderland 1887
oil on canvas 61 x 107 (E)
TWCMS : B9431

Shearer, Jacob b.1846
Training Hulk in River Wear 1900
oil on canvas 30.5 x 45.7
TWCMS : B4569

Shee, Martin Archer (circle of) 1769–1850
James F. Stanfield
oil on panel 24.1 x 19.2
TWCMS : H22101

Sheridan, W. F.
The Sailing Ship 'Waterlily' of Sunderland
(copy of an 1817 painting)
oil on millboard 46 x 61.3
TWCMS : 1998.308

Short, David T.
Still Life and Milk Bottle 1960
oil on hardboard 59.1 x 90.5
TWCMS : 1999.1235

Simpson, Charles Walter 1885–1971
Sailing through the Sunshine of Early Spring
c.1945
oil on canvas 71.2 x 90.2
TWCMS : B2505

Slater, John Falconar 1857–1937
Seascape c.1890–1920
oil on canvas 102.3 x 127
TWCMS : B5624

Slater, John Falconar 1857–1937
Woodland Scene
oil on board 61.5 x 81.3
TWCMS : G60

Smale, Phyllis Maud b.1897
Wastwater, Cumbria
oil on canvas 38.5 x 48.5
TWCMS : E2706

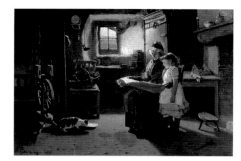

Smith, Carlton Alfred 1853–1946
News from Abroad 1885
oil on canvas 46.4 x 66
TWCMS : B2542

Smith, John 1841–1917
Sunderland Harbour, 1883 1884
oil on canvas 103.2 x 184.2
TWCMS : B11704

Smith, John 1841–1917
Holey Rock, Roker, Sunderland 1884–1886
oil on canvas 61 x 91.5
TWCMS : B9430

Smith, John 1841–1917
Beacon Rocks, Roker, Sunderland 1885
oil on canvas 61 x 91.5
TWCMS : B9428

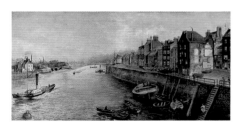

Smith, John 1841–1917
Low Quay, Sunderland 1888
oil on canvas 77 x 164
TWCMS : B10586

Smith, Keith William b.1950
Cornfield 1971
acrylic on canvas 122 x 119.4
TWCMS : C449

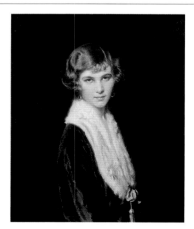

Somerville, Howard 1873–1952
Elizabeth Woodville
oil on canvas 76.2 x 63.5
TWCMS : B3589

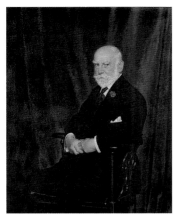

Somerville, Howard 1873–1952
Ralph Milbanke Hudson (1849–1938)
oil on canvas 127 x 99
TWCMS : B3568

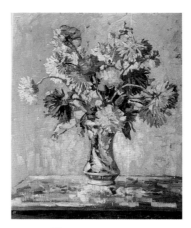

Somerville, Stuart Scott 1908–1983
Dahlias 1929
oil on canvas 60.3 x 50.8
TWCMS : B1274

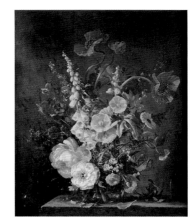

Somerville, Stuart Scott 1908–1983
Early Summer Flowers 1952
oil on canvas 76.2 x 63.5
TWCMS : B2521

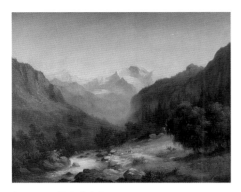

Sommer, Friedrich 1830–1867
Mountain Landscape with River
oil on canvas 73 x 91.5
TWCMS : B1285

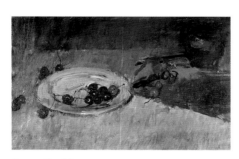

Spear, Ruskin 1911–1990
Cherries
oil on canvas 34 x 54
TWCMS : C4352

Spence, M.
Carnation
oil on canvas 74 x 31 (E)
TWCMS : E2704.7b

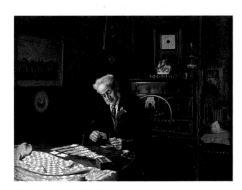

Spencelayh, Charles 1865–1958
Patience c.1935
oil on board 50 x 65.3
TWCMS : T1705

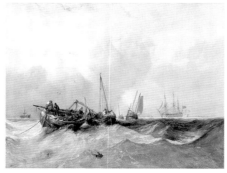

Stanfield, Clarkson 1793–1867
*The 'Chasse Mareé' off the Gull Stream Light,
the Downs in the Distance* 1838
oil on canvas 98 x 129
TWCMS : K12249

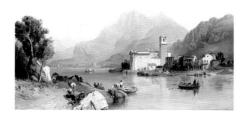

Stanfield, Clarkson 1793–1867
Lago di Garda, Italy 1858
oil on canvas 70.5 x 110.3
TWCMS : B10561

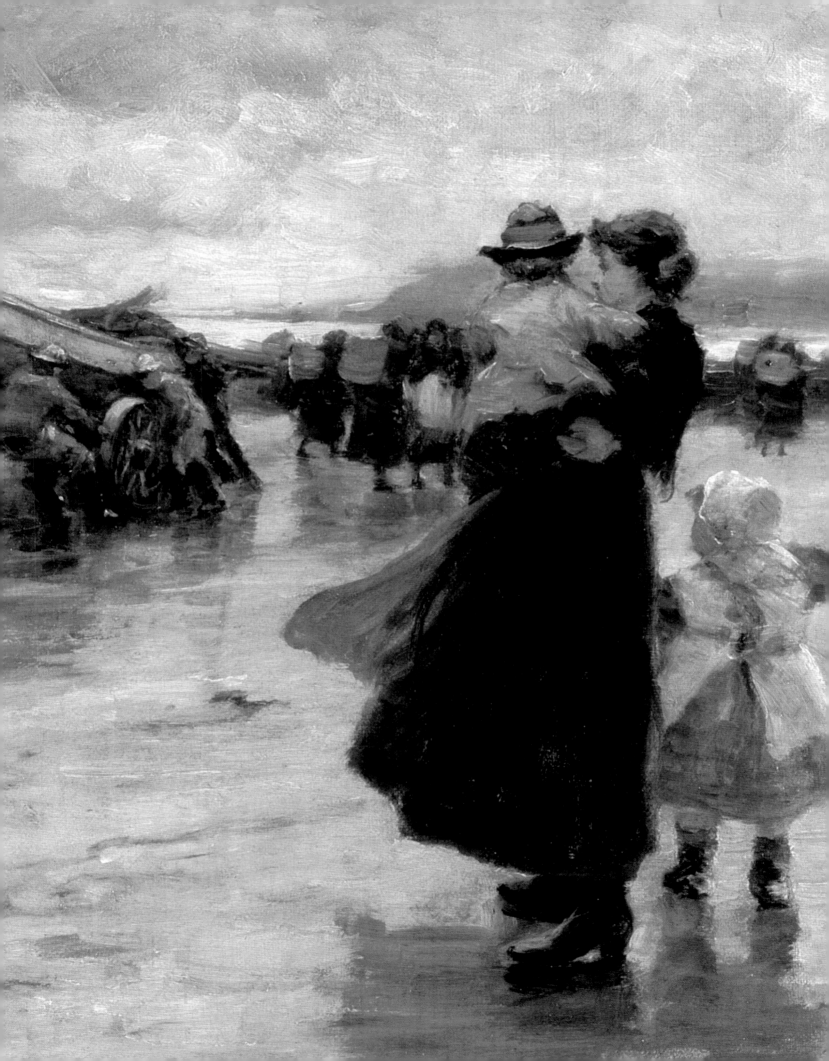

Stanfield, Clarkson 1793–1867
The Castle of Ischia from the Mole, Italy
oil on canvas 143 x 230
TWCMS : G55

Stanfield, Clarkson 1793–1867
The Port of Ancona, Italy
oil & tempera on paper 213.4 x 213.4
TWCMS : P717

Stanfield, Clarkson (follower of) 1793–1867
St Michael's Mount, Cornwall 1853
oil on canvas 51 x 64
TWCMS : C416

Stephenson, Ian 1934–2000
Burnt Penumbra 1961
oil on canvas 126.5 x 126.5
TWCMS : C4351

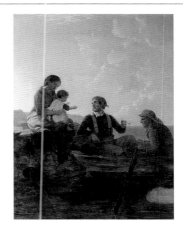

Stokeld, James 1827–1877
Fisherman's Goodnight 1860
oil on canvas 61 x 48.3
TWCMS : B4560

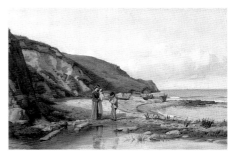

Stokeld, James 1827–1877
The Coast near Ryhope, Sunderland 1863
oil on canvas 39 x 56.5
TWCMS : C418

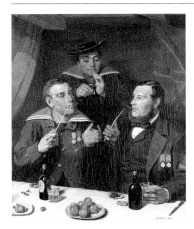

Stokeld, James 1827–1877
Pipe of Peace 1864
oil on canvas 61.6 x 50.8
TWCMS : B2528

Stokeld, James 1827–1877
Last Man Ashore 1865
oil on canvas 71 x 119
TWCMS : E2711

Stokeld, James 1827–1877
Creature Comforts 1876
oil on canvas 61 x 50.2
TWCMS : B4551

Facing page: Jobling, Robert, 1841–1923, *Hauling the Boats* (detail), 1890, Laing Art Gallery, (p. 167)

Stokeld, James 1827–1877
Giving an Estimate 1877
oil on canvas 61 x 50.8
TWCMS : B4552

Stokeld, James 1827–1877
John Anderson My Jo, John 1877
oil on canvas 71.1 x 91.5
TWCMS : B2544

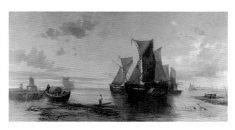

Stolz, M.
Dutch Fishing Boats Offshore (after James Webb)
oil on canvas 63.5 x 127
TWCMS : B9434

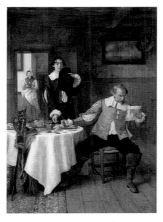

Storey, George Adolphus 1834–1919
The Hungry Messenger 1890
oil on canvas 95 x 69.9
TWCMS : B10555

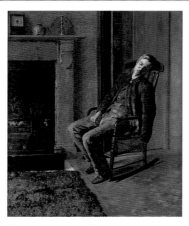

Stubbs, Joseph Woodhouse 1862–1953
Tired
oil on canvas 76.2 x 63.5
TWCMS : B2545

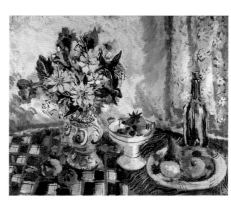

Suddaby, Rowland 1912–1972
Still Life with Fruit and Flowers
oil on canvas 50.8 x 61
TWCMS : B1252

Summers, J.
Early Voyagers, Drake Goes West, 1577–1580
1924
oil on canvas 73.5 x 172.5
TWCMS : E2704.5

Summers, J.
John Gilpin's Ride (from William Cowper's 'The Diverting History of John Gilpin')
oil on canvas 74 x 235
TWCMS : E2704.15

Surtees, John 1819–1915
River near Capel Curig, Wales 1884
oil on canvas 77 x 127.5
TWCMS : B1269

Surtees, John 1819–1915
River Llugwy, near Capel Curig, Wales
oil on canvas 76.2 x 121.5
TWCMS : B3563

Swanwick, P. active 19th C
Ruins on Island of Philae, on the Nile, prior to the building of the Nile Dam
oil on canvas 61 x 91.5
TWCMS : B4578

Syer, John James 1844–1912
Sunderland Piers, 1843 1886
oil on canvas 61 x 91
TWCMS : B9442

Symons, William Christian 1845–1911
The Little Squaw c.1890–1905
oil on panel 56 x 40.5
TWCMS : B11462

Tate, Dingwell Burn b.1859
Dicky Chilton's House, Bishopwearmouth Green, Sunderland
oil on canvas 45.7 x 61
TWCMS : B9407

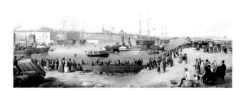

Thompson, Mark 1812–1875
Opening of the South Dock, Sunderland 1850
oil on canvas 122 x 183
TWCMS : B3576

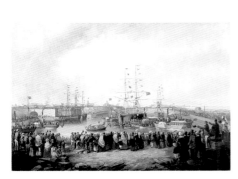

Thompson, Mark 1812–1875
Opening of the South Dock, Sunderland, 1850 1853
oil on canvas 91.5 x 132.5
TWCMS : B10585

Thompson, Mark 1812–1875
Old South Pier, Sunderland 1854
oil on canvas 92 x 61
TWCMS : B10551

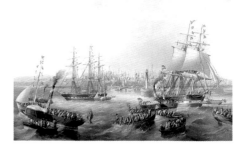

Thompson, Mark 1812–1875
Opening of the South Outlet, Sunderland Docks 1856
oil on canvas 61 x 91
TWCMS : B9403

Thompson, Mark 1812–1875
Fetching the Cow 1874
oil on millboard 31 x 23.3
TWCMS : B2516

Thompson, Mark 1812–1875
Gout
oil on panel 20.8 x 13.6
TWCMS : K6200

Thornley, Georges William (attributed to)
1857–1935
Shipping off a Headland
oil on canvas 40.8 x 30.5
TWCMS : B9408

Tift, Andrew b.1968
Changing Face 1994–1995
acrylic on metal 91 x 106
TWCMS : 2005.3003

Tift, Andrew b.1968
Welders 1995
oil on board 22.8 x 16.8; 22.8 x 16.8; 22.8 x
16.8
TWCMS : 1996.1802

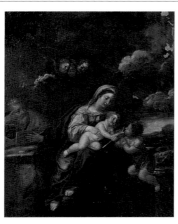

unknown artist mid-17th C
Holy Family with the Infant St John
oil on canvas 40.3 x 33
TWCMS : B4591

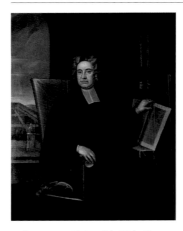

unknown artist mid-18th C
Dr John Laurence
oil on canvas 153.7 x 122.8
TWCMS : K16049

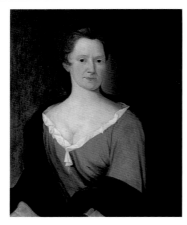

unknown artist mid-18th C
*Portrait of a Lady (thought to be Mrs John
Laurence)*
oil on canvas 74 x 61.5
TWCMS : K16050

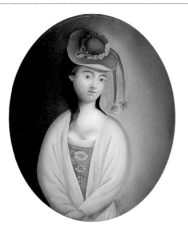

unknown artist 18th C
Elliptical Portrait of Lady Middleton
oil on glass 29.5 x 19.5
TWCMS : 1999.152

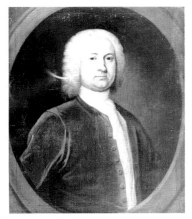

unknown artist 18th C
John Routh of Scarborough
oil on canvas 76.2 x 62.8
TWCMS : B3586

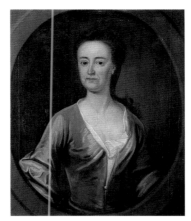

unknown artist 18th C
Mary Routh, Wife of John Routh
oil on canvas 75.5 x 63.5
TWCMS : B3585

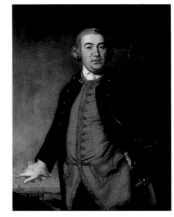

unknown artist late 18th C
John Thornhill, Military Officer
oil on canvas 117 x 91.5
TWCMS : B4570 (P)

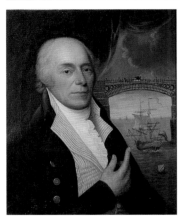

unknown artist late 18th C
Rowland Burdon (1757–1838), MP
oil on canvas 61.2 x 50.8
TWCMS : 1999.1237

unknown artist
Portrait of a Young Man c.1820
oil on canvas 236 x 145
TWCMS : B4590

unknown artist
Robert Thompson (1748–1831) 1825
oil on canvas 129.5 x 101.6
TWCMS : B2504

unknown artist
Hylton Castle, Sunderland c.1830
oil on canvas 51 x 75.5
TWCMS : B6792

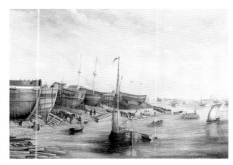

unknown artist
*William Pile's Shipyard, North Sands,
Sunderland* c.1830
oil on canvas 76.8 x 112.4
TWCMS : C423

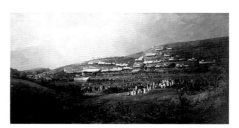

unknown artist
Sunderland, Races at Tunstall Hope
c.1835–1840
oil on canvas 99 x 189.5
TWCMS : B11703

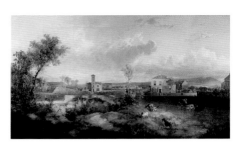

unknown artist
Bede Tower, Sunderland c.1850
oil on canvas 75.4 x 129.4
TWCMS : 99.1215 (P)

unknown artist
John Chisholm 1855
oil on canvas 70.5 x 62.5
TWCMS : 1999.1231

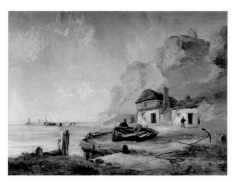

unknown artist mid-19th C
Bantry Bay, County Cork, Ireland
oil on canvas 45.7 x 60.3
TWCMS : B2546

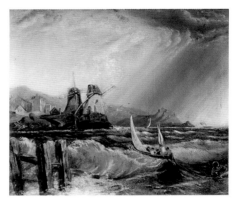

unknown artist mid-19th C
Coast with Windmills
oil on board 30 x 35.5
TWCMS : B9195

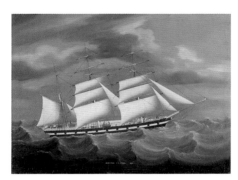

unknown artist mid-19th C
The 'Bankside'
oil on canvas 45.8 x 61.2
TWCMS : K6186

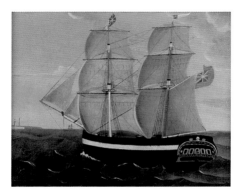

unknown artist mid-19th C
The 'Halcyon'
oil on board 43.2 x 53.8
TWCMS : G66

unknown artist mid-19th C
Wind Freshening off Hull
oil on canvas 76.1 x 126.4
TWCMS : B5623

unknown artist 19th C
Coastal Shipping
oil on canvas 44.5 x 61
TWCMS : B9183

unknown artist 19th C
Dutch Coast Scene with Windmill
oil on canvas 43.2 x 75.3
TWCMS : C421

unknown artist 19th C
Marguerite Leaving the Cathedral
oil on canvas 95.3 x 61
TWCMS : B2533

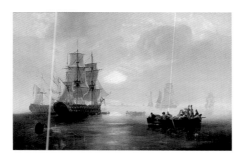

unknown artist 19th C
*Marine Study, Passengers Boarding a
Man-of-War*
oil on canvas 61 x 91.2
TWCMS : B9433

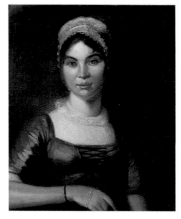

unknown artist 19th C
Mary Haddock of Sunderland
oil on canvas 61 x 50.8
TWCMS : C420

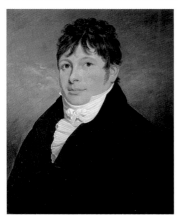

unknown artist 19th C
William Haddock of Sunderland
oil on canvas 61 x 50.8
TWCMS : C419

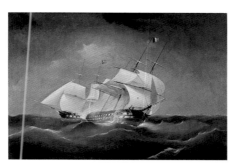

unknown artist 19th C
Naval Engagement
oil on canvas 51.4 x 73.4
TWCMS : B9199

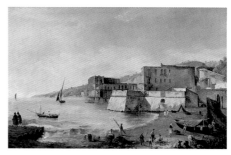

unknown artist 19th C
Palazzo Donn'Anna, Bay of Naples
oil on canvas 52.4 x 78.8
TWCMS : B4572

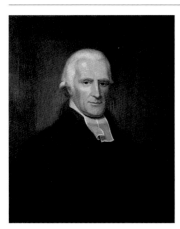

unknown artist 19th C
Portrait of a Clergyman
oil on canvas 76.5 x 63.5
TWCMS : C11829

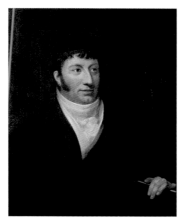

unknown artist 19th C
Portrait of a Man
oil on canvas 71.1 x 63.2
TWCMS : B5633

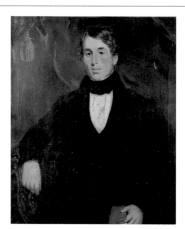

unknown artist 19th C
Portrait of a Man, Holding a Book
oil on canvas 76.2 x 63.2
TWCMS : C11828

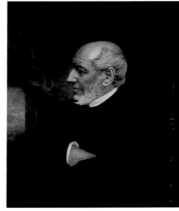

unknown artist 19th C
Portrait of a Man, Seated
oil on canvas 90.8 x 75
TWCMS : B4577

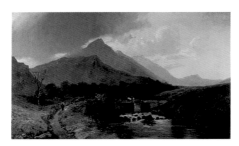

unknown artist 19th C
Scottish Highlands with Horse Riders
oil on canvas 76 x 127
TWCMS : B1279

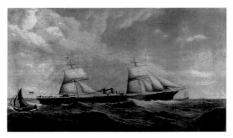

unknown artist 19th C
SS 'Buenos Aires'
oil on canvas 76 x 132
TWCMS : T1732 (P)

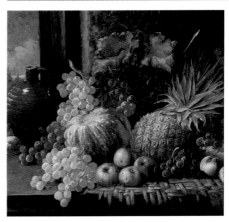

unknown artist 19th C
Still Life with Fruit
oil on canvas 69 x 71.1
TWCMS : B1280

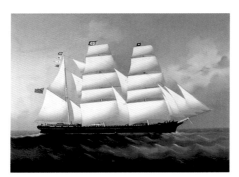

unknown artist 19th C
The Barque 'Vanora'
oil on board 58.1 x 78.8
TWCMS : B9200

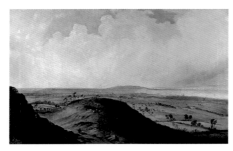

unknown artist 19th C
View of Sunderland from the Tunstall Hills
oil on canvas 64.2 x 100.2
TWCMS : 1999.1214 (P)

unknown artist late 19th C
George Robert Booth
oil on canvas 129.5 x 101
TWCMS : B3569

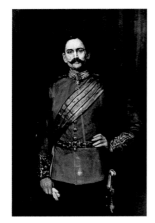

unknown artist late 19th C
John George Lambton (1855–1928), 3rd Earl of Durham
oil on canvas 150 x 95
TWCMS : B3570

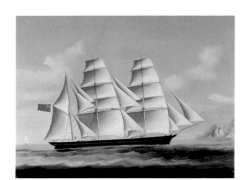

unknown artist late 19th C
'Luzon'
oil on canvas 45.7 x 60
TWCMS : B9191

unknown artist late 19th C
Portrait of a Man
oil on glass 49.1 x 39.2
TWCMS : 1999.153

unknown artist late 19th C
Portrait of a Man
oil on canvas 61 x 46
TWCMS : B4573

unknown artist late 19th C
*River Wear at Cox Green near the Penshaw
Monument*
oil on board 40.3 x 57.6
TWCMS : B3565 (P)

unknown artist early 20th C
The Wear at Fatfield
oil on canvas 32.9 x 43
TWCMS : E2739

unknown artist
Alderman Thompson (1833–1841)
oil on canvas 130 x 82
TWCMS : 2008.101

unknown artist
Girdle Cake Cottage
oil on canvas 31 x 42
TWCMS : E4182

unknown artist
*Vessel at Sea**
oil on canvas 61.5 x 90
TWCMS : 2008.103

Vaughan, John Keith 1912–1977
Mykonos, Greece 1961
oil on canvas 90 x 101
TWCMS : C4357

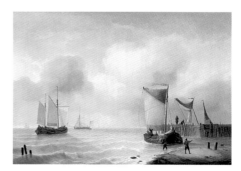

Verboeckhoven, Charles Louis 1802–1889
The Rising Tide c.1840–1860
oil on canvas 71.8 x 100.7
TWCMS : B9422

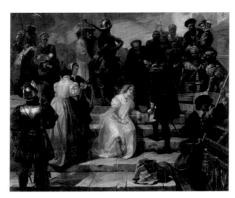

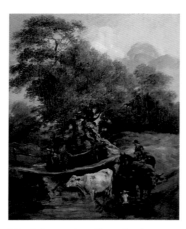

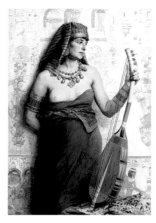

Ward, Edward Matthew 1816–1879
Anne Boleyn at the Queen's Stairs 1871
oil on canvas 130.8 x 157.5
TWCMS : B2517

Ward, James (attributed to) 1769–1859
The Watering Place
oil on canvas 61 x 50.8
TWCMS : B4559

Warren, Charles Knighton b.1856
Egyptian Musician
oil on canvas 134 x 91.5
TWCMS : B2524

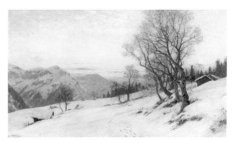

Waterhouse, Nora active 1963
Still Life
oil on board 50.8 x 56.6
TWCMS : 1998.303

Waterhouse, Nora active 1963
View from a Bridge
oil on canvas 39.4 x 51.5
TWCMS : 1998.304

Waterlow, Ernest Albert 1850–1919
Sunset in the Wengen Alps, Switzerland c.1895
oil on canvas 73.5 x 122.5
TWCMS : B1257

Waterlow, Ernest Albert 1850–1919
Autumn on the Somme, France
oil on canvas 102 x 153
TWCMS : C441

Watson, James Finlay 1898–1981
London Backwater, near St Pancras
oil on hardboard 55.9 x 45.7
TWCMS : B5604

Watson, Robert F. 1815–1885
Dutch Trawlers
oil on canvas 36 x 54.5
TWCMS : B9192

Wells, Denys George 1881–1973
The 'William and Mary' Chair 1954
oil on panel 61 x 51
TWCMS : B11465

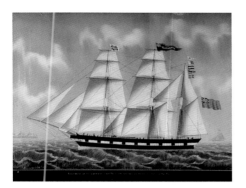

Weyts, Carolus Ludovicus 1828–1876
The 'Elizabeth' of Sunderland 1858
oil on glass 57.4 x 78.8
TWCMS : H22115

Whitfield, Joshua 1884–1954
Barrow Boys, Union Street 1951
oil on canvas 77.8 x 58.5
TWCMS : G64

Whitfield, T. W. Allan b.1944
Untitled 1965
oil on canvas 162 x 138
TWCMS : E2705

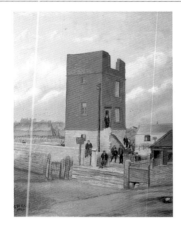

Wilkie, C.
The Tower at Doxford's Crossing, Pallion, Sunderland 1903
oil on millboard 61 x 48.3
TWCMS : B5631

Williams, Alfred Walter 1824–1905
Autumn Morning, Isle of Skye 1871
oil on canvas 84.5 x 153.4
TWCMS : B1295

Wollen, William Barnes 1857–1936
The Ambush, 1745 1907
oil on canvas 122.6 x 152.8
TWCMS : B1254

Wood, Frank
John Sealing the Magna Carta 1215
oil on canvas 74 x 231.5
TWCMS : E2704.13

Wood, Frank 1904–1985
Westerhope Burn 1945
tempera on panel 34 x 44
TWCMS : C12821

Wood, Lewis John 1813–1901
Kiln in the Wood
oil on millboard 24.4 x 35
TWCMS : B5642

Wray, R. W.
Beam Engine 1712/Locomotive 1825
oil on canvas 73.5 x 202
TWCMS : E2704.7

Facing page: Dickey, Edward Montague O'Rourke, 1894–1977, *The Building of the Tyne Bridge* (detail), 1928,
Laing Art Gallery, (p. 134)

Paintings Without Reproductions

This section lists all the paintings that have not been included in the main pages of the catalogue. They were excluded as it was not possible to photograph them for this project. Additional information relating to acquisition credit lines or loan details is also included. For this reason the information below is not repeated in the Further Information section.

Shipley Art Gallery

Barrie, Mardi 1931–2004, *Dark Cornfield*, 1964, 48 x 60.6, oil on paper, TWCMS : C11273, purchased from Mrs G. Harrison, 1964, not available at the time of photography

Berchem, Nicolaes (style of) 1620–1683, *Hilly Landscape with Cattle*, 121.4 x 173.5, oil on canvas, TWCMS : C194, bequeathed by J. A. D. Shipley, 1909, not available at the time of photography

Carrick, Anne active 20th C, *Willows*, 50.8 x 61, oil on canvas, TWCMS : C11274, purchased from G. McLean, Bondgate Gallery, 1965, not available at the time of photography

Cave, Peter le 1769–c.1811, *River Scene*, 23.9 x 30.8, oil on panel, TWCMS : G1170, bequeathed by J. A. D. Shipley, 1909, not available at the time of photography

Colyer, J. M. active 19th C, *Girl with Wheatsheaf and House*, 32.9 x 24.9, tempera on panel, TWCMS : F12348, unknown acquisition, not available at the time of photography

Creswick, Thomas (attributed to) 1811–1869, *View near Bolton Abbey*, 1860, 127.2 x 101.9, oil on canvas, TWCMS : B3223, bequeathed by J. A. D. Shipley, 1909, not available at the time of photography

Dawson, Byron Eric 1896–1968, *Saltwell Park*, 30.4 x 33.7, oil on paper, TWCMS : G12671, purchased from Mawson, Swan and Morgan, Newcastle upon Tyne, 1960, not available at the time of photography

Ewbank, John Wilson c.1799–1847, *Ben Lomond and Loch Lomond with Ross Castle*, 25.4 x 35.5, oil on metal, TWCMS : B6216, bequeathed by J. A. D. Shipley, 1909, not available at the time of photography

Hepple, Wilson 1854–1937, *Tyne*, 1888, 71.5 x 107, oil on canvas, TWCMS : F12292, transferred from the Saltwell Towers Museum, Gateshead, not available at the time of photography

Huysmans, Jan Baptist 1654–1716, *Landscape with Ruins*, 1694, 152.5 x 214, oil on canvas, TWCMS : B8433, bequeathed by J. A. D. Shipley, 1909, not available at the time of photography

Huysum, Jan van (follower of) 1682–1749, *Flowers with Fruit*, oil on canvas, TWCMS : B8423, bequeathed by J. A. D. Shipley, 1909, not available at the time of photography

Lambert, George c.1700–1765, *Classical Landscape with Horsemen and Resting Travellers*, 1750, 127 x 203.5, oil on canvas, TWCMS : B8416, bequeathed by J. A. D. Shipley, 1909, not available at the time of photography

McEune, Robert Ernest 1876–1952, *River and Woodland*, 22.8 x 30.2, oil on card, TWCMS : M161, gift from Mrs McEune, 1971, not available at the time of photography

Morris, T. W. *Venicewer*, 1965, 35 x 55.7, oil on canvas, TWCMS : F9363, unknown acquisition, not available at the time of photography

Poole, Paul Falconer 1807–1879, *The Fair Mendicant*, 27.9 x 38.1, oil on canvas, TWCMS : B3218, bequeathed by J. A. D. Shipley, 1909, not available at the time of photography

Ribera, Jusepe de 1591–1652, *Head of an Old Man*, oil on wood, TWCMS : 191, bequeathed by J. A. D. Shipley, 1909, not available at the time of photography

Roberts, David (attributed to) 1796–1864, *Stolzenfels on the Rhine*, 35.7 x 53.5, oil on canvas, TWCMS : B4913, bequeathed by J. A. D. Shipley, 1909, not available at the time of photography

Scott active early 20th C, *The Mouth of the Tyne*, 41 x 61.5, oil on canvas, TWCMS : F9375, transferred from the Saltwell Towers Museum, Gateshead, not available at the time of photography

Surtees, John 1819–1915, *The Herd Laddie*, 1848, 25.4 x 38.1, oil on canvas, TWCMS : B3213, bequeathed by J. A. D. Shipley, 1909, not available at the time of photography

Surtees, John 1819–1915, *A Welsh River Scene*, 53.3 x 78.7, oil on canvas, TWCMS : B6212, bequeathed by J. A. D. Shipley, 1909, not available at the time of photography

Teniers, David II (style of) 1610–1690, *Dutch Merrymakers*, 34 x 45.3, oil on canvas, TWCMS : C162, bequeathed by J. A. D. Shipley, 1909, not available at the time of photography

Thompson, Constance b.1882, *Anemones and Mimosa*, 1906, 50.8 x 25.3, oil on canvas, TWCMS : F12349, gift from Miss C. Kingstone, 1973, not available at the time of photography

Train, Edward 1801–1866, *Scottish Lake Scene*, 1851, 24 x 32.8, oil on canvas, TWCMS : B6213, bequeathed by J. A. D. Shipley, 1909, not available at the time of photography

unknown artist mid-19th C, *The Lonely Sea*, 16.1 x 26.6, oil on paper, TWCMS : H1212, unknown acquisition, not available at the time of photography

unknown artist 19th C, *Male Portrait*, 76 x 62.5, oil on panel, TWCMS : B3757, bequeathed by J. A. D. Shipley, 1909, not available at the time of photography

unknown artist *Portrait of a Man with a Lace Collar*, 17.8 x 15.2, oil on canvas, TWCMS : B6249, bequeathed by J. A. D. Shipley, 1909, not available at the time of photography

Laing Art Gallery

Aikman, George W. 1831–1906, *Towards Evening*, c.1896, 60.7 x 91.6, oil on canvas, TWCMS : G1335, bequeathed by the artist, 1906, not available at the time of photography

Bomberg, David 1890–1957, *Carmencita*, 1954, 70 x 57, oil on canvas, TWCMS : N2307, gift from D. Davies-Rees and J. Lamont, 1987, not available at the time of photography

Brookes, Fred b.1943, *Look Like*, 1962, 245 x 123, acrylic on canvas, TWCMS : G4180, purchased from the artist, 1969, not available at the time of photography

Campbell, Steven 1954–2007, *The Building Accuses the Architect of Bad Design*, 1984, 302.9 x 312.7, oil on canvas, TWCMS : M3382, gift from the Contemporary Art Society, 1986, not available at the time of photography

Clark, Joseph Dixon 1849–1944, *Landscape with Deer*, 91.5 x 96.5, oil on canvas, TWCMS : H985, gift from A. J. Patterson, 1942, on loan to donor, not available at the time of photography

Clausen, George 1852–1944, *Margaret Hilton*, c.1903, 52 x 37, oil on canvas, TWCMS : 1997.126, gift from Dorothea Clover, 1997, not available at the time of photography

Hemy, Bernard Benedict 1845–1913, *Shipping Scene*, 30.3 x 46, oil on board, TWCMS : F4632, bequeathed by J. B. Young, 1945, on loan to the Civic Centre, Newcastle upon Tyne, not available at the time of photography

Hoyland, John b.1934, *Red with Green and Two Greys*, 1966, 137.2 x 271.8, acrylic on canvas, TWCMS : B7408, purchased from the Waddington Galleries with the assistance of the Friends of the Laing Art Gallery and the Calouste Gulbenkian Foundation, 1968, not available at the time of photography

Lund, Neils Møller 1863–1916, *A Winter's Night*, c.1891, 183.1 x 260.3, oil on canvas, TWCMS : G4645, gift from John D. Milburn, 1925, not available at the time of photography

McKenzie, R. A. active late 19th C, *Old Houses, Head of Side*, 20.7 x 26, oil on canvas, TWCMS : F13628, gift from T. D. Pickering, 1955, not available at the time of photography

Medley, Robert 1905–1994, *Testing Trailer Pumps, St Peter's, Newcastle*, 1940, 40.6 x 61, oil on canvas, TWCMS : F3429, gift from the War Artists Advisory Committee, 1947, not available at the time of photography

Slater, John Falconar 1857–1937, *Durham*, 1912, 101.5 x 152.5, oil on canvas, TWCMS : G4646, gift from Carricks, 1957, not available at the time of photography

Sticks, Harry James 1867–1938, *Landscape, Farmyard with Figure*, 1893, 45.7 x 35.7, oil on canvas, TWCMS : F3422, gift from Mrs W. Robson, 1953, not available at the time of photography

unknown artist 19th C, *A King Crowning Himself*, 370.5 x 247, oil on canvas, TWCMS : H999, untraced find, first recorded 1983, not available at the time of photography

unknown artist 19th C, *Three Male Figures*, 25.5 x 35.6, oil on glass, TWCMS : H12775, bequeathed by A. H. Higgenbottom, 1919, not available at the time of photography

unknown artist 20th C, *Abstract Works*, 48.5 x 49.5, oil on board, TWCMS : M5115, untraced find, first recorded 1986, not available at the time of photography

unknown artist 20th C, *Estuary Scene*, 32 x 54.5, oil on canvas, TWCMS : M5112, untraced find, first recorded 1986, not available at the time of photography

unknown artist 20th C, *Fairground*, 51 x 41, oil on canvas, TWCMS : M4848, untraced find, first recorded 1987, not available at the time of photography

unknown artist 20th C, *Figure*, 41 x 56, oil on canvas, TWCMS : M5102, untraced find, first recorded 1986, not available at the time of photography

unknown artist 20th C, *Portrait of a Man*, 56 x 41, oil on canvas, TWCMS : M4850, untraced find, recorded 1986, not available at the time of photography

unknown artist 20th C, *Portrait of Young Man*, 58.5 x 48.5, oil on board, TWCMS : M5110, untraced find, recorded 1986, not available at the time of photography

unknown artist 20th C, *Sea Study*, 38.5 x 51, oil on board, TWCMS : M5116, untraced find, recorded 1986, not available at the time of photography

unknown artist 20th C, *Sketch in Blue*, 40 x 55.2, oil on canvas, TWCMS : M4847, untraced find, recorded 1986, not available at the time of photography

unknown artist 20th C, *Venice*, 40 x 54.6, oil on canvas, TWCMS : G13000, untraced find, recorded 1982, not available at the time of photography

unknown artist *'SS Normanton'*, oil, TWCMS : C10316, gift from Mr Norman Gilchrist, not available at the time of photography

White, John 1851–1933, *Diana*, 1931, 50.8 x 66, oil, TWCMS : H986, gift from Robert Temperley, 1932, on loan to donor, not available at the time of photography

Winkelmann, Johann Frederic 1767–1821, *Soldiers before Battle*, 98 x 85, oil on canvas, TWCMS : G12984, gift from F. Ridley, 1954, not available at the time of photography

South Shields Museum and Art Gallery

Chambers, John 1852–1928, *Tyne Trawlers*, 1910, 20.3 x 26.7, oil on board, TWCMS : G4217, gift from Mr M. Pescod, 1969, not available at the time of photography

Elliott, Robinson 1814–1894, *The Finding of the Cup in Benjamin's Sack*, 1843, 287 x 298, oil on canvas, TWCMS : G7266, gift from the South Shields Mechanics Institute, 1873–1874, rolled up in canvas, not accessible for photography

Elliott, Robinson 1814–1894, *Cowper's Morning Dream*, c.1843, 387 x 330.2, oil on canvas, TWCMS : G7265, gift from the South Shields Mechanics Institute, 1873–1874, rolled up in canvas, not accessible for photography

Meadows, Arthur Joseph 1843–1907, *Dinant on the Meuse*, 1898, 30.3 x 51.2, oil on canvas, TWCMS : G4291, gift from Thomas Reed, 1930, not available at the time of photography

Shotton, James 1824–1896, *Solomon Sutherland*, 84.2 x 71.5, oil on canvas, TWCMS : G7252, purchased from the artist, 1876, not available at the time of photography

Sunderland Museum and Winter Gardens

Arnfield, Marjorie 1930–2001, *Industrial Landscape, Whitehaven*, 50.2 x 77.8, oil on board, TWCMS : 1998.305, purchased from the Mowbray Fine Art Gallery, 1964, not available at the time of photography

Carmichael, John Wilson 1800–1868, *Calshot Castle, Hampshire*, 50.5 x 82, oil on canvas, TWCMS : B9444 (P), on loan from a private individual, since c.1939, not available at the time of photography

Christie, Ernest C. (attributed to) 1863–1937, *Fishing boats at Sea at Night*, 25.4 x 50.2, oil on canvas, TWCMS : B4595, acquired, before 1977, not available at the time of photography

Elgood, Thomas Scott c.1868–c.1875, *Sunderland Bridge*, c.1868, 16.5 x 24.5, oil on board, TWCMS : B8827, gift from Miss Jane O. S. Elgood, 1952, not available at the time of photography

Harmar, Fairlie 1876–1945, *The Green Hat, Portrait of Miss Guyatt*, c.1906, 53.1 x 42.5, oil on canvas, TWCMS : C437, purchased from R. E. Abbott and Co., 1956, not available at the time of photography

Hemy, Bernard Benedict 1845–1913, *Wreck near St Mary's Lighthouse, Whitley Bay*, 61 x 91.5, oil on canvas, TWCMS : B9439, gift from Mrs Robinson, 1961, not available at the time of photography

Holland, James 1800–1870, *St Ouen's Bay, Jersey*, 35 x 45.1, oil on board, TWCMS : B1292, purchased, 1884, not available at the time of photography

Hopper, W. D. *The Valley of Love, Hendon, Sunderland*, 1856, 1890, 40.6 x 61, oil on canvas, TWCMS : B5603, gift from Mr A. H. Flintoff, 1952, not available at the time of photography

Horsburgh, John A. b.c.1863, *Colonel John Joicey, MP*, 1883, 76.9 x 63.5, oil on canvas, TWCMS : B4556, unknown gift, before 1974, not available at the time of photography

Ray, Richard A. 1884–1968, *The Old Windmill, Bearhill*, 1911, 30.4 x 39.9, oil on canvas, TWCMS : T1735, purchased from Charles Bell, 1969, not available at the time of photography

Ray, Richard A. 1884–1968, *Thunder Shower over Fulwell Quarry*, 1920, 29.7 x 40.4, oil on canvas, TWCMS : T1749, purchased from Charles Bell, 1969, not available at the time of photography

Ray, Richard A. 1884–1968, *Claxheugh Rock*, 1921, 25.3 x 37, oil on canvas, TWCMS : K15202, purchased from Charles Bell, 1969, not available at the time of photography

Ray, Richard A. 1884–1968, *A Breezy Day, North Hylton*, 1922, 27.9 x 37.8, oil on canvas, TWCMS : T1740, purchased from Charles Bell, 1969, not available at the time of photography

Ray, Richard A. 1884–1968, *On the River Wear near Hylton*, 1923, 30.4 x 40.3, oil on canvas, TWCMS : K15201, purchased from Charles Bell, 1969, not available at the time of photography

Ray, Richard A. 1884–1968, *A Bright Summer Sunshine, Hylton*, 30.5 x 40.5, oil on canvas, TWCMS : T1743, purchased from Charles Bell, 1969, not available at the time of photography

Ray, Richard A. 1884–1968, *Barbara*, 44 x 33.2, oil on canvas, TWCMS : B5611, purchased from Charles Bell, 1969, not available at the time of photography

Ray, Richard A. 1884–1968, *Fan's Portrait*, 67.6 x 56.8, oil on canvas, TWCMS : B5619, purchased from Charles Bell, 1969, not available at the time of photography

Ray, Richard A. 1884–1968, *Female Life Study*, 113 x 87.6, oil on canvas, TWCMS : B5620, purchased from Charles Bell, 1969, not available at the time of photography

Ray, Richard A. 1884–1968, *Female Nude, Full-Length and Seated*, 112 x 85.7, oil on canvas, TWCMS : B5606, purchased from Charles Bell, 1969, not available at the time of photography

Ray, Richard A. 1884–1968, *Female Nude, Full-Length and Standing*, 104.1 x 69, oil on canvas, TWCMS : B5612, purchased from Charles Bell, 1969, not available at the time of photography

Ray, Richard A. 1884–1968, *Female Nude, Full-Length with Pot* (recto), 94 x 72.6, oil on canvas, TWCMS : B5617, purchased from Charles Bell, 1969, not available at the time of photography

Ray, Richard A. 1884–1968, *Landscape with Lady standing by a River*, 41.6 x 49.5, oil on canvas, TWCMS : B5621, purchased from Charles Bell, 1979, not available at the time of photography

Ray, Richard A. 1884–1968, *Male Nude, Full-Length*, 100.3 x 68, oil on canvas, TWCMS : B5607, purchased from Charles Bell, 1969, not available at the time of photography

Ray, Richard A. 1884–1968, *Male Nude, Full-Length*, 113 x 85.1, oil on canvas, TWCMS : B5609, purchased from Charles Bell, 1969, not available at the time of photography

Ray, Richard A. 1884–1968, *Male Nude, Full-Length, with Sword*, 101.6 x 68, oil on canvas, TWCMS : B5608, purchased from Charles Bell, 1969, not available at the time of photography

Ray, Richard A. 1884–1968, *Portrait of a Lady*, 33 x 28, oil on canvas, TWCMS : B5610, purchased from Charles Bell, 1969, not available at the time of photography

Ray, Richard A. 1884–1968, *Portrait of a Lady Wearing a Red Robe*, 92 x 55.9, oil on canvas, TWCMS : B5613, purchased from Charles Bell, 1969, not available at the time of photography

Ray, Richard A. 1884–1968, *Portrait of a Lady Wearing a White Blouse*, 42.3 x 31.8, oil on canvas, TWCMS : B5618, purchased from Charles Bell, 1969, not available at the time of photography

Ray, Richard A. 1884–1968, *Portrait of a Young Girl Wearing a Velvet Hat*, 59.7 x 50.8, oil on canvas, TWCMS : B5614, purchased from Charles Bell, 1969, not available at the time of photography

Ray, Richard A. 1884–1968, *Potrait of a Woman*, 58.4 x 48.2, oil on canvas, TWCMS : B5615, purchased from Charles Bell, 1969, not available at the time of photography

Ray, Richard A. 1884–1968, *Proposed President's Jewel*, 30.2 x 22.6, oil & ink on paper, TWCMS : K15215, purchased from Charles Bell, 1969, not available at the time of photography

Ray, Richard A. 1884–1968, *Study of a Young Girl, Half-Length*, 68.6 x 57.2, oil on canvas, TWCMS : B5616, purchased from Charles Bell, 1969, not available at the time of photography

Ray, Richard A. 1884–1968, *The Golden Hour, North Hylton*, 30.6 x 40.6, oil on canvas, TWCMS : K15208, purchased from Charles Bell, 1969, not available at the time of photography

Ray, Richard A. 1884–1968, *Trees at North Hylton*, 30.7 x 40.6, oil on canvas, TWCMS : T1746, purchased from Charles Bell, 1969, not available at the time of photography

unknown artist *Wreck of the Norwegian Barque 'Jernaes of Risar'*, c.1894, 30.5 x 40.4, oil on board, TWCMS : C427, gift from Mr and Mrs C. T. Dale, 1940, not available at the time of photography

unknown artist 19th C, *Portrait of a Clergyman*, 76 x 63.5, oil on canvas, TWCMS : B5634, acquired, before 1977, not available at the time of photography

unknown artist 19th C, *Portrait of a Man*, 110 x 84.5, oil on canvas, TWCMS : B4576, acquired, before 1977, not available at the time of photography

unknown artist early 20th C, *Portrait of a Lady, Half-Length*, 78.8 x 69.8, oil on canvas, TWCMS : B5632, acquired, before 1977, not available at the time of photography

Wood, Lewis John 1813–1901, *Cottage*, 35.5 x 45.7, oil on wood, TWCMS : B4585, gift from Mr R. G. Francis, 1958, not available at the time of photography

Further Information

The paintings listed in this section have additional information relating to one or more of the five categories outlined below. This extra information is only provided where it is applicable and where it exists. Paintings listed in this section follow the same order as in the illustrated pages of the catalogue.

I The full name of the artist if this was too long to display in the illustrated pages of the catalogue. Such cases are marked in the catalogue with a (…).

II The full title of the painting if this was too long to display in the illustrated pages of the catalogue. Such cases are marked in the catalogue with a (…).

III Acquisition information or acquisition credit lines as well as information about loans, copied from the records of the owner collection.

IV Artist copyright credit lines where the copyright owner has been traced. Exhaustive efforts have been made to locate the copyright owners of all the images included within this catalogue and to meet their requirements. Any omissions or mistakes brought to our attention will be duly attended to and corrected in future publications.

V The credit line of the lender of the transparency if the transparency has been borrowed. Bridgeman images are available subject to any relevant copyright approvals from the Bridgeman Art Library at www.bridgeman.co.uk

Shipley Art Gallery

Albani, Francesco (after) 1578–1660, *The Baptism of Christ*, bequeathed by J. A. D. Shipley, 1909

Andreis, Alex de 1871–1939, *Spanish Cavalier*, bequeathed by Lady Jane Cory, 1947

Ansdell, Richard (attributed to) 1815–1885, *Sheep*, bequeathed by J. A. D. Shipley, 1909

Appel, Jacob 1680–1751, *Coast Scene, Debarkation*, bequeathed by J. A. D. Shipley, 1909

Armfield, George 1808–1893, *Dogs*, bequeathed by J. A. D. Shipley, 1909

Armfield, George 1808–1893, *Terriers Ratting*, bequeathed by J. A. D. Shipley, 1909

Armstrong, Alan active 20th C, *Rough Seas*, purchased from W. H. Armstrong, 1964

Arnold, George 1763–1841, *Ruins of Rosslyn Castle, Midlothian*, bequeathed by J. A. D. Shipley, 1909

Ashby, Roger active 1966–1969, *Jeanne*, purchased from the artist, 1966

Ashby, Roger active 1966–1969, *Apple Blossom*, purchased from the artist, 1969

Asselyn, Jan (attributed to) after 1610–1652, *An Old Bridge*, bequeathed by J. A. D. Shipley, 1909

Atkinson, John II 1863–1924, *Cowhill Fair*, gift from Thomas Reed, 1919

Atkinson, John II 1863–1924,

Ploughing, gift from Thomas Reed, 1919

Aumonier, James 1832–1911, *Thames Scene*, gift from F. Harkness, 1965

Backhuysen, Ludolf I (attributed to) 1630–1708, *Sea Piece*, bequeathed by J. A. D. Shipley, 1909

Baldry, George W. active c.1865–c.1925, *John Rowell*, gift from Mr and Mrs C. F. Clayton Greene, 1969

Baldry, George W. active c.1865–c.1925, *Mrs Clara Rowell*, gift from Mr and Mrs C. F. Clayton Greene, 1969

Balen, Hendrik van I 1575–1632, *Moses Striking the Rock*, gift from M. Jacobson, 1934

Balmer, George 1805–1846, *Coast Scene with Fishing Boats*, bequeathed by J. A. D. Shipley, 1909

Balmer, George 1805–1846, *Holy Island, Northumberland*, gift from H. C. Richardson, 1924

Balmer, George 1805–1846, *Old Bridge*, bequeathed by J. A. D. Shipley, 1909

Balmer, George 1805–1846, *Scottish Lake Scene, Thunderstorm*, bequeathed by J. A. D. Shipley, 1909

Balten, Pieter c.1525–c.1598, *St John the Baptist Preaching*, bequeathed by J. A. D. Shipley, 1909

Barker, Benjamin II 1776–1838, *Landscape*, gift from W. Walters, 1954

Barker, Benjamin II (attributed

to) 1776–1838, *A Road near a Lake*, bequeathed by J. A. D. Shipley, 1909

Barker, Thomas Jones (attributed to) 1815–1882, *Landscape*, bequeathed by J. A. D. Shipley, 1909

Barrass, Dennis b.1942, *Saltwell Towers*, transferred from Saltwell Towers Museum, Gateshead

Barrass, Dennis b.1942, *The Mayor of Gateshead*, gift from Mayor Robert Ninian Baptist

Barrass, Dennis b.1942, *Matador's Dream*, gift from the artist, 1973

Barrass, Dennis b.1942, *The Blue Lion*, gift from the artist, 1973

Barrass, Dennis b.1942, *Moonlight Girl*, gift from the artist, 1980

Barrass, Dennis (attributed to) b.1942, *Saltwell Towers*, transferred from Saltwell Towers Museum, Gateshead

Barrett, Jerry 1814–1906, *Lady Seated in a Garden*, bequeathed by J. A. D. Shipley, 1909

Beelt, Cornelis (attributed to) 1640–1702, *A Fish Market*, bequeathed by J. A. D. Shipley, 1909

Bega, Cornelis Pietersz. (style of) 1631/1632–1664, *Dutch Interior*, bequeathed by J. A. D. Shipley, 1909

Belder, R. H. b.1910, *Waves*, purchased from the artist, 1956

Belin de Fontenay, Jean-Baptiste (style of) 1653–1715, *Flowers*, bequeathed by J. A. D. Shipley, 1909

Bellotto, Bernardo (attributed to) 1722–1780, *Ruins and Figures*,

Outskirts of Rome near the Tomb of Cecilia Metella, bequeathed by J. A. D. Shipley, 1909

Bisson, Edouard 1856–1939, *Winter*, gift from Mrs Hatton, 1936

Bleker, Gerrit Claesz. (attributed to) c.1600–1656, *The Meeting of Jacob and Esau*, bequeathed by J. A. D. Shipley, 1909

Bloemen, Jan Frans van 1662–1749, *Landscape with Pack Mules*, bequeathed by J. A. D. Shipley, 1909

Blythe, Peter active 20th C, *Australian Gum*, purchased from the Westgate Galleries, 1964

Boccaccio, Gino active 20th C, *The Market*, purchased, 1967

Bonington, Richard Parkes (attributed to) 1802–1828, *Cromer, Norfolk*, bequeathed by J. A. D. Shipley, 1909

Both, Jan (attributed to) c.1618–1652, *Landscape*, bequeathed by J. A. D. Shipley, 1909

Botticelli, Sandro (after) 1444/1445–1510, *Detail from Botticelli's 'Primavera'*, gift from H. C. Richardson, 1947

Boudewyns, Adriaen Frans (attributed to) 1644–1711, *River Scene with Figures*, bequeathed by J. A. D. Shipley, 1909

Bough, Samuel 1822–1878, *Borrowdale, Cumbria*, unknown acquisition

Boulogne, Valentin de (style of) 1591–1632, *The Chaste Susannah*, bequeathed by J. A. D. Shipley, 1909

Bout, Peeter (attributed to) 1658–1719, *Landscape with Old Houses*,

bequeathed by J. A. D. Shipley, 1909

Bouttats, Johann Baptiste c.1690–1738, *Dutch Mansion with Garden*, bequeathed by J. A. D. Shipley, 1909

Breanski, Alfred de 1852–1928, *A Scottish Lake*, bequeathed by J. A. D. Shipley, 1909

Breanski, Alfred de 1852–1928, *Glengarry, Scottish Highlands*, purchased from Miss B. Addie, 1944

Bromley, William 1769–1842, *The Escape*, bequeathed by J. A. D. Shipley, 1909, on loan to Albemarle Barracks, Newcastle upon Tyne

Brown, James Miller active 1875–1910, *Windsor Castle*, bequeathed by J. A. D. Shipley, 1909

Brugghen, Hendrick ter (attributed to) 1588–1629, *Pilate Washing His Hands*, bequeathed by J. A. D. Shipley, 1909

Bruyères, Hippolyte 1801–1856, *The Proposal*, bequeathed by J. A. D. Shipley, 1909

Burgess, John Bagnold 1830–1897, *Spanish Lady with a Fan*, bequeathed by J. A. D. Shipley, 1909

Buttersworth, Thomas 1768–1842, *Rescue of the 'Guardian's' Crew by a French Merchant Ship, 2 January 1790*, bequeathed by J. A. D. Shipley, 1909

T. C. active 19th C, *Ambleside Mill*, bequeathed by J. A. D. Shipley, 1909

Calderon, Philip Hermogenes 1833–1898, *His Reverence*, gift from H. C. Richardson, 1947

Callow, John 1822–1878, *Off Scarborough*, bequeathed by J. A. D. Shipley, 1909

Calvert, Edward 1799–1883, *A Woodland Glade*, bequeathed by J. A. D. Shipley, 1909

Campbell, John Hodgson 1855–1927, *Alderman Thomas McDermott, Mayor*, transferred from Gateshead Central Library, 1988

Campbell, John Hodgson 1855–1927, *Francis Joseph Finn*, transferred from Gateshead Central Library, 1988

Campbell, John Hodgson 1855–1927, *Alderman Thomas Hall*, transferred from Gateshead Central Library, 1988

Campbell, John Hodgson 1855–1927, *Robert Affleck, JP, Chairman of the Board of Guardians*, transferred from Gateshead Central Library, 1988

Canaletto (after) 1697–1768, *Grand Canal, Venice, Looking Northeast from the Palazzo Balbi to the Rialto Bridge*, bequeathed by J. A. D. Shipley, 1909

Canaletto (after) 1697–1768, *Venice, the Bucintoro Returning to the Molo on Ascension Day*, bequeathed by J. A. D. Shipley, 1909

Canaletto (style of) 1697–1768, *The Molo, Venice, Looking West*, bequeathed by J. A. D. Shipley, 1909

Carmichael, John Wilson 1800–1868, *Shipping off the Italian Coast*, gift from Mrs Stead, 1936

Carmichael, John Wilson 1800–1868, *A Clipper and an East Indiaman Leaving Port*, bequeathed by J. A. D. Shipley, 1909

Carmichael, John Wilson 1800–1868, *Shipping in the Bay of Naples*, gift from Mrs Stead, 1936

Carmichael, John Wilson 1800–1868, *Sea Piece with Ships*, bequeathed by J. A. D. Shipley, 1909

Carmichael, John Wilson 1800–1868, *Shipping*, gift from Mrs Stead, 1936

Carmichael, John Wilson (attributed to) 1800–1868, *A Breezy Evening off the Mouth of the Mersey*, bequeathed by J. A. D. Shipley, 1909

Carmichael, John Wilson (attributed to) 1800–1868, *Fishing Boats off Scarborough*, bequeathed by J. A. D. Shipley, 1909

Carolus, Jean 1814–1897, *Afternoon Tea*, bequeathed by J. A. D. Shipley, 1909

Carolus, Jean 1814–1897, *Harmony*, bequeathed by J. A. D. Shipley, 1909

Carr, H. active 19th C, *Newcastle, High Level and Swing Bridges*, unknown acquisition

Carr, Leslie b.1891, *Regional Call*, gift from G. Wilkes, 1942

Carter, Eva I. 1870–1963, *Autumn Flowers*, unknown acquisition

Carter, Eva I. 1870–1963,

Michaelmas Daisies, gift from G. Nevin Drinkwater, 1964

Carter, Eva I. 1870–1963, *Purple and Gold*, gift from G. Nevin Drinkwater, 1963

Carter, Eva I. 1870–1963, *Rhododendrons*, unknown acquisition

Carter, Eva I. 1870–1963, *Study in Grey and Gold*, gift from G. Nevin Drinkwater, 1963

Carter, Eva I. 1870–1963, *Sweet Peas*, gift from G. Nevin Drinkwater, 1963

Carter, Eva I. 1870–1963, *The Green Jug*, gift from G. Nevin Drinkwater, 1963

Carter, Eva I. 1870–1963, *Yellow Marguerites*, gift from the artist, 1950

Carter, Francis Thomas 1853–1934, *Borrowdale, Cumbria*, gift from Thomas Reed, 1919

Carter, Francis Thomas 1853–1934, *North Wales*, gift from Thomas Reed, 1920

Carter, Francis Thomas 1853–1934, *The Derwent near Lintz Green*, gift from Thomas Reed, 1919

Cartier, Victor Émile 1811–1866, *Landscape with Cattle*, bequeathed by J. A. D. Shipley, 1909

Casati active 20th C, *Seascape*, purchased, 1967

Casteleyn, Casper (attributed to) active c.1653–1660, *Croesus Showing Solon His Riches*, bequeathed by J. A. D. Shipley, 1909

Charlton, John 1849–1917, *Hunting Scene*, unknown acquisition

Charlton, John 1849–1917, *The German Retreat from the Marne*, gift from Robert Whitfield, 1920, on loan to Albemarle Barracks, Newcastle upon Tyne

Chilone, Vincenzo (attributed to) 1758–1839, *Grand Canal, Venice, with Riva del Carbon and the Rialto Bridge*, bequeathed by J. A. D. Shipley, 1909

Chilone, Vincenzo (attributed to) 1758–1839, *The Church of Santa Maria della Salute, Venice*, bequeathed by J. A. D. Shipley, 1909

Cipper, Giacomo Francesco 1664–1736, *Figure Study, Woman with Mouse Trap*, bequeathed by J. A. D. Shipley, 1909

Cipper, Giacomo Francesco 1664–1736, *Man Lighting a Pipe*, bequeathed by J. A. D. Shipley, 1909

Clark, James 1858–1943, *Models*, gift from Major R. Temperley, 1933, © the artist's estate/www.bridgeman.co.uk

Clark, Joseph Dixon 1849–1944, *Cattle*, bequeathed by J. A. D. Shipley, 1909, on loan to Albemarle Barracks, Newcastle upon Tyne

Codazzi, Viviano c.1604–1670, *Temple Ruins*, bequeathed by J. A. D. Shipley, 1909

Coecke van Aeslt, Pieter the elder

(studio of) 1502–1550, *The Descent from the Cross*, on loan from Hexham Parochial Church Council

Collins, William 1788–1847, *The Return of the Fishing Boats*, bequeathed by J. A. D. Shipley, 1909

Collins, William (attributed to) 1788–1847, *Beach, Boys Sailing a Toy Boat*, bequeathed by J. A. D. Shipley, 1909

Colyer, Edwaert (attributed to) c.1640–c.1707, *The Musician*, bequeathed by J. A. D. Shipley, 1909

Colyer, J. M. active 19th C, *Girl with Flowers and a Windmill*, unknown acquisition

Cook, Alan R. *Regatta at Beadnell, Northumberland*, purchased, 1967

Cooke, Edward William (attributed to) 1811–1880, *Coast Scene with Fishing Boats*, bequeathed by J. A. D. Shipley, 1909

Cooper, Thomas Sidney 1803–1902, *A Sunny Summer Evening in the Meadows*, bequeathed by J. A. D. Shipley, 1909

Cope, Charles West 1811–1890, *Genius between Tragedy and Comedy*, bequeathed by J. A. D. Shipley, 1909

Cope, T. active 19th C, *Moorland*, bequeathed by J. A. D. Shipley, 1909

Corbould, John active 19th C, *A Welsh Milkmaid*, bequeathed by J. A. D. Shipley, 1909

Cornish, Norman Stansfield b.1919, *Self Portrait*, purchased from the artist, 1954

Corot, Jean-Baptiste-Camille (style of) 1796–1875, *Landscape*, bequeathed by J. A. D. Shipley, 1909

Costello, J. active 19th C, *The Election of a Doge, Venice*, bequeathed by J. A. D. Shipley, 1909

Courtois, Jacques (attributed to) 1621–1676, *Landscape with Horsemen*, bequeathed by J. A. D. Shipley, 1909

Cox, David the elder (attributed to) 1783–1859, *Menlough Castle, Galway, Ireland*, bequeathed by J. A. D. Shipley, 1909

Cox, David the elder (attributed to) 1783–1859, *Wooded Landscape*, bequeathed by J. A. D. Shipley, 1909

Cox, David the elder (style of) 1783–1859, *A Sylvan Scene*, bequeathed by J. A. D. Shipley, 1909

Cozens, Ken *The Red Path*, purchased from Middlesbrough Art Gallery, 1964

Creswick, Thomas (style of) 1811–1869, *A Cumberland Trout Stream*, bequeathed by J. A. D. Shipley, 1909

Croegaert, Georges 1848–1923, *Lady with a Fan*, gift from H. C. Richardson, 1924

Crome, John (attributed to) 1768–

1821, *Landscape*, gift from H. C. Richardson, 1947

Crome, John (attributed to) 1768–1821, *View near Norwich*, bequeathed by J. A. D. Shipley, 1909

Croner, J. active 19th C, *A River Scene by Moonlight*, bequeathed by J. A. D. Shipley, 1909

Croos, Anthonie Jansz. van der c.1606–1662/1663, *Landscape with the Ruined Castle of Brederode and a Distant View of Haarlem*, bequeathed by J. A. D. Shipley, 1909

Cuyp, Aelbert (after) 1620–1691, *Landscape with Cattle*, bequeathed by J. A. D. Shipley, 1909

Cuyp, Aelbert (follower of) 1620–1691, *Dutch River Scene with Cattle*, bequeathed by J. A. D. Shipley, 1909

Cuyp, Benjamin Gerritsz. 1612–1652, *The Adoration of the Shepherds*, bequeathed by J. A. D. Shipley, 1909

Dalens, Dirck III (attributed to) 1688–1753, *Landscape with Figures and Cattle*, bequeathed by J. A. D. Shipley, 1909

Dalens, Dirck III (attributed to) 1688–1753, *Ruins with Figures and Cattle*, bequeathed by J. A. D. Shipley, 1909

Dall, Nicholas Thomas d.1776/1777, *Classical Landscape*, bequeathed by J. A. D. Shipley, 1909

Danby, Francis (attributed to) 1793–1861, *River with Old Ruins, Sunset*, bequeathed by J. A. D. Shipley, 1909

Davis, Edward Thompson 1833–1867, *Grandfather's Tale*, gift from H. C. Richardson, 1947

Davison, Thomas b.1934, *Roker Beach*, purchased from the artist, 1953

Dawson *Landscape*, gift from H. C. Richardson, 1947

Dawson, Byron Eric 1896–1968, *Still Life*, purchased from the artist, 1955

Dean, Donald b.1930, *Construction*, purchased from the artist, 1965

Dees, John Arthur 1876–1959, *The Dog Daisy Field, Low Fell, Gateshead*, purchased from Marshall Hall Associates with the assistance of the Victoria and Albert Museum Purchase Grant Fund and the Friends of the Shipley Art Gallery, 1981, on loan to the Discovery Museum, Newcastle upon Tyne

Delen, Dirck van 1604/1605–1671, *A Dutch Garden Scene*, bequeathed by J. A. D. Shipley, 1909

Deverell, Walter Howell 1827–1854, *Scene from 'As You Like It' by William Shakespeare*, bequeathed by J. A. D. Shipley, 1909

Dietrich, Christian Wilhelm Ernst (attributed to) 1712–1774, *Head of an Old Man (God the Father)*, bequeathed by J. A. D. Shipley, 1909

Dixon, A. *The Lost Child*, bequeathed by J. A. D. Shipley, 1909

Dixon, Dudley b.c.1900, *Still Life*, gift from J. A. Dixon, 1929

Dollman, John Charles 1851–1934, *Mowgli Made Leader of the Bandar-log*, gift from Miss D. Bolam, 1952

Doxford, James 1899–1978, *Vera Gomez*, purchased from the artist, 1951

Doxford, James 1899–1978, *Asters*, purchased from the artist, 1951

Droochsloot, Cornelis 1630–1673, *Dutch Village Scene*, bequeathed by J. A. D. Shipley, 1909

Droochsloot, Joost Cornelisz. (style of) 1586–1666, *A Dutch Village*, bequeathed by J. A. D. Shipley, 1909

Durdon, A. R. active 20th C, *Harbour Scene*, unknown acquisition

Dyck, Anthony van (after) 1599–1641, *An Equestrian Portrait of Charles I (1600–1649)*, bequeathed by J. A. D. Shipley, 1909

Dyck, Anthony van (after) 1599–1641, *Self Portrait, When a Youth*, bequeathed by J. A. D. Shipley, 1909

East, Alfred 1849–1913, *Arundel, Early Morning*, gift from Samuel Smith, JP, 1939

Eastlake, Charles Lock 1793–1865, *Boaz and Ruth*, gift from Mrs Luke Bell, 1920

Ellis, Edwin 1841–1895, *Harbour with Fishing Cobles*, bequeathed by J. A. D. Shipley, 1909

Emmerson, Henry Hetherington 1831–1895, *The Intruders*, gift from H. C. Richardson, 1928

Emmerson, Henry Hetherington 1831–1895, *Alderman George Davidson*, transferred from Gateshead Central Library, 1988

Emmerson, Henry Hetherington 1831–1895, *Alderman George Davidson*, transferred from Gateshead Central Library, 1988

Emmerson, Henry Hetherington 1831–1895, *The Critics*, gift from Thomas Reed, 1927

Erdmann, Otto 1834–1905, *The Music Lesson*, bequeathed by J. A. D. Shipley, 1909

Ewbank, John Wilson c.1799–1847, *Breadalbane Ferry, Loch Tay*, gift from H. C. Richardson, 1929

Ewbank, John Wilson c.1799–1847, *Loch Fyne, Herring Fishing*, bequeathed by J. A. D. Shipley, 1909

Ewbank, John Wilson c.1799–1847, *Tantallon Castle, East Lothian*, bequeathed by J. A. D. Shipley, 1909

Farrier, Robert 1796–1879, *Old Wooden Leg*, gift from H. C. Richardson, 1947

Fenn, William Wilthieu c.1827–1906, *Trellis Vine on the Lake of Lugano*, bequeathed by J. A. D. Shipley, 1909, on loan to Albemarle Barracks, Newcastle upon Tyne

Fischer, Paul 1786–1875, *Queen*

Victoria's Aviary, bequeathed by Lady Jane Cory, 1947

Flegel, Georg (attributed to) 1566–1638, *Still Life with Shellfish and Eggs*, bequeathed by J. A. D. Shipley, 1909

Fleury, James Vivien de active 1847–1896, *Morning on Lake Garda, Italy*, bequeathed by J. A. D. Shipley, 1909, on loan to Albemarle Barracks, Newcastle upon Tyne

Foschi, Francesco (attributed to) 1710–1780, *Winter Scene in the Italian Alps*, bequeathed by J. A. D. Shipley, 1909

Francken, Frans II (attributed to) 1581–1642, *John the Baptist Preaching*, bequeathed by J. A. D. Shipley, 1909

Gainsborough, Thomas (style of) 1727–1788, *Landscape, Stream with Figures*, bequeathed by J. A. D. Shipley, 1909

Gainsborough, Thomas (style of) 1727–1788, *Wooded Landscape*, bequeathed by J. A. D. Shipley, 1909

Garthwaite, William 1821–1899, *Herring Fishing*, bequeathed by J. A. D. Shipley, 1909

Garthwaite, William 1821–1899, *Entrance of a River with Shipping*, bequeathed by J. A. D. Shipley, 1909

Geeraerts, Marcus the younger (follower of) 1561–1635, *Portrait of a Man*, bequeathed by J. A. D. Shipley, 1909

Gibb, Thomas Henry 1833–1893, *Landscape with Highland Cattle*, unknown acquisition

Gill, William Ward 1823–1894, *View Near Ludlow*, bequeathed by J. A. D. Shipley, 1909

Gillie, Ann 1906–1995, *Kitchen Table*, purchased from the artist, 1956

Gilroy, John William 1868–1944, *Quayside*, gift from John Oxberry, 1934, © the artist's estate

Giordano, Luca (style of) 1634–1705, *King Solomon Offering Incense to an Idol*, bequeathed by J. A. D. Shipley, 1909

Goor, Jan van active 1674–1694, *Portrait of an Unknown Man*, bequeathed by J. A. D. Shipley, 1909

Grant, William James 1829–1866, *Juliet and the Friar 'Take thou this phial'* (from Willliam Shakespeare's Romeo and Juliet), gift from H. C. Richardson, 1924

Gray, George 1758–1819, *Fruit*, bequeathed by J. A. D. Shipley, 1909

Gray, George 1758–1819, *Fruit*, bequeathed by J. A. D. Shipley, 1909

Gray, George 1758–1819, *Fruit*, bequeathed by J. A. D. Shipley, 1909

Greuze, Jean-Baptiste (after) 1725–1805, *The Village Bridegroom*, bequeathed by J. A. D. Shipley, 1909

Grimmer, Jacob 1525–1590, *Tobias and the Angel*, bequeathed by J. A.

D. Shipley, 1909

Grimshaw, John Atkinson 1836–1893, *Autumn Regrets*, bequeathed by J. A. D. Shipley, 1909

Grimshaw, John Atkinson 1836–1893, *November Morning, Knostrop Hall, Leeds*, bequeathed by J. A. D. Shipley, 1909

Grimshaw, John Atkinson 1836–1893, *Greenwich, Half Tide*, bequeathed by J. A. D. Shipley, 1909

Guardi, Francesco (follower of) 1712–1793, *San Giustina from the Prato della Valle, Padua*, bequeathed by J. A. D. Shipley, 1909

Hair, Thomas H. 1810–1882, *Hartley Colliery after the Disaster*, bequeathed by J. A. D. Shipley, 1909

Hall, R. M. active 1887–1888, *Moor Street Primitive Methodist Church*, gift from Reverend Terence Hurst, 1993

Hancock, Charles 1802–1877 & **Noble, James Campbell** 1846–1913 *Highland Landscape with Sheep and Dogs*, bequeathed by J. A. D. Shipley, 1909

Haughton, Benjamin 1865–1924, *On the Quantocks, Somerset*, gift from Mrs Haughton, 1943

Havell, William 1782–1857, *A Stormy Day*, bequeathed by J. A. D. Shipley, 1909

Hayes, Edwin 1819–1904, *Off the Port of Boulogne*, bequeathed by J. A. D. Shipley, 1909

Hayllar, James 1829–1920, *Man's Head*, gift from H. C. Richardson, 1947

Hayter, John 1800–1891, *A Controversy on Colour*, bequeathed by J. A. D. Shipley, 1909

Heaning, A. *Man in a Gig*, bequeathed by Lady Jane Cory, 1947

Hedgecock, Derek d.1999, *View of Newcastle upon Tyne and Gateshead*, transferred, 1987, © Jan Hedgecock

Hedgecock, Derek d.1999, *View on the River Tyne*, transferred from Gateshead Education Offices, 1987, © Jan Hedgecock

Hedley, Ralph 1848–1913, *Out of Work*, purchased from Christopher Wood, 1978

Hedley, Ralph 1848–1913, *The Lay of the Last Minstrel*, gift from C. S. Moor, 1938

Hedley, Ralph 1848–1913, *Stephen Brownlow*, bequeathed by Frank Winter, 1925

Hedley, Ralph 1848–1913, *Spence Watson*, bequeathed by Spence E. Watson, 1919

Hedley, Ralph 1848–1913, *The Widow*, gift from Sir George Russell, 2007

Hedley, Ralph 1848–1913, *Potato Gatherers, Northumberland*, gift from Roger Hedley, 1939

Hedley, Ralph 1848–1913, *Summer Time*, transferred from Saltwell Towers Museum, Gateshead

Hedley, Ralph 1848–1913, *Seeking*

Situations, unknown acquisition

Heemskerck, Egbert van der elder (attributed to) 1634/1635–1704, *Exterior of a Dutch Ale House*, bequeathed by J. A. D. Shipley, 1909

Heemskerck, Egbert van der elder (style of) 1634/1635–1704, *Grace before Meat*, bequeathed by J. A. D. Shipley, 1909

Heeremans, Thomas c.1640–1697, *The Dutch Fair, Villagers Snatching at a Goose*, bequeathed by J. A. D. Shipley, 1909

Hemy, Thomas Marie Madawaska 1852–1937, *On the Look-Out*, gift from J. Donkin, 1939

Henzell, Isaac 1815–1876, *Wayside Gossip*, bequeathed by J. A. D. Shipley, 1909, on loan to Albemarle Barracks, Newcastle upon Tyne

Hepple, Wilson 1854–1937, *The Last of the Old Tyne Bridge*, bequeathed by J. A. D. Shipley, 1909

Herring, John Frederick II 1815–1907, *Interior of a Stable*, bequeathed by J. A. D. Shipley, 1909

Herring, John Frederick II 1815–1907, *Watering Horses*, bequeathed by J. A. D. Shipley, 1909

Hesketh, Richard 1867–1919, *Harter Fell, Eskdale*, gift from Thomas Reed, 1920

Heusch, Willem de (attributed to) c.1625–c.1692, *River Scene with Figures*, bequeathed by J. A. D. Shipley, 1909

Heyden, Jan van der 1637–1712, *Wooded Landscape*, bequeathed by J. A. D. Shipley, 1909

Heyn, August 1837–1920, *The Village Politicians*, bequeathed by J. A. D. Shipley, 1909

Hill, Ernest F. active 1897–1940, *Terrier and Hedgehog*, unknown acquisition

Hill, James John 1811–1882, *Near Stratford-upon-Avon*, gift from H. C. Richardson, 1947

Hobbema, Meindert (after) 1638–1709, *River Scene*, bequeathed by J. A. D. Shipley, 1909

Hobley, Edward George 1866–1916, *Cumberland Hills*, gift from Mrs Hatton, 1936

Hodgson, Stannard active 19th C, *The Young Picnickers*, bequeathed by J. A. D. Shipley, 1909

Hold, E. F. *The Orphan*, bequeathed by J. A. D. Shipley, 1909

Holland, James 1800–1870, *The Deserted Village (Goldsmith's)*, bequeathed by J. A. D. Shipley, 1909

Holland, James 1800–1870, *Low Water, Trebarwith Strand, Tintagel, Cornwall*, bequeathed by J. A. D. Shipley, 1909

Hondecoeter, Melchior de (follower of) 1636–1695, *Poultry*, bequeathed by J. A. D. Shipley, 1909

Hondecoeter, Melchior de (follower of) 1636–1695, *The Poultry Yard*, bequeathed by J. A. D.

Shipley, 1909

Horlor, Joseph 1809–1887, *Near Hailsham, Sussex*, bequeathed by J. A. D. Shipley, 1909

Hulk, Abraham I 1813–1897, *Landscape and Mill*, bequeathed by J. A. D. Shipley, 1909

Hunt, Alfred William 1830–1896, *Capel Curig, Snowdonia, North Wales*, gift from H. C. Richardson, 1947

Hutten, T. F. *Portrait of a Man Smiling*, bequeathed by J. A. D. Shipley, 1909

Huysmans, Cornelis (attributed to) 1648–1727, *Landscape*, bequeathed by J. A. D. Shipley, 1909

Huysmans, Jan Baptist (attributed to) 1654–1716, *Wooded Landscape*, bequeathed by J. A. D. Shipley, 1909

Ibbetson, Julius Caesar 1759–1817, *Kenwood, Lord Mansfield's Pedigree Cattle*, bequeathed by J. A. D. Shipley, 1909

Irving, William 1866–1943, *Joseph Cowen*, transferred from Gateshead Central Library, 1988

Irving, William 1866–1943, *The Blaydon Races, a Study from Life*, purchased from Sotheby's, Olympia, 2002

Jackson, Gilbert (attributed to) active 1621–1658, *Portrait of a Girl, Aged 8*, purchased from H. Hill, 1961, on loan to the Discovery Museum, Newcastle upon Tyne

James, David 1834–1892, *Sea Piece*, bequeathed by J. A. D. Shipley, 1909

Janssens, Abraham c.1575–1632, *Diana after the Chase*, bequeathed by J. A. D. Shipley, 1909

Jay, William Samuel 1843–1933, *The Ring Dove's Elysium*, bequeathed by J. A. D. Shipley, 1909

Jobling, Isabella 1851–1926, *Haymaking*, gift from Thomas Reed, 1920

Jobling, Robert 1841–1923, *Sunset with Boats*, unknown acquisition

Jublin, Alexis *A Harbour*, gift from H. C. Richardson, 1947

Kemm, Robert 1837–1895, *A Spanish Fruit Seller*, bequeathed by J. A. D. Shipley, 1909

Kessel, Jan van II 1626–1679, *A Chorus of Birds*, bequeathed by J. A. D. Shipley, 1909

Kessel, Jan van II 1626–1679, *The Chorus of Birds*, bequeathed by J. A. D. Shipley, 1909

Kidd, William 1790–1863, *Old Cottages at Petersfield, Hampshire*, bequeathed by J. A. D. Shipley, 1909

Kidd, William 1790–1863, *Cottages at Petersfield, Hampshire*, bequeathed by J. A. D. Shipley, 1909

Kidd, William 1790–1863, *The Stolen Kiss*, gift from H. C. Richardson, 1947

Knight, George active 1872–1892, *Off the Coast*, bequeathed by J. A. D. Shipley, 1909

Knowles, Davidson 1851–1901, *The Sign of the Cross*, gift from J. W. Stobbs, 1938

Koninck, Philips de (attributed to) 1619–1688, *Landscape, the Edge of a Wood*, bequeathed by J. A. D. Shipley, 1909

Labouchère, Pierre Antoine 1807–1873, *After Darkness, Light*, gift from James Deuchar, 1941

Laer, Pieter van 1599–c.1642, *Horseman with Cattle and Figures*, bequeathed by J. A. D. Shipley, 1909

Lambert, George c.1700–1765, *Classical Landscape*, bequeathed by J. A. D. Shipley, 1909

Lance, George (attributed to) 1802–1864, *Fruit Piece*, bequeathed by J. A. D. Shipley, 1909

Landelle, Charles 1821–1908, *Ruth*, bequeathed by J. A. D. Shipley, 1909

Landseer, Edwin Henry (after) 1802–1873, *A Random Shot*, unknown acquisition

Langevelt, Rutger van 1635–1695, *Interior of a Classical Building with a Marriage Ceremony*, bequeathed by J. A. D. Shipley, 1909

Lavery, John 1856–1941, *Mrs Katherine Vulliamy*, gift from Mrs Katherine Vulliamy, 1955, © the estate of Sir John Lavery by courtesy of Felix Rosenstiel's Widow & Son Ltd

Le Brun, Charles 1619–1690, *The Descent from the Cross*, on loan from Derek Hodgson

Lee, Barry S., *Coniston, Cumbria*, purchased from the artist, 1953

Leyden, Jan van active 1652–1669, *The Wreck*, bequeathed by J. A. D. Shipley, 1909

Lidderdale, Charles Sillem 1831–1895, *An Italian Lady*, bequeathed by J. A. D. Shipley, 1909

Linnell, James Thomas 1826–1905, *The Last Gleam*, gift from Samuel Smith, JP, 1935

Linnell, John (attributed to) 1792–1882, *A Cornfield in Surrey*, bequeathed by J. A. D. Shipley, 1909

Linnell, John (attributed to) 1792–1882, *A Sylvan Scene*, bequeathed by J. A. D. Shipley, 1909

Linnell, John (attributed to) 1792–1882, *Landscape with Cornfield*, bequeathed by J. A. D. Shipley, 1909

Linnell, John (attributed to) 1792–1882, *The Belated Traveller*, bequeathed by J. A. D. Shipley, 1909

Linnell, William 1826–1906, *People Fleeing from a Ruined Eastern Village*, bequeathed by J. A. D. Shipley, 1909

Linnell, William 1826–1906, *Shepherdess with Sheep*, bequeathed by J. A. D. Shipley, 1909

Locatelli, Andrea (attributed to) 1695–1741, *Landscape with River*, bequeathed by J. A. D. Shipley, 1909

Lodi, Gaetano 1830–1886, *Boys*

Fighting, unknown acquisition

Lodi, Gaetano 1830–1886, *Boys Smoking*, unknown acquisition

Loose, Basile de 1809–1885, *For the Sick Poor*, bequeathed by J. A. D. Shipley, 1909

Lorrain, Claude (after) 1604–1682, *Coast Scene with the Landing of Aeneas in Latium*, bequeathed by J. A. D. Shipley, 1909

Lorrain, Claude (after) 1604–1682, *The Embarkation of St Ursula*, bequeathed by J. A. D. Shipley, 1909

Loth, Johann Carl 1632–1698, *Abraham Visited by the Angels*, bequeathed by J. A. D. Shipley, 1909

Lowe, Arthur 1866–1940, *Old Church, Colston Bassett, Nottinghamshire*, gift from Mrs M. Lowe, 1944

Lucas, Albert Durer 1828–1919, *Heath, Heather, Furze and Sundew*, bequeathed by J. A. D. Shipley, 1909

Lucy, Charles 1814–1873, *The Interview of Milton with Galileo*, bequeathed by J. A. D. Shipley, 1909

Lund, Niels Møller 1863–1916, *After Rain*, gift from Mrs M. Waddington, 1926

Macdonald, Ian b.1946, *Friday Night Out*, purchased from the artist, 1978, © the artist

Mack, J. *Hurlstone Point, Somerset*, purchased from the artist, 1972

Mackay, Thomas 1851–1909, *Contentment*, bequeathed by J. A. D. Shipley, 1909, on loan to Albemarle Barracks, Newcastle upon Tyne

Mackie, Sheila Gertrude b.1928, *The Red Handkerchief*, purchased from the artist, 1952, © the artist

Macklin, Thomas Eyre 1867–1943, *Whittle Mill*, gift from A. H. Higginbottom, 1925

Manzoni, P. active 1850–1900, *On the French Coast*, bequeathed by J. A. D. Shipley, 1909

Marsell, G. *Faust and Margaret*, gift from H. C. Richardson, 1947

Martin, John (style of) 1789–1854, *The Fire, Edinburgh*, bequeathed by J. A. D. Shipley, 1909

Mason, T. active 19th C, *A Gypsy Encampment*, bequeathed by J. A. D. Shipley, 1909

Matteis, Paolo de' 1662–1728, *Esther before King Ahasuerus*, bequeathed by J. A. D. Shipley, 1909

Matteis, Paolo de' 1662–1728, *The Finding of Moses*, bequeathed by J. A. D. Shipley, 1909

Mawson, Elizabeth Cameron 1849–1939, *Holy Street Mill*, gift from Miss R. Dodds, 1939

Mayer, J. *Roses*, bequeathed by J. A. D. Shipley, 1909

Mayer, J. *Washerwomen in a Garden*, bequeathed by J. A. D. Shipley, 1909

McCulloch, Horatio 1805–1867, *The Haunt of the Red Deer*, gift from G. Henderson, 1933

McCulloch, Horatio 1805–1867, *A Scottish Landscape*, bequeathed by J. A. D. Shipley, 1909

McCulloch, Horatio 1805–1867, *On the Clyde*, bequeathed by J. A. D. Shipley, 1909

McEune, Robert Ernest 1876–1952, *Head of a Lady*, bequeathed by Mrs McEune, 1971, © the artist's estate

McEune, Robert Ernest 1876–1952, *Head of an Old Man*, bequeathed by Mrs McEune, 1971, © the artist's estate

McEune, Robert Ernest 1876–1952, *Woman in Eastern Headdress*, bequeathed by Mrs McEune, 1971, © the artist's estate

McEune, Robert Ernest 1876–1952, *Head of an Old Man*, bequeathed by Mrs McEune, 1971, © the artist's estate

McEune, Robert Ernest 1876–1952, *Still Life with Shell*, bequeathed by Mrs McEune, 1971, © the artist's estate

McEune, Robert Ernest 1876–1952, *Still Life with Silver Cup*, bequeathed by Mrs McEune, 1971, © the artist's estate

McEune, Robert Ernest 1876–1952, *Oil Study of a Sculptured Figure*, bequeathed by Mrs McEune, 1971, © the artist's estate

McEune, Robert Ernest 1876–1952, *Portrait of a Boy*, bequeathed by Mrs McEune, 1971, © the artist's estate

McEune, Robert Ernest 1876–1952, *Oil Study of a Statue of Antinous*, bequeathed by Mrs McEune, 1971, © the artist's estate

McEune, Robert Ernest 1876–1952, *Mrs Smith of the Royal Grammar School, Newcastle*, bequeathed by Mrs McEune, 1971, © the artist's estate

McEune, Robert Ernest 1876–1952, *Penrith, Cumbria*, bequeathed by Mrs McEune, 1971, © the artist's estate

McEune, Robert Ernest 1876–1952, *Boy, 1897*, bequeathed by Mrs McEune, 1971, © the artist's estate

McEune, Robert Ernest 1876–1952, *By the Sea*, bequeathed by Mrs McEune, 1971, © the artist's estate

McEune, Robert Ernest 1876–1952, *Class Study*, bequeathed by Mrs McEune, 1971, © the artist's estate

McEune, Robert Ernest 1876–1952, *Cornfield With Woods*, bequeathed by Mrs McEune, 1971, © the artist's estate

McEune, Robert Ernest 1876–1952, *Cottage Lane in Winter*, bequeathed by Mrs McEune, 1971, © the artist's estate

McEune, Robert Ernest 1876–1952, *Farm (?)*, bequeathed by Mrs McEune, 1971, © the artist's estate

McEune, Robert Ernest 1876–1952, *Female Nude*, bequeathed by Mrs McEune, 1971, © the artist's estate

McEune, Robert Ernest 1876–1952, *Female Nude*, bequeathed by Mrs McEune, 1971, © the artist's estate

McEune, Robert Ernest 1876–1952, *Female Nude*, bequeathed by Mrs McEune, 1971, © the artist's estate

McEune, Robert Ernest 1876–1952, *Fisherman Mending a Lobster Pot*, bequeathed by Mrs McEune, 1971, © the artist's estate

McEune, Robert Ernest 1876–1952, *Head of a Girl*, bequeathed by Mrs McEune, 1971, © the artist's estate

McEune, Robert Ernest 1876–1952, *Head of a Girl*, bequeathed by Mrs McEune, 1971, © the artist's estate

McEune, Robert Ernest 1876–1952, *Head of a Young Man*, bequeathed by Mrs McEune, 1971, © the artist's estate

McEune, Robert Ernest 1876–1952, *Landscape*, bequeathed by Mrs McEune, 1971, © the artist's estate

McEune, Robert Ernest 1876–1952, *Mountains*, bequeathed by Mrs McEune, 1971, © the artist's estate

McEune, Robert Ernest 1876–1952, *Mountains*, bequeathed by Mrs McEune, 1971, © the artist's estate

McEune, Robert Ernest 1876–1952, *Swiss Calves in the Bernese Oberland*, bequeathed by Mrs McEune, 1971, © the artist's estate

McEune, Robert Ernest 1876–1952, *Northumberland*, bequeathed by Mrs McEune, 1971, © the artist's estate

McEune, Robert Ernest 1876–1952, *Nude Female*, bequeathed by Mrs McEune, 1971, © the artist's estate

McEune, Robert Ernest 1876–1952, *Nude Woman*, bequeathed by Mrs McEune, 1971, © the artist's estate

McEune, Robert Ernest 1876–1952, *Oil Study of a Plaster Bust*, bequeathed by Mrs McEune, 1971, © the artist's estate

McEune, Robert Ernest 1876–1952, *Oil Study of a Plaster Bust*, bequeathed by Mrs McEune, 1971, © the artist's estate

McEune, Robert Ernest 1876–1952, *Oil Study of a Plaster Bust*, bequeathed by Mrs McEune, 1971, © the artist's estate

McEune, Robert Ernest 1876–1952, *Oil Study of Statue with Discus*, bequeathed by Mrs McEune, 1971, © the artist's estate

McEune, Robert Ernest 1876–1952, *Oil Study of the Head of a Girl*, bequeathed by Mrs McEune, 1971, © the artist's estate

McEune, Robert Ernest 1876–1952, *Portrait of a Lady*, bequeathed by Mrs McEune, 1971, © the artist's estate

McEune, Robert Ernest 1876–1952, *Portrait of a Matador*, bequeathed by Mrs McEune, 1971, © the artist's estate

McEune, Robert Ernest 1876–1952, *Portrait of a Seated Girl*,

bequeathed by Mrs McEune, 1971, © the artist's estate

McEune, Robert Ernest 1876–1952, *Portrait of a Young Man*, bequeathed by Mrs McEune, 1971, © the artist's estate

McEune, Robert Ernest 1876–1952, *Portrait of the Artist's Wife*, bequeathed by Mrs McEune, 1971, © the artist's estate

McEune, Robert Ernest 1876–1952, *Portrait of the Artist's Wife*, bequeathed by Mrs McEune, 1971, © the artist's estate

McEune, Robert Ernest 1876–1952, *River Scene*, bequeathed from Mrs McEune, 1971, © the artist's estate

McEune, Robert Ernest 1876–1952, *St Alban's Row, Carlisle*, bequeathed by Mrs McEune, 1971, © the artist's estate

McEune, Robert Ernest 1876–1952, *Sketch of a Seated Lady*, bequeathed by Mrs McEune, 1971, © the artist's estate

McEune, Robert Ernest 1876–1952, *Sky and Lake*, bequeathed by Mrs McEune, 1971, © the artist's estate

McEune, Robert Ernest 1876–1952, *Still Life, Flowers*, bequeathed by Mrs McEune, 1971, © the artist's estate

McEune, Robert Ernest 1876–1952, *Switzerland*, bequeathed by Mrs McEune, 1971, © the artist's estate

McEune, Robert Ernest 1876–1952, *Switzerland*, bequeathed by Mrs McEune, 1971, © the artist's estate

McEune, Robert Ernest 1876–1952, *Switzerland*, bequeathed by Mrs McEune, 1971, © the artist's estate

McEune, Robert Ernest 1876–1952, *The Thames at Windsor*, bequeathed by Mrs McEune, 1971, © the artist's estate

McEune, Robert Ernest 1876–1952, *Valley Landscape*, bequeathed by Mrs McEune, 1971, © the artist's estate

McEune, Robert Ernest 1876–1952, *Young Man*, bequeathed by Mrs McEune, 1971, © the artist's estate

McEune, Robert Ernest (attributed to) 1876–1952, *Flowers*, bequeathed by Mrs McEune, 1971, © the artist's estate

McGuinness, Tom 1926–2006, *Miners' Lamp Room*, purchased from Mrs G. Harrison, 1963

McNairn, John 1910–c.1975, *Landscape, Midlem*, purchased from the Westgate Gallery, 1964

McSwiney, Eugene Joseph 1866–1936, *Landing a Catch, A*, gift from A. C. Bratton, 1976

McSwiney, Eugene Joseph 1866–1936, *Landing a Catch, B*, gift from A. C. Bratton, 1976

Meadows, Arthur Joseph 1843–1907, *Low Tide, Mount Orgueil, Jersey*, gift from J. Chaston, 1923

Meehan, Myles 1904–1974, *Lilac*, purchased from the artist, 1958

Meehan, Myles 1904–1974, *Storm over the Pyrenees*, gift from the artist, 1965

Meehan, Myles 1904–1974, *The Rhone River*, gift from the artist, 1965

Meerts, Franz 1836–1896, *Old Man Sharpening a Quill Pen*, gift from Kenneth Martin, 1966

Metsu, Gabriel (after) 1629–1667, *Dutch Bird Seller*, bequeathed by J. A. D. Shipley, 1909

Michau, Theobald (attributed to) 1676–1765, *Village Scene*, bequeathed by J. A. D. Shipley, 1909

Michau, Theobald (attributed to) 1676–1765, *River with Windmill*, bequeathed by J. A. D. Shipley, 1909

Michau, Theobald (style of) 1676–1765, *River with Windmills*, bequeathed by J. A. D. Shipley, 1909

Millais, John Everett (attributed to) 1829–1896, *Meditation*, bequeathed by J. A. D. Shipley, 1909

Mitchell, John Edgar 1871–1922, *Perseus and Andromeda*, gift from Mrs Haughton, before 1947

Mitchell, John Edgar 1871–1922, *John Oxberry (1857–1940)*, transferred from Saltwell Towers Museum, Gateshead

Monamy, Peter 1681–1749, *Sea Piece with War Vessels*, bequeathed by J. A. D. Shipley, 1909

Monnoyer, Jean-Baptiste (style of) 1636–1699, *Flowers and Fruit*, bequeathed by J. A. D. Shipley, 1909

Moore, Edward d.1920, *Sea Piece*, bequeathed by J. A. D. Shipley, 1909

Moore, Henry 1831–1895, *Seascape*, gift from H. C. Richardson, 1947

Mooy, Cornelis Pietersz. de 1632–1696, *Dutch Shipping*, bequeathed by J. A. D. Shipley, 1909

More, Jacob (attributed to) 1740–1793, *Landscape with Waterfall*, bequeathed by J. A. D. Shipley, 1909

Morgan, Frederick 1856–1927, *Dinner Time*, bequeathed by J. A. D. Shipley, 1909

Morland, George (after) 1763–1804, *Interior of a Stable*, bequeathed by J. A. D. Shipley, 1909

Morland, George (style of) 1763–1804, *A Halt by the Way*, bequeathed by J. A. D. Shipley, 1909

Moroni, Giovanni Battista (style of) c.1525–1578, *The Musician*, bequeathed by J. A. D. Shipley, 1909

Morris, Philip Richard 1838–1902, *Beach with Figures*, bequeathed by J. A. D. Shipley, 1909

Mosscher, Jacob van c.1615–after 1655, *Landscape in the Dunes*, bequeathed by J. A. D. Shipley, 1909

Mulier, Pieter the elder c.1615–1670, *Dutch Shipping*, bequeathed by J. A. D. Shipley, 1909

Muller, William James (after) 1812–1845, *Eastern Scene (The White Slave)*, bequeathed by J. A. D. Shipley, 1909

Muller, William James (after) 1812–1845, *Rocky Coast Scene*, bequeathed by J. A. D. Shipley, 1909

Murray, David 1849–1933, *Church Pool*, bequeathed by the executor of the artist's estate, 1948

Murray, David 1849–1933, *Ullswater, Silver and Gold*, gift from Miss D. Bolam, 1949

Murray, David 1849–1933, *Crofts on the Island of Lewis*, bequeathed by the executor of the artist's estate, 1948

Murray, David 1849–1933, *The Watering Place*, bequeathed by the executor of the artist's estate, 1948

Murray, David 1849–1933, *Green Summertime*, bequeathed by the executor of the artist's estate, 1948

Nasmyth, Patrick (style of) 1787–1831, *Landscape with an Old Mill*, bequeathed by J. A. D. Shipley, 1909

Neal, James *Flowers*, purchased from Mrs G. Harrison, 1964

Newman, Harold active 20th C, *Chrysanthemum*, purchased from Mrs G. Harrison, 1964

Nicholls, Charles Wynne 1831–1903, *Portrait of Lady under a Tree*, bequeathed by Lady Jane Cory, 1947

Nicholls, Charles Wynne 1831–1903, *Anne McNair Alison, née Nicholls*, bequeathed by Lady Jane Cory, 1947

Nicholls, Charles Wynne 1831–1903, *Lady in Lilac*, bequeathed by Lady Jane Cory, 1947

Nicholls, Charles Wynne 1831–1903, *Portrait of a Lady*, bequeathed by Lady Jane Cory, 1947

Nicholls, Charles Wynne 1831–1903, *Portrait of Lady in a Black Dress*, bequeathed by Lady Jane Cory, 1947

Nicholson, Winifred 1893–1981, *Mount Zara*, purchased from the artist, 1978, © trustees of Winifred Nicholson

Nicol, Erskine 1825–1904, *Toothache*, gift from H. C. Richardson, 1947

Niemann, Edmund John 1813–1876, *A View on the Wharf near Pateley Bridge, Yorkshire*, bequeathed by J. A. D. Shipley, 1909

Niemann, Edmund John (attributed to) 1813–1876, *A Welsh Valley*, bequeathed by J. A. D. Shipley, 1909

Niemann, Edmund John (attributed to) 1813–1876, *Landscape*, bequeathed by J. A. D.

Shipley, 1909

Nijmegen, Gerard van 1735–1808, *A Breezy Day*, bequeathed by J. A. D. Shipley, 1909

North, John William 1842–1924, *The Sweet Meadow Waters of the West*, bequeathed by J. A. D. Shipley, 1909

Nursey, Claude Lorraine Richard Wilson 1816–1873, *The Draught Players*, bequeathed by J. A. D. Shipley, 1909

O'Connor, Patrick active 19th C, *Killarney Castle*, unknown acquisition, before 1976

Oliphant, John active 1832–1847, *William Wailes (1808–1881)*, transferred from the Saltwell Towers Museum, Gateshead

Orlik, Emil 1870–1932, *Still Life with Roses and Fruit*, gift from Mrs W. M. Alberti, c.1970

Pace del Campidoglio, Michele 1610–probably 1670, *Fruit, Flowers and Birds*, bequeathed by J. A. D. Shipley, 1909

Pace del Campidoglio, Michele 1610–probably 1670, *Fruit Piece*, bequeathed by J. A. D. Shipley, 1909

Pagano, Michele c.1697–1732, *Classical Landscape*, bequeathed by J. A. D. Shipley, 1909

Pagano, Michele c.1697–1732, *Landscape*, bequeathed by J. A. D. Shipley, 1909

Panini, Giovanni Paolo (after) c.1692–1765, *Classical Ruins with Figures*, bequeathed by J. A. D. Shipley, 1909

Panini, Giovanni Paolo (after) c.1692–1765, *St Peter's, Rome*, bequeathed by J. A. D. Shipley, 1909, on loan to Albemarle Barracks, Newcastle upon Tyne

Parker, Henry Perlee 1795–1873, *The Look Out, Shields Harbour*, bequeathed by J. A. D. Shipley, 1909

Parker, Henry Perlee 1795–1873, *Fisherfolk on a Beach*, bequeathed by J. A. D. Shipley, 1909

Parker, Henry Perlee 1795–1873, *Old Cullercoats, Spate Gatherers*, bequeathed by J. A. D. Shipley, 1909

Parker, James *Eighton Banks, Gateshead*, acquired from Mrs H. G. Maughan, 1964

Parry, Joseph 1744–1826, *Portrait of a Lady*, bequeathed by J. A. D. Shipley, 1909

Paton, Richard 1717–1791, *A Naval Engagement*, bequeathed by J. A. D. Shipley, 1909

Paul, John Dean 1775–1852, *Dedham Church, Suffolk*, bequeathed by J. A. D. Shipley, 1909

Paul, John Dean 1775–1852, *Dedham Vale, Suffolk*, bequeathed by J. A. D. Shipley, 1909

Paul, John Dean 1775–1852, *Landscape*, bequeathed by J. A. D. Shipley, 1909

Paul, John Dean 1775–1852, *Landscape*, bequeathed by J. A. D. Shipley, 1909

Paul, John Dean 1775–1852, *Willy Lott's Cottage*, bequeathed by J. A. D. Shipley, 1909

Peel, James 1811–1906, *View in Borrowdale, Cumbria*, bequeathed by J. A. D. Shipley, 1909

Peel, James 1811–1906, *A Ford on the Whiteadder, Berwickshire*, bequeathed by J. A. D. Shipley, 1909, on loan to Albemarle Barracks, Newcastle upon Tyne

Peel, James 1811–1906, *Landscape with a Farm*, bequeathed by J. A. D. Shipley, 1909

Peel, James 1811–1906, *Landscape with a River and Two Fishermen*, unknown acquisition

Peel, James 1811–1906, *Landscape with Farm Buildings*, bequeathed by J. A. D. Shipley, 1909

Peel, James 1811–1906, *Marshlands*, bequeathed by J. A. D. Shipley, 1909

Peel, James 1811–1906, *The Market Cart*, bequeathed by J. A. D. Shipley, 1909

Pelham, Thomas Kent c.1831–1907, *Venetian Balcony Scene*, bequeathed by J. A. D. Shipley, 1909

Pelham, Thomas Kent c.1831–1907, *Portrait of a Moor in National Costume*, bequeathed by J. A. D. Shipley, 1909

Percy, Sidney Richard 1821–1886, *Glencoe, Scotland*, bequeathed by J. A. D. Shipley, 1909

Pether, Abraham 1756–1812, *Landscape with a Waterfall*, bequeathed by J. A. D. Shipley, 1909

Pether, Abraham (attributed to) 1756–1812, *Wooded Landscape*, bequeathed by J. A. D. Shipley, 1909

Pether, Henry c.1801–1880, *The Doge's Palace, Venice, with the Columns of Saint Mark and Saint Theodore*, bequeathed by J. A. D. Shipley, 1909

Pether, Sebastian 1790–1844, *Landscape by Moonlight*, bequeathed by J. A. D. Shipley, 1909

Pether, Sebastian 1790–1844, *Lake Scene, Moonlight*, bequeathed by J. A. D. Shipley, 1909

Pettitt, George active 1857–1862, *Stepping Stones on the River Rothay, under Loughrigg*, bequeathed by J. A. D. Shipley, 1909

Phillips, John 1817–1867, *Gipsy and Girl*, bequeathed by Lady Jane Cory, 1947

Pillement, Jean (style of) 1728–1808, *River with Old Bridge*, bequeathed by J. A. D. Shipley, 1909

Pitt, William active 1849–1900, *Warwick Castle*, bequeathed by J. A. D. Shipley, 1909, on loan to Albemarle Barracks, Newcastle upon Tyne

Pocock, Nicholas 1740–1821, *Coastal Scene*, bequeathed by J. A. D. Shipley, 1909

Pocock, Nicholas 1740–1821, *Sea Piece with British Men-of-War*,

bequeathed by J. A. D. Shipley, 1909

Poole, James c.1804–1886, *A Silent Glen*, bequeathed by J. A. D. Shipley, 1909

Poole, Paul Falconer (attributed to) 1807–1879, *The Well*, bequeathed by J. A. D. Shipley, 1909

Potter, Paulus (after) 1625–1654, *A Dutch Milkmaid*, bequeathed by J. A. D. Shipley, 1909

Poussin, Nicolas (after) 1594–1665, *Moses Striking the Rock*, bequeathed by J. A. D. Shipley, 1909

Powell, Charles Martin (attributed to) 1775–1824, *Sea Piece with War Vessels*, bequeathed by J. A. D. Shipley, 1909

Pringle, David active 1851–1900, *Rural Scene with a Row of Cottages*, gift from Miss C. Kingstone, 1973

Pringle, David active 1851–1900, *Carr Hill Old Houses, Gateshead*, gift from Miss C. Kingstone, 1976

Pringle, David active 1851–1900, *Johnson's Quay, Gateshead*, gift from Miss C. Kingstone, 1973

Pyne, James Baker 1800–1870, *The Island of Ischia*, bequeathed by J. A. D. Shipley, 1909

Pyne, James Baker 1800–1870, *Eventide*, bequeathed by J. A. D. Shipley, 1909

Pyne, James Baker (attributed to) 1800–1870, *Lake Scene with Castle*, bequeathed by J. A. D. Shipley, 1909

Rathbone, John c.1750–1807, *River Scene*, bequeathed by J. A. D. Shipley, 1909

Redgrave, Richard 1804–1888, *The Poor Teacher*, bequeathed by J. A. D. Shipley, 1909

Reid, James Eadie b.c.1866, *Canon Moore Ede*, gift from the Gateshead Corporation Education Committee, 1930

Reid, John Robertson 1851–1926, *Shipmodel Maker with Harbour*

Reinagle, Philip 1749–1833, *Foliage, Flowers and Birds*, bequeathed by J. A. D. Shipley, 1909

Rembrandt van Rijn (after) 1606–1669, *Self Portrait*, bequeathed by J. A. D. Shipley, 1909

Rendall, Colin active 1876, *A View of Derbyshire*, bequeathed by J. A. D. Shipley, 1909

Reuss, Albert 1889–1976, *Landscape*, purchased from G. Nevin Drinkwater, 1968

Reuss, Albert 1889–1976, *Woman Dressing*, purchased from G. Nevin Drinkwater, 1968

Reuss, Albert 1889–1976, *The Poet*, purchased from the artist, 1952

Reuss, Albert 1889–1976, *Woman in an Empty Room*, unknown acquisition

Reynolds, Joshua (after) 1723–1792, *The Holy Family with St John*, bequeathed by J. A. D. Shipley, 1909

Ricci, Marco (attributed to) 1676–1730, *Landscape*, bequeathed by J.

A. D. Shipley, 1909

Ricci, Sebastiano 1659–1734, *The Ascension of Christ*, bequeathed by J. A. D. Shipley, 1909

Richardson, Thomas Miles I 1784–1848, *The Old Leith Walk, Edinburgh*, bequeathed by J. A. D. Shipley, 1909

Richardson, Thomas Miles I 1784–1848, *Carlisle, Cumbria*, unknown acquisition

Richardson, Thomas Miles I 1784–1848, *The Market Cart*, bequeathed by J. A. D. Shipley, 1909

Robbe, Louis 1806–1899, *The Sand Dunes of Calais*, bequeathed by J. A. D. Shipley, 1909

Roberts, David (attributed to) 1796–1864, *A Church Interior*, bequeathed by J. A. D. Shipley, 1909

Roberts, David (attributed to) 1796–1864, *Picnic Party*, bequeathed by J. A. D. Shipley, 1909

Roberts, David (attributed to) 1796–1864, *The Tomb of Edward III, Westminster Abbey*, bequeathed by J. A. D. Shipley, 1909

Robertson, Annie Theodora b.1896, *Bedburn, County Durham*, purchased from the artist, 1954

Robinson, William 1866–1945, *Old Lady in a Shawl*, unknown acquisition

Robinson, William 1866–1945, *Goose Girl*, unknown acquisition

Robson-Watson, John active 1928–c.1971, *Self Portrait*, gift from the artist, c.1971

Roe, Fred 1864–1947, *The Trial of Jeanne d'Arc*, gift from Samuel Smith, JP, 1935, © the artist's estate

Rogers, Charlie b.1930, *Redheugh Crossroads, Gateshead*, unknown acquisition

Rombouts, Salomon c.1652–c.1702, *Landscape with Cottages by the Water's Edge*, bequeathed by J. A. D. Shipley, 1909

Roos, Philipp Peter (attributed to) 1657–1706, *A Landscape with a Milkmaid*, bequeathed by J. A. D. Shipley, 1909

Rosa, Salvator (after) 1615–1673, *Pilate Washing His Hands*, bequeathed by J. A. D. Shipley, 1909

Rowell, R. active late 19th C–20th C, *View of the North Tyne River*, unknown acquisition

Rubens, Peter Paul (after) 1577–1640, *Susannah and the Elders*, bequeathed by J. A. D. Shipley, 1909

Rubens, Peter Paul (after) 1577–1640, *The Brazen Serpent*, bequeathed by J. A. D. Shipley, 1909

Ryott, William 1817–1883, *The Road to Redheugh Hall*, unknown acquisition

Ryott, William 1817–1883, *Rural Scene*, bequeathed by J. A. D. Shipley, 1909

Ryott, William 1817–1883, *View in Jesmond Dene, Newcastle upon*

Tyne, gift from the artist

Salimbeni, Ventura 1568–1613, *The Madonna and Child with Saints*, bequeathed by J. A. D. Shipley, 1909

Savry, Hendrik 1823–1907, *Cattle*, gift from Mrs Luke Bell, 1940

Savry, Hendrik 1823–1907, *Cattle in a Meadow*, bequeathed by J. A. D. Shipley, 1909

Schalcken, Godfried (style of) 1643–1706, *Candlelight Scene*, bequeathed by J. A. D. Shipley, 1909

Schäufelein, Hans c.1480/1485–1538/1540, *Christ in the Temple*, bequeathed by J. A. D. Shipley, 1909

Schäufelein, Hans c.1480/1485–1538/1540, *The Reviling of Christ*, bequeathed by J. A. D. Shipley, 1909

Schelfhout, Andreas 1787–1870, *Winter Scene*, gift from H. C. Richardson, 1947

Schelfhout, Andreas (style of) 1787–1870, *Dutch Winter Scene*, bequeathed by J. A. D. Shipley, 1909

Schranz, Anton 1769–1839, *Harbour Scene, Malta*, bequeathed by J. A. D. Shipley, 1909

Schranz, Anton 1769–1839, *Harbour Scene, Malta*, bequeathed by J. A. D. Shipley, 1909

Schutz, Johannes Fredrick 1817–1888, *Shipping in a Calm*, bequeathed by J. A. D. Shipley, 1909

Segal, Arthur 1875–1944, *Portrait on a Veranda, Spain*, gift from Mrs and Miss Segal, Segal Painting School, 1955, © the artist's estate

Segal, Arthur 1875–1944, *Flower Study*, gift from Mrs and Miss Segal, Segal Painting School, 1955, © the artist's estate

Serres, Dominic 1722–1793, *Shipping*, bequeathed by J. A. D. Shipley, 1909

Serres, Dominic 1722–1793, *Shipping*, bequeathed by J. A. D. Shipley, 1909

Shayer, William 1788–1879, *A Donkey and a Youth*, gift from H. C. Richardson, 1947

Shayer, William (attributed to) 1788–1879, *The Cow Byre*, bequeathed by J. A. D. Shipley, 1909

Sheard, Thomas Frederick Mason 1866–1921, *Harvesters Resting*, unknown acquisition

Simpson, Charles Walter 1885–1971, *Herring Gulls*, gift from Thomas Reed, 1921, © the artist's estate

Simpson, Charles Walter 1885–1971, *Otter Hunting*, gift from Thomas Reed, 1921, © the artist's estate

Simpson, Charles Walter 1885–1971, *The Duck Pond*, gift from Thomas Reed, 1921, © the artist's estate

Simpson, Ruth 1889–1964, *Thomas Reed*, unknown acquisition, © the artist's estate

Sirani, Giovanni Andrea (style of) 1610–1670, *Judith with the Head of Holofernes*, bequeathed by J. A. D. Shipley, 1909

Slater, John Falconar 1857–1937, *Landscape with Torrent*, unknown acquisition

Slater, John Falconar 1857–1937, *Lombardy Poplars*, unknown acquisition

Slater, John Falconar 1857–1937, *River Scene with Pink Mountain*, unknown acquisition

Slater, John Falconar 1857–1937, *Scottish Highlands*, gift from Miss F. Dobson, 1938

Smith, Anthony John b.1953, *Mr R. Hughes Arranges Flowers in a Most Attractive Manner*, purchased from the artist, 1978

Smith, John 'Warwick' 1749–1831, *River Scene*, bequeathed by J. A. D. Shipley, 1909

Smith, John 'Warwick' 1749–1831, *River with Bridge*, bequeathed by J. A. D. Shipley, 1909

Soest, Gerard (attributed to) c.1600–1681, *Unidentified Portrait*, bequeathed by J. A. D. Shipley, 1909

Somerville, Howard 1873–1952, *Zulu Head*, gift from Miss Adamson, 1958

Spalthof, Jan Philip (attributed to) active 1700–1724, *Landscape with Peasants and Cows*, bequeathed by J. A. D. Shipley, 1909

Speed, S. A. active 1954, *Flower Study*, purchased from the artist, 1954

Stack, T. H. active 19th C, *Bridge over a River*, unknown acquisition

Stanfield, Clarkson 1793–1867, *Coastal Scene*, gift from H. C. Richardson, 1924

Stanfield, Clarkson (after) 1793–1867, *The Coming Storm, Calais*, purchased from Mawson, Swan & Morgan, 1958

Stark, James 1794–1859, *Canal Scene*, bequeathed by J. A. D. Shipley, 1909

Stark, James 1794–1859, *Cattle in the Woods*, gift from Major G. Blackborn, 1959

Steenwijck, Hendrick van the elder (after) c.1550–1603, *St Pieters at Louvain, a Christening Party*, bequeathed by J. A. D. Shipley, 1909

Sticks, George Blackie 1843–1938, *Evening on the Loch*, gift from Mrs Affleck, 1944

Sticks, George Blackie 1843–1938, *The Kyles of Bute, Argyll, Scotland*, gift from Mrs Affleck, 1944

Sticks, Harry James 1867–1938, *On the Wear, Stanhope*, purchased from Councillor J. Phillips, 1919

Sticks, Harry James 1867–1938, *'Breakers', Whitley Bay*, gift from Thomas Reed, 1919

Stuart, Robin b.1970, *Councillor Joe Mitchinson*, gift from the artist, 2005

Swaine, Francis c.1720–1782, *Shipping Piece with a Ship Firing a Gun*, bequeathed by J. A. D. Shipley, 1909

Swift, John Warkup 1815–1869, *Wreck off Scarborough*, bequeathed by J. A. D. Shipley, 1909

Swift, John Warkup 1815–1869, *Cooper versus Chambers, Race on the Tyne*, transferred from Saltwell Towers Museum, Gateshead, 1958

Swift, John Warkup 1815–1869, *Mouth of the Tyne*, bequeathed by J. A. D. Shipley, 1909

Syer, John 1815–1885, *Way over the Moor*, bequeathed by J. A. D. Shipley, 1909

Sykes, Samuel 1846–1920, *The Tyne with the High Level Bridge, Newcastle*, unknown acquisition

Taylor, E. active late 19th C, *Landscape with a Windmill*, bequeathed by J. A. D. Shipley, 1909

Teasdale, John 1848–1926, *Churchyard with a Ruined Chapel*, unknown acquisition

Teniers, David I (style of) 1582–1649, *Bridge with Buildings and Figures*, bequeathed by J. A. D. Shipley, 1909

Teniers, David II 1610–1690, *Interior of a Tavern*, gift from the National Art Collections Fund, 1985

Teniers, David II (after) 1610–1690, *The Alchemist*, bequeathed by J. A. D. Shipley, 1909

Teniers, David II (style of) 1610–1690, *The Kitchen of a Dutch Mansion*, bequeathed by J. A. D. Shipley, 1909

Thomas, C. P. *Old Keep, Newcastle*, transferred from Saltwell Towers Museum, Gateshead, 1937

Thompson, B. M. *Prelude to the Fight*, on loan from a private lender, since 1972

Thompson, Constance b.1882, *Water Lilies*, gift from Miss C. Kingstone, 1973

Thompson, Constance b.1882, *River Scene, Punting*, gift from Miss C. Kingstone, 1973

Thompson, Constance b.1882, *Pears and Leaves*, gift from Miss C. Kingstone, 1973

Thompson, Constance b.1882, *Coastal Scene, Small and Bay*, gift from Miss C. Kingstone, 1973

Thompson, Constance b.1882, *Tynemouth Priory Ruins*, gift from Miss C. Kingstone, 1973

Thompson, Constance b.1882, *Daffodils*, gift from Miss C. Kingstone, 1973

Thys, Pieter 1624–1677, *Bathsheba*, bequeathed by J. A. D. Shipley, 1909

Tintoretto, Jacopo (attributed to) 1519–1594, *Christ Washing the Disciples' Feet*, purchased from the Chapter of the Cathedral of St Nicholas, Newcastle upon Tyne, with the assistance of the National Art Collections Fund, the National Heritage Memorial Fund, the Victoria and Albert Museum Purchase Grant Fund, the Pilgrim Trust and the Sir James Knott Trust, 1986

Titian (after) c.1488–1576, *Titian and Andrea de Franceschi*, bequeathed by J. A. D. Shipley, 1909

Titley, W. J. *The Choir Boys of St Paul's School*, bequeathed by Lady Jane Cory, 1947

Tol, Dominicus van (attributed to) c.1635–1676, *A Dutch Fruit Seller*, bequeathed by J. A. D. Shipley, 1909

Tol, Dominicus van (follower of) c.1635–1676, *Kitchen Scene*, unknown acquisition

Tongeren, Arent van active 1684–1689, *Flowers and Bird's Nest*, bequeathed by J. A. D. Shipley, 1909

Train, Edward 1801–1866, *Mountain Torrent*, bequeathed by J. A. D. Shipley, 1909

Train, Edward 1801–1866, *A Scottish Waterfall*, bequeathed by J. A. D. Shipley, 1909

Train, Edward 1801–1866, *A Mountain Scene with a Waterfall*, bequeathed by J. A. D. Shipley, 1909

Tucker, James Walker 1898–1972, *A Stormy Sea*, gift from Samuel Smith, JP, 1935

Tucker, James Walker 1898–1972, *The Bay at Gurnard's Head, Cornwall*, gift from Samuel Smith, JP, 1935

unknown artist *Mercenary Love*, bequeathed by J. A. D. Shipley, 1909

unknown artist *Landscape with Christ Healing a Blind Man*, bequeathed by J. A. D. Shipley, 1909

unknown artist 17th C, *The Head of John the Baptist Presented to Herod*, bequeathed by J. A. D. Shipley, 1909

unknown artist 18th C, *A Dutch River Scene*, bequeathed by J. A. D. Shipley, 1909

unknown artist 18th C, *A Landscape with Houses*, bequeathed by J. A. D. Shipley, 1909

unknown artist 18th C, *A Terrace Scene*, bequeathed by J. A. D. Shipley, 1909

unknown artist 18th C, *An Old English Mill*, bequeathed by J. A. D. Shipley, 1909

unknown artist 18th C, *Classical Landscape with Figures*, bequeathed by J. A. D. Shipley, 1909

unknown artist 18th C, *Filial Love*, bequeathed by J. A. D. Shipley, 1909

unknown artist 18th C, *Flowers in a Vase*, bequeathed by J. A. D. Shipley, 1909

unknown artist 18th C, *Flowers in a Vase*, bequeathed by J. A. D. Shipley, 1909

unknown artist 18th C, *Greenwich Hospital off Which Lies the Royal Yacht*, bequeathed by J. A. D. Shipley, 1909

unknown artist 18th C, *Harbour with Lighthouse*, bequeathed by J. A. D. Shipley, 1909

unknown artist 18th C, *Landscape with Castle*, bequeathed by J. A. D. Shipley, 1909

unknown artist 18th C, *Landscape with Tomb*, bequeathed by J. A. D. Shipley, 1909

unknown artist 18th C, *Portrait of a Man*, bequeathed by J. A. D. Shipley, 1909

unknown artist 18th C, *Portrait of a Man*, bequeathed by J. A. D. Shipley, 1909

unknown artist 18th C, *Portrait of a Man*, bequeathed by J. A. D. Shipley, 1909

unknown artist 18th C, *Portrait of a Man in a Fur Hat*, bequeathed by J. A. D. Shipley, 1909

unknown artist 18th C, *River Scene with Figures*, bequeathed by J. A. D. Shipley, 1909

unknown artist 18th C, *River Scene with Ruins*, bequeathed by J. A. D. Shipley, 1909

unknown artist 18th C, *Roman Capriccio with Obelisk*, bequeathed by J. A. D. Shipley, 1909

unknown artist 18th C, *St Anne and the Young Virgin*, bequeathed by J. A. D. Shipley, 1909

unknown artist 18th C, *St Jerome*, bequeathed by J. A. D. Shipley, 1909

unknown artist 18th C, *Still Life*, bequeathed by J. A. D. Shipley, 1909

unknown artist 18th C, *The Angels Appearing to the Shepherds*, unknown acquisition

unknown artist 18th C, *Troubadour Performing Outside an Inn*, unknown acquisition

unknown artist late 18th C, *View of Messina, Sicily*, bequeathed by J. A. D. Shipley, 1909

unknown artist *Alderman George Hawks*, transferred from Gateshead Central Library, 1988

unknown artist *Child with a Whip*, unknown acquisition

unknown artist *John Hawks*, gift from W. H. Hawks, 1946

unknown artist *Portrait of a Man*

unknown artist *Trading Post at Canton*, bequeathed by J. A. D. Shipley, 1909

unknown artist *Richard Wellington Hodgson, Mayor*, transferred from Gateshead Central Library, 1988

unknown artist *The Great Fire of Newcastle upon Tyne*, gift from Sir G. Renwick, 1927

unknown artist *Alderman Walter de Lancey Willson, Mayor*, transferred, 1988

unknown artist early 19th C, *A Gale at Sea*, bequeathed by J. A. D. Shipley, 1909

unknown artist early 19th C, *A Gamekeeper*, gift from H. C. Richardson, 1947

unknown artist early 19th C, *Chichester Cross*, on loan to Albemarle Barracks, Newcastle upon Tyne, bequeathed by J. A. D. Shipley, 1909

unknown artist mid-19th C, *Holy Family Rest, on the Flight into*

Egypt, unknown acquisition

unknown artist mid-19th C, *Juliet and the Nurse*, bequeathed by J. A. D. Shipley, 1909

unknown artist 19th C, *A Dog's Head*, bequeathed by J. A. D. Shipley, 1909

unknown artist 19th C, *A Landscape with Figures and Cattle*, bequeathed by J. A. D. Shipley, 1909

unknown artist 19th C, *A Moorland Scene*, bequeathed by J. A. D. Shipley, 1909

unknown artist 19th C, *A River Scene*, bequeathed by J. A. D. Shipley, 1909

unknown artist 19th C, *A River Scene*, bequeathed by J. A. D. Shipley, 1909

unknown artist 19th C, *A Rocky Stream*, bequeathed by J. A. D. Shipley, 1909

unknown artist 19th C, *A Shaded Pool*, bequeathed by J. A. D. Shipley, 1909

unknown artist 19th C, *A Wharf on the Thames, Moonlight*, bequeathed by J. A. D. Shipley, 1909

unknown artist 19th C, *Beach with Fishing Boats*, bequeathed by J. A. D. Shipley, 1909

unknown artist 19th C, *Canal Scene*, unknown acquisition

unknown artist 19th C, *Cattle in a Stream*, bequeathed by J. A. D. Shipley, 1909

unknown artist 19th C, *Chinese Harbour (European Legations)*, bequeathed by J. A. D. Shipley, 1909

unknown artist 19th C, *Classical Landscape with River and Ruins*, bequeathed by J. A. D. Shipley, 1909

unknown artist 19th C, *Clovelly, North Devon*, bequeathed by J. A. D. Shipley, 1909

unknown artist 19th C, *Coast Scene*, bequeathed by J. A. D. Shipley, 1909

unknown artist 19th C, *Coast Scene with Boats*, bequeathed by J. A. D. Shipley, 1909

unknown artist 19th C, *Dr Guthrie, Edinburgh*, bequeathed by J. A. D. Shipley, 1909

unknown artist 19th C, *Dutch Cottages and Figures*, bequeathed by J. A. D. Shipley, 1909

unknown artist 19th C, *Dutch Shipping*, bequeathed by J. A. D. Shipley, 1909

unknown artist 19th C, *Elizabeth Hawks*, gift from W. H. Hawks, 1946

unknown artist 19th C, *Galliot in a Gale*, bequeathed by J. A. D. Shipley, 1909

unknown artist 19th C, *Interior of an English Inn*, bequeathed by J. A. D. Shipley, 1909

unknown artist 19th C, *John Abbot Esq.*, unknown acquisition

unknown artist 19th C, *Lake Scene*, bequeathed by J. A. D. Shipley, 1909

unknown artist 19th C, *Landscape*, bequeathed by J. A. D. Shipley, 1909

unknown artist 19th C, *Landscape*, bequeathed by J. A. D. Shipley, 1909

unknown artist 19th C, *Landscape*, bequeathed by J. A. D. Shipley, 1909

unknown artist 19th C, *Landscape*, unknown acquisition

unknown artist 19th C, *Landscape with Horses and Cart*, bequeathed by J. A. D. Shipley, 1909

unknown artist 19th C, *Landscape with Pool*, bequeathed by J. A. D. Shipley, 1909

unknown artist 19th C, *Landscape with Shepherd and Flock*, bequeathed by J. A. D. Shipley, 1909

unknown artist 19th C, *Mrs John Swan*, gift from Elizabeth Mawson Cameron, c.1939

unknown artist 19th C, *Open Landscape*, bequeathed by J. A. D. Shipley, 1909

unknown artist 19th C, *Portrait of a Lady in Black with a Cameo*, unknown acquisition

unknown artist 19th C, *Portrait of a Lady with a Pearl Necklace*, bequeathed by J. A. D. Shipley, 1909

unknown artist 19th C, *Portrait of a Young Woman*, bequeathed by J. A. D. Shipley, 1909

unknown artist 19th C, *River Scene*, bequeathed by J. A. D. Shipley, 1909

unknown artist 19th C, *River Scene with a Fisherman*, unknown acquisition

unknown artist 19th C, *River Scene with a Fisherman and Ruins*, unknown acquisition

unknown artist 19th C, *River Scene with Village*, bequeathed by J. A. D. Shipley, 1909

unknown artist 19th C, *Rocky Landscape*, bequeathed by J. A. D. Shipley, 1909, on loan to Albemarle Barracks, Newcastle upon Tyne

unknown artist 19th C, *Scene in Charlecote Park, Warwickshire*, bequeathed by J. A. D. Shipley, 1909

unknown artist 19th C, *Sir Robert Shafto Hawks*, gift from Mrs M. G. Corran, 1972

unknown artist 19th C, *Virgin and Child*, bequeathed by J. A. D. Shipley, 1909

unknown artist 19th C, *Wooded Landscape*, bequeathed by J. A. D. Shipley, 1909

unknown artist *Lancelot Tulip Penman, Mayor*, transferred from Gateshead Central Library, 1988

unknown artist *Alderman Walter de Lancey Wilson*, transferred from Gateshead Central Library, 1988

unknown artist *William John Costelloe, Mayor*, transferred from Gateshead Central Library, 1988

unknown artist *Still Life*, unknown acquisition

unknown artist 20th C, *Bridge over River with Houses*, unknown acquisition

unknown artist 20th C, *Flooded Fields in Holland with Silver Birches*, unknown acquisition

unknown artist *Alderman Morrison*, on loan from the city of Newcastle upon Tyne, since 1956

unknown artist *Alderman W. Brown, Mayor*, transferred from Gateshead Central Library, 1988

unknown artist *Moorland Road*, bequeathed by J. A. D. Shipley, 1909

unknown artist *Portrait of an Unidentified Alderman**

unknown artist *Robert Stirling Newall (1812–1889)*

unknown artist *The Runner*

Unterberger, Franz Richard 1838–1902, *Ville d'Amalfi*, bequeathed by J. A. D. Shipley, 1909

Van de Beigh, Lucas active early 19th C, *Landscape with Cattle*, bequeathed by J. A. D. Shipley, 1909

van Myer, Otto active 19th C, *Dutch Canal, with Cattle*, bequeathed by J. A. D. Shipley, 1909

Varley, John II 1850–1933, *Game El Syer, Cairo*, bequeathed by J. A. D. Shipley, 1909

Varley, John II 1850–1933, *The Mosque of Emir Mindar, Cairo*, bequeathed by J. A. D. Shipley, 1909

Velde, Willem van de II (after) 1633–1707, *Fresh Gale*, bequeathed by J. A. D. Shipley, 1909

Velde, Willem van de II (follower of) 1633–1707, *Sea Piece with Shipping*, bequeathed by J. A. D. Shipley, 1909

Velde, Willem van de II (style of) 1633–1707, *Dutch Shipping*, bequeathed by J. A. D. Shipley, 1909

Venne, Adriaen van de 1589–1662, *Peasants Brawling*, bequeathed by J. A. D. Shipley, 1909

Venneman, Karel Ferdinand 1802–1875, *The Itinerant Fiddler*, bequeathed by J. A. D. Shipley, 1909

Verbeeck, Cornelis (attributed to) c.1590–c.1637, *Dutch Sea Piece*, bequeathed by J. A. D. Shipley, 1909

Verlat, Charles Michel Maria (after) 1824–1890, *Horses Straining at a Load*, bequeathed by J. A. D. Shipley, 1909

Vernet, Claude-Joseph (style of) 1714–1789, *Storm off the French Coast*, bequeathed by J. A. D. Shipley, 1909

Vickers, Alfred (attributed to) 1786–1868, *Coast Scene near a Cinque Port*, bequeathed by J. A. D. Shipley, 1909

Victoryns, Anthonie (style of) c.1620–c.1656, *Dutch Interior with Figures*, bequeathed by J. A. D. Shipley, 1909

Vivian, Jane active 1861–1877, *Gondolas on a Lake*, bequeathed by J. A. D. Shipley, 1909

Vogel, T. de active 18th C, *A Musician*, bequeathed by J. A. D. Shipley, 1909

Vogel, T. de active 18th C, *Figures and Cattle*, bequeathed by J. A. D. Shipley, 1909

Vollevens, Johannes II 1685–1758, *Portrait of a Courtier in a Wig*, bequeathed by J. A. D. Shipley, 1909

Vollevens, Johannes II 1685–1758, *Portrait of a Lady*, bequeathed by J. A. D. Shipley, 1909

Vonck, Jan 1631–1663/1664, *Dead Game*, bequeathed by J. A. D. Shipley, 1909

Vosmaer, Daniel (attributed to) active 1650–1700, *Dutch Canal Scene*, bequeathed by J. A. D. Shipley, 1909

Voss, T. *Flowers and Fruit Study*, bequeathed by J. A. D. Shipley, 1909

Vouet, Simon (attributed to) 1590–1649, *The Continence of Scipio*, gift from William Ogilvie and C. W. Lemon, 1954

Wainewright, Thomas Francis 1794–1883, *Cows in a Meadow*, bequeathed by J. A. D. Shipley, 1909, on loan to Albemarle Barracks, Newcastle upon Tyne

Wallace, John 1841–1905, *Quayside, Newcastle upon Tyne*, bequeathed by J. A. D. Shipley, 1909

Wallace, John 1841–1905, *Newcastle upon Tyne from the River*, bequeathed by J. A. D. Shipley, 1909

Wallace, John 1841–1905, *Kilingham Mills*, on loan from E. Emley

Wallace, John 1841–1905, *Prudhoe Castle, Northumberland*, bequeathed by J. A. D. Shipley, 1909

Walton, Edward Arthur 1860–1922, *Suffolk Lane*, gift from Mrs Katherine Vulliamy, 1964

Ward, Edward Matthew 1816–1879, *Sergeant Bothwell Challenging Balfour*, bequeathed by J. A. D. Shipley, 1909, on loan to Albemarle Barracks, Newcastle upon Tyne,

Wardle, Arthur (attributed to) 1864–1949, *Terrier Watching a Rabbit Warren*, bequeathed by J. A. D. Shipley, 1909, © the artist's estate

Waterlow, Ernest Albert 1850–1919, *Winter in the Lauterbrunnen Valley, Switzerland*, gift from Lady Waterlow, 1939, on loan to Albemarle Barracks, Newcastle upon Tyne

Watson, George (attributed to) 1767–1837, *The Three Brothers, the Sons of Thomas Dallas*, bequeathed by J. A. D. Shipley, 1909

Watts, Frederick William 1800–1870, *Landscape with a Stream*, bequeathed by J. A. D. Shipley, 1909

Watts, George Frederick 1817–1904, *The Family of Darius before Alexander the Great (after Paolo Veronese)*, gift from H. C. Richardson, 1947

Way, William Cossens 1833–1905, *Turnip Field*, gift from Miss R. Dodds, 1939

Webb, James 1825–1895, *Coast Scene, an Approaching Storm*, bequeathed by J. A. D. Shipley, 1909

Webb, James 1825–1895, *The White Cliffs of Dover*, bequeathed by J. A. D. Shipley, 1909

Webb, James 1825–1895, *Boats Leaving Harbour*, bequeathed by J. A. D. Shipley, 1909

Webb, James 1825–1895, *Cartagena, Spain*, gift from H. C. Richardson, 1947

Webb, James (attributed to) 1825–1895, *Homeward Bound*, bequeathed by J. A. D. Shipley, 1909

Webb, James (attributed to) 1825–1895, *Richmond Castle, Yorkshire*, bequeathed by J. A. D. Shipley, 1909

Webb, James (attributed to) 1825–1895, *Seascape with French Shipping*, bequeathed by J. A. D. Shipley, 1909

Webb, James (attributed to) 1825–1895, *Venetian Canal Scene*, bequeathed by J. A. D. Shipley, 1909

Webb, William Edward 1862–1903, *Douglas Harbour, Isle of Man*, bequeathed by J. A. D. Shipley, 1909

Weben, J. W. *Counting Her Gains*, bequeathed by J. A. D. Shipley, 1909

Weber, Theodor Alexander 1838–1907, *Fishing Boats Leaving Ostend Harbour*, bequeathed by J. A. D. Shipley, 1909

Weber, Theodor Alexander (attributed to) 1838–1907, *Fishing Boats*, gift from H. E. Galloway, 1948

Webster, Thomas George 1800–1886, *Genius*, bequeathed by J. A. D. Shipley, 1909

Webster, Thomas George 1800–1886, *Hop Garden*, gift from H. C. Richardson, 1939, on loan to Albemarle Barracks, Newcastle upon Tyne

Weir, J. T. active 19th C, *Wooded Landscape with Pheasants*, bequeathed by J. A. D. Shipley, 1909

Weisbrod, Carl Wilhelm 1743–1806, *River Scene*, bequeathed by J. A. D. Shipley, 1909

West, Kevin Barry *The Ninth Hour*

Wheatley, Francis (attributed to) 1747–1801, *Portrait of a Milkmaid*, unknown acquisition

Whistler, James Abbott McNeill (style of) 1834–1903, *A Foggy Night in London*, bequeathed by J. A. D. Shipley, 1909

Wijnants, Jan (style of) c.1635–1684, *Landscape with River*, bequeathed by J. A. D. Shipley, 1909

Wilkie, David (style of) 1785–1841, *The Invalid's Breakfast*, bequeathed by J. A. D. Shipley, 1909

Williams, Alan active 20th C,

Landscape 1, unknown acquisition
Williams, Alfred Walter 1824–1905, *Haymaking, Sunshine and Showers*, bequeathed by J. A. D. Shipley, 1909
Williams, T. *Sea Piece*, bequeathed by J. A. D. Shipley, 1909
Willis, Henry Brittan 1810–1884, *Crossing the Stream*, gift from Samuel Smith, JP, 1933
Willis, Henry Brittan 1810–1884, *Cows on the Banks of a Stream*, bequeathed by J. A. D. Shipley, 1909
Wilson, Richard (after) 1714–1787, *Classical Landscape*, bequeathed by J. A. D. Shipley, 1909
Wilson, Richard (style of) 1714–1787, *On the Coast*, bequeathed by J. A. D. Shipley, 1909
Wood, John 1801–1870, *The Love Letter*, bequeathed by J. A. D. Shipley, 1909
Wood, John 1801–1870, *The Death of Abel*, gift from M. Jacobson, 1944
Woolmer, Alfred Joseph 1805–1892, *Portrait of a Young Woman*, bequeathed by J. A. D. Shipley, 1909
Woutermaertens, Edouard 1819–1897, *Sheep and Goats Sheltering*, bequeathed by J. A. D. Shipley, 1909
Woutermaertens, Edouard 1819–1897, *Shepherdess with Flock*, bequeathed by J. A. D. Shipley, 1909
Wouwerman, Philips (after) 1619–1668, *The Farrier's Shop*, bequeathed by J. A. D. Shipley, 1909
Wtewael, Joachim Anthonisz. 1566–1638, *The Temptation of Adam and Eve*, bequeathed by J. A. D. Shipley, 1909
Wtewael, Joachim Anthonisz. 1566–1638, *The Meeting of David and Abigail*, bequeathed by J. A. D. Shipley, 1909
Wulffaert, Adrianus 1804–1873, *Portrait of a Lady*, bequeathed by Lady Jane Cory, 1947
Wyck, Thomas (follower of) 1616–1677, *A Church Interior*, bequeathed by J. A. D. Shipley, 1909
Wynfield, David Wilkie 1837–1887, *The Lady's Knight*, bequeathed by J. A. D. Shipley, 1909
Ximenes, Pio d.1919, *'Abide with me'*, gift from Thomas Reed, 1919
Young, C. P. active 20th C, *Head of a Man in Grey with a Pipe*, bequeathed by Mr Donald
Young, J. *The Vagrant*, gift from Sir G. Renwick, 1929
Young-Hunter, John 1874–1955, *The Midday Meal*, bequeathed by J. A. D. Shipley, 1909, © the artist's estate
Zampigi, Eugenio 1859–1944, *Sharing Their Pleasures*, purchased from Sidney Davis, 1948

Laing Art Gallery

Adam, Eduard Marie 1847–1929, *Sailing Boats, Le Havre*, gift from Miss L. Eldridge, 1950
Adams, Alan Henry 1892–1988, *View of Suffolk*, gift from Ken Adams, 1988, © the artist's estate
Adams, John Clayton 1840–1906, *Hay Field*, bequeathed by George E. Henderson, 1937
Adams, Ruth 1893–1949, *Sleeping Woman*, gift from Miss Grace Adams, 1951, © the artist's estate
Adams, Ruth 1893–1949, *Trewithal Farm*, untraced find, first recorded 1982, © the artist's estate
Alder, Helen Baker b.1950, *Head VII*, purchased from the artist, 1991, © the artist
Alder, Helen Baker b.1950, *Head X*, purchased from the artist, 1991, © the artist
Alder, Helen Baker b.1950, *Head XI*, purchased from the artist, 1991, © the artist
Allen, Harry Epworth 1894–1958, *Eyam, Derbyshire*, purchased from the artist, 1936, © Geraldine Lattey/Harry Epworth Allen Foundation
Alma-Tadema, Lawrence 1836–1912, *Love in Idleness*, gift from George E. Henderson, 1934
Anderson, Charles Goldsborough 1865–1936, *Mrs Goldsborough Anderson*, gift from Mrs Charles Goldsborough Anderson, 1938
Anderson, William S. 1878–1929, *Lustre*, purchased from the artist, 1921
Anderson, William S. 1878–1929, *Still Life*, gift from Samuel Smith, JP, 1929
Antoniani, Pietro 1740–1750–1805, *A Harbour in Italy (St Lucia)*, bequeathed by John George Joicey, 1919
Antoniani, Pietro 1740–1750–1805, *Naples*, bequeathed by John George Joicey, 1919
Antoniani, Pietro 1740–1750–1805, *Naples at Night with Vesuvius Erupting*, bequeathed by John George Joicey, 1919
Antoniani, Pietro 1740–1750–1805, *Naples with Vesuvius*, bequeathed by John George Joicey, 1919
Appleyard, Frederick 1874–1963, *Portrait of a Lady*, gift from Waite Sanderson, 1944, © the artist's estate
Appleyard, Frederick 1874–1963, *Roses*, purchased from the artist, 1946, © the artist's estate
Appleyard, Joseph 1908–1960, *Cleveland Hounds at Feeding Time*, on loan from a private lender, © the artist's estate, www.josephappleyard.co.uk
Armitage, Edward 1817–1896, *Souvenir of Scutari*, bequeathed by Stephen Armitage, 1912
Armitage, Edward 1817–1896, *The Cities of the Plain*, bequeathed by Stephen Armitage, 1912
Armstrong, John 1893–1973,

Icarus, purchased from Brown and Phillips Ltd, 1961, © the artist's estate
Armstrong, Thomas 1832–1911, *Woman with Lilies*, untraced find, painting in gallery since c.1940, recorded, 1969
Arpad, Romek 1883–1960, *Still Life*, gift from Samuel Smith, JP, 1937
Atkin, Gabriel 1897–1937, *Portrait of an Unknown Woman*, untraced find, recorded, 2007
Atkin, Gabriel 1897–1937, *Prince Serge of Chernatzki*, untraced find, recorded, 1987
Atkin, Gabriel 1897–1937, *Work*, untraced find, recorded, 2007
Atkinson, John II 1863–1924, *Haymaking*, gift from Daniels and Coltman, 1941
Auerbach, Frank Helmuth b.1931, *Julia*, purchased from the Beaux Arts Gallery with the assistance of the Victoria and Albert Museum Purchase Grant Fund, the National Art Collections Fund and the Friends of the Laing Art Gallery, 1987, © the artist
Ayres, Gillian b.1930, *Papua*, purchased from Knoedler Kasmin Ltd, with the assistance of the Museums and Galleries Commission/Victoria and Albert Museum Purchase Grant Fund, 1990, © the artist
Ball, Martin b.1948, *Fane*, purchased from the artist with the assistance of the Victoria and Albert Museum Purchase Grant Fund and Northern Arts, 1982, © the artist
Balmer, George 1805–1846, *Dunstanburgh Castle, Northumbria*, gift from Kenneth Glover, 1937
Balmer, George 1805–1846, *The Brig 'Hermaphrodite'*, purchased from J. H. Wray, 1978
Balmer, George 1805–1846, *The Bass Rock*, bequeathed by Miss M. J. Dobson, 1905
Balmer, George 1805–1846, *'Grey Horse Inn', Quayside, Newcastle upon Tyne*, purchased from Harold Hill, 1933
Banner, Delmar Harmond 1896–1983, *Scafell, Cumbria*, anonymous gift, 1948, © the artist's estate
Bannister, T. W. active 19th C, *John Theodore Hoyle (1808–1873), Coroner of Newcastle*, gift from Mrs A. V. Hoyle, 1954
Bardwell, Thomas 1704–1767, *Captain Robert Fenwick (1716–1802), His Wife Isabella Orde (d.1789), and Her Sister Ann*, purchased from Sotheby's with the assistance of the Museums and Galleries Commission/Victoria and Albert Museum Purchase Grant Fund, the National Art Collections Fund, the Friends of the Laing Art Gallery and the Laing Trust Fund, 1997
Bateman, James 1893–1959, *The Cook*, purchased from the artist, 1931
Bateman, James 1893–1959, *The*

Schoolyard, purchased from the artist, 1931
Bateman, James 1893–1959, *The Field Byre*, purchased from the artist, 1933
Bateman, James 1893–1959, *The Lime Burner*, purchased from the artist, 1936
Bateman, James 1893–1959, *Silage*, gift from the War Artists Advisory Committee, 1947
Batoni, Pompeo 1708–1787, *Henry Swinburne (1743–1803)*, bequeathed by Mrs O. J. Minchin, 1949
Beattie, Basil b.1935, *Sea Wall, Hartlepool*, purchased from the artist, 1953, © the artist
Beavis, Richard 1824–1896, *Fishing Boats, Brighton*, bequeathed by William Wilson, 1955
Beavis, Richard 1824–1896, *Fishing Craft off the Eddystone Lighthouse*, bequeathed by William Wilson, 1955
Beavis, Richard 1824–1896, *Fruit Boats on the Mediterranean*, bequeathed by John Lamb, 1909
Bell, Trevor b.1930, *Three Blue Lines*, purchased from the Stone Gallery, 1963, © the artist
Benner, Jean 1836–1909, *Study of Flowers*, gift from Councillor G. T. de Loriol, 1922
Bertram, Robert John Scott 1871–1953, *Newcastle upon Tyne from Gateshead, the Great Flood, AD 1771*, purchased from the artist, 1927
Best, Eleanor 1875–1957, *Winter Sunlight*, gift from the Contemporary Art Society, 1940
Best, Eleanor 1875–1957, *Women in a Gymnasium*, gift from the Contemporary Art Society, 1940
Birch, Samuel John Lamorna 1869–1955, *Landscape*, gift from Mrs M. H. Webster, 1935, © the artist's estate
Bird, Robert b.1921, *Spanish Gold*, purchased from the artist, 1965
Blacklock, William James 1816–1858, *The Ruins of Kirkoswald Castle, Cumberland*, gift from Dr Gilbert Leathart, 1982
Bland, Emily Beatrice 1864–1951, *Dover Cliffs*, purchased from the artist, 1944
Bloemen, Jan Frans van (attributed to) 1662–1749, *Campagna Landscape*, gift from T. R. Heppell, 1946
Bolton, Sylbert b.1959, *Time Out*, gift from the artist, 1994, © the artist
Bomberg, David 1890–1957, *Sunset, the Bay, North Devon*, purchased from the artist, 1952, © the artist's family
Bone, Stephen 1904–1958, *Hospital Ship*, gift from the War Artists Advisory Committee, 1947, © the artist's estate
Bossche, Balthasar van den 1681–1715, *The Studio of Giovanni Bologna*, gift from Major Cowan-Smith, 1972
Botticelli, Sandro (after)

1444/1445–1510, *The Madonna of the Magnificat*, bequeathed by Miss T. Merz, 1958
Bough, Samuel 1822–1878, *Coast Scene*, bequeathed by John Lamb, 1909
Bough, Samuel (attributed to) 1822–1878, *Landscape with Children*, gift from Charles Kydd, 1947
Bouguereau, William-Adolphe 1825–1905, *The Penitent*, gift from Colin D. Currie, 1953
Bouts, Dieric the elder (attributed to) c.1415–1475, *The Miracle of the Gallows*, bequeathed by John George Joicey, 1919
Bramtot, Alfred Henri 1852–1894, *Compassion*, gift from George L. Collins, 1931
Brangwyn, Frank 1867–1956, *Mending the Nets*, purchased from John Heaton, 1915, © the artist's estate/www.bridgeman.co.uk
Bratby, John Randall 1928–1992, *Gloria with Angst*, purchased from the artist, 1968, © the artist's estate/www.bridgeman.co.uk
Breanski, Alfred de 1852–1928, *Sentinels of the Forest*, bequeathed by Miss Gladys M. Simms, 1929
Breanski, Alfred de 1852–1928, *Henley Regatta*, gift from S. M. Garston, 1936
Breanski, Alfred de 1852–1928, *River Foyers at Abertarff, Invernesshire*, gift from Mrs Bradford, 1940
Brick, Michael b.1946, *Sous-Bois II*, purchased from the artist with the assistance of the Victoria and Albert Museum Purchase Grant Fund and Northern Arts, 1981, © the artist
Briggs, Henry Perronet 1791/1793–1844, *The Discovery of the Gunpowder Plot and the Taking of Guy Fawkes*, gift from Viscount Ridley, 1908
Bromly, Thomas b.1930, *Painting, 1966 (Divided Square No.4 Red and Blue)*, purchased from the artist, 1966, © the artist
Brooker, William 1918–1983, *Naxos 1962*, purchased from Arthur Tooth and Sons Ltd, 1963, © the artist's estate
Brown, Alexander Kellock 1849–1922, *Winter Twilight*, on loan to Lumley Castle, Chester-le-Street, County Durham, purchased from the artist, 1909
Brown, John Alfred Arnesby 1866–1955, *The Watch Tower*, purchased from the artist, 1923
Brown, Thomas Austen 1859–1924, *Ploughing*, purchased from A. H. Higginbottom, 1935
Brownlow, George Washington 1835–1876, *Collie*, acquired from G. Brownlow, 1948
Brownlow, George Washington 1835–1876, *Cottage Interior*, untraced find, recorded, 1982
Brownlow, Stephen 1828–1896, *North Shields*, gift from J. Hume, 1947
Bryce, Helen Bryne active 1918–

1931, *Street Scene*, gift from Alex McRae, 1954

Bryce, Helen Bryne active 1918–1931, *Fishing*, gift from Alex MacRae, 1954

Bryce, Helen Bryne active 1918–1931, *High Street, Burford, Oxfordshire*, gift from Alderman Sir Johnstone Wallace, 1922

Bullock, Ralph 1867–1949, *Benton Golf Course*, untraced find, recorded, 1980

Bullock, Ralph 1867–1949, *Farm*, untraced find, recorded, 1980

Bullock, Ralph 1867–1949, *The Entry of Princess Margaret into Newcastle upon Tyne, 1503*, purchased from the artist, 1934

Bunbury, Henry William 1750–1811, *A Windy Day*, bequeathed by John George Joicey, 1919

Bunbury, Henry William 1750–1811, *The Dancing Bear*, bequeathed by John George Joicey, 1919

Burdon Sanderson, Elizabeth c.1825–1925, *View in Jesmond, Newcastle upon Tyne*, gift from Miss E. S. Haldane, 1935

Burgess, John Bagnold 1830–1897, *The Trysting Place*, gift from Miss E. Convery, 1995

Burne-Jones, Edward 1833–1898, *Laus veneris*, purchased from Thomas Agnew and Sons with the assistance of the Victoria and Albert Museum Purchase Grant Fund, the National Art Collections Fund, the Pilgrim Trust, the Friends of the Laing Art Gallery and the John Wigham Richardson Bequest, 1972

Burns, Joanne b.1959, *Beach after Cullercoats, Northumberland*, gift from Jo Adams, 1990, © the artist

Burns, Peter *Empty Stockyard, Hawthorn Leslie's, Hebburn, South Tyneside*, gift from the Tyneside Shipbuilders, 1993

Callcott, Augustus Wall 1779–1844, *Windsor Castle from the Old Bridge*, bequeathed by John Lamb, 1909

Callow, William (attributed to) 1812–1908, *On the Medway*, gift from Farquhar M. Laing, 1931

Calvert, Frederick (attributed to) c.1785–c.1845, *Coast Scene*, gift from Miss Wilson, 1940

Calvert, Samuel 1828–1913, *Tynemouth Bar*, gift from G. F. Simmonds, 1963, on loan to the University of Northumbria, Newcastle upon Tyne

Cameron, David Young 1865–1945, *Balquhidder, Stirlingshire*, purchased from the artist, 1929

Camp, Jeffery b.1923, *Thames*, purchased from the Nigel Greenwood Gallery with the assistance of the Museums and Galleries Commission/Victoria and Albert Museum Purchase Grant Fund, 1989, © the artist

Campbell, John Hodgson 1855–1927, *Workman Eating Lunch*, gift from Mrs Helen Dixon, 1945

Campbell, John Hodgson 1855–

1927, *John Hall (1824–1899)*, gift from W. W. Dean, Hall Shipping Co., 1980

Cantrill, Molly active 1968–1987, *Steps: Westgate Gallery*, gift from the artist, 1987

Carelli, Consalvo (attributed to) 1818–1900, *View of Capri*, gift from R. A. Spence, 1955

Carelli, Consalvo (attributed to) 1818–1900, *View of the Bay of Naples*, gift from R. A. Spence, 1955

Carmichael, John Wilson 1800–1868, *Priory and Castle, Tynemouth*, purchased from Dunelm Fine Art with the assistance of the Victoria and Albert Museum Purchase Grant Fund, the National Art Collections Fund and the Friends of the Laing Art Gallery, 1996

Carmichael, John Wilson 1800–1868, *The Mayor's Barge on the Tyne*, purchased from Mrs Mortimer, 1927

Carmichael, John Wilson 1800–1868, *Brinkburn Grange and the Ruins of the Priory*, bequeathed by Miss M. J. Dobson, 1905

Carmichael, John Wilson 1800–1868, *Cullercoats from Tynemouth*, gift from H. J. H. Sissons, 1995

Carmichael, John Wilson 1800–1868, *Shipping Inshore, a Boat Ferrying Passengers*, bequeathed by George E. Henderson, 1937

Carmichael, John Wilson 1800–1868, *Landscape with a Country House*, gift from Samuel Smith, JP, 1938

Carmichael, John Wilson 1800–1868, *Shipping in the Open Sea*, untraced find, recorded, 1983

Carmichael, John Wilson 1800–1868, *Sunderland Old Pier and Lighthouse with Ryhope Church in the Distance*, bequeathed by George E. Henderson, 1937

Carmichael, John Wilson 1800–1868, *Durham*, gift from George E. Henderson, 1934

Carmichael, John Wilson 1800–1868, *Holme Eden, near Carlisle*, bequeathed by Miss M. J. Dobson, 1905

Carmichael, John Wilson 1800–1868, *Interior of St Peter's Church, Newcastle upon Tyne*, bequeathed by Miss M. J. Dobson, 1905

Carmichael, John Wilson 1800–1868, *Coast Scene*, bequeathed by Conrad White, 1905

Carmichael, John Wilson 1800–1868, *The Entrance to Beaufront Castle*, bequeathed by Miss M. J. Dobson, 1905

Carmichael, John Wilson 1800–1868, *The Garden Front, Beaufront Castle*, bequeathed by Miss M. J. Dobson, 1905

Carmichael, John Wilson 1800–1868, *Leith and Edinburgh from the Firth of Forth*, gift from Miss Elsie Wright, 1964

Carmichael, John Wilson 1800–1868, *Marsden Rocks, Sunderland*, bequeathed by Miss Elsie Wright,

1964

Carmichael, John Wilson 1800–1868, *Men-of-War off Portsmouth Harbour*, bequeathed by George E. Henderson, 1937

Carmichael, John Wilson 1800–1868, *Seascape*, bequeathed by Miss M. J. Dobson, 1905

Carmichael, John Wilson 1800–1868, *Seascape, Recollection of Turner*, bequeathed by Miss M. J. Dobson, 1905

Carmichael, John Wilson 1800–1868, *Off the Yorkshire Coast, Staithes*, bequeathed by Conrad White, 1905

Carmichael, John Wilson 1800–1868, *Off North Shields*, bequeathed by William Wilson, 1955

Carmichael, John Wilson 1800–1868, *Off Redcar*, bequeathed by Conrad White, 1905

Carmichael, John Wilson 1800–1868, *Tynemouth from Cullercoats*, gift from A. Laws, 1936

Carmichael, John Wilson (attributed to) 1800–1868, *After a Storm*, bequeathed by Mr M. V. Mulcaster, 1930

Carmichael, John Wilson (attributed to) 1800–1868, *Dutch Galliots off the Coast*, gift from Daniels and Coltman, 1941

Carmichael, John Wilson (attributed to) 1800–1868, *Seascape with Wreckage*, bequeathed by Miss M. J. Dobson, 1905

Carmichael, John Wilson (attributed to) 1800–1868, *The 'Elswick' off Tynemouth*, on loan from a private lender, since 1936

Carpentero, Henri Joseph Gommarus 1820–1874, *Dutch Market Scene*, bequeathed by William Wilson, 1955

Carr, Henry Marvell 1894–1970, *Sister Edna Morris, Queen Alexandra's Imperial Military Nursing Service*, gift from the War Artists Advisory Committee, 1947

Carrick, Thomas (attributed to) 1802–1874 & **Richardson, Thomas Miles I (attributed to)** 1784–1848 *Richmond, Yorkshire*, bequeathed by Reverend C. H. Steel, 1951

Carse, Andreas Duncan 1876–1938, *Roses*, gift from Mrs A. Duncan Carse, 1939

Carter, Eva I. 1870–1963, *Portrait of the Artist's Mother*, gift from Graeme Dory, 1975

Carter, Frank Thomas 1853–1934, *Eel Crag, Borrowdale*, gift from Mrs W. Robson, 1953

Carter, Frank Thomas 1853–1934, *Lake District*, gift from Mrs Bradford, 1940

Carter, Frank Thomas 1853–1934, *Landscape with Hills*, untraced find, first recorded, 1981

Carter, Frank Thomas 1853–1934, *Sunset, Lake Scene*, untraced find, recorded, 1975

Carter, Frank Thomas 1853–1934, *Sunset, Rocky Stream*, untraced find, recorded, 1975

Carter, Frank Thomas 1853–1934, *Whitley Bay*, gift from Reverend William Wakinshaw, 1938

Catterns, Edward Railton active 1876–1907, *Beech Avenue, Inverary*, gift from Alex MacRae, 1954

Caullery, Louis de before 1582–after 1621, *The Escorial, near Madrid, Spain*, bequeathed by John George Joicey, 1919

Chalmers, J. *Dunloskin, Argyll and Bute*, gift from Alex MacRae, 1954

Chalon, Henry Bernard 1770–1849, *Study of a King Charles Spaniel*, gift from Edwin Hitchon, 1948

Chapman, William 1817–1879, *Portrait of a Man*, untraced find, recorded, 1982

Charlton, John 1849–1917, *The Huntsman*, gift from Sir Alfred Molyneux Palmer, 1920

Charlton, John 1849–1917, *The Women*, bequeathed by the artist, 1917

Charlton, John 1849–1917, *French Artillery Crossing the Flooded Aisne and Saving the Guns*, gift from Dr Harrison and Mrs G. Harrison, 1951

Charlton, William Henry 1846–1918, *Whitby*, bequeathed by Ralph Atkinson, 1909

Charlton, William Henry 1846–1918, *Collie Dog*, untraced find, recorded, 1982

Cina, Colin b.1943, *MH/20*, purchased from the artist with the assistance of the Friends of the Laing Art Gallery, 1972

Clark, James 1858–1943, *Church at Montreuil-sur-Mer*, gift from the artist, 1935, © the artist's estate/ www.bridgeman.co.uk

Clark, James 1858–1943, *The Artist's Studio*, gift from the artist, 1935, © the artist's estate/www. bridgeman.co.uk

Clark, Joseph 1835–1913, *The Return of the Runaway*, gift from Miss Wilson, 1940

Clausen, George 1852–1944, *Contemplation*, gift from Colonel Arnold Irwin, 1952, © Clausen estate

Clausen, George 1852–1944, *The Stone Pickers*, purchased from J. Staats Forbes, 1907, © Clausen estate

Clausen, George 1852–1944, *Dusk*, gift from John Heaton, 1915, © Clausen estate

Clay, Rachel b.1907, *Beatrice Webb, née Potter (1858–1943)*, gift from the artist, 1968

Clennell, Luke 1781–1840, *The Baggage Wagon*, purchased from Ernest Thompson, 1945

Coessin de la Fosse, Charles-Alexandre 1829–c.1900, *Threshing*, gift from Dorothy Una McGrigor Phillips, 1938

Cole, George 1808–1883, *Landscape with Figures*, gift from Edwin Turnbull, 1904

Cole, George 1808–1883, *Landscape*, gift from the Reverend W. T. Hunter, 1940

Cole, George Vicat 1833–1893, *Landscape with Cottage and Figures*, bequeathed by John Lamb, 1909

Cole, George Vicat 1833–1893, *Landscape with Figure and Dog*, bequeathed by John Lamb, 1909

Cole, Leslie 1910–1976, *The Shaping of the Keel Plate of a Corvette*, gift from the War Artists Advisory Committee, 1947, on loan to Gerrard Ltd, Newcastle upon Tyne

Colley, Andrew 1859–1910, *Venetian Embroidery Makers*, gift from Mrs Andrew Colley, 1940

Collier, John 1850–1934, *Lady Laing (1831–1913)*, on loan from the Sunderland Shipbuilders

Collier, John 1850–1934, *Sir James Laing (1823–1901)*, on loan from the Sunderland Shipbuilders

Compton, Edward Harrison 1881–1960, *Cape Zafferano, Sicily*, gift from George E. Henderson, 1927

Connard, Philip 1875–1958, *Fanny Fillipi Dowson*, gift from Miss M. Taylor, 1953

Connell, William active 1871–1925, *Seascape off Tynemouth*, gift from Mrs I. Watson, 1951

Constable, John (after) 1776–1837, *Salisbury Cathedral from the Bishop's Grounds*, gift from F. J. Nettlefold, 1947

Cooper, Julian b.1947, *Autumn*, purchased from the artist, 1975, © the artist

Cooper, Thomas George 1836–1901, *In the Marshes near Ramsgate, Isle of Thanet*, gift from Sir G. B. Hunter, 1937

Cooper, Thomas Sidney 1803–1902, *Canterbury from Tonford*, gift from Colonel Lord Joicey, DSO, 1946

Cooper, Thomas Sidney 1803–1902, *On the Downs*, bequeathed by John George Joicey, 1919

Cooper, Thomas Sidney 1803–1902, *Midday Repose*, bequeathed by John George Joicey, 1919

Cooper, Thomas Sidney (after) 1803–1902, *Cattle and Sheep*, bequeathed by John Lamb, 1909

Cooper, Thomas Sidney (after) 1803–1902, *Landscape with Cattle in Marshland*, gift from Miss Elsie Wright, 1964

Cornish, Norman Stansfield b.1919, *Wet Friday*, purchased from the Stone Gallery with the assistance of the Friends of the Laing Art Gallery, 1976

Cornish, Norman Stansfield b.1919, *Pit Road*, purchased from the Stone Gallery, 1960

Corvan, Ned 1829–1865, *Billy Purvis Stealing the Bundle*, bequeathed by A. J. Fenwick, 1963

Coulter, Robert G. active 1953, *Tubwell Row, Darlington*, purchased from the artist, 1953

Cowen, Lionel J. b.c.1847, *Girl with a Letter*, gift from J. Brown, 1955

Cox, David the elder 1783–1859,

Circus Ponies in Stalls, bequeathed by A. J. Fenwick, 1963

Gainsborough, Thomas 1727–1788, *Peasant Ploughing with Two Horses*, purchased from the Honourable Mrs Sarah Dreverman with the assistance of the Heritage Lottery Fund, the Resource/Victoria and Albert Museum Purchase Grant Fund, the Friends of the Laing Art Gallery, and the John Wigham Richardson Bequest, 2003

Garvie, Thomas Bowman 1859–1944, *By the Waters of Babylon*, gift from Mrs I. W. Dick, 1939

Garvie, Thomas Bowman 1859–1944, *The Parish Clerk of Lyndon*, gift from the Reverend W. T. Hunter, 1940

Garvie, Thomas Bowman 1859–1944, *Olives of St Rocco*, gift from Colin D. Currie, 1956

Garvie, Thomas Bowman 1859–1944, *The Twins (Winifred and Leonora Reid, b.1911)*, bequeathed by Mrs Reid, 1936

Garvie, Thomas Bowman 1859–1944, *Henry Bell Saint*, gift from the Northumberland and Tyneside Council for Social Services, 1975

Garvie, Thomas Bowman 1859–1944, *Alderman George Bargate Bainbridge, JP*, gift from George Bainbridge, VM, 1974

Garvie, Thomas Bowman 1859–1944, *An October Flood, Ludlow, Shropshire*, gift from Jasper Salwey, 1939

Gates, Sebastian active 1904–1937, *Spoils of the Orchard*, gift from the artist, 1937

Gauguin, Paul 1848–1903, *The Breton Shepherdess*, gift from the National Art Collections Fund, 1945

Gauld, John Richardson 1885–1961, *Resting Model*, purchased from the artist, 1942

Gear, William 1915–1997, *Autumn Landscape*, gift from the Arts Council of Great Britain, 1952, © the artist's estate

Gear, William 1915–1997, *Composition printanier*, gift from the Contemporary Art Society, 1952, © the artist's estate

George, Charles 1872–1937, *Seascape with Ship*, gift from Edward George, 1947

Gertler, Mark 1892–1939, *Thomas Balston (1883–1967)*, gift from the National Art Collections Fund, 1968, © by permission of Luke Gertler

Gibb, Thomas Henry 1833–1893, *Summertime on the Cheviots*, gift from Miss Wilson, 1940

Gibb, Thomas Henry 1833–1893, *Highland Loch with Stag*, untraced find, recorded, 1982

Gibb, Thomas Henry 1833–1893, *On Tarras Moss*, gift from Miss Wilson, 1940

Gillie, Ann 1906–1995, *The Riverside*, purchased from the artist, 1960, © sons of Ann Gillie

Gillie, Ann 1906–1995, *Icelandic*

Theme, gift from the artist, 1963, © sons of Ann Gillie

Gillie, Ann 1906–1995, *Seawrack*, gift from Mrs Helen Hacking, 1989, © sons of Ann Gillie

Gillies, William George 1898–1973, *Still Life with Yellow Flowers*, purchased from Aitken Dott & Son, 1958, © the artist's estate

Gilmour, Elaine 1931–1990, *Shrubs*, purchased from the artist, 1960

Gilroy, John Thomas Young 1898–1985, *Sir T. Oliver, Tyneside Scottish*, untraced find, recorded, 1982, © the artist's estate

Gilroy, John William 1868–1944, *Hauling up the Lifeboat, Holy Island, Northumberland*, gift from W. H. Ord, 1956, © the artist's estate

Gleghorn, Thomas b.1925, *Home Town*, purchased from the Stone Gallery, 1963, © the artist

Glover, Flora A. P. *The Flood*, purchased from the artist, 1941

Glover, Kenneth M. 1887–1966, *On the Tyne*, gift from J. Leigh Turner, 1935

Goede, Jules de 1937–2007, *Outer Space*, gift from the Contemporary Art Society, 1972, © Jules de Goede estate

Good, Thomas Sword 1789–1872, *A Northumbrian Farmer*, bequeathed by John Lamb, 1909

Good, Thomas Sword 1789–1872, *The Expected Penny*, gift from Ralph Atkinson, 1908

Good, Thomas Sword 1789–1872, *Examining the Sword*, bequeathed by John Lamb, 1909

Good, Thomas Sword 1789–1872, *The Power of Music*, bequeathed by William Wilson, 1955

Good, Thomas Sword 1789–1872, *Portrait of an Old Man*, purchased from J. A. H. Sanderson, 1944

Goodall, Frederick 1822–1904, *Merrymaking*, bequeathed by George E. Henderson, 1937

Goodwin, Albert 1845–1932, *Wells Cathedral*, bequeathed by George E. Henderson, 1937

Goodwin, Albert 1845–1932, *Durham Cathedral*, bequeathed by George E. Henderson, 1937

Gosse, Laura Sylvia 1881–1968, *Dieppe, la Place Nationale*, gift from the Contemporary Art Society, 1935, © the artist's estate/www.bridgeman.co.uk

Gotch, Thomas Cooper 1854–1931, *Holy Motherhood*, purchased from the artist, 1910

Gow, Andrew Carrick 1848–1920, *Mrs William Glover*, untraced find, recorded, 1982

Gow, Andrew Carrick 1848–1920, *The Haycart*, gift from William Glover, 1911

Gow, Andrew Carrick 1848–1920, *William Glover*, untraced find, recorded, 1982

Gow, Andrew Carrick (after) 1848–1920, *The Judgement of Paris* (after Peter Paul Rubens), gift from William Glover, 1911

Gowing, Lawrence 1918–1991, *Briar and Hawthorn at Savernake*, purchased from the artist, 1956, © estate of Sir Lawrence Gowing

Graham, Anthony 1828–1908, *Landscape with Sheep*, untraced find, recorded, 1981

Graham, Peter 1836–1921, *Landscape with Cattle*, gift from H. E. Joicey, 1937

Grant, Duncan 1885–1978, *The Hammock*, gift from the Contemporary Art Society, 1935, © 1978 estate of Duncan Grant

Grant, Duncan 1885–1978, *Provençal Landscape*, purchased from Stephen Dickinson with the assistance of the Victoria and Albert Museum Purchase Grant Fund, 1976, © 1978 estate of Duncan Grant

Grant, Duncan 1885–1978, *Roses in a Vase*, bequeathed by W. Graham, 1983, © 1978 estate of Duncan Grant

Gray, George 1758–1819, *Thomas Bewick (1753–1828)*, purchased from Mrs C. L. Bewick, 1959

Gray, George 1758–1819, *Study of Fruit*, gift from Mrs M. H. Webster, 1935

Gray, George 1758–1819, *Study of Fruit with Squirrel*, gift from Miss M. E. Robinson, 1931

Greaves, Walter (attributed to) 1846–1930, *Strand*, gift from R. Weatherby, 1957

Greenberg, Mabel 1889–1933, *Helen*, purchased from the Redfern Gallery, 1931

Grimshaw, Arthur E. 1868–1913, *The Quayside, Newcastle upon Tyne*, gift from T. F. Liddell, 1952

Grimshaw, John Atkinson 1836–1893, *Under the Beeches*, anonymous gift, 1971

Grimshaw, Louis Hubbard 1870–1944, *Grainger Street, Newcastle upon Tyne*, purchased from Christopher Wood, 1978

Grimshaw, Louis Hubbard 1870–1944, *St Nicholas Street, Newcastle upon Tyne*, purchased from Christopher Wood, 1978

Grundy, Cuthbert Cartwright 1846–1946, *Plas Mawr, Conwy, North Wales*, gift from the artist, 1928

Guthrie, James 1859–1930, *Thomas Bewick (1753–1828)* (after Thomas Sword Good), gift from Mrs H. S. Greene, recorded, 1973

Gwynne-Jones, Allan 1892–1982, *The Unshaved Man*, gift from the Contemporary Art Society, 1927, © the artist's estate/www.bridgeman.co.uk

Hacking, Helen active late 20th C, *The Director*, gift from Margery Stevenson, 1986

Haddock, Aldridge 1931–1996, *Merces*, gift from the artist, 1970

Hage, Matthijs 1882–1961, *Mother's Darling*, gift from Mrs W. B. Paterson, 1951

Hair, Thomas H. 1810–1882, *Ship 'Mary'*, gift from Colin D. Currie, 1953

Haité, George Charles 1855–1919/1924, *The City of Tangier*, bequeathed by John Lamb, 1909

Halfnight, Richard William 1855–1925, *River Landscape*, gift from W. C. H. Oliver, 1937

Hall, Frederick 1860–1948, *The Duck Pond*, gift from Samuel Smith, JP, 1930, © the artist's estate/www.bridgeman.co.uk

Hall, Frederick 1860–1948, *Sir Lothian Bell (1816–1904)*, on loan from the City of Newcastle upon Tyne, 1955, © the artist's estate/www.bridgeman.co.uk

Hall, Harry (attributed to) 1814–1882, *'Bee's Wing'*, bequeathed by Miss Helen May Ord, 1962

Hall, Oliver 1869–1957, *Alcántara Bridge, Toledo, Spain*, gift from the Walker Mechanics Institute, 1942, © the artist's estate

Hamer, Cheryl b.1952, *La Belle*, purchased from the artist, 1989

Hankey, William Lee 1869–1952, *Dordrecht, Holland*, gift from the London and North Eastern Railway Advertising Department, 1935

Hankey, William Lee 1869–1952, *Butter Market, Concarneau*, purchased from the artist, 1939

Hardie, Charles Martin 1858–1916, *Touchstone and Audrey*, gift from Colin D. Currie, 1953

Hardy, Heywood 1843–1933, *Squire and Daughter*, gift from Ralph Atkinson, 1908

Hardy, Thomas Bush 1842–1897, *Towing Boats out of Calais*, bequeathed by John Lamb, 1909

Hart, Solomon Alexander 1806–1881, *Athaliah's Dismay at the Coronation of Joash*, gift from John H. Dunn, 1906

Hatton, Richard George 1865–1926, *Jarrow Slake*, purchased from Mrs Mitchell, 1926

Haughton, Benjamin 1865–1924, *Landscape with Haystacks*, gift from Mrs J. M. Haughton, 1937

Haughton, Moses the elder 1734–1804, *Fish*, gift from Edwin Hitchon, 1948

Hawthorne, Elwin 1905–1954, *At the Edge of Epping, Essex*, gift from the Contemporary Art Society, 1931

Haydon, Benjamin Robert 1786–1846, *Shall I Resign?*, gift from the National Art Collections Fund, 1941

Hayes, Edwin 1819–1904, *Dutch Pinks*, gift from George E. Henderson, 1912

Hayes, Edwin 1819–1904, *Rough Passage*, gift from George E. Henderson, 1934

Hayman, Francis c.1708–1776, *William Ellis (1707–1771), and His Daughter Elizabeth (1740–1795)*, gift from Leggatt Brothers, 1959

Hedley, Ralph 1848–1913, *Blinking in the Sun*, purchased from C. O. Pattison, 1970

Hedley, Ralph 1848–1913, *John Graham Lough in His Studio*, purchased from Christie's, 1987

Hedley, Ralph 1848–1913, *Portrait of an Old Woman*, gift from the City of Newcastle upon Tyne Library, 1972

Hedley, Ralph 1848–1913, *Proclaiming Stagshaw Fair at Corbridge, Northumberland*, gift from Mrs Zara Laing, 1950

Hedley, Ralph 1848–1913, *In School*, gift from Farquhar M. Laing, 1931

Hedley, Ralph 1848–1913, *The Ballad Seller, the Black Gate*, gift from C. D. Currie, 1953

Hedley, Ralph 1848–1913, *Last in Market*, gift from Mrs S. S. Simms, 1935

Hedley, Ralph 1848–1913, *Shoeing the Bay Mare*, gift from Mrs S. S. Simms, 1935

Hedley, Ralph 1848–1913, *A. B. C.*, gift from S. Hepworth, 1939

Hedley, Ralph 1848–1913, *Home Lessons*, gift from Mrs Marion Ross, 1944

Hedley, Ralph 1848–1913, *Going Home*, gift from Miss Ellen Bicknell, 1985

Hedley, Ralph 1848–1913, *Preparing for Market*, gift from Charles Dennis Hill, 1939

Hedley, Ralph 1848–1913, *Geordie Haa'd the Bairn*, untraced find, recorded, 1972

Hedley, Ralph 1848–1913, *Sketch for 'Seeking Sanctuary'*, gift from Reginald E. Baty, 1945

Hedley, Ralph 1848–1913, *Barge Day*, bequeathed by Julian Brown, 2006

Hedley, Ralph 1848–1913, *Sketch for 'The Lord Mayor's Barge'*, gift from Reginald E. Baty, 1945

Hedley, Ralph 1848–1913, *A Girl in Costume Knitting*, gift from Mrs Cora MacDonald, 1984

Hedley, Ralph 1848–1913, *The Old Kitchen*, gift from Miss Wilson, 1940

Hedley, Ralph 1848–1913, *Roses for the Invalid*, gift from Mrs Florence Bradford, 1940

Hedley, Ralph 1848–1913, *Henry Hetherington Emmerson (1831–1895)*, gift from Mrs E. J. de Bourier, 1941

Hedley, Ralph 1848–1913, *Meal Time*, gift from Miss Wilson, 1940

Hedley, Ralph 1848–1913, *Self Portrait*, bequeathed by W. Parker Brewis, 1940

Hedley, Ralph 1848–1913, *Barred Out (29 May)*, gift from Colonel T. A. Higginbottom, 1933

Hedley, Ralph 1848–1913, *Passing the Doctor*, gift from Andrew Nichol Dodds, 1917

Hedley, Ralph 1848–1913, *The Veteran*, gift from the Walker Mechanics Institute, 1942

Hedley, Ralph 1848–1913, *Woodsawyers*, gift from Miss Wilson, 1940

Hedley, Ralph 1848–1913, *Blind Beggar*, purchased from Mrs Gowdy, 1976

Hedley, Ralph 1848–1913, *Sharpening the Scythe*, gift from

Miss Wilson, 1940
Hedley, Ralph 1848–1913, *Paddy's Clothes Market, Sandgate*, purchased from the artist, 1911
Hedley, Ralph 1848–1913, *The Monitor*, gift from Mrs Niederhaussen, 1941
Hedley, Ralph 1848–1913, *The Winnowing Sheet*, gift from the artist's estate, 1938
Hedley, Ralph 1848–1913, *The Threshing Floor*, gift from Miss Wilson, 1940
Hedley, Ralph 1848–1913, *Threshing the Gleanings*, gift from J. T. Steel, 1923
Hedley, Ralph 1848–1913, *Alderman Sir H. W. Newton, JP*, gift from Alderman Sir H. W. Newton, 1904
Hedley, Ralph 1848–1913, *Elsie Wright*, gift from Miss Elsie Wright, 1964
Hedley, Ralph 1848–1913, *Mittens*, gift from Mrs Rowell, 1952
Hedley, Ralph 1848–1913, *Kept In*, bequeathed by Mrs Gibson, 1938
Hedley, Ralph 1848–1913, *The Sail Loft*, gift from Miss Wilson, 1940
Hedley, Ralph 1848–1913, *The Cobbler's Shop*, gift from J. Brown, 1955
Hedley, Ralph 1848–1913, *The Old Curiosity Shop*, gift from Mrs Marion Ross, 1944, on loan to the Civic Centre, Newcastle upon Tyne
Hedley, Ralph 1848–1913, *Crossing Hylton Ferry*, gift from Mrs Fenwick, 1955
Hedley, Ralph 1848–1913, *The Village School*, gift from Mrs S. S. Simms, 1935
Hedley, Ralph 1848–1913, *Old Woman Ironing*, gift from Miss Wilson, 1940
Hedley, Ralph (after) 1848–1913, *Geordie Haa'd the Bairn*, on loan from a private lender
Hemy, Bernard Benedict 1845–1913, *Seascape*, gift from Elsie Mona Findlay, 1951
Hemy, Bernard Benedict 1845–1913, *Seascape, Mouth of the Tyne*, gift from Elsie Mona Findlay, 1951
Hemy, Bernard Benedict 1845–1913, *Seascape*, gift from Mrs I. Watson, 1951
Hemy, Charles Napier 1841–1917, *Wreck of a Frigate on the Southern Coast of Spain*, bequeathed by John Lamb, 1909
Hemy, Charles Napier 1841–1917, *Under the Breakwater*, purchased from an anonymous vendor, with the assistance of the Victoria and Albert Museum Purchase Grant Fund, 1982
Hemy, Charles Napier 1841–1917, *Among the Shingle at Clovelly, North Devon*, purchased from Mrs Charlotte Frank with the assistance of the National Art Collections Fund, the Victoria and Albert Museum Purchase Grant Fund and the Pilgrim Trust, 1976
Hemy, Charles Napier 1841–1917, *Ruins of a Northumbrian Keep*, gift from Councillor F. E. Weightman,

1913
Hemy, Charles Napier 1841–1917, *Sunset Shadows*, bequeathed by William Wilson, 1955
Hemy, Charles Napier 1841–1917, *Porpoises Chasing Mackerel*, gift from Mrs Charles Napier Hemy, 1934
Hemy, Charles Napier 1841–1917, *Redbridge, Southampton*, bequeathed by Miss N. Johnstone Wallace, 1950
Hemy, Charles Napier 1841–1917, *Study for 'Pilchards'*, gift from Mrs Charles Napier Hemy, 1935
Hemy, Charles Napier 1841–1917, *Sea Study at Portscatho, Cornwall*, bequeathed by Mrs Mary Ann Williams, 1955
Hemy, Charles Napier 1841–1917, *Study of a Boat*, gift from Mrs Charles Napier Hemy, 1918
Hemy, Charles Napier 1841–1917, *Study of a Boat*, gift from Mrs Charles Napier Hemy, 1918
Hemy, Charles Napier 1841–1917, *Study of a Dinghy*, gift from Mrs Charles Napier Hemy, 1921
Hemy, Charles Napier 1841–1917, *Through Sea and Air*, purchased from the artist, 1912
Hemy, Charles Napier 1841–1917, *Hauling in Lobster Pots*, gift from Mrs Charles Napier Hemy, 1935
Hemy, Charles Napier 1841–1917, *Lobster Pot*, gift from Mrs Charles Napier Hemy, 1935
Hemy, Charles Napier 1841–1917, *Seascape with a Tug*, gift from Mrs Charles Napier Hemy, 1921
Hemy, Charles Napier 1841–1917, *Study in a Harbour*, gift from Mrs Charles Napier Hemy, 1921
Hemy, Charles Napier 1841–1917, *Study of a Sailing Dinghy*, gift from Mrs Charles Napier Hemy, 1921
Hemy, Charles Napier 1841–1917, *Trees*, gift from Mrs Charles Napier Hemy, 1935
Hemy, Thomas Marie Madawaska 1852–1937, *Women and Children First*, on loan from a private lender
Henderson, Nigel 1917–1985, *Face at the Window I*, gift from the Contemporary Art Society, 1980, © the Henderson estate
Henry, George F. 1858–1943, *Lady Margaret Sackville (1881–1963)*, gift from the artist, on loan to Lumley Castle, Chester-le-Street, County Durham, 1945
Henzell, Isaac 1815–1876, *Landscape with Figures*, bequeathed by John Lamb, 1909
Hepper, George 1839–1868, *Self Portrait (?)*, gift from V. M. Culverwell, 1986
Hepper, George 1839–1868, *Sheep on a Cliff's Edge*, gift from Mrs Joseph Hepper, 1936
Hering, George Edwards 1805–1879, *Near Arona, Lago Maggiore*, gift from Viscount Ridley, 1908
Herring, John Frederick I 1795–1865, *Horses in a Farmyard*, gift from George E. Henderson, 1934
Hesketh, Richard 1867–1919, *In Borrowdale, Cumbria*, untraced

find, recorded, 1975, on loan to Lumley Castle, Chester-le-Street, County Durham
Hesketh, Richard 1867–1919, *Upper Eskdale, Cumbria*, untraced find, recorded, 1975, on loan to Lumley Castle, Chester-le-Street, County Durham
Highmore, Joseph (attributed to) 1692–1780, *Portrait of a Man*, purchased from T. M. Miller, 1966
Hill, Rowland Henry 1873–1952, *The Primrose Gatherers*, purchased from the artist, 1936, © the artist's estate
Hill, William Robert active 1830–1884, *Portrait of a Man Seated*, gift from the City of Newcastle upon Tyne Library, 1972
Hilton, William II 1786–1839, *Cupid Disarmed*, gift from Miss M. Bowman and Mrs Warburton, 1936
Hirst, Derek 1930–2006, *Shangri-La Number III*, gift from the Contemporary Art Society, 1965, © the artist's estate
Hitchens, Ivon 1893–1979, *Terwick Mill, No.7, Splashing Fall*, purchased from Brown and Phillips Ltd, with the assistance of the Victoria and Albert Museum Purchase Grant Fund, 1959, © Ivon Hitchens' estate/Jonathan Clark & Co.
Hodgson, John Evan 1831–1895, *Chinese Ladies Looking at European Curiosities*, gift from Ralph Atkinson, 1908
Hodgson, Louisa 1905–1980, *The Collingwood Monument, Tynemouth, Trafalgar Night*, purchased from the trustees of Louisa Hodgson, 1981
Hodgson, Louisa 1905–1980, *Corpus Christi Day in Newcastle upon Tyne, c.1450 (The Shipwright's Guild)*, purchased from the artist, 1934
Hornel, Edward Atkinson 1864–1933, *Leisure Moments*, gift from Sir William Burrell, 1944
Hornel, Edward Atkinson 1864–1933, *The Little Mushroom Gatherers*, purchased from the Fine Art Society, 1915
Howe, Ralph active early 19th C, *James Howe*, gift from Mrs A. Weipers, 1952
Hubbard, Eric Hesketh 1892–1957, *Big Top with Caravans*, bequeathed by A. J. Fenwick, 1963
Hudson, Thomas 1701–1779, *Anne, Countess of Northampton (d.1763)*, gift from the Northern Art Collections Fund, 1951
Hughes, Arthur 1832–1915, *Mrs Leathart and Her Three Children*, purchased from the estate of Mrs Margaret Mele with the assistance of the Heritage Lottery Fund, the Museums and Galleries Commission/Victoria and Albert Museum Purchase Grant Fund, the National Art Collections Fund and the Friends of the Laing Art Gallery, 1998
Hughes, Arthur 1832–1915, *The*

Potter's Courtship, gift from Miss Dorothea Richardson, 1938
Hughes-Stanton, Herbert Edwin Pelham 1870–1937, *Welsh Hills near Barmouth*, purchased from the Fine Art Society, 1918
Hulme, Frederick William 1816–1884, *Woodland Scene*, gift from Miss Elsie Wright, 1964, on loan to Lumley Castle, Chester-le-Street, County Durham
Hunt, Alfred William 1830–1896, *Wasdale Head from Styhead Pass, Cumbria*, gift from Mrs M. A. Cooper, 1952
Hunt, Alfred William 1830–1896, *A North Country Stream*, on loan from Miss Wilkinson
Hunt, E. Aubrey 1855–1922, *River Scene with Shipping*, gift from Mrs G. B. Graham, 1950
Hunt, William Holman 1827–1910, *Isabella and the Pot of Basil*, gift from Dr Wilfred Hall, 1952
Jack, Richard 1866–1952, *Anglesey, Wales*, gift from George E. Henderson, 1934, © the artist's estate
Jackson, F. active 19th C, *View of the Tyne, the Ferry*, gift from William Jackson, 1937
Jackson, F. active 19th C, *View of the Tyne, Two Anglers*, gift from William Jackson, 1937
James, Louis 1920–1996, *The Entrance*, purchased from the Stone Gallery, 1963, © DACS 2008
Jamieson, Alexander 1873–1937, *The Gardens, Versailles*, purchased from Mrs Jamieson, 1939
Jobling, Isabella 1851–1926, *Fisherfolk*, purchased from Marshall Hall with the assistance of the Victoria and Albert Museum Purchase Grant Fund and the National Art Collections Fund, 1993
Jobling, Robert 1841–1923, *The Lifeboat Off*, gift from Mrs R. Robson, 1931
Jobling, Robert 1841–1923, *Sea Fret*, gift from Mrs R. Robson, 1931
Jobling, Robert 1841–1923, *Darkness Falls from the Wings of Night*, gift from Mrs R. Robson, 1931
Jobling, Robert 1841–1923, *Hauling the Boats*, bequeathed by John Lamb, 1909
Jobling, Robert 1841–1923, *Launching the Cullercoats Lifeboat*, gift from Mrs Darnell, 1947
Jobling, Robert 1841–1923, *Self Portrait*, gift from G. N. Elliott, 1942
Jobling, Robert 1841–1923, *Moonlight, Tynemouth Priory*, purchased from the artist, 1923
Jobling, Robert 1841–1923, *Anxious Times*, gift from Mrs J. Carrington, 1974
Jobling, Robert 1841–1923, *Pleasant Times*, gift from Mrs J. Carrington, 1974
Jobling, Robert 1841–1923, *Harbour Scene with Fishermen*, untraced find, recorded, 1982
John, Augustus Edwin 1878–1961,

The White Feather Boa (Lady Elizabeth Asquith, 1897–1945), purchased from the Redfern Gallery, 1953, © the artist's estate/ www.bridgeman.co.uk
John, Augustus Edwin 1878–1961, *Two Gitanas (Two Romany Women)*, purchased from Arthur Tooth and Sons Ltd, 1953, © the artist's estate/www.bridgeman. co.uk
Johnson, Nerys Ann 1942–2001, *Untitled, Grey, Green, Blue and Black*, gift from the estate of the artist, 2002, © the artist's estate
Jopling, Louise 1843–1933, *J. M. Jopling (1831–1884)*, gift from L. M. Jopling, 1935
Joseph, Peter b.1929, *Composition*, gift from the Contemporary Art Society, 1968, © the artist
Jowett, Percy Hague 1882–1955, *Cider Press Farm, Llantarnam, Wales*, gift from 'Northman', 1938, © the artist's estate
Kent, Anna Sophia d.1959, *The Ploughman*, gift from Mrs E. A. Kent, 1959
Kidd, William 1790–1863, *The Army*, bequeathed by John George Joicey, 1919
Kidd, William 1790–1863, *The Navy*, bequeathed by John George Joicey, 1919
Kiddier, William 1859–1934, *The Bridge*, gift from the artist, 1928
Kiddier, William 1859–1934, *Windmill and Dyke*, bequeathed by Alice Kiddier, 1969
Kilbourn, Oliver 1904–1993, *End of Shift*, gift from the artist, 1941, © the artist's estate
King, Haynes 1831–1904, *Mother and Child*, bequeathed by William Wilson, 1955
Kitaj, R. B. 1932–2007, *Germania: To the Brothel*, purchased from Marlborough Fine Art Ltd, with the assistance of the National Art Collections Fund and the Victoria and Albert Museum Purchase Grant Fund, 1988, © the artist's estate
Knell, William Adolphus 1802–1875, *Seascape with Boats*, bequeathed by John Lamb, 1909, on loan to the Matfen Hall Hotel, Hexham, Northumberland
Knight, Harold 1874–1961, *In the Spring Time*, purchased from the artist, 1910, © reproduced with permission of the estate of Dame Laura Knight, DBE, RA, 2008. All rights reserved
Knight, Harold 1874–1961, *The Bathing Pool*, gift from George E. Henderson, 1925, © reproduced with permission of the estate of Dame Laura Knight, DBE, RA, 2008. All rights reserved
Knight, Harold 1874–1961, *The Seamstress*, bequeathed by Sir Angus Watson, 1961, © reproduced with permission of the estate of Dame Laura Knight, DBE, RA, 2008. All rights reserved
Knight, Harold 1874–1961, *At the Piano*, bequeathed by Sir Angus

Watson, 1961, © reproduced with permission of the estate of Dame Laura Knight, DBE, RA, 2008. All rights reserved

Knight, John William Buxton 1842/1843–1908, *On the Medway, Breezy March*, purchased from T. R. Smith, 1910, on loan to the Matfen Hall Hotel, Hexham, Northumberland

Knight, Laura 1877–1970, *A Dark Pool*, bequeathed by Sir Angus Watson, 1961, © reproduced with permission of the estate of Dame Laura Knight, DBE, RA, 2008. All rights reserved

Knight, Laura 1877–1970, *The Beach*, purchased from H. W. Brooks, 1919, © reproduced with permission of the estate of Dame Laura Knight, DBE, RA, 2008. All rights reserved

Knight, Laura 1877–1970, *The Fair*, purchased, 1925, © reproduced with permission of the estate of Dame Laura Knight, DBE, RA, 2008. All rights reserved

Knight, William 1872–1958, *Landscape with Haystack*, purchased from Mrs M. Deaper, 1975

Koninck, Salomon (attributed to) 1609–1656, *A Philosopher*, gift from Mr Goldson, 1923

Kops, Franz 1846–1896, *Henry Straker*, gift from Mrs Straker, 1943

Koster, Jo (after) 1869–1944, *Joseph Skipsey (1832–1903)*, gift from the Walker Mechanics Institute, 1942

La Thangue, Henry Herbert 1859–1929, *Gathering Bracken*, gift from Sir John D. Milburn, 1905

Lambart, Alfred 1902–1970, *Juliet, Daughter of Richard H. Fox of Surrey*, gift from Mrs Juliet Fox Hutchinson, 1980

Landau, Dorothea 1881–1941, *Lady with Fruit (Gladys Holman Hunt, b.1878)*, gift from Mrs Judy Manby, 1948, © the artist's estate

Landau, Dorothea 1881–1941, *Bohémienne*, gift from Mrs Judy Manby, 1948, © the artist's estate

Landseer, Edwin Henry 1802–1873, *The Otter Speared, the Earl of Aberdeen's Otterhounds*, gift from Lord Joicey, 1924

Landseer, Edwin Henry 1802–1873, *Deer of Chillingham Park, Northumberland*, gift from H. M. Treasury, 1975

Landseer, Edwin Henry 1802–1873, *Wild Cattle of Chillingham, Northumberland*, gift from H. M. Treasury, 1975

Langley, William active 1880–1920, *Loch Etive, Argyll and Bute*, gift from Miss Wilson, 1932

Lavery, John 1856–1941, *Hazel in Black and Gold*, gift from Councillor A. M. Sutherland, 1916, © the estate of Sir John Lavery by courtesy of Felix Rosenstiel's Widow & Son Ltd

Lawrence, Alfred Kingsley 1893–1975, *The Building of Hadrian's Bridge (Pons Aelii) over the Tyne,*

c.122 AD (study for a lunette decoration), gift from Mrs M. H. Webster, 1935

Lawrence, Alfred Kingsley 1893–1975, *The Building of Hadrian's Bridge (Pons Aelii) over the Tyne, c.122 AD*, purchased from the artist, 1925

Lawrence, Thomas 1769–1830, *Mrs Littleton (1789–1846)*, purchased from the Leger Galleries, 1959

Lawrence, Thomas (after) 1769–1830, *The Duke of Wellington (1769–1852)*, untraced find, recorded, 1983

Leader, Benjamin Williams 1831–1923, *Igtham Mote, Kent*, bequeathed by John Lamb, 1909

Leader, Benjamin Williams 1831–1923, *Goring-on-Thames, Oxfordshire*, bequeathed by John Lamb, 1909

Leader, Benjamin Williams 1831–1923, *Landscape*, bequeathed by George E. Henderson, 1937

Legros, Alphonse 1837–1911, *Landscape*, gift from Walter John James, 1920

Lehmann, Rudolph 1819–1905, *Dr Collingwood Bruce (1805–1892)*, gift from J. C. Collingwood Bruce, 1948, on loan to Lumley Castle, County Durham

Leighton, Edmund Blair 1852–1922, *Market Day*, bequeathed by John George Joicey, 1919

Leighton, Edmund Blair 1852–1922, *September*, bequeathed by John George Joicey, 1919

Lewis, John Frederick 1805–1876, *The Lioness*, gift from Viscount Ridley, 1908

Liberi, Pietro (after) 1605–1687, *Diana Resting after the Chase*, untraced find, recorded, 1982

Liddell, Thomas Hodgson 1860–1925, *Newcastle upon Tyne from Gateshead*, untraced find, recorded, 2003

Lidderdale, Charles Sillem 1831–1895, *The Trysting Place*, bequeathed by Conrad White, 1905

Lidderdale, Charles Sillem 1831–1895, *A Fishergirl*, bequeathed by Conrad White, 1905, on loan to Gerrard Ltd, Newcastle upon Tyne

Lomax, John Arthur 1857–1923, *A Rare Vintage*, bequeathed by John George Joicey, 1919

Lomax, John Arthur 1857–1923, *How the Old Squire Caught the Big Jack*, bequeathed by John George Joicey, 1919

Lomax, John Arthur 1857–1923, *Interrupted Studies*, gift from George E. Henderson, 1934

Lomax, John Arthur 1857–1923, *The Moneylender*, bequeathed by George E. Henderson, 1937

Lowe, Arthur 1866–1940, *Evening*, gift from Mrs Arthur Lowe, 1944

Lowe, Arthur 1866–1940, *Farm Buildings*, untraced find, recorded, 2007

Lowe, Arthur 1866–1940, *Still Life, Chrysanthemums*, gift from Mrs Arthur Lowe, 1944

Lowe, Arthur 1866–1940, *When the Evening Sun Is Low*, gift from Mrs Arthur Lowe, 1944

Lowry, Laurence Stephen 1887–1976, *River Scene*, purchased from the artist, 1946, © courtesy of the estate of L. S. Lowry

Lowry, Laurence Stephen 1887–1976, *My Two Uncles*, gift from Mrs B. Hogg, © courtesy of the estate of L. S. Lowry

Lowry, Laurence Stephen 1887–1976, *Old Chapel, Newcastle upon Tyne*, purchased from the Stone Gallery, 1966, © courtesy of the estate of L. S. Lowry

Lucas, Seymour 1849–1923, *A Sketch Given to my Friend, G. Robinson*, gift from the City of Newcastle upon Tyne Archives, 1969

Lucas, Seymour 1849–1923, *St Paul's, the King's Visit to Wren*, purchased from H. J. Mullen, 1908

Lucas, Seymour 1849–1923, *The Drum Watch*, bequeathed by John George Joicey, 1919

Lund, Niels Møller 1863–1916, *Mid the Wild Music of the Glen*, gift from Sir G. B. Hunter, 1937

Lund, Niels Møller 1863–1916, *Newcastle upon Tyne from Gateshead*, gift from S. Lord, 1924

Lund, Niels Møller 1863–1916, *Newcastle upon Tyne from the East*, bequeathed by Sir Joseph Wilson Swan, 1928

Lund, Niels Møller 1863–1916, *Corfe Castle, Dorset*, purchased from Mrs N. M. Lund, 1917

R. M. active 20th C, *Abstract*, untraced find

MacDougall, William Brown 1869–1936, *Canal Scene, Welton Lock and Lodge*, gift from Mrs A. Watson, 1942

MacDougall, William Brown 1869–1936, *Blossom Time, Epping Forest, Essex*, gift from Mrs A. Watson, 1942

MacDougall, William Brown 1869–1936, *Early Evening on the Aut River*, gift from Mrs A. Watson, 1942

MacGregor, William York 1855–1923, *A Street in Fuenterrabia*, gift from the Contemporary Art Society, 1935

Mackay, Thomas 1851–1909, *The Trumpeter*, untraced find, recorded, 1982

Macklin, Thomas Eyre 1867–1943, *Portrait of an Alderman*, on loan from the City of Newcastle upon Tyne, since 1982

Macklin, Thomas Eyre 1867–1943, *Portrait of an Alderman*, untraced find, recorded, 2007

Macklin, Thomas Eyre 1867–1943, *Alexander Laing (1828–1905)*, gift from Alexander Laing, 1904

Macklin, Thomas Eyre 1867–1943, *Portrait of the Artist's Father*, gift from John Atkinson, 1939

Macklin, Thomas Eyre 1867–1943, *Alderman Sir Charles Frederick Hamond (1867–1943)*, on loan from the City of Newcastle upon

Tyne, since 1955

Macklin, Thomas Eyre 1867–1943, *John Hall (1824–1899)*, gift from W. W. Dean, Hall Shipping Co., 1980

Maclise, Daniel 1806–1870, *Alfred the Saxon King (Disguised as a Minstrel) in the Tent of Guthrum the Dane*, gift from Samuel Smith, JP, 1933

MacTaggart, William 1903–1981, *Studio Table*, purchased from the Stone Gallery with the assistance of the Victoria and Albert Museum Purchase Grant Fund, 1960, © by permission of the artist's family

MacWhirter, John 1839–1911, *A Spate in the Highlands*, gift from Mrs Willan, 1956

Mainds, Allan Douglass 1881–1945, *A Lesson in Chess*, gift from Mrs Allan Douglass Mainds, 1970

Mainds, Allan Douglass 1881–1945, *Silver and Spode*, purchased from the artist, 1942

Marks, Henry Stacey 1829–1898, *Thanks for Small Mercies*, bequeathed by William Wilson, 1955

Marr, Leslie b.1922, *The Stiperstones, Shropshire*, purchased from the artist, 1965, © the artist

Marsh, Arthur Hardwick 1842–1909, *Cockle Gatherers*, gift from Mrs Marsh, recorded, 1970

Marsh, Arthur Hardwick 1842–1909, *The Ploughman Homeward Plods His Weary Way*, gift from the children of T. W. Lovibond, 1923

Marston, C. active late 19th C, *Portrait of an Old Lady*, untraced find, recorded, 1981

Martin, John 1789–1854, *Clytie*, purchased from Mrs Charlotte Frank with the assistance of the National Art Collections Fund, the Victoria and Albert Museum Purchase Grant Fund and the Pilgrim Trust, 1976

Martin, John 1789–1854, *View of the Entrance of Carisbrooke Castle, Isle of Wight*, purchased from Mrs Charlotte Frank with the assistance of the National Art Collections Fund, the Victoria and Albert Museum Purchase Grant Fund and the Pilgrim Trust, 1976

Martin, John 1789–1854, *Edwin and Angelina*, purchased from Mrs Charlotte Frank with the assistance of the National Art Collections Fund, the Victoria and Albert Museum Purchase Grant Fund and the Pilgrim Trust, 1976

Martin, John 1789–1854, *The Bard*, purchased from Robert Frank with the assistance of the National Art Collections Fund, 1951

Martin, John 1789–1854, *The Expulsion of Adam and Eve from Paradise*, purchased from Mrs Charlotte Frank with the assistance of the National Art Collections Fund, the Victoria and Albert Museum Purchase Grant Fund and the Pilgrim Trust, 1976

Martin, John 1789–1854, *Solitude*,

purchased from Mrs Charlotte Frank with the assistance of the National Art Collections Fund, the Victoria and Albert Museum Purchase Grant Fund and the Pilgrim Trust, 1976

Martin, John 1789–1854, *Arthur and Aegle in the Happy Valley*, gift from Miss E. Cruddas, 1951

Martin, John 1789–1854, *The Destruction of Sodom and Gomorrah*, gift from E. F. Weidner in memory of John Frederick Weidner, JP, Lord Mayor of Newcastle upon Tyne (1912–1913), 1951

Martin, John (after) 1789–1854, *Marcus Curtius*, purchased from Mrs E. Alderson, 1953

Martin, John (follower of) 1789–1854, *Biblical Destruction Scene*, untraced find, recorded, 1971

Martin, John (follower of) 1789–1854, *Satan (?)*, gift from C. E. Appleby, 1954

Mason, Frank Henry 1876–1965, *After Trafalgar*, gift from Waite Sanderson, 1944

McAlpine, William active 1840–1880, *Evening on the Medway*, gift from Miss Wilson, 1940

McCulloch, Horatio 1805–1867, *Inverlochy, Fort William, Scotland*, gift from Samuel Smith, JP, 1933

McDonald, G. A. active 20th C, *Study of Fir Trees*, gift from Mrs G. A. McDonald, 1943

McEune, Robert Ernest 1876–1952, *Councillor John Moore*, gift from the Newcastle Area Health Authority, 1978, © the artist's estate

McEwan, R. *The Aberuchills (The Loch Aber Hills)*, gift from Alex MacRae, 1954

McGlashan, Archibald A. 1888–1980, *Head of a Child*, gift from the Northern Art Collections Fund, 1934, © the artist's estate

McKenna, Stephen b.1939, *Hommage à Piranesi*, gift from the Contemporary Art Society, 1992, © the artist

McKenzie, R. A. active late 19th C, *Benwell High Cross, Newcastle upon Tyne*, gift from T. D. Pickering, 1955

McLean, Bruce b.1944, *Towards a Performance, Good Manners or Physical Violence III*, gift from the Contemporary Art Society, 1988, © the artist

Mellor, William 1851–1931, *Oak Beck, Harrogate*, untraced find, recorded, 1981

Mendoza, A. *His Majesty King George V (1865–1936)*, gift from H. S. Thorne, 1955

Mignard, Pierre I (attributed to) 1612–1695, *Portrait of Three Children*, bequeathed by John George Joicey, 1919

Mitchell, Charles William 1854–1903, *Alderman Thomas Robinson*, on loan from the City of Newcastle upon Tyne

Mitchell, Charles William 1854–1903, *Hypatia*, gift from Major

Charles Mitchell, 1940

Mitchell, Charles William 1854–1903, *Study of a Head*, purchased from James Fox, 1939

Mitchell, Charles William 1854–1903, *The Spirit of Song*, gift from Charles Mitchell, 1940

Mitchell, John Edgar 1871–1922, *Alderman A. Munro Sutherland*, on loan from the City of Newcastle upon Tyne

Mitchell, John Edgar 1871–1922, *Alderman George Harkus (d.1915), JP*, bequeathed by Alderman George Harkus, 1915

Mole, John Henry 1814–1886, *The Listeners*, gift from T. M. Whitfield, 1931

Molnár, C. Pál 1894–1981, *The Nativity*, purchased from A. Sarkadi, 1937, ©DACS 2008

Montague, Alfred 1832–1883, *River Scene*, gift from the Reverend W. T. Hunter, 1940

Montague, Alfred 1832–1883, *Winter Scene*, gift from the Reverend W. T. Hunter, 1944

Montalba, Clara 1842–1929, *Old Watch Tower, Amsterdam*, gift from John Lamb, 1907, on loan to Lumley Castle, Chester-le-Street, County Durham

Moore, Henry 1831–1895, *Broken Weather, North Coast of Cornwall*, bequeathed by George E. Henderson, 1937

Morgan, John 1823–1886, *Whom to Punish?*, gift from Ralph Atkinson, 1908

Morland, George 1763–1804, *Paying the Ostler*, purchased from Arthur Tooth and Sons, 1956

Morris, Philip Richard 1838–1902, *Girl on a Balcony Watching a Couple by a Lake*, gift from Miss Elsie Wright, 1964

Morton, Andrew 1802–1845, *Portrait of an Old Lady*, gift from Andrew H. Morton, 1949

Morton, Andrew 1802–1845, *Self Portrait*, gift from Andrew H. Morton, 1949

Morton, Andrew 1802–1845, *Joseph Morton (father of the artist)*, gift from Andrew H. Morton, 1949

Morton, George 1851–1904, *Figure Study*, gift from Miss Morton, 1907

Morton, George Arthur active early 20th C, *Rough Sea in Moonlight*, bequeathed by Thelma Oubridge Morton, 1986

Morton, George Arthur active early 20th C, *Seascape with Rough Sea*, bequeathed by Thelma Oubridge Morton, 1986

Morton, George Arthur active early 20th C, *Stormy Sea and Rocks*, untraced find, recorded, before 1986

Mostyn, Thomas Edwin 1864–1930, *Kirkcudbright Castle*, gift from George E. Henderson, 1934

Mostyn, Thomas Edwin 1864–1930, *The Jewelled Casket*, gift from George E. Henderson, 1934, on loan to Lumley Castle, Chester-le-Street, County Durham

Mostyn, Thomas Edwin 1864–

1930, *Sunlight, Burnham Beeches, Buckinghamshire*, purchased from the artist, 1914

Mostyn, Thomas Edwin 1864–1930, *The Old Mill, Houghton, Cambridgeshire*, gift from T. Weightman, 1919

Muirhead, David 1867–1930, *The Harbour, Stonehaven*, purchased from J. E. H. Baker, 1927

Mullan, G. active 19th C, *Mountainous River Landscape*, untraced find, recorded, 1982

Mulready, Augustus Edwin 1844–1905, *A Recess on a London Bridge*, gift from Ralph Atkinson, 1908

Munnings, Alfred James 1878–1959, *Going to the Meet*, gift from Sir George Renwick, 1928, © the artist's estate

Murillo, Bartolomé Esteban (after) 1618–1682, *Pan*, gift from Mrs J. Wear, 1950

Murillo, Bartolomé Esteban (after) 1618–1682, *The Baptism of Christ*, bequeathed by Miss M. J. Dobson, 1905

Murray, David 1849–1933, *Nooning in the Hop Gardens*, gift from the artist's estate, 1939

Nash, John Northcote 1893–1977, *Mill Pond Evening*, purchased from Brown and Phillips Ltd, 1961, © the artist's estate/www.bridgeman.co.uk

Nash, Thomas Saunders 1891–1968, *Christ before the People*, purchased from the Redfern Gallery, 1933

Nash, Thomas Saunders 1891–1968, *Crucifixion*, gift from the Contemporary Art Society, 1933

Nasmyth, Patrick 1787–1831, *Landscape with Figures*, bequeathed by George E. Henderson, 1937

Nasmyth, Patrick 1787–1831, *The Aberuchills (The Loch Aber Hills)*, bequeathed by Miss A. F. Bryant, 1955

Neale, George Hall 1863–1940, *Sir George E. Carter*, gift from Carter-Horsley Ltd, 1956

Nelson, Geoffrey C. active 1914–1931, *Vieux Cagnes*, gift from the Contemporary Art Society, 1935

Nevinson, Christopher 1889–1946, *Notre Dame de Paris from Quai des Grands Augustins*, gift from the Northern Art Collections Fund, 1934, © the artist's estate/www.bridgeman.co.uk

Nevinson, Christopher 1889–1946, *Twentieth Century*, gift from the artist, 1943, © the artist's estate/www.bridgeman.co.uk

Newbery, Francis Henry 1855–1946, *The Lady of the Carnation*, purchased from the artist, 1919

Newton, Duncan b.1945, *The Rite of Spring*, purchased from the artist with the assistance of the Victoria and Albert Museum Purchase Grant Fund, 1984

Nicholls, Bertram 1883–1974, *Old Mill, Midhurst, West Sussex*, purchased from the artist, 1945

Nicholson, Ben 1894–1982, *1933 (design)*, gift from the

Contemporary Art Society, 1946, © Angela Verren Taunt 2008. All rights reserved, DACS

Nicholson, William 1781–1844, *Thomas Bewick (1753–1828)*, purchased from Lord Ravensworth, 1951

Nicholson, Winifred 1893–1981, *Evening at Boothby*, purchased from J. Nicholson, 1986, © trustees of Winifred Nicholson

Nicol, Erskine 1825–1904, *Old Mickie*, bequeathed by John Lamb, 1909

Nicol, John Watson 1856–1926, *The Bottom of the Punch Bowl*, bequeathed by John Lamb, 1909

Nicol, John Watson 1856–1926, *A Nightcap*, bequeathed by John Lamb, 1909

Niemann, Edmund John 1813–1876, *Evening on the French Coast*, bequeathed by John Lamb, 1909, on loan to the Matfen Hall Hotel, Hexham, Northumberland

Niemann, Edmund John 1813–1876, *Newcastle upon Tyne*, gift from George E. Henderson, 1927

Norman, M. active 20th C, *Central Station, Newcastle upon Tyne*, gift from Mrs Aldridge, 1960

Northbourne, James Walter John 1869–1932, *Evening*, untraced find, recorded, 1980

Oakes, John Wright 1820–1887, *Loch Muick, Aberdeenshire*, gift from George E. Henderson, 1906

O'Connor, James Arthur 1791–1841, *Landscape*, gift from G. W. Appleby, 1950

Ogilvie, Frank Stanley (after) 1858–after 1935, *Interior, Woman Reading to an Old Man*, gift from Colonel T. A. Higginbottom, 1955

Oliver, Daniel 1830–1916, *Holy Island, Northumberland*, gift from Mrs D. Oliver, 1919

Olsson, Albert Julius 1864–1942, *Evening, St Ives, Cornwall*, gift from G. F. Charlton, 1924

O'Neill, Daniel 1920–1974, *The Doll Maker*, purchased from Arthur Tooth and Sons Ltd, 1955, © DACS 2008

Orpen, William 1878–1931, *Sir Charles Algernon Parsons (1854–1931)*, bequeathed by Lady Charles Algernon Parsons, 1933

Orpen, William 1878–1931, *Portrait of the Artist*, bequeathed by John George Joicey, 1919

Orrock, James 1829–1913, *The Solway, Criffel in the Distance*, bequeathed by John Lamb, 1909

Owen, William 1769–1825, *Lord Stowell (1745–1836)*, on loan from the City of Newcastle upon Tyne

Parker, Henry Perlee 1795–1873, *George Gray (1758–1819)*, gift from Thomas Bowden, 1906

Parker, Henry Perlee 1795–1873, *Judy Dowling, Keeper of the Town Hutch*, bequeathed by Miss Helen May Ord, 1962

Parker, Henry Perlee 1795–1873, *The Fisherman*, bequeathed by Miss Elsie Wright, 1964

Parker, Henry Perlee 1795–1873,

The Old Fish Market, Sandhill, Newcastle upon Tyne, purchased from Owen Humble, 1966

Parker, Henry Perlee 1795–1873, *Smugglers Attacked*, gift from Ralph S. Waddle, 1932

Parker, Henry Perlee 1795–1873, *The Outlook*, gift from Miss Elsie Wright, 1964

Parker, Henry Perlee 1795–1873, *The Banquet Given on the Occasion of the Opening of the Grainger Market, Newcastle upon Tyne, 1835*, purchased, 1954, on loan to the Discovery Museum, Newcastle upon Tyne

Parker, Henry Perlee 1795–1873, *Smugglers Playing Cards*, purchased from B. and R. Moss with the assistance of the Friends of the Laing Art Gallery, 1976

Parker, Henry Perlee 1795–1873, *Pitmen Playing Quoits*, gift from Ralph Atkinson, 1908

Parker, Henry Perlee 1795–1873, *Glastonbury, Somerset*, bequeathed by Mrs S. Patterson, 1937

Parker, Henry Perlee (after) 1795–1873, *Eccentric Characters of Newcastle*, gift from Miss N. Marshall, 1948

Pasmore, Victor 1908–1998, *Girl with a Mirror*, purchased from the Redfern Gallery, 1948, © Victor Pasmore estate

Paton, Joseph Noel 1821–1901, *The Man of Sorrows*, gift from John George Joicey, 1914

Pattison, Thomas William 1894–1993, *The Building of the New Castle, Newcastle upon Tyne, c.1177 AD*, purchased from the artist, 1925

Pattison, Thomas William 1894–1993, *Tankers at Middle Dock, South Shields*, purchased from the artist, 1951

Pattison, Thomas William 1894–1993, *On the Tyne, Shipbuilding*, purchased from the artist, 1956

Pattison, Thomas William 1894–1993, *Portrait of a Lady*, untraced find, recorded, 1982

Peel, James 1811–1906, *Easby Abbey, North Yorkshire*, gift from George E. Henderson, 1934

Peel, James 1811–1906, *Mill near Sheppard, Devon*, gift from Squadron Leader J. Brown, 1955

Peel, James 1811–1906, *Pont-y-Pant and the Lledr Valley, North Wales*, purchased from W. H. Benn, 1907

Peel, James 1811–1906, *Cotherstone, Yorkshire*, bequeathed by John Lamb, 1909

Pelham, Thomas Kent c.1831–1907, *An Italian Girl*, gift from Mrs L. Monkhouse, 1954

Penny, Edward (attributed to) 1714–1791, *Sir William Benett*, purchased from the Leger Galleries, 1960

Peploe, Samuel John 1871–1935, *Yellow Tulips and Statuette*, purchased from Reid and Lefevre Ltd, 1948

Pether, Sebastian (attributed to)

1790–1844, *Landscape with Ruins*, gift from the City of Newcastle upon Tyne, 1954

Philipson, Robin 1916–1992, *Cathedral Interior, Thanksgiving*, purchased from Aitken Dott and Son, 1965, © the artist's estate

Piper, John 1903–1992, *Town from Water Meadows*, purchased from Brown and Phillips Ltd, 1957, © the artist's estate

Pitchforth, Roland Vivian 1895–1982, *The Elm Tree*, gift from the Contemporary Art Society, 1952, © the artist's estate

Pitchforth, Roland Vivian 1895–1982, *The Removal*, gift from the Contemporary Art Society, 1952, © the artist's estate

Pittuck, Douglas Frederick 1911–1993, *Figures in an Industrial Setting*, purchased from the artist, 1963, © the artist's estate

Poelenburgh, Cornelis van 1594/1595–1667, *Landscape with Ruins and Figures*, gift from Samuel Smith, JP, 1938

Pollentine, Alfred 1836–1890, *The Grand Canal, Venice*, on loan from a private individual, since 1931

Pollentine, Alfred 1836–1890, *Santa Maria della Salute, Venice*, on loan from Mrs A. Brewis

Poole, Paul Falconer 1807–1879, *The Prodigal Son*, gift from Mrs Hilda Sample, 1956

Powell, James *Billy Purvis (1784–1853)*, bequeathed by A. J. Fenwick, 1963

Poynter, Edward John 1836–1919, *The Catapult*, gift from Lord Runciman of Chathill, 1945

Pringle, Agnes c.1853–1934, *The Flight of Antony and Cleopatra from the Battle of Actium*, bequeathed by the artist, 1934

Procter, Dod 1892–1972, *Girl in Blue*, gift from the Contemporary Art Society, 1931, © the artist's estate/www.bridgeman.co.uk

Procter, Ernest 1886–1935, *Night and Evening*, purchased from the artist, 1935

Procter, Ernest 1886–1935, *The Cottage*, purchased from the artist, 1931

Procter, Ernest 1886–1935, *The Family*, gift from Mrs Dod Procter, 1936

Pyne, James Baker 1800–1870, *The Harbour, Littlehampton, West Sussex*, bequeathed by John Lamb, 1909

Raeburn, Henry 1756–1823, *Robert Allan of Kirkliston (1740–1818)*, purchased from Arthur Tooth and Sons, 1965

Ramsay, Allan 1713–1784, *James Adam (1732–1794)*, purchased from Graham Baron Ash, 1967

Ramsay, Allan (after) 1713–1784, *George III (1738–1820)*, on loan from the City of Newcastle upon Tyne

Ramsay, James 1786–1854, *William Armstrong (1810–1900)*, gift from Armstrong Whitworth and Co. Ltd, 1937

Ramsay, James 1786–1854, *Self Portrait*, purchased from Reverend James Schofield with the assistance of the Victoria and Albert Museum Purchase Grant Fund, 1981

Ramsay, James (attributed to) 1786–1854, *Mrs Richard Grainger*, purchased from Mrs M. E. Else, 1966

Ramsay, James (attributed to) 1786–1854, *Richard Grainger (1797–1861)*, purchased from Mrs M. E. Else, 1966

Raphael (after) 1483–1520, *The Holy Family of Francis I*, bequeathed by Felix Lavery, 1954

Rea, Cecil Wiliam 1860–1935, *Fields Elysian*, gift from Mrs Constance Rea, 1942

Rea, Cecil Wiliam 1860–1935, *Portrait of a Lady*, gift from Mrs Constance Rea, 1939

Rea, Cecil Wiliam 1860–1935, *Self Portrait*, gift from Mrs Constance Rea, 1951

Redfern, June b.1951, *The Arc*, purchased from Greville Worthington, 1988

Redfern, June b.1951, *The Arc*, purchased from Greville Worthington, 1988

Redpath, Anne 1895–1965, *The Valley of San Martino di Lota, Corsica*, purchased from Reid and Lefevre Ltd, 1961, © the artist's estate/www.bridgeman.co.uk

Reid, Flora 1860–c.1940, *Comrades*, gift from George E. Henderson, 1934

Reuss, Albert 1889–1976, *Lady Reading a Book*, purchased from the artist, 1945

Reynolds, Alan b.1926, *Pastoral*, purchased from the Redfern Gallery, 1960, © the artist

Reynolds, Joshua 1723–1792, *Mrs Elizabeth Riddell (1730–1798)*, purchased from R. C. Riddell with the assistance of the Victoria and Albert Museum Purchase Grant Fund, the National Art Collections Fund, the James Knott Fund and the Pilgrim Trust, 1965

Reynolds, Joshua (after) 1723–1792, *Mrs Robinson (1758–1800)*, gift from the National Art Collections Fund, 1955

Reynolds, Joshua (after) 1723–1792, *The Infant Samuel*, gift from Mrs M. Shackleton, 1963

Richardson, Thomas Miles I 1784–1848, *Newcastle from Gateshead Fell*, on loan from the City of Newcastle upon Tyne, since 1915

Richardson, Thomas Miles I 1784–1848, *The Tyne from Windmill Hills, Gateshead*, gift from Beaumont Pease, Howard Pease and Miss Pease, 1919

Richardson, Thomas Miles I 1784–1848, *The Old Mill, Ambleside, Cumbria*, gift from the family of the late Mrs F. C. Marshall, 1926

Richardson, Thomas Miles I 1784–1848, *Barnard Castle, County Durham*, bequeathed by R.

Sheriton Holmes, 1921

Richardson, Thomas Miles I 1784–1848, *Evening View on Heaton Dene, Lancashire, from an Eminence near Mable's Mill*, gift from Beaumont Pease, Howard Pease and Miss Pease, 1919

Richardson, Thomas Miles I 1784–1848, *Young Anglers, Barras Bridge, Newcastle upon Tyne*, gift from Lord Joicey, 1921

Richardson, Thomas Miles I 1784–1848, *Jedburgh Abbey, Scotland*, gift from Ralph Atkinson, 1908

Richardson, Thomas Miles I 1784–1848, *Lindisfarne Priory, Northumberland*, bequeathed by G. H. Tully, 1953

Richardson, Thomas Miles I 1784–1848, *Teesdale, County Durham*, gift from Miss Elsie Wright, 1964

Richardson, Thomas Miles I 1784–1848, *Lake Lucerne with William Tell's Chapel*, gift from the family of the late Mrs F. C. Marshall, 1926

Richardson, Thomas Miles I 1784–1848, *Excavations for the High Level Bridge, Newcastle upon Tyne*, gift from W. B. Paterson, 1941

Richardson, Thomas Miles I 1784–1848, *Conway Castle, North Wales*, gift from Andrew Reid and Co. Ltd, 1930

Richardson, Thomas Miles I (attributed to) 1784–1848, *Landscape, Bridge and Figures*, bequeathed by William Wilson, 1955

Richardson, Thomas Miles I (attributed to) 1784–1848, *Percy Bay, Tynemouth*, gift from Councillor F. E. Weightman, 1912

Richardson, Thomas Miles II 1813–1890, *Highland Lake Scene*, purchased from A. H. Higginbottom, 1935

Richardson, Thomas Miles II 1813–1890, *Tynemouth Castle from Percy Bay*, purchased from A. H. Higginbottom, 1935

Richmond, William Blake 1842–1921, *The Hun and the Crucifix*, bequeathed by John George Joicey, 1919

Ritchie, John active 1857–1875, *A Border Fair*, purchased from Bonhams with the assistance of the Victoria and Albert Museum Purchase Grant Fund, 1983

Roberts, David 1796–1864, *Edinburgh Castle from the Grassmarket*, bequeathed by John Lamb, 1909

Roberts, Derek b.1947, *Early Summer*, purchased from the artist, 1990, © the artist

Robertson, Charles Kay active 1888–1931, *Judge William Digby Seymour*, on loan from the City of Newcastle upon Tyne

Robertson, Christina active 1823–1850, *A Group of Children*, gift from Miss E. Drew, 1946

Roe, Henry Robert *Scarborough,*

North Yorkshire, gift from Samuel Smith, JP, 1939

Rogers, Claude 1907–1979, *The Broad Walk, Regent's Park*, purchased from the Leicester Galleries, 1958, © Crispin Rogers

Rowe, Elizabeth b.1955, *Dysphoria*, purchased with the assistance of the Victoria and Albert Museum Purchase Grant Fund, 1991

Rowntree, Kenneth 1915–1997, *Black Painting 1*, purchased from the artist with the assistance of the Friends of the Laing Art Gallery, 1977, © the artist's estate

Rowntree, Kenneth 1915–1997, *West Front, Durham*, purchased from the artist, 1977, © the artist's estate

Royle, Stanley 1888–1961, *Dappled Sunlight on Snow*, purchased from the artist, 1925, © the artist's estate/www.bridgeman.co.uk

Ruben, Franz Leo 1842–1920, *Venice*, bequeathed by John Lamb, 1909

Rubens, Peter Paul (after) 1577–1640, *The Meeting of Abraham and Melchisedech*, untraced find, recorded, 1982

Ryott, James Russell c.1788–1851, *Newgate, Newcastle upon Tyne*, purchased from F. W. Smallwood, 1930

Ryott, James Russell c.1788–1851, *The Keep, Newcastle upon Tyne*, purchased from F. W. Smallwood, 1930

Sadler, Walter Dendy 1854–1923, *The Village Postman*, bequeathed by John George Joicey, 1919

Saedeleer, Valerius de 1867–1942, *Landscape with Apple Tree*, gift from Edwin Hitchon, 1948

Sanquirico, Alessandro 1777–1849, *View of the Projected Foro Bonaparte, Milan 1800*, bequeathed by John George Joicey, 1919

Sansbury, Geoff b.1941, *A1(M) to Zoe*, purchased from the artist, 1965, © the artist

Sansbury, Geoff b.1941, *Two Interior States. Blossom/Small Black Menace*, purchased from the artist, 1968, © the artist

Sargeant, Gary b.1939, *Viaduct, Durham*, purchased from the artist, 1966, © the artist

Sargent, John Singer 1856–1925, *Henry Richardson*, gift from Mrs O. H. Macartney, 1939

Sartorius, John Nost 1759–1828, *Chestnut Horse in a Landscape*, purchased from P. Carrick with the assistance of the Friends of the Laing Art Gallery, 1976

Scott, John 1802–1885, *Seascape with Shipping*, gift from the Reverend W. T. Hunter, 1940

Scott, John 1802–1885, *The Steam Tug 'Alfred' off Tynemouth*, gift from the Reverend W. T. Hunter, 1940

Scott, John 1802–1885, *The Sailing Ship 'Anne' Leaving the River Tyne*, gift from A. J. Patterson, 1946

Scott, John 1802–1885, *Tynemouth with Shipping*, gift from A. J.

Patterson, 1942

Scott, John 1802–1885, *The Sailing Ship 'Isabella'*, untraced find, recorded, 1971

Scott, William Bell 1811–1890, *Bell-Ringers and Cavaliers Celebrating the Entrance of Charles II into London on Restoration*, purchased from Aitken Dott and Son, 1909

Scott, William Bell 1811–1890, *Study of Flowers and Fruit*, gift from Mrs W. Cosens Way, 1905

Seddon, Christine b.1915, *Standing Figure and Landscape No.4*, gift from Mrs Helen Hacking, 1989

Sefton, Brian b.1938, *Landscape Reference, Over and Under*, purchased from the artist, 1968, © the artist

Seifert, Alfred 1850–1901, *Study of a Head*, bequeathed by John Lamb, 1909

Seifert, Alfred 1850–1901, *Study of a Head*, bequeathed by John Lamb, 1909

Shackleton, William 1872–1933, *Amberley*, gift from Mrs W. Shackleton, 1938, on loan to Gerrard Ltd, Newcastle upon Tyne

Shackleton, William 1872–1933, *Putney Bridge*, gift from Mrs W. Shackleton, 1938

Shackleton, William 1872–1933, *Study for 'The Mussel Gatherers'*, gift from Mrs W. Shackleton, 1938

Sharkey, J. *Alnwick Castle, Northumberland*, gift from M. Tulip, 1972

Sharp, Dorothea 1874–1955, *The Primrose Way*, gift from W. H. Renwick, 1916

Shaw, John Byam Liston 1872–1919, *The Fool Who Would Please Every Man*, gift from Sir John D. Milburn, 1905

Shayer, William 1788–1879, *Landscape with Cattle*, bequeathed by John Lamb, 1909

Shayer, William (attributed to) 1788–1879, *Gypsy Encampment*, bequeathed by William Wilson, 1955

Sheringham, George 1884–1937, *Fan Design*, purchased from Abbott and Holder, 1975

Sherrin, David b.1868, *Near Guildford, Surrey*, gift from Isabella Beattie, 1934

Sickert, Walter Richard 1860–1942, *Piazza San Marco, Venice*, purchased from the Redfern Gallery, 1932, © estate of Walter R. Sickert/DACS 2008

Simpson, Charles Walter 1885–1971, *Herring Gulls and a Black Back*, on loan from a private lender, since 1929, © the artist's estate

Simpson, Charles Walter 1885–1971, *The Herring Season*, purchased from Charles W. Simpson, 1926, © the artist's estate

Simpson, Charles Walter 1885–1971, *Marshland*, gift from Samuel Smith, JP, 1930, © the artist's estate

Simpson, Charles Walter 1885–

1971, *The Afterglow*, gift from Thomas Reed, 1921, © the artist's estate

Simpson, William Graham b.1855, *Thomas Young (d.1888)*, gift from Miss D. F. D. Adamson and Y. D. Adamson, 1983

Singleton, Henry 1766–1839, *Lingo and Cowslip*, bequeathed by John George Joicey, 1919

Skelton, Joseph Ratcliffe 1865–1927, *Kirkstall Abbey, Leeds*, unknown gift, 1957

Slater, John Falconar 1857–1937, *Quayside at North Shields*, gift from A. J. Ward, 1994

Slater, John Falconar 1857–1937, *The Wood Cart*, gift from Mrs Robson, 1956

Slater, John Falconar 1857–1937, *Seascape*, gift from R. B. Jackson, 1929

Slater, John Falconar 1857–1937, *Winter Scene*, gift from Mrs Robson, 1956

Slater, John Falconar 1857–1937, *Two Horses and a Caravan*, bequeathed by A. J. Fenwick, 1963

Slater, John Falconar 1857–1937, *Seascape*, gift from E. C. Braithwaite, 1949

Slater, John Falconar 1857–1937, *Cullercoats, Northumberland*, bequeathed by Angus Watson, 1961

Slater, John Falconar 1857–1937, *A Glen*, gift from the Reverend W. T. Hunter, 1944

Slater, John Falconar 1857–1937, *Cottage and Stream*, gift from Mrs Robson, 1956

Slater, John Falconar 1857–1937, *Hexham, Northumberland*, gift from Angus Watson, 1930

Slater, John Falconar 1857–1937, *Landscape with Mountain Stream*, gift from Miss G. Dodds, 1940

Slater, John Falconar 1857–1937, *Landscape with Windmill*, gift from the Reverend W. T. Hunter, 1940

Slater, John Falconar 1857–1937, *North Shields, North Tyneside*, gift from the Reverend W. T. Hunter, 1990, on loan to Gerrard Ltd, Newcastle upon Tyne, 1940

Slater, John Falconar 1857–1937, *St Mary's Lighthouse*, gift from R. B. Jackson, 1929

Slater, John Falconar 1857–1937, *Seascape*, gift from the Reverend W. T. Hunter, 1944

Slater, John Falconar 1857–1937, *Seascape*, gift from H. Cecil Vickers, 1938

Slater, John Falconar 1857–1937, *Seascape*, gift from Mrs Robson, 1956

Slater, John Falconar 1857–1937, *Seascape*, untraced find, recorded, 1982

Slater, John Falconar 1857–1937, *Tynemouth Pier*, gift from R. B. Jackson, 1929

Smith, George 1829–1901, *Study for 'The Early Visitor'*, bequeathed by William Wilson, 1955

Smith, George V. *Country Lane*, bequeathed by George E.

Henderson, 1937

Smith, Matthew Arnold Bracy 1879–1959, *Creole Girl*, purchased from the Redfern Gallery, 1948, © by permission of the copyright holder

Smith, Matthew Arnold Bracy 1879–1959, *Still Life with Green Background*, purchased from Arthur Tooth and Sons Ltd, 1959, © by permission of the copyright holder

Smyth, Montague 1863–1965, *An Eventide*, gift from Lilian Hatton, 1951

Snow, John Wray 1800–1854, *Charles William Bigge (1773–1849)*, gift from the Walker Mechanics Institute, 1942

Spear, Ruskin 1911–1990, *Still Life with Fish*, purchased from the artist, 1948, © the artist's estate/ www.bridgeman.co.uk

Spencelayh, Charles 1865–1958, *A Cure for Everything*, purchased from the artist, 1947, © the artist's estate/www.bridgeman.co.uk

Spencer, Gilbert 1893–1979, *Lansdowne Crescent, London*, gift from the Contemporary Art Society, 1950, © the artist's estate/ www.bridgeman.co.uk

Spencer, Stanley 1891–1959, *The Lovers (The Dustmen)*, purchased from Arthur Tooth and Sons Ltd, 1948, on loan to the Museum voor Schone Kunsten, © estate of Stanley Spencer/ DACS 2008

Spenlove-Spenlove, Frank 1866–1933, *The Green Shutters, Viaticum, Belgium*, purchased from the artist, 1918

Stephenson, Kate active late 19th C, *William Stephenson*, gift from Children North East, 1987

Stevenson, Bernard Trevor Whitworth 1899–1985, *Lock near Barnoldswick, Lancashire*, purchased from the artist, 1941

Sticks, George Blackie 1843–1938, *Tantallon Castle, near North Berwick, Scotland*, bequeathed by Conrad White, 1905

Sticks, George Blackie 1843–1938, *Derwentwater and Bassenthwaite Lakes, Keswick*, bequeathed by Conrad White, 1905

Sticks, George Blackie 1843–1938, *Mountainous Landscape and Stream, Keswick*, bequeathed by Conrad White, 1905

Sticks, George Blackie 1843–1938, *Dewy Eve*, gift from Mrs Ross, 1944

Stone, Marcus C. 1840–1921, *In Love*, bequeathed by John George Joicey, 1919

Stott, Edward 1859–1918, *The Widow's Acre*, purchased from the Fine Art Society with the assistance of the Victoria and Albert Museum Purchase Grant Fund, 1977

Straker, Henry 1860–1943, *The Linen Cupboard*, gift from Mrs Henry Straker, 1943, © Henry Straker

Straker, Henry 1860–1943, *Her Task*, gift from Mrs Henry Straker, 1943, © Henry Straker

Straker, Henry 1860–1943, *Hanover Square*, gift from Mrs Henry Straker, 1943, © Henry Straker

Straker, Henry 1860–1943, *Bavarian Peasant Woman*, gift from Mrs Henry Straker, 1943, © Henry Straker

Straker, Henry 1860–1943, *Garden*, untraced find, recorded, 1981, © Henry Straker

Straker, Henry 1860–1943, *Garden*, untraced find, recorded, 1981, © Henry Straker

Straker, Henry 1860–1943, *Garden Scene*, untraced find, recorded, 1981, © Henry Straker

Straker, Henry 1860–1943, *Interior Study*, gift from Mrs Henry Straker, c.1943, © Henry Straker

Straker, Henry 1860–1943, *Portrait of a Woman in Profile*, untraced find, recorded, 1982, © Henry Straker

Straker, Henry 1860–1943, *Portrait of an Old Woman*, gift from Mrs Henry Straker, 1943, © Henry Straker

Straker, Henry 1860–1943, *Ruins in a Wood*, gift from Mrs Henry Straker, 1943, © Henry Straker

Straker, Henry 1860–1943, *Seated Woman*, gift from Mrs Henry Straker, 1943, © Henry Straker

Straker, Henry 1860–1943, *Tess*, gift from Mrs Henry Straker, 1943, © Henry Straker

Straker, Henry 1860–1943, *Woman Looking at Books*, gift from Mrs Henry Straker, 1943, © Henry Straker

Straker, Henry (attributed to) 1860–1943, *Nude Female Figure*, untraced find, recorded, 1981, © Henry Straker

Strother-Stewart, Ida Lillie 1890–1954, *Francis, Wife of Ronald Adamson*, untraced find, recorded, 1982

Strother-Stewart, Ida Lillie 1890–1954, *Portrait of a Man*, untraced find, recorded, 1981

Surtees, John 1819–1915, *On the Lledr, Wales*, gift from the City of Newcastle upon Tyne Town Hall, 1954

Surtees, John 1819–1915, *Summertime on the Thames, Bisham Church and Abbey, Berkshire*, gift from S. G. Ward, 1909

Surtees, John 1819–1915, *Portrait of an Old Woman*, gift from Mrs Willis, 1940

Surtees, John 1819–1915, *Young Companions*, bequeathed by Conrad White, 1905

Sutton, Philip b.1928, *View from Falmouth, Cornwall*, gift from the Contemporary Art Society, 1972, © Philip Sutton RA

Swan, Douglas 1930–2000, *The Milking Machine*, gift from Kenneth Stanger, 1971, © DACS 2008

Swarbreck, Samuel Dukinfield c.1799–1863, *Rosslyn Chapel, Roslin, Midlothian*, purchased from the Silvertop Sale, 1957

Swift, John Warkup 1815–1869, *Seascape with Boats*, gift from Sarah Greenfield, 1941, on loan to the Matfen Hall Hotel, Hexham, Northumberland

Swift, John Warkup 1815–1869, *Seascape with Shipping*, bequeathed by Conrad White, 1905

Swinburne, Marjorie *Four Hour Sketch*, gift from Lady L. Swinburne, 1954

Swinburne, Marjorie *Portrait of a Man*, gift from Lady L. Swinburne, 1954

Syer, John 1815–1885, *Mountainous Landscape*, on loan from a private lender, 1931

Talmage, Algernon Mayow 1871–1939, *Freshness of Morning*, purchased from the Fine Art Society Ltd, 1921

Teasdale, John 1848–1926, *Black Gate*, bequeathed by William Wilson, 1955

Teniers, David II (after) 1610–1690, *Interior with Figures*, gift from Samuel Smith, JP, 1938

Thomson, John Leslie 1851–1929, *Washing Place, Normandy*, purchased, 1925

Thorpe, W. (attributed to) active 19th C, *Cornfield*, gift from Miss Wilson, 1940

Thubron, Harry 1915–1985, *Winter Sea*, untraced find, recorded, 1981, © the artist's estate

Thubron, Harry 1915–1985, *Painting in Plaster and Plaster Cloth*, purchased from the Lord's Gallery, 1971, © the artist's estate

Tirr, Willy 1915–1991, *Abstract*, purchased from the artist, 1964, © the artist's estate

Titian (style of) c.1488–1576, *The Holy Family with Saint John*, bequeathed by John George Joicey, 1919

Tolidze, S. *Ice Breaker 'Ermac'*, gift from the Walker Mechanics Institute, 1942

Torrance, James 1859–1916, *April, Boat of Garten, Scotland*, bequeathed by the artist, 1921

Townsend, Henry James 1810–1890, *Leonardo and His Models*, gift from Lady L. Swinburne, 1951

Train, Edward 1801–1866, *Mountainous Landscape*, gift from George E. Henderson, 1913

Train, Edward 1801–1866, *Landscape with Waterfall*, bequeathed by Conrad White, 1905

Tucker, James Walker 1898–1972, *Amiens, France*, gift from Samuel Smith, JP, 1930

Tucker, James Walker 1898–1972, *Charles I in Newcastle upon Tyne, 13 May 1646*, purchased from the artist, 1931

Tucker, James Walker 1898–1972, *Gathering Shell Fish, St Servan, France*, purchased from the artist, 1932

Tucker, James Walker 1898–1972, *Hiking*, purchased from the artist, 1936

Tudgay, I. active 1836–1865, *Seascape*, gift from the Reverend W. T. Hunter, 1940

Tunnard, John 1900–1971, *Installation A*, purchased from McRoberts and Tunnard Ltd, with the assistance of the Victoria and Albert Museum Purchase Grant Fund, 1962

unknown artist 15th C, *Annunciation* (left wing), *Nativity* (centre panel), *Circumcision* (right wing), bequeathed by John George Joicey, 1919

unknown artist 15th C, *Madonna and Child with Two Angels in a Landscape*, bequeathed by John George Joicey, 1919

unknown artist 16th C, *The Adoration of the Magi*, untraced find, recorded, 1972

unknown artist late 16th C-early 17th C, *Icon of Virgin and Child*, bequeathed by Miss Margaret Rankin-Lyle, 1967

unknown artist *Sir John Marlay*, purchased from Mrs C. St John Blake, 1969

unknown artist 17th C, *Christ Appearing to the Disciples*, bequeathed by John George Joicey, 1919

unknown artist 17th C, *Dutch Interior*, gift from Eldred S. Wightman, 1942

unknown artist 17th C, *Head of St John*, gift from S. M. Bell, 1951

unknown artist 17th C, *St Joachim and the Virgin Mary*, gift from Manuel José Pelegrin, 1907

unknown artist 17th C, *The Flight into Egypt*, untraced find, recorded, 1973

unknown artist *George Bacon (c.1674–1702/1703)*, gift from Mrs A. V. Hoyle, 1954

unknown artist *John Bacon (1644/1645–1736)*, gift from Mrs A. V. Hoyle, 1954

unknown artist *Portrait of a Gentleman*, untraced find, recorded, 1972

unknown artist *Portrait of a Lady*, untraced find, recorded, 1972

unknown artist *A Farmyard*, bequeathed by John George Joicey, 1919

unknown artist *Sir William Middleton (d.1757)*, purchased from Sir Stephen Middleton, 1962

unknown artist *Portrait of a Newcastle Alderman*, untraced find, recorded, 1974

unknown artist *Benjamin Gibson*, gift from Mrs A. V. Hoyle, 1954

unknown artist *Richard Errington (1720–1796)*, gift from Miss Beatrice Loveland, 1950

unknown artist *Boy Holding a Tambourine, with a Dog*, untraced find, recorded, 1974

unknown artist early 18th C, *William Bacon (d.1748)*, gift from Mrs A. V. Hoyle, 1954

unknown artist 18th C (?), *Christ and the Tribute Money*, gift from E. Brown, 1944

unknown artist *Menagerie*, bequeathed by A. J. Fenwick, 1963

unknown artist *New Bridge over Pandon Dene*, purchased from Browne & Browne, 1931

unknown artist *Robert Laidlaw (1783–1855)*, gift from R. B. Laidlaw, 1968

unknown artist *Mary Ann Laidlaw (1799–1870)*, gift from R. B. Laidlaw, 1968

unknown artist *'A' Pit, Backworth, Newcastle upon Tyne*, purchased from R. D. Steedman, 1933

unknown artist *Portrait of a Lady*, untraced find, recorded, 1982

unknown artist *Mouth of River*, gift from Helen Dixon, 1945

unknown artist *Thomas Green, Painter*, untraced find, recorded, 1994

unknown artist *Billy Purvis (1784–1853)*, bequeathed by A. J. Fenwick, 1963

unknown artist *Reverend John Wesley's Study, Orphan House, Newcastle, 1856*, gift from E. Thompson, 1950

unknown artist *Dancing Girl*, gift from Miss C. M. A. Jack, 1941

unknown artist *Caernarvon Castle, North Wales*, bequeathed by Conrad White, 1905

unknown artist *The Opening of Tyne Dock, 3 March 1859*, gift from the Port of Tyne Authority, 1998

unknown artist *Still Life*, untraced find, recorded, 1982

unknown artist early 19th C, *Armoured Soldiers in Mountainous Landscape*, untraced find, recorded, 1982

unknown artist early 19th C, *Portrait of Two Women*, untraced find, recorded, 1982

unknown artist mid-19th C, *Landscape*, bequeathed by Miss M. J. Dobson, 1905

unknown artist mid-19th C, *William Armstrong*, gift from Barbara Robson, recorded, 1982

unknown artist 19th C, *Billy Purvis (1784–1853)*, bequeathed by A. J. Fenwick, 1963

unknown artist 19th C, *Billy Purvis (1784–1853)*, bequeathed by A. J. Fenwick, 1963

unknown artist 19th C, *Christ in the Temple*, untraced find, recorded, 1982

unknown artist 19th C, *Coast Scene with Boats and Figures*, gift from Sarah Greenfield, 1941

unknown artist 19th C, *Cupid*, gift from the Walker Mechanics Institute, 1942

unknown artist 19th C, *Dutch Interior*, gift from Samuel Smith, JP, 1938

unknown artist 19th C, *Emerson Muschamp Bainbridge (1817–1892)*, gift from George Bainbridge, VM, 1974

unknown artist 19th C, *Euphemia Scott (The Fishwife)*, gift from the Reverend William Wakinshaw, 1938

unknown artist 19th C, *Grace Darling (1815–1842)*, bequeathed by William Wilson, 1955

unknown artist 19th C, *Haydon Bridge, Hexham, Northumberland*, gift from Thomas Balston, 1957

unknown artist 19th C, *Highland Cattle*, gift from Miss Wilson, 1940

unknown artist 19th C, *Interior with a Carcass*, gift from J. H. Bernstone, 1933

unknown artist 19th C, *Interior with a Seated Woman*, gift from the City of Newcastle upon Tyne Archives, 1969

unknown artist 19th C, '*John Bowes*', purchased from Sotheby's, 1991

unknown artist 19th C, *John Brand*, purchased from Arthur Rogers, 1961

unknown artist 19th C, *Judith Dowling*, untraced find, recorded, 1982

unknown artist 19th C, *Landscape*, gift from Miss Elsie Wright, 1964

unknown artist 19th C, *Landscape*, gift from Miss Caroline M. A. Jack, 1941

unknown artist 19th C, *Landscape*, gift from Miss Caroline M. A. Jack, 1941

unknown artist 19th C, *Landscape with Figures, Sunset*, untraced find, recorded, 1975

unknown artist 19th C, *Landscape with Gipsy Encampment*, bequeathed by John Lamb, 1909

unknown artist 19th C, *Landscape with Horse and Cart*, untraced find, recorded, 1982

unknown artist 19th C, *Man with Horse and Lantern*, bequeathed by Sarah Ellen Dennison, 1954

unknown artist 19th C, *Mary, Queen of Scots (1542–1587)*, untraced find, recorded, 1981

unknown artist 19th C, *Moonlight Scene with Ruins*, untraced find, recorded, 1975

unknown artist 19th C, *Pietà*, untraced find, recorded, 2007

unknown artist 19th C, *Portrait of a Gentleman*, gift from L. N. Nicholson, 1947

unknown artist 19th C, *Portrait of a Lady*, gift from L. N. Nicholson, 1947

unknown artist 19th C, *Portrait of a Lady*, gift from T. R. Heppell, 1946

unknown artist 19th C, *Portrait of a Lady*, untraced find, recorded, 1982

unknown artist 19th C, *Portrait of a Man*, untraced find, recorded, 1981

unknown artist 19th C, *Portrait of a Man*, untraced find, recorded, 1983

unknown artist 19th C, *Portrait of a Young Woman*, untraced find, recorded, 1987

unknown artist 19th C, *Rustic Portrait*, untraced find, recorded, 1986

unknown artist 19th C, *Scene Outside an Inn*, untraced find, recorded, 1982

unknown artist 19th C, *Seated Man*, bequeathed by William

Wilson, 1955

unknown artist 19th C, *The Great Fire of Newcastle upon Tyne*, gift from G. H. Hill, recorded, 1983

unknown artist 19th C, *The Judgement of Paris*, untraced find, recorded, 1982

unknown artist 19th C, *The Keep, Newcastle upon Tyne*, purchased from W. M. Power, 1930

unknown artist 19th C, *The River Tyne at Prudhoe*, untraced find, recorded, 1982

unknown artist 19th C, *The Tug 'Sunbeam'*, acquired from Miss Boardman, 1949

unknown artist 19th C, *The Wife of Bartholomew Kent (Lady Susan Butler)*, gift from Mrs E. A. Kent, 1954

unknown artist 19th C, *Thomas Bewick (1753–1828)*, gift from Miss Pickering, 1942

unknown artist 19th C, *Thomas Wilcke*, untraced find, recorded, 1982

unknown artist 19th C, *Woodland Scene*, untraced find, recorded, 1982

unknown artist 19th C, *Youth in Soldier's Uniform*, untraced find, recorded, 1986

unknown artist late 19th C, *Eagle on a Cliff*, untraced find, recorded, 1981

unknown artist late 19th C, *Portrait of a Man*, untraced find, recorded, 1994

unknown artist late 19th C, *Seated Fisherman*, gift from Mrs J. Carrington, 1974

unknown artist *Setting Up the Fair*, bequeathed by A. J. Fenwick, 1963

unknown artist early 20th C, *Portrait of a Man*, gift from the City of Newcastle upon Tyne Library, 1972

unknown artist *Shipping Scene*, untraced find

unknown artist early 20th C, *Study of Trees*, untraced find, recorded, 1982

unknown artist 20th C, *Abstract*, untraced find, recorded, 2007

unknown artist 20th C, *Dancing Figures*, untraced find

unknown artist 20th C, *Expressionistic Abstract*, untraced find, recorded, 1986

unknown artist 20th C, *Landscape with Pond*, untraced find, recorded, 1982

unknown artist 20th C, '*Mauritania*', donated by the Parsons Marine Steam Turbine Company, Ltd, recorded, 2007

unknown artist 20th C, *Portrait of a Gentleman Holding a Cigarette*, gift from Mrs M. H. Webster, 1935

unknown artist 20th C, *Portrait of an Unknown Man*, untraced find, recorded, 2007

unknown artist 20th C, *Portrait of a Woman*, untraced find, recorded, 1986

unknown artist 20th C, *Portrait of a Young Man*, untraced find,

recorded, 1986

unknown artist 20th C, *Reclining Figure*, untraced find, recorded, 1986

unknown artist 20th C, *Self Portrait*, untraced find, recorded, 1986

unknown artist 20th C, *Still Life, the Little Philosopher*, untraced find, recorded, 1982

unknown artist 20th C, *Town Scene*, untraced find, recorded, 2007

unknown artist 20th C, *Two Nudes*, untraced find, recorded, 1986

unknown artist late 20th C, *Jesmond Dene, Newcastle upon Tyne*, on loan from the City of Newcastle upon Tyne

unknown artist *Robert Stephenson with 'Rocket'*, untraced find, recorded, 1961

Varley, John II 1850–1933, *Avenue of Cryptomeria Leading to the Temple of Fiaharajinshu, Nikko, Japan*, gift from Edwin Hitchon, 1948

Vaughan, John Keith 1912–1977, *Woodman in a Clearing*, gift from the Contemporary Art Society, 1959, © the estate of Keith Vaughan/DACS 2008

Verboeckhoven, Eugène Joseph 1799–1881, *Sheep in a Byre*, gift from George E. Henderson, 1934

Vinall, Joseph William Topham 1873–1953, *The Port of Liverpool*, gift from the artist, 1941

Votture, Jean active 20th C, *Fishermen with Nets*, untraced find, recorded, 1982

Wadsworth, Edward Alexander 1889–1949, *Marine Set*, purchased from the artist, 1948, © estate of Edward Wadsworth 2008. All rights reserved, DACS

Wadsworth, Edward Alexander 1889–1949, *Le Havre, France*, purchased from the artist, 1948, © estate of Edward Wadsworth 2008. All rights reserved, DACS

Walker, Ethel 1861–1951, *The Forgotten Melody*, purchased from the Fine Art Society, 1951, © the artist's estate/www.bridgeman.co.uk

Walker, Ethel 1861–1951, *In a Pensive Mood*, purchased from R. H. Spurr, 1949, © the artist's estate/www.bridgeman.co.uk

Walker, Ethel 1861–1951, *Mrs Walker and Her Children*, gift from Miss Olivia Walker, 1955, © the artist's estate/www.bridgeman.co.uk

Wall, B. (attributed to) active 19th C, *Landscape with Figures and Cattle*, bequeathed by John Lamb, 1909

Wallace, John 1841–1905, *Newcastle upon Tyne from the South-West*, gift from Samuel Smith, JP, 1930

Wallace, John 1841–1905, *Farmyard Scene*, purchased from Mrs D. White, 1976

Wallace, John 1841–1905, *October*

Bloom, Ravensworth, gift from Daniels and Cotman, 1941

Walton, Allan 1891–1948, *St Paul's*, gift from the Contemporary Art Society, 1928

Ward, Florence 1912–1984, *Quartz Inset*, purchased from the artist, 1965, © the artist's estate

Ward, Florence 1912–1984, *Integrated Shapes*, gift from the artist, © the artist's estate

Ward, James 1769–1859, *Michael Bryan and His Family*, purchased from Wellesley College, Massachusetts with the assistance of M. D. Leather, other members of the Bryan family and the National Art Collections Fund, 1958

Waterhouse, John William 1849–1917, *A Grecian Flower Market*, bequeathed by John Lamb, 1909

Waterhouse, Nora active 1963, *Linked Forms*, purchased from the artist, 1963

Waterlow, Ernest Albert 1850–1919, *Mountainous Landscape in Winter*, gift from Lady Waterlow, 1938

Waterlow, Ernest Albert 1850–1919, *Suffolk Marshes*, gift from Lady Waterlow, 1938

Waters, Ralph I 1720–1798, *Figures and Bathing Machines in the Bay below Tynemouth Castle*, purchased from Anderson and Garland with the assistance of the Museums and Galleries Commission/Victoria and Albert Museum Purchase Grant Fund, the Friends of the Laing Art Gallery and the City of Newcastle upon Tyne Trust Fund, 1986

Waters, Ralph II (attributed to) 1749–1817, *St Nicholas' Church, Newcastle upon Tyne, from the South-East*, gift from the National Art Collections Fund, 1942

Waterston, George Anthony c.1858–c.1918, *Moonlight on the Tyne*, gift from the Port of Tyne Authority, 1998

Watson, Harry 1871–1936, *A Tale by the Way*, purchased from the artist, 1922

Watson, Lyall 1908–1994, *The Market Place*, gift from Lyall Watson Junior, 1994

Watson, Robert F. 1815–1885, *Ships and Fishing Boats in Rough Seas*, gift from Miss Elsie Wright, 1964

Webb, James 1825–1895, *Seville, Spain*, bequeathed by John Lamb, 1909

Webb, James 1825–1895, *View of Mayence, Germany, with Market Boats*, gift from J. H. Dunn, 1906

Webb, James 1825–1895, *Sunset after Rain*, gift from Miss Agnes Cochrane, 1953

Webster, George 1797–1864, *Boats, Mouth of the Tyne*, bequeathed by William Wilson, 1955

Weight, Carel Victor Morlais 1908–1997, *The Alarm*, purchased from the Fieldborne Galleries with the assistance of the Friends of the Laing Art Gallery, 1976, © the estate of the artist

Weiss, José 1859–1919, *A Bright Day on the Arun*, bequeathed by George E. Henderson, 1937

Wells, Henry Tanworth 1828–1903, *Lord Armstrong (1810–1900)*, on loan from the City of Newcastle upon Tyne

Welton, Peter b.1933, *Rich Picture*, purchased from the artist, 1965, © the artist

Wetherbee, George Faulkner 1851–1920, *The Harvest Moon*, gift from John Lamb, 1907

Wil, W. D. *Young Man in Uniform*, untraced find, recorded, 1969

Wilkie, David 1785–1841, *Reading the News*, bequeathed by George E. Henderson, 1937

Wilkinson, Edward Clegg b.1862, *Spring, Piccadilly*, gift from T. Wakefield, 1906

Willats, Stephen b.1943, *Endless Cycle* (panel 1), purchased from the Lisson Gallery with the assistance of the Museums and Galleries Commission/Victoria and Albert Museum Purchase Grant Fund, 1988

Willats, Stephen b.1943, *Endless Cycle* (panel 2), purchased from the Lisson Gallery with the assistance of the Museums and Galleries Commission/Victoria and Albert Museum Purchase Grant Fund, 1988

Willis, John Henry b.1887, *Ascension Day on the Tyne in the Eighteenth Century*, purchased from the artist, 1935

Wilson, Harry P. active 1935–1938, *10 a.m.*, purchased from the artist, 1938

Wilson, Harry P. active 1935–1938, *Roundabout and Swings*, purchased from the artist, 1938

Wilson, John H. 1774–1855, *Fair on the Town Moor, Newcastle*, purchased from J. S. Bisset, 1931

Wilson, John H. 1774–1855, *St Nicholas Church, Newcastle upon Tyne*, bequeathed by Miss M. J. Dobson, 1905, on loan to Northern Rock

Wilson, John H. (attributed to) 1774–1855, *Seascape with Boats and Figures*, bequeathed by John Lamb, 1909

Wilson, Joseph Thomas (attributed to) 1808–1882, *Rabbits*, gift from Mrs M. Grove, 1928

Wilson, Richard 1714–1787, *The Alban Hills, Italy*, purchased from Arthur Tooth and Sons, 1954

Wilson, Richard (after) 1714–1787, *Landscape with Fishermen*, untraced find, recorded, 1982

Wilson, Richard (after) 1714–1787, *On the Arno, Italy*, gift from Mr Goldson, 1923

Wiszniewski, Adrian b.1958, *Aloft in the Loft*, purchased from the Nigel Greenwood Gallery with the assistance of the Museums and Galleries Commission/Victoria and Albert Museum Purchase Grant Fund, 1988, © the artist

Wit, Jacob de 1695–1754, *Autumn and Winter*, gift from Mrs Judy

Mr J. Summerbell

Helmick, Howard 1845–1907, *The Wayward Daughter*, gift from Samuel Smith, JP, 1935

Hemy, Bernard Benedict 1845–1913, *Marsden Rock*, gift from Mr J. Summerbell

Hemy, Bernard Benedict 1845–1913, *St Mary's Island*, gift from Mr J. Summerbell

Hemy, Bernard Benedict 1845–1913, *The Entrance to the Tyne*, gift from Mrs M. Laycock, 1953

Hemy, Bernard Benedict 1845–1913, *Seascape*, unknown acquisition, 1961

Hemy, Charles Napier 1841–1917, *London River, the Limehouse Barge-Builders*, gift from Mr William Albert White, 1933–1934

Hemy, Charles Napier 1841–1917, *The Last Boat In*, purchased from Dunelm Fine Art with the assistance of the Victoria and Albert Museum Purchase Grant Fund, 1990

Hill, David Octavius 1802–1870, *The Vale of the Forth and Stirling*, gift from Alderman George T. Scott, 1899

Hodge, Robert b.c.1875, *Old Shields, Wapping Street and Union Lane*, gift from Miss Wright, 1961

Hopkinson, Joseph W. active 1965–1967, *'The Old Vigilant' Inn*, gift from the artist, 1967

Horton, George Edward 1859–1950, *North Shields Fish Quay*, possibly gift from Nellie Horton, after 1956, © the artist's estate

Ireland, Jennie Moulding d.1945, *The Island, Marsden*, bequeathed by Mr David Ireland, 1952

Jefferson, Charles George 1831–1902, *Shields Beach and Tynemouth Castle*, gift from Lieutenant Colonel John Reid, 1945

Jefferson, Charles George 1831–1902, *Trow Rocks, South Shields*, gift from Mr E. Oliver, 1955–1956

Jefferson, Charles George 1831–1902, *Jesmond Dene, Newcastle upon Tyne*, gift from Mr E. Oliver, 1955–1956

Jefferson, Charles George 1831–1902, *Frenchman's Bay, South Shields*, gift from Mrs Jefferson, 1903–1904

Jefferson, Charles George 1831–1902, *Shipwreck off Tynemouth*

Jobling, Robert 1841–1923, *Fishergirl and Child*, unknown acquisition

Jobling, Robert 1841–1923, *Winter Fuel*, gift from Mr Thomas Reed, 1921

Kell, Robert John Shipley d.1934, *Peacocks Farm and Ballast Hills, Newcastle upon Tyne*, gift from Mrs M. Reed, 1966

King, Yeend 1855–1924, *Christmas Morning*, gift from Mr Thomas Reed, 1921

Langlade, Pierre 1812–1909, *La ville de La Rochelle, France*, gift from South Shields Town Hall, c.1977

Langley, William active 1880–

1920, *Aber, North Wales*, gift from Thomas Reed, 1921

Langley, William active 1880–1920, *Loch Katrine*, unknown acquisition

Langley, William active 1880–1920, *The Pass of Brander, Argyll and Bute*, unknown acquisition

Leader, Charles active 1900, *Landscape*, unknown acquisition, before 1947

Leader, Charles active 1900, *Twilight*, unknown acquisition

Leathem, William J. 1815–1857, *Sea Piece*, gift from Alderman George T. Scott, 1896

Lee, Nicholas *The Brig 'Brotherly Love' and Tug 'William'* (copy after John Scott), gift from Mr Bullock, 1959–1960

Liddell, John Davison 1859–1942, *Marsden Rock*, unknown acquisition

Liddell, John Davison 1859–1942, *St Mary's Island*, unknown acquisition

Lowe, Arthur 1866–1940, *Dry Watercourse*, gift from Mrs A. Lowe, 1944

Macklin, Thomas Eyre 1867–1943, *Alderman Thomas Dunn Marshall, Mayor (1898–1899)*, unknown acquisition

Macklin, Thomas Eyre 1867–1943, *Edmund John Jasper Browell*, unknown acquisition

McLea, Duncan Fraser 1841–1916, *The Mouth of the River Tyne, North Bank*, unknown acquisition, before 1947

McLea, Duncan Fraser 1841–1916, *Sailing Vessel in a Storm*, unknown acquisition

McLea, Duncan Fraser 1841–1916, *Scottish Landscape*, unknown acquisition

McLea, Duncan Fraser 1841–1916, *The Opening of the Albert Edward Dock, Port of Tyne*, unknown acquisition

McLea, Duncan Fraser 1841–1916, *The Wreck of the Barque 'Jacob Rothenberg', 28 November 1878*, gift from Mrs S. G. Ward, 1954

McLea, Duncan Fraser 1841–1916, *Self Portrait*, gift from Mr John Grimes, 1932

McLea, Duncan Fraser 1841–1916, *Robert Watson (1815–1885)*, gift from the South Shields Art Club Committee, before 1898

McLea, Duncan Fraser 1841–1916, *The Wreck off the South Pier*, unknown acquisition

McLea, Duncan Fraser 1841–1916, *A Bit of Old Shields*, gift from Mrs A. E. Goudie, 1976

McLea, Duncan Fraser 1841–1916, *The Entrance to the Tyne, Sunset*, gift from Mrs A. P. Whitehead, 1980

McLea, Duncan Fraser 1841–1916, *Bents House*, gift from Mrs A. P. Whitehead, 1980

McLea, Duncan Fraser 1841–1916, *Marsden Bay*, gift from Mrs B. Gasquet, 1968

Morton, J. S. active mid-20th C,

South Shields Market Place, unknown acquisition, before 1983

Nelson, Oliver *Peacocks Farm and Cottages*, gift from Councillor T. Lincoln, 1956–1957

O'Brien, Alfred Ainslie 1912–1988, *To the Rear of Woodbine Street, South Shields*, purchased from the artist, 1977

Ogilvie, Frank Stanley 1858–after 1935, *Alderman Robert Readhead, Mayor (1893–1894, 1894–1895 & 1910–1912)*, gift from Alderman Robert Readhead, 1912

Ogilvie, Frank Stanley 1858–after 1935, *John Thomas*, gift from Mr William Thomas, 1913

Ogilvie, Frank Stanley (copy of) 1858–after 1935, *Alderman Robert Readhead, Mayor (1893–1894, 1894–1895 & 1910–1912)*, unknown acquisition

Oliver, William 1804–1853, *Shipping off Dover*, gift, 1973

Pearson, J. active 1942–1964, *Wartime Scene at the Mouth of the Tyne*, gift from the artist, 1964

Pearson, J. active 1942–1964, *Comical Corner, 1929*, gift from the artist, 1957–1958

Pettitt, Edwin Alfred 1840–1912, *The Glaslyn Stream*, gift from Thomas Reed, 1927

Pick, Anton 1840–c.1905, *Alpine Scene*, unknown acquisition

Reed, Colin C. *Venice*, unknown acquisition

Robinson, C. *The 'Agincourt' Entering the Tyne*, gift from Mrs Rewcastle, 1962

Robson, J. active 1958, *Marsden Cottage, Salmon's Hall*, gift from the artist, 1958

Robson, John *The Hartley Men*, gift from Mr W. S. Robson, 1955–1956

Robson, Robert Kirton *The Mouth of the Tyne from the Black Middens*, gift from Mrs S. G. Ward, 1954

Robson, Robert Kirton (style of) *The Southern End of Marsden Bay*, unknown acquisition

Rosell, Alexander 1859–1922, *A Present for the Front*, gift from Mr Thomas Reed, 1921

Rutherford, Charles active 1890–1911, *Marsden Rock*, unknown acquisition

Rutherford, Charles active 1890–1911, *North Bay, Tynemouth*, unknown acquisition

Schafer, Henry Thomas 1854–1915, *Feeding the Pigeons*, gift from Samuel Smith, JP, 1935

Scott, H. C. B. *The Wreck of the Russian Ketch 'Julerneck' off Marsden Cliffs, 1901*, purchased from Mr G. E. Elliot, 1964

Scott, John 1802–1885, *The Brig 'Margaret'*, gift from Miss Amy Celia Flagg, 1945–1946

Scott, John 1802–1885, *Tyne Wherry at the Mill Dam*, bequeathed by Mr Benjamin Gibson, 1888

Scott, John 1802–1885, *The Paddle-Tug 'Henry Wright'*, unknown acquisition

Scott, John 1802–1885, *The Opening of Tyne Dock*, gift from Mr J. H. Oliver, 1967

Scott, John 1802–1885, *A Wreck off the South Pier*, gift from the Scott Family, 1885

Scott, John 1802–1885, *The Brig 'Brotherly Love' and Tug 'William'*, bequeathed by Mr William Allen, 1961

Scott, John 1802–1885, *The Collier Brig 'Mary'*, gift from Mrs Wheldon, 1953

Scott, John 1802–1885, *The Collier Brig 'Sicily'*, gift from Mr J. Davis, 1962

Scott, John 1802–1885, *The Entrance to the Tyne*, purchased from Mrs Bessie Schofield, 1954

Scott, John 1802–1885, *The Wreck*, gift from Mr George Scott, 1959–1960

Shearer, Jacob b.1846, *Shipwreck*, unknown acquisition

Slater, John Falconar 1857–1937, *Afterglow, Hexham, Northumberland*, gift from Mr Thomas Reed, before 1929

Slater, John Falconar 1857–1937, *Cullercoats Bay*, unknown acquisition

Stanger, J. H. active early 20th C, *A Mountain Forest*, gift from Mrs Mee, 1963

Stephenson, Henry active 1889–1921, *Alderman John Taylor, Mayor (1915–1916)*, transferred from South Shields Town Hall, c.1977

Sticks, George Blackie 1843–1938, *The Cliffs at Marsden Bay*, gift from Mrs M. Strachan, 1950

Surtees, John 1819–1915, *A Fine Morning in the Valley of the Lledr, North Wales*, gift from Thomas Reed, 1920

Thompson, Mark 1812–1875, *The Opening of Tyne Dock*, gift from Robert King, 1942–1943

Thornton, Ronald William b.1936, *Marine Grotto, Marsden*, gift from the artist, 1969, © the artist

unknown artist *South Shields Market Place*, gift from Mr Thomas Henderson, 1875–1876

unknown artist *Shipwrecks off the Tyne*, unknown acquisition

unknown artist *Harbour and Castle at Sunset*, unknown acquisition

unknown artist *Portrait of a Man*, unknown acquisition

unknown artist *James Cochran Stevenson (1825–1905)*, transferred from South Shields Town Hall, c.1977

unknown artist *Elisa Ramsay Stevenson, née Anderson (1830–1908)*, transferred from South Shields Town Hall, c.1977

unknown artist *The Brig 'Darius'*, gift from Miss Bell, 1961

unknown artist *Portrait of a Child*, unknown acquisition

unknown artist mid-19th C, *Portrait of a Young Man*, unknown acquisition

unknown artist mid-19th C, *Portrait of an Unknown Man*,

unknown acquisition

unknown artist 19th C, *British Men-O'-War*, unknown acquisition

unknown artist 19th C, *East Indiaman and Cutter*, unknown acquisition

unknown artist 19th C, *Entrance to the Tyne*, gift from Thomas Reed, 1926–1927

unknown artist *Portrait of an Unknown Man* (possibly Harry McDermott), gift from Mr H. McDermott, 1962

unknown artist *Farmyard Scene*, gift, 1970

Vernet, Horace (after) 1789–1863, *The Departure of Napoleon for Elba*, unknown acquisition

Sunderland Museum and Winter Gardens

Adams, John Clayton 1840–1906, *Weeds by the River Dart*, purchased, 1893

Allan, Griselda b.1905, *The Construction of Thompson's Shipyard, Southwick*, purchased from Mrs Griselda Buddeberg, 1979

Allan, Griselda b.1905, *Berkshire Landscape*, purchased from Mrs Griselda Buddeburg, 1958

Allan, Griselda b.1905, *Clematis*, transferred from Sunderland Borough Council, 1970

Allan, Griselda b.1905, *Larkspur*, transferred from Sunderland Borough Council, 1970

Allan, Griselda b.1905, *Michaelmas Daisy*, transferred from Sunderland Borough Council, 1970

Allinson, Adrian Paul 1890–1959, *Flower Piece*, purchased from the artist, 1949

Anderson, E. *Introduction of Printing into England, Caxton, 1477*, transferred from Sunderland Borough Council, 1970

Ansdell, Richard 1815–1885, *A Spate in Glen Spean, Inverness*, bequeathed by John Dickinson, 1908

Anthony, Henry Mark (attributed to) 1817–1886, *Sunset, the Woodman's Cottage*, bequeathed by John Dickinson, 1908

Archer, Roy D. active 1963–1964, *Yellow Figure*, purchased from the artist, 1964

Ayrton, Michael 1921–1975, *Slow Dance for the Nativity*, purchased from Mrs Elizabeth Ayrton with the assistance of the Victoria and Albert Museum Purchase Grant Fund, 1978, © the artist's estate

Bailey, Dulcie *Bramble*, transferred from Sunderland Borough Council, 1970

Bailey, Dulcie *Daffodil*, transferred from Sunderland Borough Council, 1970

Bailey, Dulcie *Foxglove*, transferred from Sunderland Borough Council, 1970

Banner, Delmar Harmond 1896–

1983, *Great Gable from Wandope*, gift from the artist, 1948, © the artist's estate

Barland, Adam active 1843–1916, *Mountain Landscape with River*, untraced find

Baxter, Charles 1809–1879, *Mrs Thompson of Sunderland*, bequeathed by Mr T. Thompson, 1895

Beavis, Richard 1824–1896, *The Story of the Wreck*, purchased, 1893

Beavis, Richard 1824–1896, *A Border Raid on an English Castle*, bequeathed by John Dickinson, 1908

Beavis, Richard 1824–1896, *The Passage of the Bidassoa*, bequeathed by John Dickinson, 1908

Beddall, Kathlyn b.1920, *Sunlight in Old Church Street, Chelsea*, purchased from the New English Art Club Exhibition, 1949

Bell, J. active 1885–1895, *SS 'J. W. Taylor', Sunderland*, gift from Miss E. E. Brown, before 1970

Bell, Stuart Henry 1823–1896, *Bents Farm, Whitburn*, gift from Mrs E. Leckonby, 1959

Bell, Stuart Henry 1823–1896, *Moving of the Old North Pier Lighthouse, Sunderland, 1841*, bequeathed by Howell Egglishaw, 1928

Bell, Stuart Henry 1823–1896, *Marsden Rock*, gift from Miss M. H. Williams, 1991

Bell, Stuart Henry 1823–1896, *Sunderland 1855, Morning after a Heavy South-Eastern Gale*, gift from Alderman J. F. Whitehead, 1961

Bell, Stuart Henry 1823–1896, *'Sea-Coopering' Fishing Up Christmas Cheer*, gift from Miss Robinson, 1984

Bell, Stuart Henry 1823–1896, *Sunderland Harbour in 1859, the Barque 'Hedvig'*, gift from Mr Holmes, 1948

Bell, Stuart Henry 1823–1896, *Wreck in Sunderland Harbour* (as it appeared about 1850), gift from Captain W. J. Oliver, 1952

Bell, Stuart Henry 1823–1896, *Entrance to Sunderland Harbour in a North-East Gale*, on loan from a private individual, since 1962

Bell, Stuart Henry 1823–1896, *Old South Pier and Lighthouse, Sunderland*, on loan from a private individual, since 1962

Bell, Stuart Henry 1823–1896, *Sunderland Harbour in 1854*, purchased from Mrs E. Gibbins, 1936

Berrie, John Alexander Archibald 1886–1962, *King George V at Doxford's Shipyard, 16 June 1917*, transferred from the Sunderland Corporation, 1968 (?)

Bewick, William (attributed to) 1795–1866, *Mrs Andrew White*, gift from John Sanderson, JP, 1894

Bewick, William (attributed to) 1795–1866, *Andrew White (1792–1856), Mayor of Sunderland*, gift from John Sanderson, JP, 1894

Birch, Samuel John Lamorna 1869–1955, *The Morning Mist*, purchased from the artist, 1938, © the artist's estate

Blackman, E *Poppy*, transferred from Sunderland Borough Council, 1970

Blair, John 1850–1934, *The Tweed above Norham Castle, Northumberland*, purchased, 1887

Bolton, Elaine *Landscape with Trees*, untraced find

Bradford, William 1823–1892, *Arctic Regions*, bequeathed by Sir E. T. Gouley, 1903

Bradshaw, George Fagan 1888–1961, *'HMS Delhi'*, gift from the artist, 1944, © the artist's estate

Bradshaw, George Fagan 1888–1961, *Lobster Fishing*, purchased from the artist, 1944, © the artist's estate

Brett, John 1830–1902, *Procession of Craft up to Bristol in a Fog*, purchased, 1901

Brewster, Paul b.1960, *Christina Kirk*, gift from the artist, 1998

Brown, J. Gillis 1808–1892, *Salvation Army*, gift from Miss Rutter, 1930

Brown, J. Gillis 1808–1892, *Tommy Sanderson, Town Crier*, gift from Miss Rutter, 1930

Brown, J. Gillis 1808–1892, *William Brown of Monkwearmouth*

Brown, R. *Miss Barnes*, gift from Charles Johnson, 1962

Brown, R. *Dr William Barnes*, bequeathed by Charles Johnson, 1962

Buckner, Richard 1812–1883, *Portrait of a Lady Wearing a White Dress*, acquired, before 1974

Burgess, Arthur James Wetherall 1879–1957, *The 'Reedsman'*, gift from North Eastern Shipbuilders Ltd, 1989, © the artist's estate

Burgess, G. *Bede Conversing in the Guest House*, transferred from Sunderland Borough Council, 1970

Burrows, Robert 1810–1893, *Gainsborough's Lane*, acquired, before 1974

Caffieri, Hector 1847–1932, *Little Truant*, purchased, 1887

Cairns, Joyce W. b.1947, *Midnight Manoeuvres*, gift from the Contemporary Arts Society, 1988, © the artist

Cairns, Joyce W. b.1947, *Warning Bell on the North Pier*, gift from the Contemporary Arts Society, 1988, © the artist

Campbell, M. *'You must think beautiful thoughts '*, (from 'Peter Pan' by J. M. Barrie), transferred from Sunderland Borough Council, 1970

Campbell, Meriel b.1912, *Lackagh Bridge, County Donegal, Ireland*, purchased from the Art Exhibitions Bureau, 1959

Carmichael, John Wilson 1800–1868, *Old Hartlepool*, bequeathed by John Dickinson, 1908

Carmichael, John Wilson 1800–1868, *Murton Colliery, County Durham*, purchased from Anderson and Garland, 1954

Carmichael, John Wilson 1800–1868, *The Opening of Sunderland South Docks, 20 June 1850*, gift from the Port of Sunderland Authority, 1973

Carmichael, John Wilson 1800–1868, *The Opening of Sunderland South Docks, 20 June 1850*, transferred from the Port of Sunderland Authority, 1973

Carmichael, John Wilson 1800–1868, *Entrance to Sunderland Harbour*, transferred from the Port of Sunderland Authority, 1973

Carmichael, John Wilson 1800–1868, *Sunderland Pier*, transferred from the Port of Sunderland Authority, 1973

Carmichael, John Wilson 1800–1868, *Sunderland Harbour*, purchased from Messrs Frost and Reed with the assistance of the Victoria and Albert Museum Purchase Grant Fund, 1967

Carmichael, John Wilson 1800–1868, *Off Whitby*

Carmichael, John Wilson 1800–1868, *Shipping on the Solent, off Calshot Castle*, on loan from Mrs K. Doxford

Carmichael, John Wilson 1800–1868, *Sunderland Harbour, 1866*, purchased from Mawson, Swan and Morgan, 1934

Carmichael, John Wilson 1800–1868, *Wind Freshening off Hull*, gift from Dr Elizabeth N. Neil, 1941

Carmichael, John Wilson (attributed to) 1800–1868, *Sunderland Pier with the Old Lighthouse*, transferred from the Port of Sunderland Authority, 1973

Carmichael, John Wilson (attributed to) 1800–1868, *Shipping in a Calm*, purchased, 1884

Chalon, Alfred Edward (follower of) 1780–1860, *Sarah Dorothy Hall (1831–1874)*, gift from Mr A. S. Bowes, 1964

Chalon, John James 1778–1854, *Shipping in an Estuary*, purchased, 1896

Chevalier, Nicholas 1828–1902, *Sunny Climes, Tahiti*, bequeathed by John Dickinson, 1908

Chevalier, Nicholas 1828–1902, *Seeking Fortune*, purchased, 1890

Christie, Ernest C. 1863–1937, *Marsden Bay*, acquired, before 1977

Christie, J. W. (attributed to) *Seascape*, untraced find, 1985

Clark, James 1858–1943, *Magnificat*, purchased, 1888, © the artist's estate/www.bridgeman.co.uk

Clark, Joseph 1835–1913, *The Sick Boy*, purchased, 1899

Claughan, Edward. W. *Kepier Hospital Gateway, Durham*, gift from Mrs E. Hawes, 1954

Clough, Prunella 1919–1999, *Midland Landscape II*, purchased from the Piccadilly Gallery with the assistance of the Victoria and Albert Museum Purchase Grant Fund, 1965, © estate of Prunella Clough 2008. All Rights Reserved DACS.

Cockerham, Charles active c.1900–1935, *'SS Winkfield' Bound for South Africa with Troops, July 1890*, on loan from Short Brothers Shipbuilders, since 1962

Cole, George Vicat (attributed to) 1833–1893, *Farmyard with Stables*, gift from Mr F. M. Johnson, 1953

Collier, John 1850–1934, *James Laing (1823–1901)*, gift from the Port of Sunderland Authority, 1973

Collier, John 1850–1934, *Theban Hills from Luxor*, purchased from the artist, 1920

Colquhoun, Alice E. *The Pied Piper of Hamelin*, transferred from Sunderland Borough Council, 1970

Connell, William active 1871–1925, *Holey Rock, Roker, Sunderland*, gift from Mrs E. Cowie, 1967

Cornthwaite, René *Columbine*, transferred from Sunderland Borough Council, 1970

Cornthwaite, René *Cornflower*, transferred from Sunderland Borough Council, 1970

Cracknell, Gertie *Viper's Bugloss*, transferred from Sunderland Borough Council, 1970

Cracknell, Gertie *Water Flag*, transferred from Sunderland Borough Council, 1970

Cracknell, Gertie *Wild Rose*, transferred from Sunderland Borough Council, 1970

Crawford, Edmund Thornton 1806–1885, *Shields Harbour*, purchased from John Grant Ltd, 1946

Crosby, Frederick Gordon 1885–1943, *Well at Fulwell, 1879*, bequeathed by Mr and Mrs C. Bell, 1976

Crosby, Frederick Gordon 1885–1943, *The Village Pond and West Farm, Fulwell*, bequeathed by Mrs Margaret Dixon, 1982

Crosby, William 1830–1910, *Roker Beach*, purchased from Sotheby's, 1990

Crosby, William 1830–1910, *William Snowball*, gift from William Snowball, before 1900

Crosby, William 1830–1910, *Edward Backhouse (1808–1879)*, gift from the artist

Crosby, William 1830–1910, *Whitburn Bay*, gift from Mr J. Moore, before 1906

Crosby, William 1830–1910, *Holey Rock, Roker, Sunderland*, on loan from a private individual, since c.1936–1939

Crozier, William b.1930, *Red Hill*, purchased from Messrs A. Tooth & Sons, 1965, © William Crozier

Dalrymple-Smith, Edith Alexandra 1895–1958, *Mowbray Park, Sunderland, Early Morning*, purchased from Miss M. Dalrymple-Smith, 1959, © the artist's estate

Danby, James Francis 1816–1875, *Loch Fyne with Inverary Castle from the South West*, bequeathed by John Dickinson, 1908

Danby, Thomas 1818–1886, *Poet's Dream*, bequeathed by John Dickinson, 1908

Dibdin, J. active 19th C, *Shipping*, gift from Mrs Robinson, 1961

Dicksee, Thomas Francis 1819–1895, *Juliet*, bequeathed by Miss E. Dickinson, 1937

Dixon, Alfred 1842–1919, *Forsaken*, gift from friends of the artist, before 1974

Dixon, Alfred 1842–1919, *Thomas Dixon (1831–1880)*, gift from Thomas Dixon, 1887

Dodd, Francis 1874–1949, *Spring in the Suburbs*, purchased from the Art Exhibitions Bureau, 1950, © the artist's estate

Douglas, Phoebe Sholto b.1906, *Clarence Lawson Wood (1878–1957)*, gift from the artist, 1958

Drinkwater, Alfred Milton 1860–1917, *Portrait of a Woman and a Dog*, gift from Miss Duncan, 1970

Drinkwater, Alfred Milton 1860–1917, *Landscape with Lake*, gift from J. S. Mason, 1964

Drinkwater, Alfred Milton 1860–1917, *Landscape with Mountain and Lake*, gift from J. S. Mason, 1964

Drinkwater, H. F. C. 1862–1949, *Girdle Cake Cottage on the Wear*, purchased from Mr B. G. Blyth, 1939

Duffield, William 1816–1863, *Fruit*, bequeathed by John Dickinson, 1908

Elliott, Robinson 1814–1894, *School Time*, purchased, 1884

Emmerson, Henry Hetherington 1831–1895, *Wool Gathering*, purchased, 1883

Emmerson, Henry Hetherington 1831–1895, *North Tyne*, gift from Miss Jane O. S. Elgood, 1952

Etty, William (attributed to) 1787–1849, *Aaron the High Priest*, bequeathed by Mr T. Thompson, 1895

Ewbank, John Wilson c.1799–1847, *Calm Morning off the Dutch Coast*, gift from Snaton Hall, before 1974

Faed, Thomas 1826–1900, *'Oh, why I left my hame?'*, purchased, 1901

Faed, Thomas 1826–1900, *'And with the burden of many years'*, purchased, 1901

Fannen, John 1857–1904, *Steamship 'German Emperor'*, gift from Mr William Todd , 1971

Fannen, John 1857–1904, *Iron Barque 'Regent'*, purchased from Robert Thompson and Sons, 1933

Fannen, John 1857–1904, *The 'Royal Duke'*, unknown acquisition

Farthing, Stephen b.1950, *Fish Dish*, gift from the Contemporary Arts Society, 1983, © the artist

Fell, Sheila Mary 1931–1979, *Winter, Cumberland I*, purchased from the Messrs Tooth Gallery

with the assistance of the Contemporary Art Society, 1963

Ferguson, James W. active 1885–1922, *The Tug 'Rescue' Towing the Brig 'Polly' into Sunderland Harbour*, gift from Mrs J. Edmundson, 1945

Foley, Henry John 1818–1874, *Market Day at a Town in Normandy, France*, gift from Mr J. M. Mackay, 1964

French, Nancy *Honeysuckle*, transferred from Sunderland Borough Council, 1970

French, Nancy *Thistle*, transferred from Sunderland Borough Council, 1970

Frost, Terry 1915–2003, *Suspended Forms*, gift from the Contemporary Arts Society, 1972, © the estate of Terry Frost

Gallon, Robert 1845–1925, *Tributary of the Wharfe, Yorkshire*, bequeathed by John Dickinson, 1908

Garland, Henry 1834–1913, *Crossing the Ford*, purchased, 1886

Garrick, Jean Olive d.1972, *Abstract No.3*, bequeathed by the artist, 1972

Garrick, Jean Olive d.1972, *The Snow Scene*, bequeathed by the artist, 1972

Garrick, Jean Olive d.1972, *Yachts, Roker*, bequeathed by the artist, 1972

Garrick, Jean Olive d.1972, *Young Girl*, bequeathed by the artist, 1972

Garvie, Thomas Bowman 1859–1944, *Harry Poore Everett*, gift from the Port of Tyne Authority, 1970

Giachi, E. active 1890–1891, *Tavern Brawl*, gift from the Port of Sunderland Authority, 1973

Gibb, Thomas Henry 1833–1893, *Thus Far*, gift from Mr Robert Thompson, 1883

Gilbert, John 1817–1897, *Brigands Dividing the Booty*, purchased, 1896

Glindoni, Henry Gillard 1852–1913, *'To be or not to be'*, purchased, 1903

Goodall, Frederick 1822–1904, *Subsiding of the Nile*, purchased, 1899

Graham, George 1881–1949, *Wensley Village, Yorkshire*, purchased from R. E. Abbott and Co., 1958

Grant, Francis 1803–1878, *George Hudson (1800–1871)*, gift from the Port of Sunderland, 1973, on loan to Monkwearmouth Station Museum

Green, Ernest d.1960, *Durham Road, Silksworth Lane Corner*, gift from the artist, 1952

Green, Ernest d.1960, *'Dun Cow' Inn, Seaton village*, purchased from J. Tiplady, 1973

Green, Ernest d.1960, *Seaton Village*, purchased from J. Tiplady, 1973

Green, Ernest d.1960, *Seaton Village*, purchased from J. Tiplady, 1973

Grimshaw, Louis Hubbard 1870–

1944, *Sunderland Harbour*, purchased from Mr A. H. Dodd with the assistance of the National Art Collections Fund and the Museums and Galleries Commission/Victoria and Albert Museum Purchase Grant Fund, 1997

Gross, Anthony 1905–1984, *Wheatfield*, purchased from Brown, Ernest and Phillips Ltd, with the assistance of the Victoria and Albert Museum Purchase Grant Fund, 1963, © Anthony Gross, RA, CBE - painter/etcher

Halfnight, Richard William 1855–1925, *Eventide*, gift, before 1969

Halfnight, Richard William 1855–1925, *Summertime on the Thames*, gift from Mr T. W. Backhouse, 1892

Hall, Frederick 1860–1948, *Hampshire Downs*, purchased from the Cornish Art Exhibition, 1938, © the artist's estate/www.bridgeman.co.uk

Hall, Oliver 1869–1957, *Ronda, Spain*, gift from J. W. Corder, 1947, © the artist's estate

Hall, R. M. active 1887–1888, *Mill at Ryhope Grange, Sunderland*, bequeathed by Mrs Margaret C. Mellentin, 1980

Hard, R. *The Brig 'Thomas and Elizabeth' of Sunderland*, gift from Mr N. Carter, 1963

Harding, James Duffield 1798–1863, *Beilstein on the Moselle, Germany*, bequeathed by John Dickinson, 1908

Harper, Edward b.1970, *Gun Street*, presented by the Contemporary Art Society, 2000, © the artist

Hastings, Edward 1781–1861, *Sunderland Harbour from Roker*, purchased from Ackerman, 1977

Haswell, John 1855–1925, *Mountain Torrent, Melting Snow*, gift from Miss P. Haswell, 1969

Haswell, John 1855–1925, *After the Storm*, gift from Mr P. Haswell, 1955

Haswell, John 1855–1925, *Philip and V. M. Haswell, Aged 8 and 6*, gift from Miss P. Haswell, 1970

Hedley, Johnson 1848–1914, *'Emily Smead', Aground at Sunderland*, gift from Mr E. Green, 1952

Hedley, Johnson 1848–1914, *Girdle Cake Cottage*, bequeathed by A. Victor C. Cross, 1992

Hedley, Johnson 1848–1914, *Hylton Ferry*, gift from Mr E. Green, 1951

Hedley, Johnson 1848–1914, *Holey Rock, Roker, Sunderland*, gift from Mr J. M. Mackay, 1964

Hedley, Johnson 1848–1914, *Red House Farm, Tunstall Road*, gift from Mr E. Green, 1952

Hedley, Ralph 1848–1913, *Smithy, Hexham, Bridge End*, gift from Alderman Preston, 1885

Hedley, Ralph 1848–1913, *Duty Paid*, purchased, 1897

Hedley, Ralph 1848–1913, *John*

Dickinson (d.1908), gift from John Dickinson, 1908

Hedley, Ralph 1848–1913, *Ralph Milbanke Hudson (1849–1938), JP*, transferred from the Port of Sunderland Authority, 1973

Hedley, Ralph 1848–1913, *Hylton Ferry*, gift from Mr F. Aitchison, 1948

Hemy, Thomas Marie Madawaska 1852–1937, *Old Sunderland*, gift from T. W. Backhouse, before 1978

Herbert, John Rogers 1810–1890, *Landscape with Lake and Greek Soldiers*, gift from Mr W. M. Quenet, 1965

Herring, John Frederick II 1815–1907, *Ducks and Ducklings*, gift from James Wilson, 1955

Herring, John Frederick II 1815–1907, *The Valley of Love, Hendon, Sunderland*, gift from Mr and Mrs C. T. Dale, 1940

Hindley, Godfrey C. active 1873–1914, *A Chapter of Accidents*, purchased, 1881

Hiram (attributed to) active early 20th C, *'SS Hesleyside'*, purchased from Mr B. W. Ardin, 1983

Holder, Edward Henry 1847–1922, *Borrowdale, Cumbria*, gift from Samuel Smith, JP, 1934

Holmes, Walter b.1936, *The 'Challenger'*, gift from the North Eastern Shipbuilders Ltd, 1989, © Walter Holmes, www.walterholmesart.com

Hopper, J. D. *The Valley of Love, Hendon, Sunderland*, gift from Mr A. H. Flintoff, 1952

Hornel, Edward Atkinson 1864–1933, *In a Japanese Garden*, purchased, c.1923/1924

Horsley, Thomas (attributed to) active 1784–1790, *Reverend John Wesley (1703–1791)*, unknown acquisition, before 1900

Huckwell, T. active late 20th C, *The 'Cedarbank'*, gift from the North Eastern Shipbuilders Ltd, 1989

Hudson, John 1829–1897, *Snow 'Charles Henry'*, gift from R. C. Anson, 1950

Hudson, John 1829–1897, *Brig 'Friends'*, gift from Mr J. W. Sheraton, 1969

Hudson, John 1829–1897, *SS 'Cogent' of Sunderland*, purchased from Owen Humble, 1975

Hudson, John 1829–1897, *Barque 'Lota'*, gift from Miss L. Hall, 1950

Hudson, John 1829–1897, *Steam Tug 'Rescue'*, gift from Mr R. L. C. Baister, 1948

Hudson, R. M. 1899–1956, *North Dock, Sunderland*, purchased from the Sunderland Art Club, 1956

Hughes, Terence active 20th C, *Blue Landscape*, purchased from the Northern Advisory Council for Further Education, 1964

Hughes-Stanton, Herbert Edwin Pelham 1870–1937, *The Road to the Sea*, purchased from R. E. Abbott and Co., 1958

Hughes-Stanton, Herbert Edwin Pelham 1870–1937, *Autumn Day from Brithdir, North Wales*,

purchased from Charles Bell, c.1969

Hulk, Abraham I (attributed to) 1813–1897, *Dutch Fishing Boats*, gift from Mr H. Hayes, 1884

Hulk, Abraham II 1851–1922, *Alverston Mill, Isle of Wight*, gift from Mr R. Spain, 1947

Hunt, Edgar 1876–1953, *Farmyard Scene*, gift from James Wilson, 1956

Hunt, Edgar 1876–1953, *Just in Time*, acquired, before 1974

Hunt, Edgar 1876–1953, *Hens with Their Young*, bequeathed by Mr Robert Youll, 1919

Hunt, Walter 1861–1941, *Babes in the Wood*, purchased, 1893

Jack, Richard 1866–1952, *Love Tunes the Shepherd's Reed*, purchased, 1930, © the artist's estate

Jack, Richard 1866–1952, *Stansfield Richardson, JP*, gift from Mrs Richardson and Mr S. P. Richardson (son), 1920, © the artist's estate

Jack, Richard 1866–1952, *Mrs Stansfield Richardson, MBE*, gift, 1921, © the artist's estate

Jack, Richard 1866–1952, *Irish Landscape*, purchased from R. E. Abbott and Co., 1956, © the artist's estate

Jefferson, John active 1811–1825, *Robert Thompson (1748–1831)*, transferred from Sunderland Borough Council, 1948

Jobling, Robert (attributed to) 1841–1923, *Boats on a Slipway*, purchased, 1883

Johnston, Alexander 1815–1891, *A Scene from 'The Lady of the Lake'*, bequeathed by John Dickinson, 1908

Jones, Allen b.1937, *Sun Plane*, purchased from Messrs A. Tooth & Sons with the assistance of the Victoria and Albert Museum Purchase Grant Fund, 1963, © Allen Jones

Jonniaux, Alfred 1882–1974, *A Member of the Short (Shipbuilding) Family*, gift from Mr John H. Short, 1964

Kemm, Robert 1837–1895, *The Sleeping Priest*, gift from John Dickinson, 1879

Kite, W. F. active mid-20th C, *Street Scene No.1*, purchased from the Annual Exhibition of the Sunderland Art Club, 1961

Klin, Leo 1887–1967, *Silver Tankard*, purchased from the artist, 1948

Kneller, Godfrey (style of) 1646–1723, *Jane Ettrick (d.1700)*, on loan from the Sunderland Antiquarian Society

Koekkoek, Hendrik Pieter 1843–c.1890, *Landscape with Cattle*, gift from Councillor Jackson, 1899

Lambert, Walter H. 1870/1871–1950, *Cottage and Garden*, acquired from the Sunderland Corporation, 1975

Landseer, Charles 1799–1879, *A Scene from Walter Scott's 'The*

Talisman', bequeathed by John Dickinson, 1908

Landseer, Edwin Henry 1802–1873, *Bolton Court in Olden Times*, bequeathed by John Dickinson, 1908

Lee, Rosa b.1957, *Reflection*, gift from the Contemporary Art Society, 1986, © the artist

Lee, Sydney 1866–1949, *Durham Cathedral*, purchased from R. E. Abbott and Co., 1955

Legros, Alphonse 1837–1911, *Tired Wanderer*, gift from the artist, 1879

Legros, Alphonse 1837–1911, *Thomas Dixon (1831–1880)*, gift from the artist, 1879

Legros, Alphonse 1837–1911, *Portrait of a Lady*, gift from the artist, 1881

Leycester-Roxby, Edmund 1913–2001, *Mother and Child*, gift from Mr L. M. Angus-Butterworth, 1971, © the artist's estate

Lindoe, V. b.1918, *Ancient Mariner, 'Alone, alone, all, all alone, alone on a wide, wide sea!'*, transferred from Sunderland Borough Council, 1970

Lindoe, V. b.1918, *The Walrus and the Carpenter', from Lewis Carroll*, transferred from Sunderland Borough Council, 1970

Linnell, John (attributed to) 1792–1882, *On the Thames*, gift from Mr Samuel Smith, JP, 1935

Lowe, Arthur 1866–1940, *Tollerton Lake, near Nottingham*, gift from Mrs M. Lowe, 1944

Lowes, Audrey *Broom*, transferred from Sunderland Borough Council, 1970

Lowes, Audrey *Globe Flower*, transferred from Sunderland Borough Council, 1970

Lowry, Laurence Stephen 1887–1976, *River Wear at Sunderland*, purchased from the Lefevre Gallery with the assistance of the National Art Collections Fund, 1963, © courtesy of the estate of L. S. Lowry

Lowry, Laurence Stephen 1887–1976, *Dockside, Sunderland*, purchased from Michael Singer with the assistance of the Heritage Lottery Fund, the Museums, Libraries and Archives Council/Victoria and Albert Museum Purchase Grant Fund, the Friends of Sunderland Museum and the Insurance Fund, 2004, © courtesy of the estate of L. S. Lowry

Lowry, Laurence Stephen 1887–1976, *The Sea at Sunderland*, purchased from Michael Singer with the assistance of the Heritage Lottery Fund, the Museums, Libraries and Archives Council/Victoria and Albert Museum Purchase Grant Fund, the Friends of Sunderland Museum and the Insurance Fund, 2004, © courtesy of the estate of L. S. Lowry

Lowry, Laurence Stephen 1887–1976, *Self Portrait I*, purchased from Michael Singer with the

assistance of the Heritage Lottery Fund, the Museums, Libraries and Archives Council/Victoria and Albert Museum Purchase Grant Fund, the Friends of Sunderland Museum and the Insurance Fund, 2004, © courtesy of the estate of L. S. Lowry

Lowry, Laurence Stephen 1887–1976, *Girl in a Red Hat on a Promenade*, on loan from a private collection, © courtesy of the estate of L. S. Lowry

Lowry, Laurence Stephen 1887–1976, *Self Portrait II*, bequeathed to Tyne and Wear Museums Service, 2004, © courtesy of the estate of L. S. Lowry

MacPherson, Neil b.1954, *The Singing Lovers' Farewell*, gift from the Contemporary Art Society, 1992, © the artist

Marshall, Daniel Whiteley active 1875–1900, *Mackie's Corner, Sunderland, High Street West, Looking East*, gift from Mrs A. Germain, 1971

Marshall, Daniel Whiteley active 1875–1900, *Reverend Arthur A. Rees*, gift from the artist, before 1906

Marshall, Daniel Whiteley active 1875–1900, *Tunstall Road, Sunderland*, unknown acquisition

Marshall, Daniel Whiteley active 1875–1900, *Winter Gardens Interior, Sunderland*, bequeathed by Mrs Annie Marshall, 1949

Marshall, Daniel Whiteley active 1875–1900, *Fawcett Street, Sunderland about 1895*, gift from J. A. B. Whitehouse, 1949

Marshall, Daniel Whiteley active 1875–1900, *John Green*, unknown acquisition

Marshall, John Fitz 1859–1932, *Fragrant Hawthorn*, purchased, 1886

McCrum, J. P. *Early Man on the Wear*, transferred from Sunderland Borough Council, 1970

McCrum, J. P. *'Saw the heavens fill with commerce'*, transferred from Sunderland Borough Council, 1970

McLea, Duncan Fraser 1841–1916, *Robert Thompson's Shipyard at Southwick*, purchased from Messrs Robert Thompson and Sons, 1933

Merriott, Jack 1901–1968, *The Open Gate*, purchased from the Art Exhibitions Bureau, 1959

Methuen, Paul Ayshford 1886–1974, *Winter Landscape, Corsham, Wiltshire*, purchased from Abbott and Holder, 1962, © trustees of the Corsham estate

Metz, Gustav 1817–1853, *The Death of Rachel*, gift, 1880

Miles, Thomas Rose active 1869–c.1910, *Away to the Goodwin Sands (Dover Lifeboat)*, acquired, 1906

Mills, R. *Off Sunderland*, gift from Robert Stobbs, 1957

Mills, Frederick 1855–1939, *In the Heart of the Cotswolds*, gift from Mr H. S. P. Maitland, 1920

Milner, Frederick 1855–1939, *In the Valley, Vale of Lanherne, Cornwall*, gift from Mrs S. Milner, 1940

Mogford, John 1821–1885, *Culzean Castle, Ayrshire*, purchased, 1899

Moore, Sally b.1962, *Figure in a Studio*, gift from the Contemporary Art Society, 1986, © the artist

Morris, Philip Richard 1838–1902, *Where They Crucified Him*, purchased, 1903

Moseley, Richard S. c.1843–1914, *'Rose', 'Shamrock' and 'Thistle'*, gift from Councillor J. W. Wayman, before 1906

Mostyn, Thomas Edwin 1864–1930, *In an Old-World Garden*, gift from Councillor James Wilson, 1920

Muller, Robert Antoine c.1821–1883, *Visit of the Doge of Venice to Titian*, gift from J. Wallace Taylor, 1903

Muncaster, Claude 1903–1979, *March Morning, Newby Bridge, Cumbria*, purchased from the Art Exhibitions Bureau, 1958, © the artist's estate

Murray, David 1849–1933, *Where the Wind and the Waves and a Lone Shore Meet*, gift from the executor's of the artist's estate, 1939

Murray, Edward active 1973–1974, *Low Tide, Bembridge, Isle of Wight*, purchased from the artist, 1974

Nash, John Northcote 1893–1977, *Flowers in a Blue Vase*, purchased from Abbott and Holder, 1961, © the artist's estate/www.bridgeman.co.uk

Newton, Herbert H. 1881–1959, *Steepy Shore, French Riviera*, gift from C. Hanrott, 1926

Niemann, Edmund John 1813–1876, *Richmond Castle, Yorkshire*, purchased from O. Barnett, 1951

Noble, John Sargeant 1848–1896, *On the Moors*, bequeathed by John Dickinson, 1908

Nockolds, Roy Anthony 1911–1979, *Short Sunderland Flying Boat on Convoy Patrol*, gift from Short Brothers Shipbuilders, 1942

Norman, Walter 1912–1994, *Wear Tugs*, purchased from the artist, 1955

Norman, Walter 1912–1994, *River Wear, Sunderland with Shipyards*, purchased from the artist, 1955

Normand, Ernest 1857–1923, *Esther Denouncing Haman to King Ahasuerus*, purchased from Messrs A. Tooth & Sons, 1895

Ogilvie, Frank Stanley c.1856–after 1935, *Robert Cameron (1825–1913), MP*, gift from Councillor George S. Lawson and Robert Cameron, 1913

Oliver, William 1823–1901, *Mistletoe Bough*, purchased, 1888

Olsson, Albert Julius 1864–1942, *Off Cornwall*, gift from Mrs Stanfield Richardson, 1920

Olsson, Albert Julius 1864–1942, *Coast Scene, Moonlight*, gift from Mrs J. Olsson, 1957

Panini, Giovanni Paolo c.1692–1765, *Architectural Capriccio, Roman Ruins with Figures*, gift from the National Art Collections Fund, 1955

Panini, Giovanni Paolo c.1692–1765, *Architectural Capriccio, Arch of Titus with Figures*, gift from the National Art Collections Fund, 1955

Paoletti, Antonio Ermolao 1834–1912, *Little Rest, St Mark's Square*, purchased, 1890

Parker, Henry Perlee 1795–1873, *Smugglers on the Look-Out*, gift from Mr Alfred Hutchinson, 1898

Parkin, A. *Steamship Entering Sunderland Harbour*, gift from Mr G. D. Gibbons, 1980

Parton, Ernest 1845–1933, *Derbyshire Farmstead*, bequeathed by John Dickinson, 1908

Parton, Ernest 1845–1933, *Landscape in Derbyshire*, bequeathed by John Dickinson, 1908

Paterson, Emily Murray 1855–1934, *Spring Bunch*, gift from Mrs T. L. Steven, 1935

Paulson, E. active 1845–1865, *'City of Carlisle'*, purchased from Messrs Robert Thompson Shipyard, 1933

Peace, John b.1933, *Whitburn with Stormy Sky*, purchased from the Mowbray Fine Art Gallery, 1966

Pearson, Raymond active 1954, *Cornfield, Houghall, County Durham*, purchased from the artist, 1954

Peel, James 1811–1906, *Landscape in Cumberland*, purchased, 1899

Peel, James 1811–1906, *Borrowdale, Cumbria*, purchased, 1886

Peel, James 1811–1906, *Sunrise on Loughrigg, Cumbria*, gift from John Peel, before 1906

Percy, Sidney Richard 1821–1886, *Lake in North Wales*, bequeathed by John Dickinson, 1908

Perugini, Charles Edward 1839–1918, *Labour of Love*, purchased from Lister Dyson, 1899

Petersen, Jakob 1774–1854/1855, *'Favourite'*, gift from Miss J. E. Stevenson, before 1970

Pether, Sebastian 1790–1844, *The Thames at Greenwich*, bequeathed by John Dickinson, 1908

Philipson, Robin 1916–1992, *Church Interior with Chandeliers*, purchased from Messrs Roland, Browse and Delbanco with the assistance of the Victoria and Albert Museum Purchase Grant Fund, 1963, © the artist's estate

Porter, Michael b.1948, *Close to the Ground Series*, gift from the Contemporary Art Society, 1992, © the artist

Potter, J. *Roker Promenade*

Potter, J. *Roker Promenade*

Priestman, Bertram 1868–1951, *Evening on the Marshes*, unknown acquisition

Purvis, Thomas G. 1861–1933, *'SS Clan MacDougall'*, purchased from N. J. Arlidge, 1986

Pyne, James Baker 1800–1870, *Thirlmere*, bequeathed by John Dickinson, 1908

Pyne, James Baker (attributed to) 1800–1870, *View in Wales*, purchased from Mr Gilbert, 1881

Quinn, Ged b.1963, *The Happy Garden*, gift from the Contemporary Art Society, 2005, © the artist

Rae, Henrietta 1859–1928, *J. E. Dawson*, gift from the Port of Sunderland Authority, 1973

Rae, Siebel M. *It is very nice to think the world is full of meat and drink, with little children saying grace, in every kind of Christian place'* (from Robert Louis Stevenson's 'A Child's Garden of Verses'), transferred from Sunderland Borough Council, 1970

Ramsay, J. A. *Sunderland Lighthouse*, purchased from S. N. Yeadon, 1950

Ray, Richard A. 1884–1968, *A Fisherman's Home, Venice*, acquired, 1923

Ray, Richard A. 1884–1968, *Sunshine after Rain, Clymping, Sussex*, purchased from the artist, 1942

Ray, Richard A. 1884–1968, *The 'Helvellyn'*, gift from the North Eastern Shipbuilders Ltd, 1989

Read, C. Stanley active 1956–1959, *Washington Old Hall*, purchased from the artist, 1957

Read, C. Stanley active 1956–1959, *Glebe Colliery, County Durham*, purchased from the artist, 1959

Reay, John active 1838–1900, *Dr William Reid Clanny (1776–1850)*, gift from proprietors of the Exchange Building, before 1974

Richardson, Thomas Miles I 1784–1848, *Prudhoe Castle, Northumberland*, gift from the Guild of St George

Richardson, Thomas Miles I 1784–1848, *Sunderland Piers in a Storm*, transferred from the Port of Sunderland Authority, 1973

Richter, Herbert Davis 1874–1955, *Diana*, purchased from the Art Exhibitions Bureau, 1944

Rios, Luigi da 1844–1892, *The Fashion Plate*, purchased, 1888

Robertson, David Thomas 1879–1952, *Cox Green, County Durham*, purchased from Gill Bridge Antique Dealers, 1960

Robertson, David Thomas 1879–1952, *Snow on Tunstall Hills, Sunderland*, purchased from the artist, 1928

Robertson, David Thomas 1879–1952, *Dr Carruthers of Southwick*, unknown acquisition

Robinson, R. active 1797–1802, *John Emery as Tyke in Thomas Morton's 'The School of Reform'*, purchased, 1896

Roe, Robert Ernest 1852–1921, *Harbour Entrance, Sunderland*, bequeathed by A. S. Usher, 1972

Roe, Robert Ernest 1852–1921, *Between Sunderland Piers*,

purchased from Mr H. N. Milner, 1968

Rogerson, Edith Hardy *Plant Form*, purchased from the Sunderland Art Club, 1954

Rutledge, William 1865–1918, *Portrait of a Young Girl*, gift from Miss M. Mowat, 1967

Rutledge, William 1865–1918, *Walt Whitman (1819–1892)*, gift from the Guild of St George, before 1906

Sajó, Gyula 1918–1979, *Landscape with Playing Children*, purchased from the Art Exhibitions Bureau, 1961, © the artist's daughter

Sant, James 1820–1916, *General Tytche*, acquired, before 1977

Schafer, Henry c.1841–c.1900, *Interior of the Church of St Lawrence, Nuremberg, Germany*, gift from Alderman S. S. Robson, before 1974

Scott, John 1802–1885, *'SS Hiogo'*, gift from North Eastern Shipbuilders Ltd, 1989

Scott, John (attributed to) 1802–1885, *William Brockie (1811–1896)*, gift from Mrs Brockie, 1921

Scott, John Douglas b.c.1845, *Highland Loch, Rosshire, Scotland*, bequeathed by John Dickinson, 1908

Scott, John Douglas b.c.1845, *Plockton on Loch Kishorn, Rosshire, Scotland*, bequeathed by John Dickinson, 1908

Sefton, Brian b.1938, *Organic Development, Cluster*, purchased from the Mowbray Gallery, 1966, © the artist

Shackleton, William 1872–1933, *Jane with a Bowl of Roses*, gift from Mrs May Shackleton, 1938

Shayer, William (attributed to) 1788–1879, *A Farmstead, Milking Time*, bequeathed by John Dickinson, 1908

Shearer, Jacob b.1846, *The Baltic Fleet Leaving Sunderland*, transferred from the Port of Sunderland Authority, 1973

Shearer, Jacob b.1846, *Training Hulk in River Wear*, gift from the Port of Sunderland Authority, 1973

Shee, Martin Archer (circle of) 1769–1850, *James F. Stanfield*, purchased from Phillips, 1983

Sheridan, W. F. *The Sailing Ship 'Waterlily' of Sunderland* (copy of a 1817 painting), gift from Mr Elliott, 1963

Short, David T. *Still Life and Milk Bottle*, purchased from the 16th Annual Exhibition of the Sunderland Art Club, 1960

Simpson, Charles Walter 1885–1971, *Sailing through the Sunshine of Early Spring*, purchased from the Art Exhibitions Bureau, 1956, © the artist's estate

Slater, John Falconar 1857–1937, *Seascape*, gift from Mr W. M. Quenet, 1965

Slater, John Falconar 1857–1937, *Woodland Scene*, gift from E. W. Chapman, 1982

Smale, Phyllis Maud b.1897,

Wastwater, Cumbria, purchased from the Art Exhibitions Bureau, 1943

Smith, Carlton Alfred 1853–1946, *News from Abroad*, purchased, 1887

Smith, John 1841–1917, *Sunderland Harbour, 1883*, gift from the Misses Smith, 1933

Smith, John 1841–1917, *Holey Rock, Roker, Sunderland*, gift from the artist's daughter, before 1962

Smith, John 1841–1917, *Beacon Rocks, Roker, Sunderland*, gift from Mr R. A. Anderson, 1950

Smith, John 1841–1917, *Low Quay, Sunderland*, gift from the Misses Smith, 1933

Smith, Keith William b.1950, *Cornfield*, purchased from the artist, 1972

Somerville, Howard 1873–1952, *Elizabeth Woodville*, gift from Miss Winifred Adamson, 1957

Somerville, Howard 1873–1952, *Ralph Milbanke Hudson (1849–1938)*, transferred from the Port of Sunderland Authority, 1973

Somerville, Stuart Scott 1908–1983, *Dahlias*, purchased from Abbott and Holder, 1959

Somerville, Stuart Scott 1908–1983, *Early Summer Flowers*, purchased from the Art Exhibitions Bureau, 1953

Sommer, Friedrich 1830–1867, *Mountain Landscape with River*, acquired, 1975

Spear, Ruskin 1911–1990, *Cherries*, purchased from Brown, Ernest and Phillips Ltd with the assistance of the Victoria and Albert Museum Purchase Grant Fund, 1963, © the artist's estate/www.bridgeman.co.uk

Spence, M. *Carnation*, transferred from Sunderland Borough Council, 1970

Spencelayh, Charles 1865–1958, *Patience*, gift from Miss E. Summerbell, 1992, © the artist's estate/www.bridgeman.co.uk

Stanfield, Clarkson 1793–1867, *The 'Chasse Mareé' off the Gull Stream Light, the Downs in the Distance*, purchased from Phillips and Jollys with the assistance of the National Art Collections Fund and the Victoria and Albert Museum Purchase Grant Fund, 1985

Stanfield, Clarkson 1793–1867, *Lago di Garda, Italy*, purchased from Agnew's, 1901

Stanfield, Clarkson 1793–1867, *The Port of Ancona*, anonymous donation, 1988

Stanfield, Clarkson 1793–1867, *The Castle of Ischia from the Mole, Italy*, purchased from Sotheby's with the assistance of the Victoria and Albert Museum Purchase Grant Fund, 1981

Stanfield, Clarkson (follower of) 1793–1867, *St Michael's Mount, Cornwall*, purchased from C. Edwards, FRSA, 1951

Stephenson, Ian 1934–2000, *Burnt Penumbra*, gift from the Contemporary Arts Society, 1965,

© the artist's estate

Stokeld, James 1827–1877, *Fisherman's Goodnight*, purchased, 1881

Stokeld, James 1827–1877, *The Coast near Ryhope, Sunderland*, purchased from Miss B. Newrick, 1960

Stokeld, James 1827–1877, *Pipe of Peace*, gift from Captain R. N. Heard, before 1906

Stokeld, James 1827–1877, *Last Man Ashore*, purchased from Mr Marshall Hall with the assistance of the Victoria and Albert Museum Purchase Grant Fund, 1980

Stokeld, James 1827–1877, *Creature Comforts*, bequeathed by John Dickinson, 1908

Stokeld, James 1827–1877, *Giving an Estimate*, bequeathed by John Dickinson, 1908

Stokeld, James 1827–1877, *John Anderson My Jo, John*, bequeathed by John Dickinson, 1908

Stolz, M. *Dutch Fishing Boats Offshore* (after James Webb), gift from Councillor J. S. Thompson, before 1967

Storey, George Adolphus 1834–1919, *The Hungry Messenger*, purchased, 1890

Stubbs, Joseph Woodhouse 1862–1953, *Tired*, gift from Mrs Gertrude Nicholson, 1962

Suddaby, Rowland 1912–1972, *Still Life with Fruit and Flowers*, purchased from Abbott and Holder, 1962, © the artist's estate

Summers, J. *Early Voyagers, Drake Goes West, 1577–1580*, transferred from Sunderland Borough Council, 1970

Summers, J. *John Gilpin's Ride* (from William Cowper's 'The Diverting History of John Gilpin'), transferred from Sunderland Borough Council, 1970

Surtees, John 1819–1915, *River near Capel Curig, Wales*, bequeathed by John Dickinson, 1908

Surtees, John 1819–1915, *River Llugwy, near Capel Curig, Wales*, purchased, 1883

Swanwick, P. active 19th C, *Ruins on Island of Philae, on the Nile, prior to the building of the Nile Dam*, purchased, 1885

Syer, John James 1844–1912, *Sunderland Piers, 1843*, gift from Mr and Mrs Armstrong, 1960

Symons, William Christian 1845–1911, *The Little Squaw*, gift from the Contemporary Arts Society, 1923

Tate, Dingwell Burn b.1859, *Dicky Chilton's House, Bishopwearmouth Green, Sunderland*, gift, 1881

Thompson, Mark 1812–1875, *Opening of the South Dock, Sunderland*, purchased, 1850

Thompson, Mark 1812–1875, *Opening of the South Dock, Sunderland, 1850*, gift from Sir G. B. Hunter, 1930

Thompson, Mark 1812–1875, *Old South Pier, Sunderland*, gift from Mr E. F. Dix, 1943

Thompson, Mark 1812–1875, *Opening of the South Outlet, Sunderland Docks*, gift from T. Pinkney, before 1962

Thompson, Mark 1812–1875, *Fetching the Cow*, acquired, before 1970

Thompson, Mark 1812–1875, *Gout*, untraced find, c.1962

Thornley, Georges William (attributed to) 1857–1935, *Shipping off a Headland*, gift from Mr J. M. Mackay, 1964

Tift, Andrew b.1968, *Changing Face*, purchased from the artist with the assistance of the Friends of Sunderland Museum and the Museums, Libraries and Archives Council/Victoria and Albert Museum Purchase Grant Fund, 2005, © Andrew Tift

Tift, Andrew b.1968, *Welders*, purchased from the artist, 1996, © Andrew Tift

unknown artist mid-17th C, *Holy Family with the Infant St John*, unknown acquisition, before 1977

unknown artist mid-18th C, *Dr John Laurence*, gift from Mr C. P. Wallace, 1985

unknown artist mid-18th C, *Portrait of a Lady* (thought to be Mrs John Laurence), gift from Mr C. P. Wallace, 1985

unknown artist 18th C, *Elliptical Portrait of Lady Middleton*, gift from Miss M. E. Wright, 1967

unknown artist 18th C, *John Routh of Scarborough*, acquired, before 1960

unknown artist 18th C, *Mary Routh, Wife of John Routh*, acquired, before 1960

unknown artist late 18th C, *John Thornhill, Military Officer*, on loan from St John's Church

unknown artist late 18th C, *Rowland Burdon (1757–1838), MP*, purchased from Peter Schweller Fine Art, 2000

unknown artist *Portrait of a Young Man*, acquired, before 1974

unknown artist *Robert Thompson (1748–1831)*, transferred from the Port of Sunderland Authority, 1973

unknown artist *Hylton Castle, Sunderland*, gift from Miss F. Armstrong, 1968

unknown artist *William Pile's Shipyard, North Sands, Sunderland*, bequeathed by Mrs M. I. Pile, 1948

unknown artist *Sunderland, Races at Tunstall Hope*, acquired, before 1974

unknown artist *Bede Tower, Sunderland*, on loan from Sunderland Antiquarian Society

unknown artist *John Chisholm*, gift from Mr Richard Abbott, 1999

unknown artist mid-19th C, *Bantry Bay, County Cork, Ireland*, gift from Mr M. B. Short, 1953

unknown artist mid-19th C, *Coast with Windmills*, gift from Alderman W. Burns, 1896

unknown artist mid-19th C, *The 'Bankside'*, purchased from Andrew Gray Antiques, 1985

unknown artist mid-19th C, *The 'Halcyon'*, gift from Miss A. Robinson, 1983

unknown artist mid-19th C, *Wind Freshening off Hull*

unknown artist 19th C, *Coastal Shipping*, acquired, before 1977

unknown artist 19th C, *Dutch Coast Scene with Windmill*, acquired, before 1978

unknown artist 19th C, *Marguerite Leaving the Cathedral*, anonymous gift, before 1906

unknown artist 19th C, *Marine Study, Passengers Boarding a Man-of-War*, gift from Mr J. W. Corder, 1947

unknown artist 19th C, *Mary Haddock of Sunderland*, acquired, before 1967

unknown artist 19th C, *William Haddock of Sunderland*, acquired, before 1967

unknown artist 19th C, *Naval Engagement*, gift from T. Pinkney, 1886

unknown artist 19th C, *Palazzo Donn'Anna, Bay of Naples*, gift from Mr E. Robson, 1936

unknown artist 19th C, *Portrait of a Clergyman*, acquired, before 1978

unknown artist 19th C, *Portrait of a Man*

unknown artist 19th C, *Portrait of a Man, Holding a Book*

unknown artist 19th C, *Portrait of a Man, Seated*, acquired, before 1977

unknown artist 19th C, *Scottish Highlands with Horse Riders*, gift from Councillor W. L. Wilbarn, 1944

unknown artist 19th C, *SS 'Buenos Aires'*, on loan from the Sunderland Shipbuilders

unknown artist 19th C, *Still Life with Fruit*, gift from Councillor W. L. Wilbarn, 1944

unknown artist 19th C, *The Barque 'Vanora'*, gift from Robert Crozier, 1962

unknown artist 19th C, *View of Sunderland from the Tunstall Hills*, on loan from the Sunderland Antiquarian Society

unknown artist late 19th C, *George Robert Booth*, transferred from the Port of Sunderland Authority, 1973

unknown artist late 19th C, *John George Lambton (1855–1928), 3rd Earl of Durham*, transferred from the Port of Sunderland Authority, 1973

unknown artist late 19th C, *'Luzon'*, gift from Mrs Ann Cable, 1948

unknown artist late 19th C, *Portrait of a Man*, gift from Mrs Simpson, 1968

unknown artist late 19th C, *Portrait of a Man*, gift from Mrs Isobella Symes Eccles, 1970

unknown artist late 19th C, *River Wear at Cox Green near the Penshaw Monument*, on loan from a private individual

unknown artist early 20th C, *The Wear at Fatfield*, acquired, before 1974

unknown artist *Alderman Thompson (1833–1841)*

unknown artist *Girdle Cake Cottage*

unknown artist *Vessel at Sea**

Vaughan, John Keith 1912–1977, *Mykonos, Greece*, gift from the Contemporary Arts Society, 1968, © the estate of Keith Vaughan/DACS 2008

Verboeckhoven, Charles Louis 1802–1889, *The Rising Tide*, gift from Councillor William Wilson, 1881

Ward, Edward Matthew 1816–1879, *Anne Boleyn at the Queen's Stairs*, purchased, 1893

Ward, James (attributed to) 1769–1859, *The Watering Place*, bequeathed by Mr T. Thompson, 1895

Warren, Charles Knighton b.1856, *Egyptian Musician*, purchased, 1881

Waterhouse, Nora active 1963, *Still Life*, purchased from the Sunderland Art Club, 1962

Waterhouse, Nora active 1963, *View from a Bridge*, purchased from the Sunderland Art Club, 1960

Waterlow, Ernest Albert 1850–1919, *Sunset in the Wengen Alps, Switzerland*, gift from Lady Ernest Waterlow, 1928

Waterlow, Ernest Albert 1850–1919, *Autumn on the Somme, France*, purchased via public subscription, 1920

Watson, James Finlay 1898–1981, *London Backwater, near St Pancras*, purchased from the artist, 1955

Watson, Robert F. 1815–1885, *Dutch Trawlers*, unknown acquisition, 1881

Wells, Denys George 1881–1973, *The 'William and Mary' Chair*, purchased from the Art Exhibitions Bureau, 1956

Weyts, Carolus Ludovicus 1828–1876, *The 'Elizabeth' of Sunderland*, gift from Miss A. Anderson, 1955

Whitfield, Joshua 1884–1954, *Barrow Boys, Union Street*, gift from Mrs Catherine Akinhead, 1983

Whitfield, T. W. Allan b.1944, *Untitled*, purchased from the artist, 1967, © the artist

Wilkie, C. *The Tower at Doxford's Crossing, Pallion, Sunderland*, gift from Mrs E. Donaldson, 1957

Williams, Alfred Walter 1824–1905, *Autumn Morning, Isle of Skye*, purchased from Mr Gilbert, 1881

Wollen, William Barnes 1857–1936, *The Ambush, 1745*, gift from Mr J. G. Simpson, 1945

Wood, Frank *John Sealing the Magna Carta 1215*, transferred from Sunderland Borough Council, 1970

Wood, Frank 1904–1985, *Westerhope Burn*, purchased from the artist, 1946

Wood, Lewis John 1813–1901, *Kiln in the Wood*, gift from Mr R. J. Francis, 1958

Wray, R. W. *Beam Engine 1712/ Locomotive 1825*, transferred from Sunderland Borough Council, 1970

Collection Addresses

Gateshead

Shipley Art Gallery
Prince Consort Road
Gateshead NE8 4JB
Telephone 0191 477 1495

Newcastle upon Tyne

Laing Art Gallery
New Bridge Street
Newcastle upon Tyne NE1 8AG
Telephone 0191 232 7734

Tyne & Wear Museums Maritime and
Industrial Collection
Discovery Museum
Blandford Square
Newcastle upon Tyne NE1 4JA
Telephone 0191 232 6789

South Tyneside

South Shields Museum and Art Gallery
Ocean Road
South Shields NE33 2JA
Telephone 0191 456 8740

Sunderland

Sunderland Museum and Winter Gardens
Burdon Road
Sunderland SR1 1PP
Telephone 0191 553 2323

Index of Artists

In this catalogue, artists' names and the spelling of their names follow the preferred presentation of the name in the Getty Union List of Artist Names (ULAN) as of February 2004, if the artist is listed in ULAN.

The page numbers next to each artist's name below direct readers to paintings that are by the artist; are attributed to the artist; or, in a few cases, are more loosely related to the artist being, for example, 'after', 'the circle of' or copies of a painting by the artist. The precise relationship between the artist and the painting is listed in the catalogue.

Supporters of the Public Catalogue Foundation

Master Patrons

The Public Catalogue Foundation is greatly indebted to the following Master Patrons who have helped it in the past or are currently working with it to raise funds for the publication of their county catalogues. All of them have given freely of their time and have made an enormous contribution to the work of the Foundation.

Peter Andreae (*Hampshire*)
Sir Henry Aubrey-Fletcher, Bt, Lord Lieutenant of Buckinghamshire (*Berkshire and Buckinghamshire*)
Sir Nicholas Bacon, DL, High Sheriff of Norfolk (*Norfolk*)
Peter Bretherton (*West Yorkshire: Leeds*)
Richard Compton (*North Yorkshire*)
George Courtauld, DL, Vice Lord Lieutenant of Essex (*Essex*)
The Marquess of Downshire (*North Yorkshire*)
Jenny Farr, MBE, DL, Vice Lord Lieutenant of Nottinghamshire (*Nottinghamshire*)
John Fenwick (*Tyne & Wear Museums*)

Mark Fisher, MP (*Staffordshire*)
Patricia Grayburn, MBE DL (*Surrey*)
The Lady Mary Holborow, Lord Lieutenant of Cornwall (*Cornwall*)
Tommy Jowitt (*West Yorkshire*)
Sir Michael Lickiss (*Cornwall*)
Lord Marlesford, DL (*Suffolk*)
Malcolm Pearce (*Somerset*)
The Most Hon. The Marquess of Salisbury, PC, DL (*Hertfordshire*)
Julia Somerville (*Government Art Collection*)
Phyllida Stewart-Roberts, OBE, Lord Lieutenant of East Sussex (*East Sussex*)
Leslie Weller, DL (*West Sussex*)

The Public Catalogue Foundation is particularly grateful to the following organisations and individuals who have given it generous financial support since the project started in 2003.

National Sponsor

Christie's

Benefactors (£10,000–£50,000)

The 29th May 1961 Charitable Trust
City of Bradford Metropolitan District Council
Deborah Loeb Brice Foundation
The Bulldog Trust
A.& S. Burton 1960 Charitable Trust
Christie's
The John S. Cohen Foundation
Department for Culture. Media and Sport
Sir Harry Djanogly, CBE
Mr Lloyd Dorfman
Fenwick Ltd
The Foyle Foundation

Hampshire County Council
The Charles Hayward Foundation
Heritage Lottery Fund
Peter Harrison Foundation
Hiscox plc
David Hockney CH, RA
ICAP plc
Kent County Council
The Linbury Trust
The Manifold Trust
Robert Warren Miller
The Monument Trust
Miles Morland
National Gallery Trust